Essential
MONET

First published in 1999 by Dempsey Parr
Dempsey Parr is an imprint of Parragon

Parragon
Queen Street House
4 Queen Street
Bath BA1 1HE

Copyright © Parragon 1999

Created and produced for Dempsey Parr by
FOUNDRY DESIGN AND PRODUCTION,
a part of The Foundry Creative Media Co. Ltd
Crabtree Hall, Crabtree Lane
Fulham, London, SW6 6TY

ISBN: 1-84084-514-7

Printed and bound in Singapore.

Essential
MONET

VANESSA POTTS

Introduction by Dr Claire O'Mahony

DP

DEMPSEY
PARR

Contents

Introduction6

Dandy au Cigare/Dandy with a Cigar16

Petit Panthéon Théâtral/Little
Theatrical Group............................18

Trophée de Chasse/Sporting Prizes...................20

La Rue de la Bavolle à Honfleur/Bavolle
Street, at Honfleur22

Le Déjeuner sur l'Herbe/The Picnic
on the Grass24

Camille ou la Femme à la Robe Verte/
Camille (Woman in the Green Dress)26

Femmes au Jardin/Women in the Garden ..28

*Jeanne-Marguerite, le Cadre au
Jardin*/Jeanne-Marguerite, the Image in
the Garden..................................30

Camille au Petit Chien/Camille
with a Little Dog32

*La Charrette, Route sous la Neige à
Honfleur*/The Cart, Route through the Snow
at Honfleur..................................34

Portrait d'Homme/Portrait of a Man36

*La Route de la Ferme, St-Simeon en
Hiver*/The Road to the Farm,
St-Simeon in Winter38

Glaçons sur la Seine à Bougival/Ice Floes
on the Seine at Bougival40

Terrasse à Ste-Adresse/Terrace at Ste-Adresse.....42

Portrait de Madame Gaudibert/Portrait of Madame
Gaudibert...................................44

*Voltigeurs de la Garde Flanant au Bord de
l'Eau*/Soldiers Strolling by the Riverside46

Camille sur la Plage/Camille on the Beach48

Sur la Plage à Trouville/On the Beach at
Trouville....................................50

La Plage à Trouville/The Beach at Trouville52

Chasse-Marée à l'Ancre, Rouen/Fishing Boat at
Anchor, Rouen54

Bateaux de Plaisance/Pleasure Boats56

Carrières-St-Denis58

Nature Morte au Melon/Still Life
with Melon60

La Liseuse/The Lover of Reading...................62

La Capeline Rouge, Portrait de Madame Monet/The
Red Cape, Portrait of Madame Monet64

La Falaise de Ste-Adresse/Ste-Adresse Cliffs66

Boulevard des Capucines..........................68

Zaandam70

La Zuiderkerk à Amsterdam/Zuiderkerk at
Amsterdam72

Impression, Soleil Levant/Impression,
Sunrise74

Les Coquelicots a Argenteuil/Poppies
at Argenteuil................................76

Le Pont de Chemin de Fer, Argenteuil/
The Railway Bridge, Argenteuil78

Au Pont d'Argenteuil/The Bridge
at Argenteuil................................80

Au Pont d'Argenteuil/The Bridge
at Argenteuil82

Femme Assise sur un Banc/Woman
Seated on a Bench.........................84

Les Déchargeurs de Charbon/
Unloading Coal.............................86

La Japonaise/The Japanese Woman...................88

Un Coin d'Appartement/A Corner
of the Appartment90

En Promenade près d'Argenteuil/
Walking near Argenteuil92

Les Dindons/The Turkeys.........................94

Le Pont de l'Europe, Gare St-Lazare/
Europe Bridge, St Lazare Station96

La Route à Vétheuil/The Road to Vétheuil.......98

Chrysanthèmes/Chrysanthemums100

L'Escalier/The Stairs102

Pommiers près de Vétheuil/Apple
Trees near Vétheuil104

*La Rue Montorgeuil Fête du 30 Juin
1878*/Montorgeuil Street Fete,
30 June 1878106

Le Givre/The Frost.............................108

L'Eglise à Vétheuil, Neige/The Church
at Vétheuil in the Snow110

Portrait de Michel Monet Bébé/Portrait
of Michel Monet as a Baby......................112

Portrait de Jeunesse de Blanche Hoschedé/
Portrait of the Young Blanche Hoschedé.....114

Portrait de Michel en Bonnet à Pompon/
Portrait of Michel in a Pompom Hat..........116

Portrait de Jean Monet/Portrait of
Jean Monet.................................180

Le Jardin de Vétheuil/The Garden
at Vétheuil120

Fleurs à Vétheuil/Flowers at Vétheuil..............122

*Barques de Pêche devant la Plage et les Falaises de
Pourville*/Fishing Boats in front of the Beach
and the Cliffs of Pourville...........................124

Chemin dans les Blés à Pourville/Path
through the Corn at Pourville126

La Plage à Pourville, Soleil Couchant/
The Beach at Pourville, at Sunset...............128

Les Galettes/The Cakes..........................130

Eglise de Varengeville, Effet du Matin/
Varengeville Church, Morning Effect..........132

*La Chemin Creux dans la Falaise de
Varengeville*/The Path through the
Hollow in Varengeville Cliff.....................134

❋ CONTENTS ❋

La Seine à Port-Villez/The Seine at
Port-Villez...136

Le Château de Dolceacqua/
The Dolceacqua Château138

Etreat, la Plage et la Falaise d'Aval/
Etreat, the Beach and the Aval Cliff140

Bordighera ...142

Le Cap Martin ...144

Portrait de l'Artist dans son Atelier/
Portrait of the Artist in his Studio146

Portrait de Poly/Portrait of Poly148

L'Eglise à Bellecoeur/The Church
at Bellecoeur ..150

Glaïeuls/Gladioli...152

Tempête, Côtes de Belle-Ile/Storm on
the Coast of Belle-Ile154

Les Roches de Belle-Ile/The
Belle-Ile Rocks ..156

Champ de Tulipes, Hollande/Tulip
Field, Holland...158

Essai de Figure en Plein Air (Vers la Gauche)/
Study of a Figure Outdoors (Facing Left) ...160

La Barque/In the Rowing Boat162

Champ d'Iris Jaunes à Giverny/Field
of Yellow Irises at Giverny........................164

Prairie de Limetz/Limetz Meadow..................166

Vue d'Antibes/View of
Antibes...168

Antibes, Vue de Cap, Vent de Mistral/Antibes, View
of the Cape in the Mistral Wind170

Antibes, Vue de la Salis/Antibes,
View of the Fort ..172

Paysage avec Figures, Giverny/
Landscape with Figures, Giverny.................174

Creuse, Soleil Couchant/The
Creuse, at Sunset..176

Vallée de la Creuse, Effet du Soir/Valley
of the Creuse, Evening Effect.....................178

Peupliers au Bord de l'Epte/Poplars,
on the Bank of the Epte180

Blanche Hoschedé Peignant/Blanche
Hoschedé Painting......................................182

*Vue de Rouen depuis la Côte de Ste
Catherine*/View of Rouen
near the Coast of Ste Catherine.................184

La Seine à Bennicourt, Hiver/The
Seine at Bennicourt, in Winter....................186

Les Meules, Effet du Soir/Haystacks,
Evening Effect..188

Les Meules/The
Haysheaves ...190

La Seine près de Giverny/The
Seine near Giverny192

La Cathédrale de Rouen, Effet de Soleil/
Rouen Cathedral, Sunlight Effect194

Norvège, les Maisons Rouges à Bjornegaard/Norway,
the Red
Houses at Bjornegaard................................196

Paysage Norvège, les Maisons Bleues/
Norwegian Landscape, the Blue Houses......198

Le Mont Kolsaas en Norvège/Mount
Kolsaas in Norway200

Le Mont Kolsaas en Norvège/Mount
Kolsaas in Norway202

Bras de la Seine près de Giverny/Branch
of the Seine near Giverny204

Matinée sur la Seine, Effet de Brume/
Morning on the Seine, Mist Effect..............206

Matinée sur la Seine, Effet de Brume/
Morning on the Seine, Mist Effect..............208

Sur la Falaise près de Dieppe/On the
Cliffs near Dieppe210

Le Bassin aux Nympheas, Harmonie Verte/
Water Lily Pond, Harmony in Green..........212

Le Bassin aux Nympheas, les Iris d'Eau/
Water Lily Pond, Water Irises214

Vétheuil..216

La Seine à Port-Ville/The Seine
at Port-Ville ...218

Waterloo Bridge...220

Charing Cross Bridge, La Tamise/
Charing Cross Bridge, The Thames.............222

Le Parlement, Couchant de Soleil/
The Houses of Parliament at Sunset224

Gondole à Venice/Gondolas at Venice...............226

Le Grand Canal et Santa Maria della Salute/The
Grand Canal and Santa Maria della Salute ..228

Le Palais de Mula/Venice, Palazzo da Mula.....230

Nympheas/Water Lilies232

Nympheas/Water Lilies234

Nympheas/Water Lilies236

Nympheas/Water Lilies238

Les Hemerocalles/Hermerocallis240

Le Pont Japonais/The Japanese Bridge242

Le Pont Japonais/The Japanese Bridge244

La Maison d'Artist Vue de Jardin aux Roses/The
Artist's House Seen from the Rose Garden .246

La Maison Vue du Jardin aux Roses/
The House Seen From the Rose Garden....248

Iris Jaunes/Yellow Irises 250

Iris ...252

Les Roses/The Roses.....................................254

INTRODUCTION

CLAUDE OSCAR MONET is in many senses the quintessential Impressionist painter. The spontaneity and vivacity of his painting technique and his devotion to the close observation of nature have been the focus of most discussions of his art. However, the range of his subject matters, the complexities of his exhibiting strategies and his responses to the variety of artistic and socio-historical transformations experienced during his long lifetime are fundamental to understanding his unique contribution to the history of art.

Born in 1840 in Paris, where his father was a wholesale grocer,

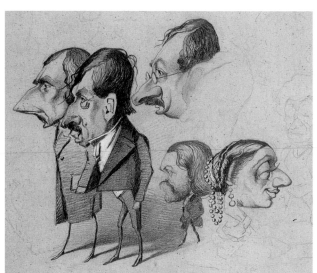

Monet lived in Le Havre from the age of five; the Normandy region was to be a vital influence on him throughout his life. His earliest artistic reputation was as a caricaturist, but by the mid-1850s Monet, with the encouragement of the atmospheric landscape painter Eugène Boudin (1824–98), had begun to paint from the motif in the open-air.

Monet's artistic career began in earnest with his first trip to Paris in 1859. On his arrival in the capital he was befriended by a number of painters associated with the Realist movement, most notably the Brabizon painter Constant Troyton (1810–65) and the young Camille Pissarro (1830–1903). He also received his first formal training, becoming a pupil for two years in the studio of the academic painter Charles Gleyre (1808–74). It was there that he made a number of artistic friendships that were to have a formative influence on him; he met Pierre Auguste Renoir (1841–1919), Frédéric Bazille (1841–70) and Alfred Sisley (1839–99).

Despite legends stating the contrary, Monet had a degree of success at provincial exhibitions as well as at the annual state-sponsored art exhibition held in Paris each year in May, the Salon. In 1865,

having made painting trips to the forest of Fontainebleau and the Normandy coast at Honfleur and Le Havre, where he met the Dutch open-air landscape painter Johan Barthold Jongkind (1819–91), Monet sent two of his seascapes to the Salon exhibition, and they were accepted. A portrait of his mistress, Camille Doncieux, and a landscape were also accepted in 1866 and another seascape in 1868.

Inspired in part by the controversial paintings Edouard Manet (1832–83) was producing in the last years of the 1860s, Monet began to wrestle with subjects derived from the modern life of Paris. The capital had been undergoing a process of extraordinary transformation on the initiative of Emperor Napoleon III's prefect, Baron Haussmann. 'Haussmannisation' cut a series of huge boulevards, lined with large-scale expensive apartment blocks and arcades of shops, through the city's labyrinthine medieval streets, so beloved of an earlier generation of Romantic poets and artists. These changes necessitated the transplantation of the workers of Paris – who had lived in small upper rooms of the old buildings above the more lavish apartments of wealthier Parisians – to a new region of suburbs beyond the city walls. Monet, like many artists of the Impressionist circle, became fascinated with both the new phenomena of boulevard culture and the suburban districts, in which many pleasure spots blossomed alongside the factories on the banks of the river Seine.

Monet's technique and style reflect a wonderful awareness of the achievements of his teachers and contemporaries while also creating a unique and constantly transforming personal vision. The young Monet synthesised the open-air techniques practised by Boudin and Jongkind and theorised by the drawing master Lecoq de Boisbaudran with the controversial subject matter of modern experience. The more abrupt handling and traditional palette of his earliest works were derived from the manner of Realist painters such as Gustave Courbet (1819–77) and followers of the Brabizon School. In the following decades, Monet moved away from the traditional modelling in black and white, known as *chiaroscuro*, to a sense of depth and volume created entirely through colour relationships. Rather than using the dark reddish-brown

underpainting typical of the nineteenth century, Monet began to paint on canvases primed in white or light beige tones to enhance the brilliance of his colours.

Monet experimented with varying degrees of finish throughout his career, although it was not until the 1880s that he would exhibit his most sketchy works publicly. (Sketches such as the famous paintings of La Grenouillère and the beach at Trouville, now in the National Gallery, London, were almost certainly intended as private notations rather than as works for public exhibition.) However, his practice of building up a work was to be fairly consistent throughout his life. He

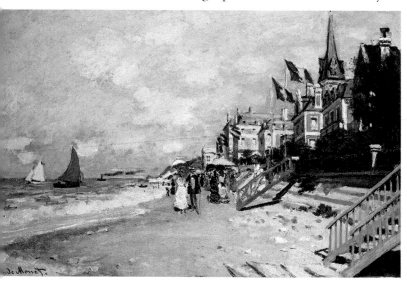

would first lay in the main elements of the composition in the appropriate colours in a loose underpainting, and he would then work up all these areas in a range of broad contours and small surface brushstrokes, as fitting to the feature being described. Despite his protestations in later life, this process of elaboration was not always performed in front of the subject, but rather over a

period of days or often months in the studio, as Monet's letters of the 1880s to the dealer Durand-Ruel testify.

Many of Monet's views of Paris from the 1860s adopt unusual viewpoints and incorporate ambiguous hints of narratives about the relationships of the tiny figures evoked through his summary brushstrokes. The overall effects of these compositional devices had many precedents, not only the unusual perspectives typical of the Japanese prints of which Monet was an avid collector, but also his awareness of the world of the *flâneur* described with such verve in Charles Baudelaire's *The Painter of Modern Life*. This delightful and influential essay, which nominally describes the achievement of

Constantin Guys (1802–92), a draughtsman who evocatively captures the fashions and social types of the Second Empire, articulates the unique freedom and anonymity available to the young man as he wanders around absorbing the spectacle of the new Paris. Monet eloquently captures this mood of exploration and mystery in his aloof aerial views of the manicured public gardens, bridges and boulevards at the heart of Paris and the chance encounters of its suburban fringes.

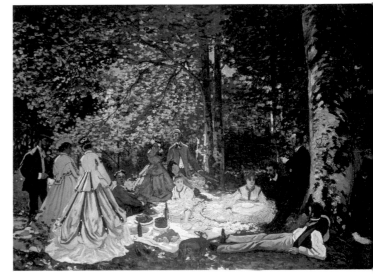

In 1866, Monet began his response to Manet's scandalous painting *Déjeuner sur l'Herbe*, which had been rejected by the Salon of 1863 on the grounds of indecency, with a monumental painting of a picnic enjoyed by elegant Parisian men and women. Regrettably, it never came to fruition, and only a sketch and a few fragments survive. Monet did complete a second large-scale painting of fashionable women at play, *Women in the Garden*, which he executed entirely in the open air. However, it was rejected by the Salon of 1867. This was a period of some personal and professional strain for Monet. His mistress Camille was pregnant with their son Jean and, although Monet's father had been supportive of his son's artistic career, he would not tolerate this romantic alliance. Suffering financial difficulties, Monet returned to the family home in Le Havre and left Camille in Paris. However, they were reunited after Jean's birth, living first at Etretat and then in Bougival, where Renoir and Pissarro were frequent visitors and colleagues on sketching trips around suburban pleasure spots such as the floating restaurant, La Grenouillère.

In 1870, Monet and Camille were married and made a honeymoon trip to Trouville, a resort on the Normandy coast. With the outbreak of the Franco-Prussian War in July of 1870, the Monets took the decision to flee to London. A number of other artistic figures

had also left for London, including, most significantly for Monet, the leading art dealer Paul Durand-Ruel, who soon became a vitally important and lifelong patron for Monet and the Impressionist circle. During the nine months the family spent in London, Monet painted numerous views of the city's parks and of the River Thames. After travelling through Holland in the summer, where he painted at Zaandam near Amsterdam, the Monets returned to France and settled in a suburb to the west of Paris called Argenteuil. Monet remained there until 1878, and many of his friends – Renoir, Sisley, Gustave Caillebotte (1848–94) and Manet – joined him there to paint the life of the river Seine, a site of pleasure boating, swimming and river cafés as well as a burgeoning industrial town.

Durand-Ruel had been an avid buyer for these paintings, but in 1873 he suffered financial losses. Monet and his friends had to find a new set of patrons, and they embarked on planning an independent exhibition to draw attention to their work. On the Boulevard des Capucines in the studio of Nadar, a leading photographer of the day, the Société Anonyme des Peintres, Sculpteurs et Graveurs held its first exhibition in April of 1874. A contemporary critic coined the term 'Impressionism' in response to Monet's unusually sketchy view in greyish-blue and orange of the industrial harbour at Le Havre

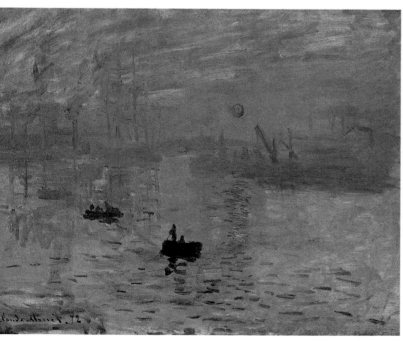

enshrouded in fog entitled *Impression, Sunrise*. This exhibition achieved a certain notoriety, although it did little to raise the prices that the artists could ask for their works, as proved by the 1875 auction of the Jean-Baptiste Fauré collection of works by Berthe Morisot (1841–95), Renoir and Sisley. Monet also showed paintings at the second, third, fourth and

seventh of the eight exhibitions mounted by the Impressionist group between 1876 and 1884.

Monet met Ernest Hoschedé and his wife Alice in 1876, and they were to play an important role in his later life. Hoschedé commissioned Monet to paint four paintings to create a decorative ensemble for the main receiving-room at his home just outside Paris, the Château de Rottembourg at Montgeron. After Hoschedé's bankruptcy and the birth of Monet's second son, Michel, in 1878, the two couples and their eight children decided to form a joint household in Vètheuil. However, Camille, who seemingly had a disease of the womb, died in the autumn of the next year. Alice Hoschedé and Monet were to form an open, rather unconventional relationship that may have contributed to Monet's gradual distancing from his Parisian painter friends and their exhibitions.

Though intimate, the couple lived largely autonomous lives. Although Ernest Hoschedé had created a separate life for himself in the 1880s, Monet and Alice did not marry until after Ernest's death in 1892. After a brief sojourn in Poissy, the family moved to their now-famous house in Giverny. They rented this house until Monet was able to purchase it in 1890, due to a new-found affluence achieved in a large part by Durand-Ruel's adept and financially rewarding cultivation of American collectors interested in purchasing Monet's works. The family were to spend the rest of their lives at Giverny.

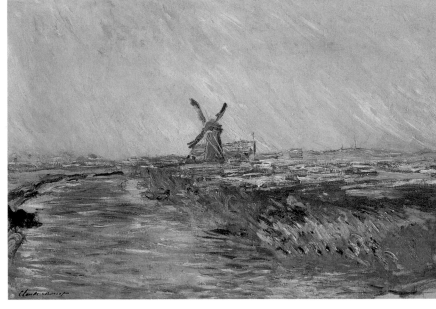

With Alice caring for his children, Monet embarked on a period of frequent painting trips to picturesque corners of France throughout the 1880s. He returned several times to the Normandy and Brittany

coasts, as he had always done, but now he chose to paint the more remote sites rather than the tourist-filled resorts. The Parisians at play in Trouville and Ste-Adresse, celebrated in his canvases of the 1860s, gave way to the lonely tempest-tossed shores and rock pools of Fécamp and Pourville and the majestic isolation of the hilltop church at Varengeville in 1881 and 1882. He found a favourite motif in the dramatic cliffs and needles of Etretat (a subject made famous a decade before by Courbet). He returned there in 1883, 1885 and 1886, when he also painted many views of Belle-Ile off the southern coast of Brittany. In 1886, Monet also began to explore more distant regions within France and even the tulip fields of Holland. His life-long fascination with the cool light and coastal storms of the north was coupled with new explorations of the warm brilliance of the Mediterranean. He visited the south-eastern tip of France, painting Bordighera, Antibes and Juan-les-Pins in 1884 and 1889. He also travelled to the Creuse Valley in the heart of France in 1889.

The 1880s and '90s saw a shift of focus in Monet's life on many levels, in the kind of subject matter he explored, the venues he selected for exhibiting his works and the huge success and fame which he achieved. Like so many artists and writers at the end of the nineteenth century, he became dissatisfied with the themes of modernity and urban experience. His art became much more focused on a world of personal sensation before the wonders of nature. A monumental, decorative quality creeps in to his late works. Rather than the external spectacle that delighted Manet and Baudelaire, these paintings offer private spaces of contemplation which engulf the viewer in their gentle colour harmonies and bold compositions. These paintings achieve a world of escape and private reverie which was analogous to the artistic ambitions championed by the Symbolist painters and poets and Art Nouveau designers.

These new subjects not only widened Monet's own experience and modes of expression but also they attracted keen buyers and dealer-patrons. After the acceptance to the Salon of a painting of an ice floe in 1880, Monet embarked on a new cycle of one-man and

group exhibitions with several of the leading private art dealers of the day. In 1883 Monet held a one-man show at the gallery of his old friend and supporter Durand-Ruel. He participated in the group shows organised by Georges Petit in 1885, 1886 and 1887. This relationship with Petit culminated in a retrospective of Monet's work in 1889 which confirmed the popularity and sales of his work. On his return from the trips to Antibes, Monet also exhibited 10 paintings with the dealers Boussod and Valadon, which their manager, Theo van Gogh, had purchased. Interestingly, Monet ended this hugely successful exhibition by refusing one of the highest accolades from the French state, the *légion d'honneur*. While rejecting honours for himself, he sought a place in the nation's museums for his mentor Manet by orchestrating a campaign of subscriptions to pay for the purchase of the famously scandalous and innovative painting of a Parisian courtesan, *Olympia*, of 1865.

The artistic explorations undertaken on Monet's many painting trips of the 1880s were essentially preliminary work for his great series paintings of the 1890s. In the series, Monet would select a particularly resonant site and subject, such as grainstacks, poplar trees on the River

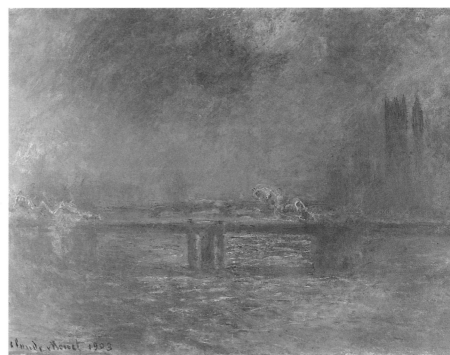

Epte or the façade of Rouen Cathedral, and paint suites of paintings portraying the motif under various different conditions of light and season. These series lay at the heart of Monet's public exhibiting career in the last decade of the nineteenth century. In a one-man exhibition held in Durand-Ruel's gallery in 1891, Monet included 15 paintings

from the grainstack series. He also created single-theme exhibitions for subsequent motifs throughout the following years. He showed the poplars at Durand-Ruel's gallery in 1892, the façade of Rouen Cathedral in 1893, the first water-garden series in 1900, the London views in 1904 and a series of 48 water lily paintings, known as 'waterscapes', in 1909. The views of Pourville and of early mornings on the Seine were included in his one-man exhibition at the Georges Petit Gallery in 1898, and the Venice views were shown at the Bernheim-Jeune Gallery in 1912.

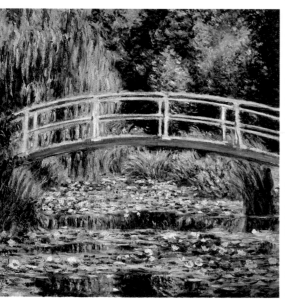

Monet's other great artistic project of the 1890s was the creation of his water garden at Giverny. As soon as he had purchased the house, he began to create an elaborate flower garden incorporating every shade of colour and variety of bloom – a palette made of flowers. In 1893, he had the opportunity to buy a second plot of land on the opposite side of the road and railway track which run through the property to this day. Monet elaborated on the indigenous pond and stream by gaining planning permission to alter the flow of water entering the stream and by repeatedly enlarging the pond in 1901 and 1910. Perhaps his most dramatic addition was a bridge, of typical arched Japanese design, which he built at one end of the pond. This peaceful idyll of his own devising was to be Monet's final subject, which he painted daily for 20 years.

The water lily series paintings led Monet to his last great project: the decorations for the Orangerie. Decorative painting had witnessed an extraordinary revival in the last quarter of the nineteenth century in both official and more esoteric artistic circles. In a speech at the awards banquet for the Salon of 1879, Jules Ferry, Minister of Fine Arts and Education, had called for the decoration of all France's public buildings. Town halls, schools, churches and museums throughout France were decorated with vast mural schemes celebrating the Third

Republic. This revival of decorative art was paralleled among a set of wealthy patrons who commissioned numerous decorative paintings to ornament the salons of their villas. Similarly, many leading restaurants, such as Maxime's and Le Train Bleu, the latter built at the Gare de Lyon for the World Fair of 1900, sought sympathetic decorative schemes to enhance the Belle Epoque elegance of their dining-rooms. Leading artists from every aesthetic camp of the day were commissioned to create these decorations, from the members of the Nabis group, such as Pierre Bonnard (1867–1947) and Edouard Vuillard (1868–1940), to leading Salon painters such as Albert Besnard (1849–1934) and Henri Gervex (1852–1929).

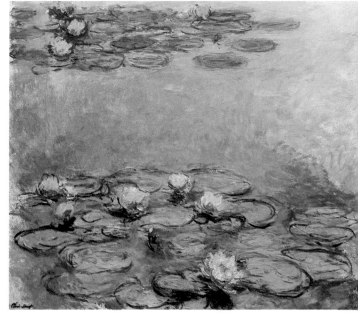

The powerful Republican politician Georges Clemenceau was a close friend and a vociferous champion of Monet's painting. Concerned at his friend's gloom after the death of both his beloved wife Alice in 1910 and his elder son Jean in 1914, Clemenceau cajoled the old painter to embark on a colossal decoration inspired by the water garden. Monet built a special studio in his garden so that he could work in comfort on such monumental proportions. In 1918, he decided to donate the work to the French state. Despite suffering from cataracts in both eyes, Monet worked on the project continuously until his death in 1926. Initially, the ensemble was to be housed in a specially built pavilion in the grounds of the Hôtel Biron (now the Musée Rodin), but in 1921 it was announced that the murals would be housed in the Orangerie in the Tuilleries Gardens near the Louvre. The architect Camille Lefèvre designed two oval rooms at ground level to house the paintings, and they were opened to the public on 16 May 1927.

Dr Claire O'Mahony

DANDY AU CIGARE (c. 1857–58)
Dandy with a Cigar

Musée Marmottan. Courtesy of Giraudon

MONET started his artistic career as a caricaturist in his home town. His caricatures were displayed in the local frame shop, where they attracted much attention because he frequently used well-known and therefore recognisable people from Le Havre as his subjects. Thanks to the success of these caricatures, Monet was able to save enough money to study art in Paris.

The frame shop manager also displayed landscapes by the then more famous artist Eugène Boudin (1824–98). This effected an introduction between the two artists, and Boudin took Monet painting with him on many occasions. Boudin believed that an artist should have a full experience with his art and complete the entire landscape outdoors. This was unheard of before Boudin and became known as *plein-air* technique. Monet embraced this concept wholeheartedly, and it became an important feature of his work throughout his career.

Dandy au Cigare is a typical caricature, complete with exaggerated features and the recognisable accessories of a dandy. The oversized cigar distorts the face, rendering the man ridiculous. In the more serious *Portrait de Poly* (1886), Monet retains some sense of the caricature that is especially obvious with the treatment of the sitter's large red nose. Notice this dandy has a similar affliction.

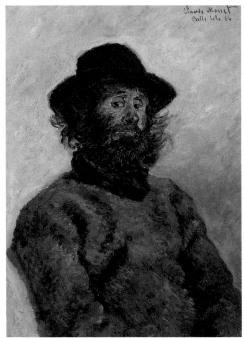

Portrait de Poly (1886)
Portrait of Poly
Musée Marmottan. Courtesy of Giraudon. (See p. 148)

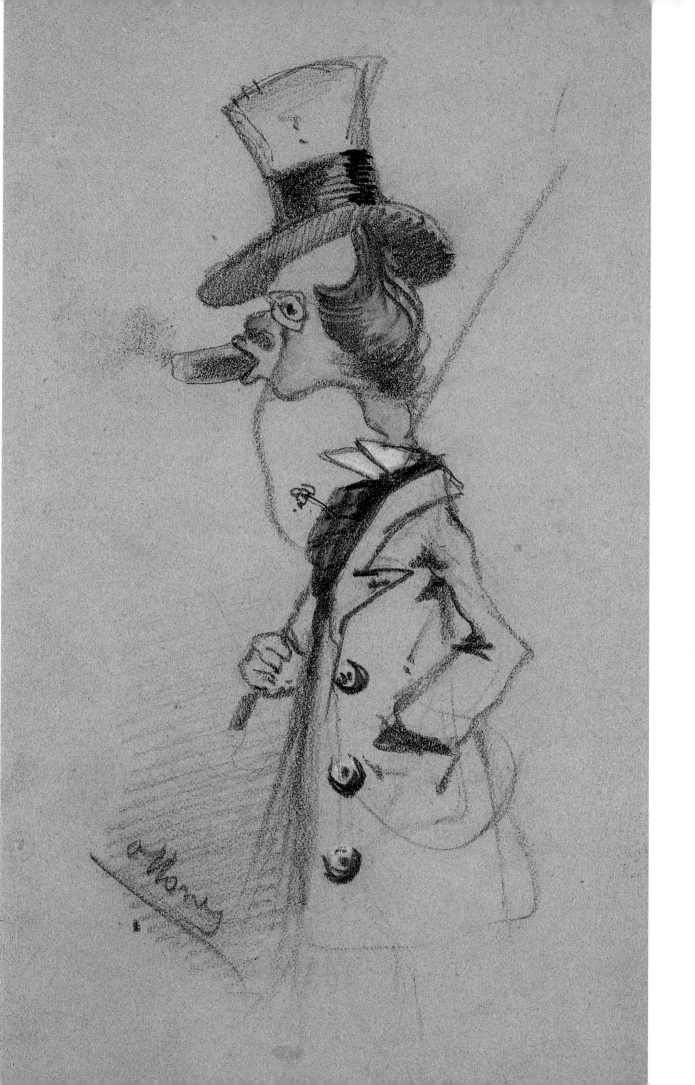

PETIT PANTHÉON THÉÂTRAL
(c. 1857–60)
LITTLE THEATRICAL GROUP
Courtesy of Giraudon

THE object of a caricature is to exaggerate the features that make an individual identifiable for humorous purposes. This unfinished picture demonstrates Monet's abilities in this field to great effect.

In particular the nose of each person best illustrates Monet's skill. He does not appear to have a stock of funny noses that he simply applies to the face; each person in the picture has a different nose from the others. These range from a gallic monstrosity on one gentleman to a tiny button of a nose on another. Their eyes, lips and foreheads are also uniquely individual. The whole effect is to create a face that the viewer can 'read' in order to understand the character of the person portrayed. Thus each man could appear intelligent, mean-spirited or kind, depending on how Monet has drawn his characteristic features.

What this picture does show is the quickness of eye that Monet had. He notes the details of the features and then interprets them in a new way. This is the approach he takes with other more serious paintings where the subjects he chooses to paint are not an exact replica of reality but his response to it.

TROPHÉE DE CHASSE (1862)
SPORTING PRIZES

Musée d'Orsay. Courtesy of Giraudon

*T*ROPHÉE *de Chase* is unusual when compared with Monet's later work. However, what cannot be overlooked is his determination to succeed as an artist: this led him in the early years to paint what can be considered conservative paintings. His choice of subject matter was frequently based on what would be acceptable to the art community.

The colours used here are true to life and lack the brilliance that was to emerge later in Monet's life. They are blended together to create a more traditional palette. Still life was never to be a priority in his career, and this is one of the rare examples of it. However, he took two still lifes with him to Paris to show round the art schools.

The elaborate composition and detailed treatment of the birds demonstrate how Monet was growing in confidence about his abilities at that time. The quality of execution shows how determined Monet was to understand the basics behind good art through traditional training. This level of detail would not be of such great concern in his later career, when the general impression became more important.

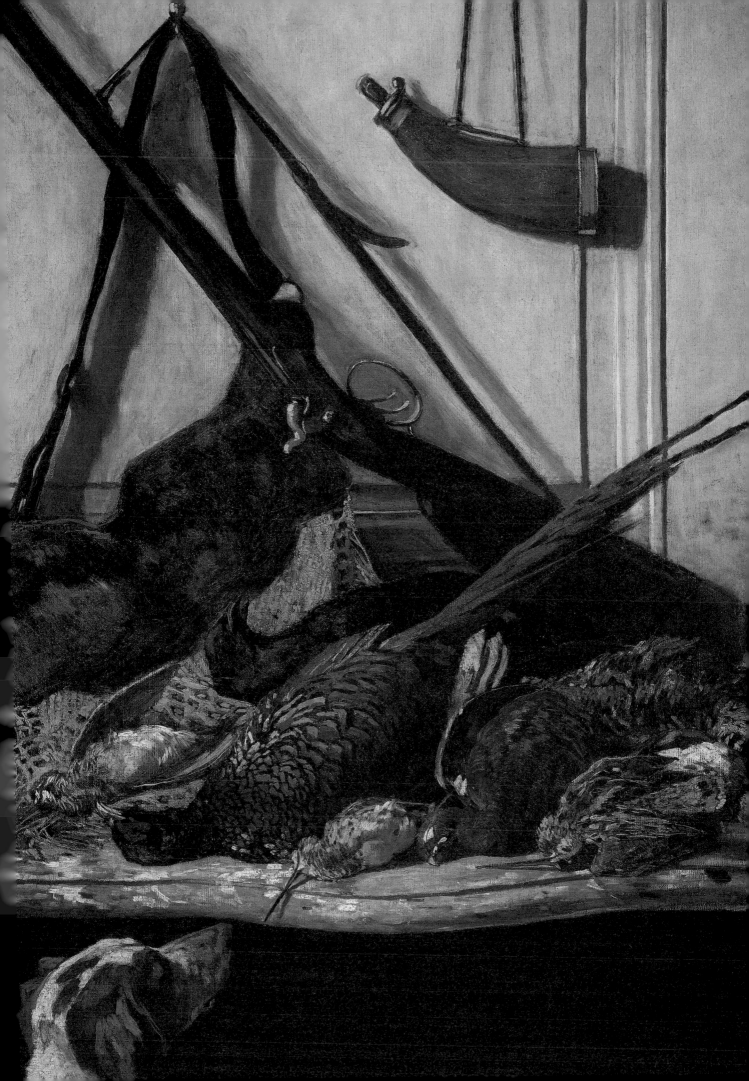

LA RUE DE LA BAVOLLE, À HONFLEUR (c. 1864)
BAVOLLE STREET, AT HONFLEUR

Mannheim Stadtische Kunsthalle. Courtesy of Giraudon

*T*HERE is some confusion over the exact date in which *La Rue de la Bavolle, à Honfleur* was painted. However, it is definitely an early piece and one that is distinctly unusual for Monet, even as an early work.

Honfleur has many buildings dating from the sixteenth century, making the village very picturesque. For this reason it is an unusual subject for Monet to pick, as he normally veered away from the picturesque, particularly when it came to buildings. His preference was for modern subjects, such as St Lazare Station. The painting *Le Pont de l'Europe, Gare St Lazare* (1877) has all the hallmarks of the sort of city scene that Monet liked. There are modern buildings in the background, a new bridge built in contemporary materials and, most impressive of all, a steam engine. The street scene from Honfleur lacks all of these attributes – its old-fashioned buildings and quiet street are lacking in the bustle and action characteristic of the later painting.

There is no sense of urgency to the scene; it has the tranquillity that Camille Corot (1796–1875), one of Monet's artistic predecessors and influences, would have been proud of. The technique used here does not even hint at the style that was to become synonymous with Impressionism, present in Monet's later works..

Le Pont de L'Europe, Gare St-Lazare (1877)
Europe Bridge, St Lazare Station
Musée Marmottan. Courtesy of Giraudon. (See p. 96)

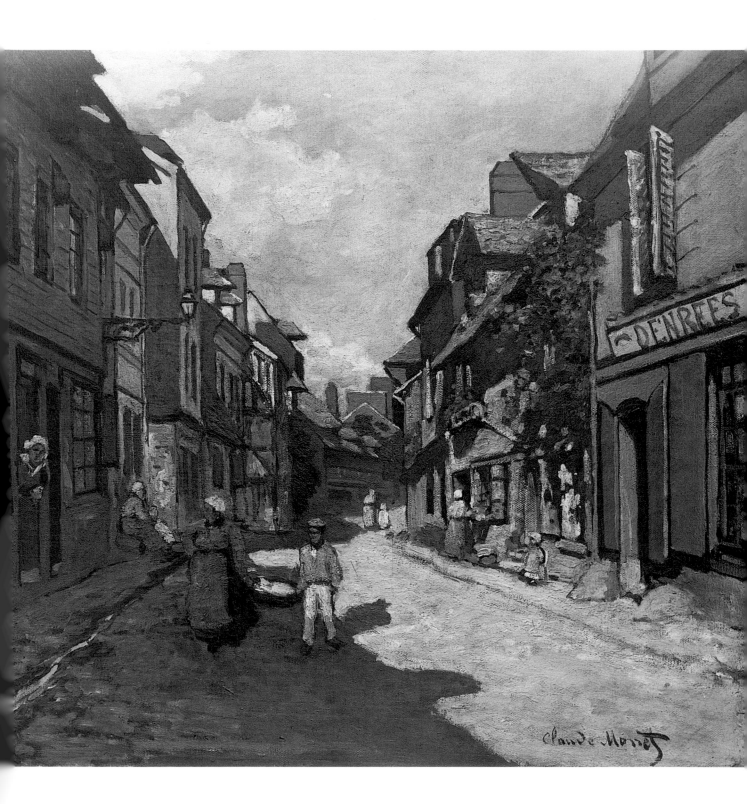

LE DÉJEUNER SUR L'HERBE (1865)
THE PICNIC ON THE GRASS

Pushkin Museum, Moscow. Courtesy of Giraudon

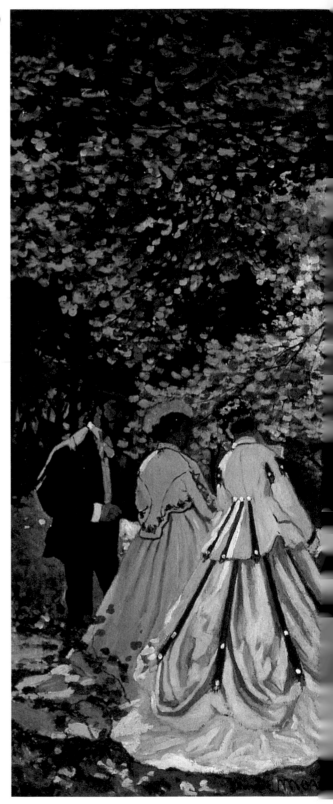

THE subject-matter of this painting is not controversial, but Monet's treatment of it is. Monet started work on this massive canvas with the intention of submitting it to the Salon exhibition of 1866 and causing a sensation. The sheer scale of the work meant it was not ready in time, and Monet abandoned it.

The unfinished canvas reveals a conventional scene of picnickers in the forest. However, Monet is attempting to treat the people as a natural part of the landscape. There is no story line to the painting, and this is emphasised by the uncentred composition: the eye is not drawn to any one point, and the people are simply a part of their surroundings. Monet wanted to create a sense of spontaneity with this painting, as if it were the capturing of a moment. This is underlined by the casual actions of the figures. One woman is caught in the act of touching her hair; another is about to put down a plate. This realism was very unusual in art of this period. Manet's influence is felt in the painting, but Monet hoped to avoid the moral judgement that Manet suffered with *Olympia* by not using controversial subject matter such as nude figures.

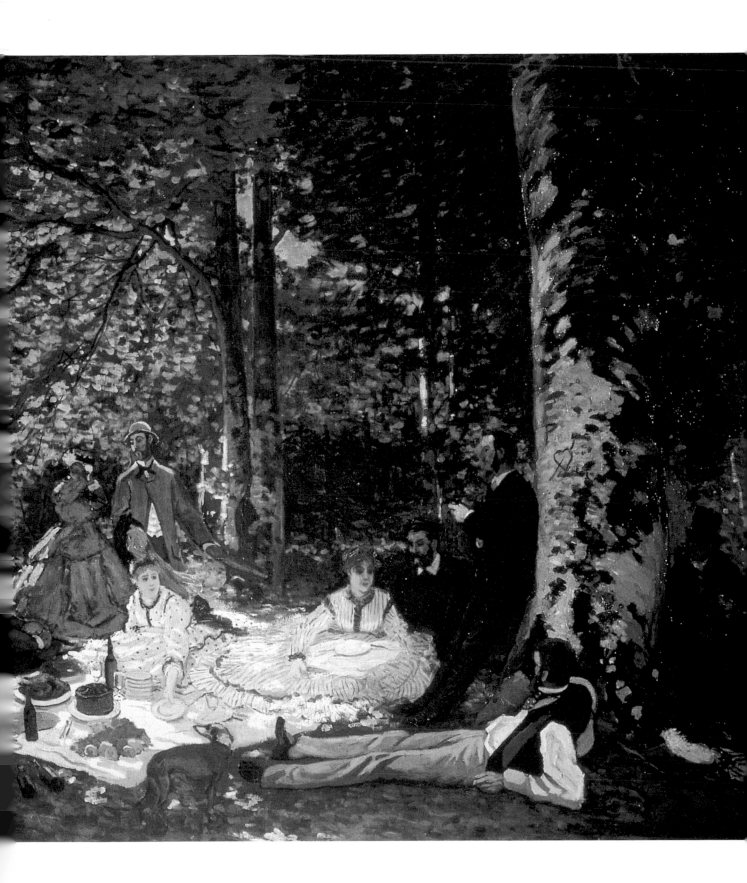

CAMILLE OU LA FEMME À LA ROBE VERTE (1866)
CAMILLE (WOMAN IN THE GREEN DRESS)
Bremen Kunsthalle. Courtesy of the Visual Arts Library, London

CAMILLE Doncieux, Monet's mistress and later his wife, was the artist's favourite model and he used her repeatedly in his work. Here she is posed in an attitude that is relatively informal.

The most striking aspect of this painting is the green of the skirt. Monet's love of colour and his desire to paint modern subjects probably prompted the choosing of this dress for the painting. The skirt dominates to the point that the woman's personality is secondary. Camille as an individual in her own right is not captured.

The lack of background detail is quite deliberate so that the woman is the only focus of attention. By not providing a setting, her character remains mysterious, with only her clothing hinting at her background. Camille has been painted as if captured mid-action, a spontaneous reaction on the part of the artist to the aesthetic picture her image makes.

Monet submitted this painting to the Salon exhibition and was successful in getting it chosen. The Salon was the state-run exhibition which had a strict and traditional selection process for inclusion in one of its exhibitions. An unknown artist could expect to achieve some notoriety from being selected, and with notoriety often came financial reward.

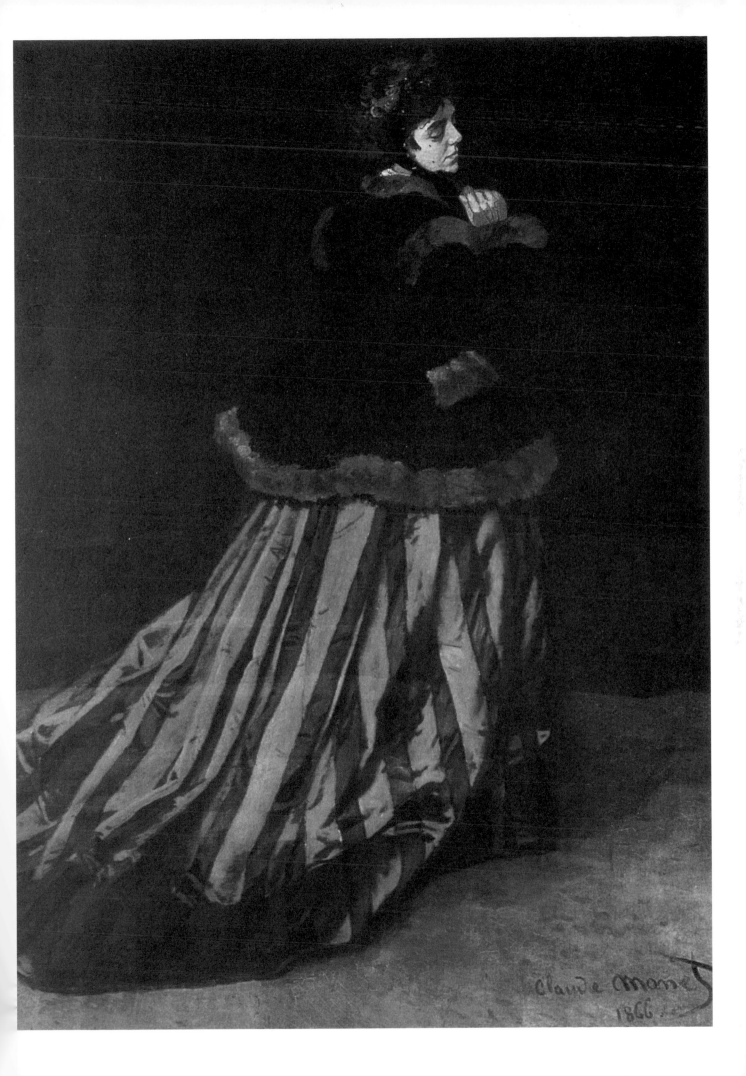

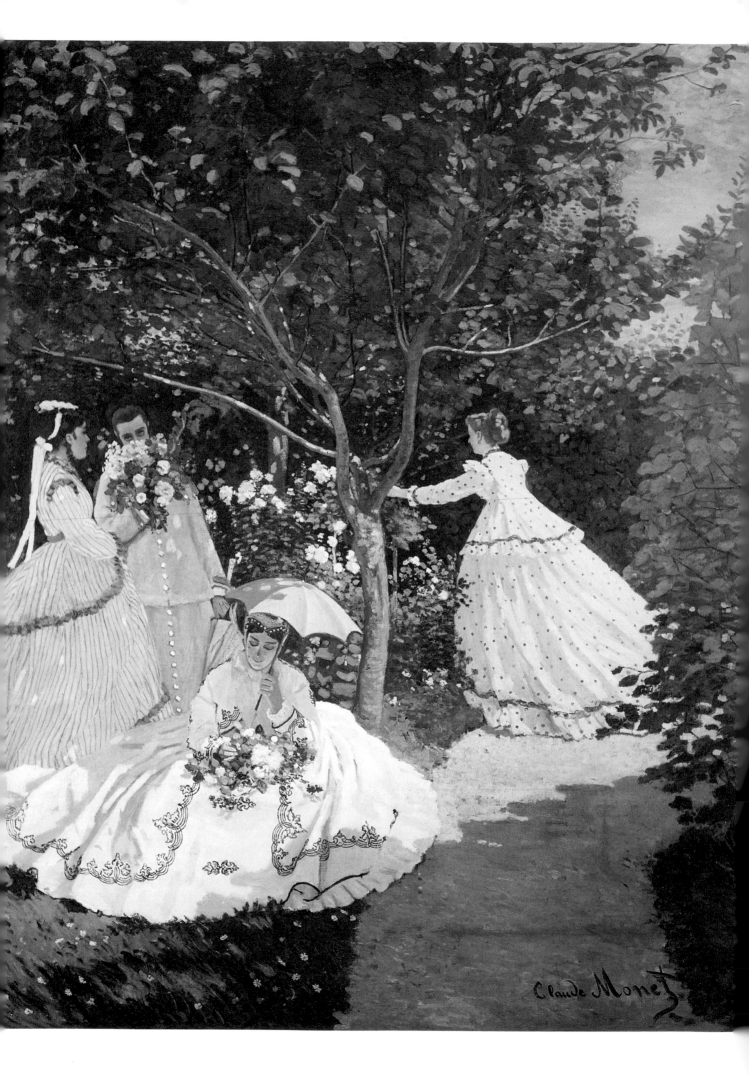

FEMMES AU JARDIN (1866)
WOMEN IN THE GARDEN

Courtesy of Topham

CAMILLE Doncieux posed for all four women in this painting, wearing hired dresses: the impoverished Monet could not afford clothes like these. Monet submitted the painting, which was painted at Ville d'Avray, for the 1867 Salon, but it was rejected. Artists such as Daumier and Manet also criticised the picture.

Monet was aiming to make two significant points with *Femmes au Jardin*. This large size of canvas was traditionally reserved for historical or religious paintings that carried a moral message for the viewer. By painting an unremarkable modern scene, Monet was declaring that these everyday moments, painted in a realistic manner, were just as important in the art world as esteemed historical or religious subjects.

His second point was concerned with the spontaneity of art and painting exactly what was in front of the artist. Instead of sketching the scene and then completing it in a studio, Monet painted the entire work in the open air. This became known as *plein-air* technique. So determined was he to make this painting seem real that he dug a trench in the garden in order to have the canvas at the right level.

JEANNE-MARGUERITE, LE CADRE AU JARDIN (1866)
JEANNE-MARGUERITE, THE IMAGE IN THE GARDEN

The Hermitage, St Petersburg. Courtesy of Topham

ANOTHER work that was inspired by Manet's artistic style, *Jeanne-Marguerite, le Cadre au Jardin* completes the isolation of the individual that Monet had attempted to capture in *Femmes au Jardin* (1866). In the slightly earlier work, although the women form a group, they seem removed from each other. Here Monet finalises that isolation by having a lone female in the garden.

Her isolation is further completed by placing her to the far left edge of the canvas, so she is removed from the main focus of the picture. This gives an unsettled feel to the composition that is similar to that achieved in the earlier work. In *Femmes au Jardin* three of the women are placed left of centre, and the eye struggles to find a main focal point between the women. This is achieved in *Jeanne-Marguerite, le Cadre au Jardin* by patches of colour. The viewer is drawn repeatedly from the yellow to the red flowers and then across to the white dress.

The technique of using blocks of colours employed in *Femmes au Jardin* is repeated here with more vigour. The sky is almost a solid patch of blue, the dress a block of white and the grass a strip of green. This gives a flat effect to the picture.

Femmes au Jardin (1866)
Women in the Garden
Courtesy of Topham. (See p. 29)

CAMILLE AU PETIT CHIEN (1866)
CAMILLE WITH A LITTLE DOG

Private Collection, Zurich. Courtesy of Giraudon

THIS intimate portrait is one of the few that shows Camille in a formal pose. Although not shown face on, her features have been recorded in the kind of detail lacking in many of the paintings she posed in for Monet as a model.

The difference in his attitude to the woman between this painting and *La Liseuse* (1872) is interesting. In the main picture his aim is to create a portrait of Camille: there is no vivid background to distract the eye and she is definitely the centre of attention. Her profile is emphasised by being painted against a dark colour. The quick brushstrokes representing the shaggy dog contrast with the careful work on Camille's face and underline that Monet was trying to make Camille the only subject of interest. This is not the case with *La Liseuse*. Here the background, and even Camille's dress, are perhaps more important than who she is. She is painted as part of the scenery, almost an incidental feature of the landscape.

By posing Camille with her face turned down towards her book, her features are not easily distinguishable. In *Camille au Petit Chien*, she looks steadily forward, and some sense of her character can be gleaned from the attitude of the head and the quiet pose.

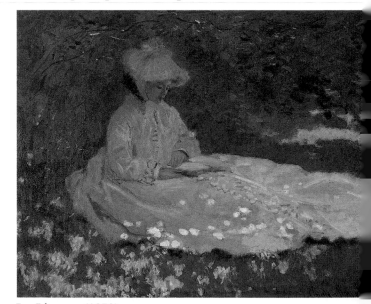

La Liseuse (1872)
The Lover of Reading
Walters Art Gallery, Baltimore. Courtesy of Giraudon. (See p. 62)

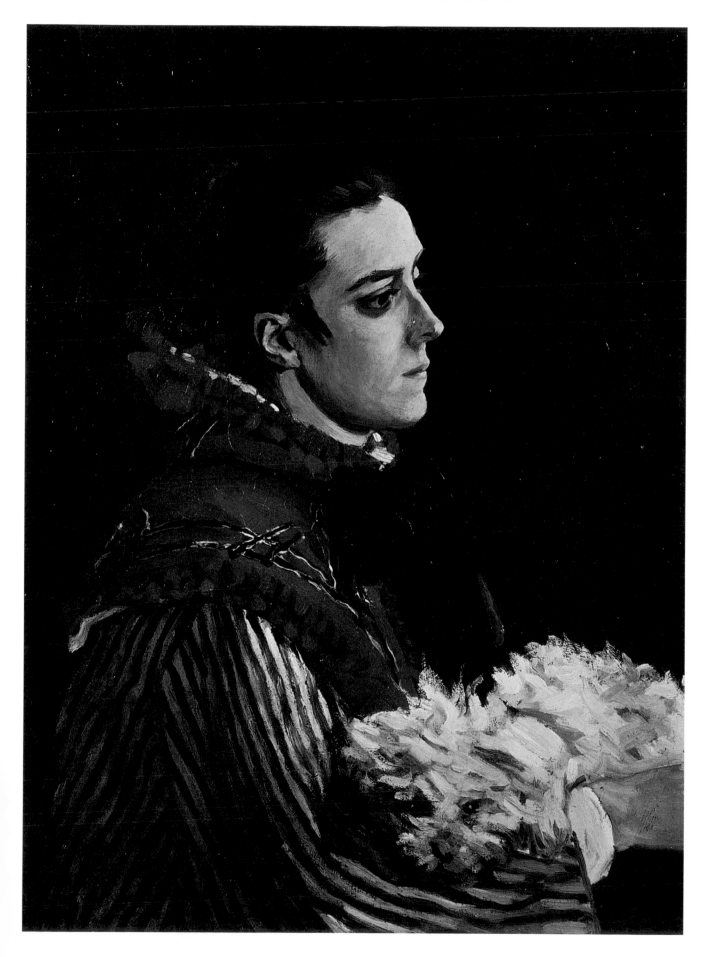

LA CHARRETTE, ROUTE SOUS LA NEIGE À HONFLEUR (1865)
THE CART, ROUTE THROUGH THE SNOW AT HONFLEUR

Louvre, Paris. Courtesy of Giraudon

IN 1865, Monet successfully exhibited two paintings, including this one, at the Salon in Paris for the first time. This was an important breakthrough in his career. One of the pictures exhibited was a marine scene painted at Honfleur.

La Charrette, Route sous la Neige à Honfleur shows the town as seen from the approach road. It is a winter's day, but the painting is not dark and gloomy as Monet's snowscapes often are. Instead there is a light in the sky that seems to be generated by the sun, which not yet visible. The white of the snow is not diluted by too much darkness from the buildings or the cart. The overall effect is quite bright.

Although this is an early work, some elements of Monet's later technique are evident within it. There is some short brushwork, using contrasting shades of white, on the snow on the road. Also, Monet is conscious of the parallel lines formed by the cartwheels in the snow and the ditch by the side of the road. This use of lines and shapes in the landscape would become very important in his later work.

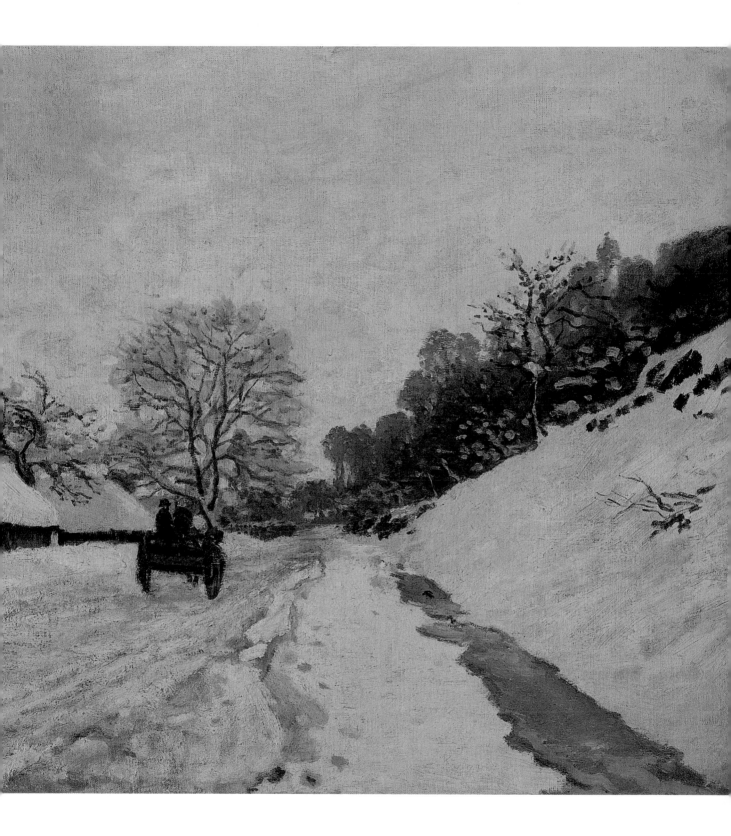

❋ LA CHARRETTE, ROUTE SOUS LA NEIGE À HONFLEUR ❋

PORTRAIT D'HOMME (1865)
PORTRAIT OF A MAN

Kunsthaus, Zurich. Courtesy of Giraudon

*T*HIS is a portrait of Victor Jacquemont, a watercolourist and engraver who worked for several newspapers at the time. However, the picture has been repeatedly catalogued with varying titles and it is difficult to confirm which is the correct one, leading it to be known simply as *Portrait d'Homme.*

Manet's influence can be seen in the picture, as it can be in others of Monet's from this period; the lack of detailed shading on the figure means he has been painted with solid contrasting colours. Working up the body, Monet starts with white only for the shoes. He then switches to grey for the trousers, with only a little shading around the knees and ankles, brown for the jacket and waistcoat, and flesh for the face. The colours are not varied in tone, so that the figure seems very flat on the canvas. The effect of sunlight or the shadow from the umbrella is not painted in.

A similar technique was used in *Camille sur la Plage* (1870–71). However, in the latter, Monet has taken it to its logical conclusion. The brushstrokes have become thicker and the paint is laid on heavily. He concentrates purely on colour, so that Camille's face does not have any features. The sky is one solid colour, and even the sea has little variety.

Camille sur la Plage (1870–71)
Camille on the Beach
Courtesy of Giraudon. (See p. 48)

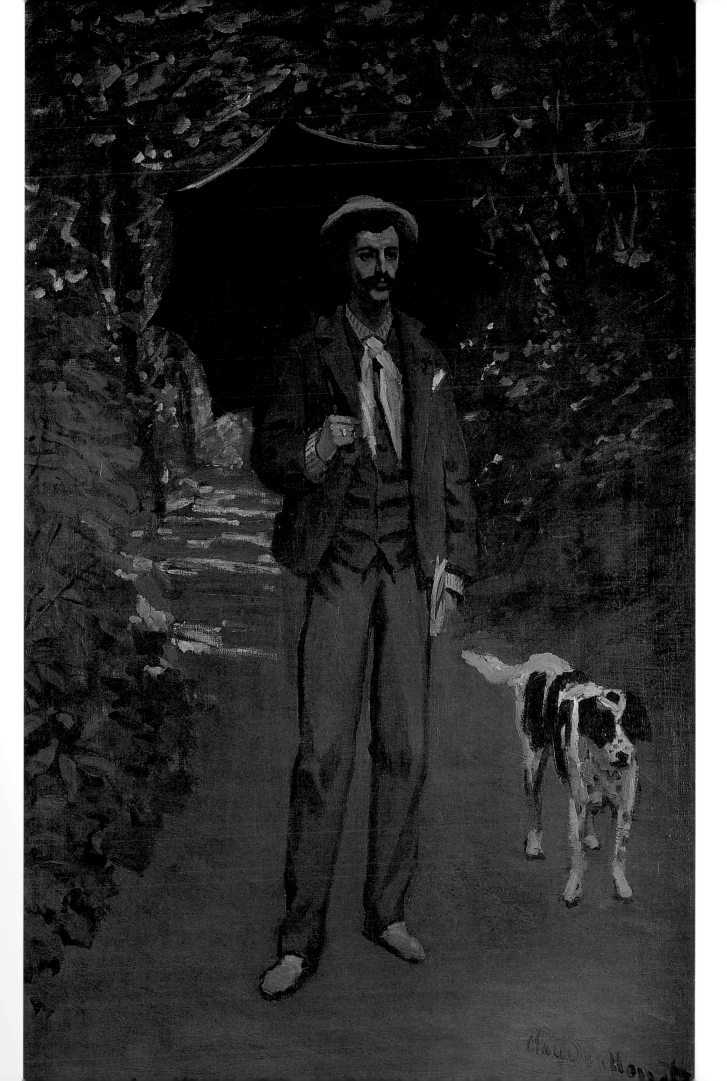

LA ROUTE DE LA FERME,
ST-SIMEON EN HIVER (1867)
THE ROAD TO THE FARM,
ST-SIMEON IN WINTER

Private Collection. Courtesy of Image Select

S NOW interested the Impressionist painters because of the effects it created with light and because of the way it changed the shape of the landscape. Like other snowscapes Monet painted, this one contrasts the white of the snow with dark patches. This is a very different treatment of colour from that used in *Norvège, les Maisons Rouges à Bjornegaard* (1895), where the white emphasises the red of the buildings and the blue of the sky.

The contrast between white and dark in the St-Simeon painting makes the picture seem sombre. The figures on the road are alone in their surroundings, their isolation echoed in the birds in the sky. Both form dark patches against a light background, and each seem equally unconnected to their companions. The sky and snow are painted in the same colours, giving the painting a timeless quality. In contrast, the Norwegian buildings are caught with the sun falling on them, giving the painting some specificity of time.

The Norwegian painting is not as stark as the earlier work. The snow reflects pink from the sun, and the blue sky is more welcoming than the grey in the main picture. The paint is laid on with quick brushstrokes, whereas the earlier picture has an air of precision to its brushwork.

**Norvège, les Maisons Rouges
à Bjornegaard (1895)**
Norway, the Red Houses at Bjornegaard
Courtesy of Giraudon. (See p. 196)

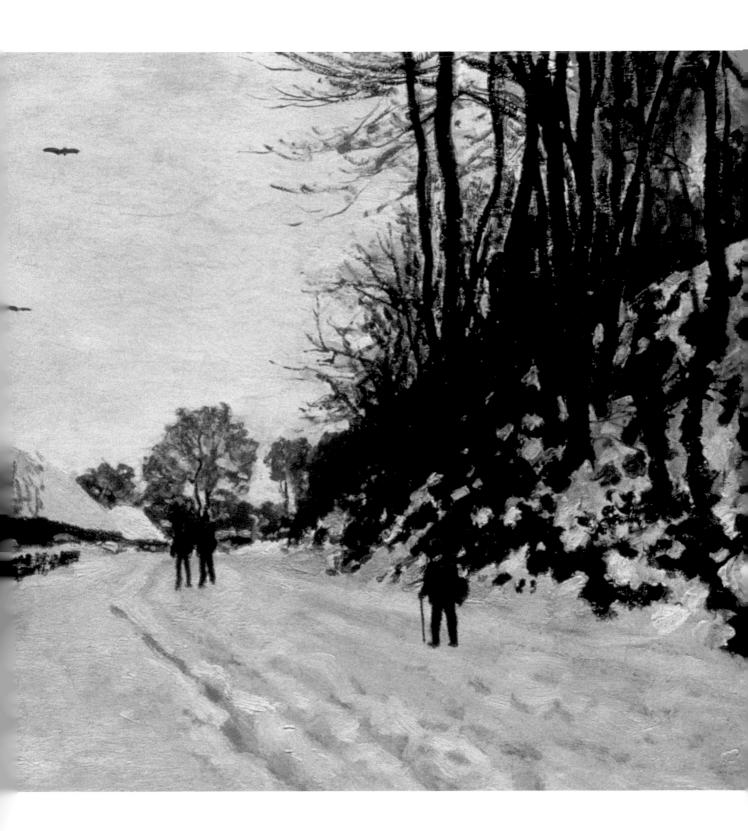

GLAÇONS SUR LA SEINE À BOUGIVAL (1867)
ICE FLOES ON THE SEINE AT BOUGIVAL

Musée d'Orsay. Courtesy of Image Select

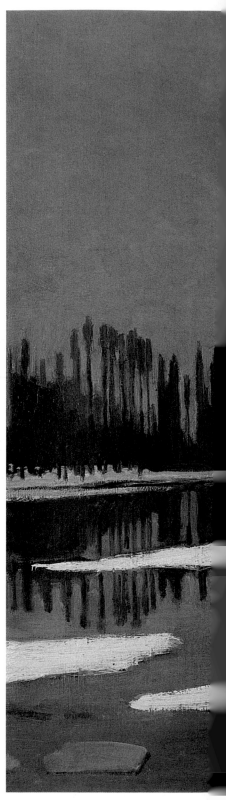

THE composition of this painting, and its date, suggest that Monet was still interested in the same techniques that he had been using in while in Normandy. Three years earlier, he had been engrossed in painting snow scenes, but not in the same style as this.

The painting is almost monochromatic in colour scheme with little variety from the grey and white of the palette. This seems suitable for recording a dull winter's day. It is in contrast to his later treatment of the Seine in winter as depicted below. In *La Seine a Bennicourt, Hiver* (1893) the colour scheme is more varied, and the touches of yellow and light blue help to give the picture a warmer tone. In addition, his use of colour and brushstroke is preoccupied with laying on small brushstrokes of individual colours to create an all-encompassing atmosphere. In *Glaçons sur la Seine à Bougival*, the technique is more concerned with toning in brushstrokes to create a solid block of colour.

The trees to the left are painted as vertical lines that form a screen that is reflected in the water. This is reminiscent of contemporary Japanese art. The use of colour and the decorative and simplistic interpretation of the landscape are all in keeping with Japanese art, which was very popular at this time.

La Seine à Bennicourt, Hiver (1893)
The Seine at Bennicourt in Winter
Courtesy of Christie's Images. (See p. 186)

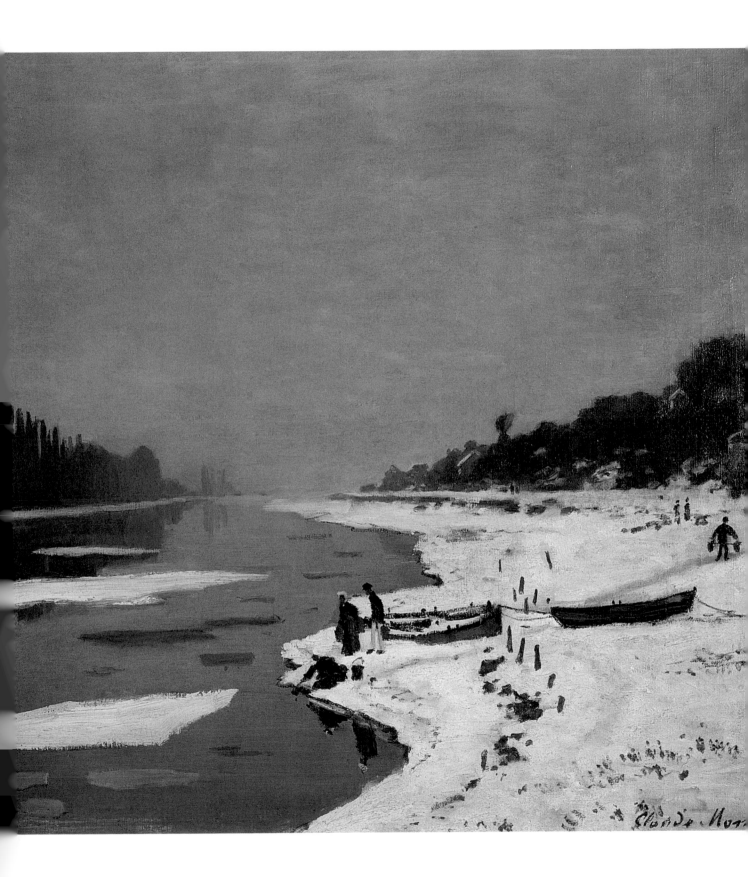

TERRASSE À STE-ADRESSE (1867)
TERRACE AT STE-ADRESSE
M.O.M.A., New York. Courtesy of Giraudon

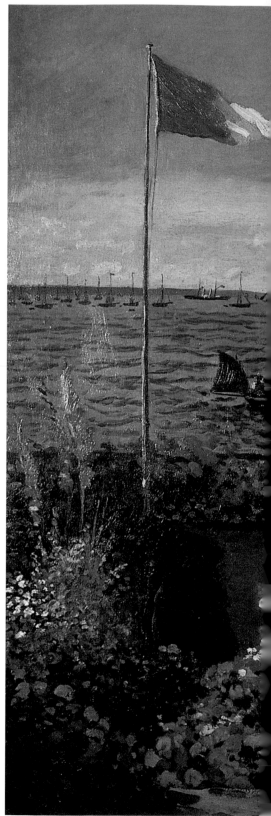

*P*OVERTY forced Monet to return to the family home around 1867, and while there he painted this view from one of the upstairs rooms. The man seated is Monet's father. Monet's stepson commented later that the abundance of flowers on the terrace suggests that Monet's love of flowers was inherited from his parents. The painting appears composed and almost artificial when compared with some of the earlier works, which are deliberately given a more spontaneous feel.

Monet later referred to this painting as the 'Chinese painting with flags'. At that time the words 'Japanese' and 'Chinese' were often interchanged. He owned some Japanese prints, and their influence is seen in this work. The flags that dominate the picture dissect the three horizontal bands of the painting – the terrace, the sea and the sky – providing a vertical balance.

The composition itself is unconventional, with the faces of the people turned away from the viewer. The boats and ships in the background emphasise the modernity of the scene, as they were vital to trade in the town. Their shapes on the horizon are sharply geometric, contributing to the oriental tone of the painting. While Monet's treatment of the sky is flat, the sea shows signs of his fascination with its every changing colour, a fascination that emerges strongly in later works.

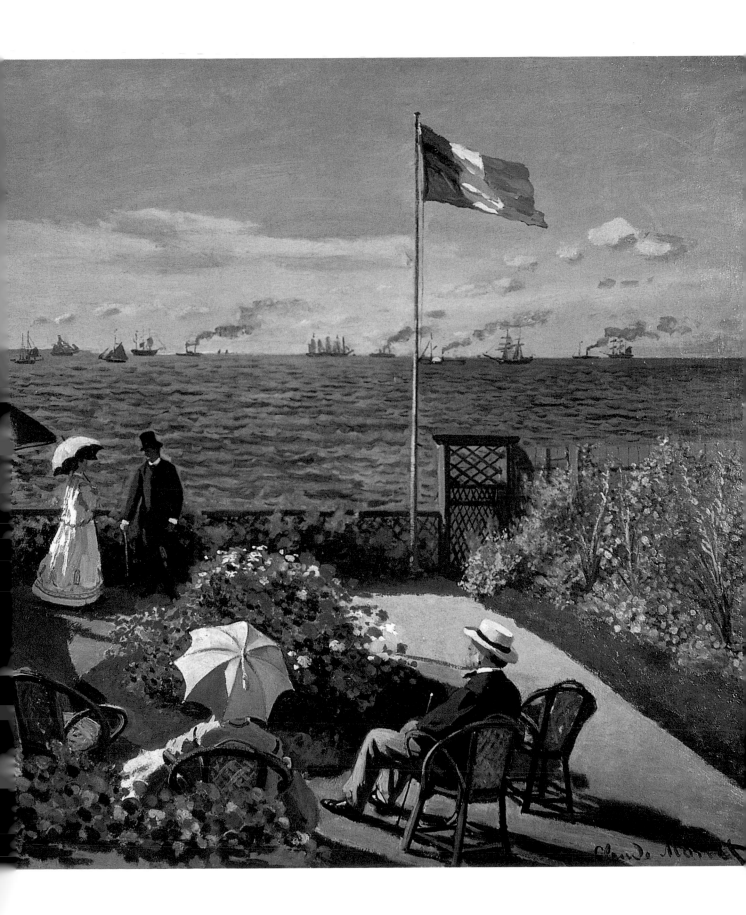

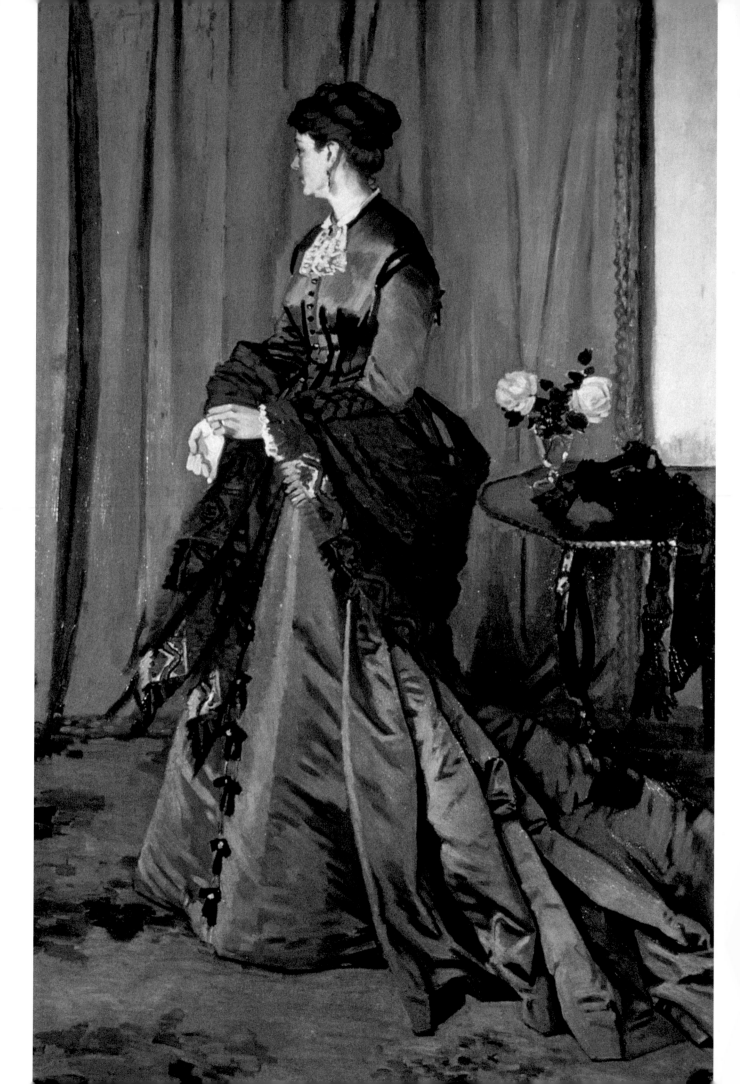

PORTRAIT DE MADAME GAUDIBERT (1868)
PORTRAIT OF MADAME GAUDIBERT

Musée d'Orsay. Courtesy of Image Select

MADAME Gaudibert was the wife of one of Monet's patrons, who commissioned this painting from him at a time when he was in desperate financial straits. This is actually a life-size portrait.

Monet had painted portraits earlier in his career. In particular, *Camille, ou la Femme à la Robe Verte* (1866) was especially successful. However, this slightly later work, while mimicking the pose of the earlier portrait, has advanced in technique; the composition is more complex. The averted face is intriguing, particularly as this was a commissioned portrait. As can be seen in the later work *Essai de Figure en Plein Air* (1886), this pose was one Monet favoured greatly. The head turned to one side turns the woman into an anonymous figure. Monet has painted a fashionable woman of society rather than a detailed individual portrait.

The later painting reveals how Monet takes the anonymity of the figure to new levels. In *Portrait de Madame Gaudibert*, the face of the woman may not be shown fully, but the features that are revealed can be discerned easily. In the secondary image, the face is not averted as far as Madame Gaudibert's, yet the features are blurred and unidentifiable. As the title of the painting suggests, the later work was concerned entirely with aesthetic composition.

**Essai de Figure en Plein Air
(Vers la Gauche) (1886)**
Study of a Figure Outdoors (Facing Left)
Courtesy of Giraudon. (See p. 160)

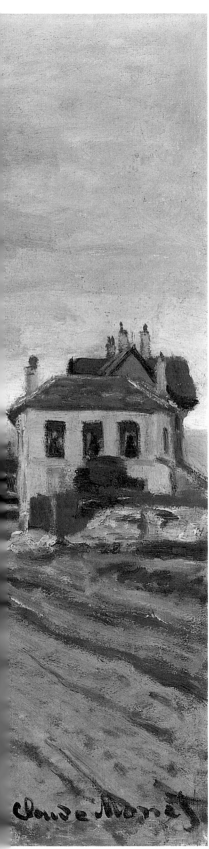

VOLTIGEURS DE LA GARDE FLANANT
AU BORD DE L'EAU (1870)
SOLDIERS STROLLING BY THE RIVERSIDE

Courtesy of Christie's Images

THE steamboat on the water and the guards patrolling the riverbank give *Voltigeurs de la Garde Flanant au Bord de l'Eau* a modern element, preventing the rural setting from being timeless. Similarly *Prairie de Limetz* (1887) relies on the dress of Alice Hoschedé to date the painting to contemporary times.

The figures in both pictures are treated in a similar cursory technique that does not allow for any detailed paintwork. However, they do draw the eye towards them. Alice achieves this by her prominent position in the painting and the pink splash that her dress makes. She is, however, just another aspect of the landscape. The guards in this painting also attract the eye through the bright colour they make against a dusty brown background. The eye then moves from them to the woman

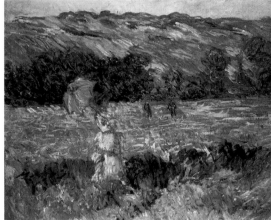

Prairie de Limetz (1887)
Limetz Meadow
Courtesy of Christie's Images. (See p. 166)

seen further along the road. Monet creates a depth in both paintings by using two distinct groups of people with a distance between them. In *Voltigeurs de la Garde Flanant au Bord de l'Eau*, the road running straight ahead into the distance adds to the depth.

Monet's treatment of light on the surface of the water is of interest. He shows an incomplete reflection of the steamboat as a result of light reflecting strongly off the water and cutting the boat off from its reflection. Water, light and reflection become increasingly important elements in his work.

CAMILLE SUR LA PLAGE (1870–71)
CAMILLE ON THE BEACH

Courtesy of Giraudon

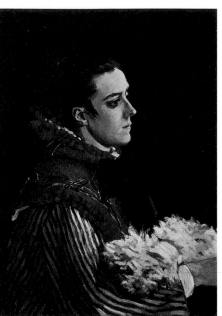

Camille au Petit Chien (1866)
Camille with a Little Dog
Private Collection, Zurich.
Courtesy of Giraudon. (See p. 32)

*T*HE treatment of the subject in this painting is simplistic. The figure poses on the beach facing towards the viewer and in close proximity, yet she has no features to her face, with the merest hint of an outline for her nose and eyes. She is an anonymous woman without identity.

Monet's formal portrait of Camille (*Camille au Petit Chien* (1866)) is in stark contrast to this work. It depicts Camille in profile but with careful attention paid to her features, so that her face is revealed in detail. Her clothes are treated to the same level of care, and she would be recognisable as the subject in reality. Part of Camille's lack of detail in *Camille sur la Plage* may be due to the unfinished nature of the work – in places the canvas shows through. While this alone does not necessarily indicate that a work is unfinished, the lack of a signature adds weight to the assumption. Monet did not sign all his finished work, but in this case it seems certain he had not finished the painting.

The brushstrokes are laid on thickly and are clearly visible to the viewer. The work has an air of spontaneity that is especially evident when examining the sea, which is painted in with a few brushstrokes using only three colours.

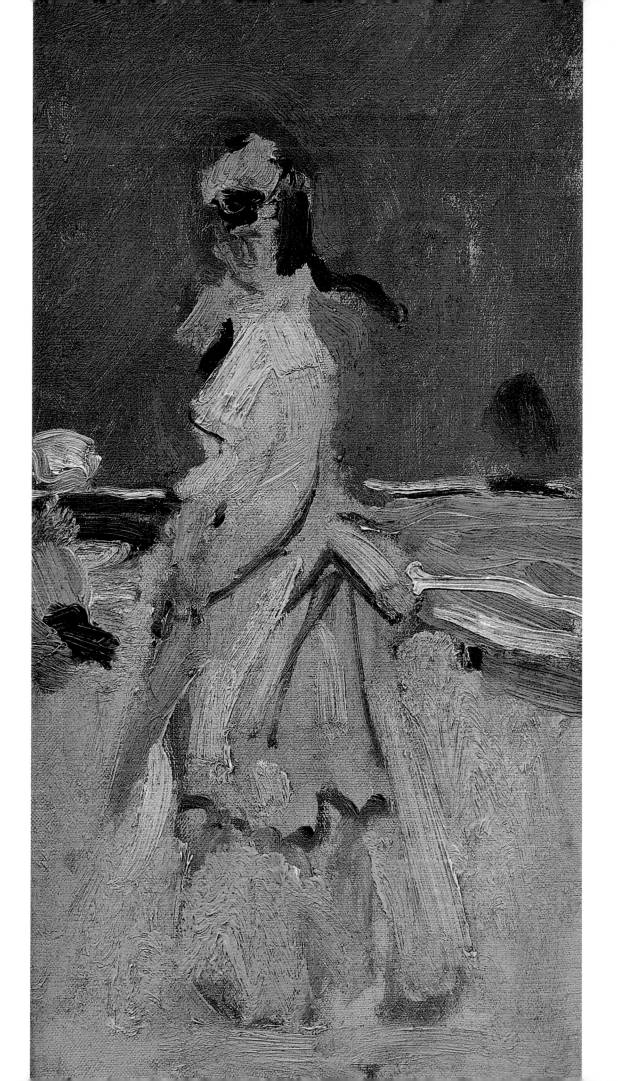

SUR LA PLAGE À TROUVILLE (1870–71)
ON THE BEACH AT TROUVILLE

Musée Marmottan. Courtesy of Giraudon

PAINTED while on holiday with Boudin, this picture depicts both Camille and Boudin's wife on the beach at the popular French tourist spot of Trouville. Monet's choice of subject again reflects his desire to record modern scenes. He chose to show this familiar resort in an untraditional way.

Firstly the viewer is thrust in very close to the two women. This is the opposite technique to that used in *La Plage à Trouville* (1870). The result is to make the viewer slightly uncomfortable, as if he were invading an intimate scene. This discomfort is furthered by the relationship between the two women. The central space between them is empty; neither woman acknowledges the presence of the other. Their features are not detailed, so there is an air of anonymity about them. Similarly, the people walking in *La Plage à Trouville* are not painted in detail.

In the background other tourists can be seen, also devoid of identifiable features. This, combined with the quick, heavy brushstrokes, adds to the spontaneity of the painting. In both works Monet is advocating the *plein-air* technique of painting.

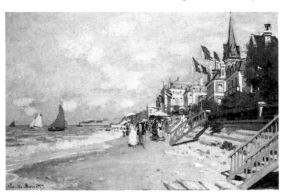

La Plage à Trouville (1870)
The Beach at Trouville
Courtesy of Christie's Images. (See p. 52)

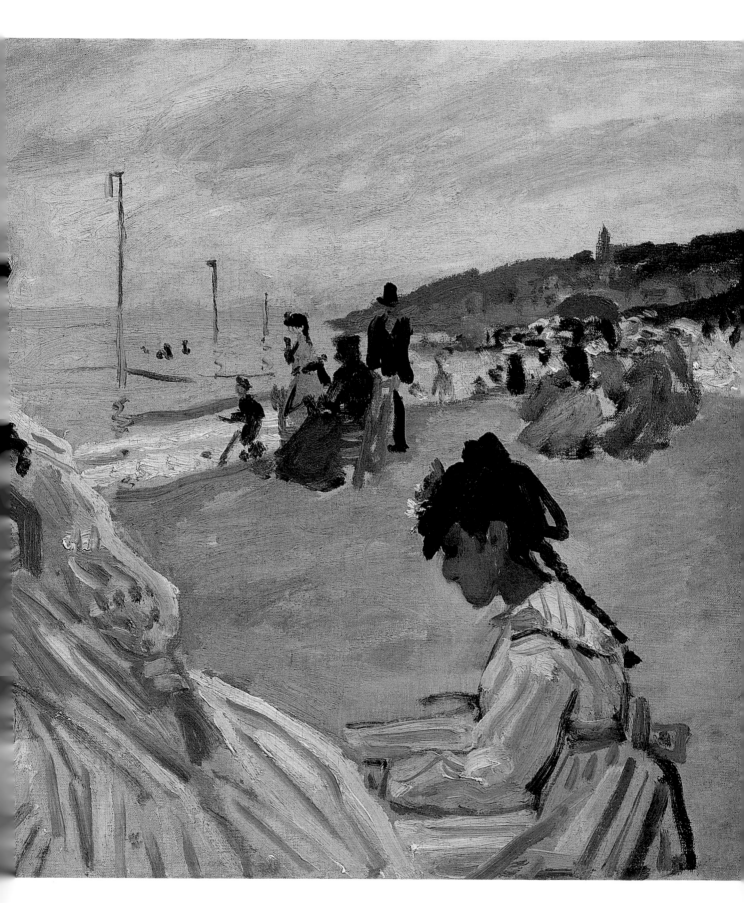

LA PLAGE À TROUVILLE (1870)
THE BEACH AT TROUVILLE

Courtesy of Christie's Images

IN both *La Plage à Trouville* and *Barques de Pêche devant la Plage et les Falaises de Pourville* (1882), Monet sought to perpetrate the concept of *plein-air* painting. The cursory depiction of the figures and the quick dashes of paint on the canvas add to the idea that these are works of spontaneity. Each depicts leisure activities being carried out.

However, the Trouville painting shows a number of people walking along the beach. In contrast, the Pourville work depicts a solitary individual, the lack of buildings in the picture adding to his air of isolation. In *La Plage à Trouville* the viewer becomes the isolated person. A strip of sand at the front of the painting is empty of people, and the viewer is facing towards the approaching tourists, which means the viewer has the sensation of walking against the general flow of people. Despite the fashionable location, the viewer is removed from the main action.

The colours used in this work are brilliant. The flags give the painting a lively air, and the luminosity of the sunshine makes the whole picture warm. In contrast, the colours used in the Pourville painting are more muted. The sky is nearly filled with cloud, and the palette used is less jewel-like.

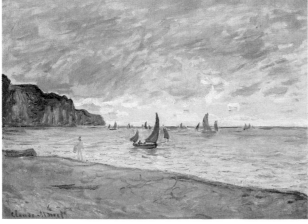

Barques de Pêche devant la Plage et les Falaises de Pourville (1882)
Fishing Boats in front of the Beach and Cliffs of Pourville
Courtesy of Christie's Images. (See p. 124)

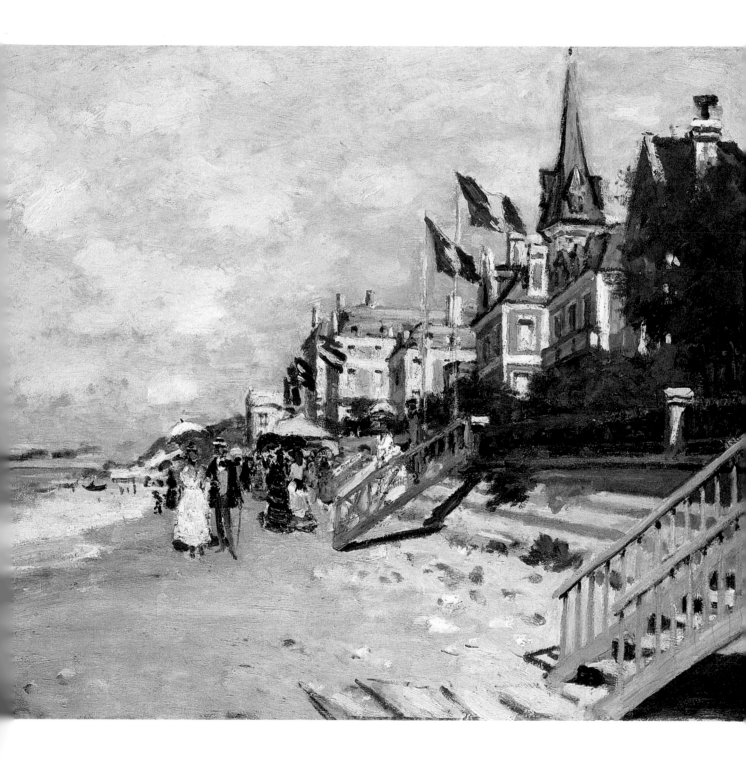

CHASSE-MARÉE À L'ANCRE, ROUEN (1872)

Louvre, Paris. Courtesy of Giraudon

THERE is an overwhelming feeling of loneliness to this painting. The stillness that surrounds it adds to that sensation. The lack of movement in the water and on land, and the non-specific time of day, give it a timeless quality.

The figure on the ship is isolated in his environment by the sheer size of the boat and its masts thrust up into the sky. The straight lines formed by the masts mimic the lines of the poplars on the behind the ship on the banks, and these also pierce the sky. The sky itself covers a large part of the canvas, adding to the timeless nature of the painting. The vastness of the sky is exaggerated by its becoming almost one with the water, so that the painting is dominated by their blueness.

Against this background the ship stands out. Her masts dissect the sky, preventing it from completely overwhelming the picture. The detail of the ship's rigging is a complex arrangements of lines that contrast with the simplicity of sky and water. A restful painting, this also causes a feeling of disconcertion as the ship passes through the silent world around it.

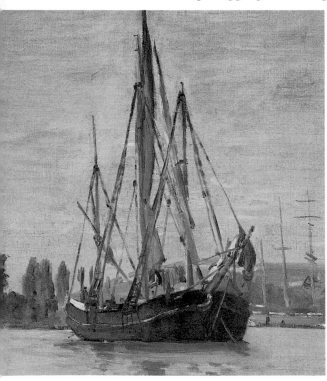

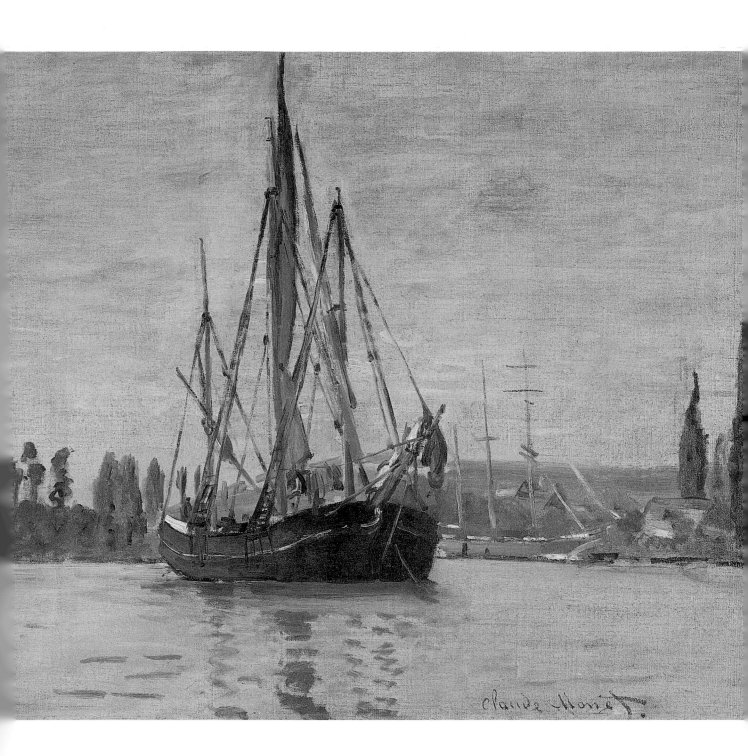

BATEAUX DE PLAISANCE (1872)
PLEASURE BOATS
Musée d'Orsay. Courtesy of Giraudon

BOATING as a hobby and pastime became very popular in France in the nineteenth century. At the time many people worked long days in the city, choosing the weekends to either visit the country or seaside, where many went aboard the pleasure boats.

For Monet, his boating scenes represented the attempts by a typical Frenchman to enter into a dialogue with nature. For this reason the paintings are frequently empty of people and seem very isolated moments. In this picture there are only a couple of people on the bank, and their features are indiscernable. In *Chasse-Marée à l'Ancre* (1872) there is only one man on board the ship, and his isolation is exaggerated by the size of the ship. Both paintings devote a lot of space to the sky, which adds to the insignificance of the individuals.

Prior to his move to Argenteuil, Monet painted only merchant ships and working boats. The *Chasse-Marée à l'Ancre* shows such a ship. Once at Argenteuil, however, Monet rarely produced marine paintings that did not feature pleasure boats, and *Bateaux de Plaisance* is typical of those he painted at the time.

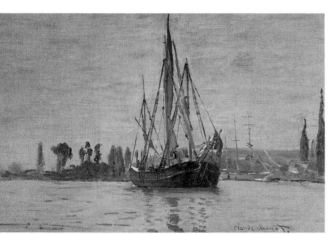

Chasse-Marée à l'Ancre, Rouen (1872)
Fishing Boat at Anchor, Rouen
Louvre, Paris. Courtesy of Giraudon. *(See p. 54)*

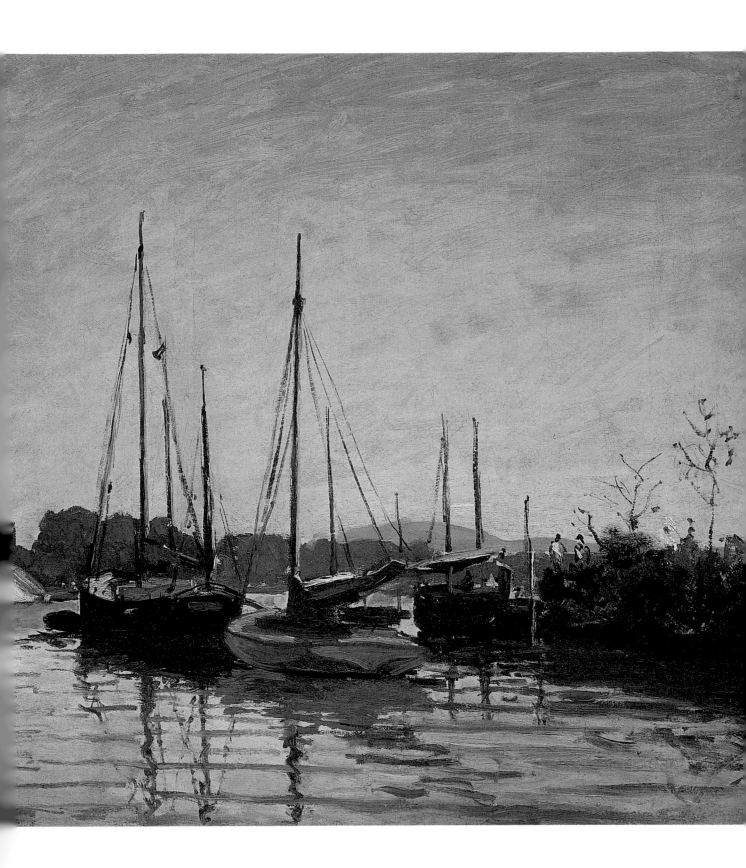

CARRIÈRES-ST-DENIS (1872)

Courtesy of Giraudon

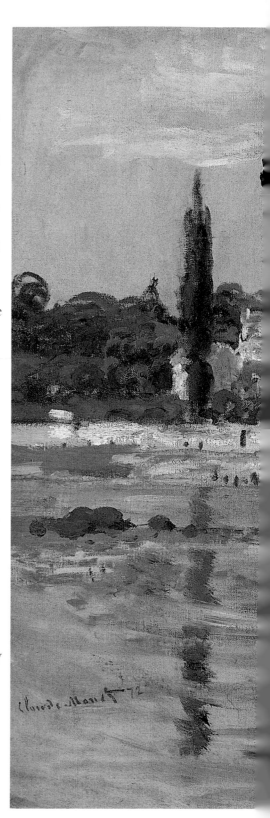

THIS landscape contains many of the traditional Impressionist trademarks. Some of the techniques within it can be traced to later landscapes, such as *Antibes, Vue de Cap, Vent de Mistral* (1888). Even though they contain contrasting subjects, one being a natural landscape, the other a town, there are some similarities.

Carrières-St-Denis has three broad horizontal bands going across the canvas. In the foreground is the water; above it is the town with its patchwork of roofs forming blocks of colours. To the left some bushes and poplar trees prevent the town from completing a full band across. The poplars reach into the blue sky that forms the third band. In *Antibes, Vue de Cap, Vent de Mistral*, the banding is made up of four elements of land, sea, mountains and sky. The presence of water in both was to become a common element in Impressionist work and appears repeatedly in later paintings.

The brushstrokes on the water form strong linear bands in places that disrupt the reflection of the poplars to the point that they disappear in patches. The later painting is concerned with capturing the colour of the sea to such an extent that the strength of the blue prevents any reflections from appearing.

Antibes, Vue de Cap, Vent de Mistral (1888)
Antibes, View of the Cape in the Mistral Wind
Courtesy of Christie's Images. (See p. 170)

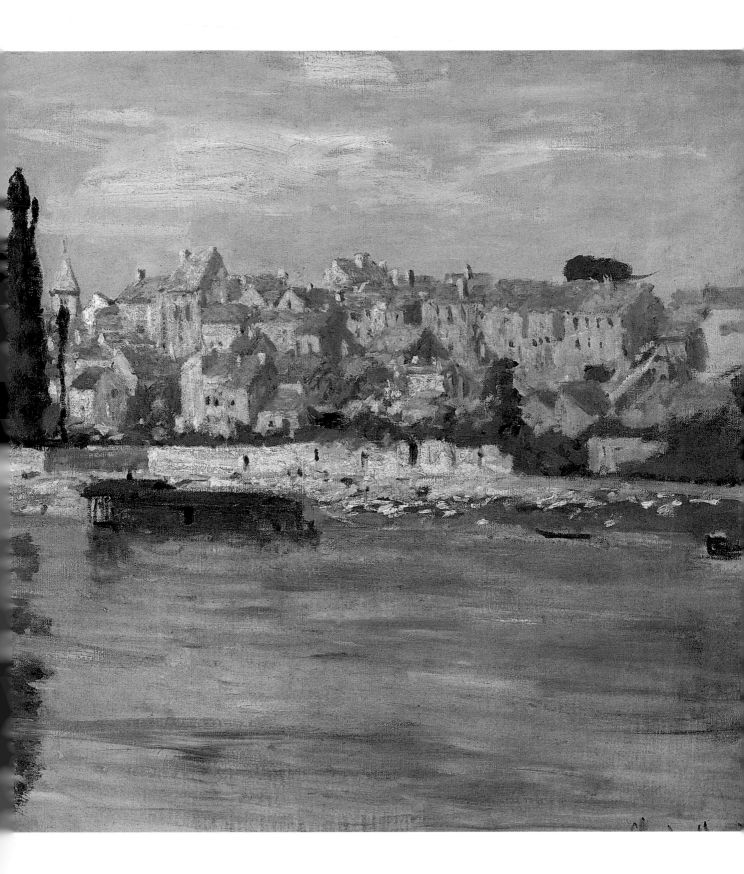

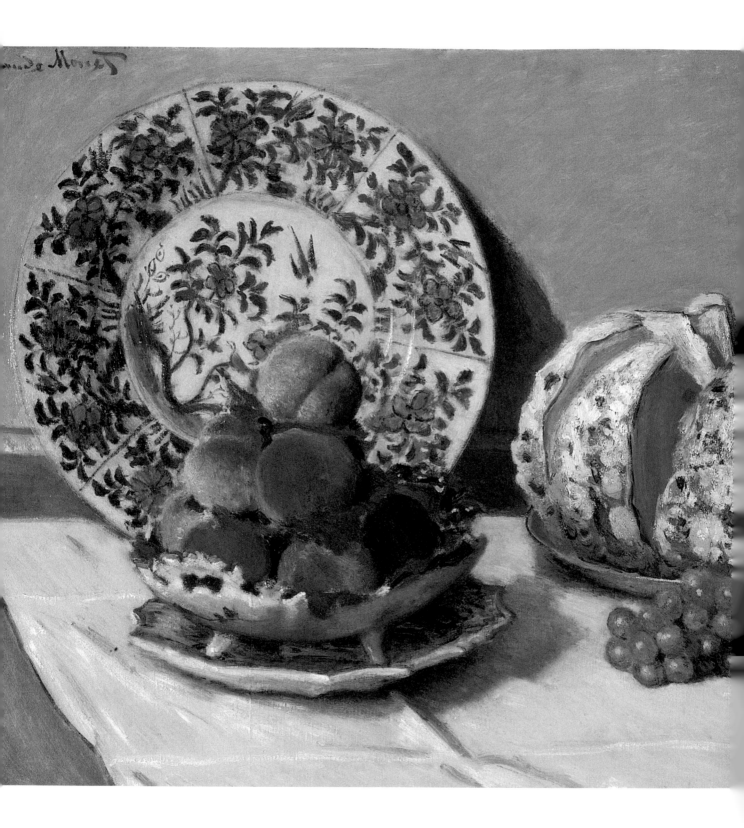

NATURE MORTE AU MELON (1872)
STILL LIFE WITH MELON

Courtesy of Giraudon

ONET painted very few still lifes. This study of fruit is treated in a similar manner to his landscape paintings, in the sense that the composition is structured around parallel planes. *Nature Morte au Melon* is not treated with the obvious banding approach evident in some of Monet's landscapes, although this compositional technique is present. The wall in the background forms one strip of colour; the tablecloth creates another square of colour that is prevented from reaching completely across the canvas by the strip of dark tabletop painted in the middle and side of the picture. These lines of varying colour create strong geometric shapes on the canvas. It is easy to see a triangle in the right-hand corner where the wood meets the tablecloth and the frame. Similarly, the wall forms a rectangle.

These geometric shapes are disrupted by the fruit and plates used as the focal points of the composition. It is not by accident that Monet chose round fruits as his subject: the roundness of the melon, grapes, peaches and the plate contrast with the geometric shapes of their

background. The treatment of varying colour and light on these draw the eye away from the solid colours with which the backdrops have been painted in. As a result, the whole is harmonised.

LA LISEUSE (1872)
THE LOVER OF READING

Walters Art Gallery, Baltimore. Courtesy of Giraudon

URING the eighteenth century, women often featured in paintings as allegories or with allegorical subjects. There would be a narrative context to the paintings that could be read by the symbolism included in the painting.

In *La Liseuse*, Monet has taken Camille and painted her in an attitude that is reminiscent of these earlier paintings. However, he has given the treatment a modern rendition and there is no symbolism or allegory to the work. Camille's face is shown side on and her expression is not anything other than serene. There is no story to be read into the work; as it is a painting of purely aesthetic purpose. The woman in her pink dress is reminiscent of the flowers around her. This association between nature and the female as a flower is evident in *La Barque*

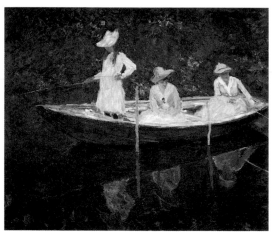

La Barque (1887)
In the Rowing Boat
Courtesy of Topham. (See p. 162)

(1887), where the women are connected to their surroundings by the colour of their dresses and the colour of the flowers on the bank.

La Liseuse was unusual in its time for posing the woman outdoors. This later became a common practice, but at the time it added to the originality of the painting. Both paintings celebrate the female in harmony with a natural background of flowers.

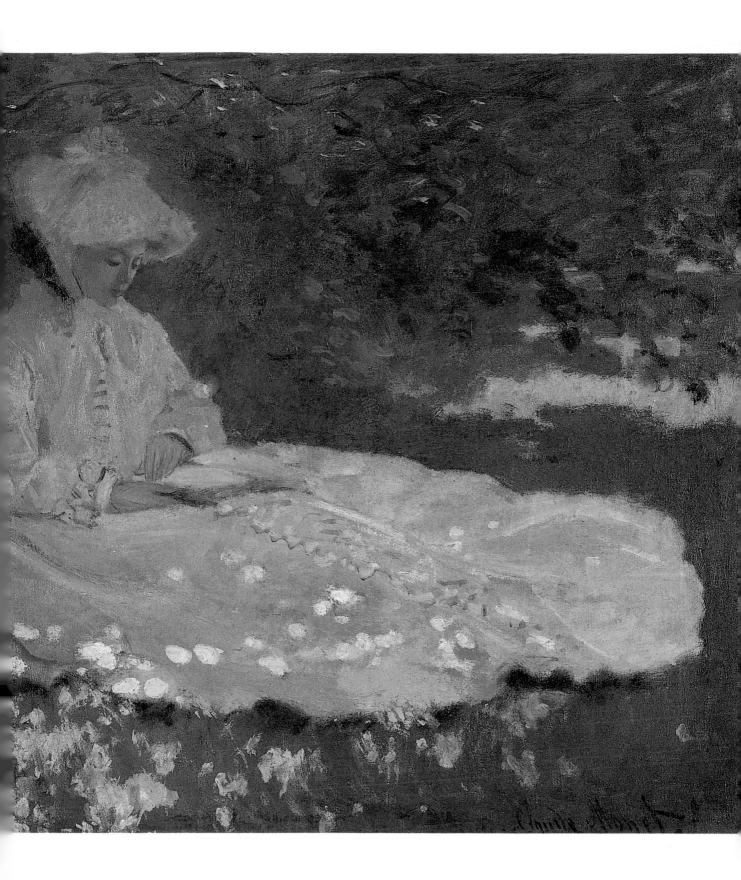

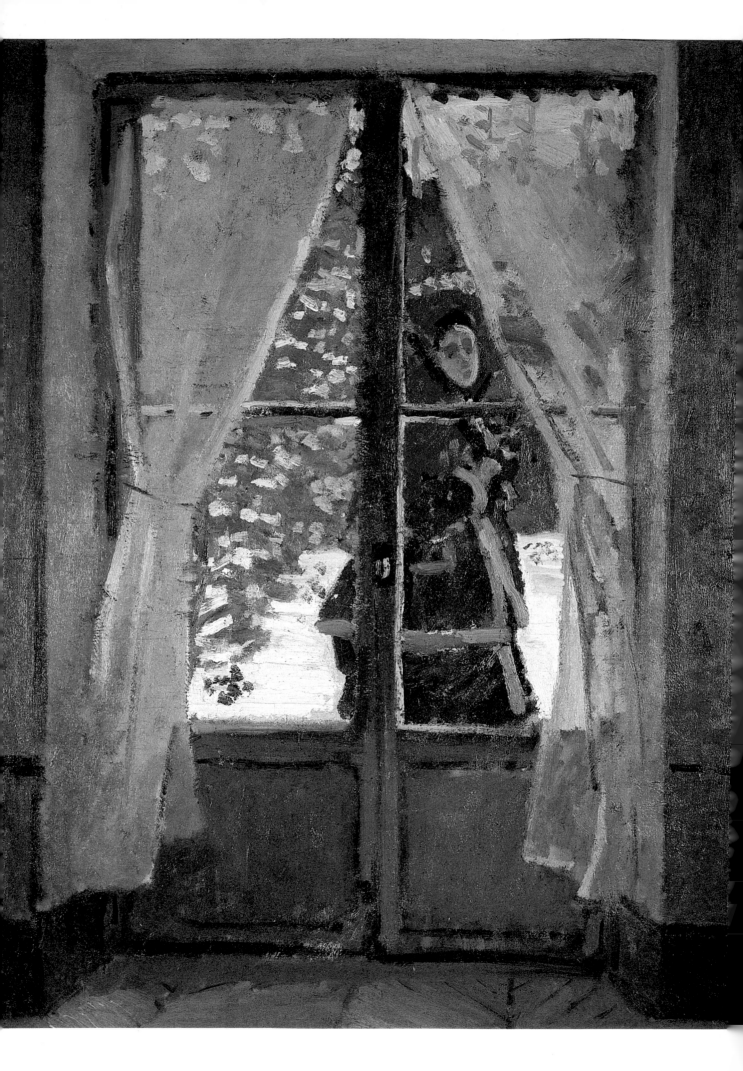

LA CAPELINE ROUGE,
PORTRAIT DE MADAME MONET (1873)
THE RED CAPE, PORTRAIT OF MADAME MONET
Cleveland Museum of Art. Courtesy of Giraudon

PAINTED at Argenteuil, this work depicts Camille Monet caught as she passes the window. The air of spontaneity about the picture contrasts strikingly with the more formal pose of *Femme Assise sur un Banc* (1874). The intimacy of Madame Monet's portrait is conveyed in the glance she throws over her shoulder at Monet as she passes.

Unlike the composition of *Femme Assise sur un Banc*, in *La Capeline Rouge, Portrait de Madame Monet* the artist uses a very obvious frame around his central subject in the form of the curtains and windowed doors. The frame invades that painting to the point of covering most of the canvas. In the secondary image the subject fills the canvas to the extent that all of her dress cannot be contained in the picture. In this painting the woman is set apart from her natural background. In Madame Monet's portrait the outside and inside world are connected through the white of the snow and the white of the curtains.

Femme Assise sur un Banc (1874)
Woman Seated on a Bench
Courtesy of the Tate Gallery. (See p. 84)

The red hood draws the eye of the viewer to Madame Monet. Her face turned towards the viewer is intimate. The combination of the hood and her gaze make her the focus of the painting. In a similar way the seated woman of 1874 is striking against her green background. Her eyes also form a connection between the viewer and the painting.

LA FALAISE DE STE-ADRESSE (1873)
STE-ADRESSE CLIFFS
Courtesy of Christie's Images

*I*N both these paintings Monet has restricted himself to the essentials only, his aim to create an overall impression. For this reason there is no detail on the sea or the shore of *La Falaise de Ste-Adresse* but merely strokes of colour. The difference between these two paintings lies in Monet's tension between land and sea in *Etreat, La Plage et la Falaise d'Aval* (1884) and the calmer landscape of *La Falaise de Ste-Adresse*.

The horseshoe of land provides a balanced curve in the main painting. The curves and rounded ends to the cliffs give the whole picture a softer feel than in the later work. In this the jagged point of the cliff end and the uneven beach and sea surface make for a more dramatic painting. *La Falaise de Ste-Adresse* has a wash of yellow that encompasses the land and the beach, creating a warm glow that is reflected in the sky.

The paintings Monet produced of the Normandy coast were exhibited in 1898 and proved very popular with the buying public. The combination of familiar scenes and aesthetic presentation meant that these pictures sold easily.

Etreat, La Plage et la Falaise d'Aval 1884
Etreat, the Beach and the Aval Cliff
Courtesy of Christie's Images. (See p. 140)

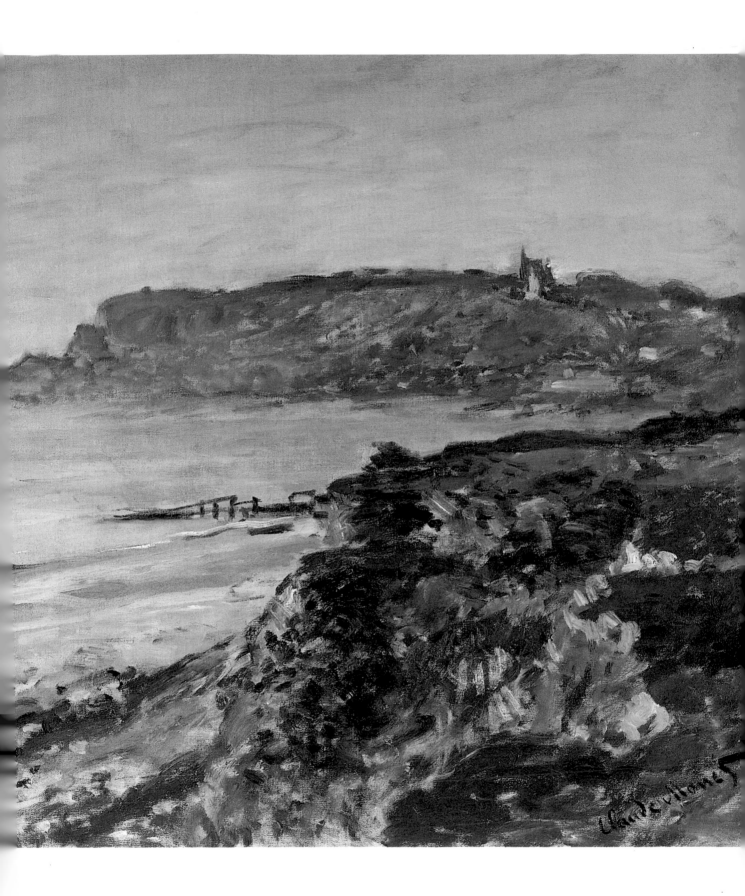

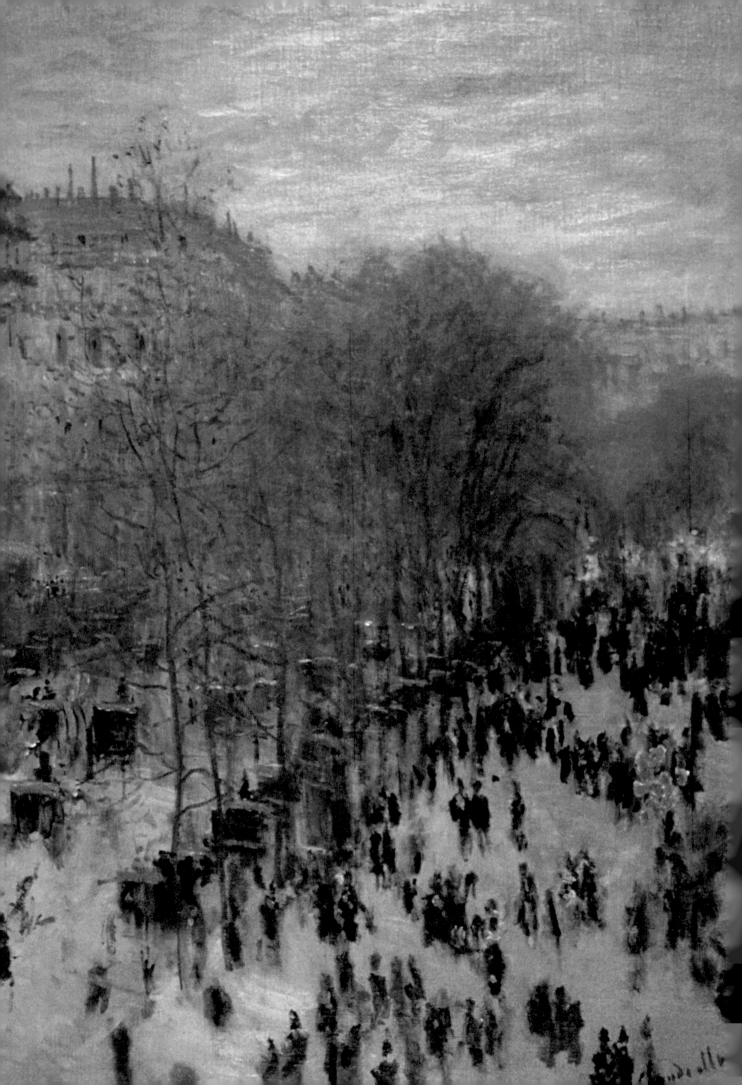

BOULEVARD DES CAPUCINES (1873)

Courtesy of the Visual Arts Library, London

*D*EPICTING a modern scene, Monet shows a Paris that is bustling and full of action. He has caught the fleeting nature of movement precisely by dabbing on paint to represent people, rather than dwelling on their detail. This technique is also used in *La Plage à Trouville* (1870) where the people are equally as lacking in detail. He also picks another modern subject; that of the tourist resort.

As well as creating a spontaneous painting that dwells on the instantaneousness of the moment, Monet is also investigating the effects of winter light in *Boulevard des Capucines*. This is the cause of the off-white glow in the sky which reflects on to the street below. Against this, the people seem like dark marks, and this earned them the description of 'black tongue-lickings' from the critic Leroy. The different effects of sunlight would especially be understood by the contemporary viewer as the work was displayed with a companion piece depicting the street in summer.

In *La Plage à Trouville*, Monet paints on a level with his subject, so that everything is seen to scale and the numbers of people are camouflaged. In the main picture, his view is from above, looking down. This increases the impression of the people as a small, scurrying crowd in a city of wide boulevards and tall, modern buildings.

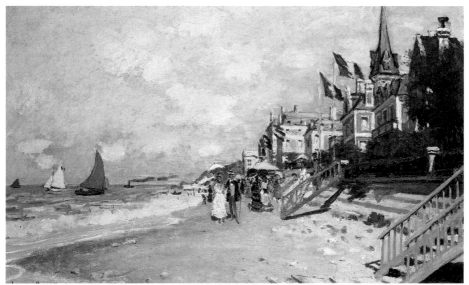

La Plage à Trouville (1870)
The Beach at Trouville
Courtesy of Christie's Images. (See p. 52)

ZAANDAM (1871)

Courtesy of Image Select

MONET visited Holland on his way back from England at the end of the Franco-Prussian War. Whilst there he painted 24 canvases in just three months. The combination of architecture and water in a flat landscape was what attracted him most. This combination appears again and again in his work.

This painting is reminiscent of some of the marine pictures from Argenteuil, particularly in the technique used on the water. The reflections of the buildings are sharp and the colours clear. *La Zuiderkerk, Amsterdam* (1872) has the same clarity of colours but the surface of the water has been treated differently. It is not the mirror that the canal is in the main picture. The strokes used on the water are short flecks of varying colours. In *Zaandam* the water is painted with smooth brushwork. Long lines of white colour are used to indicate where the water reflects light alone. The ripples of the water are also depicted by the wobbly reflection, particularly evident when looking at the reflected masts of the boat.

Both paintings use blocks of colours when it comes to the buildings. In *Zaandam*, a block of red is placed next to a block of blue, representing the house fronts. The architectural nuances are not detailed.

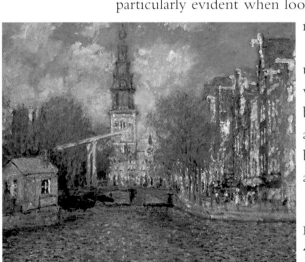

La Zuiderkerk, Amsterdam (1872)
Zuiderkerk at Amsterdam
Philadelphia Museum of Art. Courtesy of Image Select. (See p. 72)

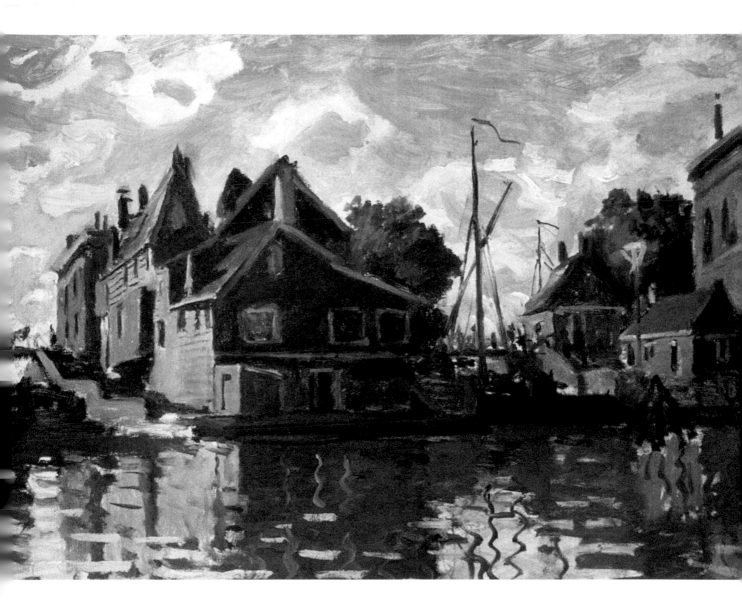

LA ZUIDERKERK, AMSTERDAM (1872)
ZUIDERKERK AT AMSTERDAM

Philadelphia Museum of Art. Courtesy of Image Select

*T*HERE is some confusion about the date of this painting. Monet visited Holland in the summer of 1871, yet this painting is dated 1872. It is now generally agreed that, despite the date, this and another painting, also dated 1872, are part of the 1871 series.

The composition of this painting is centred on the spire, with the canal leading up to it. On the right are the tall buildings of Amsterdam, with people moving along the pavement and over the bridge. These people are painted as flecks. The reflections of the buildings on the water are represented by yellow brushstrokes only, with no detail to them. This is the same as in *Le Parlement, Couchant de Soleil* (1904), where the buildings' reflection is identified only as a dark patch on the water.

A comparison of these two paintings reveals that by 1904 Monet was less concerned about observing the boundaries between building and water. It is difficult to identify where building ends and reflection begins. In *La Zuiderkerk, Amsterdam* the water is clearly separated from the buildings and there is no danger of building and reflection merging. The painting is in focus and uses strong blocks of colour, whereas the London painting has a mist over it that prevents a detailed look at the subject.

Le Parlement, Couchant de Soleil (1904)
Houses of Parliament, Sunset
Courtesy of Christie's Images. (See p. 224)

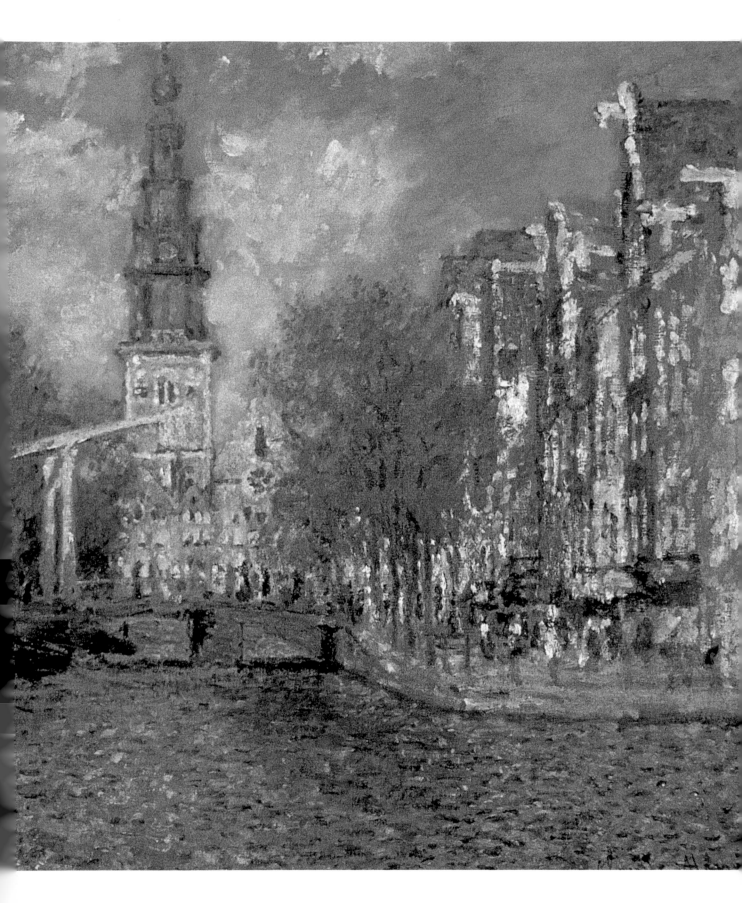

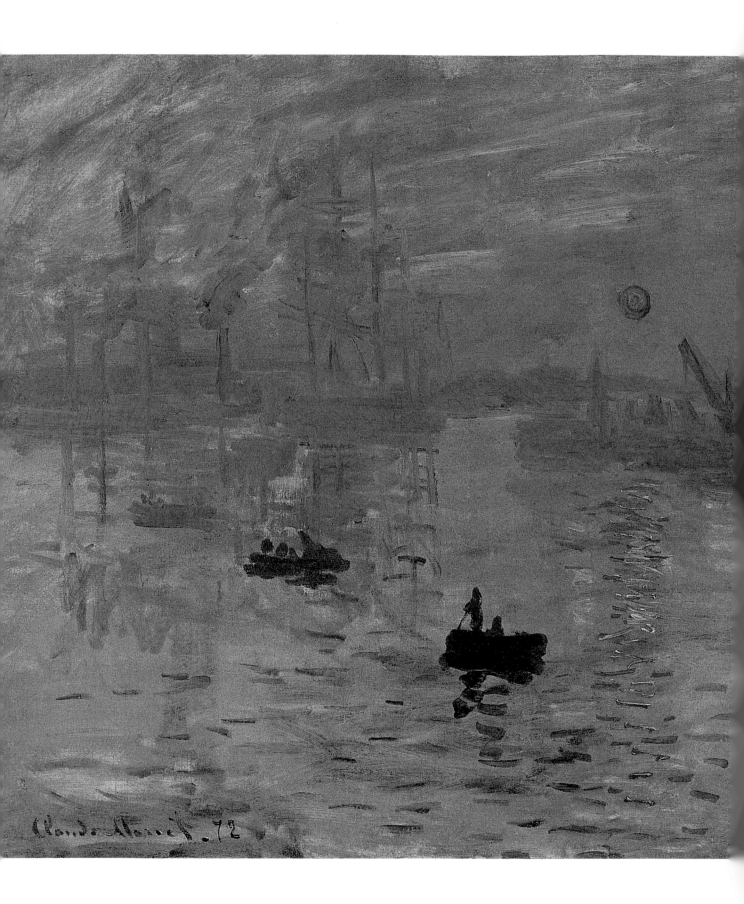

IMPRESSION, SOLEIL LEVANT (1872)
IMPRESSION, SUNRISE
Courtesy of Giraudon

THIS painting is responsible for the birth of the term 'Impressionist'. It was included in the first exhibition held by the Society of Painters, Sculptors and Engravers in 1874. Monet was a founder member of this society, which had originated from the express desire to end the artistic stranglehold of the Salon.

A critic who attended the exhibition, M. Louis Leroy, wrote a now famous article in *Le Charivari* in which he used the term 'Impressionist' based on the title of this painting. Despite the fact that Leroy had used the word derisively, the group decided to adopt it and painters such as Renoir and Degas were happy to be called Impressionists. Impressionist art is concerned with capturing on canvas the light and colour of a fleeting moment, usually with brilliant colours painted in small strokes, side by side, rather than blended together.

Ironically, *Impression, Soleil Levant* is not typical of Monet's work, although it does carry elements of his normal style. The horizon has disappeared and the water, sky and reflections have all merged together. The buildings and ships in the background are only vague shapes and the red sun dominates the painting. As Monet himself commented: 'It really can't pass as a view of Le Havre'. His aim was not to create an accurate landscape, but to record the impressions formed while looking at that landscape.

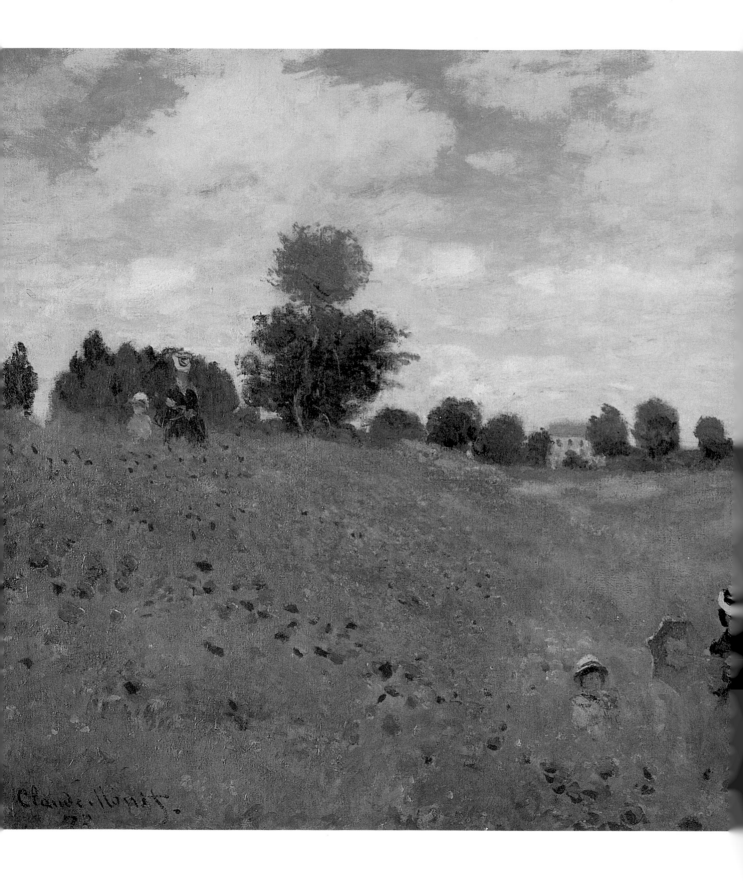

Les Coquelicots, Argenteuil (1873)
Poppies at Argenteuil

The Louvre, Paris. Courtesy of Giraudon

THIS scene from nature contrasts with the recent paintings that Monet had been doing, which were mainly of city subjects. Its soft tranquillity reflects some of the warmth of a summer's day: the figures merge with their surroundings, almost melting into them; the boy at the front of the painting has a body that disappears into the grass, and the dress of the woman matches some of the darker shades of grass on the right.

Figures that fade into a rural background are entirely appropriate to Monet's views on nature. He felt that nature was not there to serve man but that man was a part of nature. Hence, the figures in this painting are not the main focus. If it were not for the sloping edge of the poppies drawing the eye of the viewer back from the first group of people to the second on the horizon, the figures could be overlooked. The dominant force of this painting is without doubt the poppies.

Painted in an almost abstract style, the splashes of red draw the observer's eye at once, despite the fact that roughly half the canvas is given over to sky, creating a feeling of an airy summer's day. The blue of the sky contrasts with the red of the poppies and ensures that the landscape, as opposed to the people, leaves the strongest impression on the viewer.

LE PONT DE CHEMIN DE FER, ARGENTEUIL (1874)
THE RAILWAY BRIDGE, ARGENTEUIL

Musée d'Orsay. Courtesy of Giraudon

MONET was fascinated with painting this railway bridge during his time at Argenteuil. For him it represented the coming together of modernity and nature. He always painted it with a train rushing across and billowing smoke. This explosion of energy was contrasted with the tranquillity of the water. The bridge, which has contact with both, links the two different worlds.

This is in contrast to *Les Déchargeurs de Charbon* (1875), where the bridge appears to be a barrier separating the workers from the passers-by. The solid paint on the bridge in the main painting is contrasted with the colours used on the water. In places the brushwork is applied sketchily. However, when Monet wishes to illustrate the movement of light over the water he uses denser and more detailed strokes. This is especially evident on the water moving under the bridge.

Les Déchargeurs de Charbon has dark colours used repeatedly to give the whole painting a gloomy appearance. The main painting does not have one dominant colour or tone; instead each section is given a colour of its own that complements its neighbour and also separates it: for example, the greeny yellow of the grass is not related to the grey of the bridge, but the tones manage to complement one another.

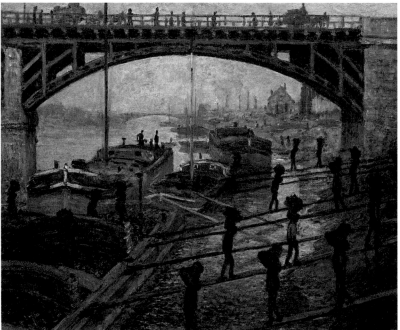

Les Déchargeurs de Charbon (1875)
Unloading Coal
Courtesy of Giraudon. (See p. 86)

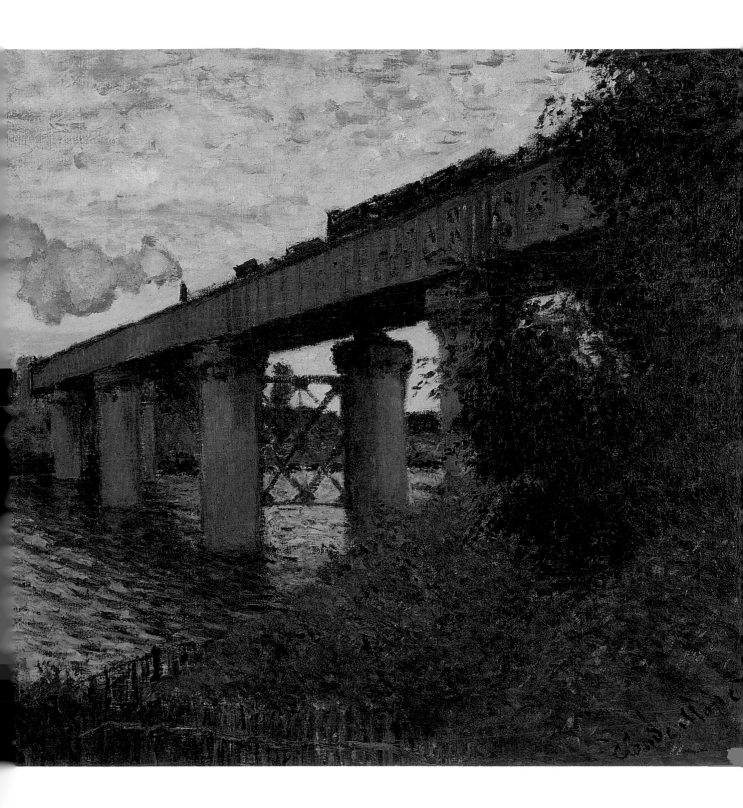

AU PONT D'ARGENTEUIL (1874)
THE BRIDGE AT ARGENTEUIL

Musée d'Orsay. Courtesy of Giraudon

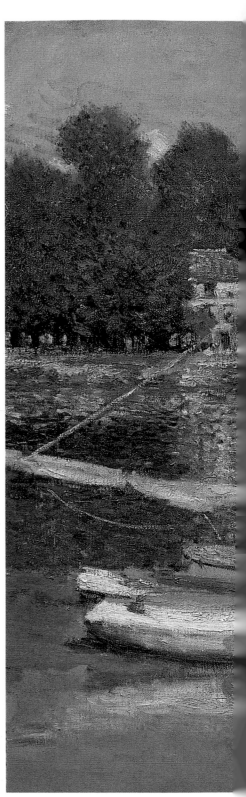

A NUMBER of paintings from Argenteuil depict boats and this is a classic example. Monet had a very commercial mind and, as boating was a popular pastime for Parisians in the 1890s, his choice of subject matter was guaranteed to appeal to the buying public. The whole is a tranquil scene that has a translucent air to it.

The colours harmonise together to help create an aesthetic view. Broken colour is used where it is necessary to depict the surface of the water affected by light, and under the arches of the bridge where the light reflects off the water. By using adjacent lines, an almost translucent effect is created. The bridge to the right is another feature that Monet favoured in paintings at this time. In this picture the lines and arches provide a geometric balance to the translucence of the water.

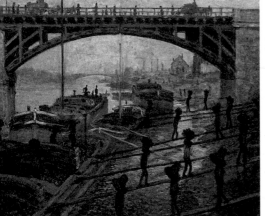

Les Déchargeurs de Charbon (1875)
Unloading Coal
Courtesy of Giraudon. (See p. 86)

Les Déchargeurs de Charbon (1875) is a contrasting vision both of the river and of a bridge. In this painting the river is a source of industry, not relaxation. The bridge is used as a dark frame across the top half of the painting and appears threatening. In *Au Pont d'Argenteuil* the river is peaceful and the bridge a complement to it.

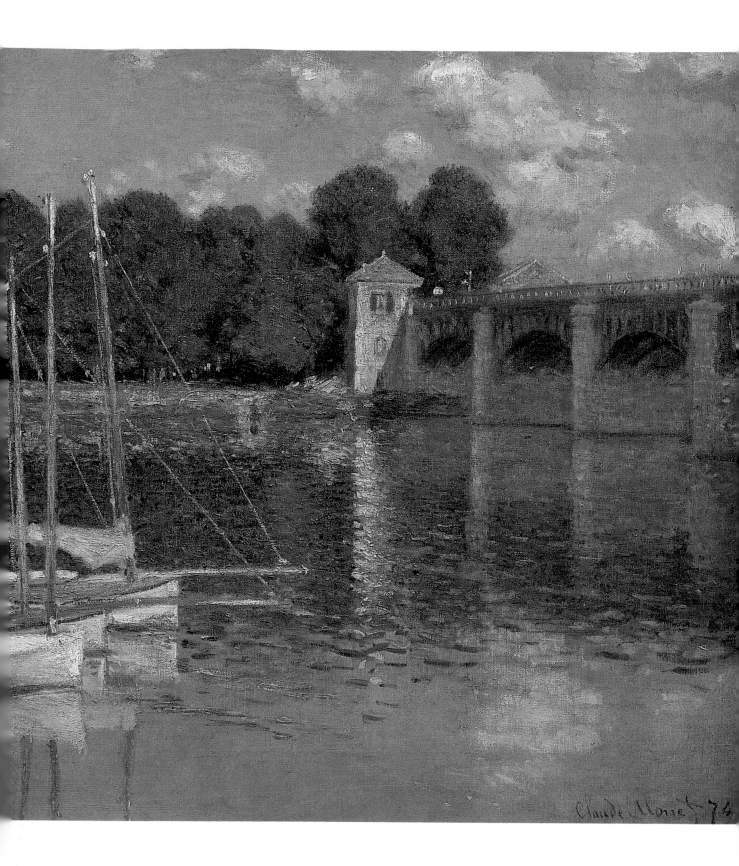

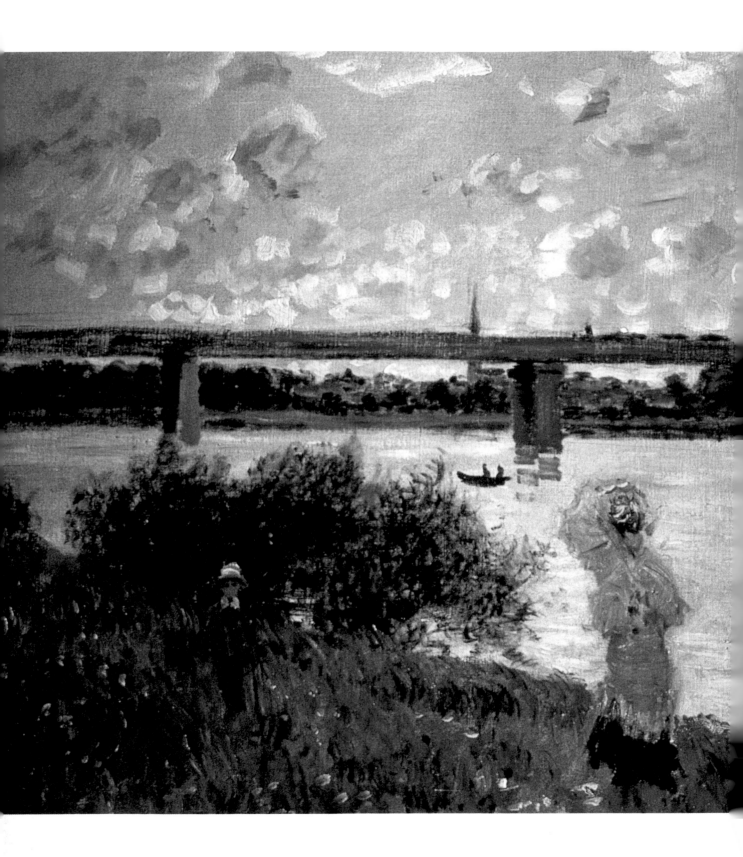

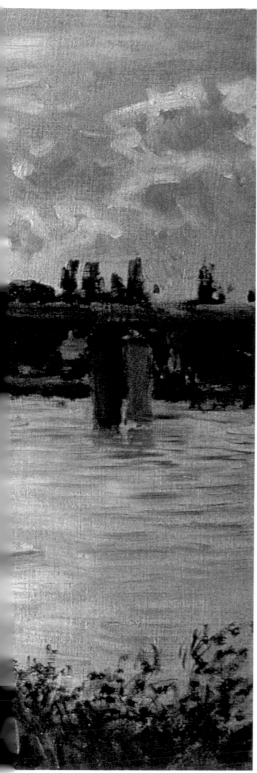

LE PONT D'ARGENTEUIL (1874)
THE BRIDGE AT ARGENTEUIL
Courtesy of Image Select

WHAT makes this landscape dramatic is the railway bridge in the background. Its presence dominates the painting and forms a solid structure that spans the canvas.

Its very solidness contrasts with the bushes and the woman – both of which are curved and rounded shapes – the antithesis of the straight lines of the bridge. Similarly the green of the grass is fresh and natural compared with the grey of the bridge. Monet is painting the meeting of modernity with tradition. The line of the bridge is echoed in the line of the horizon. However, the natural world and modern are not harmonised in the same way as they are in *Waterloo Bridge* (1902). In this painting, bridge, water and sky merge together. The focal point is the patch of sunlight on the water rather than the bridge. Even the smoking chimney stack in the background seems to be a balanced part of the painting.

It is interesting to note that in the 1874 picture, Monet deliberately chose this view of the bridge so that it did not include the factories that lay just to the left of where the canvas ends. For *Au Pont d'Argenteuil*, he obviously felt that he could not harmonise industry into a natural background as he had learnt to do when he painted *Waterloo Bridge*.

Waterloo Bridge (1902)
Courtesy of Christie's Images. (See p. 220)

FEMME ASSISE SUR UN BANC (1874)
WOMAN SEATED ON A BENCH
Courtesy of the Tate Gallery

THIS woman forms a striking presence on the canvas. Instead of being in harmony with her surroundings, Monet places her against a backdrop of a green bench and green trees. Her dress of pink and white makes a strong shape in contrast with this. She is deliberately placed out of harmony with her surroundings, and this gives her a commanding presence.

Her parasol, hat and dress define her as a fashionable woman. Monet uses these to form shapes and solid lines that are geometric in design. Little effort is made to shade her dress or to make use of any shadowing in the painting. The strong, solid shape of the woman is balanced by regular horizontal lines on the bench and vertical lines representing the foliage behind. This style has often been compared to Manet's.

The bench itself is flat and, were it not for the woman seated on it, would appear as a screen of green rather than with depth to it. Perspective and depth are not of importance in this painting. Monet is primarily concerned with creating an overall impression using strong shapes and lines.

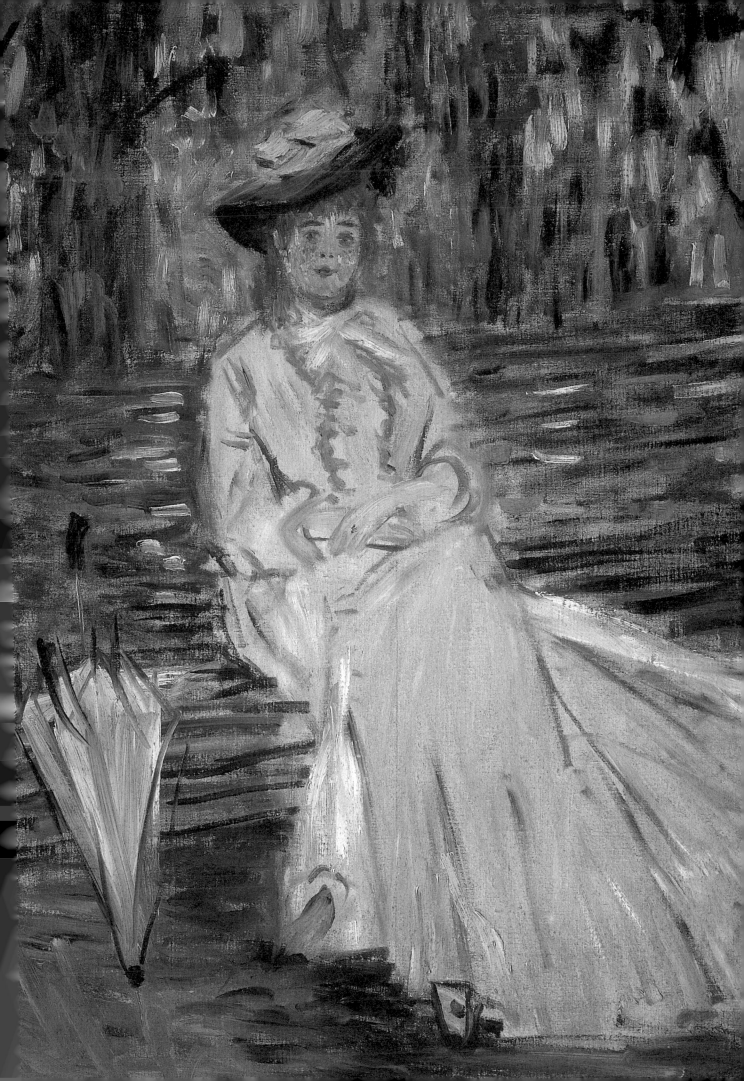

LES DÉCHARGEURS DE CHARBON (1875)
UNLOADING COAL
Courtesy of Giraudon

PAINTED just outside Argenteuil, this picture is unique in Monet's work: it is the only one of his paintings that depicts labourers at work. The result is a dramatic painting that has a schematic composition to it.

A sense of mechanisation is achieved by the regular spacing and number of men walking up and down the planks. The men are a part of the machine. The regularity of their movement and the depiction of industrial work going on are countered by the casual passers-by on the bridge. This subject is a very marked contrast to the idyllic boating paintings from the same period. The colour scheme is dark and gloomy compared with the lighter tones of the boating paintings. However, although illustrating an industrial scene, Monet does achieve a harmony and balance to the painting, which is achieved by his use of the vertical and horizontal. The bridge forms a strong network of grid lines that provides a frame over the picture.

The men moving across the planks are a strong vertical balance to the horizontal lines of the planks. The overall effect is to create an order within the painting that harmonises the picture and adds to the machine qualities of it.

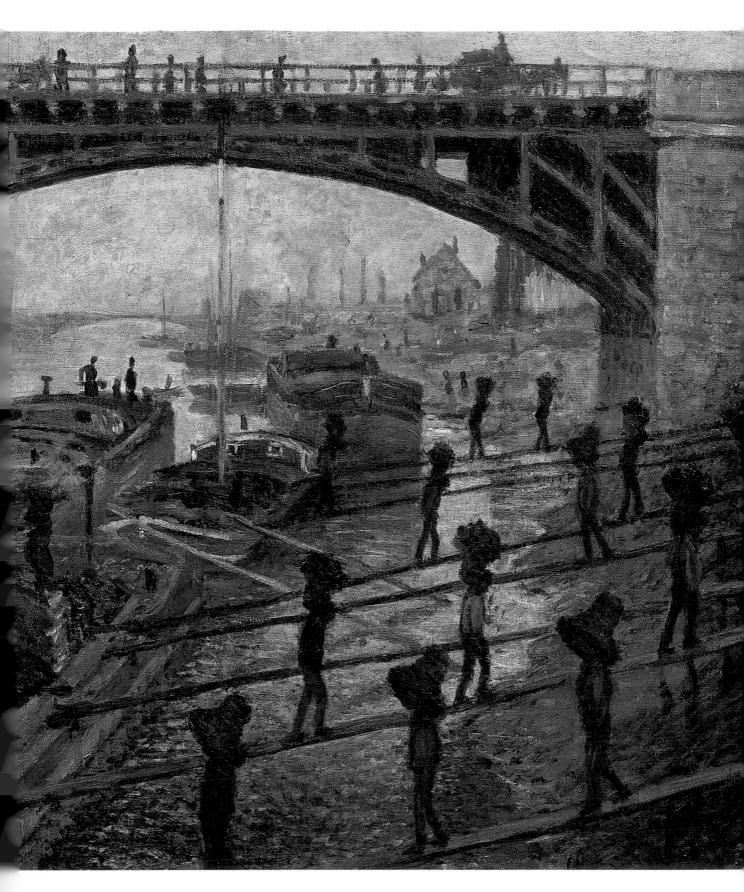

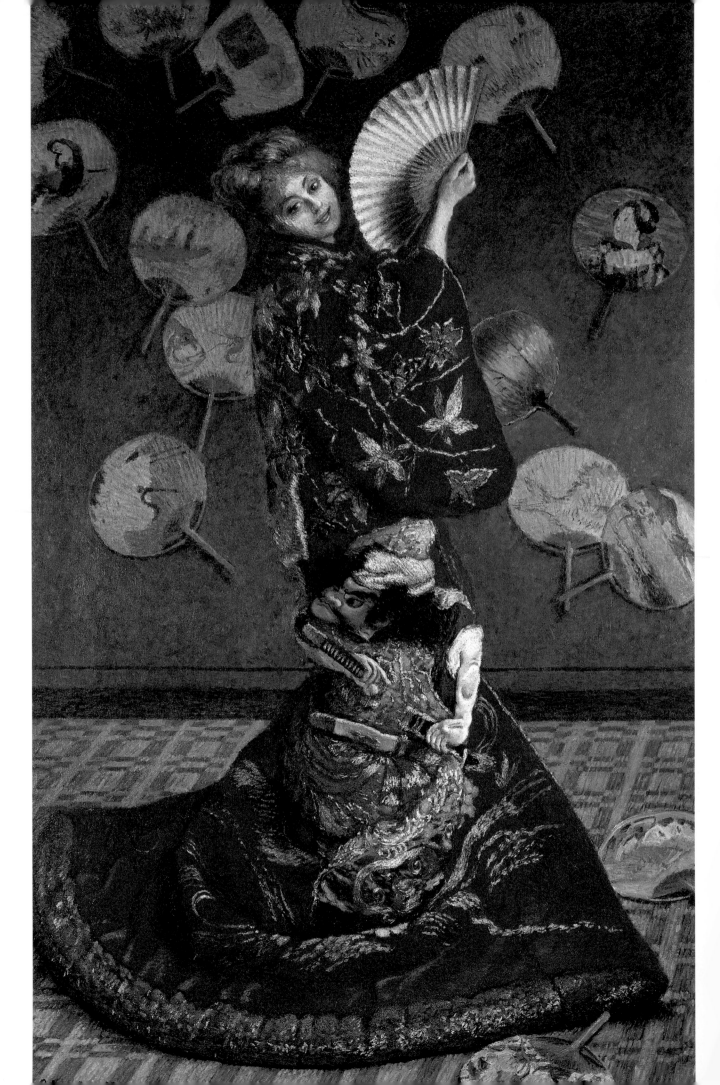

LA JAPONAISE (1875)
THE JAPANESE WOMAN

Boston Museum of Art. Courtesy of Giraudon

INCLUDED in the second Impressionist Exhibition, this work
was an abrupt departure from the style that Monet had been
cultivating over the preceding decade. At the time it caused a
sensation. One critic praised its 'solid colouring' and 'emphatic impasto'.

It harks back to *Camille, ou la Femme à la Robe Verte* (1866),
which was painted in a style that the Salon would appreciate. Monet
was very poor at this time, and one theory holds that he chose
deliberately to paint a conventionally posed painting that would have
a high chance of selling, with perhaps the added benefit of attracting a
new patron. Monet had a strong commercial instinct that lies behind
some of his choices of subject matter and style.

The careful composition and posing of Camille in this painting
lacks all the spontaneity that Monet had been looking to capture in
other works. Camille is not true to life, as she is wearing a blonde wig.
The robe itself is magnificent, and Monet's depiction of the samurai
warrior contrasts with the sweetness of Camille's face. Monet's interest
in Japanese art that had influenced some of his earlier work was
obviously still strong at this time.

Un Coin d'Appartement (1875)
A Corner of the Apartment

Courtesy of Giraudon

IN both these paintings, Monet experiments with a pictorial frame around the subject. In the main picture, he repeats the shape of the curtains and plants in the foreground in the curtains in the background. The frame has the dual purpose of drawing the eye forward and also adding to the perception of the subject. By making the frame well lit compared with the subject, Monet emphasises the darkness of the room.

He is clearly experimenting with light and dark. In the earlier painting of 1873, Madame Monet is in contrast to the dark interior because she is well lit and wears a bright colour. In the later picture, Jean Monet, who stands at the centre, is one of the darkest patches on the canvas; the light reflecting from the floor at his feet emphasising his darkness.

Jean Monet is isolated in the room and is separated from the woman at the table. He makes a disturbing figure because he is painted so dark and because of the steady gaze he directs at the viewer. Madame Monet has a similar direct gaze, but hers is a more intimate, loving look. Jean Monet is also vulnerable; his size is exaggeratedly small when compared with the height of the plants, which appear to threaten to engulf him.

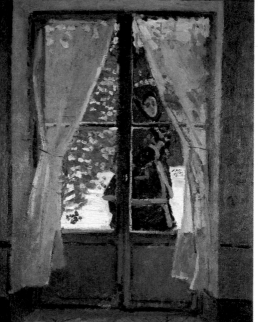

La Capeline Rouge, Portrait de Madame Monet (1873)
The Red Cape, Portrait of Madame Monet
Cleveland Museum of Art. Courtesy of Giraudon. (See p. 65)

EN PROMENADE PRÈS D'ARGENTEUIL (1875)
WALKING NEAR ARGENTEUIL

Courtesy of Giraudon

MANY of Monet's paintings of summer days in the countryside around Argenteuil share an intensity about them. Both *Les Coquelicots, Argenteuil* (1873) and *En Promenade près d'Argenteuil* are concerned with capturing the essence of a summer's day. The passion with which Monet wanted to preserve this particular day is evident in the colours used.

Both paintings have a beautiful blue sky with soft white clouds billowing across them, but the real colour comes from the flowers. In the earlier painting Monet concentrated on capturing the incredible strength of the red of the poppies. In this later painting, the poppies are again present, but other flowers also shine through so there are blues and whites as well as red in the grass. Both paintings share the fact that the flowers are represented by a dash of colour rather than a detailed presentation.

In *Les Coquelicots, Argenteuil*, the flowers appear to threaten to swamp and overwhelm the people. In the main painting, the figures stand out above the flowers and are seen in full length. They are not dominated by their environment but form a family unit that is in harmony with the natural world around them. No buildings appear in this painting, adding to its pastoral, natural tone.

Les Coquelicots à Argenteuil (1873)
Poppies at Argenteuil
Louvre, Paris. Courtesy of Giraudon. (See p. 76)

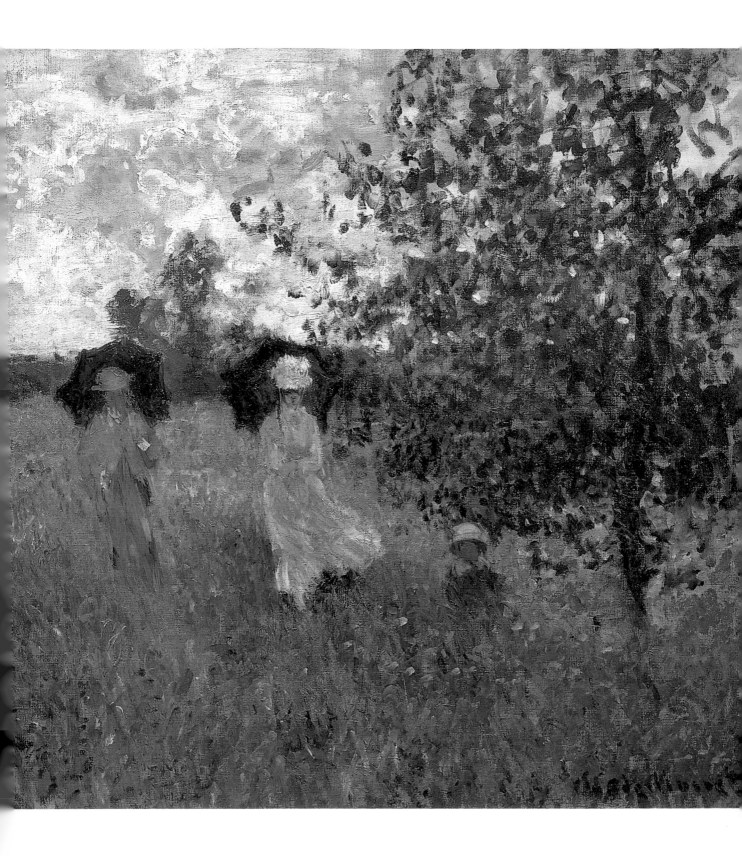

LES DINDONS (1876)
THE TURKEYS
Courtesy of Giraudon

IN 1874 Ernest Hoschedé invited Monet to stay on his estate and commissioned four decorative panels from him. This is one of them. While the subject matter itself is very traditional, Monet's treatment of it is not.

One can compare this to *Trophée de Chasse* (1862), which was created early in Monet's career, while he was still careful to follow the traditions of art. It depicts dead game birds in a conventional composition, the whole carefully arranged for the artist's benefit. The formality of this earlier painting is not in evidence in *Les Dindons*. The birds, painted realistically to life size, ramble across the painting at will. This has the result of making the composition seem asymmetrical. The carefully arranged triangular symmetry of the still life is not in evidence here. Monet even has the audacity to cut one bird off at the neck, unheard of in paintings of the establishment, adding to the spontaneity of the painting.

The viewer is placed on a level with the birds, as if he were lying on the grass. In *Trophée de Chasse* the distance is carefully maintained between subject and viewer. The different angle taken in the later painting adds to the informality of the whole picture.

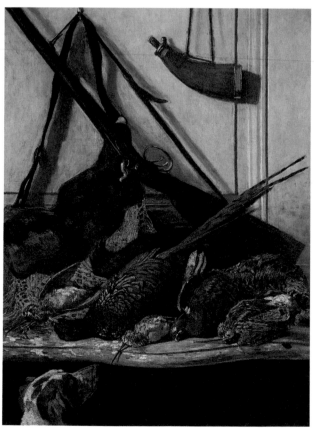

Trophée de Chasse (1862–63)
Sporting Prize
Musée d'Orsay. Courtesy of Giraudon. (See p. 20)

Le Pont de l'Europe, Gare St-Lazare (1877)
Europe Bridge, St Lazare Station
Musée Marmottan. Courtesy of Giraudon

DURING the months of January to April 1877, Monet painted 12 pictures of the Gare St Lazare. Although these are sometimes referred to as Monet's first attempt at series paintings, they differ from each other too widely to justify such a title, but they do show his growing interest in using the same subject again and again. Monet's choice of a station as a subject reflects his desire to paint modern scenes. The author Emile Zola described them as 'paintings of today'.

Monet uses the smoke from the engines in a similar way to the fog in *Charing Cross Bridge, La Tamise* (1903): as a tool to distort light and colour patterns. However, whereas this is made into a localised effect in *Le Pont de l'Europe, Gare St Lazare*, the later painting is dominated by fog, creating a haze over the setting. The architecture is not recreated in detail, as in the earlier work, but becomes shadowy as a result of the fog. Monet's aim with *Le Pont de l'Europe, Gare St Lazare* is to paint a modern subject. The buildings, the bridge and the train are all synonymous with modern Paris. There is an air of bustle in this that is missing from the serene Charing Cross Bridge painting altogether.

Charing Cross Bridge, La Tamise (1903)
Charing Cross Bridge, The Thames
Courtesy of Christie's Images. (See p. 222)

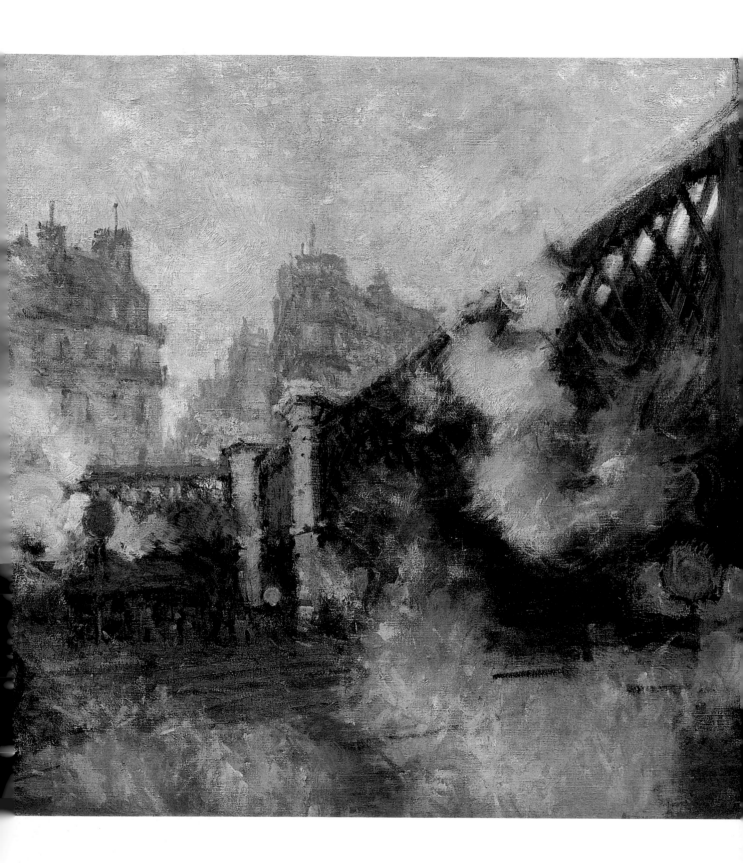

LA ROUTE À VÉTHEUIL (1878)
THE ROAD TO VÉTHEUIL
Phillips Collection. Courtesy of Image Select

*L*A ROUTE *à Vétheuil* is very similar in composition to *La Route de la Ferme, St-Simeon en Hiver* (1867). Both show the broad sweep of a road approaching buildings in the distance; however, the two works are set in contrasting seasons and the effect of these different seasons is that the snow muffles the winter scene.

La Route à Vétheuil is dominated by geometric shapes and lines. The road in both paintings draws the eye in and forms a broad vertical line on the canvas. However, although the snow markings in the St Simeon painting underline this linear aspect, the concentration of white effectively dampens the overall impact. The road in the later painting is not only free of snow but has been painted using obvious vertical brushstrokes. The bank forms a triangle on the canvas, and the hills in the background also form a geometric shape. A comparison of the treatment of the bank in the winter scene reveals that this geometry is lacking; the trees on the bank prevent it from forming a distinct triangle.

Monet uses light to emphasise the geometry of the painting so that the dark hills in the background contrast with the well-lit bank in the foreground. Similarly, the shadows of trees not visible in the painting fall across the road, creating parallel horizontal bands of darkness that contrast with the vertical light band of the road.

La Route de la Ferme, St-Simeon en Hiver (1867)
The Road to the Farm, St Simeon in Winter
Private Collection. Courtesy of Image Select. (See p. 38)

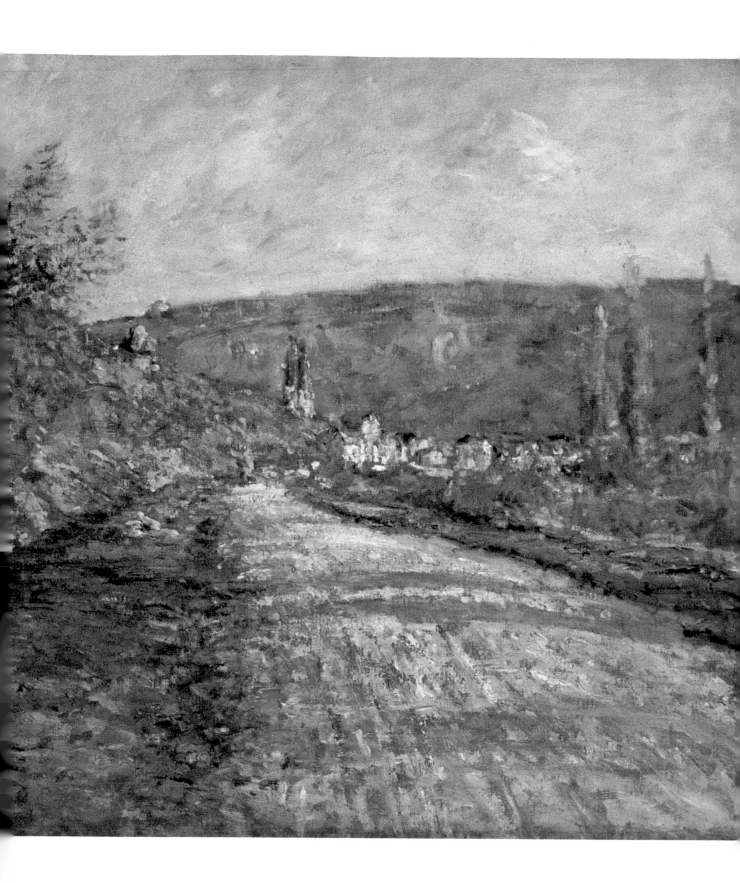

CHRYSANTHÈMES (1878)
CHRYSANTHEMUMS
Courtesy of Christie's Images

THE strange, almost three-dimensional effect of the flowers on the wallpaper is reminiscent of the Japanese fans in *La Japonaise* (1975). The flowers float in an uncomfortable way behind the basket of flowers. This effectively causes two different points of interest in the painting, so that the eye struggles between the wallpaper and the flowers to find a central focal point.

This is in contrast to *Les Roses* of 1925–26, where Monet's treatment of the flowers is based purely around the pattern they create. The flowers are painted without the detail afforded to the chrysanthemums in the main painting. In *Les Roses,* Monet's aim is entirely decorative. Here the flowers do not float across the canvas but are given a strong background and are placed in an obvious domestic setting. Although not a conventional still life, this picture does depict flowers in a more traditional way.

The quick brushstrokes that cross each other create a blurring around the centre of the flowers. Out of the mass of pink and white, the individual petals emerge to spiky effect. The roses are painted as dashes of colour that have little definition. By the later painting Monet is more concerned with the impression of the flower than with the detail.

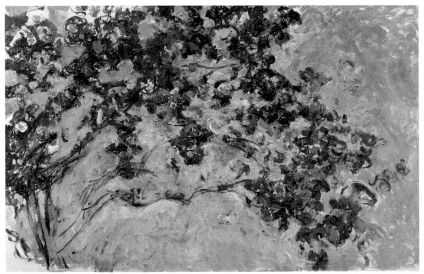

Les Roses (1925–26)
The Roses
Courtesy of Giraudon. (See p. 254)

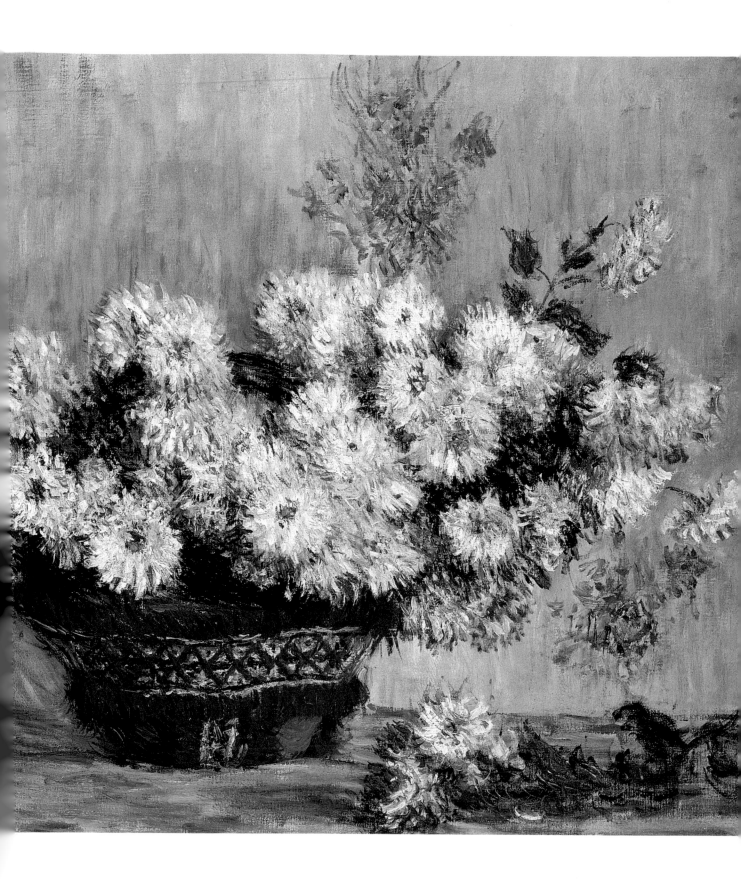

L'ESCALIER (1878)
THE STAIRS
Courtesy of Christie's Images

THIS painting is one that was sold to an American buyer, although later it was bought back by the collector Durand-Ruel. America proved to be a profitable market for the Impressionists, thanks to Durand-Ruel, who opened it up to them through exhibitions.

The appeal of *L'Escalier* lies in its subject matter and composition. The stairs leading up are inviting, while the archway provides a provocative glimpse into the courtyard. This is in contrast to *Vétheuil* (1901), where the town is seen from a distance and the viewer is set apart from the town by an expanse of water. *L'Escalier* is an intimate and inviting view of a building at close hand, with the viewer now at the heart of the town, not apart from it. *L'Escalier* is unusual for its choice of an everyday rural building as its subject. Most Monet paintings of buildings are either depicting modern or Gothic architecture or are seen as a group from a distance, as in *Vétheuil*.

The warm pinks and golden colours used combine with the deep blue of the sky to create the effect of a balmy, lazy summer's day. Even the shadow falling across the bottom left corner of the painting does not detract from the warmth.

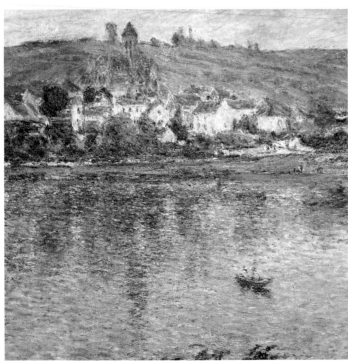

Vétheuil (1901)
Pushkin Museum, Moscow. Courtesy of Topham. (See p. 216)

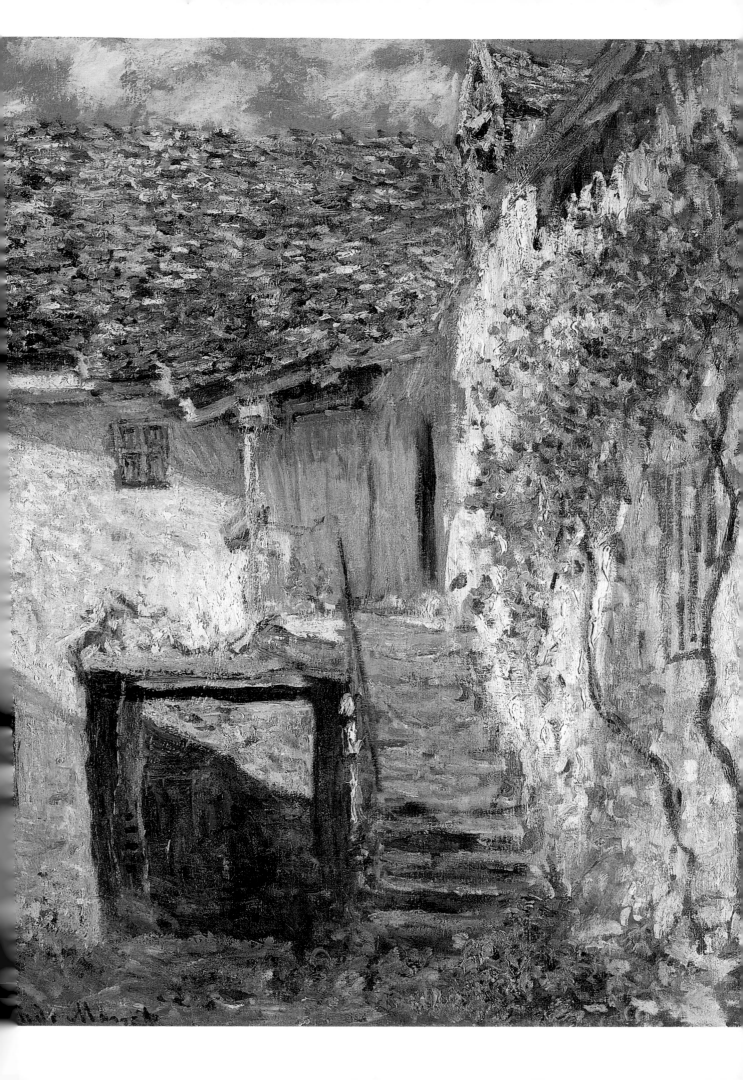

POMMIERS PRÈS DE VÉTHEUIL (1878)
APPLE TREES NEAR VÉTHEUIL
Courtesy of Christie's Images

THIS painting depicts the view down into the valley of Vienne-en-Artheis. It is typical of the rural scenes that Monet produced once he moved to Vétheuil. There is no evidence of industrialisation in this painting, which instead focuses on the apple trees in the foreground.

Monet uses small brushstrokes of differing colours on the trees to create the effect of sunlight falling across the blossoms. These smaller strokes gradually become longer as Monet moves down into the valley on the canvas. These longer strokes have the effect of merging colours together and creating a blurring of lines so that the trees in the foreground appear to be strongly in focus compared with the valley in the background.

The critic, Philippe Birty, saw this painting exhibited at Durand-Ruel's gallery, along with others by Monet. His response was as follows: 'It is from afar that these paintings must be judged, and the near-sighted and insensitive will only perceive a confused mixed-up, tough or shaggy surface resembling the underside of a Gobelin tapestry with an excessive use of chromium-yellows and orange-yellows.' The belief that Monet's paintings are best viewed from a distance still persists among critics today.

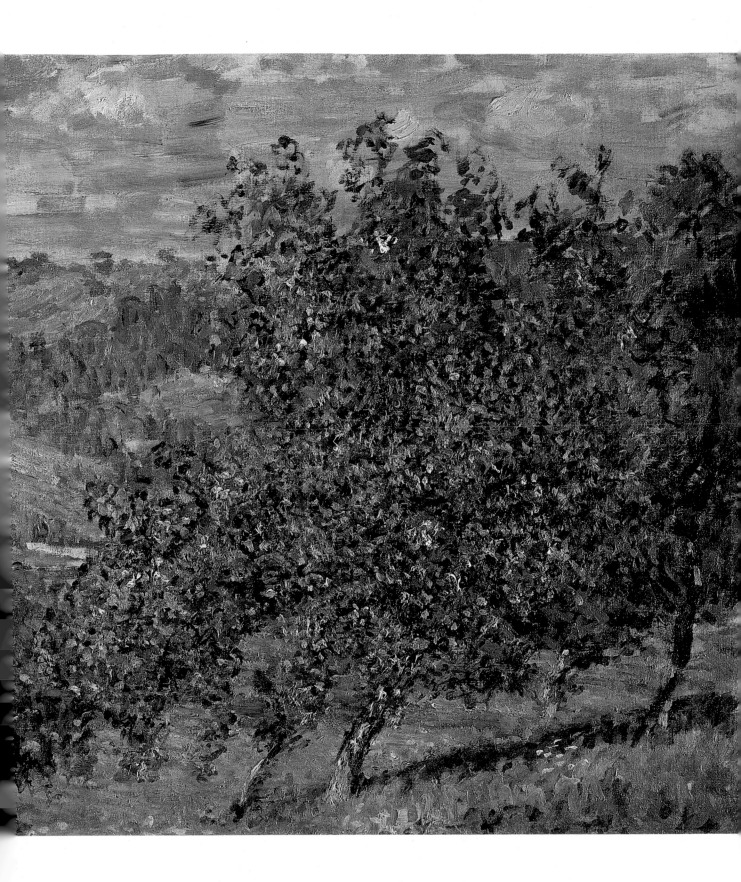

LA RUE MONTORGEUIL FÊTE DU 30 JUIN 1878 (1878)
MONTORGEUIL STREET FETE, 30 JUNE 1878
Musée d'Orsay. Courtesy of Giraudon

THIS painting is easily confused with *Rue St-Denise Celebrations, 30 Juin 1878* (1878) as they depict virtually identical scenes. It is a testimony to Monet's enthusiasm for the subject that he devoted two canvases to the cause of reproducing the excitement in the streets on one day.

The occasion was a celebration of the World Fair that Paris had been hosting. As can be seen from the painting, the streets were decked with flags and banners. A sense of national pride is present in this work, as well as an incredible air of spontaneity. Monet's pride in his country is evident in the overpowering national colours of red white and blue. The quick brushstrokes and pulsing colours are all testimony to Monet's desire to capture quickly the atmosphere of the scene. His rendition of a street below had been painted in a similar manner earlier in *Boulevard des Capucines* (1873). The level Monet paints from in both pictures is from an upper storey, providing a similar perspective to both views.

In addition, Monet chooses to depict the crowds in both paintings by using quick, dark brushstrokes that emphasise the individuals being caught in mid-movement. In both these works, the people are anonymous, but in the later work this has developed to the extent that even the men and women cannot be differentiated.

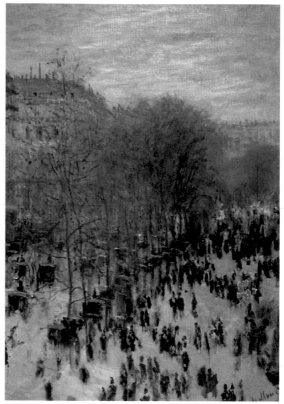

Boulevard des Capucines (1873)
Courtesy of the Visual Arts Library, London.
(See p. 68)

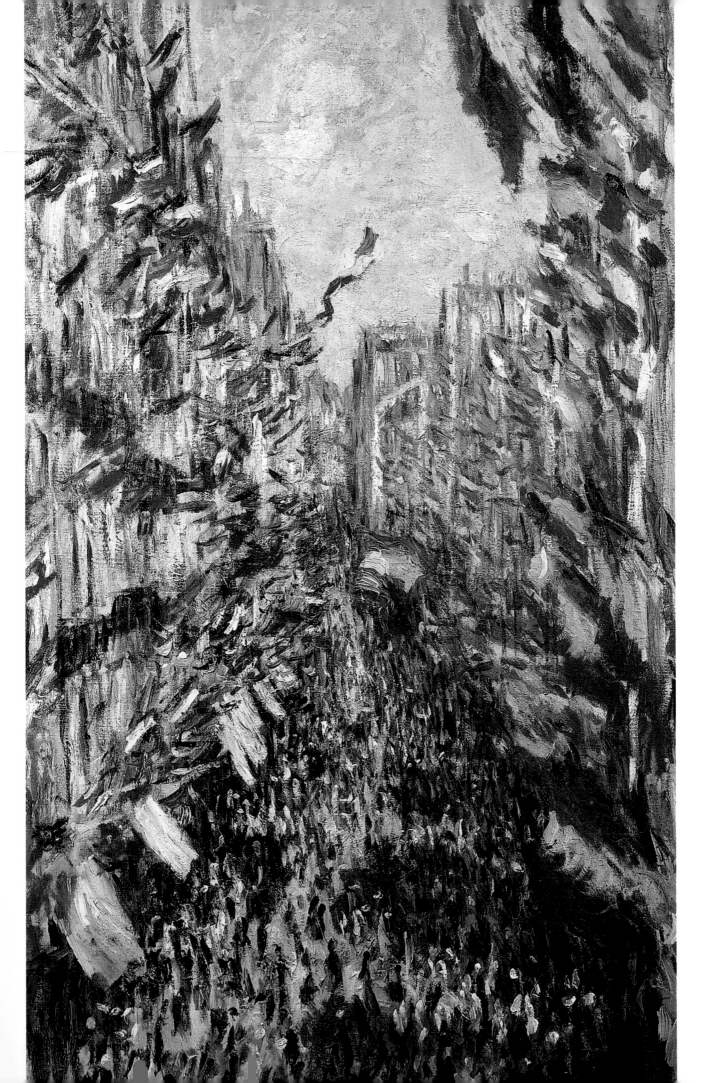

LE GIVRE (1879)
THE FROST

The Louvre, Paris. Courtesy of Giraudon

THIS period was a desolate one for Monet. Financially, the household was stricken, and he was heavily in debt. The winters of 1878 and 1879 were severe, forcing prices up. In September 1879 Camille died.

Many critics have attempted to draw parallels between the mood of Monet at this time and his paintings. It is true that the gloom of *L'Eglise à Vétheuil, Neige* (1879) could reflect his emotions, but a look at *Le Givre* undermines this. Although the subject matter itself could represent Monet's personal desolation, his treatment of it defies this. *Le Givre* shows ice and frost sparkling in the sunlight, the white frost warmed up with pink and blue. Although a barren scene, the colours used give it a warmth lacking in the buildings of *L'Eglise à Vétheuil, Neige*. The whole scene is harmonised through the use of strong horizontal strokes on the ice and small vertical strokes on the bushes. The vertical of the poplars balances the horizontal of the river bank. This use of horizontal and vertical balance can be found in *L'Eglise à Vétheuil, Neige* as well.

Although it is difficult to try to read the artist's personal life into his work, these paintings do reveal that Monet's changing moods meant that he was being attracted to very different styles.

L'Eglise à Vétheuil, Neige (1879)
The Church at Vétheuil, Snow
Louvre, Paris. Courtesy of Giraudon.
(See p. 110)

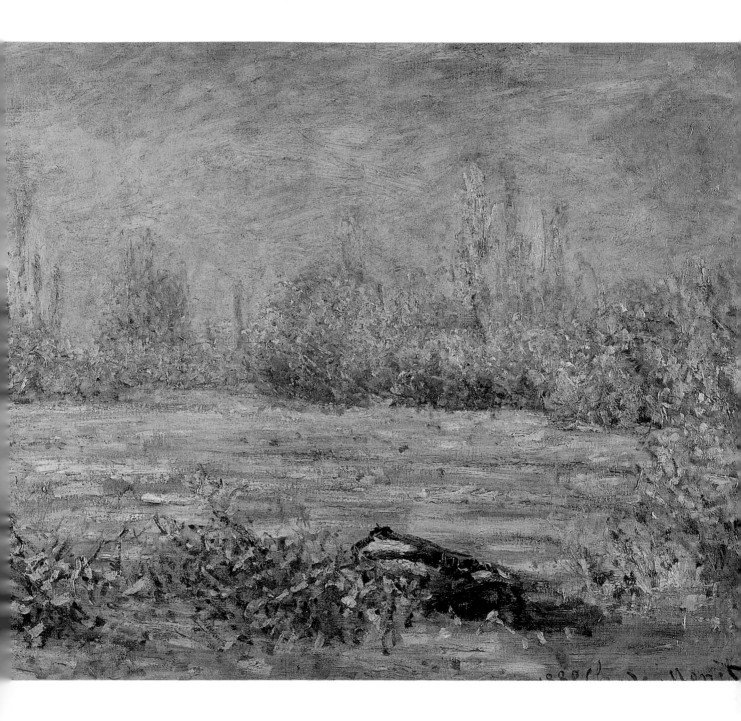

L'EGLISE À VÉTHEUIL, NEIGE (1879)
THE CHURCH AT VÉTHEUIL, IN SNOW

The Louvre, Paris. Courtesy of Giraudon

*P*AINTED from the opposite bank of the river, this sombre work is very different from some of Monet's summer paintings in Vétheuil. The palette of colours used is extremely restricted, offering very little relief from the white and dark colours. *Le Jardin de Vétheuil* (1881) provides a useful contrast to demonstrate how tightly controlled this palette was.

Matching this rigid colour scheme, Monet adheres equally as doggedly to the rules of symmetry. The bank forms a solid horizontal line that is repeated in the hedgerow growing above, counterbalanced by the vertical of the church tower and the poplar trees. The buildings all form solid shapes on the canvas, making a pattern of oblongs, squares and triangles. In *Le Jardin de Vétheuil*, the house, veranda and steps form similar shapes on the canvas and attempt to replicate the balance of horizontals and verticals. However, this is disrupted by the garden with the strong twisting shape of the tree dominating the rigid shape of the house.

Some relief from the rigidity of the painting is given by the short broken brushstrokes used to create the water surface; these help to soften the impact of the flatter bank above.

Le Jardin de Vétheuil (1881)
The Garden at Vétheuil
Courtesy of Christie's Images.
(See p. 120)

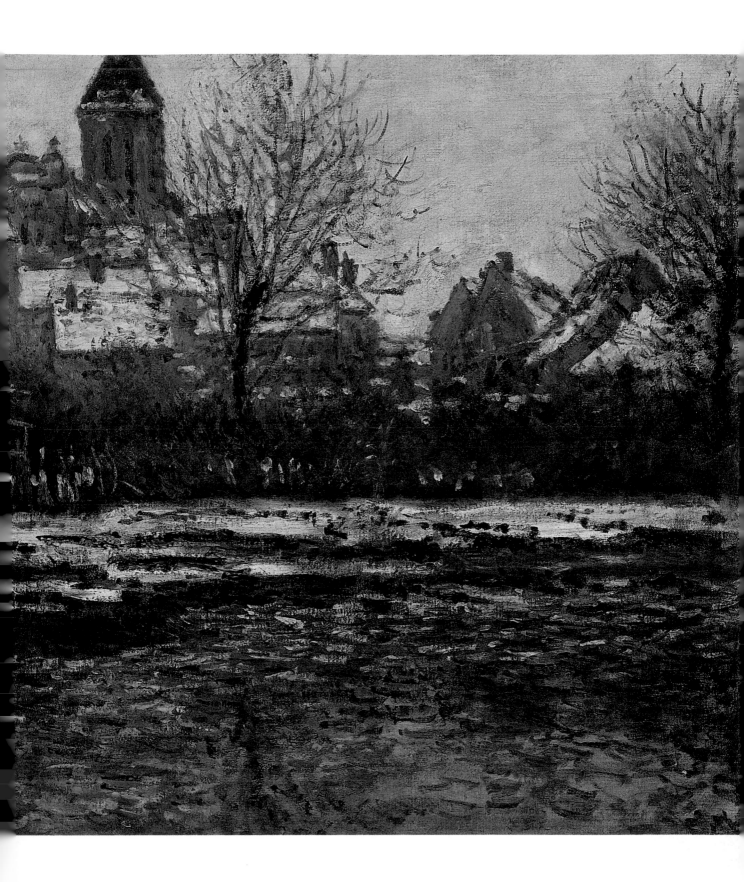

❋ L'EGLISE À VÉTHEUIL, NEIGE ❋

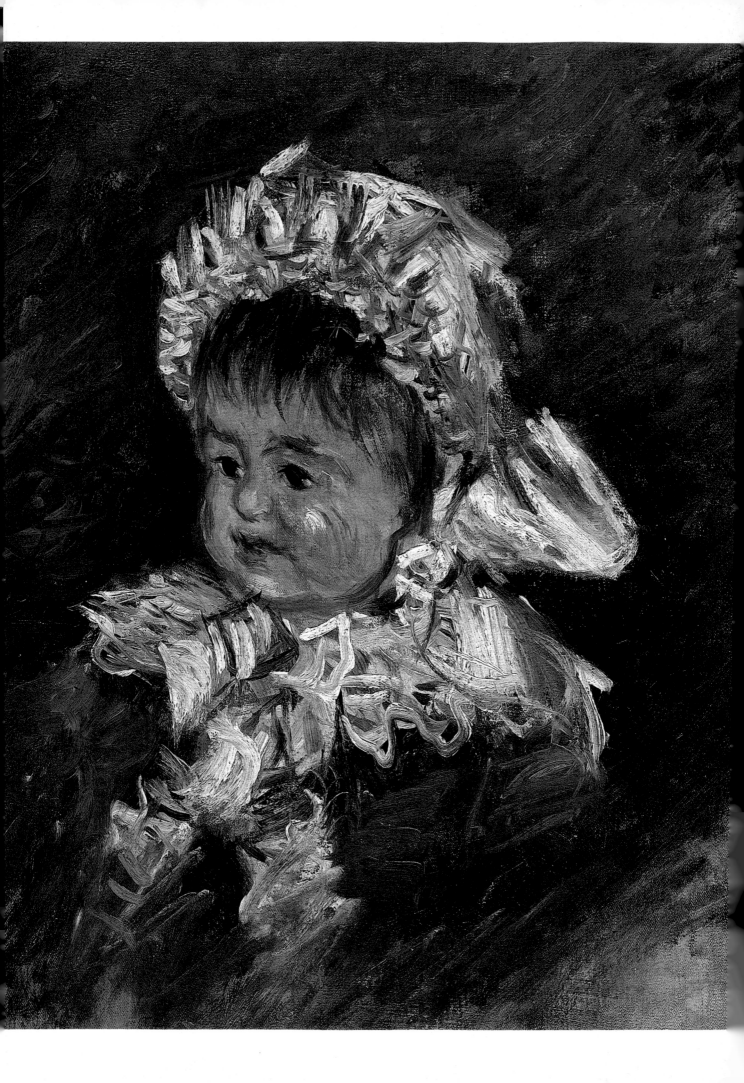

PORTRAIT DE MICHEL MONET BÉBÉ (1878–79)
PORTRAIT OF MICHEL MONET AS A BABY
Courtesy of Giraudon

THIS painting was produced not long after Michel was born. He still has the full cheeks of a very young baby, although he does have a lot of hair. Despite the quick brushwork, Monet succeeds in creating an impression of Michel that is immediately recognisable as the same child in later portraits.

This style of creating an impression of the person rather than producing a detailed portrait was a change from his earlier work; Monet treats his portraits from this period in the same style as his landscapes. There are a number of portraits of his sons from around this period. His family had until this date often featured as the human presence in many of his landscapes. However from around 1880 onwards Monet included people less and less in his landscapes, which might explain his desire to record them in portraits.

The portrait of Michel is intimate and does not attempt to exaggerate any features or caricature the child. This is a very different style from that used in *Portrait de Poly* (1886), where the man posing is painted in a manner suggestive of his personality. When looking at Michel's portrait, there is no indication as yet of his character.

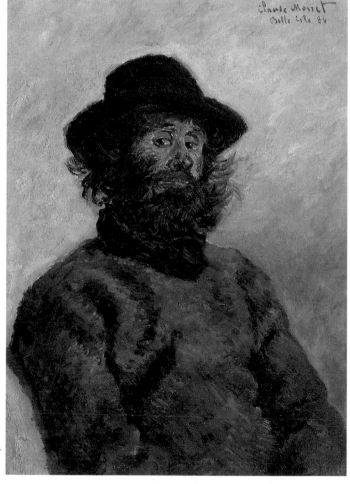

Portrait de Poly (1886)
Portrait of Poly
Musée Marmottan. Courtesy of Giraudon. (See p. 148)

PORTRAIT DE JEUNESSE DE BLANCHE HOSCHEDÉ (1880)
PORTRAIT OF THE YOUNG BLANCHE HOSCHEDÉ

Musée des Arts, Rouen. Courtesy of Giraudon

BLANCHE Hoschedé was 14 when this portrait was painted. It is the essence of a young girl, her rosy cheeks, bright eyes and red lips making her the stereotype of youth. Monet painted a number of portraits of his extended family at this time, although few of his family were featured in his landscape work during this period.

This portrait is very different from that of Camille made 14 years earlier. The style is more in keeping with Monet's Impressionism. The brushwork is more obvious across the portrait, whereas *Camille au Petit Chien* (1866) has this type of brushwork only on the dog. There is a merging of colours across the whole painting, so that there is a blurred effect especially noticeable on Blanche's dress. Although her features are clear, they are not painted in the same sharp style as Camille's. Blanche

is painted with a strongly patterned wallpaper behind her that prevents her figure from dominating in this painting in the same way that Camille does.

The colours used are mostly pastels, but the red of the hat attracts the eye. This colour helps to emphasise Blanche's red lips, but it also distracts the viewer's gaze away from the face. Blanche is painted as part of an overall design, Camille as a separate entity.

Camille au Petit Chien (1866)
Camille with a Little Dog
Private Collection, Zurich. Courtesy of Giraudon. (See p. 32)

PORTRAIT DE MICHEL EN BONNET À POMPON (1880)
PORTRAIT OF MICHEL IN A POMPOM HAT
Courtesy of Giraudon

MICHEL Monet was Monet's second son with Camille. At the time of this portrait he was two years old. Monet's initial uncertainty about fatherhood had gone by the time Michel was born. Both this portrait and *Portrait de Jean Monet* (1880) are testimony to the love that he felt for his children.

In Michel's portrait, the two-year-old sat apparently docile while his father painted him. The quick brushstrokes, used on the red coat and the red of his cheeks in particular, suggest that Monet at least wanted to create the impression of the portrait having been dashed off. This is especially noticeable when compared to the shorter strokes used on Jean's portrait. Although Michel's features are identifiable, the nose, lips and eyes are not painted in as much detail as the features are in Jean's portrait.

Both paintings share an anonymity of background. A blanket colour has been applied so that the focus of the paintings is genuinely the boys. In some of Monet's portraits of fashionable women, the background and clothing are given as much detail as the face and body of the woman. This makes a statement about how the women are perceived. With both of these portraits the individual child is the centre of attention.

Portrait de Jean Monet (1880)
Portrait of Jean Monet
Courtesy of Giraudon. *(See p. 118)*

PORTRAIT DE JEAN MONET (1880)
PORTRAIT OF JEAN MONET
Courtesy of Giraudon

JEAN Monet would have been around the age of 13 when this portrait was done. Monet had used Jean frequently in landscape paintings before this portrait, sometimes with Camille and sometimes on his own. However, in all of these, he can be identified only as a small child rather than as an individual in his own right.

This portrait is entirely concerned with Jean as Jean. Care is taken to record his features, and he is painted as a full-face portrait. When compared with *Portrait de Madame Gaudibert* (1868), where the woman's face is averted to the point that her features are almost hidden, the intimacy of *Portrait de Jean Monet* is understood. Monet is recording Jean in a very personal style. The lack of detail to the background compared with *Portrait de Madame Gaudibert*, where even her clothes are carefully recorded, indicates clearly that Monet is interested in illustrating the individual that is Jean. Madame Gaudibert is recorded as yet another society woman whose identity is found in her clothes and her home rather than in her face.

Monet's style has changed over the intervening years between these paintings. The brushstrokes are thicker, and he is not afraid to use blocks of colour solidly placed on the canvas. No attempt is made to offer a variety of shading on Jean's top, as had been done with Madame Gaudibert's dress.

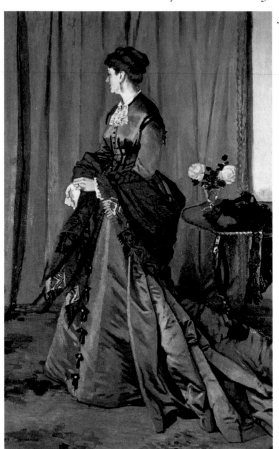

Portrait de Madame Gaudibert (1868)
Portrait of Madame Gaudibert
Musée d'Orsay. Courtesy of Image Select. (See p. 45)

LE JARDIN DE VÉTHEUIL (1881)
THE GARDEN AT VÉTHEUIL
Courtesy of Christie's Images

HERE Monet shows an unruly and untamed garden. When compared with the earlier work *Jeanne-Marguerite, le Cadre au Jardin* (1866), this disorder is particularly marked. The regularity and structure provided by the steps and the china-blue plant pots on the terrace are fighting a losing battle with the foliage. The tree on the left of the painting snakes across the canvas and virtually obliterates the house. The shadow on the lawn is irregular in shape and adds to the sense of chaos. In *Jeanne-Marguerite, le Cadre au Jardin*, the shadows of the woman and the flowerbeds are neat blocks of black. In this later painting, the garden is trained and controlled, the beds and trees providing a safe environment to walk in. In *Le Jardin de Vétheuil* there is no one walking in the garden; its unruly appearance suggests that nature has gone wild.

Jeanne-Marguerite, Le Cadre au Jardin (1866)
Jeanne-Marguerite, the Image in the Garden
The Hermitage, St Petersburg. Courtesy of Topham.
(See p. 30)

The colours used in the earlier work are laid on to the canvas as separate blocks so that the woman forms a block of white, the lawn a block of green and so on. This clear distinction is lost in *Le Jardin de Vétheuil*, where colours merge into each other, making one element difficult to differentiate from the next. The white of the house becomes the white on the tree leaves.

FLEURS À VÉTHEUIL (1881)
FLOWERS AT VÉTHEUIL

Courtesy of Christie's Images

THE town depicted in *Fleurs à Vétheuil* is small and vulnerable on the canvas, isolated by a grey sky that matches the grey water in front of it in colour. The same is not true in *Vétheuil* (1901), where the town has a strong presence on the canvas and attracts the eye to its jumble of colourful rooftops.

In contrast, the eye is drawn to the riot of colour formed by the flowers in the foreground of *Fleurs à Vétheuil*. In fact, the flowers are not restricted to the foreground but threaten to envelop the picture. Their colour is so strong that the town in the background seems washed out in comparison. Although the opening in the bushes provides a vista of Vétheuil, the tall flowers that spike up from the general melee of colour that covers the bottom half of the canvas are threatening to close over the gap. Vétheuil is in danger of being swallowed up by nature, but in *Vétheuil*, the little town is serenity itself.

The colours used in the main picture form connections between themselves. The red flowers that band across the picture are repeated in colour on the spiked flowers. These also have the rosy white colour of the flowers in the foreground. This provides them with a unity out of the confusion of colours.

Vétheuil (1901)
Pushkin Museum, Moscow.
Courtesy of Topham. (See p. 216)

BARQUES DE PÊCHE DEVANT LA PLAGE ET LES FALAISES DE POURVILLE (1882)
FISHING BOATS IN FRONT OF THE BEACH AND THE CLIFFS OF POURVILLE
Courtesy of Christie's Images

IN ORDER to paint this picture, Monet made a great effort to reach the exact location that he thought was necessary for the best viewpoint. It is recorded that he was seen clambering over cliffs and rocks dragging six or seven canvases with him. This would be in keeping with his ideals concerning *plein-air* technique, although the reality was that he finished most of the canvases in his studio.

Barques de Pêche devant la Plage et les Falaises de Pourville and *La Falaise de Ste-Adresse* (1873) seem to lack some of the obvious spontaneity evident in other paintings, although the scurrying clouds in the former have some sense of being captured on canvas on location. The painting depicts sailing boats, which had already proved a popular subject when Monet lived at Argenteuil. Here the lonely figure on the shore is isolated by being detached from the fun of the boats at sea. This isolation is emphasised by the careful blocking Monet adopts with each element. Strong lines separate the shore from the sea and the sea from the sky. There is no blurring of the boundaries in either painting, as has been seen in other work. Instead, each element is clearly differentiated from its neighbour.

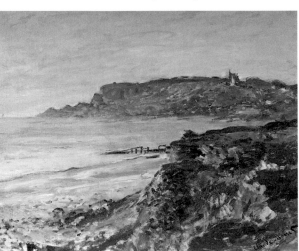

La Falaise de Ste-Adresse (1873)
The Ste-Adresse Cliffs
Courtesy of Christie's Images. (See p. 66)

CHEMIN DANS LES BLÉS À POURVILLE (1882)
PATH THROUGH THE CORN AT POURVILLE

Courtesy of Christie's Images

WHAT is most noticeable about this painting are the strong, bright colours. The blue of the sea is reminiscent of some of Monet's paintings from the Mediterranean. What he set out to do was to capture the effects of a brilliant summer's day on the beach landscape.

By using strong colours that contrast with each other rather than blend together, he achieves the effect of each colour appearing even stronger. Thus, where the red of the wheat touches the blue of the sea, each benefits from the contrast; the same is true where the sea meets the shore. This time the effect of the sun is to render the sand a brilliant white. These blocks of colours work together to create an impression on the viewer. There is actually very little detail in the picture itself.

This painting has strong lines that form horizontals and verticals. In the picture the curved path not only draws the eye towards the sea but also provides a vertical curve that meets the sand and continues to the horizon. This balances the horizontal of the sea and cliff.

LA PLAGE À POURVILLE, SOLEIL COUCHANT (1882)
THE BEACH AT POURVILLE, AT SUNSET
Musée Marmottan. Courtesy of Giraudon

*T*HE effect of the sun setting on the beach is entirely decorative. The sweep of the beach across the bottom of the painting is balanced in equal measure by the sea and the sky. Unlike other paintings from this period, there is no sense of drama between the three elements.

La Plage à Pourville, Soleil Couchant is harmonised by the colours used. The orange and yellows of the sun in the sky are reflected on to the water beneath and again in the colours used on the beach. This strengthens the link between the three elements and harmonises the picture. Similarly, blue paint is used on the shore as well as the sea and sky. The painting has been produced purely for the pleasure of viewing it. Monet has dispensed with the previously held beliefs of the official French art world that paintings need to have a purpose other than beauty. Prior to the appearance of the Impressionist artists, paintings with moral or religious significance were considered correct subjects for art.

The painting is purely concerned with the harmony of nature. No humans are present in the painting, and no message is intended. 'Art for art's sake' was soon to become one of Monet's central beliefs.

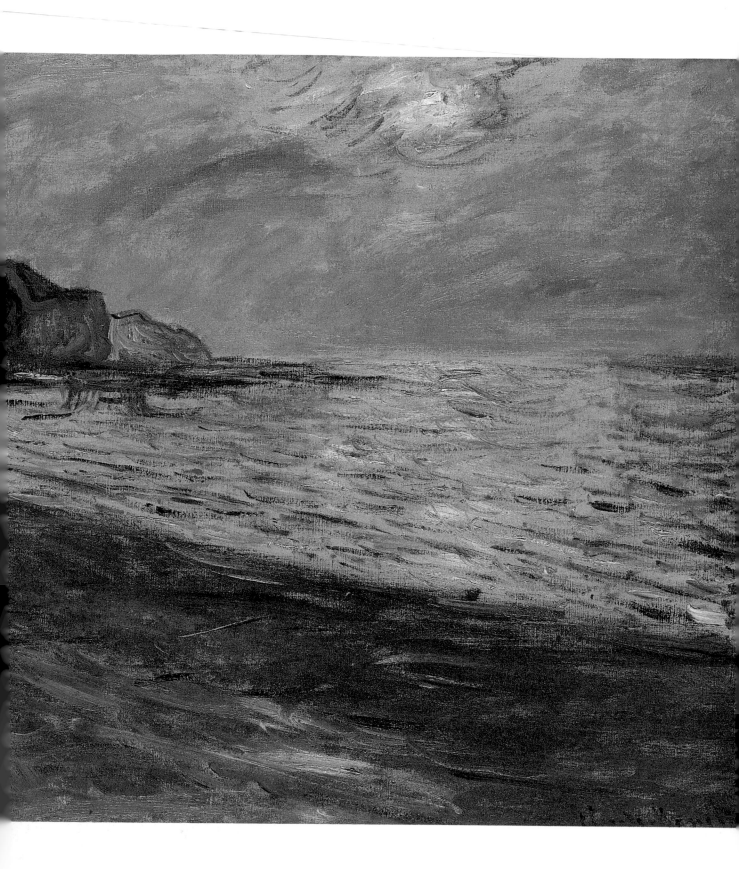

LES GALETTES (1882)
THE CAKES
Courtesy of Giraudon

ALTHOUGH Monet did not paint many still lifes, he chose to present one to the Municipal Council of Le Havre. This suggests that he felt strongly that they were of significance within the portfolio of his work. His still life paintings tended to appear in the earlier part of his career, from the late 1860s to the early 1880s.

This later work in the period shows evidence of his changing technique. The treatment of the tablecloth compared with *Nature Morte au Melon* (1876) reveals much more vigorous brushwork and thicker strokes. Similarly the cakes are painted with obvious brushwork and are not attempting to be an exact copy of the subject in the same way as was Monet's treatment of the grapes in *Nature Morte au Melon*. More startling still is his use of perspective. The earlier work shows the subjects on a tablecloth with a wall behind; the plate leaning against the wall helps the viewer understand the perspective. No such aid is provided in *Les Galettes*. The cakes are painted onto a tablecloth which is merely a flat background of colour. No sense of depth is given to the picture, so that the cakes are in danger of sliding off what appears to be a vertical plane. This is a huge step forward in terms of Monet's perception of his subjects.

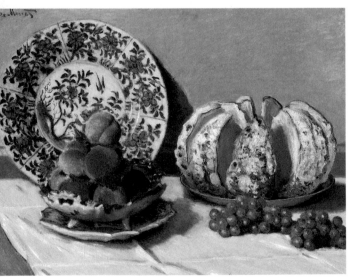

Nature Morte au Melon (1876)
Still Life with Melon
Courtesy of Giradoun. (See p. 60)

EGLISE DE VARENGEVILLE, EFFET DU MATIN (1882)
VARENGEVILLE CHURCH, MORNING EFFECT
Courtesy of Christie's Images

THIS remarkable painting is unusual for its composition. Many paintings from this period of Monet's painting were created from the viewpoint of the top of the cliffs looking down or along, but here he has broken that precedent and chosen to paint the cliffs at their base, and face on.

To reach this position Monet would have had to make strenuous efforts, dragging his canvas with him. His desire to paint this particular subject is expressed in the enthusiastic manner in which the paint is applied to the canvas. Swift strokes of varying colours are laid side by

side. The cliff face in particular is a medley of colour. No effort to tone in the paint is made, so each colour stands in stark contrast to its neighbour. This gives the painting its sense of drama and an overall brilliancy of colour. This lack of washing colours together and, instead, contrasting them with each other has become synonymous with Impressionist work.

Monet creates a sense of the scale of the cliffs by using long vertical brushstrokes on the cliff face, their height is emphasised by the small strip of canvas reserved for the sky, so that the cliffs completely dominate the space. Finally, the perilous nature of the cliffs is expressed by the church that stands at their apex; it is almost threatening to tip over.

LA CHEMIN CREUX
DANS LA FALAISE DE VARENGEVILLE (1882)
THE PATH THROUGH THE HOLLOW
IN VARENGEVILLE CLIFF

Walsall Art Gallery. Courtesy of Topham

WHAT must have appealed to Monet about this scene has to be the strong geometric shapes that are formed by the valley and the sea. This is in contrast to the cliff paintings such as *Sur la Falaise près de Dieppe* (1897), where the view of the coastline does not lend itself to such shapes.

The triangular shape of the hills is complemented by the inverted triangle of the sea. The top of the cliffs and the horizon form horizontal lines that are counterbalanced by the vertical path. This path draws the eye forwards towards the sea. It is now that the viewer realises that the perspective cannot be accurate. The sea appears to be about to fall on to the heads of the women walking along. Monet must have manipulated the scene in order to emphasise the geometric qualities of the landscape. A similar problem occurs with the Dieppe painting, where, in order to understand the perspective of the cliff banking on the right in relation to the cliffs on the horizon, the viewer assumes the viewpoint to be taken from a hollow.

The minute figures in the Varengeville painting appear to be overwhelmed by the land swelling around them and by the sea in front of them. They are tiny and derive their importance only as a focal point to draw the observer's eye forwards along the path.

Sur la Falaise près de Dieppe (1897)
On the Cliffs near Dieppe
Courtesy of Image Select. (See p. 210)

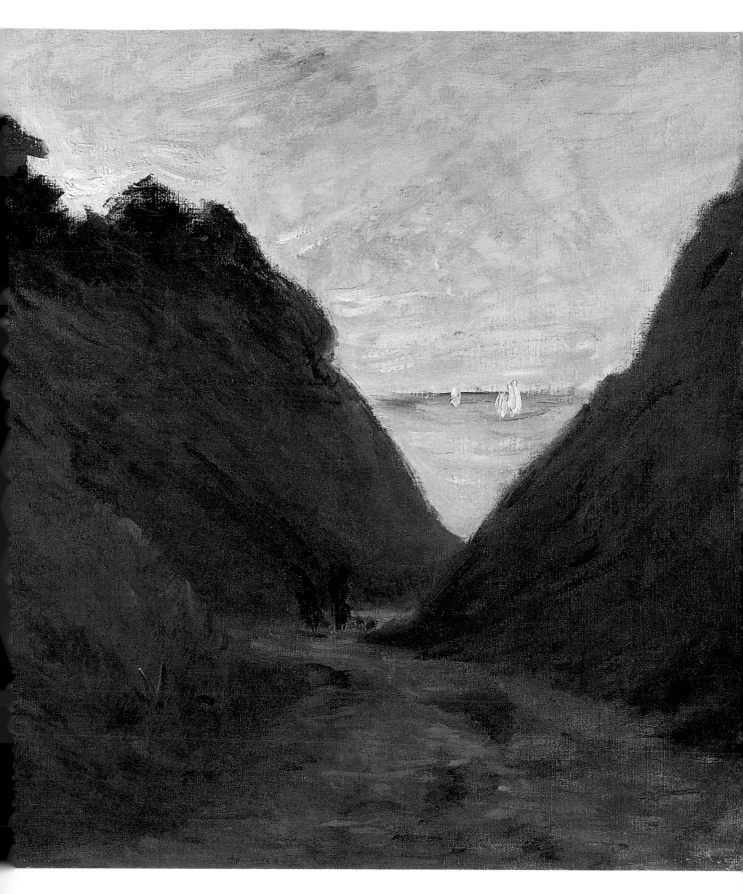

LA SEINE À PORT-VILLEZ (1883)
THE SEINE AT PORT-VILLEZ
Courtesy of Christie's Images

*I*N this picture of 1883, Monet chose to paint the view without including either buildings or people in it, unlike his recreation of the same subject in 1908–09. The result is a tranquil picture that focuses on the contours of the land.

The tranquillity is matched by the water, which is calm and reflects the scene around it almost perfectly. The shorter brushwork on the surface of the water differentiates it from the land. The whole blends together to form a harmonised view of nature. The same cannot be said for the later piece with an identical title. In this, Monet has included the town as the central focus. The simplicity of the scene used in the 1883 painting has been extended to a simplicity of colour and style in the 1908–09 work. Here colours are applied as thick bands on the canvas in contrasting tones to each other so that harmony is not the object of the piece.

The artist chose warm gold and yellow tones to complement the green of the land in the earlier work. The water has no colour to call its own, as it simply reflects the tones of the land. The result is a very restful painting.

La Seine à Port-Villez (1908–09)
The Seine at Port-Villez
Courtesy of Christie's Images. (See p. 218)

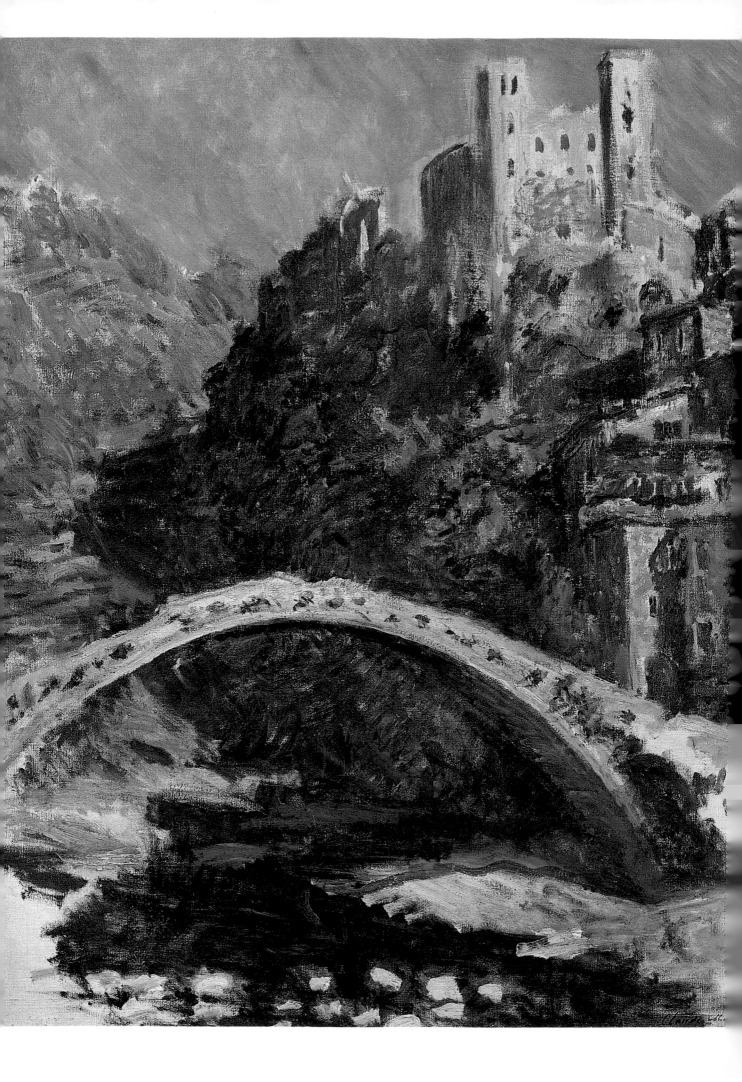

LE CHÂTEAU DE DOLCEACQUA (1884)
THE DOLCEACQUA CHÂTEAU
Musée Marmottan. Courtesy of Giraudon

*P*AINTED in 1884, this winter scene of the château has a
symmetry to it that makes it aesthetically pleasing. The curve
of the bridge which cuts horizontally across the painting is
counter-balanced by the curve of the river bed, which moves from
front to back of the painting.

The buildings on the right of the valley are a sign of human life,
but the opposite side of the river is free to nature. The green of the left
bank has encroached on the right and is creeping up the sides of the
château. This suggests that, rather than man dominating nature, nature is
claiming back the land. This theme occurs increasingly in the artist's
later work. Monet's preoccupation with the power of nature is
particularly evident in the paintings he did of the Creuse Valley. *Vallée de
la Creuse, Effet du Soir* (1889) is typical of these, perfectly capturing the
barrenness of the wild landscape.

In *Le Château de Dolceacqua* Monet suggests that, in a few years'
time, nature will have completely reclaimed the land and the valley will
be like the Creuse. The comparison is furthered by the sweep of the
river bed in both pictures, forming the central dissection of the canvas.

Vallée de la Creuse, Effet du Soir (1889)
Creuse Valley, Evening Effect
Musée Marmottan. Courtesy of Giraudon. (See p. 178)

ETREAT, LA PLAGE ET LA FALAISE D'AVAL (1884)
ETREAT, THE BEACH AND THE AVAL CLIFF
Courtesy of Christie's Images

THERE is evidence from Monet's sketchbook that, in 1884, he was experimenting with the idea of 'framing' within a picture. In this painting the cliff juts into the picture on the left, creating a frame. In the earlier work, *Chemin dans les Blés à Pourville* (1882), there is no attempt to frame the piece; instead, the landscape fills the canvas to the edge.

The cliff frame in *La Plage et la Falaise d'Aval* gives the painting some depth. The second painting lacks this. The main painting establishes a relationship between the cliffs and the sea in two ways. First, the horizontal lines of the waves are paralleled in the horizontal shading on the far cliffs and on the shore. Although their purpose on the sea is to denote movement and on the shore unevenness, they do help to establish a relationship between the two. In a black and white reproduction of this painting, it is almost impossible to distinguish where the sea ends and the shore begins.

A second relationship is established by the use of shade and light. Using purple to indicate the effect of light softens the solidity of the rock. This is especially evident around the base of the rock on the shore. The sea in turn has patches of dark colour, indicating shadow that gives it some solidity.

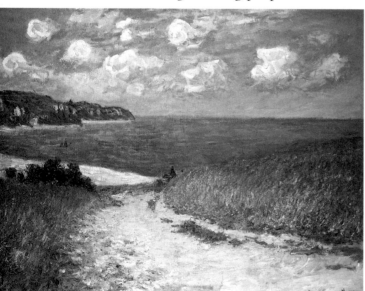

Chemin dans les Blés à Pourville (1882)
Path through the Corn at Pourville
Courtesy of Christie's Images.
(See p. 127)

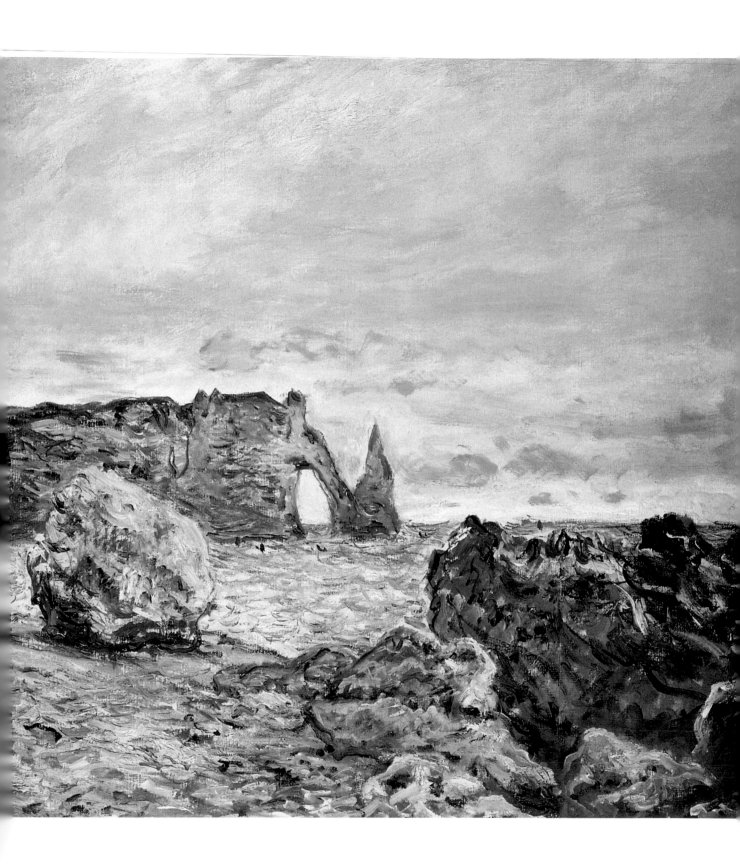

BORDIGHERA (1884)

Chicago Art Institute. Courtesy of Giraudon

THIS painting of a view of Bordighera is dominated by the trees in the foreground. Their trunks rhythmically twist across the picture, dissecting the view of the town and preventing the strong blue of the sea from forming a solid band of colour across the canvas.

This is in contrast to *Bras de la Seine près de Giverny* (1897), where the trees are used as a frame to the view. The contrast in styles between these paintings is obvious. For the earlier landscape Monet uses a palette of vibrant colours that mark out each element against each other; the green of the trees contrasts with the blue of the sea. With the Seine painting, Monet concentrates on harmonising the colour. The colours are subtler and flow together so that it becomes difficult to identify where one colour ends and another begins. Across the whole, a pale blue seems to hang. In *Bordighera* the landscape is sharp in comparison. No one colour pervades the whole painting.

The tangle and shape of the trees form a contrast to the solid squares and oblongs of the town. The brushstrokes on the leaves are rounded with flecks of white paint. The surface of the sea is expressed using several horizontal lines of contrasting blue. Thus, each element is unique not in colour and in brushstroke.

Bras de la Seine près de Giverny (1897)
Branch of the Seine near Giverny
Musée Ile de France. Courtesy of Giraudon. (See p. 204)

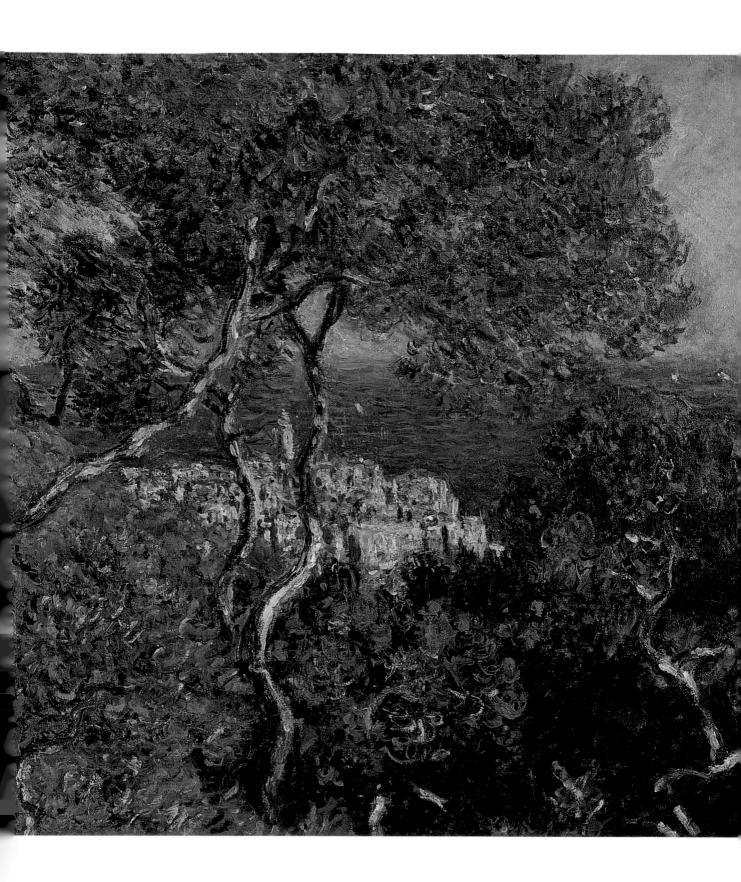

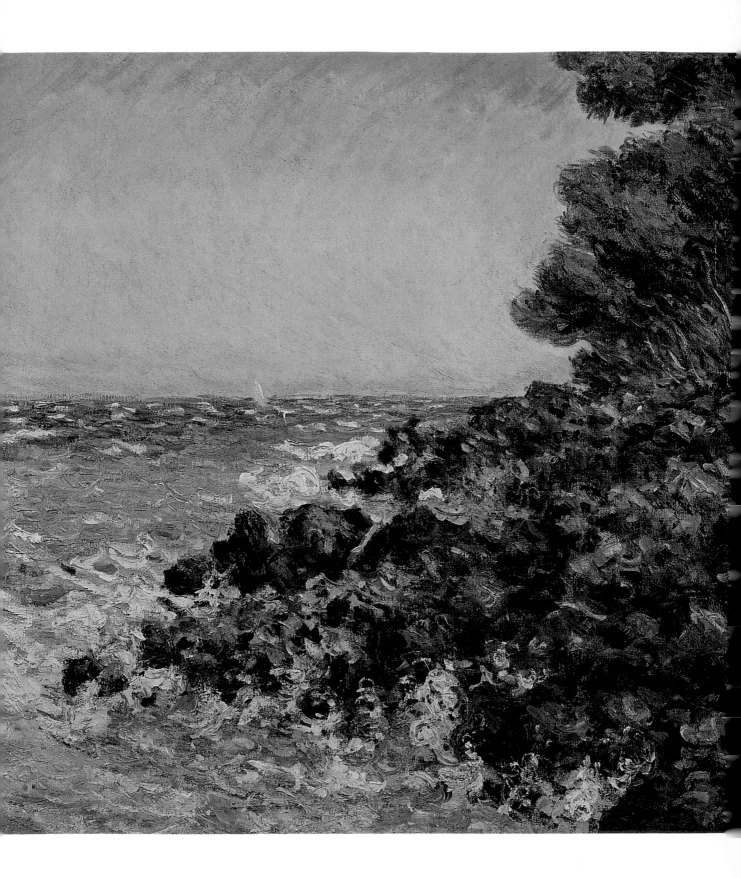

LE CAP MARTIN (1884)

Musée des Beaux Arts, Tournai. Courtesy of Giraudon

MONET first discovered the beauties of this headland when he came here with Renoir. They intended to paint it together, but in 1884 Monet secretly visited the area on his own in order to paint. The resulting pictures are full of energy and colour.

The roughness of the rocks complements the uneven brushstrokes used on the sea. The strokes are laid on quickly and thickly, the sea has odd broad white dashes of colour on it to represent the waves and the horizontal lines of the sea contrast with the rocks, with brushstrokes painted in several directions. The trees provide the vertical line that balances the horizon. The horizontal and vertical are particularly emphasised in this painting by the contrasting techniques used on the sky, sea and trees. The sky is painted as a smooth surface, making use of pale colours; the sea and trees are painted in stronger colours using shorter brushstrokes, and a definite line is formed where they each meet the sky.

On the sea a single vertical white line is highlighted against the pink skyline, this represents a sail. When compared with Monet's earlier detailed paintings of boats at Argenteuil, it is obvious how his technique and composition have changed. By 1884, Monet was content to represent the boat as a dash of white paint, an impression on the horizon.

PORTRAIT DE L'ARTIST DANS SON ATELIER (1884)
PORTRAIT OF THE ARTIST IN HIS STUDIO
Musée Marmottan. Courtesy of Giraudon

*T*HIS painting is unsigned, and the bottom half of the canvas has been worked on only slightly. It can therefore be assumed that this is an unfinished work. Monet did other self-portraits, but what makes this interesting is its setting in his studio.

Unlike the 1880 portrait of Michel (*Portrait de Michel en Bonnet à Pompon*), Monet felt the need to include a background to his own portrait. Significantly, he does not refer to this as a self-portrait but titles it in the third person. This is a portrait of him as artist, not as a person with other aspects to his character; his definition comes from his art. Also, unlike the portrait of his son, his eyes are averted from the viewer, not inviting an intimate response as Michel's do. Thus, although the viewer is being given access to the artist's studio, the experience is not an intimate one, and the viewer of the painting is slightly removed from the subject of the picture.

Despite this, the portrait of Michel appears more formal than this painting. Michel is posed, whereas Monet is pictured caught at an idle moment, his look distant and his hands relaxed on to his legs. It is interesting that Monet chose to paint himself as an artist at a moment when he is not actually working.

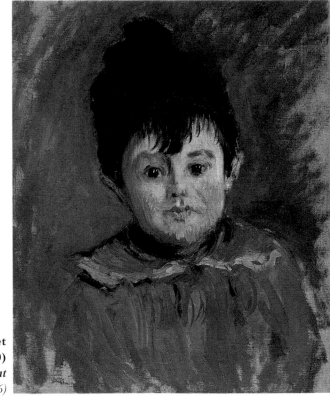

**Portrait de Michel en Bonnet
à Pompon (1880)**
Portrait of Michel in a Pompom Hat
Courtesy of Giraudon. (See p. 116)

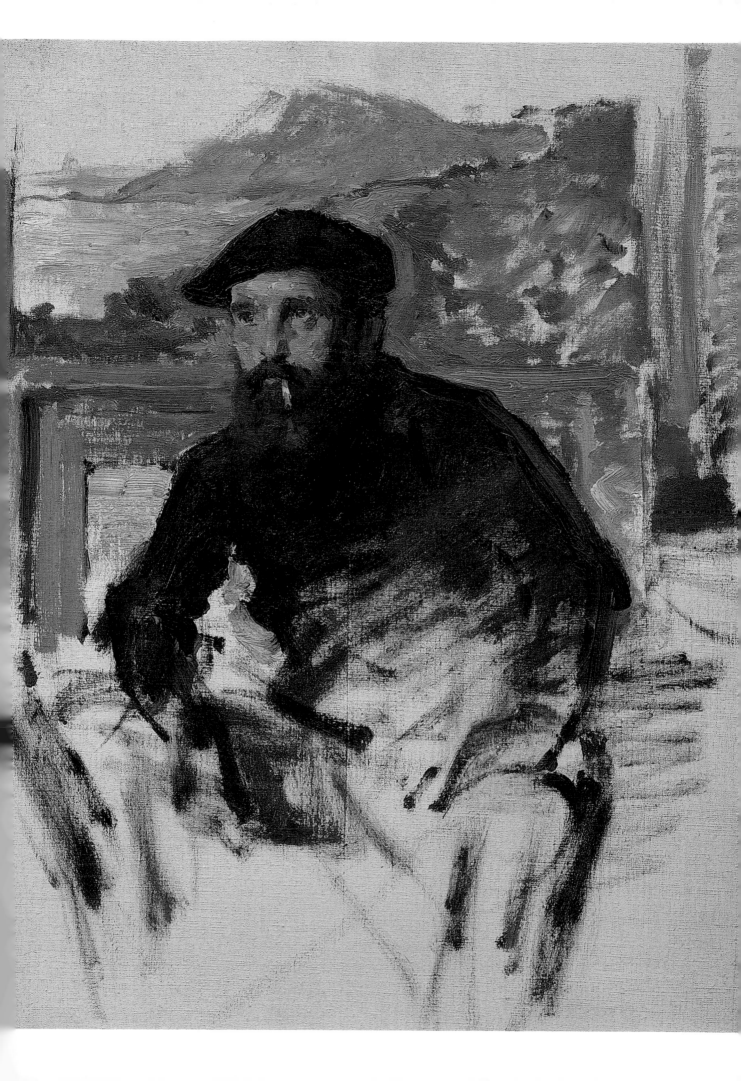

PORTRAIT DE POLY (1886)
PORTRAIT OF POLY
Musée Marmottan. Courtesy of Giraudon

WHILE Monet was working at Belle-Ile, the fisherman Guillaume Poly frequently visited the inn where he was staying. Monet painted this portrait during that period.

What appears to have attracted Monet to Poly as a subject was his features – he began his career as a caricaturist, earning money to go to Paris from selling caricatures of well-known people in his home town. This makes it surprising that Monet did not produce very many portraits, as he was clearly interested in the human face. Unlike portraits of his children or of himself, as depicted in *Portrait de l'Artist dans son Atelier* (1884), this portrait of Poly is full of character. The eyes are turned towards the viewer, the nose is rounded and the cheeks are ruddy; the hat and beard add character to the face.

In Monet's own portrait he is also wearing a cap and has a beard, but there is no sense of his personality. He is defined as an artist by the canvases in the background. With the painting of Poly, it is easy to read a story into the portrait; his face invites the viewer to read it, and he requires no background to generate interest.

Portrait de l'Artist dans son Atelier (1884)
Portrait of the Artist in his Studio
Musée Marmottan. Courtesy of Giraudon. (See p. 146)

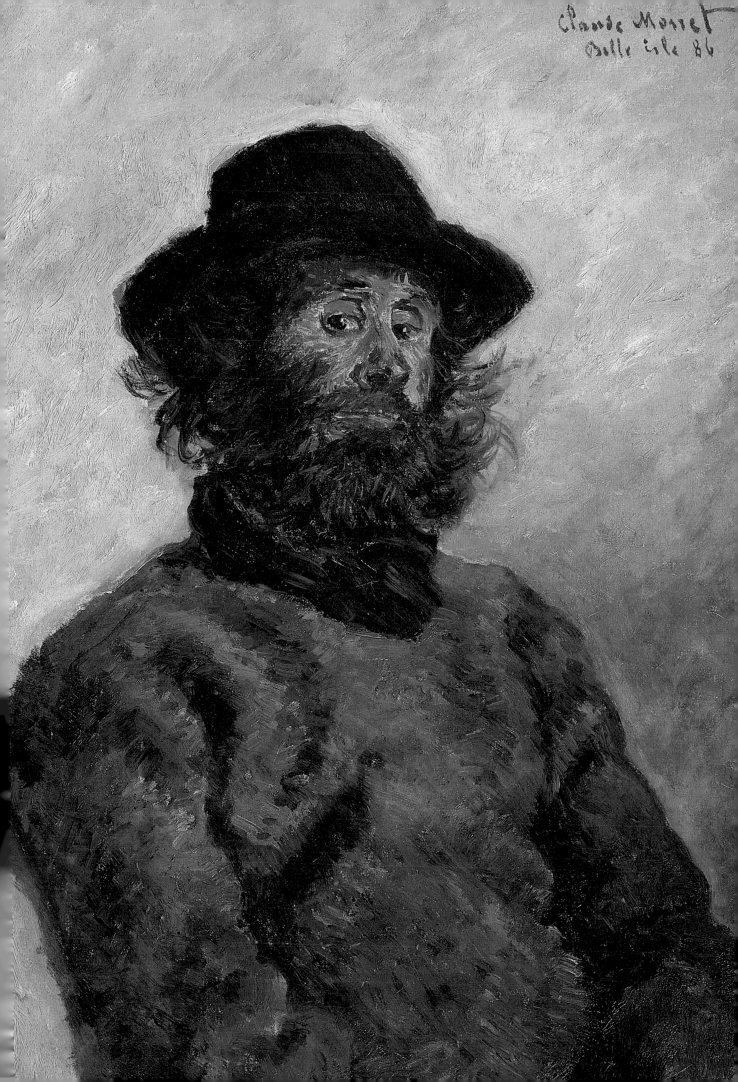

L'EGLISE À BELLECOEUR (1885)
THE CHURCH AT BELLECOEUR
Courtesy of Image Select

PAINTED only a few years apart, both *L'Eglise à Bellecoeur* and *L'Escalier* (1878) are intimate, close views of a rural setting. Both are devoid of people and concentrate on the beauty of the buildings. In the main painting, Monet shows a little more of the village, which seems sleepy in the warm sun.

The difference between the two paintings is that *L'Eglise à Bellecoeur* appears to have a greater preoccupation with shapes and patterns than *L'Escalier*. The buildings form a pattern of oblongs, squares and triangles. They are all, apart from the church, depicted with the slant of their roofs facing the viewer, creating a contrast between the red of the roof and the white of the walls that emphasises the geometric shapes. The low walls running around the properties echo this. *L'Escalier* does have a similar pattern with its walls and roof, but because the viewer is positioned closer to a single building this pattern is much more difficult to appreciate.

In the later painting, the clouds in the sky provide a contrast to the regular shapes below. The tree in the foreground also helps to disrupt the regularity of the pattern. The amount of space given over to the blue sky helps to prevent the complex of buildings overwhelming the painting.

L'Escalier (1878)
The Stairs
Courtesy of Christie's Images. (See p. 102)

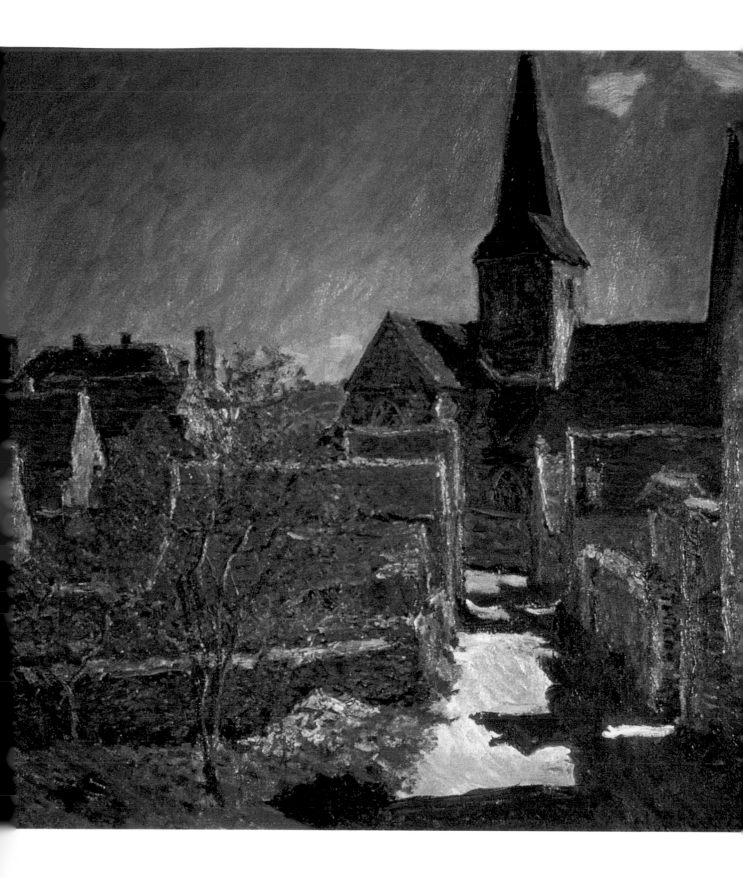

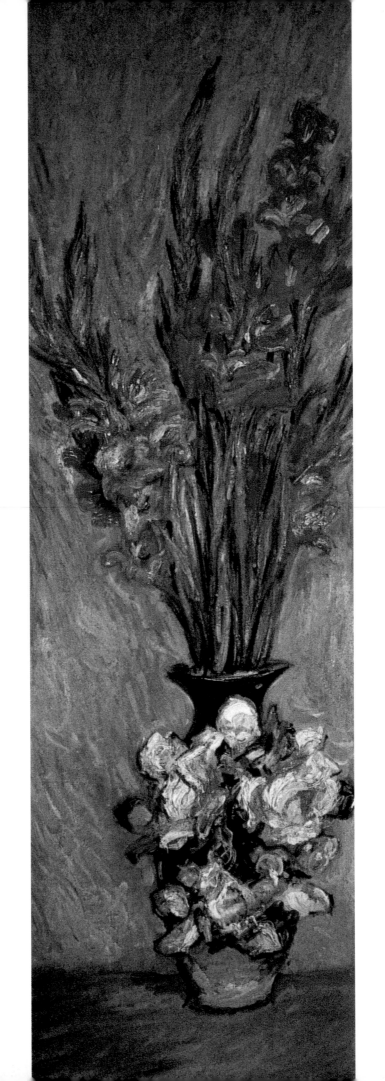

GLAÏEULS (1882–85)
GLADIOLI
Private Collection, Paris. Courtesy of Image Select

THE agent Durand-Ruel commissioned Monet to paint a further set of decorative panels; it took the artist over two years to complete them. They each depicted either fruit or flowers and were designed to reflect the changing seasons.

The shape of the gladioli is perfect for an upright panel. Painted positioned on what appears to be a tabletop, the background is very simple, unlike in *Chrysanthèmes* (1878), where the wallpaper pattern is clearly in evidence behind the flowers. By placing the gladioli against a blue background the colours of the flowers are revealed to startling effect. In contrast, the chrysanthemums lose impact to the effect created by the flowers on the wallpaper. Whereas the chrysanthemums move across the canvas, the gladioli form vertical lines counterbalanced by the edge of the table.

The strange vase that the flowers are presented in forms a second focal point, drawing the eye away from the gladioli and down the canvas to the white flowers on the vase. With the chrysanthemums it is the wallpaper that draws the eye up. The vertical linear rhythm of the gladioli painting is pleasing to the eye.

Chrysanthèmes (1878)
Chrysanthemums
Courtesy of Christie's Images. (See p. 100)

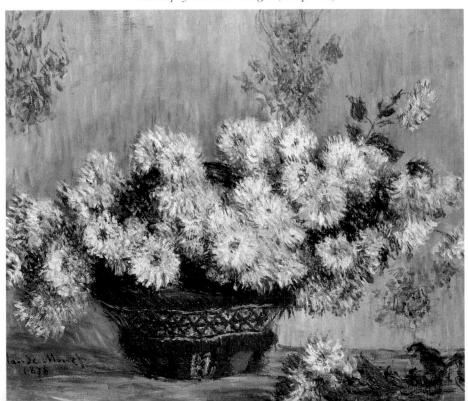

TEMPÊTE, CÔTES DE BELLE-ILE (1886)
STORM ON THE COAST OF BELLE-ILE
Courtesy of Giraudon

MONET found the changing weather conditions on the Brittany coast very exciting. In particular, when the weather was rough, he was impatient to capture the moment on canvass. The swiftness of the brushstrokes in these Belle-Ile paintings adds to the air of dashing the pictures off in a frenzy of excitement.

In both paintings, a sense of drama is created by moving the horizon very high up the canvas, making the sea appear to be flooding into the sky. *Tempéte, Côtes de Belle-Ile* in particular exaggerates this effect by using similar colours for both the sky and the sea. The swift brushwork on the sea versus the more solid strokes of the sky help the viewer to identify the horizon. In *Les Roches de Belle-Ile* (1886) Monet uses a bank of cloud to identify the dividing line.

In *Tempéte, Côtes de Belle-Ile*, the sea itself is painted with a lot of white. The turbulence of the waves hitting the rocks is the cause of this colouring. Because the painting has been

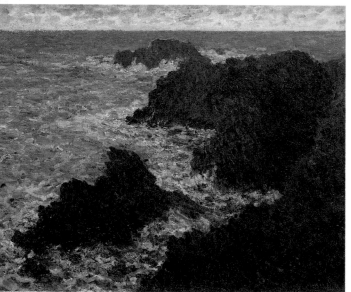

cropped on the left, the viewer feels that he has been placed on a level with this turbulence. In *Les Roches de Belle-Ile* the artist's viewpoint is higher, which helps to maintain a distance from the water, leaving the observer removed from the intensity of the action.

Les Roches de Belle-Ile (1886)
The Belle-Ile Rocks
Musée d'Orsay. Courtesy of Giraudon.
(See p. 156)

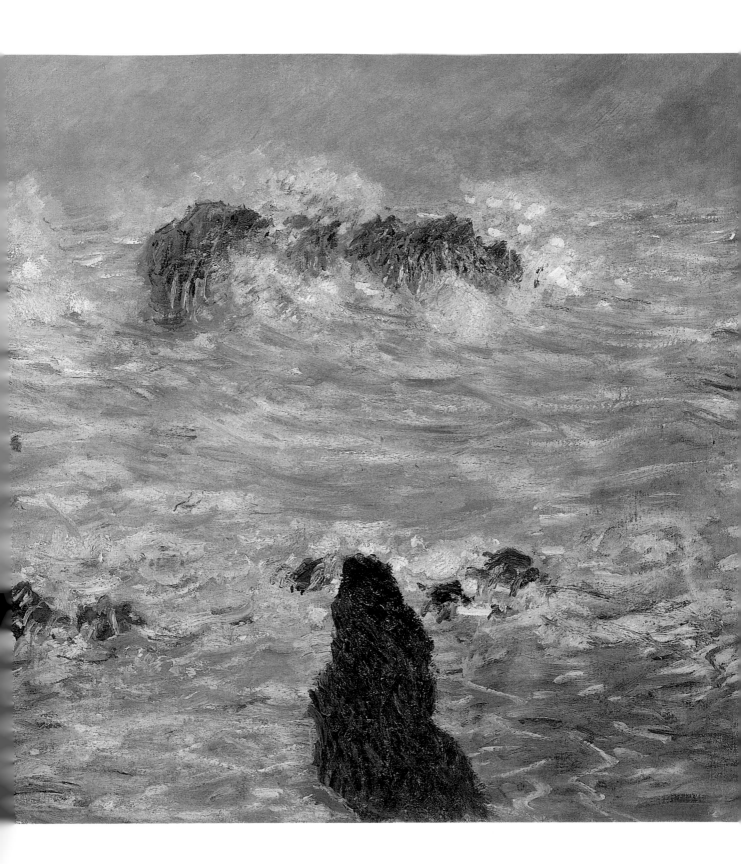

LES ROCHES DE BELLE-ILE (1886)
THE BELLE-ILE ROCKS
Musée d'Orsay. Courtesy of Giraudon

THE wildness of the sea is captured here by Monet's use of colour, the dark blues and greens typical of a stormy day. In contrast, when the sea is viewed on a calm day, as in *La Plage à Pourville, Soleil Couchant* (1882), the sea has softer tones. The colour of the sea in *Les Roches de Belle-Ile* does not indicate a specific time of day, but the end of day is explicit in the second painting.

La Plage à Pourville, Soleil Couchant (1882)
The Beach at Pourville, at Sunset
Musée Marmottan. Courtesy of Giraudon. (See p. 128)

The drama of this painting lies entirely in the stormy waves of the sea. Their power is complemented by the solid dark mass of the rocks. The movement of the waves is presented by using short brushstrokes and by laying different colours next to each other, so that a dark blue stroke may be placed alongside a green one. In *La Plage à Pourville, Soleil Couchant* Monet lengthens the brushstrokes along the surface of the sea to produce a more regular surface and manages to create the impression of tranquillity.

The menacing presence of the rocks actually takes up nearly the same amount of canvas space as the sea. By painting them as encroaching across to the bottom left of the painting, but losing ground to the sea in the top right-hand corner, Monet depicts the eternal battle between land and sea.

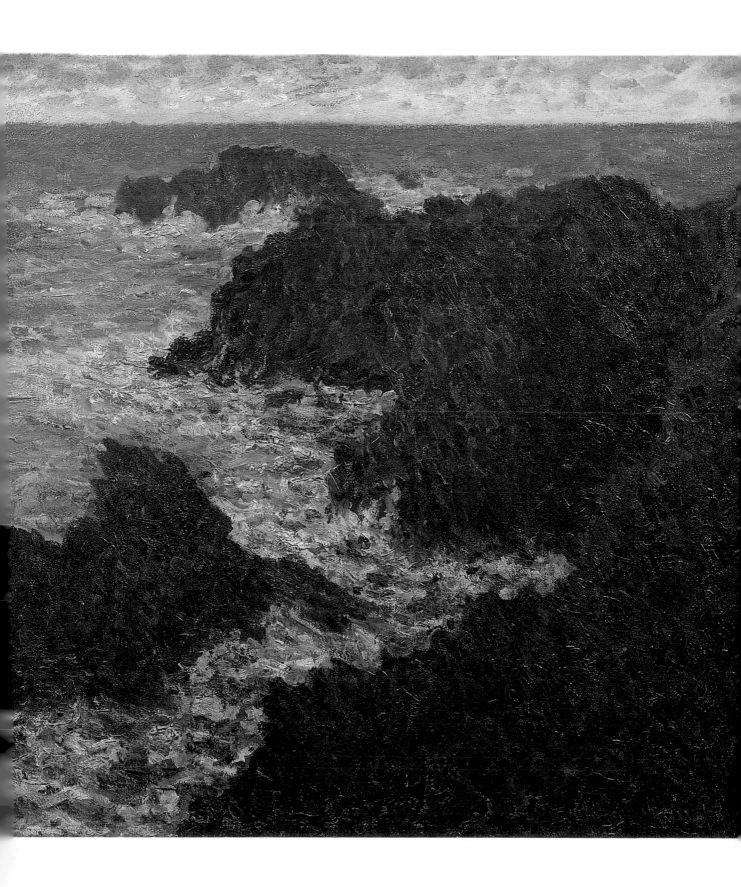

CHAMP DE TULIPES, HOLLANDE (1886)
TULIP FIELD, HOLLAND
Courtesy of Giraudon

MONET was inspired by the flatness of Holland when he visited the country in 1871. This picture emphasises that flatness by the equal split between land and sky. The windmill at the centre helps break up the never-ending horizon and gives a perspective to the view.

It was not just the flat landscape that inspired Monet; he was animated by the colours he saw as well. This is evident in the quick brushwork that switches from colour to colour. Such chaos of colour is echoed in *Le Bassin aux Nympheas, les Iris d'Eau* (1900–01), where contrasting colours are painted on to the canvas side by side. The result in both works is an explosion of colour that floods the viewer's sensations. So inspired by the colour was Monet that he did not feel it necessary to give the flowers form. Their colour is their essence, so it was sufficient to represent them by a patch of red or purple. This is especially noticeable in *Champ de Tulipes, Hollande*, where the scope of a view does not require a detailed rendition of a flower as if viewed from up close.

**Le Bassin aux Nympheas,
les Iris d'Eau (1900–01)**
Water Lily Pond, Water Irises
Courtesy of Christie's Images. (See p. 214)

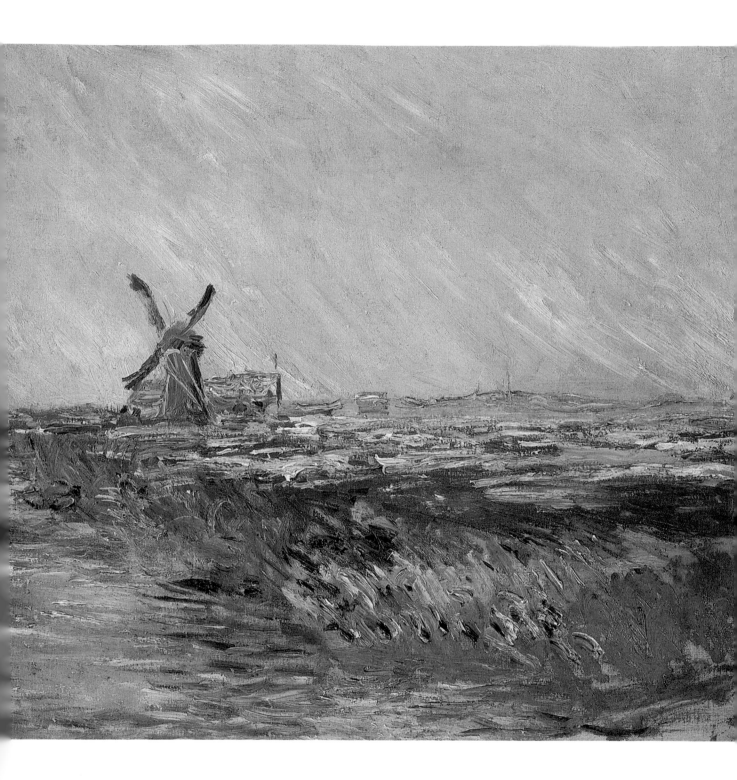

ESSAI DE FIGURE EN PLEIN AIR
(VERS LA GAUCHE) (1886)
STUDY OF A FIGURE OUTDOORS (FACING LEFT)
Courtesy of Giraudon

MONET painted a pair of figure pictures, one depicting a woman turned to the left and one to the right, in 1886. The model for both was Suzanne Hoschedé. Following Camille's death, Suzanne had become Monet's favourite model. This painting is reminiscent of one of Camille produced in 1873.

Suzanne's features are blurred, making her an anonymous figure. Monet deliberately did not want the viewer to be looking for a

personality or story in this painting. Because she has no expression, the woman becomes a part of the overall picture and should be viewed as part of the landscape. The wind is seen to affect her in a similar manner as it does the grass. Her skirt is being blown against her legs, and the ribbon from her hat is blowing forward. The majority of the short brushstrokes representing the grass are moving in the same direction. The more defined grass on the brow of the hill can be seen clearly to bend in the wind.

The colours used on the grass are very different from those in Monet's earlier work. This time they include pinks and whites, as well as green and yellow. This helps to harmonise the figure with her environment. The flecks of white from the grass make a connection with the white of her dress and with the clouds.

LA BARQUE (1887)
IN THE ROWING BOAT
Courtesy of Topham

FOR some critics, this painting is concerned with the nature of girls passing into womanhood. Their looks and bodies are undergoing constant change. This perpetual development is illustrated in the three girls by the lack of features shown. Even when compared with Blanche Hoschedé's face in *Blanche Hoschedé Peignant* (1892), which is only rendered in the vaguest terms, these girls' faces are sparse of detail.

Their association with nature is strong. Not only is Monet recording them at their most transient and developmental period in their lives, but, unlike Blanche Hoschedé, their clothing identifies them with the natural background they are in. The pink on their dresses is a reflection of the pink in the grassy bank behind the boat. For some critics this is symbolic of nature often being referred to as a female; to them Monet was using the women as a representation of nature.

Whether this was his aim is impossible to assert. What is certain is that this picture is one of harmony and balance. The boat is equally balanced by its reflection in the water, and all the colours work with the subject to create a tranquil painting.

Blanche Hoschedé Peignant (1892)
Blanche Hoschedé Painting
Courtesy of Christie's Images. (See p. 182)

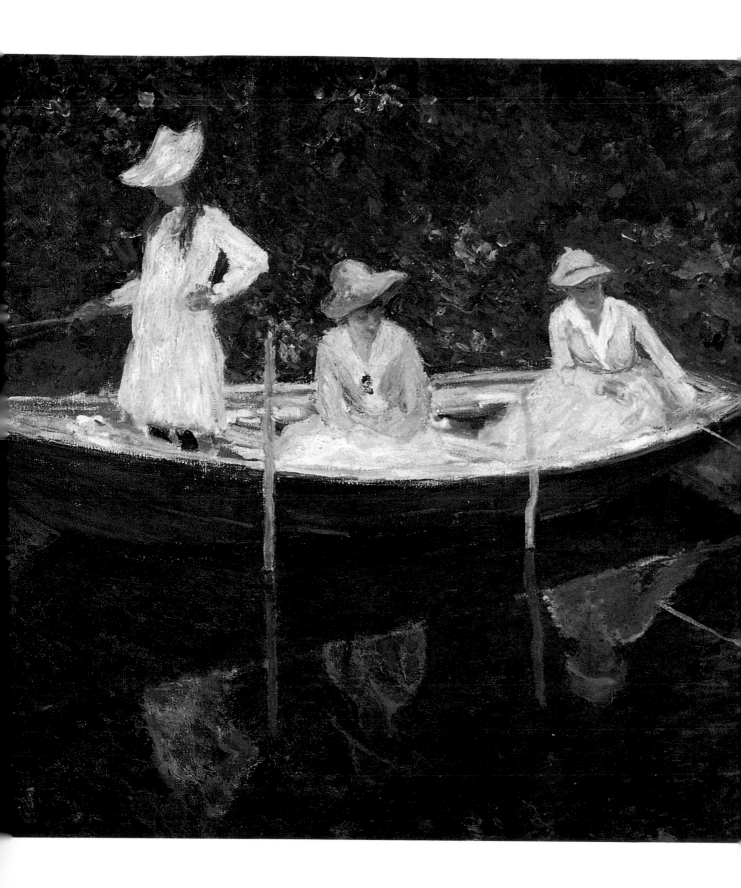

CHAMP D'IRIS JAUNES A GIVERNY (1887)
FIELD OF YELLOW IRISES AT GIVERNY

Musée Marmottan. Courtesy of Giraudon

DESPITE the fact that this painting is entitled *Champ d'Iris Jaunes à Giverny*, two colours dominate, yellow and purple. The purple in the foreground is repeated in the hedges that span the middle of the painting. This is a very different treatment of the iris compared with the later *Iris Jaunes* (1924–25). In that painting, the yellow of the flower is the main focus; here it has been dampened in effect by being mixed with purple.

A second obvious difference is that the flowers themselves are the primary focus of *Iris Jaunes*. Deprived of a background, it is the essence of the plants that Monet is demonstrating. In the main work,

Monet is putting the flowers in their context. They are painted in their natural habitat with a hedge and sky as background. They have none of

the Oriental style that can be found in *Iris Jaunes* when placed back in a natural background.

This painting has the horizontal banding found in many other Monet paintings. The field of flowers forms the first band, the hedge the second and the sky the third. Painted in landscape format, this linear design is very obvious.

Iris Jaunes (1924–25)
Yellow Irises
Courtesy of Christie's Images. (See p. 250)

PRAIRIE DE LIMETZ (1887)
LIMETZ MEADOW
Courtesy of Christie's Images

*T*HE figure in the foreground is believed to be Alice Hoschedé, later to become Alice Monet. The two boys following behind are her sons. This is one of the few paintings where Alice acted as model.

A natural scene, it captures the moment when the family is walking from Giverny. This summer outing is a theme that frequently recurs in Monet's work. The warmth of the day is made explicit by the parasol Alice carries; the use of yellow on the field adds to the warmth of the painting. The brushwork reflects the angle of the different planes it is used on: thus, horizontal brushstrokes are used on the field because it is a flat plane and diagonal ones are used on the hill in the background to emphasise the angle of the slope. Monet is trying to capture the nature of each element not only in terms of colour but also its substance. The grass seems long and wild in the foreground precisely because it is painted with quick strokes that dart in all directions. This is of more importance to Monet than painting a detailed accurate picture of the grass.

ANTIBES, VUE DE CAP, VENT DE MISTRAL (1888)
ANTIBES, VIEW OF THE CAPE IN THE MISTRAL WIND
Courtesy of Christie's Images

WHEN Monet arrived in Antibes, he wrote to Alice Hoschedé complaining about the difficulties that he was having capturing the unusual colour of the local light. He wrote: 'You swim in blue air, it's frightful'.

This one is an example of the jewel colours he used in many of his Mediterranean paintings. The blue of the sea is almost unreal in colour and is perhaps a symbol of what he was seeing rather than an accurate rendition. When compared with the pale sea in *Antibes, Vue de la Salis* (1888) it is even more startling. It is not allowed to dominate the painting too much by being kept in check by the bushes in the foreground. These form a horizontal line across the bottom of the work made up of yellows, greens and pinks. The bushes are allowed to push into the band of colour that is the sea and to break up its horizontal dominance. The sky, mountains and city all form striking horizontals across the canvas. This trait is present in *Antibes, Vue de la Salis*, but the subtler colours prevent it from seeming so obvious.

Monet's palette of colours during this trip became enriched with new tones. In his earlier work he would never have used such a strong blue to represent the sea. This painting is testimony to Monet's confidence in his work.

Antibes, Vue de la Salis (1888)
Antibes, View of the Fort
Courtesy of Christie's Images. (See p. 172)

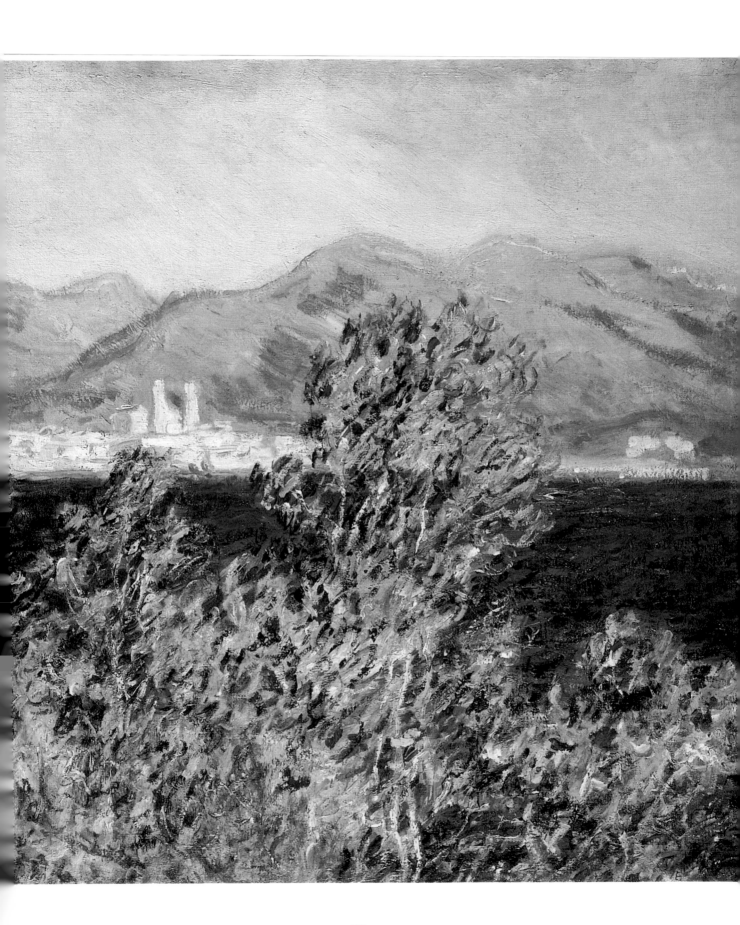

ANTIBES, VUE DE LA SALIS (1888)
ANTIBES, VIEW OF THE FORT
Courtesy of Christie's Images

MONET'S motifs are said to shift between the rough and the soft. *Antibes, Vue de la Salis* is definitely a soft subject. The colours glow with hints of gold, pink and turquoise.

The harmonisation of colours present in this painting appears again 20 years later in *Le Grand Canal et Santa Maria della Salute* (1908). The composition is also very similar. Both paintings feature a large expanse of water in the foreground, a building that appears to be floating on the water's surface and an expanse of sky above. This similarity arises from Monet's preoccupation with buildings next to water. His treatment of reflection in both works demonstrates how he was fascinated by the effect of light on a solid structure when it is placed by water. The reflection is reduced to the reflection of colour rather than shape, so that the fort's reflection is lines of gold and the Santa Maria della Salute's becomes shimmers of pink.

The colours used in both are soft and pastel in tone. However, the Venetian work is dominated by blue and pink to the point that water, sky and building are all represented in these colours. A*ntibes, Vue de la Salis* has more variety using rose, gold, white, blues and greens. Each part of the picture is painted as distinct from its neighbour rather than merged together.

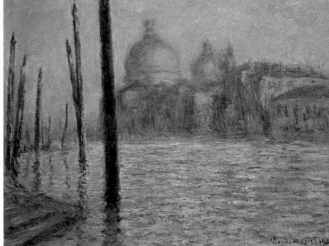

Le Grand Canal et Santa Maria della Salute (1908)
The Grand Canal and Santa Maria della Salute
Courtesy of the Tate Gallery.
(See p. 228)

PAYSAGE AVEC FIGURES, GIVERNY (1888)
LANDSCAPE WITH FIGURES, GIVERNY
Courtesy of Image Select

IN the second half of the 1880s, Monet returned to figure painting. He painted 16 pictures of his family between 1885 and 1889; striving to capture figures in a natural background in true *plein-air* style. Monet started trying to achieve this initially in 1865, with *Le Déjeuner sur l'Herbe*. His aim was to approach figure painting in the same spontaneous manner in which he worked on landscapes.

The early work tries to do this by painting the figures as if unrelated to each other and with strong blocking of colour on the women that is unconcerned with shading. They are caught in the middle of an action rather than in a posed setting. In *Paysage avec Figures, Giverny* there is the same detachment between the figures. The first and second group are separated by a large space, the three figures in the foreground apparently unconcerned with each other. The viewer is positioned uncomfortably close to the first three people. This unusual angle adds to the air of spontaneity.

The colours used to signify the figures are repeated in the tones of the grass, trees and hills in the background. Here Monet is using colour to incorporate the figures as an integral part of the landscape.

Le Déjeuner sur l'Herbe (1865)
The Picnic under the Trees
Pushkin Museum, Moscow. Courtesy of Giradoun.
(See p. 24)

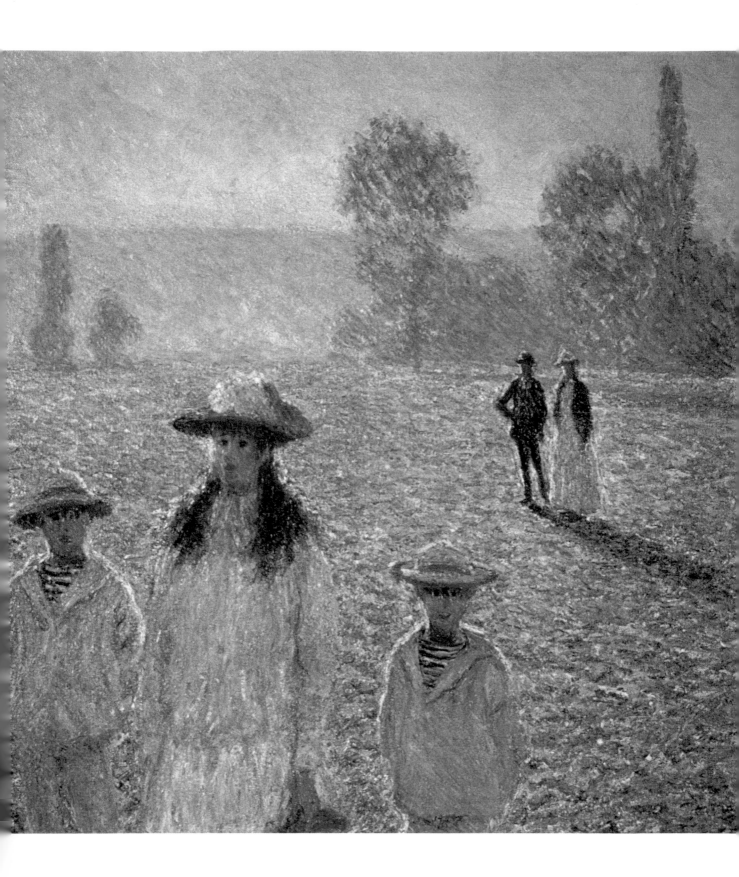

CREUSE, SOLEIL COUCHANT (1889)
THE CREUSE AT SUNSET
Courtesy of Christie's Images

WHEN Monet visited the Massif Central region of France, its bleakness and savagery instantly impressed him. He decided to paint the region around the River Creuse and try to capture that barren and dramatic landscape. When he started it was winter. To his horror, while he was still working on the details of a tree, spring arrived, causing the tree to bud. Unable to cope with his subject changing into a green and leafy tree, Monet paid the owner to strip the buds off. This demonstrates that Monet was perhaps not so receptive or reactive to nature as he would have liked his public to believe.

The river and the rocks around it appear in many of the pictures of the region. This one depicts the river in the glory of a late afternoon. The effect of the light is to make the hills form a solid dark mass against which the sky and water stand out.

Vallée de la Creuse, Effet du Soir (1889)
Valley of the Creuse, Evening Effect
Musée Marmottan. Courtesy of Giradoun. (See p. 178)

In contrast, the same view in the evening is cooler but allows the features of the hillside to emerge. The bleakness of the area is enhanced by the lack of vegetation, and the only source of warmth comes from the sky. This glow has gone from the hills by the evening.

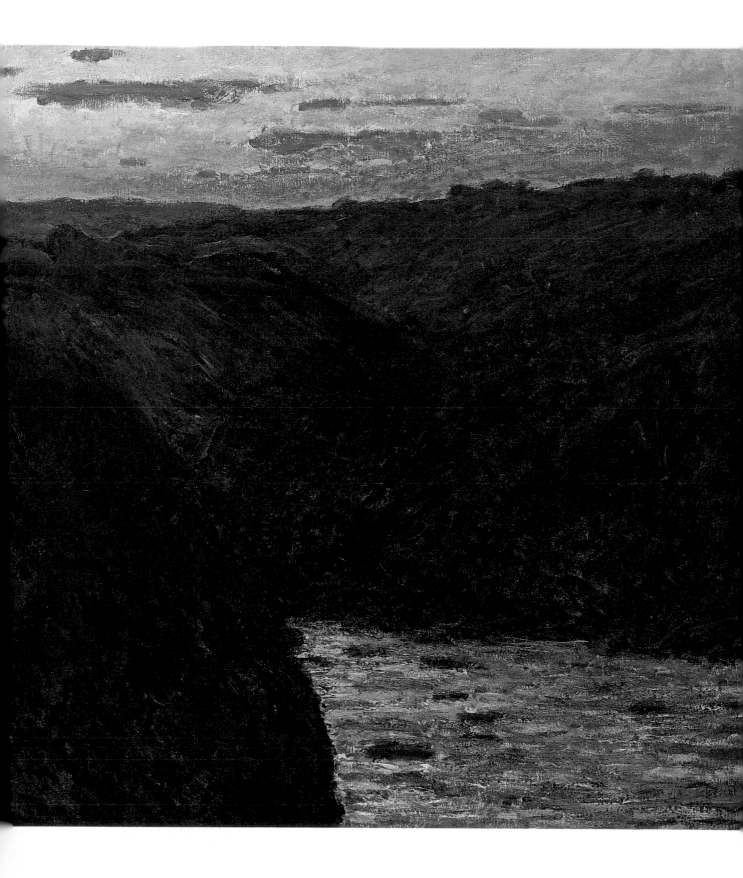

VALLÉE DE LA CREUSE, EFFET DU SOIR (1889)
VALLEY OF THE CREUSE, EVENING EFFECT

Musée Marmottan. Courtesy of Giraudon

THE barren landscape of the Creuse Valley intrigued Monet, and he sought to capture its savagery. This is in contrast to other work from the period, such as *Sur la Falaise près de Dieppe* (1897). In that painting, Monet renders a rough landscape soft. Here the Creuse is empty and cold.

The strange blue light of the evening adds to the coldness of the painting. The blue touches the hills and the water. In contrast the hills seem red. They swell up on the

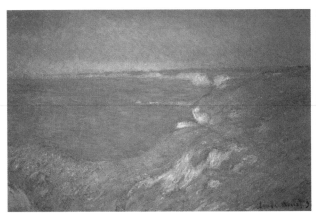

Sur la Falaise près de Dieppe (1897)
On the Cliffs near Dieppe
Courtesy of Image Select. *(See p. 210)*

canvas to form imposing rounds that seem to be never-ending. The sense of infinity that surrounds them is achieved by having them stretch right across the canvas and by giving them the appearance of forcing the sky back so that only a slim strip is left. In *Sur la Falaise près de Dieppe*, the expanse of sky adds to the sense of tranquillity.

What is interesting about the Creuse paintings is the range of effects Monet creates from the same subject. His study of different light at different times of day produced a set of pictures that come alive through the variety of colours used. Here blue has a strong presence; in others, orange, red or purple are the dominant colours. In this way Monet maintains the interest of the viewer.

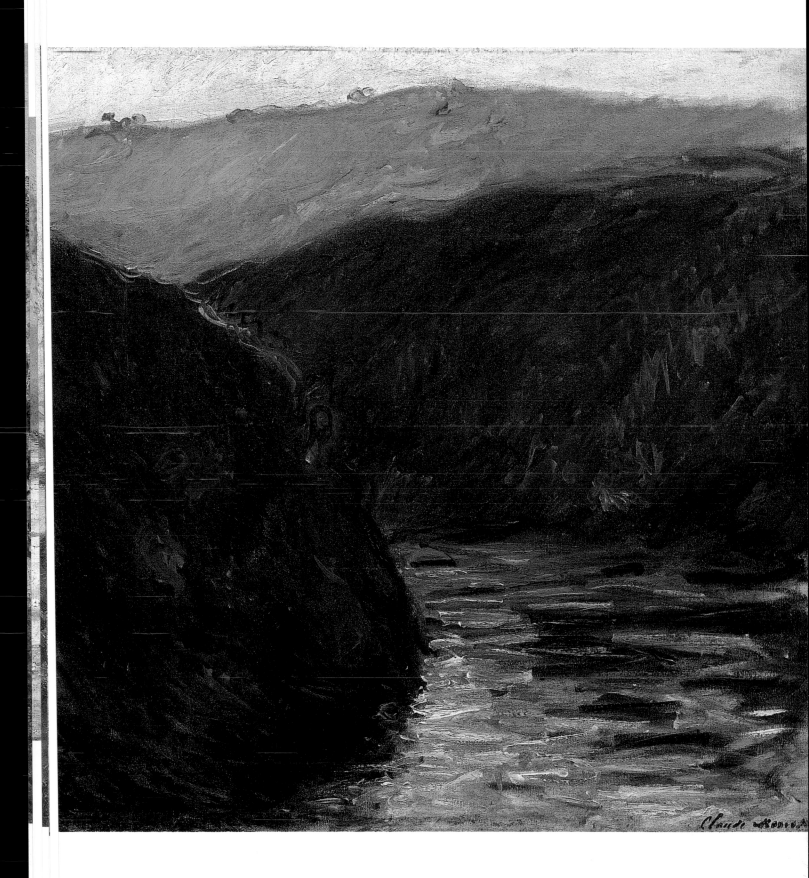

❋ VALLÉE DE LA CREUSE, EFFET DU SOIR ❋

LES MEULES (1887)
THE HAYSHEAVES
Courtesy of Image Select

*T*HIS is a contrasting view of haysheaves to many of the others that Monet painted. The angle is similar in both paintings so that the viewer is taken quite close to the haysheaves and is given an intimate view. However, these paintings do have an empty air to them. They are devoid of people or any evidence of them. The strange regularity of the sheaves in this work has a disquieting effect.

The primary focus of the work is the haysheaves, unlike in *Les Meules, Effet du Soir* (1884) where it can be argued that the poplars are equally as important. Here, the sheaves' triangular shape is in keeping with the geometry of the overall picture. Broad bands of colour representing grass, hedge and sky are emphasised by the lines of the sheaves. In the earlier work, the rounded shape of the sheaves and the rounded heads of the poplars are a counterbalance to the lines of the trees, hills and grass. The effect of the sun dappling across the field also helps to keep the strength of the linearity from dominating. One of the striking aspects of this painting is its simplicity of composition, which Monet employed in the grainstacks series of the 1890s.

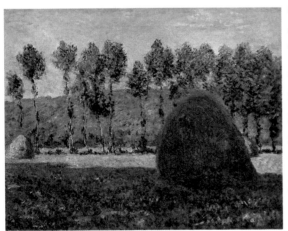

Les Meules, Effet du Soir (1884)
Haysheaves, Evening Effect
Pushkin Museum, Moscow. Courtesy of Giraudon. (See p. 188)

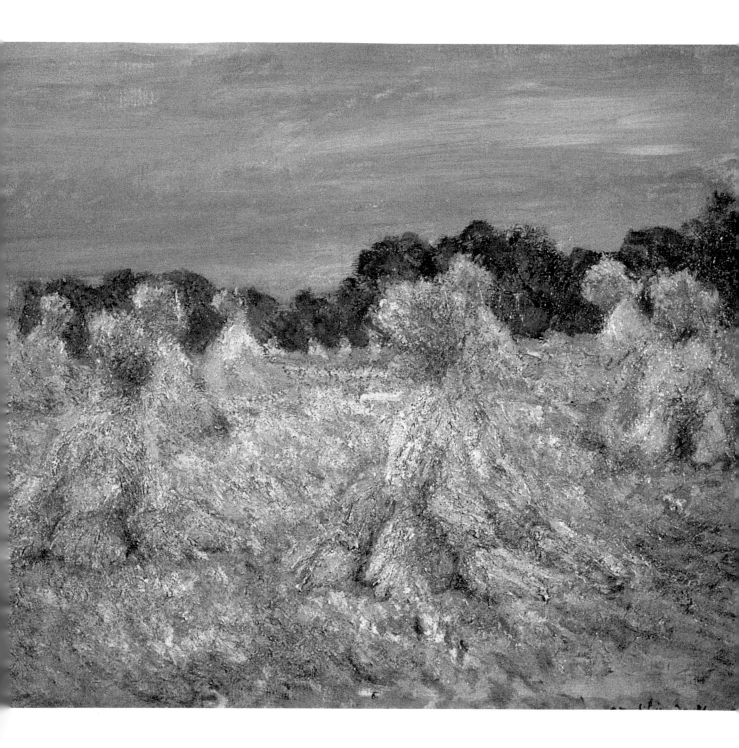

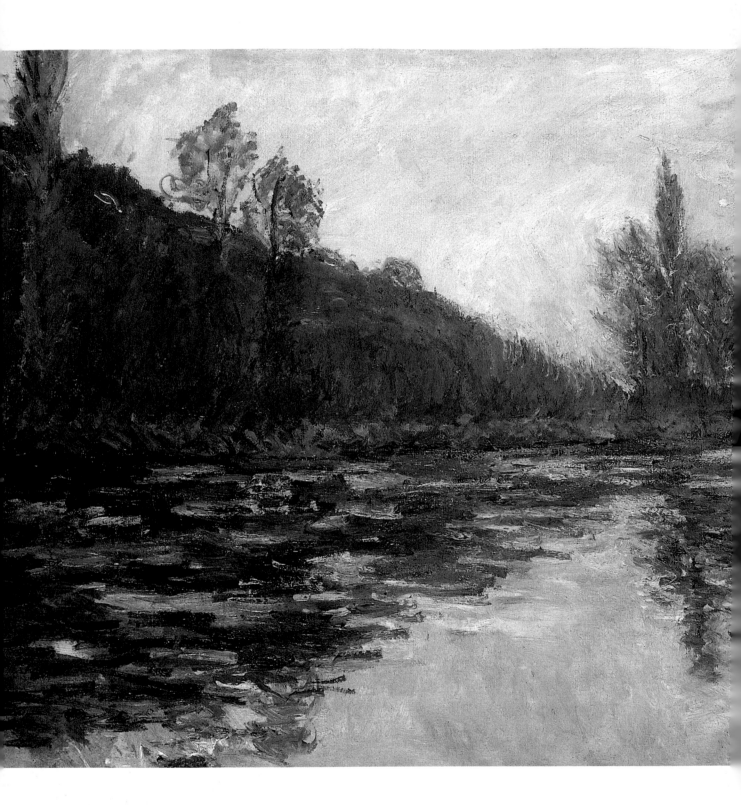

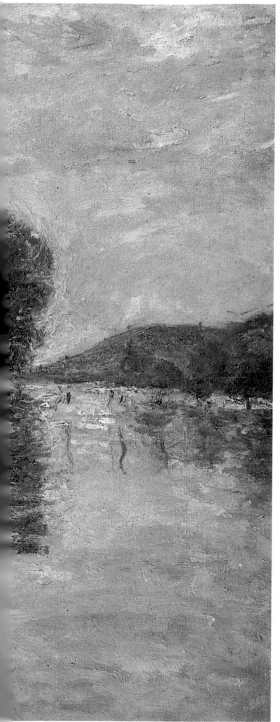

LA SEINE PRÈS DE GIVERNY (1894)
THE SEINE NEAR GIVERNY

Courtesy of Christie's Images

THE main feature of this work is the water. The viewer is on a level with the river, which flows forward, drawing the eye along its course. It fills the bottom of the canvas; in fact the water dissects the canvas virtually in a straight line. Above that line its colour is reflected in the colour of the sky. A comparison of the bottom left and top left corner reveals almost identical brushwork and tone.

The land that divides the water and sky prevents them from becoming one. It is only where the land is reflected on to the water that any indication of movement on the water's surface occurs. The brushstrokes become long, horizontal lines of varying colours to indicate the ripples, in contrast to the water away from the dark reflection, where the colour is almost one block of paint.

This treatment of the Seine is different from that in *La Seine à Port-Ville* (1908–09). Here there is no sense of perspective. The banding of water, land and sky present in the main painting is simplified into three broad bands of colour. This is broken only by the circular strokes of green for the trees, the yellow for the shore and the odd black stroke indicating the surface of the water.

La Seine à Port-Ville (1908–09)
The Seine at Port-Ville
Courtesy of Christie's Images. (See p. 218)

LA CATHÉDRALE DE ROUEN, EFFET DE SOLEIL (1893)
ROUEN CATHEDRAL, SUNLIGHT EFFECT
Clark Art Institute, Williamstown. Courtesy of Image Select

ROUEN Cathedral became the subject of another series of paintings by Monet, and the first to concentrate so exclusively on an architectural subject. The rationale behind his choice of Rouen Cathedral was in line with his subjects for previous series of paintings, in that it is distinctly French.

Monet's letters of the time describe the struggle he had with his subject: this series took three years to reach exhibition. As can be seen by comparing *Le Château de Dolceacqua* (1884), Monet has abandoned the conventions of setting and taken the viewer uncomfortably close to Rouen cathedral. Unlike the château, Monet does not paint in the entire building; only a part of the cathedral is shown. Neither painting dwells on architectural detail but aims to capture the moment. In *Cathédrale de Rouen* in particular the primary interest is the effect of light on the surface of the building. The cathedral is shown here in full sunlight, which creates a golden glow on the building.

As Monet took a year's break between painting these pictures, he often painted over sections of a picture again, so the canvases have a crustation of paint on them. Some critics have found this reminiscent of the actual stonework of the building.

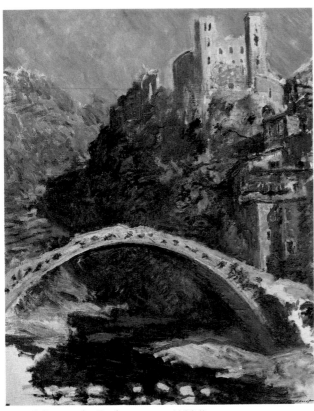

Le Château de Dolceacqua (1884)
The Dolceacqua Chateau
Musée Marmottan. Courtesy of Giraudon. (See p. 138)

Norvège, les Maisons Rouges à Bjornegaard (1895)
Norway, the Red Houses at Bjornegaard

Courtesy of Giraudon

PART of the commercially unsuccessful series of Norwegian paintings, both of these canvases depict snow landscapes. In contrast to *Paysage Norvège, les Maisons Bleues* (1895), this painting has a more complex arrangement to the scene. Rather than taking a viewpoint of the buildings as a part of the landscape, Monet has moved in close so that they dominate the picture.

Although not as simplistic in arrangement as *Paysage Norvège, les Maisons Bleue, Norvège, les Maisons Rouges a Bjornegaard* does have a symmetry to it. The blocks of colours used on the buildings and the lack of architectural detail allow the geometric shapes to emerge from the canvas. The result is that the buildings become secondary to the pattern of squares and oblongs that they make. The redness of the walls is striking in contrast with the deep blue of the sky. Painted at a different time of day, there is little evidence of the rosiness that the sun causes in *Paysage Norvège, les Maisons Bleues*. The contrasting colours help to emphasise the geometry of the painting.

The overall effect is one of remoteness, with no human figures disturbing the white landscape. However, there is a pervading sense of calm that is shared with some of Monet's seascapes.

Paysage Norvège, les Maisons Bleues (1895)
Norwegian Landscape, the Blue Houses
Courtesy of Giraudon. (See p. 198)

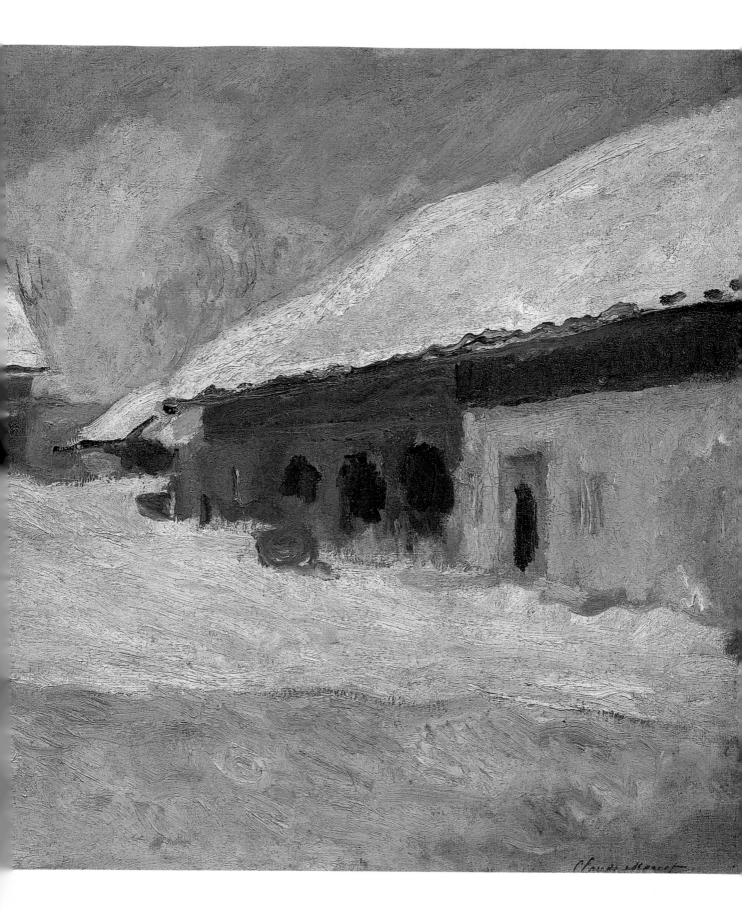

Paysage Norvège, les Maisons Bleues (1895)
Norwegian Landscape, the Blue Houses
Courtesy of Giraudon

THE simplicity of content for this painting means that the true subject matter is the effect of the light and the snow. Monet had been looking forward to painting the snow of Norway because he found the effects of light on snow exciting. However, when he arrived in Norway he found the realities of painting snow in the northern light very difficult. The flatness of the painting is perhaps testimony to those difficulties. The snow blankets all features, making it difficult for distinct shapes to emerge.

So determined was he to try and capture the strange light of Norway that Monet actually painted many of these pictures in defiance of the cold, with icicles forming in his beard as he worked. In this painting he has concentrated on depicting the true nature of that light and how it affects the colours around. Hence the snow is not pure white but blue and pink, and the sky is yellow and pink. In terms of composition, the painting is reminiscent of the haysheaves painting of 1884.

The composition – a band of ground with a central subject matter set against a line of landscape and a band of sky above – is identical in both pictures. The haysheaves are painted from a viewpoint closer to the subject, which gives the stacks greater prominence than the houses in the Norwegian work, but the similarity in composition cannot be denied.

Les Meules, Effet du Soir (1884)
Haysheaves, Evening Effect
Pushkin Museum, Moscow. Courtesy of Giraudon. (See p. 188)

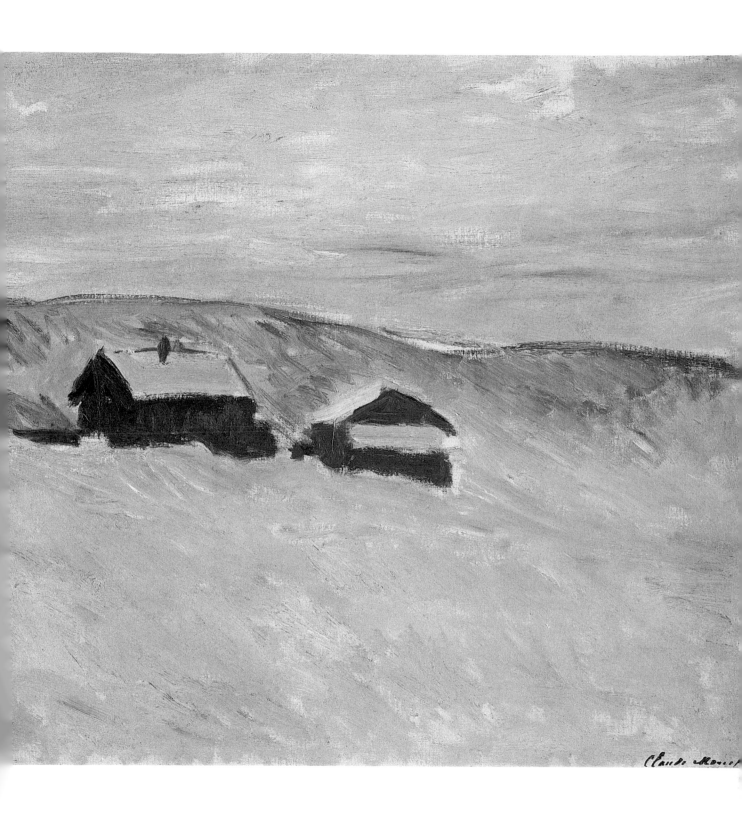

LE MONT KOLSAAS EN NORVÈGE (1895)
MOUNT KOLSAAS IN NORWAY
Courtesy of Giraudon

IN 1895, Monet decided to take a trip to Norway. His purpose was two-fold: he wished to visit his now step-son, Jacques Hoschedé, who lived there; and he was looking for inspiring new subject matter.

On arriving, Monet struggled to paint the snowy scenes in the strange Scandinavian light. His problems were solved on discovering Mount Kolsaas. Eventually he painted 13 canvases of this subject, marking the different light effects at various times of day. Unlike previous series paintings, these were all painted from the same viewpoint. Despite this, the paintings are not identical in composition. This can be attributed to Monet's desire to capture the impression of the moment rather than the detail. These two paintings demonstrate how the light at different times of day makes the mountain appear with a rosy hue in the main picture and with more blue in the secondary image. The main painting uses more vertical brushstrokes, which create a blurred effect, whereas the smaller format image is more sharply defined.

Painted on nearly identical-sized canvases these Mount Kolsaas pictures are considered most powerful when displayed as a series next to each

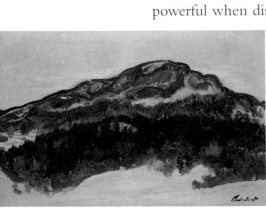

other. They then resemble a range of mountains. Although attractive, the paintings lack the complex palette of colours from previous paintings, and their non-French subject matter made them unpopular when exhibited.

Le Mont Kolsaas en Norvège (1895)
Mount Kolsaas in Norway
Musée Marmottan. Courtesy of Giraudon. (See p. 202)

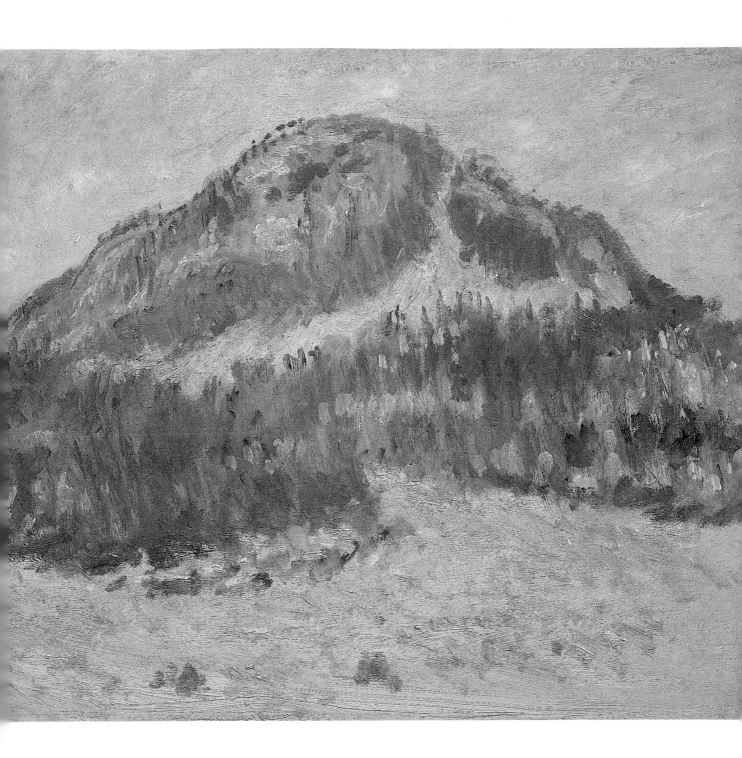

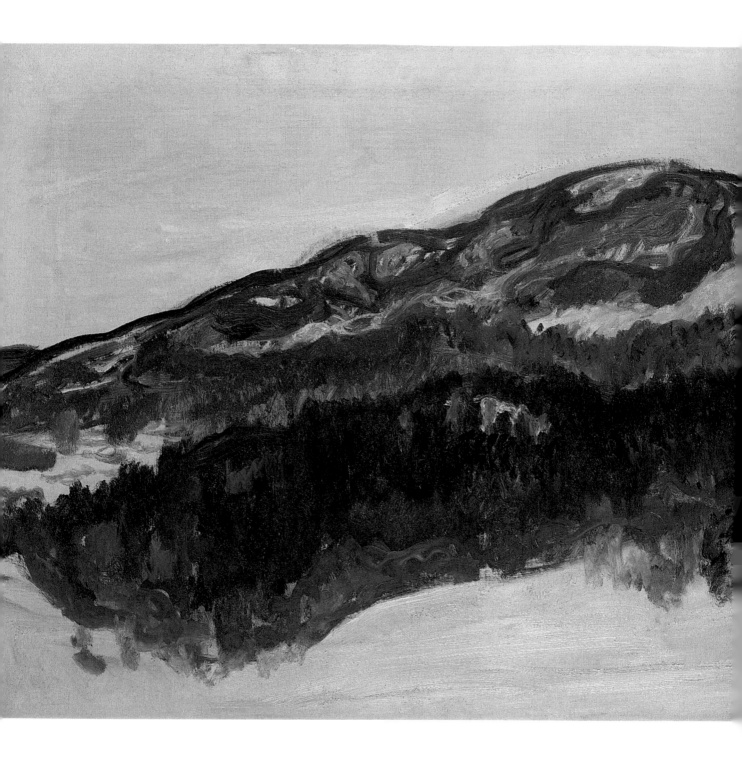

LE MONT KOLSAAS EN NORVÈGE (1895)
MOUNT KOLSAAS IN NORWAY

Musée Marmottan. Courtesy of Giraudon

PAINTED within a year of each other, *Le Mont Kolsaas en Norvège* and *La Cathédrale de Rouen, Effet de Soleil* (1893) are each part of their own series. What is of interest here is the different approaches to the use of a single motif.

The painting of Mount Kolsaas is a more conventional composition in the sense that the viewer is placed at a distance from the subject and can see the entire mountain. To a certain extent the mountain is given a context, with sky above and snow at its base. With *Cathédrale de Rouen*, a less traditional stance is taken. The viewer is thrust close to the subject. The whole of the building cannot be seen, and little context is provided, to the point that only a small amount of sky is shown. The mountain is painted in a simpler style, comprising bands of colours that contrast and merge together at different points.

The colours used in the Norwegian picture are either placed in contrast to each other, as with the green line near the base next to the purple line above it, or whirled together, such as at the tip where violet, blue and white merge. The whole is harmonised through either brushstrokes or colour.

La Cathédrale de Rouen, Effet de Soleil (1893)
Rouen Cathedral, Sunlight
Clark Art Institute. Courtesy of Image Select. (See p. 194)

BRAS DE SEINE PRÈS DE GIVERNY (1897)
BRANCH OF THE SEINE NEAR GIVERNY

Musée Ile-de-France. Courtesy of Giraudon

T HE Seine, a symbol of France, features in so many of Monet's work that it became his most used motif. In 1896 to 1897, Monet decided to use the river in a remarkable series of paintings. In all he produced 21 pictures in the series.

What renders this series like no other is that it records the dawn on one single motif, moment by moment, within one period. Although critics had assumed this was what Monet was attempting in other series paintings, none of the previous series had been concerned with the changing light within such a tight time-frame. As can be seen in both *Bras de Seine près de Giverny* and *Matinée sur la Seine, Effet de Brume* (1897), the dawn on the river causes varying tones to appear and disappear. The former has a soft blue, almost lilac colour that hangs across the whole of the painting but centralises where the river meets the sky. In comparison, *Matinée sur la Seine, Effet de Brume* was painted a little later in the morning, when the sun begins to rise. The blue tones are beginning to disappear and the green of the trees, especially in the foreground, to emerge. On the horizon, the sky is starting to glow. Although these two paintings record changes in light which are easy to identify, the differences between other paintings in the series are less clear.

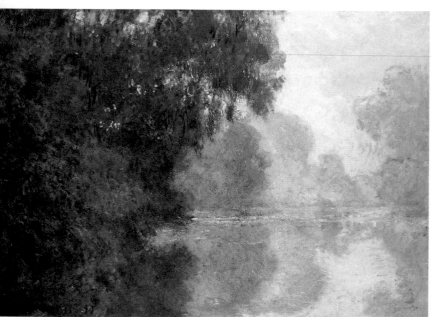

Matinée sur la Seine, Effet de Brume (1897)
Morning on the Seine, Mist Effect
Courtesy of Christie's Images. (See p. 206)

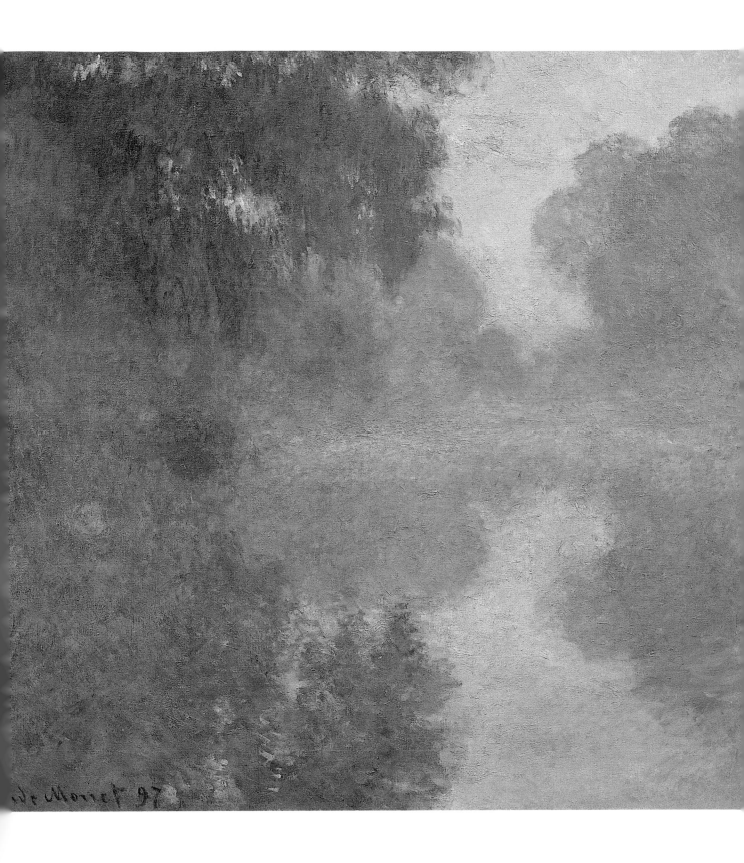

Matinée sur la Seine, Effet de Brume (1897)
Morning on the Seine, Mist Effect
Courtesy of Christie's Images

MORE than any other of Monet's series, the Seine paintings require hanging in a specific order for viewers to be able to appreciate the subtle changes in colour. Some appear to be virtually identical.

The colours used in the paintings are harmonious, and the effect created has tapestry qualities. In both these paintings the eye is drawn through the work to where the sky meets the water. This is the point that is the source of light in both paintings. In each, the sun is starting to rise, causing a rose effect in the sky and a tint to the nearest trees. The two paintings must have been painted very close together in terms of time.

The brushstrokes used are integrated to add to the harmony of the work. The atmospheric tone of each centres around one colour – blue – and how it fades slowly with the approaching sun. Here it has almost disappeared. In order to capture the progress of this different light, Monet would get up each morning at before dawn to work. The end results were exhibited in 1898 and received by most critics as being pictures of true quality.

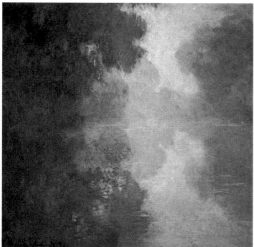

Matinée sur la Seine, Effet de Brume (1897)
Morning on the Seine, Mist Effect
Private Collection. Courtesy of Image Select
(See p. 208)

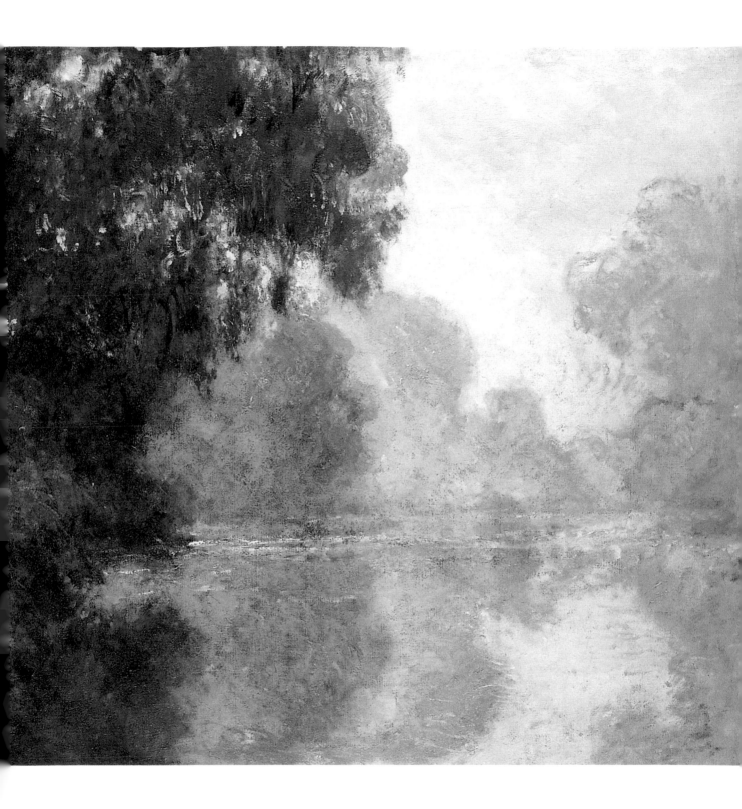

MATINÉE SUR LA SEINE, EFFET DE BRUME (1897)
MORNING ON THE SEINE, MIST EFFECT

Private Collection. Courtesy of Image Select

*T*HE effect created in the Seine series is purely decorative. The colours are manipulated from reality in order to create different combinations. This can make some of the paintings seem very pale when reproduced on the page.

For Monet, the Seine provided the challenge of capturing the changing nature of the natural world in different conditions. It had the combination of light on water that had intrigued him so many times before. As can be seen in these two paintings, his treatment of reflection changed over the years. In *La Seine près de Giverny* (1894), the reflection of the trees is not rendered in detail, instead it is a dark patch that is comparable to the subject only in outline. Monet uses strokes of white paint to infiltrate the dark reflection to represent the effect of light on water, sparkling off the surface.

In the Seine paintings the nature of reflection has changed. The water has become a mirror image of the subject both in colour and density. There is a solidity around the reflection that is missing in other work. In addition, the trees framing the water give the work an enclosed feeling which is lacking in the open landscape of *La Seine près de Giverny*.

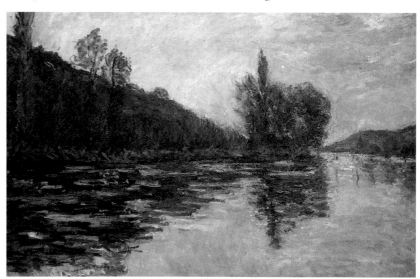

La Seine près de Giverny (1894)
The Seine near Giverny
Courtesy of Christie's Images. (See p. 192)

SUR LA FALAISE PRÈS DE DIEPPE (1897)
ON THE CLIFFS NEAR DIEPPE
Courtesy of Image Select

THE beauty of Monet's cliff-top paintings lies in their simplicity. The basic elements are sky, sea and land. No particular time of day can be attributed to them and so they are imbued with a timeless quality.

In this painting it is not the strength of the sea that is on show; instead, it is a calm image that demonstrates a softer view of nature than that present in the paintings of the Creuse. In those, Monet wanted to capture the savagery of nature; in this painting he wants to depict an equally harsh landscape – but in a gentler manner. The soft curves of the cliff as it swells into the picture and gently falls into the sea are softened even further by the pastel colours used.

The viewpoint taken from the top of the cliff is repeated in many other paintings. In some it is used to more dramatic effect than it is here. In this way the cliff pictures are similar to some of Monet's earlier work such as *Boulevard des Capucines* (1873). His obvious interest in differing perspectives from higher viewpoints is still in evidence with these cliff paintings. However, the earlier work is concerned with capturing the business of a moment. Here the impression of serenity is what is most important.

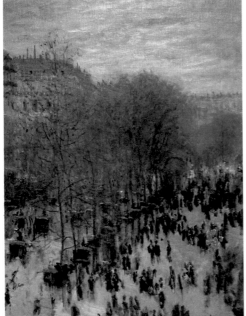

Boulevard des Capucines (1873)
Capucines Boulevard
Courtesy of the Visual Arts
Library, London. (See p. 68)

210

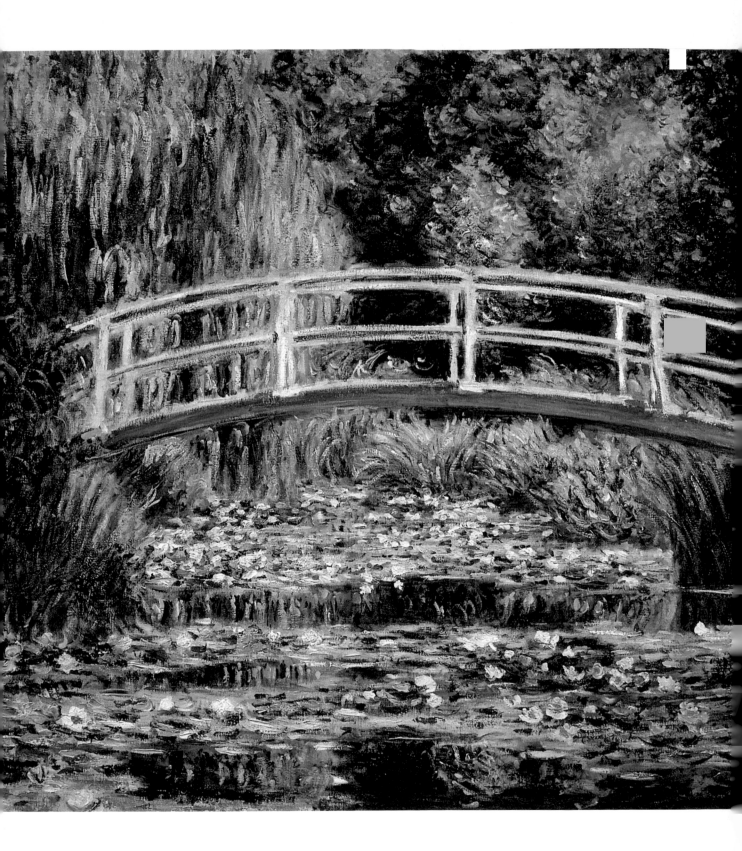

LE BASSIN AUX NYMPHEAS, HARMONIE VERTE (1899)
WATER LILY POND, HARMONY IN GREEN

Pushkin Museum, Moscow. Courtesy of Giraudon

MONET began building his water lily garden at Giverny in the 1890s as an oriental complement to the more traditional western flower garden that he had already designed. A keen gardener, Monet employed a team of workers to maintain the gardens even when he claimed he had very little money.

His gardens at Giverny became virtually his only subject for painting for the remaining 26 years of his life. Monet had long believed that a close relationship with nature on an almost primitive level helped to develop an individual's understanding of himself and the world around him. The Japanese were thought to be a nation that particularly understood this regenerative relationship. His choice of an oriental garden as a theme effectively underlines his beliefs.

Although a painting of a distinctly un-French subject, the palette of colours Monet chose for it are nevertheless quite traditional. The water draws the eye of the viewer into the distance through a world harmonised in green and blue. The serenity of the scene is derived from the subject matter and the complementary colours. In addition, balance is provided by the water that ends almost exactly at the centre of the picture and reflects the foliage in the top half. The bridge spanning the pond forms a symmetrical rounded shape that adds to this balance.

LE BASSIN AUX NYMPHEAS, LES IRIS D'EAU (1900–01)
WATER LILY POND, WATER IRISES
Courtesy of Christie's Images

THIS painting is rich in colour and tones. Some of this riot of colour is present in the earlier picture *Fleurs à Vétheuil* (1881), hinting at the extraordinary use of colour employed in Monet's later work. The bottom half of the painting shows a vast mixture of flowers of different colours.

By the time Monet painted *Le Bassin aux Nympheas, les Iris d'Eau*, the flowers and foliage are dominating nearly the entire canvas. The later painting uses a wider variety of colours that clash together to increase the drama. Each flower is painted with less detail but becomes a splash of colour. The colours of the irises by the pond are repeated on the footpath and on the water where the lilies are. Even the sky has a tint of pink to it so that the entire area is suffused with colour.

Fleurs à Vétheuil (1881)
Flowers at Vétheuil
Courtesy of Christie's Images. (See p. 122)

The earlier painting shows a view of Vétheuil, which is about to be swallowed up by the flowers and bushes. In the main painting, the garden appears to have won the battle. Although the bridge and the footpath suggest the presence of humans, the lack of people or buildings gives the garden an air of wilderness. Only a tiny square of sky is left, and even that looks destined to be covered over by the willow. Nature in both paintings is seen as a strong force.

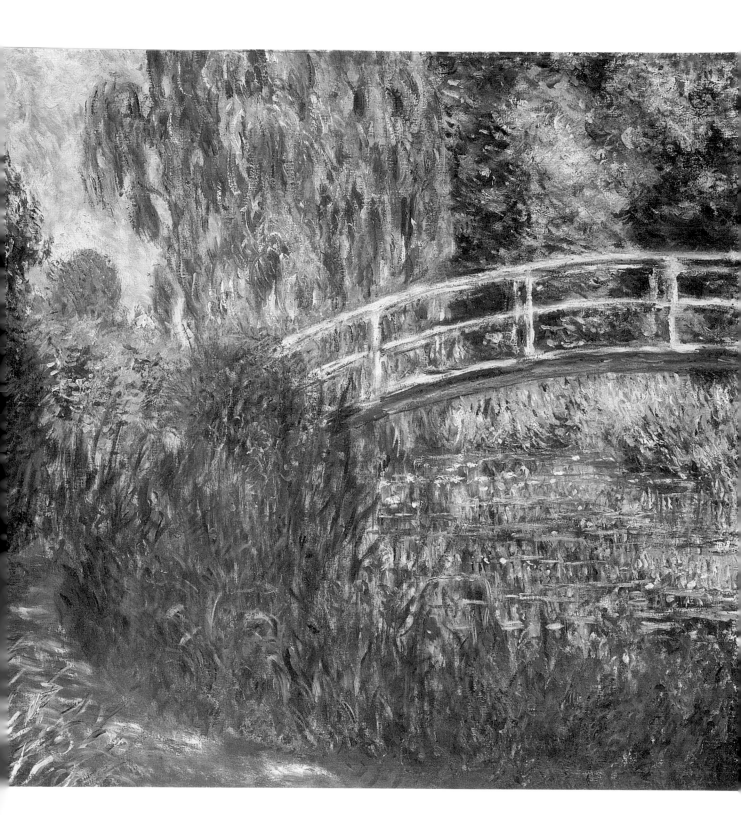

VÉTHEUIL **(1901)**

Pushkin Museum, Moscow. Courtesy of Topham

WHEN Monet moved to Vétheuil, he moved his family to a more rural town than they had previously encountered. Unlike their previous home of Argenteuil, there was no industry at Vétheuil and the people who lived there were mainly agricultural workers.

This rural setting meant Monet changed his approach to the subject matter. In *Au Pont d'Argenteuil* (1874), the artist celebrated the harmony of nature and industry. In Vétheuil there is no sign of industry. The town exists against a backdrop of hills. The presence of people has been reduced, in physical size as well as in intention: the boat is tiny and the figures unidentifiable. In many of Monet's paintings from this period people are absent altogether. The town provides the focus, the viewer's eye being led up to it by the flow of the water. The town's reflection in the water helps its presence to dominate the work; similarly, the spire of the church thrusts up into the sky. The town is equal to all elements. In *Au Pont d'Argenteuil*, the bridge forms a dominant line across the canvas and, in the foreground, a woman and child are depicted taking a leisurely walk. The scene in *Vétheuil* is restful, with the water calm and the boat helping to break up its expanse. The colours here are muted and warm, with none of the cold, grey tones found in *Au Pont d'Argenteuil*.

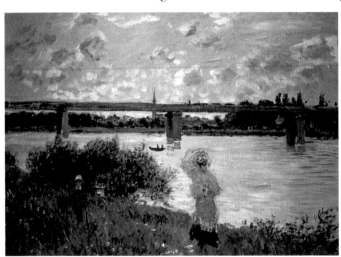

Au Pont d'Argenteuil (1874)
The Bridge at Argenteuil
Courtesy of Image Select. (See p. 83)

LA SEINE À PORT-VILLE (1908–09)
THE SEINE AT PORT-VILLE

Courtesy of Christie's Images

THIS painting represents Impressionism taken to the borders of Abstract art. The whole view has been simplified around three bands of colour; the sea is turquoise, the land purple and the sky a very pale blue. Against these, details such as the boat on the shore are added without any attempt at complexity.

The surface of the water is indicated by irregular brushstrokes and the occasional black line. Similarly, the trees are represented by swirls of green, brown and yellow. Some similarities in technique can be seen in *Antibes, Vue du Cap, Vent de Mistral* (1888), in which the sea is a broad band of colour, with the town, mountains and sky beyond. The sea in both has been painted with a strong colour, but in the earlier picture Monet has detailed the town and mountains more clearly than in Port-Ville. In addition, he gives the viewer some sense of depth to the painting by including the tree in the foreground.

In *La Seine à Port-Ville* there is no clear indication of time of day or season, although the weather is presumably clear as the sky is blue. With the Antibes work, however, Monet took great care to record the sunlight on the hills and the wind in the trees. His representation of nature is strongly conventional in comparison with the Port-Ville painting.

Antibes, Vue du Cap, Vent de Mistral (1888)
Antibes, View of the Cape in the Mistral Wind
Courtesy of Christie's Images. (See p. 170)

WATERLOO BRIDGE (1902)
Courtesy of Christie's Images

THE mirage quality of the bridge in this painting is taken to the point where it virtually disappears from view. The ethereal quality of the painting can be explained partly by the London fog; Monet was attracted to the constantly changing light that it created. The painting is an example of Monet trying to capture what he referred to as the 'envelope' of light that seeps from the subject and surrounds it, giving movement to a static object. He struggled to understand the ever-changing effects that the London climate created.

Here, there is a shroud of romance around the familiar landmark. The boatman in the foreground adding to the sense of mystery and the bridge shimmers in the background as if it is in close danger of disappearing altogether. Reality tempers the romance in the form of the smoking chimneys just visible in the background. The bridge itself is reduced to a silhouette. The eye is automatically drawn to the boat, which is highlighted by a patch of lighter yellow and white flecks on the canvas.

The real subject of the painting is not the bridge but the fog and the way in which it constantly changes the landscape around it, so that at one moment one area is given prominence, at the next another.

221

CHARING CROSS BRIDGE, LA TAMISE (1903)
CHARING CROSS BRIDGE, THE THAMES
Courtesy of Christie's Images

P AINTED during Monet's second trip to
London, this picture is in the same style as
the others produced around this time. The
London fog is used to distort colours and cloud
buildings so that only outlines appear. It reflects the
colour of the sun across the whole of the painting so
that the canvas is transfused with a pink glow.

The unreal quality that the fog gives the
painting is similar to that created in some of the
water lily paintings. As with *Nympheas* (1903), the
water lilies often appear as if they are hovering over
the canvas. There is no reflection in the water, and
their presence is not put into any context. *Charing
Cross Bridge, La Tamise* clearly has a context in that
the Houses of Parliament are recognisable landmarks,
but their ghostly appearance does not give them a
solid presence in the painting. The trains crossing the
bridge are equally as insubstantial, represented purely
by plumes of smoke.

The difference between the two works is that
Nympheas is an intimate
painting that forces the
viewer close to the subject.
*Charing Cross Bridge, La
Tamise* lacks that intimacy
because it is painted from
an obscured distance.

Nympheas (1914–17)
Water Lilies
Courtesy of Christie's
Images. (See p. 234)

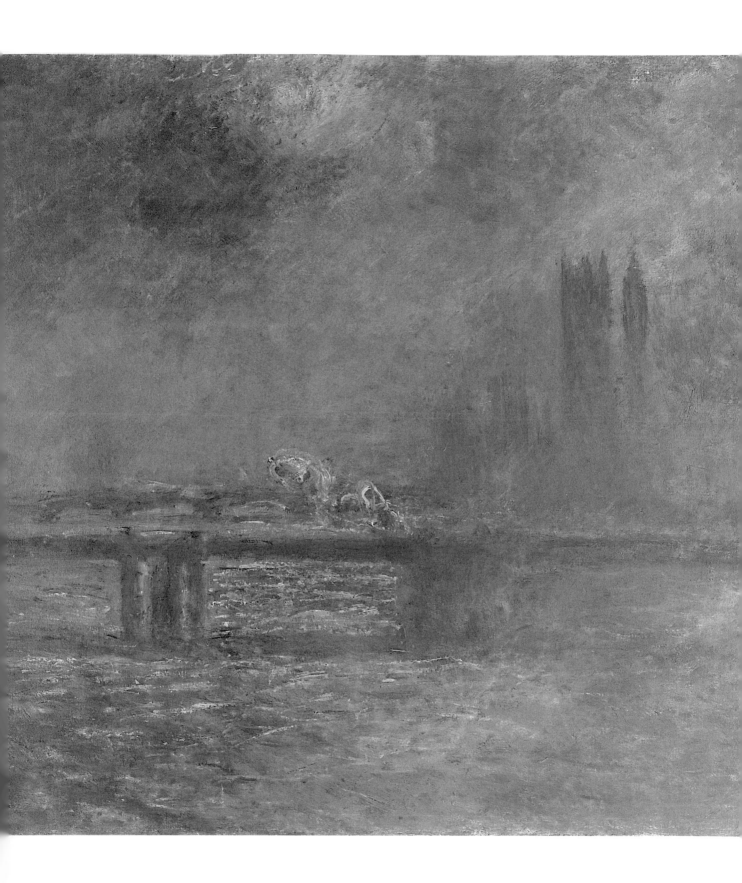

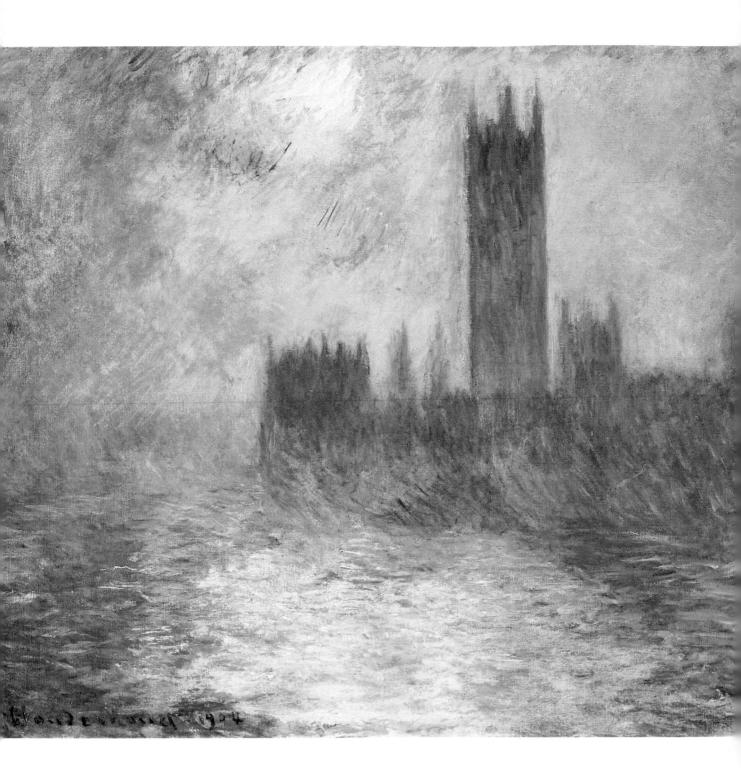

LE PARLEMENT, COUCHANT DE SOLEIL (1904)
THE HOUSES OF PARLIAMENT AT SUNSET

Courtesy of Christie's Images

THIS image was among the most controversial subjects from Monet's London trip, because J.M.W. Turner (1775–1851) had, prior to Monet, successfully painted this among his London scenes. By choosing London as a subject and including in the series landmarks already painted by such an acknowledged master as Turner, Monet was deliberately laying down a challenge. He wanted to prove that his method of painting was the superior.

Monet undoubtedly admired Turner's work and was influenced by him, but he felt that art had moved since his time. His London paintings have also been compared to James Whistler's (1834–1903) *Nocturnes* (subsequently accepted as groundbreaking art although at the time of their creation, they received a mixed reception). Monet had been friendly with Whistler and was therefore familiar with his work.

Here Monet is concentrating on the cumulative atmosphere created when architecture is placed near water and suffused with an eerie light. The Gothic spires of the Houses of Parliament have almost succeeded in piercing through the fog, but they are still reduced to a vague image that does not create a strong reflection in the water. The sun and its reflection cast a warm glow upon the scene and provide two focal points; one at the top of the painting and another at the bottom. The whole work adheres to Monet's aesthetic principles of being pleasing to the eye.

GONDOLE À VENICE (1908–09)
GONDOLAS IN VENICE

Musée des Beaux Arts, Nantes. Courtesy of Giraudon

THIS is an unfinished piece of work and it is possible to trace the shadowing of outlines for the gondola beyond the finished end. In this unfinished state it lacks the harmony of the completed *Le Grand Canal et Santa Maria della Salute* (1908).

The gondola and water are painted like the finished work, using mainly greens and blues, but the tones are much darker, giving the painting a moody air. The patch of purple that represents another boat helps to lift the atmosphere slightly. The reflection of the gondola in the water is painted simply as a dark patch. As with *Santa Maria della Salute*, Monet is not interested in painting a water surface that reflects like a mirror. The water itself has been treated differently in the two paintings: the finished work uses short horizontal strokes of a variety of colours, which help to capture the movement of the water and the varying colours. In *Gondole à Venice*, the water is painted horizontally again, but with long swirls of paint which denote the reflections. The rest of the water, where painted, is created from one colour laid on the canvas in a variety of directions.

Although it is hard to judge from an unfinished work, it would seem that Monet was trying out a different style from his earlier Venetian subjects in this painting.

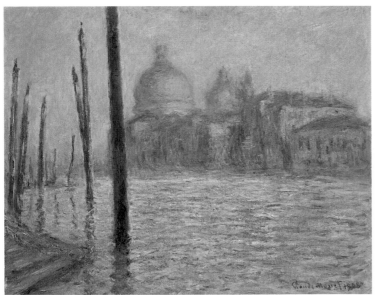

Le Grand Canal et Santa Maria della Salute (1908)
The Grand Canal and Santa Maria della Salute
Courtesy of the Tate Gallery. (See p. 228)

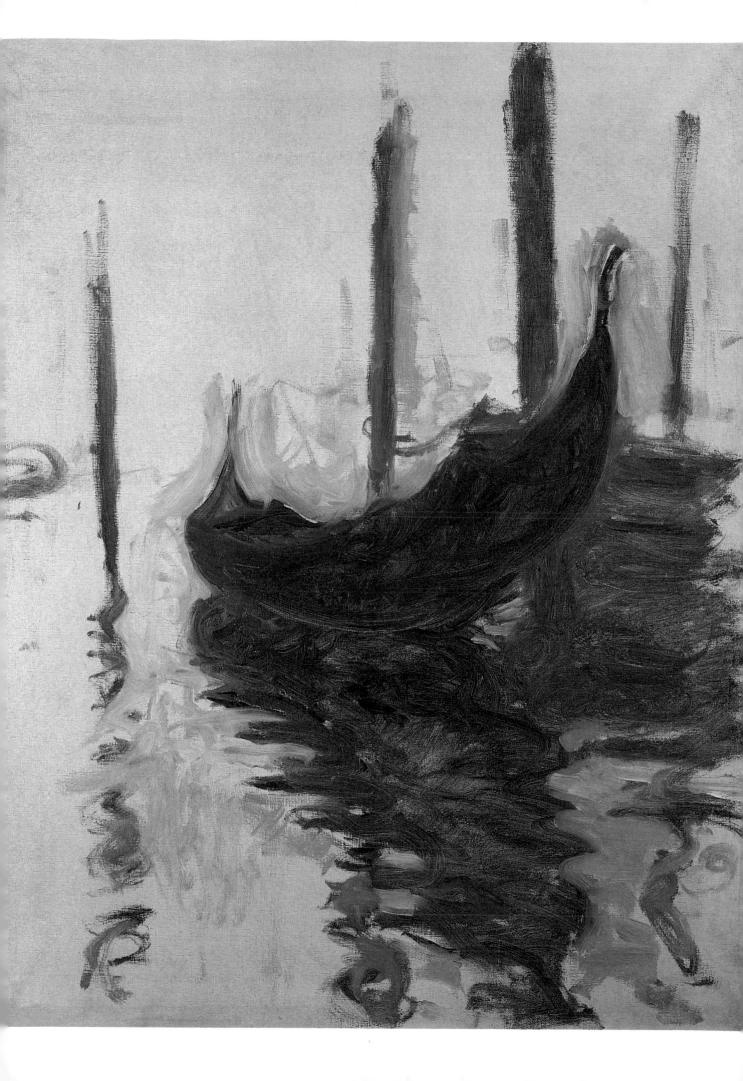

LE GRAND CANAL ET SANTA MARIA DELLA SALUTE (1908)
THE GRAND CANAL AND SANTA MARIA DELLA SALUTE

Courtesy of the Tate Gallery

MONET visited Venice for the first time in 1908. Staying with a friend of the artist John Singer Sargent (1856–1925), Monet was inspired by the magical effects of the light. It is surprising that Monet had not visited Venice before, as with its unusual combination of water, architecture and sky it had all the elements Monet often sought in his work.

Venice has proved fertile ground for artists stretching back across the centuries, but Monet was not interested in recording the city in a conventional style. He was instead more concerned with the effects of light on the buildings. In this picture the architectural details of the Santa Maria della Salute are reduced to outlines. The strong lines of the edges of the building create a vertical and horizontal grid in the right-hand corner. The vertical lines of the painting are emphasised by the gondola poles rearing out of the water and reaching for the sky.

Painted from the centre of the canal, Monet has thrust the viewer on to the water with very little land to act as a boundary. Santa Maria della Salute seems to be floating on the water, an effect furthered by the water reflecting greens and blues on to the side of the building and the white of the stonework reflecting back down on to the water.

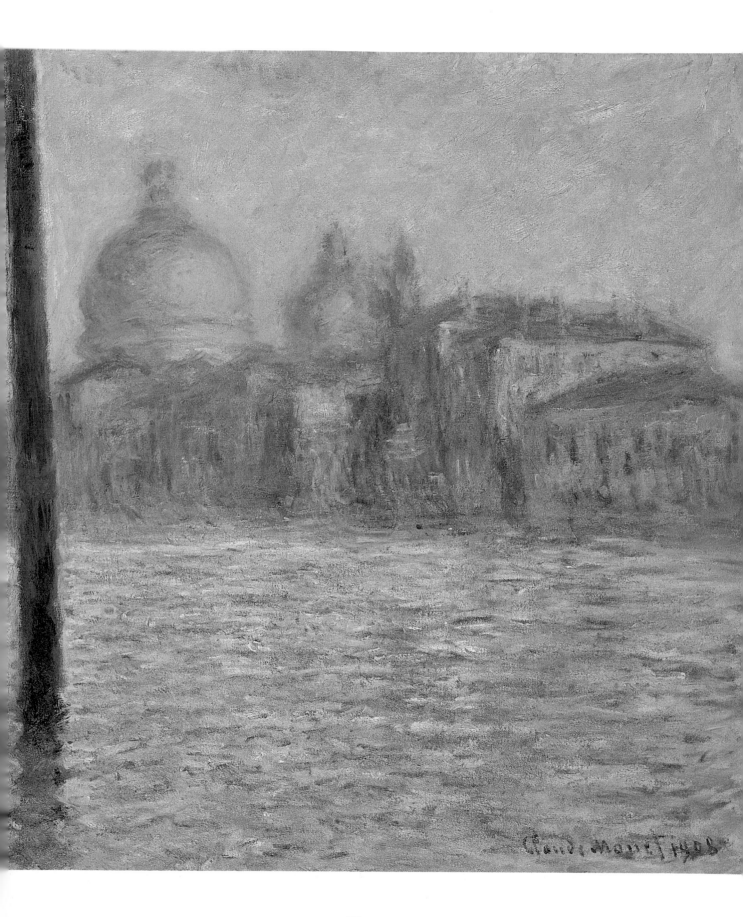

LE PALAIS DE MULA (1908)
VENICE, PALAZZO DA MULA

National Gallery, Washington, D.C.. Courtesy of Image Select

AFTER the close intimacy of Monet's garden paintings from Giverny, these dramatic pictures from Venice mark a return to painting on a monumental scale. This extraordinary work confirms that Monet's main interest was the effect of light. Traditionally the *Palazzo da Mula* would have been depicted in all its glory as the primary focus of a painting, with its architectural details accurately recorded. Here Monet has dispensed with this notion; the building has been cropped short so that the top floors are not shown and, by removing the sky and showing only part of the palazzo, he has disassociated it from its surroundings. The horizontal and vertical lines of the architecture provide him with a grid which he deconstructs. By focusing on the relationship between the colours of the water and the colours of the building, Monet has made the palazzo a part of nature rather than being apart from nature.

Some critics have found elements of abstract design in this painting. The emphasis on the grid work of the building and the fading away to nothing of the actual details of the stonework has led them to connect this with work by more established Abstract artists.

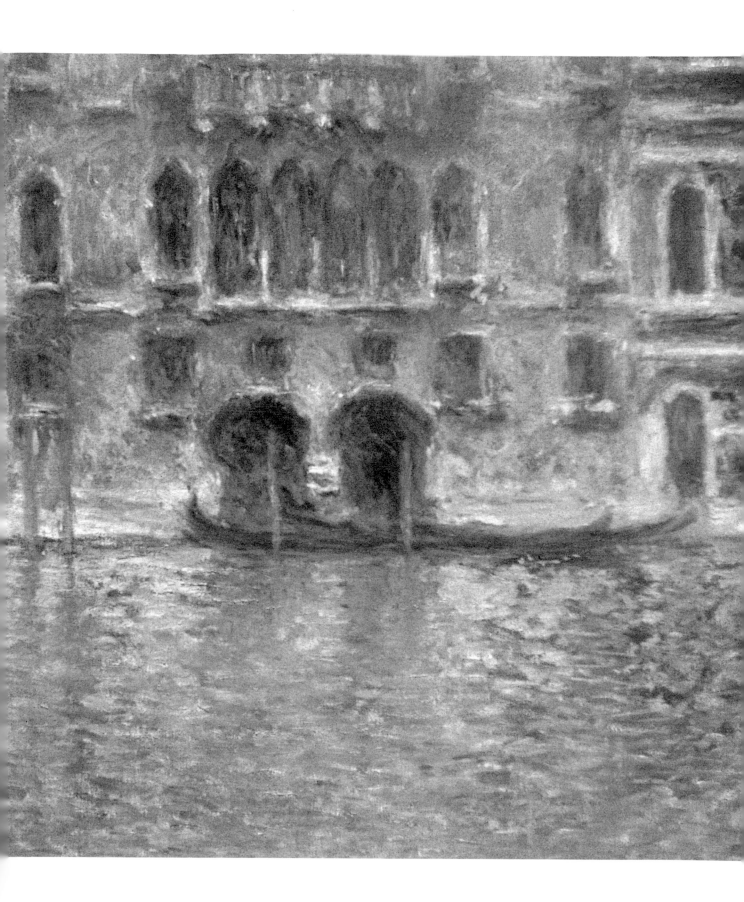

NYMPHEAS (1907)
WATER LILIES
Courtesy of Christie's Images

*T*HERE is a sense of suspension about many of the water lily paintings, particularly those that depict water without land or sky above it, as both these paintings do. The viewer is suspended in this strange place where surroundings have been dispensed with and all that remains is the world of water.

The 1907 painting is a prime example of this world of water. The reflection of clouds can just be made out, and what appears to be the reflection of willow trees appears on the left and right. However, by filling the canvas entirely with water, the planes of the water and of the canvas have become one. The water lilies are carefully laid on the canvas in horizontal lines in both this picture and the later *Nympheas* (1914–17).

Both the 1907 and the 1914–17 paintings are intimate to Monet because they not only represent his own private garden but also his peculiar vision of that garden. By having a subject that is so intimate, Monet pulls the viewer in to his own experience of the painting. The brushstrokes in the later works become progressively broader, which was primarily a result of his failing eyesight.

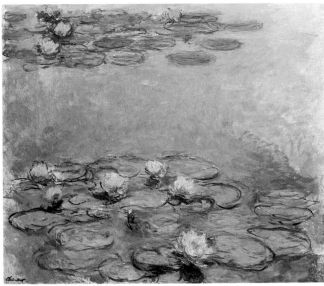

Nympheas (1914–17)
Water Lilies
Courtesy of Christie's Images. (See p. 234)

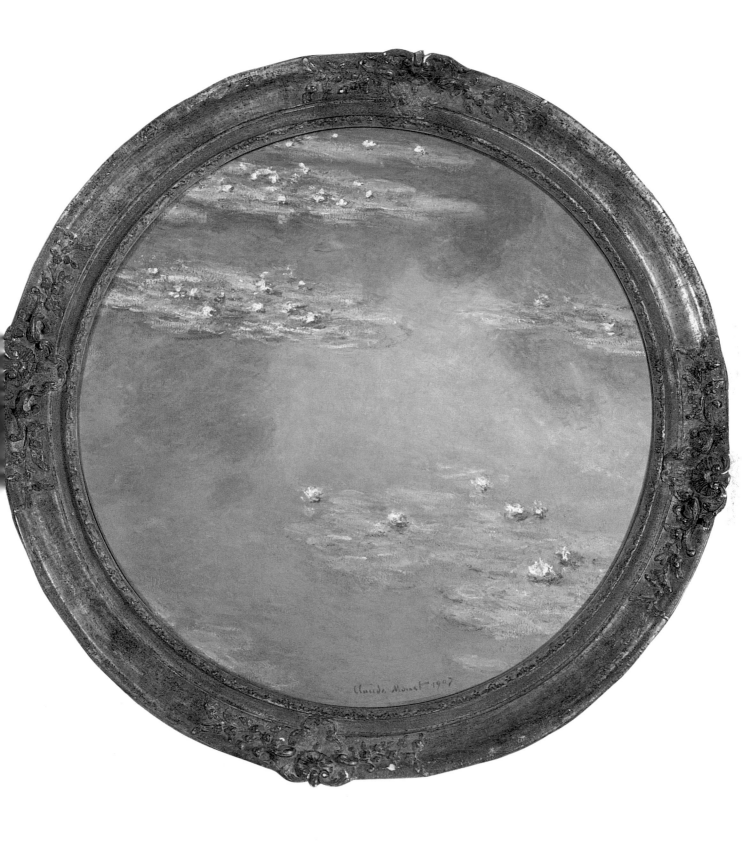

NYMPHEAS (1914–17)
WATER LILIES
Courtesy of Christie's Images

PRIME Minister Clemenceau had always been a loyal supporter of Monet's work. In 1914 he urged the artist to work on a larger project, which became a formal state commission in 1916. This was for a set of large canvases depicting water lilies that would be displayed together permanently. Between now and his death this was to be the main preoccupation of Monet's work.

The paintings were destined to be hung in two basement rooms of l'Orangerie in Paris. The paintings were hung together all the way around the two oval rooms so that the viewer is completely surrounded by Monet's water lilies. This style of painting extends the experience the artist has had with the subject out to the viewer. It was the ultimate resolution of all of Monet's series work.

A comparison between this intimate painting and the earlier *En Promenade près d'Argenteuil* (1875) demonstrates how far Monet's style had changed. The earlier landscape is open, balanced and keeps the viewer at a distance. The use of horizontals is common to both paintings but *Nympheas* forces the viewer close to the subject so all that is visible is the flower in a background of water. Nothing else exists.

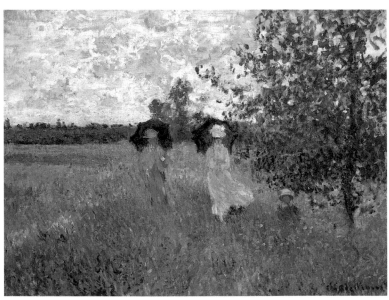

En Promenade près d'Argenteuil (1875)
Walking near Argenteuil
Courtesy of Giraudon. (See p. 92)

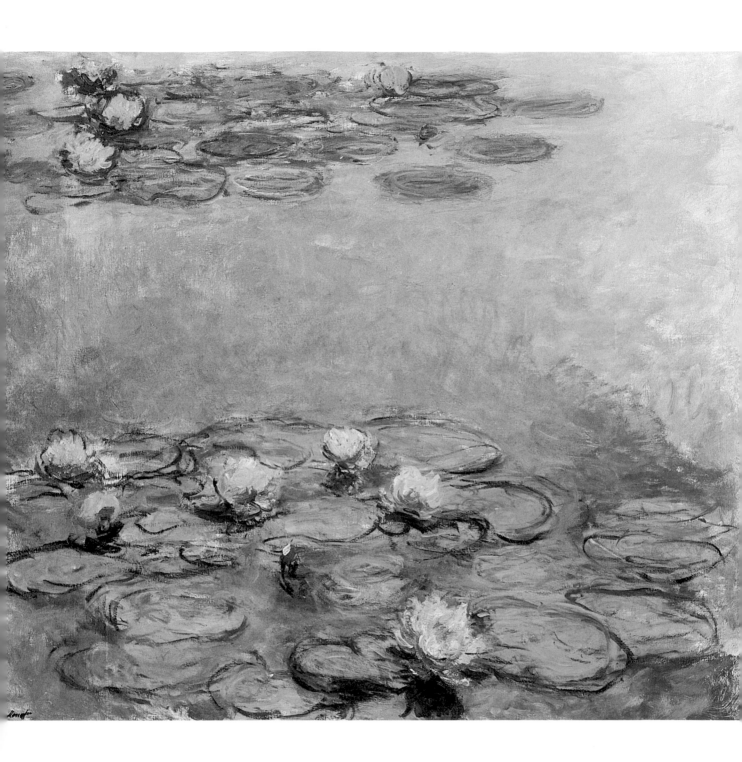

NYMPHEAS (1914–17)
WATER LILIES
Courtesy of Christie's Images

DURING the course of this painting, Monet's cataracts were getting progressively worse. He could see so badly that he had to read the names on the tubes of paint to find out which colours he was using. Nevertheless, his sense of colour and harmony was not affected, and this painting is a stunning testimony to that.

The effects of the cataracts can be seen primarily in the brushstrokes. A comparison between this and the painting of c. 1919 shows that the main painting has been done with thicker strokes. There is a mixture of broad horizontal and vertical brushwork that is especially noticeable in the top of the painting, which suggests a sense of urgency on the part of the artist. There is also a pervading sense of darkness that is missing from the second picture. This comes from the dark colours used combined with these heavy strokes, causing the delicacy of the lilies to be lost. Monet was so concerned that his cataracts would ruin the water lily paintings that he abandoned work on them until his eye had been operated on. These two paintings together provide an excellent study of how he could treat the same subject completely differently. One is tranquil and calm, the other full of drama and frenzy.

Nympheas (c.1919)
Water Lilies
Courtesy of Christie's Images. (See p. 239)

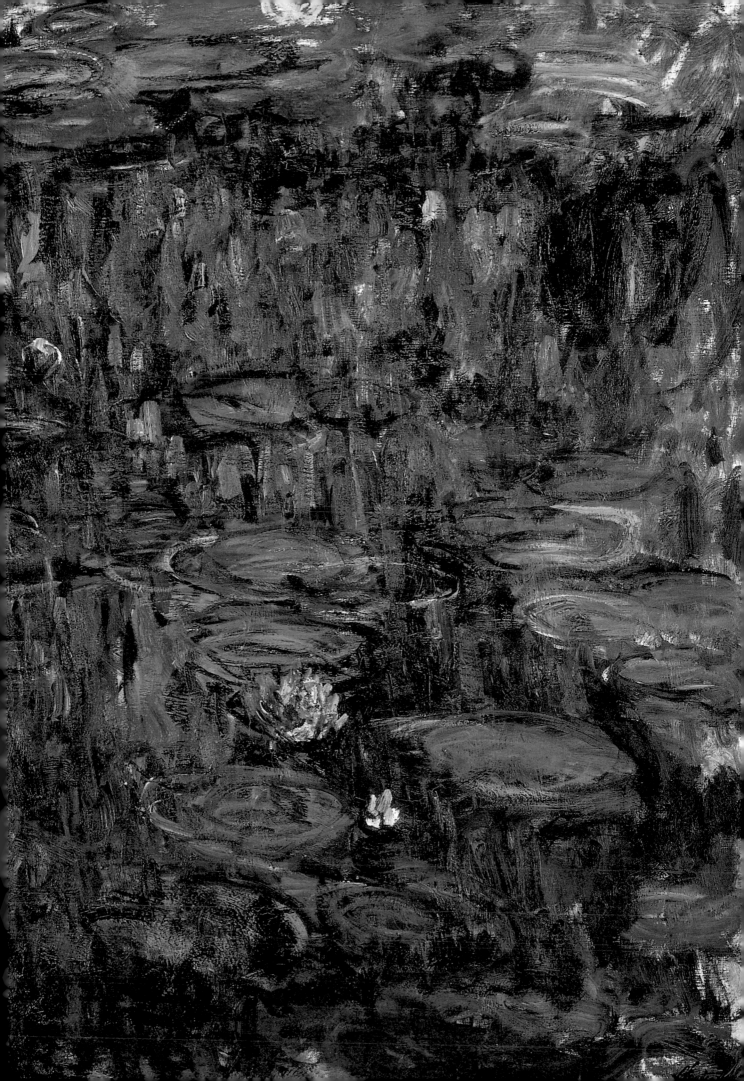

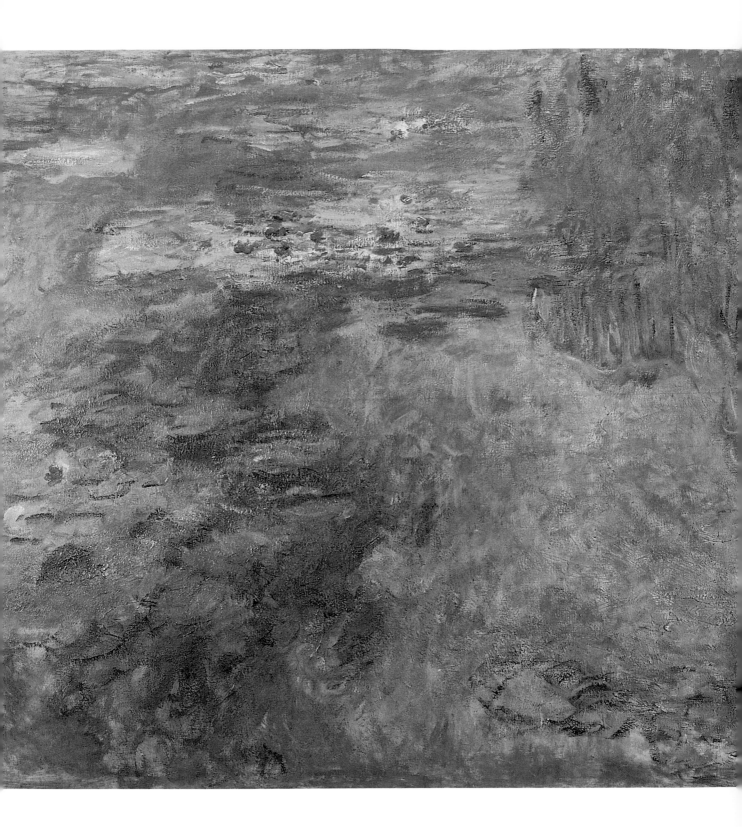

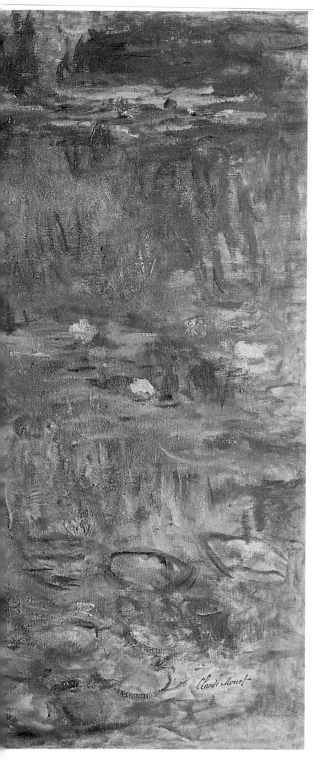

NYMPHEAS (c. 1919)
WATER LILIES
Courtesy of Christie's Images

MONET returned time and again to his garden for inspiration. Between the years 1903 and 1908 he had painted numerous canvases of water lilies – 48 were exhibited by Durand-Ruel in 1909. Contemporary critics exclaimed over the beauty of the paintings. He came back to the subject towards the end of his life.

In all of these paintings, Monet focuses on the surface of the water. He dispenses with any representation of the land or sky, only showing their reflection in the water. This painting is typical, with the willows present only as a reflection. The sky, with its white clouds, is reflected in the water, so the blue of the sky and the blue of the water are one. Only the presence of the water lilies helps the observer to understand that this is a reflection. The painting is done in such a way that it is difficult to judge depth in it, and it becomes a very flat canvas.

As the sky has clouds in it, the surface of the water is hard to identify. The wispiness of the edges of clouds could be the ripples of the water. The overall effect is of a harmonised world where water and sky have truly become one, and land has almost disappeared.

LES HEMEROCALLES (1914–17)
HERMEROCALLIS

Musée Marmottan. Courtesy of Giraudon

LIKE others in Monet's series of flower paintings, this depicts the plant in isolation. Unlike others, however, this picture does have a variety of colours and shadings as background. There is the merest hint that other plants are present, particularly on the left-hand side, where the blue brushstrokes may represent other plant leaves.

The flowers erupt from the central bush of the leaves and are painted without any detail to the flower head. Once again Monet is striving to give an overall impression rather than to represent any specific detail. The brushwork was quickly and roughly applied, and the same technique can be seen in *Nympheas* also painted in the same time. This technique has the effect of blurring the central image so that the colours merge together. However, in *Les Hemerocalles*, the plant can still be seen in isolation from its surroundings. In *Nympheas* the flowers were painted on to a background of water which becomes part of the essence of the flowers; the downward strokes on the surface cut across both the water and the flowers.

The colours used in the painting are vibrant, testifying to the problems that Monet was encountering as a result of his cataracts. The strong red and the yellow in the background indicate this in particular.

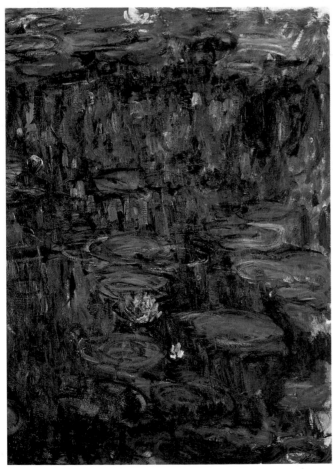

Nympheas (1914–17)
Water Lilies
Courtesy of Christie's Images.
(See p. 236)

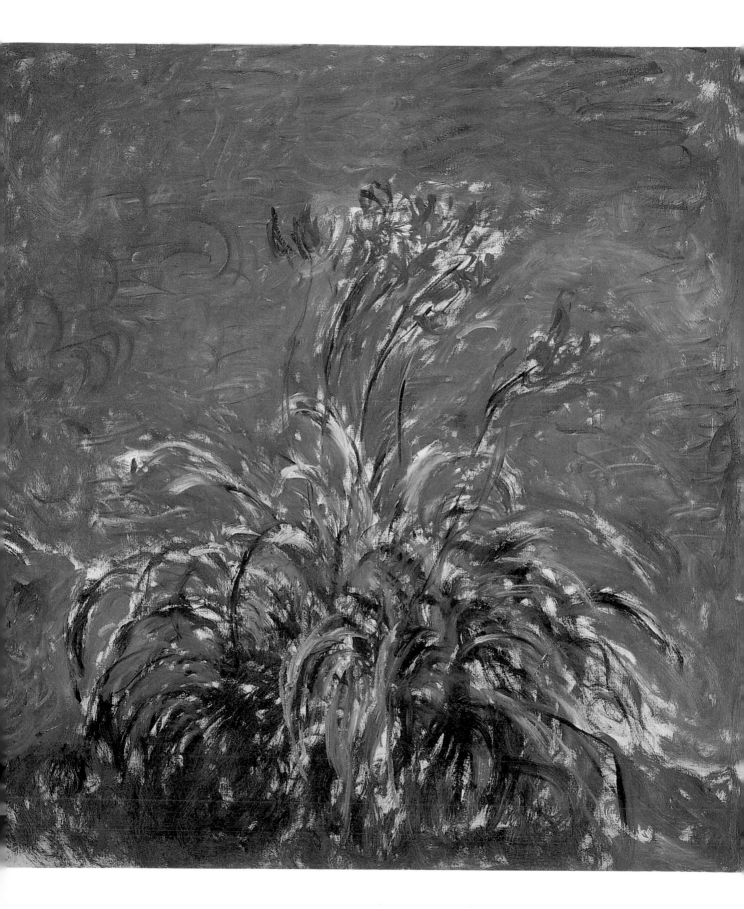

LE PONT JAPONAIS (1918–24)
THE JAPANESE BRIDGE
Musée Marmottan. Courtesy of Giraudon

THE colours and brushstrokes date this picture to the time that Monet was most affected by cataracts. His strong use of yellows and reds had been growing over the years as his sight declined. The effect of the chosen paints is to create a chaos of bright contrasting colours on the canvas from which the outline of the bridge emerges as a shadowy presence. This is in stark contrast to *Le Bassin aux Nympheas, Harmonie Verte* (1899), which shows the same bridge harmonised in green and blue. The earlier painting was made before the introduction of the wisteria bower over the bridge, visible in *Le Pont Japonais* as a higher green line. Even when studying the bridge and the foliage above it, Monet still sees some red and yellow so that brushstrokes in these strong colours are present in the greenest part of the painting.

The artist's treatment of the bridge has changed to the point where the structure is not easy to distinguish. This is typical of the Expressionist response to nature that occurs more and more in Monet's work at this time. The angle he painted from is closer to the bridge than in the earlier work and the overall spatial structure still seen there has collapsed here.

Le Bassin aux Nympheas, Harmonie Verte (1899)
The Water Lily Pond, Harmony in Green
Pushkin Museum, Moscow. Courtesy of Giraudon. (See p. 213)

243

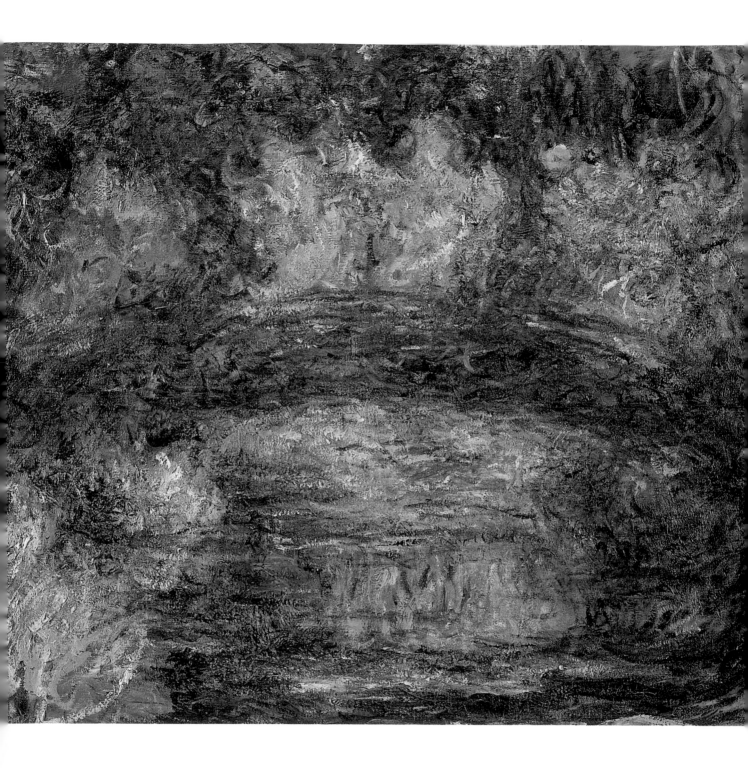

LE PONT JAPONAIS (1918–19)
THE JAPANESE BRIDGE
Courtesy of Giraudon

HERE Monet's treatment of the Japanese bridge changes dramatically from the earlier pictures. Following the very green paintings of the late 1890s and early 1900s, Monet has painted the bridge with a blue cast over it. In terms of colour, a comparison between this version of the bridge and the later version (1918–24) is striking. Monet moves from a still-harmonious blue and green palette of colours to a riot of red and yellow.

This painting may not indicate the brighter colours that were to appear in Monet's later work, but it does contain some of the Expressionist elements that emerged in force in the later work. The brushstrokes have become wilder and the bridge is merging with its surroundings, making it harder to define than in earlier works. There is still some sense of spatial awareness created by the plant positioned in the foreground, but this is not as strong as in earlier paintings. The flatness that appears in the later work is present in this picture.

Both paintings were created from a similar viewpoint, which makes it easier to appreciate how much Monet's work changed and developed over the intervening years.

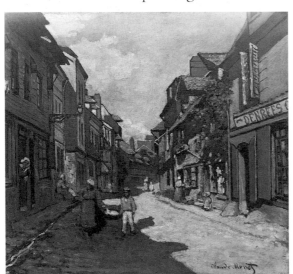

La Rue de la Bavolle, à Honfleur (c. 1864)
Bavolle Street, at Honfleur
Mannheim Stadtische Kunsthalle.
Courtesy of Giraudon. (See p. 22)

LA MAISON D'ARTIST VUE DE
JARDIN AUX ROSES (1922–24)
THE ARTIST'S HOUSE SEEN FROM THE ROSE GARDEN

Bavaria Bildagentur. Courtesy of Giraudon

IN 1923 Monet was finally persuaded to have one of the cataracts that were affecting his vision removed. The cataracts had distorted his vision since around 1908, and his sense of colour had been disrupted. The effect of the cataracts had made the world appear as if he were looking through a yellow lens. As they grew worse, his vision became browner and browner.

This painting is evidence of that effect. The colours that dominate are yellow and red, with very little blue in the picture. It is not easy to identify any subject in the painting, but the chimney and part of the roof of the house are visible in the left corner, painted in pink. The thick brushstrokes and extremes of colour are thought by some to be indicative of the anguish Monet was feeling about his inability to see properly. Paintings like this have been called early examples of Abstract Expressionism rather than Impressionist.

Monet's despair over his vision meant that he suspended work on the Orangerie *Nympheas* paintings until he was confident he would not ruin them with his poor vision. Prime Minister Clemenceau finally persuaded Monet to put aside his fear of the operation and have the cataract removed from one of his eyes.

LA MAISON VUE DU JARDIN AUX ROSES (1922–24)
THE HOUSE SEEN FROM THE ROSE GARDEN
Musée Marmottan. Courtesy of Giraudon

THE effects of Monet's eye operation are seen instantly in this painting. The colour that virtually screams from the canvas is blue. This is dramatic when compared with the pre-operation painting *La Maison d'Artist Vue du Jardin Aux Roses* (1922–24). The riot of pink and yellow in that painting has completely gone.

Although it is easier to identify objects in this later painting, the overall effect is a cacophony of colour rather than a concentration on subject matter. Monet found great difficulty in coping with the sudden transformation of his perception of colour. He resorted to wearing yellow-tinted glasses to help prevent him from being overwhelmed by blue. However, because only one eye had been operated on, he was struggling to focus properly, so he resorted to wearing a patch over his affected eye. This had the effect of taking away his binocular vision, and as a result he lost an appreciation of depth.

The artist chose to destroy many of his paintings from this period, and he fought hard to return to a style that he desired. Paintings from these years are sometimes referred to as Monet's 'blue period'; very few of them remain.

La Maison d'Artist Vue du Jardin aux Roses (1922–24)
The Artist's House Seen from the Rose Garden
Bavaria Bildagentur. Courtesy of Giraudon. (See p. 247)

IRIS JAUNES (1924–25)
YELLOW IRISES

Courtesy of Christie's Images

*T*HIS painting's strength lies in Monet's use of colour. The brilliance of the yellow flower is enhanced by being placed against a strong blue background. It is the flower that attracts the eye; unlike the painting *Iris* (1924–25), where the flower itself is secondary to the pattern formed by the leaves.

The straight stems and leaves in *Iris Jaunes* is reminiscent of the poplars in *Peupliers au Bord de l'Epte* (1891). As with those, the heads of the flowers form parallel horizontal lines to counter the vertical green lines. This is an even simpler pattern than that in *Iris*. What both paintings share is not just a common subject but a common treatment of it. Neither is given a background to put it in context; the plant exists entirely in isolation.

The simplicity of *Iris Jaunes* coupled with the grid formation used gives it an oriental tone. By choosing a flower as a subject set against a single-colour background, the effects of Monet's interest in Japanese art can be seen. Several of Monet's paintings of flowers have these traditional Japanese elements within them.

Iris (1924–25)
Musée Marmottan. Courtesy of Giraudon. (See p. 252)

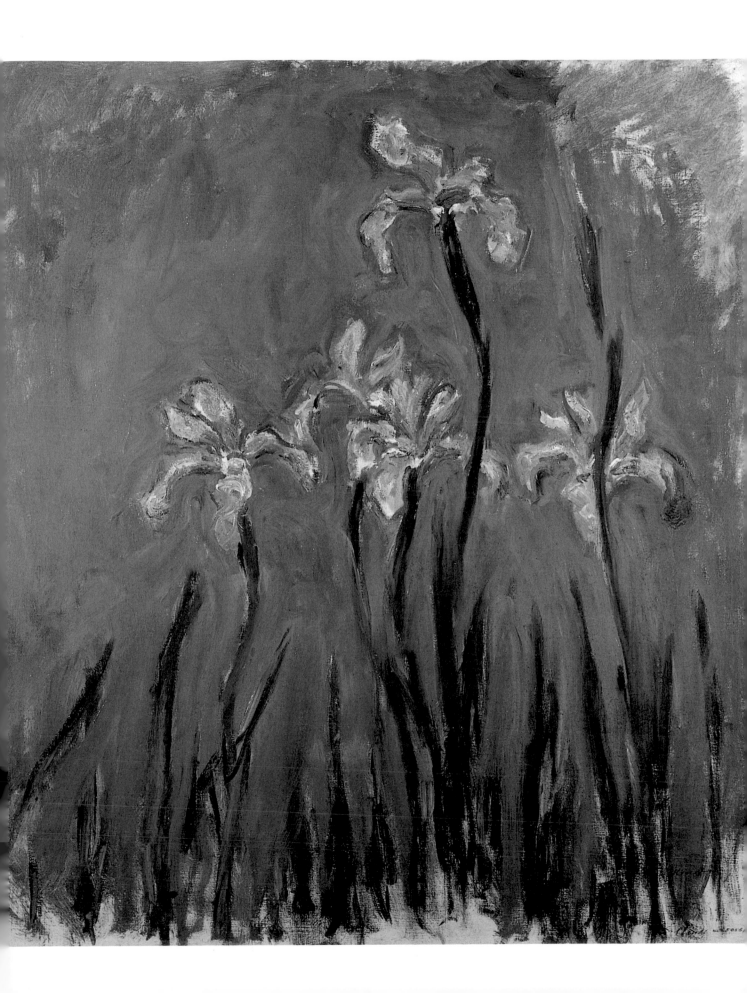

IRIS (1924–25)

Musée Marmottan. Courtesy of Giraudon

THIS painting is among the last that Monet worked on. Even at this late stage in his career he was still developing as an artist and trying new techniques. This is one of the many reasons why he has gained the respect of critics over the years.

With *Iris*, Monet has moved in to give an intimate view of the plant. The background is a swirl of colour that is indecipherable as representative of anything in particular, so the plant exists without any distractions to the eye. It is a depiction of an iris in its purist form. Unlike his earlier paintings, it is not the amazing violet and lilac tones of the flowers that have caught Monet's eye. Instead it is the shape of the leaves; their greenness, and even orange on one leaf, that are the focus of the painting.

What interests Monet, as can be seen in work dating back to the beginning of his career, is the grid of horizontal and vertical lines created by the leaves; the sweep of the leaves forming horizontal and vertical lines that cross each other. The informality of the symmetry is

further emphasised by the curves of the leaves, ensuring that the whole has a softened and harmonised effect.

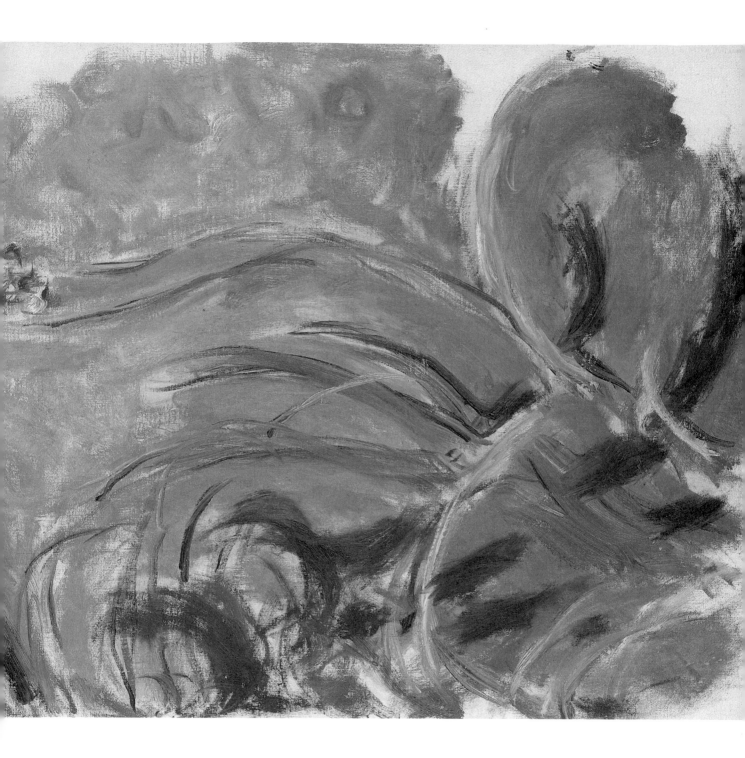

LES ROSES (1925–26)
THE ROSES
Courtesy of Giraudon

*L*ES *Roses* has an obvious oriental influence. The tree is painted against a blue background that could represent the sky, although it is so anonymous it would be difficult to state that for certain. The shape of the tree as it curves across the canvas is reminiscent of Japanese art. In particular an examination of the branches reveals that they are represented by thin black lines that barely connect together. This willowy effect, combined with the depiction of flowers by simple touches of colour, is synonymous with oriental art.

Water lilies as a subject are also a traditional oriental theme. Monet's treatment of them in *Nympheas* (1914–17) is similar to that of the roses; the main difference between the two being the fact that the tree branches have a defined end, whereas the water lilies float to the edge of the canvas and create the illusion that they continue floating for further than the artist (or the viewer) can see.

The colours used here are soft pastels and light blues, creating the effect of colour for the sake of it. Monet chose this subject because of the beauty of the combination of colours. The pattern they create together was more important to him than an accurate representation of the tree.

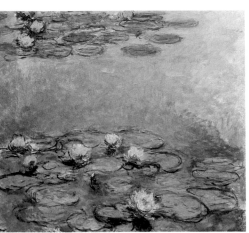

Nympheas (1914–17)
Water Lilies
Courtesy of Christie's Images.
(See p. 234)

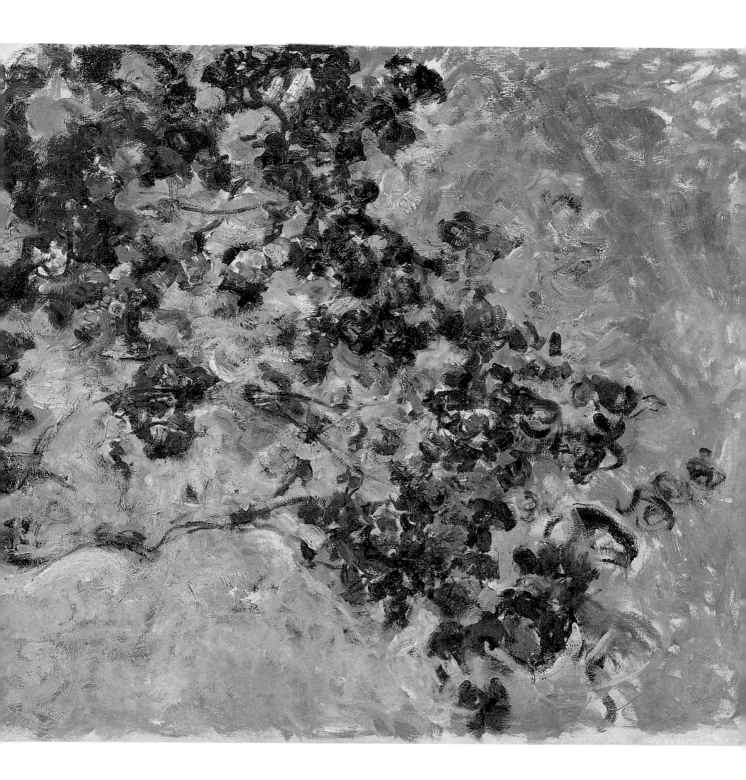

AUTHOR BIOGRAPHIES AND ACKNOWLEDGMENTS

To Greg, with love and gratitude.

Vanessa Potts was born in Sunderland in 1971. She completed a B.A. Hons in English and American Literature at Warwick University in 1992. Since then she has completed an M.A. in Literature and the Visual Arts 1840–1940 at Reading University, from where she graduated in 1998. Vanessa currently combines her writing career with her job as a buyer for a major retail company.

For my father, for sharing his love of landscape.
Dr Claire I. R. O'Mahony has a BA from the University of California at Berkeley and an MA and PhD from London's Courtauld Institute of Art. Her specialist subject is nineteenth-century art, in particular mural decoration in Third Republic France and images of the life model in the artist's studio. She is a visiting lecturer at the Courtauld Institute and Curator for the nineteenth-century exhibitions at the Richard Green Gallery, London.

While every endeavour has been made to ensure the accuracy of the reproduction of the images in this book, we would be grateful to receive any comments or suggestions for inclusion in future reprints.

With thanks to Image Select and Christie's Images for assistance with sourcing the pictures for this series of books. Grateful thanks also to Frances Banfield, Lucinda Hawksley and Sasha Heseltine.

BOOK OF
BRITAIN'S
COUNTRYSIDE

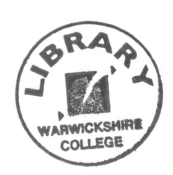

MIDSUMMER BOOKS

Published by AA Publishing Ltd (a trading name of Automobile
Association Developments Limited, whose registered office is
Norfolk House, Priestley Road, Basingstoke, Hampshire
RG24 9NY; registered number 1878835).

Find out more about AA Publishing and the wide range of
services the AA provides by visiting our Web site at
www.theaa.co.uk.

Produced for AA Publishing by Midsummer Books Ltd,
179 Dalling Road, London W6 0ES, UK.

For Midsummer Books:
Publisher: Stan Morse
Managing Editor: Rose Catt
Project Editor: Karen Frazer
Commissioning Editor, site material: Linda Bennett
Editors: Rick Morris, Rebecca Snelling, Ben Way
Art Director: Maggi Howells
Designers: Maggi Howells, Phil Barfoot, Victoria Wren
Indexer: Patricia Coward

ISBN 0 7495 1860 X
A catalogue record for this book is available from the
British Library.

Colour origination by Bright Arts Graphics, Singapore;
Chromagraphics, Singapore; and Modern Litho, Southall.
Printed and bound by Fratelli Spada SpA, Italy.

Contributors

Natural History Consultant
Dr Paul Sterry

WEST COUNTRY

Dr Bob Gibbons, author, photographer, tour leader and ecologist (Introduction). Dr Paul Sterry (discovering habitats). Michael Proctor, University of Exeter (Reading the Landscape). Sue Goodfellow, head of ecology and wildlife conservation for Dartmoor National Park Authority (Dartmoor). David Lloyd, principal conservation officer for Exmoor National Park Authority (Exmoor). Graham Madge, marketing officer for RSPB South-West Regional Office (Exe Estuary). Leigh Lock, RSPB South-West Regional Office (The Scilly Isles). Sue Hocking, conservation officer for the Cornwall Wildlife Trust (The Lizard). Debora Elton, ecologist and council member the Dorset Wildlife Trust (Portland and Chesil). Dr Leslie Haskins, chairman of the Scientific Committee of the Dorset Wildlife Trust (The Dorset Heaths). Michael Woods, journalist, council member of the Somerset Wildlife Trust and the Mammal Society (Cheddar Gorge & Mendip Hills). Joe Blossom, environmental consultant and former education officer at the Wildfowl and Wetlands Trust, Slimbridge (Slimbridge & River Severn). Andrew Clements, corporate manager, English Nature (Forest of Dean). Robin Williams, local writer and photographer (Somerset Levels). Kevin Cook, warden on Brownsea Island for the Dorset Wildlife Trust (Poole Harbour).

WALES AND THE BORDERS

Roger Lovegrove, former director, RSPB Wales, member of Council for Countryside Council for Wales (Introduction). Dr Paul Sterry (discovering habitats). Michael Proctor, University of Exeter (Reading the Landscape). Martin Collins, local writer (Snowdonia). Dr Paul Whalley, council member for the North Wales Wildlife Trust (Anglesea). David Saunders, conservation officer for the West Wales Wildlife Trust and local writer (Skomer and Skokholm). Tim Sime, local writer (Pembrokeshire). Ray Woods, area officer for the Countryside Council for Wales, local writer and broadcaster (Brecon Beacons). Winnie Weston, local expert (Gower Peninsular). Roger Lovegrove, former director, RSPB Wales, member of council for Countryside Council for Wales(Tregaron and Kite Country). Dr George Peterken, local environmental consultant (Wye Valley). John Tucker, conservation project manager for the Shropshire Wildlife Trust (The Welsh Marches).

SOUTHERN ENGLAND

David Streeter, local writer and reader in ecology at Sussex University (Introduction). Dr Paul Sterry (discovering habitats). Michael Proctor, University of Exeter (Reading the Landscape). Clive Chatters, conservation officer for the Hampshire and Isle of Wight Wildlife Trust (New Forest). Colin Pope, ecology officer with the Isle of Wight Council (Isle of Wight). Bob Chapman, site manager for English Nature, North Solent (South Coast Estuaries). Nicky Marriable, local environmental consultant (Ashdown Forest). Peter Raine, county environment officer for Kent County Council (North Downs). Richard Williamson, local writer and former reserve manager of Kingley Vale NNR (South Downs). Professor David Goode, director of London Ecology Unit (London). David Tomlinson, local writer specialising in birds (Romney Marsh and Dungeness). David Tipling, writer and photographer specialising in birds (Thames Estuary). Simon Melville, Thames and Chilterns team, English Nature (The Chilterns).

HEART OF ENGLAND

Dr Oliver Rackham, author and professor emeritus of Corpus Christi College, Cambridge (Introduction and Forests of Middle England). Dr Paul Sterry (discovering habitats). Michael Proctor, University of Exeter (Reading the Landscape). Andrew Clements, corporate manager, English Nature (North Norfolk Coast). Derek Moore, director of Suffolk Wildlife Trust (Breckland). Adrian Colston, warden of Wicken Fen, Cambridgeshire (Fenland). Rob Hume, author and editor of RSPB Birds magazine (Ouse Washes). George Samuels, local writer (The Broads). Geoff Welch, manager of RSPB's Minsmere Reserve (Minsmere). Tim Appleton, nature reserve manager at Rutland Water (Rutland water)

NORTHERN ENGLAND

Roly Smith, local writer and lecturer, chairman of the Outdoor Writers' Guild and former head of information services at the Peak District National Park (Introduction, The Dark Peak & the White Peak). Dr Paul Sterry (discovering habitats). Michael Proctor, University of Exeter (Reading the Landscape). Alan Shepley, local writer and lecturer (Lake District). Dr Colin Speakman, local author and secretary of the Yorkshire Dales Society (Yorkshire Dales). Alan Staniforth, coast ranger on the North Yorkshire and Cleveland Heritage Coast, former information officer for the North Yorks Moors National Park Authority (North York Moors). Lesley Silvera, local writer (Northumberland National Park). Tony Hopkins, environmental and education consultant and writer (Farne Islands and Holy Island). Tim Dickson, local writer (East Coast). Linda Bennett, consultant and former editor of Natural World, the magazine of The Wildlife Trusts (Isle of Man). David Robinson, member of council of Lincolnshire Wildlife Trust, former editor of Lincolnshire Life (Lincolnshire Wolds).

SCOTLAND

Dr Kenneth Taylor, highland officer, Scottish Wildlife Trust, broadcaster and writer (introduction and Caledonian Forest). Dr Paul Sterry (discovering habitats). Michael Proctor, University of Exeter (Reading the Landscape). Dr Bryan Nelson, writer and ornithologist (North Solway Coast). Malcolm Ogilvie, local writer and editor (Islay). Andrew Curry, writer and lecturer (Skye & the Small Isles). Dr John Love, local writer working for Scottish Natural Heritage (Outer Hebrides). Roy Dennis, local writer and consultant (Cairngorms). Keith Fairclough, senior site manager, RSPB officer, Orkney (Orkney). Roger Smith, writer and editor (Border Country). Katherine MacDonald, writer and ornithologist (Ardnamurchan & Argyll). Peter Ellis, RSPB officer, Shetland Islands (Shetland). Euan McIlwraith, journalist and broadcaster (Loch Lomond).

IDENTIFYING WILDLIFE

Dr Andrew Cleave MBE, writer and nature reserve warden.

Contents

INTRODUCTION 10

GETTING THE MOST OUT OF THIS BOOK 12

WEST COUNTRY 14

Isles of Scilly 26
The Lizard 28
Dartmoor 30
Exe Estuary 32
Dorset Coast 34
Dorset Heaths 36
Poole Harbour 38
Exmoor 40
Somerset Levels 42
Mendip Hills 44
The River Severn & Slimbridge 46
Forest of Dean 48

SOUTHERN ENGLAND 50

Isle of Wight 62
The New Forest 64
South coast estuaries 66
South Downs 68
Ashdown Forest 70
Romney Marsh & Dungeness 72
North Downs 74
Thames Estuary 76
London 78
Chiltern Hills 80

WALES AND THE BORDERS 82

Skomer & Skokholm 94
Pembrokeshire 96
Gower Peninsula 98
Kite Country 100
Brecon Beacons 102
Wye Valley 104
The Marches 106
Snowdonia 108
Anglesey 112

HEART OF ENGLAND 114

Forests of Middle England 126
Rutland Water 128
Ouse Washes 130
Breckland 132
Minsmere 134
The Broads 136
North Norfolk Coast 138
The Fens 140
The Wolds 142

NORTHERN ENGLAND 144

The White Peak 156
The Dark Peak 158
East Coast 160
Morecambe Bay 162
Yorkshire Dales 164
North York Moors 166
Isle of Man 168
Lake District 170
Northumberland 174
The Farnes & Lindisfarne 176

SCOTLAND 178

North Solway Coast 190
Border Country 192
Islay 194
Loch Lomond 196
Argyll & Ardnamurchan 198
Tayside 200
The Cairngorm Mountains 202
Caledonian Forest 204
Skye & the Small Isles 206
Outer Hebrides 208
Orkney Islands 210
Shetland 212

IDENTIFYING WILDLIFE 214

Mammals 216
Birds 222
Reptiles 255
Amphibians 256
Fish 257
Invertebrates 261
Plants 279

INDEX 316

Introduction

The new AA Book of Britain's Countryside is a fascinating journey through the best places to visit in the country. It is a colourful guide to Britain's wonderful wildlife, and is the ideal companion for a perfect day out.

This book is a celebration of our natural heritage which enables everyone to get the best out of our unique environment, with its hugely varied landscapes, plants and animals.

ANCESTRY

Twenty-five years ago the first *AA Book of the British Countryside* was published. It was heralded as a landmark book, and proved enormously popular. Now, a quarter of a century on, most households with an interest in our landscapes and wildlife still have a copy on their bookshelves.

But much has changed in the intervening years and, with the millennium fast approaching, the time is right for a thoroughly new definitive work on the subject of British nature and the environment in which we live.

SMALL BUT RICH

Although we live on a comparatively small island, Britain is an extremely special place. It is wonderfully diverse, and none of our neighbours in Europe can boast so rich and varied a collection of habitats juxtaposed in such a small area.

Thanks to the harmonious effects of climate, geographical position and geological heritage, in many parts of Britain you can travel from saltmarshes, estuaries and cliffs on the coast to heaths, forests and grassland within the space of a half-hour's drive. Add to that our extensive wetlands, and mountain ranges high enough to harbour collections of unique upland plants, and you have a veritable paradise for every outdoor enthusiast.

Britain's wildlife is as rich and diverse as its landscape is varied. Since most plant and animal species have very specific requirements, it follows that the greater the diversity in habitats the richer and more varied the wildlife. From otters, golden eagles and red deer, to dolphins, swallowtail butterflies and barn owls – Britain's got it all!

Much of our landscape appears pristine and untouched, and it comes as a surprise to many people to discover that almost every area and habitat in Britain has been modified or influenced by man over the many centuries that these islands have been colonised.

Many of our sea cliffs and estuaries, along with the highest mountain peaks, have remained essentially unchanged since the retreat of the last Ice Age – but almost everywhere else has felt the effects of human presence.

In many respects, people have had a profoundly positive influence on the landscape. After all, heathland and grassland habitats would not exist as they do without the forest clearance and grazing regimes of past and present generations, and the diversity of woodland wildlife is generally enhanced by sympathetic exploitation methods. Of course, with our capacity to influence the environment comes a responsibility of care of which land owners and land-users are increasingly aware.

RESURGENCE

The last 25 years have seen a startling increase in interest in the British countryside. No single book on British wildlife and the countryside can hope to cover all aspects of these incredibly rich islands. However, what this book does do is to provide the reader with insight and understanding about all our major habitats together with a guide to the most wonderful places to visit throughout Britain.

This book has been put together by a unique group of people. Combined, they have many hundreds of years of hands-on knowledge of our countryside. The sincere wish of these experts is to bring their in-depth understanding of Britain's glorious natural heritage to everybody.

Each of the regional sections of the book places natural history in the context of geology, climate and land use. Every one gives a fascinating insight into the most important elements for each of the beautiful places to visit.

The field guide enables you to verify or identify all the most frequently encountered species you see with certainty. Getting to know the individual species and their habits gives an extra dimension to your experience.

This book will provide everything you need to get that bit more out of our countryside, and will enable you to enjoy some fantastic days out.

Getting the most out of this book

This book will help you get more out of Britain's countryside. Whatever you use it for – to give you ideas about where to go for days out, where to book your next holiday, how to find a great local picnic spot, where to find pleasant countryside drives, how to identify the creatures you see, or simply to discover more about our glorious natural heritage – you'll find a wealth of information in this book.

To make this book accurately reflect the wonderful diversity of our countryside and wildlife, there are two main sections. The first contains information about the best sites for wildlife and the second serves as an identification guide.

Fortunately for the roving nature-lover and outdoor enthusiast, the best sites for wildlife are scattered across the length and breadth of Britain, so wherever you live or go for days out or holidays, there will be plenty to see.

WELCOME TO THE COUNTRYSIDE

The sites section of the book is divided into six regions, as shown opposite. These regions are: West Country, Southern England, Wales and the Borders, the Heart of England, Northern England and Scotland.

At first glance, some of these divisions may seem rather arbitrary, but all the regions have surprisingly well-defined characteristics and natural history interest that set them apart from their neighbours. In addition, the use of regions enables sites with close links – both in terms of proximity and wildlife interest – to be compared with ease.

Each regional section begins with an essay introducing its wildlife interest and placing it in the context of the region's geology, climate, land use and human history. In parallel to these essays, a strand of text describes Britain's main habitats and reveals how to read the landscape in each area.

As a forerunner to describing the key sites in detail, a straightfoward, easy-to-use map helps pinpoint the key sites and place them in the geographical context of the region as a whole. On the same pages, other important sites that harbour significant wildlife interest and also merit a visit are also indicated. There are far too many great places to visit to give each the space it deserves!

On the pages below the map, each key site is described with authoritative and readable text which highlights its seasonal wildlife interest and importance in a national context. Key species to be found there are described, along with information, where appropriate, about access and conservation.

WEALTH OF WILDLIFE

In this book, reference has been made to a large number of species. Almost every species mentioned in the regional sites is illustrated either on the page, or in the identifying wildlife section towards the back of the book. The identification section is comprehensive enough that almost every species common or regularly encountered in Britain is covered. It can also be used as a stand-alone guide.

SCOTLAND
page 178

NORTHERN
ENGLAND
page 144

HEART OF
ENGLAND
page 114

WALES &
THE BORDERS
page 82

SOUTHERN
ENGLAND
page 50

WEST COUNTRY
page 14

West Country

Stretching out into the Atlantic Ocean, the south-west peninsula is probably the most scenically varied part of Britain, and certainly one of the most beautiful. Its long coastline, ranging from dramatic cliffs and sandy coves to flat marshland and river estuaries, combined with a mild climate, have made it a prime holiday destination. Offshore are the Scilly Isles and Lundy Island. Inland, hill ranges such as the limestone Cotswolds and the Mendips, and the high moorland of wild Dartmoor and gentler Exmoor, both national parks, bring their own particular character and wildlife.

Land's End looks out west towards the Scilly Isles, 40km (25 miles) or so offshore. Beyond that, there is nothing but open ocean. The peninsula's rugged coast and stunted vegetation reflect the battering they get from the full force of the Atlantic.

The acidic uplands of Dartmoor, Exmoor, Bodmin Moor and even the Quantocks are high enough to create their own northern atmosphere, not very different from the uplands of northern Britain. Meanwhile, the chalk and limestone hills of Gloucestershire, Wiltshire, Dorset and Somerset are more rounded and gentle, and, with the exception of the Mendips, they are not high enough to be significantly colder.

The Cotswold Hills run from north of Bath across Gloucestershire and into Oxfordshire. Their rolling landscape and pretty villages are the quintessence of rural England.

The pasqueflower is restricted to a few sites on chalk grassland.

HILL COUNTRY

The Mendip Hills are formed from a wall of Carboniferous limestone that stretches across north Somerset to the Bristol Channel. Over 300m (1,000ft) high in places, they have marvellous old limestone grassland on their southern slopes, and are breached here and there by dramatic gorges such as Cheddar and Ebbor.

The Cotswolds lie mainly in Gloucestershire, and are a wonderfully intimate range of hills, encompassing much that is best in the English countryside: mellow stone villages in sheltered valleys, woods and flowery grasslands. The underlying rock is oolitic limestone, which allows a rich flora to flourish on unimproved grasslands and in ancient woods. Places such as Minchinhampton and Rodborough commons, not far from Stroud, have been unspoilt grassland rich in flowers for many centuries. Here there are early purple orchids, pasqueflowers and cowslips, and a host of butterflies including the brown argus. Almost every scarp in the Cotswolds has its fine old woodlands, often though not exclusively dominated by beech, and these are marvellous places in early summer, alive with flowers and birdsong.

A little to the south and east, in Wiltshire, the rock changes to chalk, and the land has a quite different character. These rounded slopes were cultivated early in the history of farming, and subsequently used for sheep grazing. This led to a wide open landscape, with springy turf, rich in wildflowers, butterflies and skylarks singing overhead. There are still places like this to be found on the Wiltshire Downs and Salisbury

WEST COUNTRY HABITATS

Discover open sea

The open sea is an incredibly productive habitat for wildlife but is not readily accessible to most of us. However, this does not mean that the natural history of the oceans is completely out of reach: with a little knowledge and insight some spectacular and fascinating animals can be seen from land, while ferries and pelagic (open sea) boat trips offer the prospect of seeing even more.

The coastline of Britain is fringed by a geological formation known as the continental shelf. As a consequence, coastal waters are comparatively shallow and are generally less than 300m (1,000ft) deep; it is not until the abrupt edge of the shelf is reached, well beyond the sight of land, that the sea bed plunges down into the deep abyss.

The seabird colonies that are dotted around the coasts of Britain are a testament to the productivity of the sea. In

Watch for seabirds such as skuas, petrels and shearwaters from boats and ferries.

Kittiwakes return to cliffs to nest but spend most of their time out at sea, well beyond the sight of land. They have a buoyant, confident flight, even in the roughest of weather.

The brown argus is an attractive spring butterfly of chalk grassland.

The dramatic chalk cliffs of Old Harry Rocks near Swanage support little wildlife on their flanks, but a rich flora carpets the flat tops.

Plain, but sadly this easily ploughed country-side has also proved highly suitable for arable farming, and vast areas are now under grain crops, rape or flax. The flowery chalk turf, with its beautiful blue butterflies, and orchids such as burnt-tip, now survives only on slopes that are too steep to plough, or where some special use (particularly as training grounds by the armed forces) has preserved it. Large areas of chalk grassland survive in the Salisbury Plain military training area, though most of it is normally inaccessible to the public.

Although hills give the West Country its scenic character, many of its richest wildlife areas lie in the lowlands and are some of the finest nature conservation sites in Britain. The best landscapes are covered in more detail in the following pages, but some areas spring immediately to mind: the Somerset Levels, nationally known for their wildlife; the more secluded Gordano Valley, to the north, and the Gloucestershire stretch of the Severn Vale. The heaths of east Devon and south Dorset, particularly on the extraordinary Isle of

Purbeck, are great places for wildlife, with species such as smooth snake and sand lizard (both in Dorset only), bee-killer wasp, marsh gentian and lesser bladderwort – a scarce species in the south.

COASTAL COUNTRY

The coast is the most remarkable aspect of the West Country: spectacular throughout, incredibly varied and remarkably unspoilt, considering that this is our most popular holiday area. In east Dorset, near Bournemouth, the harbours of Poole and Christchurch are vital refuges for birds at all times of year. Poole is particularly fascinating, as one of the largest natural harbours in the world, with wildlife-rich islands such as Brownsea (where red squirrels can still be seen), and a fringe of unspoilt habitats around its

The rare smooth snake is confined to a handful of southern counties and is most readily seen on the heathlands of Dorset.

Bottle-nosed dolphin

Tursiops truncatus

Bottle-nosed dolphins are regularly reported around British coasts by the growing band of whale- and dolphin-watchers. Groups of dolphins appear to be partly resident around the Land's End and Lizard peninsulas, as well as off the Welsh coast. Bottle-nosed dolphins appear all-dark when viewed from the shore. Their size and proportionally much larger fin distinguish them from the smaller porpoise.

see also page 221

After a dive, bottle-nosed dolphins typically spend several minutes at the surface, replenishing their air supply before diving once again in search of fish.

On good days, hundreds if not thousands of Manx shearwaters, European and Leach's storm-petrels, gannets, great and Arctic skuas and seaducks can be seen; there is even the prospect of sighting the occasional long-tailed skua, sooty shearwater or Sabine's gull, species seldom encountered in Britain other than during such seawatches.

Whales, dolphins and porpoises – collectively known as cetaceans – also occur in British waters, although hunting, entrapment in fishing nets and the depletion of their food by overfishing have reduced their numbers.

Resident populations of bottle-nosed dolphins can still be found off the coasts of Purbeck in Dorset, the Land's End peninsula and in Cardigan Bay, while common dolphins are regularly seen from Strumble

Arctic skuas, especially juveniles, pass the coasts of Britain in good numbers in autumn on migration to their southerly wintering grounds.

Head in Pembrokeshire.

Ferry crossings of the Irish Sea and to many of the Scottish islands also offer opportunities for cetacean-watching, with pilot whales occurring in waters off the northern isles and minke whales around the Hebrides.

autumn, at the end of the breeding season, some of the species move out to sea. Many migrate to wintering grounds south of the region, and are joined in their journey by vast numbers of seabirds from further north in Europe and from within the Arctic Circle.

The majority of these movements occur in offshore waters, but gale-force westerly winds in September and October will often drive the birds close to land, providing spectacular views for observers sited on strategic headlands in Cornwall, Devon and west Wales.

Although still endangered, otters are now thought to have recolonised almost every major river in the West Country.

plant, strapwort, as well as otter and mink. From here around the rest of south Devon, the whole of Cornwall, and the north coast of the peninsula as far as Minehead, there is an almost endless succession of spectacular, hard rock cliffs, the grassy tops of which are rich in flowers such as spring and autumn squill. Here and there they are broken by estuaries or stretches of sand dunes (particularly in north Cornwall and Devon). Yet there is no sense of monotony, despite the great length of these cliffs – every vista is different, and the character of the cliffs changes constantly, from the sheer Bedruthan Steps on the north Cornish coast to the long, vegetated, sloping cliffs of the Exmoor coast.

The whole of the Lizard peninsula, Britain's most southerly point, is strewn with special wildlife habitats, home to many rare plants, such as Cornish heath and thyme broomrape, and the coastal scenery is magnificent. Land's End, at the very western tip of Cornwall, is especially dramatic in rough weather, and this is as good a place as any on the coast to watch for dolphins and whales offshore (though they are best spotted in calm, clear conditions).

On the north side of the peninsula, in north Devon, the huge area of sand dunes known as Braunton Burrows, not far from Barnstaple, is a site famous for its special plants, including round-leaved wintergreen and sand toadflax.

Pentire Head, near Padstow, north Cornwall, is typical of much of the region's coast, the shores being eroded by the pounding waves.

southern and western shores. To the west, in Dorset, chalk and limestone cliffs stretch as far as the Isle of Portland (much of which is now being considered as a World Heritage Site), and are home to the Lulworth skipper butterfly and the rare early spider orchid.

Chesil Beach is one of Europe's largest shingle beaches, a long, narrow strip running westwards from Weymouth and enclosing the large lagoon known as the Fleet. Beyond this are more cliffs, and a jumble of slumped undercliff between Lyme Regis and Axmouth, which is largely protected as a national nature reserve.

The Exe Estuary in Devon and associated habitats such as Dawlish Warren are well known for breeding and wintering birds, and for their special flowers including the sand crocus. Towards the southernmost point of Devon lies the fascinating lagoon and reedbed of Slapton Ley, with the rare and inconspicuous

WEST COUNTRY HABITATS

Discover rocky shores

At low tide rocky shores, such as this one on Lundy, are festooned with seaweeds. Many of the species grow in distinct zones.

Rocky shores are without doubt the most fascinating of the intertidal habitats that fringe the British coastline. The hard substrate provides a firm attachment for seaweeds and sedentary creatures, and a permanent complex of plants and animals develops across the shoreline from the drift line down to the low-tide mark.

For the wildlife enthusiast, part of the fascination of exploring a rocky shore comes from the sheer abundance and variety of life encountered; this includes plant and animal groups that are not found on land or in freshwater. Another attraction is that no two

days are ever precisely the same – the animal species will differ.

Rocky shores are subject to daily tidal rhythms and the plants and animals that live there show a spectrum of tolerances to the twice-daily inundation by seawater and exposure to air. Unsurprisingly, their differing adaptations are reflected in the positions at which they occur on the shore. This is called zonation and, although it can be observed in all intertidal environments, nowhere is it more apparent than on a rocky shore.

Marine biologists recognise the different zones by the species of seaweed that predominate at any given level. Well-defined bands of subtly different coloured seaweeds are often visible at low tide from a considerable distance. Other factors that influence

In late spring, Lundy Island is carpeted with thrift, the pink flowers and lichen-covered boulders creating a natural rock garden.

There many other smaller and lesser-known sites such as Northam dunes, near by, or Penhale, in north Cornwall.

Not far away, the Hayle Estuary, just east of St Ives, is an important area for birds, especially in autumn and winter, and it is one of the places (like the Scilly Isles) where North American vagrant birds regularly turn up.

Colonies of puffins breed on Lundy, which is owned by the National Trust. Summer boat trips to the island run from Ilfracombe.

ISLAND LIFE

Offshore, there are relatively few islands, but these include some very special ones. The Scillies are a world apart, lying some 40km (25 miles) south-west of Land's End and consisting of almost 150 granite islands and major rocks, only five inhabited.

The granite island of Lundy (from the old Norse, meaning 'puffin island') lies about 17km (11 miles) off the north Devon coast, and is only about 5km (3 miles) long. Set in clear, unpolluted water well away from the mainland, and ringed by towering cliffs, Britain's first marine nature reserve provides a breeding ground for many seabirds, including puffins and the nocturnal Manx shearwaters. It also boasts its own endemic species, which occur nowhere else in the world – the Lundy cabbage and two species of beetle. The seas around Lundy are particularly rich in inter-

tidal, inshore and oceanic life.

Further east, off the coast of Somerset, the distinctive forms of Steep Holm and Flat Holm, out in the Bristol Channel, can be made out from the English and Welsh shores. These islands of limestone, with their sheltered estuarine setting, are very different in character to the Scillies and to Lundy, and neither has such outstanding wildlife – but both are interesting places to visit.

MARSHLAND AND RIVER

From Minehead eastwards, the character of the coast changes dramatically, as the high, hard and predominantly acid cliffs of the far south-west give way to softer, lime-rich rocks in sheltered estuaries. The huge tidal range here (said to be the second highest in the world) and the lack of exposure to the Atlantic breakers produces quite different conditions, with extensive silt and mudflats. The Parrett Estuary, near Bridgwater, includes a national nature reserve, home to waders and waterfowl, and famous as a gathering ground for flocks of moulting shelduck in autumn.

Further east still, right into the upper reaches of the Severn Estuary, a huge area of mudflats, saltings and grassland reclaimed from saltmarsh is the setting for the Slimbridge Wildfowl Reserve, where vast numbers of ducks, geese, swans and waders arrive every year from the north, many of them remaining through the winter.

Even the estuary is dotted with cliffs along its southern shore: around Watchet and Blue Anchor, they are rich in fossils, and have veins of pinkish alabaster. The great finger of Brean Down lies north of the dunes and saltmarshes

which seaweeds and marine animals thrive on a rocky shore include geographical location and the degree of wave exposure.

Explore a rocky shore at low tide and you will find seaweed covering all but the most exposed rocky aspects. It is not until you part the tangled mats that encrusting animals such as limpets and barnacles will be exposed, along with mobile seashore life such as crabs and marine snails.

Purple sandpipers are well camouflaged against rocks and can be hard to spot, but they are often extremely approachable when found on the shore in winter.

In the absence of a covering of water, the flattened mass of seaweed creates the impression of a rather one-dimensional environment. Although this is clearly the situation at low tide, it can create a rather false impression of shore life when the tide is in. Rock pools give a good idea of the true nature of life on the inundated shore, with seaweeds floating buoyantly in the water.

For a real feeling of life on the rocky shore, however, try snorkelling on a sheltered beach where the currents are known to be safe. As soon as you submerge you will enter an entirely unexpected world. In some areas, the seaweeds recall a grassy meadow through which shoals of fish and other creatures swim while, in deeper water, to refer to the immense growth of seaweed as a 'forest' is often no exaggeration.

Common limpet

Patella vulgaris

Limpets are molluscs. The conical shell hides and protects a snail-like body and a muscular foot. The shape of the shell helps the limpet withstand pounding waves. A limpet is invariably faithful to a particular area of rock, the rim of the shell growing and wearing to fit its contours. A tight fit prevents dehydration at low tide and stops the limpet being dislodged by predators or freak waves. The animals feed by grazing minute algae from the rock surface; examine the area around a limpet to spot its zig-zag feeding tracks.

see also page 275

The height and angle of any limpet shell is influenced by the degree to which it is exposed to the elements. Limpets on sheltered shores tend to be more conical than those on shores battered by the waves.

The velvet swimming crab has a justified reputation for being the most aggressive of its kind. If provoked, it raises its pincers aloft as a defiant response to whatever is threatening it.

Bell heather and gorse. A number of species in these families are typical members of any heathland plant community.

of Berrow. This Carboniferous limestone peninsula is covered with ancient limestone grassland and scattered with archaeological remains, and its spectacular early summer display of flowers includes the rare white rock-rose and hybrids with the common rock-rose. The similar but smaller Middle Hope and Sand Point are further north, and beyond Bristol the cliffs at Aust, near the older Severn Bridge, are a famous landmark.

NATURE'S HERITAGE

Why is the south-west of England so varied and special? Why is it so unspoilt and rich in wildlife, when other parts of the country have lost so much of their heritage? There is no simple answer to this, but three factors have played their part: geology, recent history and the generally mild climate.

It has been said that parts of south-west England are more varied geologically than anywhere else in the world. This may be difficult to substantiate, but it certainly indicates the wide geological range found here. Most of the rock formations that fan out through southern Britain meet along a band that stretches from coast to coast through Gloucester, Somerset and Dorset, so almost every type is represented here. Harder or newer rocks stand out as hills, or form cliffs where they meet the sea, and softer or older rocks are more eroded: so a geologically varied area provides a range of landscapes. But the effects of geology go much deeper than this. Different rocks form different soils, some suited

The patchwork of small fields, neat hedges and copses is typical of much of Exmoor, an area primarily grazed by sheep and cattle.

to intensive agricultural use, others barely productive at all.

The heaths of Dorset and Devon lie over very acid soils, where crop cultivation was unprofitable before the arrival of modern methods, so they were mainly used for rough grazing. Steep slopes on light soils, such as chalk or limestone, were cultivated when ploughing methods were simpler and other areas were unavailable, though from medieval times they, too, tended

WEST COUNTRY HABITATS

Discover hedgerows and verges

For centuries, hedgerows have been a familiar part of the British landscape, taken for granted by many and enthused over by a few. Their importance as stock-proof barriers and boundary markers may have declined but, in recent years, naturalists have become increasingly aware of the role hedges play both as wildlife habitats and as a feature of the British landscape. Sadly, destruction of these precious natural havens was at least partly responsible for firing this interest.

Despite the problems, however, Britain is still blessed with an abundance of hedgerows in many regions. Restoration work will hopefully restore many neglected or damaged hedgerows to their former glory in years to come.

Woody shrubs and trees form the backbone of any hedgerow and the species usually reflect the soil type and the composition of any neighbouring woodland. Some hedgerows have alien species planted in their midst, but the majority of trees and shrubs are likely to have found their own way there. Thus, ash, hawthorn and hornbeam will

Mature hedgerows become great natural larders in autumn, laden with berries and nuts.

Early purple orchid grows on hedgerow banks and roadside verges throughout mainland Britain. It is commonest in southern England.

to be used for rough grazing, producing the familiar downlands of today.

Throughout most of Devon, Cornwall and west Somerset, the terrain is too hilly and acid for intensive arable use, so fields are smaller and many hedges have remained as they are useful in pasture farming.

The geology can even affect the climate. The higher hills of the region, and particularly Dartmoor, Exmoor and Bodmin Moor, make their own climate. They are considerably cooler and wetter than the surrounding lowlands – and this, in turn, affects the type of farming and vegetation.

Above the underlying geology, a long chain of events has brought about the vegetation that we see today. At the end of the last Ice Age, about 10,000 years ago, the cold killed off all significant vestiges of vegetation, wiping the slate clean. Over succeeding millennia, the region was gradually colonised by different forms of forest as the climate warmed, culminating in an almost complete mantle of mixed broadleaved forest about 7,000 years ago. At the same time, there was a dramatic increase in sea levels (ice caps had taken up much of the world's water; in fact, during the peak of the Ice Age, sea levels were at least 100m (330ft) lower than they are today). As a result, there were great changes in the coastline. Parts of the mainland became islands, 'Britain' became separated from 'Europe', and the whole coastline changed. Many of our present coastal features are a result of these changes, as the sea has been

A mile-long shingle ridge separates the freshwaters of Slapton Ley, south of Dartmouth, from incursions by seawater.

attacking new areas of land, rather than reaching equilibrium, and in the process has created extensive dunes and shingle beaches.

THE ROLE OF MAN

From about this time, man began to have a discernible effect on the landscape as he cleared the wood for his own purposes. As the population expanded and agricultural skills developed, the effect on the landscape increased, and more of the woodland was felled. Throughout this period, right up to the present day, farming has ebbed and flowed in reaction to climate change, plagues and wars that have decreased the population, and changing techniques, but in general the area of farmland has steadily grown.

Heath spotted-orchid is found on heaths and moorlands on acid, peaty or mineral soils across the south-west. It seems equally at home on the dry, sandy heathland of west Dorset and the wet springlines among moor-grass on Dartmoor.

occur more frequently near woodland on basic soils, while oak and rowan will predominate on acid soils.

Many of our hedgerows are ancient and an interesting exercise in ageing can be undertaken: count the number of woody plant species in a 30m (100ft) stretch and the figure is likely to correspond to the age of the hedge in centuries.

Parallels are often drawn between hedgerows and woodland edges, hedges being seen as a natural extension of the woodland. In wildlife terms, this similarity has a profound importance since woodland edge harbours an appreciably greater diversity of plant and animal life than woodland interior.

Hedgerows reflect the changing seasons. In spring and summer the framework of a hedgerow supports climbing plants such as honeysuckle, old man's beard

Alexanders

Smyrnium olusatrum

Recognised by its lush green foliage and yellow umbels of flowers, alexanders is also distinctive because it is one of the first plants – and certainly the first umbellifer or member of the carrot family – to appear each spring. It is invariably in full flower by April and in parts of west Cornwall it can found as early as February in particularly mild winters. The leaves have a slightly waxy look and the whole plant has a rather unpleasant smell when crushed. Alexanders seldom grows far from the sea and in the West Country is locally common along the banks of coastal lanes and beside paths.

Despite the rather rank smell associated with the foliage, alexanders was introduced to this country as a pot herb. The cooked stems have a taste similar to that of its cousin in the carrot family, celery.

and bramble, and the tangle of vegetation encourages an abundance of insects and other invertebrates. These are eaten by a variety of mammals and birds, and many birds nest within the hedge. Autumn offers the

prospect of a bountiful harvest of seeds, nuts and fruits that feed not only the hedgerow's resident creatures but also the influx of winter-visiting birds.

The hedgerow bottom can be as important as the hedge itself in

terms of the birds, mammals, invertebrates and plants that it supports. Grey partridges nest here, rabbits burrow away and cinnabar moth caterpillars feed on ragwort.

Alongside roads the hedgerow bottom often extends into a verge. Periodic cutting of the vegetation means that grassland flowers are often encouraged – plenty of important sites for orchids, for example, lie just a few feet from passing traffic.

Often cultivated for its climbing habit and fragrant flowers, honeysuckle is widespread.

Although individual areas may have changed from, say, simple arable to downland or heathland, virtually all non-woodland areas in the south-west are of man-made origin, including most of the moorlands of Dartmoor.

In many areas of Britain, the changes wrought by man have been so vast that few traces of the original vegetation or early farming remain. But in much of the south-west, a combination of factors has led to the survival of a high proportion of historic landscapes. The climate and soils make it easier to keep the countryside the way it is, and many parts of the south-west have field and woodland patterns that date back to prehistoric times. Two of the best examples are on the West Penwith peninsula, between St Ives and Land's End, where there is a remarkable concentration of archaeological relics and ancient field patterns; and on

Dartmoor, where a deteriorating climate towards the end of the Bronze Age probably led to the abandonment of numerous marginal farming areas, many of which remain uncultivated today.

Through medieval times, a pattern of agriculture was established. It varied, of course, according to geology, climate and other factors, but generally each settlement had a proportion of arable land, hay meadow, managed pasture, rough pasture and woodland, to provide for the community's various needs. Many of the woods from this period – which may themselves date back to the natural, post-Ice Age woodland – still survive, and they are usually much richer in flowers than any newer woodland.

Often the rough grazing – which could be grassland, heathland, moorland or even fen – became formally adopted as commonland,

The gnarled and twisted sessile oak trees of Wistman's Wood on Dartmoor are festooned with epiphytic lichens and mosses.

owned by an individual but where the community had rights to graze, collect wood and cut peat or turf. There are commons throughout the south-west, from the high moorlands of Exmoor, Dartmoor and the Quantocks to the flowery grasslands of the Cotswolds and Mendips, or the rough heath and bog of the Isle of Purbeck. The largest areas of surviving commons were often in former royal forests, where originally hunting was paramount and agriculture discouraged. Some royal forests were sold off and became intensive agricultural land quite quickly, while others, including Exmoor, Dartmoor and Purbeck, have survived in something like their original form.

The long-abandoned medieval village at Hound Tor on Dartmoor. The moor has many archaeological relics including the remains of ancient tin mines.

WEST COUNTRY HABITATS

Reading the landscape

Granite outcrops such as Great Mis Tor are the most distinctive natural features of Dartmoor.

The West Country falls into two very different halves, roughly divided by the M5 motorway. The eastern part is a continuation of neighbouring southern England, though it is often hillier and on a grander scale. To the west, hard rocks create more dramatic and angular landscapes, with stark contrasts between the bleak high moors and the rugged, storm-beaten coast, and the deep, sheltered valleys and high-hedged fields of fertile farmland.

As you drive south on the M5, the Jurassic limestone scarp of the Cotswolds rises steeply on your left. These rocks have provided the characteristic building stones

of the area, and stone for the field walls of the high Cotswold ridge.

Approaching the West Country from London or the south-east, you will drive across chalklands – the expanse of Salisbury Plain on the A303, or the Dorset chalk on the A35. The escarpment edging this big tract of chalkland, obvious enough on the M4 south of Swindon, is often very striking farther south, as near Mere on the A303, and across much of north and west Dorset. All the roads cross stretches of lower, undulating country on softer rocks, with more resistant limestones and sandstones standing out as low escarpments or isolated hills here and there.

At Bristol, the Avon Gorge is cut into Carboniferous limestone, seen again where the M5 skirts

THE SOMERSET LEVELS

One of the most intriguing south-western landscapes, where man and nature have worked together over the millennia, is the Somerset Levels. This is a vast area of land, all at about sea level, south of the Mendips. As the sea re-invaded after the Ice Age, this became a huge area of estuary mud, that gradually dried as the sea retreated again, becoming wet, peaty fenland with areas of open water. Colonisation by man was initially on the low hills (such as at Glastonbury) that stood above the Levels.

Gradually, with a combination of pump drainage and a network of ditches, against a background of fluctuating sea levels, the whole area has been drained for agriculture. Because it still floods in winter, when no amount of pumping can clear it if the sea is higher than the land, it is used almost exclusively as pasture, and has become a patchwork of flowery fields dissected by a network of ditches ('rhynes'), edged with pollarded willows. Other levels in the region have a broadly similar history.

Surrounded by the flat landscape of the Somerset Levels, Glastonbury Tor stands out like a beacon for miles around.

FIELD BOUNDARIES

Field boundaries reflect the prevailing conditions and materials: in the Levels, they are ditches; on Exmoor, and in other higher parts, they are broad earth banks topped with beech or other trees in hedge form; while in Cornwall they are often just banks of stone and earth (still known as hedges), alive with flowers in the spring. In the stony uplands, local materials are used – blocks or slabs of granite on Dartmoor, rough grey limestone on the Mendips, and smooth, mellow limestone in the Cotswolds, for example.

In other areas, such as much of west Dorset, the most readily available hedging material is local vegetation – older hedges were as mixed as a thin strip of woodland, while later ones were often planted specifically with hawthorn and blackthorn. Almost everywhere in this part of

Old stone walls on the Cornish coast soon become cloaked in lichens and a rich and colourful range of maritime plants.

the country, there are field boundaries that reveal something of the region and its past.

As you travel through this marvellous area, perhaps on your way to visit some of the places described on the following pages, it is worth looking closely at the whole landscape; with practice, it can be read almost like a book, revealing its complex and fascinating history.

White Horses, such as this one at Westbury on the Salisbury Plain, have been carved into the chalk downs in several locations.

Gordano, and making its greatest landscape impact in the Mendips, which stand like a wall along the northern edge of the Somerset Levels. The grey rock, harder than the Cotswold stone, meets the eye everywhere on the steeper

slopes and is most impressive in Cheddar Gorge.

The Levels have much in common with the Cambridgeshire fens, but were drained later and less intensively, so more of their wetland character remains.

West from the Levels, the Quantock Hills are a foretaste of the heathery old red sandstone moorland of Exmoor, and a contrast to anything farther east. Exmoor is the culmination of the wide hilly expanse of hard Carboniferous and Devonian rocks – shales, slates and grits – that occupy much of mid-Devon; similar shales and slates underlie gentler countryside in south Devon and Cornwall.

Dartmoor and Bodmin Moor are the highest of a line of granite masses, roots of an ancient mountain range, continued in the china-clay area of St Austell, and the granite of Land's End and

the Scilly Isles. The tors crowning many hilltops are resistant remnants left after deep rock-weathering followed by erosion in the severe climate while northern Britain was in the grip of ice.

The hard-rocks of the south-west and exposure to the Atlantic combine to produce spectacular coastal scenery: drowned valleys, raised beaches and flat erosion

The great stresses that the land has undergone are visible in the folded strata at Lulworth Cove.

surfaces on the coast and inland show that the sea level was not always where it is now. A turbulent geological history created the ores for centuries of tin- and copper-mining, of which many reminders can be seen in Devon and Cornwall.

WHERE TO GO

West Country

Perhaps more than any other part of Britain, the West Country epitomises glorious warm summer days out. You don't need a bucket and spade to get the most out of this wonderful part of Britain though – the wildlife is all around.

1. BRIDGWATER BAY

The vast shallow mudflats of Bridgwater Bay are best known as the main British moulting area for shelduck. Up to 2,000 flightless duck gather here in late summer, but a few are always present throughout the year. In winter, dunlin and curlew dominate, with wigeon, mallard and teal present in smaller numbers. In spring whimbrel gather; these are passage birds feeding on the Somerset Levels to the east but flying in at sundown to roost on Stert Island. Yellow horned-poppies grow beside the paths with other shingle-loving species such as henbane and knotted clover.

2. COTSWOLD HILLS

The striking golden stone that characterises the pretty Cotswolds villages is used to build the field walls as well as the attractive houses and barns, and traditional farming has produced the picturesque landscape of fields and copses between larger woods. A special feature of these hills is the beechwoods on the scarps, stunning in spring when the light shines through the young, pale green leaves; special plants include green hellebore and bird's-nest orchid. Grassland commons, rich in orchids, are scattered throughout the hills but especially at the western end. The pristine, clear waters of the Cotswold rivers support good populations of the declining white-clawed crayfish.

3. COTSWOLD WATER PARK

This system of flooded pits in the Thames basin, where the river rises as a young stream, is the largest complex in England with a total water area greater than that of the Norfolk Broads. In the winter pochard, tufted duck and coot are numerous, along with large numbers of lapwing and golden plover. The loud song of the sedge warbler and the harsh call of sand martins heralds summer. A good variety of dragonflies hunts the water's edge, including the impressive emperor dragonfly.

4. GORDANO VALLEY

The small, flower-rich wet meadows form a wildlife oasis amid the industrial and housing developments of south Bristol. Redpolls and siskins feed in the alder woods along the valley floor, while the hedgerows attract flocks of winter thrushes – redwings in particular. In summer the scene changes with buzzards riding the updraughts and lapwings performing their tumbling display flights; ragged-robin and marsh orchids add splashes of colour to the meadows. Heron breed in the valley and stalk the rhynes (the early 19th-century ditches that form the field boundaries) for unsuspecting frogs and fish.

5. HAYLE ESTUARY

The sheltered, south-westerly situation of the Hayle Estuary attracts migrants as well as wintering waders and wildfowl. Pectoral and white-rumped sandpipers and long-billed dowitcher are American species which have been seen several times over the years, but far more common are dunlin and curlew, along with bar-tailed godwit, oystercatcher and ringed plover. Wigeon, teal and shelduck are the most numerous wildfowl. The attractive purple-blue flowers of sea aster bloom along the estuary along with scurvy-grass, so-called because it was used to prevent scurvy before citrus fruits became readily available.

6. LAND'S END PENINSULA

The Land's End peninsula differs remarkably from its neighbour, the Lizard. Both have rugged coastlines, but the Lizard is flat tableland composed of serpentine rock and boulder-strewn gabbro, while Land's End is granite with a rugged moorland-covered spine running from St Ives to Whitesand Bay. The moors glow purple and gold with gorse and heather in late summer, while the cliff-tops are clothed in carpets of spring and autumn squill, rock sea-lavender and golden samphire. Grey seals lounge along the coast, and orcas and dolphins can be spotted out at sea. Gulls, auks and shags breed along the cliffs, but the serious bird-watcher comes to Porthgwarra for vagrants such as hoopoe and woodchat shrike.

7. LUNDY ISLAND

Botanists and coleopterists are drawn to Lundy as it is the only site in the world for Lundy cabbage and two species of beetle. It also attracts scuba-divers as the sea around has been designated a marine nature reserve, and it is one of the few locations with all five species of British coral. Although the island is only 5km (3 miles) long and less than 1km (2 miles) wide, some 40 species of bird breed on it, with razorbills and puffins on the cliffs, lapwings and curlews on the moorland and warblers in the derelict gardens.

Lying at the mouth of the Bristol Channel, the eroded granite cliffs of Lundy create some of the finest coastal scenery in the region.

Although essentially man-made, most of the lakes in the Cotswold Water Park are now fringed with emergent vegetation and their waters support thriving communities of invertebrates and fish. A rich variety of bird species breed here and this wetland complex acts as a magnet for migrant birds in spring and autumn as well as wintering wildfowl.

8. NORTH CORNWALL COAST

The South West coast path picks its way from headland to headland, overlooking sandy bays and rocky shores, rising and falling along some of the most beautiful coastline in Britain. The grassland is a tapestry of tiny flowers – spring and autumn squill, kidney vetch, thrift and bladder campion. Streams find their way to the sea down scrub-filled valleys. Fulmar, kittiwakes, herring and lesser black-backed gulls wheel over the cliffs. Puffin, guillemots and razorbills nest on some of the small islands and gannets can be seen fishing off shore. Listen for the protesting *kek kek kek* of the peregrine and the *kruk kruk* call of the raven.

9. PURBECK COAST

The coastline along the southern edge of the Isle of Purbeck is renowned for its spectacular scenery. Great shaly cliffs dominate the deep curve of Kimmeridge Bay and below the beach slopes gently, allowing a large area to be exposed at low water. The pools are like natural aquaria, with anemones, starfish, limpets and periwinkles. The coastpath is a wonderful way to enjoy this area; follow it east and there are impressive views from St Alban's Head. The next headland, Durlston, is limestone with a wonderful array of chalk-loving flowers including early spider and bee orchids and autumn lady's-tresses. The nationally rare Lulworth skipper butterfly can be seen here, along with the adonis blue.

Trevose Head
Padstow

Newquay A392

8

A3075

Truro

St Ives Redruth

Camborne A39

St M

St Just

5

Penzance

Falmou

Sennen A30 A394 Helston

Land's End 6

Mou
Ba

THE LIZARD
page 28

Lizard
Lizard
Point

ISLES OF SCILLY
page 26

Isles of Scilly

10. THE QUANTOCKS

Red deer are the emblem of the Quantocks; look out for them on the heath and in woods. The tops of these sandstone hills are clad in heather and bilberry, and offer views across the Bristol Channel to Wales. Buzzards and ravens soar overhead, and stonechat and the occasional Dartford warbler can be seen in the gorse. At dusk the eerie call of the nightjar can be heard. Pied flycatchers, redstarts and wood warblers abound in the coppice oak woodlands in the combes and on the slopes. The conifer plantations to the south support populations of crossbills.

11. TAW/TORRIDGE ESTUARY

This is 'Tarka' country, immortalised by Henry Williamson's famous tale of the otter. The two rivers, Taw and Torridge, meet to form a large sandy estuary surrounded by extensive areas of saltmarsh. At the mouth there are two important areas of sand dunes, to the north lies Braunton Burrows, characterised by its rare plants such as sand toadflax, water germander and sea stock. Part of the area is used for military training so keep out if red flags are flying. To the south is Northam Burrows where the pretty dune pansy grows. The estuary itself supports large populations of waders particularly lapwing, golden plover and dunlin. The Tarka trail runs inland, following both rivers.

12. WEMBURY

The marine conservation area, set up in 1981, stretches from Gara Point to Fort Bovisand, a predominantly rocky coast with patches of sand backed by cliffs. The numerous rock pools support a great deal of shorelife and further out at sea the underwater life is superb, with colourful cuckoo wrasse and numerous corals. Turnstones forage along the strandline all year, to be joined in winter by ringed plover and purple sandpiper. Further inland cirl bunting feed on the stubble in the company of yellowhammers.

13. WILTSHIRE DOWNS

As you journey down to the south-west of Britain you cannot fail to be impressed by the rolling folds of chalk grassland that form the Wiltshire Downs; Salisbury Plain and Marlborough Downs being the two main areas. Where it remains untouched by the plough, the thin, poor soil with its coating of fine grass, produced by countless years of sheep grazing, supports up to 40 plant species in a square metre, including a dozen orchids. Early purples and common spotted-orchids are numerous, and other specialities include chalk milkwort, horseshoe vetch and devil's-bit scabious. Butterflies, particularly members of the blue family, abound.

Level ground and sheltered spots in the Quantock Hills are characterised by lush, green pastures defined by a mosaic of mature hedgerows and scattered woodland. On the more exposed hill tops a cover of scrub and moorland growth replaces the more verdant lowlands. The whole area is rich in breeding birds and offers superb opportunities for walking all year round.

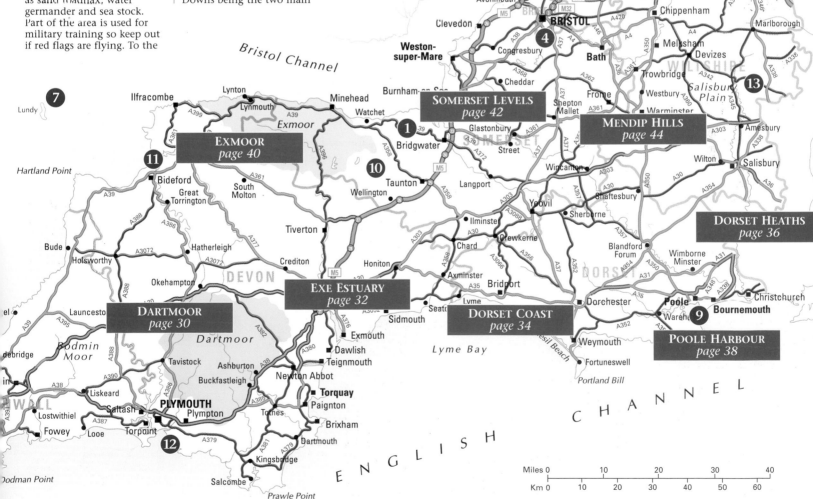

Isles of Scilly

While most of the 200 or so islands of the archipelago off Land's End are small, rocky and sparsely vegetated, the larger ones, including the five that are inhabited, support a wide range of habitats.

Although essentially a southern European species, the hoopoe turns up every year on the Scillies, records sometimes involving several individuals in a single season.

THE COASTLINE VARIES from exposed granite cliffs to sheltered boulder-strewn or sandy beaches. Inland, more exposed areas with thin soils support maritime grassland and stunted maritime heath. Where it is more sheltered, there are reed-fringed pools and wet moors with stands of willow. Large areas of the inhabited islands (St Mary's, Tresco, Bryher, St Martin's and St Agnes) are farmed, with much of the land being put down to flower-growing. Tiny fields with banks topped by hedges of introduced shrubs are a characteristic feature of the islands, as are the hedges and stands of elm that have now all but disappeared in Britain following the devastation to the species caused by Dutch elm disease.

Spring arrives early on the islands. A luxuriant growth of three-cornered leek provides a soft green and white carpet below the elms, while golden celandines, red campion and bluebells add further colour. Migrant birds arrive from March onwards, when wheatears can be seen hopping across coastal heaths and the first swallows of the year might be found hawking insects over the low-lying moors. Bird migration peaks in April

Common dolphins are occasionally seen from the ferry Scillonian, or on summer boat trips between the islands.

and May and at this time the regular visitors are frequently joined by more exotic southern species; you might be fortunate enough to spot a hoopoe or golden oriole.

Although relatively few land birds breed on the islands, you cannot avoid noticing the song thrush. This beautiful songster has declined by more than 73 per cent across Britain's farmland areas in the last 25 years due to changing agricultural practices, but on these islands, with their small fields and hedgebanks, it is able to thrive.

The farmland is notable for its arable weeds – a group of plants that has become very rare elsewhere due to increased use of herbi-

cides and changes in cropping patterns. On the Scilly Isles, golden fields of corn marigolds are a beautiful reminder of how cultivated land across much of Britain looked in the past. Many rare species also occur; for example, the western ramping-fumitory, which occurs nowhere else in the world outside of the Scilly Isles and west Cornwall.

SUMMER LIFE
In summer, the shallow seas between the islands come alive with a fine array of different seaweeds, from spiral wrack at the top of the shore to dense beds of kelp on the lower shore.

The archipelago is of international importance for its seabirds, including the enigmatic storm-petrel and Manx shearwater – both largely nocturnal and nesting in burrows and crevices on boulder beaches on the least disturbed rocky islands; both species can be seen from special island boat trips. The rare roseate tern bred alongside the common tern until recently, and efforts are under way to attract it back.

Dolphins are regularly sighted offshore and in summer the huge plankton-feeding basking shark is regularly seen. Grey seals are abundant – the many sheltered and undisturbed coves and

Western clover

Trifolium occidentale

This species is the western coastal counterpart of the widespread and familiar white clover. Whereas that species has a white mark on each leaflet, however, western clover's trefoil (divided into three) leaves are unmarked; the leaflets are also nearly circular in outline. Western clover is generally a low-growing plant, favouring tracks and paths where it often creeps over stones and banks; it is usually found within sight of the sea. The flower heads, which appear from March to May, are rather more compact than those of white clover and red stipules give them an attractive, red-centred appearance. They are a good source of early nectar for bees.

Western clover seems to be able to tolerate a reasonable amount of trampling, which explains its survival on coastal tracks.

From the island of Samson, the shallow seas and clear, unpolluted waters that bathe the islands can be fully appreciated.

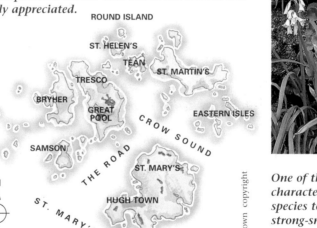

ROUND ISLAND

ST. HELEN'S

TEAN

ST. MARTIN'S

TRESCO

BRYHER

GREAT POOL

EASTERN ISLES

CROW SOUND

SAMSON

THE ROAD

ST. MARY'S

HUGH TOWN

N

ST. MARY'S SOUND

ANNET

ST AGNES

WESTERN ROCKS

© Crown copyright

Miles 0 1 2 3

Km 0 1 2 3 4

small islands providing ideal haul-out and pupping sites.

Summer fades into autumn and the heathlands lose the startling brilliance of golden gorse and purple heather flowers; the stately elms lose their leaves.

As the weather becomes unstable, winter migrant birds arrive on the islands. Flocks of waders congregate on windswept beaches. Some species, such as sanderling, ringed plover and turnstone, will remain throughout the winter and occur in nationally important numbers, while others move on. Fieldfares and redwings join the resident song thrushes, and flocks of finches gather in weedy bulb fields.

It is among these that rare vagrants from Asia, Europe and America occur. Few places in the world offer such exciting bird-watching opportunities; almost anything can turn up – a goldcrest-sized Pallas's warbler from Siberia, or an exotic yellow-billed cuckoo from North America.

Rock sea-spurrey and English stonecrop combine to create the effect of a natural rock garden on many of the coastal cliffs around the islands.

ISLES OF SCILLY HIGHLIGHTS
Three-cornered leek amid celandines, red campion and bluebells. Early migrant birds – swallows in March. Exotic birds like golden oriole or hoopoe. Numerous song thrushes. Arable weeds including corn marigolds. A rich array of seaweeds. Dolphins and grey seals **offshore**.

AND ALSO
LOOK OUT FOR...
● fulmar ● shag ● dunlin
● redshank ● curlew
● herring gull ● woodpigeon
● blackcap ● stonechat
● black redstart ● robin
● corkwing wrasse ● ling
● Cornish sucker ● thrift
● hummingbird hawkmoth
● painted lady ● sea campion

Tresco Great Pool is a magnet for migrating wetland birds, and has yielded numerous unusual vagrants over the years.

One of the most characteristic spring species to be seen is the strong-smelling three-cornered leek.

Song thrushes are extraordinarily tame on the Scillies and will sing or feed quite happily within a few feet of observers.

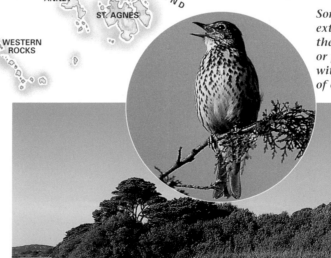

The Lizard

The remote and beautiful Lizard peninsula is the most southerly part of the British mainland. Its name is thought to be derived from the old Cornish word 'Lisart', meaning 'palace on a high place'.

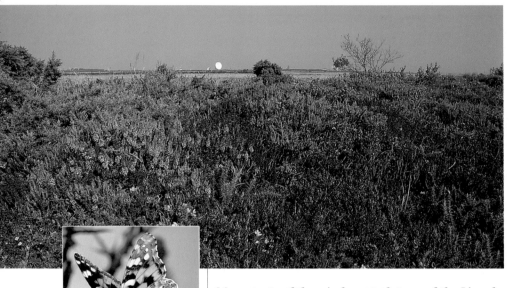

Many parts of the windswept plateau of the Lizard, such as the Goonhilly Downs, are covered with colourful lowland heath.

Painted lady butterflies, summer migrants, sometimes breed in Britain but the offspring produced in September and October do not survive the winter.

THIS IS A LANDSCAPE of contrasts: hot, dry, bee-buzzing, heather-scented summers and bleak, rain-drenched, gale-tossed winters; the flat heaths, stretching as far as the eye can see, and the rugged, wild coast with its characteristic serpentine cliffs. The large white dishes of the Goonhilly Satellite Earth Station and the towering wind turbines of the Bonython wind farm sit incongruously with the Bronze Age tumuli and hut circles, but have nevertheless become an integral part of the landscape.

One of the most striking features of the Lizard is the stark, treeless nature of the southern part of the plateau. The soft sediments of the northern section, cut by an ancient sea when the land was under water in Tertiary times, have since eroded into the gently undulating landscape of the 'Meneage', dissected by deep wooded valleys and the sheltered inlet of the Helford River, now designated a Voluntary Marine Conservation Area. Particularly significant here are the beds of eelgrass and maerl, a coral-like calcified seaweed.

The harder igneous and metamorphic rocks of the southern plateau, on the other hand, resisted this post-marine erosion and remain flat. Its unusual rocks include the famous, coloured serpentine rock, fashioned into curios and sold in Lizard village to holidaymakers. The serpentine gives rise to nutrient-poor soils, rich in magnesium and toxic heavy metals. In part the plateau is overlain by an ancient wind-blown granitic sand called loess. The climate, too, is unusual for Britain. Sun-scorched, dry springs and early summers combine with mild, wet and windy winters – frosts are rare – to give Mediterranean-type conditions.

It is this combination of unusual geology, soils and climate that is the key to the unique flora of the Lizard. On the serpentine soils a taller, pale-coloured heathland community, unknown anywhere else in the world, has developed. It is this that supports the striking Cornish heath which paints the plateau with its pastel pink in summer, combining exquisitely with the gold of the dwarfed western gorse.

Nationally rare or scarce plant species include long-headed clover and pigmy

Superb clumps of bloody crane's-bill can be found in sheltered gullies, encouraged by the underlying serpentine rocks.

rush, only known from the Lizard and the most threatened of the classic 'Lizard rarities', plus the delicate spring sandwort, pale heath-violet and three-lobed water-crowfoot, a plant of pools on rutted tracks.

VARIED FLOWERS

The unusual chemistry of the serpentine soils means that lime-hating plants such as heather grow happily alongside species typical of chalk and limestone, including harebell and the spectacular bloody crane's-bill, while the low fertility has in part helped to save the flora from the plough.

Although a third of the Lizard heaths have been lost this century, efforts are being made to safeguard the remainder and English Nature has designated large areas as a national nature reserve.

The best time to enjoy the beauty of the cliff flowers is in mid-May, when the early blue haze of spring squill is giving way to the summer pinks and yellows of thrift and kidney vetch and the white of sea campion. The climate favours clovers and these are at their best

Cornish heath

Erica vagans

Although extremely restricted in its distribution, Cornish heath is often abundant where it does grow. Its range is limited to heaths on the Lizard peninsula, and there invariably where the base-rich rock serpentine occurs; cliffs and heaths at Kynance Cove support some of the most impressive stands of this otherwise rare plant. Cornish heath forms compact and often sizeable clumps, the upright stems carrying whorls of four to five narrow leaves. Spikes of attractive flowers are produced from July to September. In shape, these are typical of the heather family, but they can be distinguished – apart from the more impressive appearance – by the protruding, rich-brown anthers. It often grows alongside moor-grass.

Like other members of the heather family, Cornish heath produces bell-shaped flowers which are extremely attractive to insects such as bees.

Hairy greenweed
Genista pilosa

Although locally abundant on parts of the Lizard peninsula and the north Cornwall coast, hairy greenweed is an extremely rare plant in Britain, being known only from two other sites, both in Wales. The best place to look for it is on the clifftops. At first glance, the plant may resemble a miniature version of broom. The flowers are much smaller, however, and it almost always grows in a prostrate form. Its best distinguishing feature, as its name suggests, is its covering of hairs, found both on the leaves and flowers.

Without its bright yellow flowers, which appear in May and June, hairy greenweed can be easily overlooked. The flowers are extremely popular with insects and are pollinated by bees.

The hummingbird hawkmoth, a day-flying species, hovers in mid-air while feeding with its long proboscis. Its rapid wingbeats make an audible hum.

in late May/early June. Fourteen species grow alongside the elusive land quillwort in the Caerthillian Valley, the richest place for clovers in Britain. Exposure to the elements means that many of the cliff plants grow horizontally: prostrate juniper, prostrate broom, prostrate asparagus and hairy greenweed to name but a few. Other rarities of the cliff outcrops and clitters

include chives, and the strangely named fringed rupture-wort. Summer also sees the arrival of clouds of migrant insects, with hummingbird hawkmoths and painted ladies (in variable

numbers) being among the most conspicuous.

Much of the area, protected by the National Trust, is managed traditionally by grazing with agile sheep and Shetland ponies. Excellent serpentine cliff scenery can be seen between Mullion and Kynance and from Kennack to Black Head.

Herring gulls – ever on the look-out for a possible meal – are commonly encountered around the coast.

AND ALSO LOOK OUT FOR...
- bottlenose dolphin ● grey seal ● fulmar ● kittiwake
- Manx shearwater ● gannet ● shag ● kestrel
- great black-backed gull ● small pearl-bordered fritillary
- grayling butterfly ● rock sea-spurrey ● sea campion
- English stonecrop

Map scale:
Miles 0 — 1 — 2 — 3 — 4 — 5
Km 0 — 1 — 2 — 3 — 4 — 5 — 6 — 7 — 8

HELSTON
ORTHLEVEN
GWEEK
Loe Pool
CULDROSE AIRFIELD
Helford River
MAWGAN
MANACCAN
GUNWALLOE
PORTHALLOW
EARTH STATION ●
MULLION
GOONHILLY DOWNS
TRABOE DOWNS
ST KEVERN
MULLION COVE
CROUSA DOWNS
COVERACK
PREDANNACK AIRFIELD
LIZARD DOWNS
KENNACK COVE
BLACK HEAD
CADGWITH
DEVIL'S FRYING PAN
KYNANCE COVE
LIZARD VILLAGE
CAERTHILLIAN VALLEY
LIZARD POINT

N

LIZARD HIGHLIGHTS
Serpentine rock in the **southwest**. Cornish heath dotted with western gorse on **heathland**. Large scattered boulders formed from gabbro on **Crousa Downs**. Spring squill on the **cliffs**. Maerl, a coral-like calcified seaweed, at the mouth of the **Helford River**.

The Lizard's list of rare plants includes the showy long-headed, or Lizard, clover.

Kynance Cove is a beautiful part of the Lizard coastline, topped by a wonderful array of flowers.

Dartmoor

This is the largest area of wild country in southern Britain, epitomised by harsh weather and wide open moorland. It is symbolised by the sturdy Dartmoor pony, which has lived here for centuries.

Wheatear
Oenanthe oenanthe

The dumpy and upright-standing wheatear is one of the first migrants to arrive in spring, many reaching the shores of the West Country as early as March. It is an attractive bird, the male having blue-grey upperparts, buffish underparts and a black patch through the eye; the female's plumage is more subdued. Both sexes, however, share a distinctive feature which enables easy identification: in flight they reveal a conspicuous white rump. The loud 'tchack' alarm call, which sounds like two pebbles being knocked together, is another good pointer to the bird's identification. Wheatears are hole nesters, sometimes using an old rabbit burrow, or occasionally a hole in a stone wall.

see also page 248

Wherever they occur on Dartmoor, wheatears are curious about human visitors to their territories and perch prominently on stone walls or boulders so they can follow the progress of the intruder.

THE LANDSCAPE OF Dartmoor, with habitats that are rare elsewhere in Britain – blanket bog, heather moorland, ancient woodland and traditional hay meadows – provides a huge range of opportunities for wildlife. Arctic species such as club-mosses cling to windswept tors a few miles away from bastard balm, a plant from southern Europe. In summer, upland waders such as golden plover and dunlin breed just a short flight from lowland birds, including woodlark and cirl bunting.

At any time of the year, there is plenty to see and hear. In spring, the valley woodlands are carpeted with primroses, bluebells, wild garlic and daffodils,

The marsh fritillary, extremely local in its distribution and almost impossible to find in some years, favours wet meadowland.

Dartmoor ponies are wild and hardy animals, adapted to survival in a landscape which, in winter, can be harsh and unforgiving.

and resound with birdsong.

Migrant pied flycatchers, wood warblers and redstarts join the resident tits and woodpeckers. If you walk quietly along the rushing rivers you may glimpse a handsome brown-and-white dipper bobbing on a stone, the brilliant flash of a kingfisher, or even an otter – though you are more likely to see its spraint on prominent boulders or under bridges.

Many wooded valleys have public footpaths, or you can visit the nature reserve at Dunsford Wood on the B3212, or Yarner Wood national nature reserve near Bovey Tracey.

In summer, the secrets of Dartmoor's farmland are revealed. The rough grassland snaking along valley bottoms comes to life with the emergence of marsh fritillary butterflies and other insects, and when meadow thistle, orchids and a myriad of bog plants are flowering this pasture is magical.

The traditional hay

The tinkling song of the woodlark is sometimes delivered in flight, when the bird can also be recognised by its short tail and rounded wings.

meadows are also at their best at this time. Taller herbs such as ox-eye daisies, hawkbits and hardheads wave above eyebrights, trefoils and butterfly orchids, while meadow brown and blue butterflies flutter overhead. Although these habitats occur on working farms, where access is sometimes limited, the National Park Authority runs regular guided walks throughout the season.

THE HIGH MOOR Summer is also a good time for exploring the blanket bog on the highest plateau. Cottongrass flowers among the heather and bog mosses, frogs and toads migrate to the bog pools, and the song of skylarks fills the air.

Although much of this area is a military range, there is no firing at weekends or during the latter half of July and August. Check local noticeboards, or enquire at information centres for firing times.

In August the heather moorland turns a glorious purple, splashed with the gold of western gorse. This wonderful display can be seen from the main roads across Dartmoor, particularly the B3212 between Moretonhampstead and Princetown, or the B3387 across Haytor Down. Alternatively, walk up on to the high moor and experience the heady smell of heather in flower,

Western gorse

Ulex gallii

When in flower, gorse-covered slopes are one of the glories of the West Country. Western gorse is one of two gorse species to be found in the region, the other being common gorse, and is by far the most widespread and abundant. Its later flowering period, from July to October, also helps distinguish it, as does the richer green colour of the plant itself. When unrestricted, western gorse will grow to form a fair-sized shrub, reaching a height of 1.5m (5ft). Around the coast, however, the pruning effects of the wind, sometimes combined with grazing pressure, mean that it is usually low-growing.

The plant's spines and interwoven stems provide an almost impenetrable retreat in which all manner of small animals find a safe refuge.

Granite tors – bare, rocky hills – are a distinctive feature of the landscape and provide landmarks for those walking the moorland.

During the summer months, damp ground is often studded with the flowers of bog pimpernel and tormentil.

DARTMOOR HIGHLIGHTS
Grazing Dartmoor ponies on the **moorland**. Dipper, grey wagtail and perhaps signs of otter along clear, rushing **streams**. Pied flycatchers and redstarts in **valley woodlands**. Marsh fritillary butterflies with devil's bit scabious in **rough grassland**. Meadow brown and blue butterflies over **flower-filled meadows**. Wild daffodils and lesser spotted woodpeckers at **Dunsford Wood**.

Miles 0 5 10
Km 0 5 10 15

AND ALSO LOOK OUT FOR...

- fox ● short-tailed vole ● buzzard ● adder ● kestrel
- grey wagtail ● stonechat ● ring ouzel ● nuthatch
- common toad ● bog asphodel ● heath spotted orchid

Pied flycatchers are boldy marked migrants that arrive in mid-April. The birds nest in tree holes, generally in mature oak woodland.

Wistman's Wood is an ancient wood of stunted oaks and is renowned for the luxuriant growth of ferns, mosses and lichens on the trees.

the lazy buzz of bees and perhaps the guttural call of a red grouse.

With autumn rains, river levels rise allowing salmon to reach their spawning grounds upriver. Dramatic runs of fish can be seen on the major Dartmoor rivers, particularly at weirs where there are usually fish passes. The woods and hedgerows are now full of food for the forthcoming winter.

Dormice are common in many woods and hedgerows, and you can often find their empty hazelnut shells nibbled to a distinctive smooth edge. Badger runs can be more easily traced across hedges and footpaths as the vegetation dies down.

In winter, a walk can be enhanced by the glimpse of a ghostly hen harrier quartering a valley mire, or a russet fox streaking across a boulder slope. Mosses and lichens thrive in the damp, unpolluted air, clothing trees, stone walls and even tors.

Exe Estuary

Creating a deep gash in the south Devon coastline, the estuary marks the end of the great river's journey to the sea from its source on Exmoor. Twice a day this rush of freshwater is halted by the salty barrier of the rising tide.

Dark-bellied brent geese fly in every winter and form large flocks that wheel over the estuary. They return to Siberia in the spring.

Although avocets are only winter visitors to the Exe Estuary, courtship behaviour can sometimes be observed in early spring before the birds depart.

The charming yellow bartsia grows in damp hollows – known as 'slacks' – in the dunes of Dawlish Warren.

Glasswort

Salicornia europaea

Looking more like a miniature cactus than a native British plant, glasswort is a common species on estuaries and saltmarshes in the West Country. Like other plants found in these habitats, it has to withstand twice-daily inundation by seawater when the tide is in. The fleshy, succulent leaves envelop the stem and give the plant a segmented appearance. Typically, the colour of the plant is fresh green, although red tinges are often seen. The flowers, which appear in late summer, are too tiny to be noticed without the aid of a hand-lens.

see also page 284

At low tide, the stems of glasswort are often adorned with the shells of tiny molluscs. The plant is sometimes misleadingly referred to as 'samphire', the correct name of another coastal plant.

INTERESTING AT ANY time of year, the estuary is best appreciated at first light on a winter's day, when the only sounds to pierce the cloaking mists are the calls of the 20,000 or so birds that arrive from northern latitudes seeking food and shelter. At the northernmost point flocks of 300 to 400 avocets occur in winter, feeding largely on shrimps by scything the soft ooze and shallow brackish water. Topsham, which lies at the confluence of the rivers Exe and Clyst, is the easiest place to see them. At low water they are scattered over the mudflats – along with black-tailed godwit, curlew, lapwing, redshank, oystercatcher and grey plover – and they are viewable from a raised platform.

Beyond Topsham the estuary broadens out to its widest point, but several convenient access points on the eastern shore, particularly Lympstone, Exmouth and Exton, allow the cyclist, motorist or rail passenger to see a diversity of birds across the estuary.

On the western side access is more restricted, although a footpath heads upstream toward Turf Lock and the start of the Exeter Canal. On this side of the estuary the mudflats are narrower as the deep channel cuts closer to the shore. From the footpath, on a rising tide, flocks of duck, including shoveler, wigeon, shelduck, teal and pintail, swim in rafts, just off shore, while sprinkled over the mudflats knot and bar-tailed godwit occur in small numbers.

SKEINS OF GEESE

In winter, at every spot around the estuary, flocks of cackling, dark-bellied brent geese can be seen and heard flying over to feed in fields or on the estuary itself, where they are attracted by the eelgrass beds that grow in certain locations. In rocky areas they are often joined by a grey heron, or a little egret or two.

In spring, parties of waders in breeding plumage, including knot, common sandpiper, godwit and grey plover, stop off at Turf Lock for a few days on their northward migration. Grey seals are sometimes

glimpsed here too, but good views require luck and patience. Try searching for them, along with Slavonian grebe and red-breasted merganser, in the deep channel between Turf Lock and Dawlish Warren.

MARSH AND SAND
At Turf Lock, the footpath continues northward between the canal and the RSPB reserve at Exminster Marshes. In summer, the marsh-marigold- and reed-lined canal and dikes are the haunt of nearly 20 species of damselfly and dragonfly. A few pairs of nesting redshank and lapwing provide interest for the bird-watcher in summer and, although it is extremely skulking, the rare Cetti's warbler gives away its presence with its explosive song. The canal is a favoured spot for the elusive grass snake, which can often be seen hunting on the water surface.

At the mouth of the estuary the shifting sands of Dawlish Warren stem the river's route to the sea. This dune-rich sand

As the tide pushes in, waders such as oystercatchers become concentrated in the shallows, probing the mud for invertebrates.

spit, managed as a local nature reserve, is of great botanical interest. In early spring the sand crocus, a tiny ground-hugging jewel, finds its only home on the British mainland. Later, Sandwich and common terns are

frequent offshore. The reserve, complete with a visitor centre, has an enviable record for attracting rarities, including great spotted cuckoo, lesser crested tern, dusky warbler and semi-palmated plover.

The loud, piping calls of oystercatchers are uttered in alarm but also form an integral part of courtship, seen in early spring.

Broad-bodied chasers often perch on twigs and are easiest to see in the morning when they are relatively inactive.

EXETER
R. Exe
Exeter Canal
COUNTESS WEAR
R. Clyst
TOPSHAM
EXMINSTER
EXMINSTER MARSHES
GOATWALK
TURF INN
EXTON
POWDERHAM
KENTON
POWDERHAM CASTLE
LYMPSTONE
STARCROSS
EXMOUTH
COCKWOOD
DAWLISH WARREN
DAWLISH
N

Miles 0 1 2 3
Km 0 1 2 3 4 5

EXE ESTUARY HIGHLIGHTS
Winter flocks of avocet at **Topsham**. Shoveler, wigeon, teal and pintail on **western side of estuary**. Dark-bellied brent geese feeding on **beds of eelgrass**. Spring parties of knot, godwit and grey plover at **Turf Lock**. Cetti's warbler at **Exminster Marshes**. Sand crocus at **Dawlish Warren**.

The spring-flowering sand crocus is found only on the golf course at Dawlish Warren and in the Channel Islands.

Ringed plover
Charadrius hiaticula

The ringed plover is a small and rather dumpy wader seen around coasts in the West Country. During the breeding season, pairs try to nest on shingle ridges and sandy beaches. In autumn and winter, the birds move to estuaries and mudflats to feed. They usually form loose associations with others of their kind but are seldom seen in sizeable flocks. Ringed plovers' feeding behaviour is characteristic: they run along the shore and then stop dead, tilting their body forwards; after briefly remaining motionless, they pick at the item that attracted them.

see also page 233

Dawlish Warren is one of the few areas in the West Country where ringed plovers are afforded a degree of protection from human disturbance and can therefore nest successfully.

Dorset Coast

Dorset is renowned for its beautiful and varied coastline and Chesil Beach, the 28km- (18 mile-) long shingle bank stretching in a gentle arc westwards from the Isle of Portland, is possibly its best-known feature.

THE COASTAL SCENERY between the sand dunes of Studland and the spectacular cliffs around Lulworth Cove is truly magical. Dominating the landscape is unspoilt limestone downland, supporting a wide range of wildflowers and butterflies. Look out for the adonis, chalkhill and common blue butterflies, along with the Lulworth skipper, whose only home is along these cliffs. You can also search for pyramidal, fragrant and

The chalk scenery of Durdle Door is among the most spectacular in Britain. The cliffs are covered with flowers.

bee orchids. But be careful; there are lots of adders inhabiting the area's drystone walls and old quarries.

Westwards, Chesil Beach encloses and shelters the shallow Fleet lagoon, which runs some 13km (8 miles) up the coast from its narrow tidal

Appropriately enough, the fragrant orchid is best located by its subtle but attractive scent.

inlet at Smallmouth in Portland Harbour. The beach links the mainland with Portland, a peninsula of limestone jutting several miles out into the English Channel.

The much-quarried land is rich in lime-loving wild flowers and invertebrates, especially butterflies and moths. One quarry is now a nature reserve managed primarily to protect the silver-studded blue butterfly. Rock samphire, broomrape, marjoram and wild madder flower on the cliff tops, while fulmars and kittiwakes nest on the ledges. There is also the chance of spotting a

gannet out at sea, or a dolphin or porpoise.

Portland is important as a landfall and departure point for migrating birds and a former lighthouse at the Bill, the southernmost tip of the island, now serves as the Portland Bird Observatory.

On the way there most visitors stop off at the RSPB reserves at Radipole Lake and Lodmoor, on the fringes of Weymouth. These freshwater wetlands offer a wealth of insects, flowers

Teal are winter visitors. Small flocks occur at Radipole, Lodmoor and on the Fleet.

and breeding birds in summer, migrants in spring and autumn, and wintering birds from October to March.

CHESIL BEACH
At Ferrybridge, south-west of Weymouth, the Chesil Beach Centre is a good place from which to explore the beach and the Fleet. In winter the invertebrate-rich sand and mudflats of the Fleet attract thousands of coot, wigeon, teal and brent geese, as well as waders such as dunlin, redshank and oystercatcher.

In spring the scene changes and the beach comes alive with pink thrift and white sea

Mute swans find a year-round haven at Abbotsbury and nest in considerable numbers at the swannery.

The Lulworth skipper is found nowhere else in Britain other than on this short stretch of the Dorset coast.

Rock samphire forms spectacular clumps on the more stabilised stretches of Chesil Beach's shingle.

campion. The piercing calls of little terns may be heard as they hover and dive for sand smelt; a small colony breeds on the shingle. Ringed plover may also be seen – they nest among the sea-purslane and shrubby sea-blite near the edge of the water where their pebble-like eggs are well camouflaged.

In summer, trips in glass-bottomed boats up to the Narrows offer a chance to view the rich plant and animal life of the warm, shallow waters. The Fleet is noted for its massive beds of eelgrass and more than 1,400

species of algae – a major habitat for marine life and food source for the swans and other wildfowl.

West of the Narrows, the Fleet is very largely undisturbed. The best place to visit the West Fleet is at Abbotsbury, famous for its colony of more than 500 mute swans The swannery

offers a fascinating insight into the life of swans and the management of the surrounding reedbed, copses, grassland and wetland. Reed and sedge warblers, Cetti's warbler, bearded tit, water rail and heron are among the other birds that may be seen, or heard, here at different times of year.

Portland sea-lavender
Limonium recurvum

During the summer months, on a sunny day, Portland Bill is thronged with visitors, most of whom mill around the lighthouse and southernmost tip of the island. Walk a short distance from the car park, however, and you will soon be able to appreciate the natural history interest of the area in peace. At this time of year the flowers are the things most likely to catch the eye of the visiting naturalist. Lime-loving

Along with several other scree-loving coastal plants, Portland sea-lavender has benefited from the centuries of quarrying that have scarred the landscape of the Isle of Portland.

species abound in the grassland but it is on the east coast that one of Portland's gems occurs. Portland sea-lavender can be found growing in rock crevices and on scree-covered slopes near the sea. It forms small clumps, and sprays of the pale lilac flowers are borne on recurved stems. This is the species' only known site in Britain.

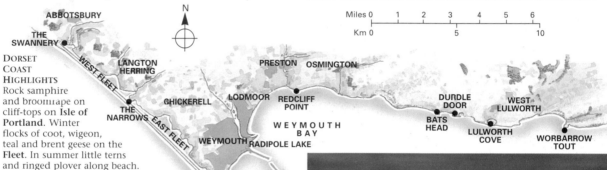

DORSET COAST HIGHLIGHTS
Rock samphire and broomrape on cliff-tops on **Isle of Portland**. Winter flocks of coot, wigeon, teal and brent geese on the **Fleet**. In summer little terns and ringed plover along beach. Mute swans at **Abbotsbury**. Yellow horned-poppy, sea pea and sea-holly on **Chesil Beach**. Cetti's warbler and bearded tit at **Radipole Lake**. Lulworth skipper at **Lulworth Cove**.

© Crown copyright

Golden samphire
Inula crithmoides

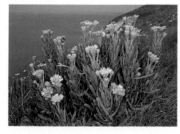

Golden samphire is exclusively a coastal species and seldom grows out of sight of the sea. Unsurprisingly, the plant is tolerant of salt-spray and salt-laden soils.

The sight of a mass of golden samphire in full bloom is one of the coastal glories of the West Country. It is mainly a saltmarsh plant but also occasionally occurs on sea cliffs too, as is the case on Portland. It is a late-flowering species, being in bloom mainly in

August and September during which time clusters of bright yellow flower heads can be seen. On close inspection, these comprise rather ragged-looking radiating rays and a dense central disc. The flowers are carried on stems which bear blunt-ended, narrow leaves which overlap to give the stem a more robust appearance than it actually has in reality.

see also page 303

Thrift growing on the shingle of Chesil Beach is at its most showy in May and early June.

Migrant wood sandpipers pause for a few days at Radipole Lake and Lodmoor during August and early September.

AND ALSO LOOK OUT FOR...
● cormorant ● grey heron
● pintail ● glaucous gull
● common tern ● rock pipit
● swallow ● whitethroat
● large skipper ● great green bush-cricket ● yellow-wort
● marjoram ● thyme
● sea campion ● red valerian

Dorset Heaths

Some 200 years ago a traveller riding in a horse and carriage called the Dorset heaths 'a most dreary waste'. Today's visitor need only explore a little to see that nothing could be further from the truth.

The beautiful bright blue marsh gentian is a rare, autumn-flowering plant favouring bogs and wet heathland.

Silver-studded blues are restricted to heathland areas where their larval foodplants, ling and gorse, occur.

VISIT THE HEATHS IN late summer or early autumn to know their full glory. Then the high, dry ground will be a purple carpet of ling and bell heather, dotted with the yellow stars of one of the creeping dwarf gorses.

A stroll along one of the sandy tracks may be rewarded with a glimpse of the heaths' most famous inhabitant, the handsome sand lizard, basking in the warmth of the sun. Dorset supports 80 per cent of the British population of this rare reptile. Another rarity, often in the same areas as the sand lizard (upon which it preys), is the smooth snake. Both species hibernate between October and April.

Sandy tracks are also the places to watch for solitary bees and wasps excavating their burrows;

Western gorse and bell heather create a colourful, if rather spiny, display on Canford Heath during August.

The heaths are the finest sites in Britain for reptiles, including the rare smooth snake which feeds on other reptiles and insects.

they stock these with paralysed prey for their larvae. All around the air is filled with the chirping of grasshoppers and crickets; in this habitat one contributor to the cacophony could be the heath grasshopper, a real Dorset speciality, otherwise known only in the New Forest.

BOG PLANTS

While the zoologist could spend all day exploring the high ground, a botanist will gravitate to the lower, wetter parts of the heaths. Here purple of a paler hue comes from the cross-leaved heath, while the bog asphodel provides the bright yellow splendour – purple and yellow are the heaths' colours. In and around Purbeck, the cross-leaved heath is likely to be joined by the splendid Dorset heath, and on a few sites in Purbeck and beyond it is possible to admire the bold blue trumpet-shaped flowers of the scarce marsh gentian.

The delicate white flowers of the sundews are easily overlooked – it is their rosette of sticky leaves which draw attention. Upon these, surprisingly large insects become trapped and drained of their nutrients; an enterprising way to supplement the plant's diet in this nutrient-poor habitat.

Heathland is not rich in butterflies, but no matter, because the one species

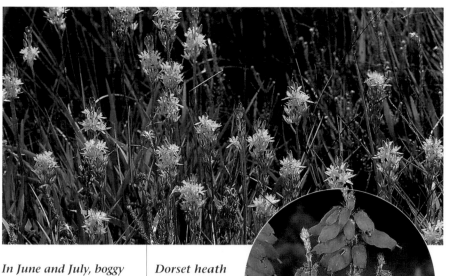

In June and July, boggy areas become studded with bright yellow spikes of bog asphodel. After flowering has finished, these turn golden brown and persist well into the autumn.

which is strongly associated with the area has interest enough. The silver-studded blue, like its more famous cousin the large blue, has a complex lifestyle in which the pupae reside in certain ants' nests. The butterfly is found on young, wet heath.

Venturing on to the really wet parts – the true bogland – requires care. Carpets of bog-moss hold and ooze water like a giant sponge. White tufts of cotton-grass bob in the breeze and are reflected in the bog pools. Beneath their shimmering surface the tiny bladders of the aptly named bladderwort suck in suspended insects, while larvae of dragonflies and damselflies feed ferociously before emerging as colourful adults to hunt on the wing. Look carefully for the raft spider poised at the water's edge, hoping its prey will betray itself by vibrating the surface.

Any part of the heaths may afford sight or sound

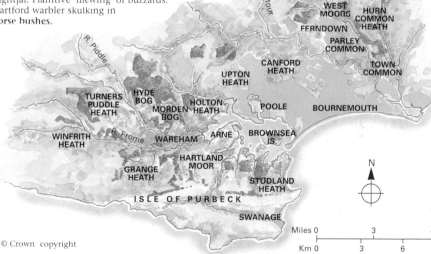

Dorset heath is a speciality plant of the region, seen in flower in July and August.

of one of their several special birds, but a clump of common gorse is the best spot to listen for the harsh chatter of the Dartford warbler. Gorse bushes provide the nest-sites, excellent insect-foraging and vital shelter from snow in the winter. Dartfords – frustratingly – tend to skulk low in the vegetation so that the bird perched on the top of the bush is more likely to be the stonechat whose song does indeed sound like two stones being knocked together.

DASHING HOBBY
There is nothing to equal the sight of a hobby in swift and agile pursuit of dragonflies over the heaths. Although this beautiful small raptor mostly now breeds on farmland, the heaths of Dorset still play a key role in its national success.

In the evening, the heaths have a special feel: the 'churr' of the nightjar may be followed by a glimpse of this strange bird as it flies, mouth agape, in search of moths.

Great green bush-cricket
Tettigonia viridissima

A loud, reeling sound, rather mechanical in character, and coming from a bramble patch, is likely to be the song of a male great green bush-cricket. Although these magnificent creatures are among the largest insects to be found in Britain, they can be incredibly difficult to spot, even if you think you have pinpointed the source of the sound. They are mainly found along the south coast and Purbeck is one of the best places to search or listen for them. Females possess a fearsome-looking ovipositor, which, although resembling a giant sting, is harmless and used for egg-laying. The species feeds on leaves and small insects.

Bush-crickets reach maturity in August and can be seen through to October.

DORSET HEATHS HIGHLIGHTS
Three heathers: ling, bell heather and cross-leaved heath. Sand lizard sunning itself on the **heath**. Silver-studded blue butterfly in areas where heather is sparse. Insect-eating bladderwort in **bog pools**. Blue flowers of marsh gentian on **Purbeck**. Nighttime 'churr' of the nightjar. Plaintive 'mewing' of buzzards. Dartford warbler skulking in **gorse bushes**.

© Crown copyright

Sand lizard
Lacerta agilis

Unlike its common cousin, the sand lizard has an extremely restricted range in Britain. It occurs on dunes on the Lancashire coast and a few heaths in the New Forest, and on the Hampshire–Surrey border, but the species' real stronghold is on the heathlands of Dorset. Following their emergence from hibernation in April, the lizards can be found basking in the sun on bare patches of sand or on fallen branches. Males are more strikingly marked than females and during the breeding season acquire an intense green colour. The larger head and generally bulkier appearance help distinguish it from the common lizard.

see also page 255

Being cold-blooded, sand lizards are fond of sun-bathing, an exercise that raises their body temperature and makes them more active.

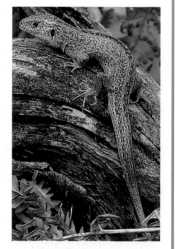

Poole Harbour

This is one of the largest natural harbours in the world, and those prepared to linger and explore will find an unspoilt world of hidden creeks and mudflats, lagoons, secret reedbeds, heathlands and wooded islands.

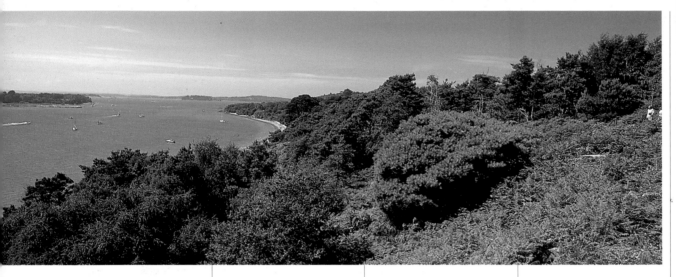

All year round, the heaths that fringe Poole Harbour are a stronghold for the Dartford warbler.

ENTRANCE TO THE harbour is between the headlands of Sandbanks and Studland, which are linked by a car ferry drawn across on chains. The harbour's 3,500ha (8,641 acres) are encircled to the north-east by Poole, but the natural bays and beaches still remain. Shore Road overlooks the bay known as Whiteley Lake, which is a haunt of geese and waders in the winter. There are pleasant shoreline walks at Holes Bay and bird hides in Upton Country Park, accessible from the A350.

In contrast to the built-up north-eastern shoreline, the southern sweep, from Lytchett Bay round to Bramble Bush Bay near the chain ferry, is very different. Here the harbour waters lap an enormous natural area, mostly inaccessible by road, comprising tiny creeks, extensive reedbeds at Holton, the broad Wareham Channel, the promontory of Arne and the intricate pattern of tidal creeks of Middlebere Lake, Wych Lake, Ower and Brand's Bay.

In places the mudflats, spartina beds and saltmarsh extend into the superb heathland nature reserves of Holton, Arne and Studland, where specialities such as sand lizards and Dartford warblers can be seen. Acting as a backdrop to the region are the forests of Rempstone and the distant Purbeck Hills.

VISITING BIRDS

Poole Harbour's waters and mudflats are rich in fish and invertebrates that are invaluable to coastal birds. In autumn, thousands of waders migrate to southern Europe or Africa,

From Brownsea Island, superb views can be obtained of the whole harbour. The island is a refuge for nesting birds and red squirrels.

lingering to feed in the harbour before continuing on their journey. At this time ruff, knot, little stint, ringed plover and common sandpiper share the mudflats with the resident redshank, dunlin and curlew.

As winter progresses more migrants arrive, staying until spring when they return north, perhaps to Scotland or

Scandinavia, to breed.

The harbour supports nationally important numbers of some species: black-tailed godwits from Iceland are found around the muddy southern shores, bar-tailed godwits from the Arctic prefer the sandier bays of the northern shoreline, while more than 700 avocets comprise one of the country's largest flocks. These elegant black-and-white waders, generally migrants from the Netherlands and Germany, roost and feed on Brownsea lagoon or along the Wych Channel.

Cold northern winters force geese and ducks south to join the resident flocks of shelduck. Over 1,000 brent geese arrive from Siberia, and northern ducks such as red-breasted merganser, eider and goldeneye are seen on the open water along with great northern

Common tern

Sterna hirundo

Pointed wings, a long tail and graceful flight easily separate terns from gulls. Of the several species that can occur in the south-west, the common tern is the most likely to be encountered. A few stay to breed, but most pause from migration to feed in estuaries and river mouths in the region. Seen at close range, the common tern has a black-tipped, orange-red bill and red legs, the former feature separating it from its close relative the Arctic tern, which has a blood-red bill. Small flocks of common terns sometimes gather in areas where small fish are shoaling, the birds plunge-diving repeatedly into the surface waters.

see also page 238

Common terns are migrants to Britain, present during the breeding season from late April until early September. A small but thriving colony can be found on Brownsea Island, nesting on man-made islets.

As evening approaches, small herds of sika deer venture out from wooded cover to graze on the luxuriant saltmarshes that fringe the harbour.

Little egrets are relative newcomers to Britain but have started breeding alongside the grey herons on Brownsea Island.

Arne, the RSPB's heathland reserve, overlooks Poole Harbour and is at its most colourful in July and August when the ling and dwarf gorse are in full flower.

The insectivorous sundew is common on the heaths, and damselflies are often trapped on the sticky hairs.

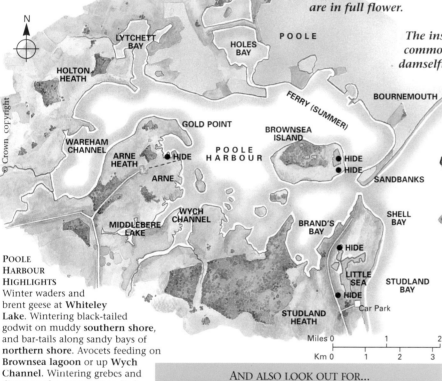

POOLE

LYTCHETT BAY

HOLES BAY

HOLTON HEATH

FERRY (SUMMER)

BOURNEMOUTH

GOLD POINT

BROWNSEA ISLAND

WAREHAM CHANNEL

POOLE HARBOUR

ARNE HEATH • HIDE

• HIDE

ARNE

• HIDE

SANDBANKS

WYCH CHANNEL

MIDDLEBERE LAKE

BRAND'S BAY

SHELL BAY

• HIDE

LITTLE SEA

STUDLAND BAY

• HIDE

Car Park

STUDLAND HEATH

© Crown copyright

N

Miles 0 1 2
Km 0 1 2 3

POOLE HARBOUR HIGHLIGHTS
Winter waders and brent geese at **Whiteley Lake**. Wintering black-tailed godwit on muddy **southern shore**, and bar-tails along sandy bays of **northern shore**. Avocets feeding on **Brownsea lagoon** or up **Wych Channel**. Wintering grebes and divers on the **open water**. Red squirrels in **Brownsea Island woods**. Nesting common and Sandwich terns in reserve on **Brownsea Island**.

Cormorants survive well on a diet of eels and flatfish, caught by diving in the harbour's creeks.

AND ALSO LOOK OUT FOR...
● little grebe ● goldeneye ● wigeon ● teal ● herring gull
● greenshank ● ringed plover ● emperor dragonfly ● glasswort
● common sea-lavender ● sea purslane ● golden samphire

divers and great crested or, sometimes, Slavonian grebes. At the harbour entrance, cormorant, shag and the occasional razorbill or guillemot, or even a seal, may be seen.

Despite the hubbub of summer boats, the calls of redshanks and oyster-catchers, and the harsh cries of common and Sandwich terns, can be heard round the harbour.

In spring, the terns fly in from Africa to nest at the Dorset Wildlife Trust's reserve on Brownsea Island, their only nesting site in the West Country. Totalling about 200ha (500 acres), the island, owned by the National Trust, is the largest of the harbour islands; it opens to the public in summer.

Here you can still see native red squirrels –

Brownsea and the Isle of Wight are their last strongholds in southern England – and the island supports one of Britain's largest colonies of grey herons. A recent coup for Brownsea is that little egrets have started to breed; hitherto, although common on the coastal waterways of southern England, the species did not breed in Britain.

Black-headed gull

Larus ridibundus

This is the commonest of the smaller gulls found in Britain. Although the species is more prevalent in the south during the winter months, black-headed gulls still occur in spring and summer. Breeding colonies are dotted along the coast, and there is a thriving one on Brownsea Island. During the breeding season, the birds have a dark-chocolate hood (not black, as their name suggests); at other times of year, this is lost and replaced with variable dark smudges. Black-headed gulls are gregarious throughout the year and, outside the breeding season, sizeable flocks can sometimes be seen on mudflats, along estuaries and on freshwater reservoirs.

see also page 237

If they are protected from undue human disturbance, black-headed gulls will nest on saltmarshes or sand dunes, making a cup of vegetation for the eggs.

Exmoor

There is a surprising variety to be found within the boundaries of one of Britain's smallest national parks: towering cliffs, sweeps of moorland and ancient woodland, contrasting with hedged fields and traditional farmsteads.

Some of the most spectacular coastal views are to be had at the Valley of the Rocks near Lynton.

THE COASTLINE IS Exmoor's wilderness. Around North Hill and Selworthy Beacon is a wonderful area of coastal heath where the European gorse attracts stonechats and Dartford warblers – the latter having recently colonised the area, while whinchats are found along the bracken fringes.

From Hurtstone Point eastwards the jumble of boulders and scree is enlivened by thrift and stonecrop, along with dark green fritillary butterflies; there is also a chance of seeing both peregrine and raven overhead. Looking west, the high land falls away into the fertile Vale of Porlock where some of the finest malting barley grows. Here the land meets the sea in the sweep of Porlock Bay and a magnificent shingle bank stretches all the way to Porlock Weir harbour.

Birds abound here at any time of year – shelduck, heron, the occasional little egret, and waders such as curlew, redshank and golden plover. In summer you can find the lovely yellow horned-poppy growing on the shingle.

Beyond Porlock Weir the coastal scenery changes; oak woodland tumbles to the sea and there are several spectacular landslips. Hidden in a wooded combe past tiny Culbone Church are rare endemic whitebeams.

THE MOORLAND TOPS Inland, a fine area of heather moorland is found around the highest point, Dunkery Beacon. Here are Exmoor's only red grouse; ring ouzels breed in the valleys; and merlins hunt skylarks and meadow pipits.

It is here, too, that the majority of the heath fritillary's colonies occur in bracken-covered combes where its food-plant, cow-wheat, grows. This butterfly, which has its national stronghold on Exmoor, is also found on Haddon Hill overlooking

Short-eared owls appear in the winter months and quarter the open moorland in search of small mammals and birds during daylight.

Wimbleball Reservoir. The vegetation here is transitional between upland and lowland heath – crowberry and clubmoss growing alongside bog myrtle – while nightjars and tree pipits add to the lowland feel.

A very different type of moorland is found in the former royal hunting forest of Exmoor around Simonsbath. Here purple moor-grass dominates, but areas of upland bog are more interesting with bog asphodel and occasional wild cranberries among cottongrass and cross-leaved heath.

The area is at its best in winter when the saturated Sphagnum moss forms rich feeding areas for snipe. Short-eared owls

Badgworthy Water in the Doone Valley is an upland stream typical of the region; dippers and grey wagtails can often be seen on the boulders.

Bell heather

Erica cinerea

Acid soils, where the underlying rock is granite, are perfect for bell heather. The plant can tolerate quite dry, well-drained situations and, judging by its local abundance near the sea, is fairly tolerant of salt spray. Bell heather is woody and perennial, the upright stems bearing needle-like, dark green leaves in whorls of three. From May to August, spikes of attractive bell-shaped flowers appear. These are a rich reddish-purple in colour. This is one of the main component plants of maritime heaths in the West Country, sometimes forming a continuous carpet interspersed with low-growing western gorse.

see also page 296

The flowers of bell heather are attractive not only to our eyes but also to the insects that visit for a feast of nectar or pollen, and in turn fertilise the plant.

Buzzard
Buteo buteo

A distinctive mewing cry is often the first clue to the presence of a buzzard circling high overhead. These impressive birds of prey are relatively common in the West Country and favour open country where they can ride the updraughts and thermals. Buzzards are quite variable both in terms of size and colour. Most are a rich brown, although extremely dark individuals and almost pure white birds are not unknown. Despite its size, the diet of a buzzard comprises largely of earthworms, beetles and other invertebrates; carrion or small mammals will also be taken. Take an early-morning drive and you are likely to see a buzzard perched on a telegraph pole or dead branch beside the road.

see also page 229

Buzzards spend a lot of time on the lookout for food. During the breeding season they become secretive.

Red deer are very much a part of the Exmoor scene and are often easiest to see during the winter months, when the reddish coat turns a grey-brown colour.

Small but thriving colonies of the heath fritillary are found in a few woodlands throughout the region. Look for them on sunny days in late June.

and hen harriers hunt over the rolling grass moor. Exmoor ponies, said to be our oldest native breed, graze in the deep, sheltered combes.

HAUNT OF RED DEER
The home of the red deer, for which Exmoor is famous, is the valley oak woods, once coppiced to produce tan bark and charcoal. Wood ants build large, mound-like nests in the sunny glades, and the oaks themselves are clothed with lichens. The rare tree lungwort lichen can be found on most old ash trees beside the River Barle; look out, too, for dipper, grey wagtail and perhaps even goosander.

Higher up the catchment, the valley mires beside the river are rich in plants such as pale butterwort, bog pimpernel, ivy-leaved bellflower and marsh violets; the latter support large numbers of small pearl-bordered fritillaries.

South-facing bracken slopes are home to the much rarer high brown fritillary, while on unimproved grasslands grazed by cattle the spectacular hornet robber-fly hunts its grasshopper prey.

© Crown copyright

EXMOOR HIGHLIGHTS
Red deer in the **valley oak woodlands**. Exmoor ponies in **sheltered combes** on the **moor**. Shelduck, heron and redshank on marshes at **Porlock Vale**. Rare endemic whitebeams in **Culbone Woods**. Old English goats in **Valley of the Rocks**. Heath fritillary butterflies on **Dunkery Beacon** and **Haddon Hill**. Beech hedges on **Brendon Hills**.

AND ALSO LOOK OUT FOR...
- fox ● short-tailed vole
- badger ● woodpigeon
- tawny owl ● nuthatch
- green woodpecker
- whitethroat ● pied flycatcher
- long-tailed tit ● adder
- green hairstreak
- emperor moth
- golden-ringed dragonfly
- red campion ● broom

Pale butterwort is a tiny insectivorous plant that thrives on moorland bogs in the region. The delicate flowers appear in early summer.

Many of the steep valleys are cloaked with deciduous woodland largely made up of sessile oak.

41

Somerset Levels

Thousands of years ago a great bite of the sea extended from Bridgwater Bay into the very heartland of Somerset. Today, artificially drained, the area presents a flat landscape of streams, pasture and pollarded willows.

THE SLOW PROCESS of drainage of the Levels was started by the monks of Glastonbury Abbey, and in 1085 the *Domesday Book* records it as being well under way. But it was not until the end of the 18th century that enclosure took place on much of these wastes, and final control of the elements was only really completed with the introduction of diesel (followed by electric) pumps after World War II.

During this long period the area has changed from being marshland flooded for much of the year to a source of summer grazing and finally to prime agricultural land. However, it is still subject to flooding. All man's engineering works can be rendered useless when high tides combine with heavy winter rain, flooding the length and breadth of the Brue Valley.

Wide open views and a network of ditches typify the Somerset Levels, a rich habitat for wetland wildlife.

Sea walls keep 12m- (39ft-) high tides off the land, which lies just above sea level. Each field is surrounded by a complicated series of ditches flowing into rhynes that in turn carry the water to the main drains. The rivers and drains enter the sea through sluices, locally called clyses, which open only when the tide falls below river level.

A WATERY DOMAIN

The Brue Valley is the lowest-lying section of the Levels and mainly consists of peatland, in places up to 4.5m (15ft) deep. The bulk of this area has remained permanent grassland since the enclosures.

These great flatlands are given scale and interest by the hills surrounding them. To the north the great massif of Mendip rises more than 300m (987ft) straight up from the moors; to the east looms the round outline of Glastonbury Tor, crowned by its church tower; while the Poldens to the south and the Quantocks to the west complete the chain.

South of the Poldens, Sedgemoor is largely clay-based and, with its arable crops, has a quite different appearance. Pollard willows line many of the ditches and rhynes, and the horizon seems to go on forever. Villages with intriguing names such as Westonzoyland and Chedzoy add to the air of mystery which pervades this landscape.

The Levels are a wonderful place to explore, with excellent access via the grassy droves lined with yellow flags and purple loosestrife in spring and summer.

There are many wildlife reserves, including the peat diggings at Shapwick, run by English Nature. The area, which has been allowed to flood, has become a

The abundance of water creates an ideal environment for aquatic insects. Larger species can attract the attention of hobbies, particularly in late May and early June.

The showy blooms of flowering rush are a characteristic sight along the margins of drainage ditches that run beside grazed watermeadows.

Redshank

Tringa totanus

Although this attractive wader can be seen at any time of the year on estuaries and tidal stretches of river in the south-west, during the breeding season birds concentrate at suitable inland wetland sites such as the Somerset Levels. As its name suggests, the redshank's most distinctive feature is indeed its red legs. The birds tend to be rather solitary in their feeding habits, probing and picking at the surface of the mud – often just at the edge of the water – with their long bill. They feed on small molluscs and crustaceans, along with all sorts of other invertebrates, small fish, frogs, seeds and berries.

see also page 235

The redshank feeds along the water's edge. In spring, it can be seen in display flights, rising and falling on rapidly beating wings.

paradise for wildlife ranging from otter to ducks, from marsh harriers and warblers to a wealth of dragonflies. The ditches hold many species of diving beetles and there are notable species of bees and wasps.

RSPB RESERVE

Another great reserve, run by the RSPB, is West Sedgemoor, off the A378 between Fivehead and Langport. This is a vast area with carefully controlled water levels. When winter arrives it becomes home to huge gatherings of ducks, particularly teal and wigeon, as well as Bewick's swans, for which the reserve is famous: the sound of their bugling calls overhead is magical.

Masses of wild flowers – meadowsweet, marsh cinquefoil, common marsh-bedstraw, to name just a few – and shimmering dragonflies with the occasional hobby snatching them on the wing make summer visits memorable.

Very often huge flocks of lapwings line the shallower parts of flooded fields, sometimes rising like smoke into the air as some distant peregrine catches their eye. At dusk, wherever there is woodland or farmland,

With their webbed feet and thick waterproof underfur, otters are well adapted to the watery environment of the Somerset Levels. However, their nocturnal habits mean they are rarely seen.

you are likely to see Britain's commonest bat, the diminutive pipistrelle.

During the winter months it is possible to come across roe deer sleeping under a bush or even grazing in an open field. In spring, whimbrel stop off on their long migration northwards, while curlew stay behind to breed in the remoter, damper fields among the colourful ragged robin and marsh-orchids.

The silver water beetle is our largest aquatic beetle. While the adult is entirely vegetarian, the larva is predatory, feeding on water snails.

Linnet
Carduelis cannabina

The twittering calls of small flocks of linnets are a familiar sound around the south-west coast wherever there are patches of rough ground. Here the birds find cover in the bramble and gorse clumps that serve as nest sites in the breeding season, and provide a supply of seeds in autumn and winter. In spring, the male linnet is one of our most attractive birds with reddish patches on the breast, a blue-grey head and a chestnut back; the female has more subdued plumage but can usually be told by size and shape, and her invariable association with a male. In addition to their distinctive, if easily overlooked, calls linnets have a delightful song, rather like a warbling twitter.

With a nest full of young at stake, male linnets often perch prominently, keeping a watchful eye out for intruders and rivals in their territory.

SOMERSET LEVELS
HIGHLIGHTS
Ditches surrounding each field which flow into rhynes. Rivers and main drains taking water to the sea. Peatland area of the **Brue Valley**. Clay area of **Sedgemoor** with arable crops. Pollarded willows and yellow flag along **ditches**. Wildfowl and marsh harriers at **Shapwick Heath**. Bewick's swan, teal and wigeon at **West Sedgemoor RSPB reserve**.

WESTON-SUPER-MARE
MENDIP HILLS
CHEDDAR
R. Axe
BURNHAM-ON-SEA
BRIDGWATER BAY
R. Brue
NORTH DRAIN
WELLS
R. Huntspill
SHAPWICK HEATH
GLASTONBURY
POLDEN HILLS
QUANTOCK HILLS
BRIDGWATER
KING'S SEDGEMOOR DRAIN
R. Parrett
TAUNTON
LANGPORT
R. Tone
WEST SEDGEMOOR
R. Isle
R. Yeo
R. Parrett
YEOVIL

Miles 0 5 10
Km 0 5 10 15

AND ALSO LOOK OUT FOR...
● grey heron ● kestrel ● golden plover ● pintail
● mallard ● kingfisher ● great willowherb ● grass snake
● emperor dragonfly ● pond skater

After spending the winter in Africa, reed warblers return in May to build their nests among the reeds.

Mendip Hills

The ramparts of the escarpments that guard the Mendip Hills rear steeply up from the wide expanses of the Somerset Levels, defining as sharp a contrast between landscapes as it is possible to imagine.

Buzzards soar effortlessly for hours on end, frequently uttering their distinctive mewing calls.

The eroded cliffs of Cheddar Gorge form a stunning backdrop to the wealth of plant life on the lower slopes.

Hazel woods in the Mendips are important strongholds in Britain for the endangered dormouse.

Cheddar pink

Dianthus gratianopolitanus

Clinging to the steep slopes of Cheddar Gorge, this eponymous member of the pink family is one of our most localised plants. Eroded by water over countless millennia, the limestone cliffs that flank the gorge provide the only site in Britain for Cheddar pink; conservationists regard it as so vulnerable that it is now afforded complete protection by law. As its name suggests, the flowers of this attractive perennial are indeed pink and appear at their best from June to early August; they are popular with bees, hoverflies and butterflies, these visitors serving to pollinate the plant. In its natural habitat, it is relatively easy to see, especially with binoculars.

Cheddar pink grows in precarious sites on the crumbling slopes of Cheddar gorge. Established plants form sizeable clumps.

ESSENTIALLY, THE Mendips form a wedge-shaped plateau of Carboniferous limestone, 325m (1,069ft) high at Blackdown, their highest point. The thin end of the wedge is in the west where the hills taper through the narrowing ridges of Shute Shelve, Wavering Down and Crook Peak.

The flat top of the Mendips is characterised by green fields surrounded by drystone walls of pale grey limestone and by commonland where rocks protrude though the thin soil, while the steep flanks are thickly wooded. This is typical dry limestone country, where any running water is quickly swallowed by swallets and slockers – often just dimples in the fields – which act as funnels. Trickling through cracks and fissures underground, the water reappears as resurgences and risings in the valleys far below and feeds a series of reservoirs.

The most spectacular limestone feature is Cheddar Gorge, a rocky cleft with vertical cliffs towering 120m (395ft) above the road. Several caves bite into the sides of the gorge but the most prominent are the main show caves, Gough's and Cox's, with their magnificent array of stalactites and stalagmites. The Gorge is probably best explored on foot, as much of its rim is protected for nature conservation. Visit in the spring when the dark yews contrast with the pale-green leaves of whitebeam, the yapping cries of nesting jackdaws echo around the rocks and the resident herd of Soay sheep, the largest wild flock in mainland Britain, has lambs at foot.

BAT CAVES

There are other, smaller gorges. Burrington Combe cuts through the northern scarp slope and, above Wells, Ebbor Gorge, a national nature reserve, slices down to Wookey Hole show cave from whose impenetrable maw slide the dark waters of the River Axe. These hills are honeycombed with caves (though most no longer carry water) and are a stronghold for bats, especially greater and lesser horseshoes, which even use parts of the show caves.

Not all of the Mendips' exposed rock is limestone, however. Essentially these hills consist of a sandstone dome with a thick limestone coating. At the highest points this layer has been eroded away until, like a boiled egg with the top sliced off, the old red sandstone within has been revealed. The most notable sites are Blackdown, North Hill, Beacon Hill and Pen Hill, where heather flourishes on exposed acid soils, and the views are stunning.

The Mendips are a curious mix, for while the

plateau is a truly upland area the south-facing slopes grow grapes and early strawberries. Ancient woodlands of small-leaved lime and hazel coppice clothe these slopes which are carpeted in spring with bluebells, wood anemones, ramsons and primroses. They are home to the endangered common dormouse, to foxes, roe deer and a large population of badgers, as well as to a host of woodland birds from goldcrests to jays.

It is not unusual to hear the high-pitched cries of buzzards or the honks of acrobatic ravens. Peregrines have also made a comeback and now breed in the area.

Commonest and most easily seen of all the birds of prey is the kestrel.

Many of the Mendip caves were lived in by ancient man and there are signs of his presence littered all over the plateau. The pools and rough grassland around the old mining area at Charterhouse, close to the Charterhouse Centre, form one of the best areas in the south-west for reptiles and amphibians. Follow the paths from here down through Velvet Bottom and Black Rock, or up into Long Wood and on to Cheddar Gorge and you will begin to appreciate just what is so special about these beautiful hills.

Caves in the Mendips are important winter sanctuaries for several species of bat, including this lesser horseshoe. The bats benefit from the cool but fairly constant temperatures.

In Gough's Cave, age-old rock formations adorn the walls and roof, creating a spectacular sight for the visitor when floodlit.

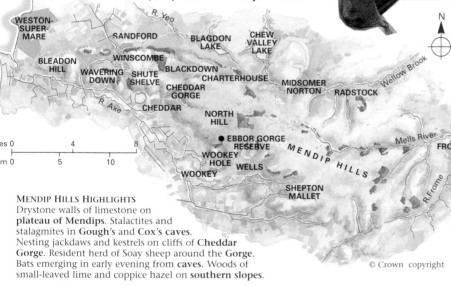

© Crown copyright

MENDIP HILLS HIGHLIGHTS
Drystone walls of limestone on **plateau of Mendips**. Stalactites and stalagmites in **Gough's** and **Cox's caves**. Nesting jackdaws and kestrels on cliffs of **Cheddar Gorge**. Resident herd of Soay sheep around the **Gorge**. Bats emerging in early evening from **caves**. Woods of small-leaved lime and coppice hazel on **southern slopes**.

AND ALSO
LOOK OUT FOR...
● sparrowhawk ● turtle dove
● swallow ● house martin
● blackcap ● garden warbler
● ringlet ● eyed hawkmoth
● speckled bush-cricket
● glow-worm
● brown-lipped snail
● angelica ● primrose
● autumn gentian
● lady's bedstraw ● selfheal
● calamint ● yellow-rattle
● hemp agrimony

Ox-eye daisy flowers are visited by a constant succession of pollinating insects.

Spring sandwort is the most attractive member of a small and select group of plants capable of growing on lead spoil tips.

Small copper
Lycaena phlaeas

Meadow flowers of all sorts are favoured by the small copper butterfly which visits them to feed on nectar. This small species is one of our most attractive butterflies, the upperwings having a beautiful orange-copper sheen to them while the underwings are buffish with dark spots. The sexes are similar. Small coppers are usually particularly common around the south-west coast because the foodplants of their larvae – docks and sorrels – are themselves so common.

see also page 262

The adult butterflies are on the wing in May and June and again in late summer as a second brood. In flight, the sheen on the wings can make the species difficult to follow.

The River Severn & Slimbridge

The Severn, the longest river in Britain, rises in Mid Wales and reaches the sea via the Bristol Channel. During the highest tides the inrush of sea water funnels the river upstream to create a spectacular wave known as the Severn Bore.

HISTORICALLY, THE river has been famous to fishermen for its salmon, eels and lampreys. Young eels, or elvers, arrive in their millions in early spring from their hatching ground in the Sargasso Sea. Other less well-known fish include twaite, shad and thin-lipped grey mullet. Huge conger eels have been recorded as far upstream as Sharpness.

The Berkeley Vale, stretching between Gloucester and Bristol, was once known for its cider orchards, Gloucester old spot pigs and double Gloucester cheese. Berkeley Castle is surrounded by parkland with many magnificent broad-leaved trees. Huge oaks shade herds of fallow and

Tens of thousands of ducks, geese and swans visit Slimbridge each year, providing superb close-up views.

red deer, while all three British woodpeckers, hole-nesting tits and stock doves find nest sites, and the occasional raven and buzzard fly overhead.

Near the castle there is a small museum to the memory of Edward Jenner, the 18th-century Berkeley-born doctor who discovered vaccination against smallpox. He was also the first to record a young cuckoo ejecting eggs from another bird's nest, and he marked birds to establish migration as a fact, so refuting the belief that birds hibernated at the bottom of ponds.

The Severn has long

been used as a highway for shipping to Gloucester and beyond, and when sea-going vessels increased in size, the Gloucester & Sharpness Canal was dug to transfer the freight by barge to Gloucester docks. Today, the canal is home to pleasure craft, but the towpath provides good views over adjacent meadows and the river. Pollarded willows provide nesting sites for little owls, wagtails and treecreepers.

New Grounds, the reclaimed saltmarsh at Slimbridge, has been protected by the Berkeley

family for centuries. The Wildfowl and Wetlands Trust, founded by the late Sir Peter Scott in 1946, has its headquarters here and manages 500ha (1, 235 acres); it is home to a comprehensive collection of the world's wildfowl.

SLIMBRIDGE HIDES

Screened walkways and hides allow visitors to watch the birds without causing disturbance. However, the appearance of a fox or the stoop of a peregrine immediately alarms the flocks of feeding wigeon or teal.

Up to 8,000 European white-fronted geese and

Treecreepers feed unobtrusively on trees, probing the bark with their long bills in search of insects.

numerous waders benefit from this winter sanctuary. All European species of goose have been recorded, and Slim-bridge remains the most likely place in Britain to see the lesser white-fronted goose. Most of the geese breed in the Siberian Arctic tundra and start to arrive in October.

Ducks – wigeon, pintail, shoveler, teal and gadwall – tend to range more widely, and waders use the estuary as a resting and feeding area on migration. In December, the reserve is a sanctuary for as many as 12,000 wildfowl and a similar number of waders, including lapwing,

Bewick's swans are the star attractions of the region with most birds being known individually by researchers on account of their unique bill markings.

The nodding flowers of water avens appear by damp ditches and in wet hollows in spring.

Shelduck

Tadorna tadorna

Striking black and white plumage, pink legs and a bright red bill make the shelduck easy to spot as it feeds out on the mudflat or estuary. Shelducks are usually seen in small groups, feeding by sifting small creatures from the surface of the mud. Although they can be seen throughout the year in the south-west, their numbers build up in the autumn and winter. In the spring, pairs nest in old rabbit burrows, often in areas of sand dunes. Not surprisingly, there are comparatively few areas left where they are not vulnerable to disturbance or predators.

Shelduck numbers on the River Severn build up in late summer. After breeding, birds move here from other parts of Britain to undergo their annual moult.

see also page 225

As its name implies, the drinker moth is invariably associated with damp habitats, especially those with lush grass growth.

dunlin, curlew, redshank, ruff, snipe and golden plover.

Slimbridge is specially known for the overwintering population of Bewick's swans. They were first recorded as regular visitors to the Severn in 1948, when they were attracted to Slimbridge by the tame North American whistling swans, to which they are closely related. Up to 500 now arrive each winter. Birds can be identified individually by their unique black and yellow bill pattern, and they have all been given names.

Over the seasons researchers have recorded longevity – a swan named Casino has been returning for 27 years – and the permanence of pair bonds.

South Finger hide provides views of wild geese in winter, while in summer you might see kingfishers. The South Lake with its reedbeds attracts warblers and waders, with Bewick's swans in winter. From raised boardwalks you can admire purple loosestrife, kingcups, fleabane and ragged-robin, and spot water voles, a Slimbridge speciality.

Each year, an influx of tiny elvers – an immature stage in the freshwater eel's life-cycle – arrives in the River Severn.

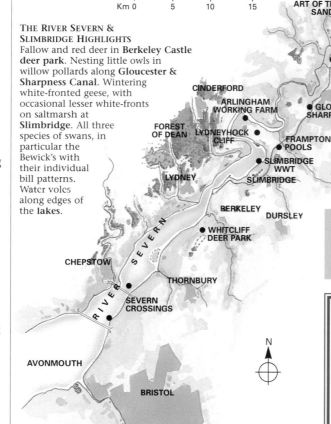

THE RIVER SEVERN & SLIMBRIDGE HIGHLIGHTS
Fallow and red deer in **Berkeley Castle deer park**. Nesting little owls in willow pollards along **Gloucester & Sharpness Canal**. Wintering white-fronted geese, with occasional lesser white-fronts on saltmarsh at **Slimbridge**. All three species of swans, in particular the Bewick's with their individual bill patterns. Water voles along edges of the lakes.

© Crown copyright

Despite the fact that it is common and widespread, meadow buttercup is an extremely attractive plant, the more so when it grows in great profusion.

AND ALSO LOOK OUT FOR...

● water vole ● grey heron ● moorhen ● water rail ● lapwing ● snipe ● black-headed gull ● reed bunting ● jackdaw ● osier ● alder ● ragged robin ● marsh-marigold ● celery-leaved buttercup

White-fronted goose

Anser albifrons

This attractive bird is a winter visitor to Britain, arriving in October and November and staying until the following March. Like other grey geese, the plumage is largely grey-brown with white on the stern and irregular black barring on the underparts. The species' diagnostic feature is the white forehead blaze seen in all adults. Birds from Greenland, which have orange bills, occur mainly in Scotland and Ireland while the European race, showing pink bills, occurs in England and south Wales. One of the largest concentrations of European birds, involving several thousand geese, is found at the Wildfowl Trust's reserve at Slimbridge in Gloucestershire.

see also page 225

Wet meadows and marshes on the banks of the River Severn at Slimbridge provide ideal feeding grounds for the thousands of white-fronted geese that visit the site each winter.

The Severn Bore is a surge caused by the incoming tide in the Bristol Channel being funnelled up the narrow river.

Forest of Dean

One of the most extensive areas of woodland in England, the Forest of Dean has long been managed for its timber; today it is a rich mix of mature oak, planted conifers and open clearings.

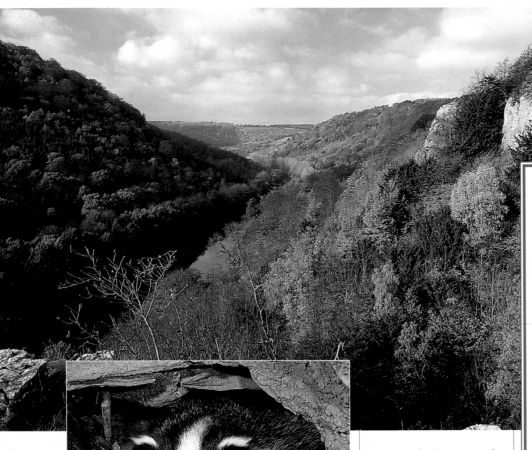

Small herds of fallow deer can be found feeding in rides and glades. They are most conspicuous in autumn and winter.

Panoramic views over the dense forest canopy can be seen from the rocky crag of Symond's Yat.

Pied flycatcher

Ficedula hypoleuca

The pied flycatcher is a bird of open woodland, favouring the so-called hanging oak woodland that covers some of the region's steepest valley sides. This is a migrant species, males often arriving before females in late April. It is an aptly named bird, at least as far as males are concerned, being an active insect catcher with striking black and white colouring. The female has similar patterning to the male but the black element in the plumage is replaced with brown. Pied flycatchers are hole-nesters and so favour woods with gnarled trees. They will, however, take readily to nest boxes and large colonies can be established by their provision, as at the RSPB's Nagshead reserve.

see also page 248

Pied flycatchers are among the most attractive of all our migrant birds, and newly arrived males sing a tuneful and distinctive song. Once breeding has finished, the birds become extremely difficult to see.

A T THE HEART OF THE forest is the Speech House Hotel, and an early morning walk in this area will be rewarded with a good selection of woodland birds. The thin, robin-like calls of hawfinches can be heard among the tall oaks, and marsh and willow tits can be seen easily here, with crossbills calling from the conifers beside the path.

In winter, the nearby lake holds interesting wildfowl, including

Badgers are surprisingly common in the region, although they seldom venture out of their setts until after dark.

goosander. Groups of fallow deer can usually be seen among the trees, while the smaller roe deer feed in the grassy clearings at dusk and dawn. Dusk is also the best time to try and see the nocturnal badger, emerging from its underground sett to follow

well-established routes to its feeding grounds.

South of this area is New Fancy, where a disused spoil-heap from mining activities affords an excellent viewpoint across the forest canopy. On sunny, still mornings in spring, raptors may be displaying, including the goshawks which have colonised the mature conifer plantations. The mewing calls of buzzard echo across the forest and the occasional peregrine commutes from its estuary hunting-grounds to nest-sites on the Wye Valley cliffs. Ravens, too, utter their honking calls as they tumble and roll in

display flights on clear February days.

A nearby disused railway line offers pleasant walking conditions through open woodland, with typical flora of bramble and blackthorn, bracken and foxgloves. Lineside vegetation dominated by rosebay willowherb provides nectar for insects, including conspicuous butterflies – silver-washed fritillary and white admiral are the specialities of high summer.

Honeysuckle flowers provide food for dormice in areas where continuous

canopy cover lets them travel through the wood.

In summer, the lake at Speech House is good for dragonflies, and the woodland rides and paths provide sunny perches for larger species such as the four-spotted chaser and the emperor dragonfly; the rare club-tailed dragonfly, which is a May breeder on stretches of the Wye, also feeds along the forest rides. North of the lake, woodland gives way to a more heathy area, where at dusk in summer the nightjar can be heard.

One of the best places

In flight, great spotted woodpeckers reveal striking black-and-white patterns on their broad wings.

It has been estimated that it takes around 200 years for a continuous carpet of bluebells to develop on undisturbed ground.

Foxglove
Digitalis purpurea

Although the foxglove can be found growing in a variety of habitats in Britain, it is primarily thought of as a woodland species. Glades and rides in the Forest of Dean provide ideal settings for this striking and distinctive plant. Foxglove has soft, oval leaves which are largest at the base and grow as a rosette before the flower spike appears. The broad, tubular flowers are attractive both in terms of shape and colour and the angle at which they are held ideally suits the bumblebees that visit them for nectar; at the same time, they pollinate the flowers. Foxglove is a source of the drug digitalin, which is used to treat heart disease.

see also page 301

In common with many other woodland flowers, foxgloves respond well to traditional woodland practices such as coppicing, the plants taking full advantage of the increased light on the woodland floor.

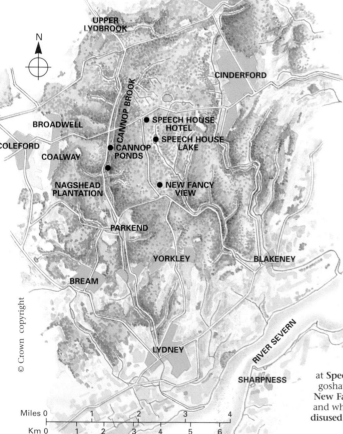

© Crown copyright

DRYBROOK
UPPER LYDBROOK
CINDERFORD
BROADWELL
COLEFORD
COALWAY
CANNOP BROOK
SPEECH HOUSE HOTEL
SPEECH HOUSE LAKE
CANNOP PONDS
NAGSHEAD PLANTATION
NEW FANCY VIEW
PARKEND
YORKLEY
BLAKENEY
BREAM
LYDNEY
RIVER SEVERN
SHARPNESS

N

Miles 0 1 2 3 4
Km 0 1 2 3 4 5 6

AND ALSO LOOK OUT FOR...
● pipistrelle ● yellow-necked mouse ● sparrowhawk
● turtle dove ● cuckoo ● blackcap ● garden warbler
● siskin ● speckled wood ● orange-tip ● holly blue
● Welsh poppy ● angelica ● wood-sage
● hedge woundwort ● sneezewort ● dryad's saddle
● honey fungus ● wood blewits ● clouded agaric

As its name suggests, wood spurge is a forest species that thrives where sunlight penetrates to the forest floor.

FOREST OF DEAN HIGHLIGHTS
Wild daffodils in **open grassy clearings** of the forest. Hawfinches, and marsh and willow tits at **Speech House**. Dragonflies at **Speech House Lake**. Displaying goshawks above the conifers from **New Fancy**. Silver-washed fritillary and white admiral butterflies along **disused railway**.

In September, the delicate flowers of autumn crocus appear on grassy areas in many parts of the forest.

ditions favour a wealth of mosses and liverworts.

Bats are also well represented in the forest: the country's largest colony of lesser horseshoe bats is found here, while one of England's 15 known breeding roosts for greater horseshoe bats can also be found in an old manor house at the heart of the forest.

Visiting bats' breeding or hibernation sites causes too much disturbance, but evening watches over unimproved grasslands with old hedges may provide exciting sightings.

in the forest for bird-watching is around Parkend village, and particularly at the RSPB reserve at Nagshead. The village churchyard in winter often holds a good flock of brambling,

feeding on tree seeds.
Nagshead is one of the very best sites in England for pied flycatcher; its song is often heard with the trilling of wood warblers high above in the tall beeches and oaks.

The bird community of summer visitors is completed by the conspicuous song-flighting of tree pipits and the flickering, brick-coloured tail of shy redstarts. These woods are also a good place to see all three woodpeckers.

Just to the north of Nagshead is Cannop Brook, which has been dammed in places to form small ponds. The brook itself is the summer haunt of dipper and grey wagtail, while mandarin duck has been recorded on the ponds in winter. Siskins feed in the alders in winter, and damp con-

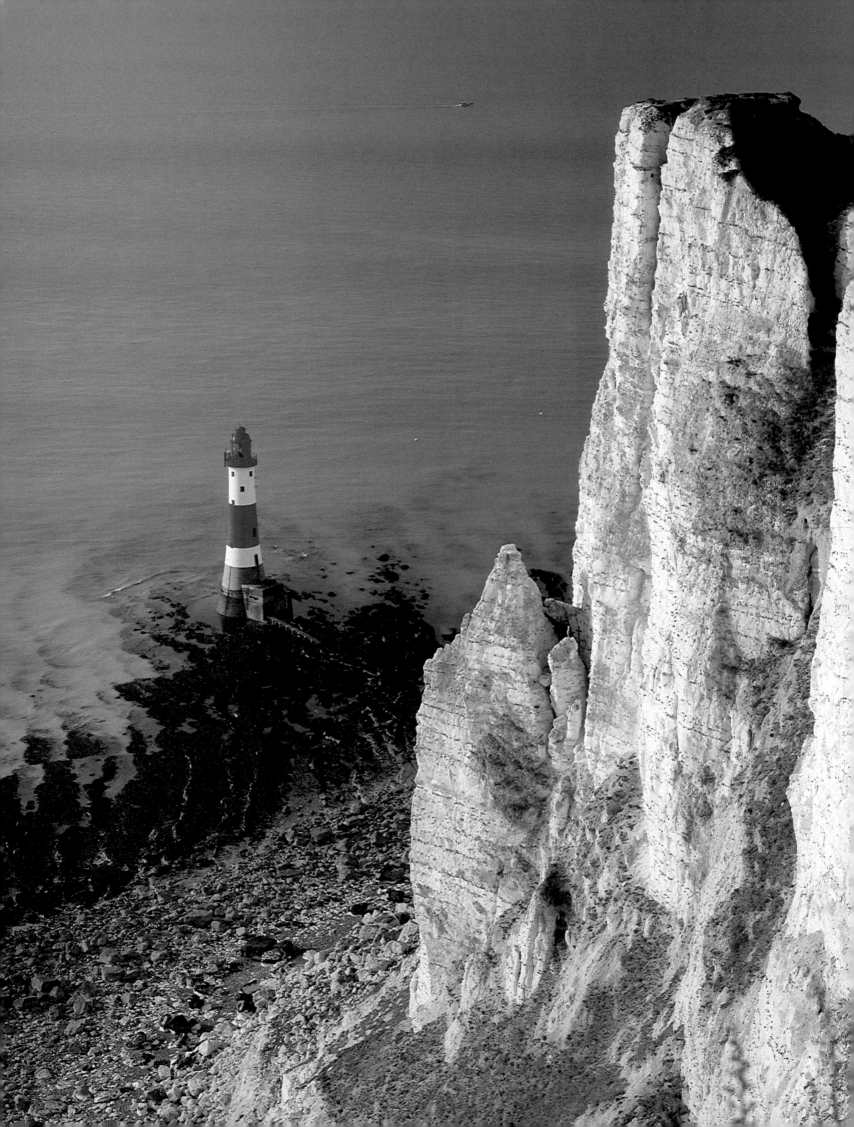

Southern England

Southern England is a region of enormous contrasts. Sitting at its heart is London, one of the world's busiest capital cities. But wander away from the towns and you find a wonderful landscape of woods, heaths and downs, of Medieval forests and deer parks, of rivers, mudflats, dunes and shingle beaches. The region has a uniquely Continental flavour. Brighton is as close to Paris as it is to Birmingham, and warm southern summers attract many fabulous species that reach their northerly limits in south-east England.

Like natural battlements, the chalk cliffs of Beachy Head and the Seven Sisters define southern England's boundaries in a dramatic way. The short turf – part of the South Downs – on the top of the cliffs is rich in flowers and insects, some of which find their ideal sites here on the edges of the English Channel.

Geology provides the bones of the landscape. Although the soft sedimentary rocks of lowland Britain may lack the drama of the more rugged north and west, the contrast between sandstone, clay and chalk, together with a varied coastline, produces a landscape of great diversity and variety of habitat.

THE ROCKFACE

For centuries, most visitors' first glimpse of England has been the dramatic chalk cliffs of the South Foreland, rising 100m (330ft) vertically from the sea. Throughout history, the White Cliffs of Dover have stood as an icon of the English nation; in fact, chalk provides the framework of the whole region, defining and encompassing its various parts.

Chalk is a soft limestone of amazing purity, laid down on the bed of the warm tropical sea that covered most of north-west Europe between 70 and 100 million years ago. The dry, thin soils that developed over the chalk hills are exceedingly infertile, and this is largely responsible for the extraordinary richness of the sheep-grazed downland turf. The soil is too poor to enable luxuriant species to suppress less vigorous neighbours, with the result that up to 40 differ-

Even when scrub encroaches on to the short, open turf of the South Downs, the landscape is often enriched by colourful flowering shrubs, and their associated insects.

ent species can be found growing within a square metre/square yard of turf, including many rare species of orchid. The warm south- and west-facing slopes are also famous for their downland butterflies, with rarities such as the adonis blue, chalkhill blue and silver-spotted skipper. Much of the old downland turf has been lost to agricultural improvement in recent years and relatively little now remains outside nature reserves. There is some hope that schemes such

as 'set-aside' and the Wildlife Enhancement Scheme may begin to reverse the process.

UP ON THE DOWNS

From where they meet the sea, between Folkestone and Sandwich, the North Downs swing inland through north Kent into Surrey, narrowing to less than 0.5km (500 yards) at the Hog's Back, before widening into the great expanse of the Hampshire Downs, westwards to Salisbury Plain.

To many, Sussex is synonymous with the South Downs. From Beachy Head and the Seven Sisters, Gilbert White's 'chain of majestic mountains' runs westward for 90km (56 miles) to join

SOUTHERN ENGLAND HABITATS

Discover shingle beaches

Try walking across an area of shingle and you will soon discover the unstable nature of this unusual habitat. At first glance such a stony environment might seem too hostile and precarious to support life, making the prospect of visiting an area of coastal shingle in search of wildlife an uninviting one. Once there, however, look carefully and you will quickly discover a thriving community of specialised plants and animals.

Shingle beaches can be found along many stretches of the British coastline in areas where currents and coastal geology are suitable. The pebbles, from which

The shifting substrate may limit plant life on the shingle shore but just behind this you will find plenty of hardy colonists.

shingle beaches are made, is formed by wave action in the general process of coastal erosion. In some areas, shingle fringes long stretches of the coast, the stones having been thrown up by vigorous wave action above the level of silt and sand lower down the beach. Elsewhere, long spits

Yellow horned-poppy is a wonderfully hardy plant, able to thrive in unstable, free-draining shingle lashed by salt-laden winds.

the Hampshire chalk at Butser Hill. From Salisbury Plain the chalk ridge continues north-eastwards, via the Vale of Pewsey, to the rolling hills of the Marlborough and Berkshire Downs. North of the Goring Gap, the heavily wooded slopes of the Chilterns provide a strong contrast. The steep scarp slope faces north-west, giving fine views over the intensively cultivated clays of the Vale of Aylesbury towards Oxford and the limestone ridge of the Cotswolds.

While much of the downland scenery consists of gently undulating hills of grassland and arable land, other areas are heavily wooded. The core of the Chilterns, in Buckinghamshire, is known for beechwoods, and in Kent, woodland clothes the North Downs west of Canterbury. Likewise, in West Sussex, west of the Arun, almost all of the Downs belonging to the great estates are wooded, and are even thought to include small remnants of the primeval down-land forest of wych elm, large-leaved lime, ash and maple. Some 7km (4 miles) north of Chichester is Kingley Vale, the largest yew wood in Europe and one of Britain's first national nature reserves.

DOWN IN THE WEALD

Enclosed by the rim of the North and South Downs and the Hampshire chalk lies the Weald. The word 'weald' is the Anglo-Saxon for 'forest', and the Anglo-Saxon Chronicle for the year 892 describes the area as 'that great wood which we call Andred as being 120 miles or more from east to west and 30 miles from north to south'. Even today, this is still the most heavily wooded part of the country and, viewed from a high vantage point on the South Downs, gives the impression of a more or less uninterrupted stretch of forest.

Thursley Common is one of our best heathland sites. It is managed and conserved by English Nature as a National Nature Reserve.

Gorse is one of the most characteristic heathland plants. The stunning yellow flowers are beloved of pollinating insects.

The beautiful Adonis blue is restricted to areas of chalk downland in southern England where its larval foodplant – horseshoe vetch – flourishes.

The Surrey and West Sussex heathlands, golden with gorse in the spring and purple with heather in the summer, are among the best left in western Europe. Meadow and tree pipits, skylark, woodlark, stonechat and hobby are among the characteristic birds, while summer evenings are enhanced by the evocative churring of nightjars. The natterjack toad, once common in many larger ponds, still maintains a precarious existence. Valley bogs covered by multi-coloured sphagnum moss become yellow and white with bog asphodel and cottongrass in mid-summer. This flavour of the moorlands is offset by dragonflies, crickets, grasshoppers and solitary wasps

Little terns are attractive summer visitors to the region and nest successfully on sites protected from disturbance.

are created by drift, the pebbles being carried along by the currents of the sea.

View a shingle beach in cross-section and the seaward side is invariably steep and continually shifting. It is hardly surprising that little plant or animal life can be found here, but follow the beach up and over the ridge and it is a different matter. Specialised

plants such as sea sandwort, yellow horned-poppy and sea kale soon colonise and the stability they create allows less pioneering but nonetheless hardy species such as sea campion, thrift and sea radish to flourish.

A range of invertebrates can be found in and on the shingle, typically where plants have colonised successfully, and these provide food for passing migrant birds as well as a few resident species. In ornithological terms, however, shingle beaches are best known for the colonies of seabirds such as terns and gulls that they support. Like the ringed plovers and oystercatchers which also frequently nest on shingle, the birds are effectively excluded by human disturbance from all but the most isolated or protected of beaches. Fortunately, there are several coastal shingle sites where all or part of the area receives protection during the breeding

Sea-holly

Eryngium maritimum

Few plants can boast as fearsome an array of protective spines as sea holly. This beautiful species is characteristic of sand dunes and shingle beaches around the south-west. As its name suggests, the leaves are superficially holly-like and incredibly spiny. Both the leaves and stems are an attractive blue-green or grey-green colour. Sea holly grows in dense clumps upon which there are blue flower heads from June to September.

See also page 294

The sharp spines of the sea-holly are a deterrent to any grazing animal. Cultivated relatives of this plant will be familiar to many gardeners.

season; Pagham Harbour and Rye Harbour, both on the south coast, are both excellent.

Dungeness in Kent is one of the best-known shingle sites in Britain, a vast triangular area of stones comprising innumerable ridges laid down successively by time and tide. The wildlife of Dungeness is prolific by shingle standards and many species are unique, or nearly so, to the area. Away from the sea, large-scale extraction has created a new series of habitats in the form of flooded pits that now serve as magnets for breeding and wintering birds.

of a much more southerly distribution.

Between the rocky outcrops known as Greensand and the High Weald is the broad expanse of clay country known as the Low Weald. Traditionally, this is an area of small-scale mixed farms and woodland. In Kent it is a land of orchards and hop-gardens which, together with the neighbouring part of the High Weald, have earned it the title 'garden of England'. The western Low Weald is the most densely wooded of the whole area. Much of it is old wood-common, from which the grazing animals have long gone. But the ancient glades are a stronghold of the purple emperor, white admiral, silver-washed fritillary and wood white butterflies.

HISTORICAL ROOTS

Halfway between London and the south coast lies Ashdown Forest, the largest single tract of open countryside in southern England, east of the New Forest. Once a royal forest, the 25sq km (10 square miles) of valley woodlands, heath and bog were granted to John of Gaunt by Edward III in 1372. About half the original forest survives as commonland. This is the core of the Weald, where you can stand and view both the North and the South Downs from the same spot: a landscape made famous by E A Shepherd's sketch map in Winnie the Pooh (although few at the time knew where the 'Six Pines' and 'Hundred Akerwood' were located).

The heathland is much like that of the western Weald, but its topography is more varied, with headstreams of the Wealden rivers excavating deep ravines. Here tree and meadow pipit and skylark sing overhead, while whitethroat, Dartford warbler and stonechats

Although much of Ashdown Forest is in fact heathland, considerable areas of wealden woodland can be found. Autumn colours provide a romantic setting for an afternoon stroll.

Open heathland, studded with gorse bushes, is ideal for stonechats which luckily often perch prominently.

take up residence in the gorse. The forest is also home to the country's largest population of nightjars. In September, for those who know the secret, the sky-blue trumpets of the marsh gentians can be found scattered among the purple moor-grass.

Ashdown Forest lies at the centre of the High Weald. This part of the densely populated south-east has a remote and intimate feel, particularly to the east of the forest. In places, the narrow green lanes, wooded streams, steep ravines, small irregular fields and broad strips of woodland, known locally as shaws, remain almost unchanged since the Middle Ages. However, the Weald was not always a place of peace and rural tranquillity. In the Middle Ages the Wealden iron industry was one

SOUTHERN ENGLAND HABITATS

Discover heathland

A visit to an area of southern heathland on a warm spring day can be an unforgettable experience. A heady fragrance of coconut fills the air from the mass-flowering gorse, which turns whole slopes bright yellow for a few weeks of the year. Singing birds and flying insects are everywhere to be seen, giving an almost Mediterranean feel. A return visit later in the season will be no less memorable, the entire landscape becomes purple when the ling is in flower during the summer months.

Heathland is essentially a man-made habitat; at the very least it is heavily human-influenced.

Heathlands are dominated by members of the heather family. Chief among them is ling which flowers in July and August.

Once much of southern Britain was covered with forest but the tree cover was gradually removed by early Britons so that the timber could be used for fuel and building, and the land for grazing. Where cleared lowland areas were sited on free-draining sandy soils,

The nightjar is a rather strange nocturnal bird which visits Britain in the summer.

of the most important in the country, and dominated the landscape until it was finally supplanted by coke-fired furnaces at the end of the 18th century.

The Weald produced the finest oaks in the kingdom, the legacy of which can be seen in its fine timber-framed buildings. Its woods were traditionally managed as coppice-with-standards, the coppice producing the charcoal for the iron industry as well as the wood for the more traditional rural crafts. Much of the coppice was – and still is – sweet chestnut, with hornbeam on the poorer, damper soils. Recently there has been a resurgence of interest in traditional woodland management and rural crafts, and increasing areas of coppice are being restored to productivity.

A special feature of the woodlands of the High Weald are the massive outcrops of sandstone, known locally as Ardingly Stone. Particularly good examples can be seen at High Rocks, near Tunbridge Wells. When quarried and dressed it makes a fine building stone, extensively used in local churches and houses. These damp, wooded sandstone outcrops support an extraordinary assemblage of plants, such as the Tunbridge filmy-fern, that are more characteristic of the wetter western edge of the country. The streams, known locally as gills, that flow in the deep ravines in the sandstone are home to the delightful grey wagtail, and buzzards are beginning to return to the more secluded valleys.

ANCIENT FOREST

Almost exactly midway along the south coast of England, sandwiched between the Hampshire Downs and the sea and bordered on the east by the Solent and on the west by the River Avon, lies one of the most exciting wildlife areas in western Europe – the New Forest. Some time around 1079, William the Conqueror declared this area a royal hunting forest. The original perambulation enclosed 37,904 ha (93,659 acres), and the 20,000ha (49,000 acres) of unenclosed forest now constitute the largest area of wild countryside in lowland Britain.

To the visitor travelling westwards along the A31 towards Ringwood, the forest looks like a vast area of heathland with occasional glimpses of woodland. However, it also boasts the largest area of lowland acid valley bogs in Europe, where careful searching will reveal such rarities as the bog orchid, long-leaved sundew and marsh gentian. For many, the most dramatic and evocative aspect of the forest is the primeval woodlands, with their massive, majestic, ancient oaks and beeches – it is the largest woodland of its kind in western Europe.

Royal forests were established primarily to protect deer and their grazing grounds, and to enable the Norman and Plantagenet kings to indulge in their love of the chase. (Indeed, William II was killed by an arrow while hunting in the New Forest.) Today the most conspicuous animals are the New Forest ponies which, together with the deer and domestic cattle, are responsible for the lawn-like appearance of much of the area – this kind of management is known as pasture woodland. The ponies' origins are lost in history, but it is thought that the stock has been 'improved' at various times with the introduction of Arab blood. Of deer species, the fallow are the most numerous in the forest and are thought to be the direct descendants of those introduced by the Normans. Native red deer

Marsh gentian is a highlight of the botanical autumn. Its intense blue trumpet-shaped flowers can be found in damp grassland on a few heaths in southern England; where conditions suit it, it can be common.

The beautiful banded demoiselle is a widespread damselfly in the south. Look for it near streams.

Dartford warbler

Sylvia undata

Perched on top of a spray of gorse and uttering its distinctive churring alarm call, the Dartford warbler is one of the most characteristic birds of southern heathlands. Uniquely among British warblers, it is a year-round resident. Even at a distance and in silhouette, this tiny bird is fairly easy to identify because of its habit of cocking its tail almost vertically when perched.

See also page 247

In poor light and at a distance, a Dartford warbler can look all dark. In good light its plumage can be appreciated to the full.

the acid, nutrient-poor conditions encouraged heathland communities of plants to flourish. The most characteristic floral elements are members of the heather family that lend the habitat its name. The three widespread heather species – ling, cross-leaved heath and bell heather – show a preference for soil moisture. Their precise occurrence reflects the underlying soil saturation. Particularly waterlogged areas of heath develop into acid bogs, the terrain turned bright green by the bog moss that predominates.

Part of the thrill of visiting a heathland is the prospect of discovering species found in no other habitat in Britain. The habitat is particularly good for reptiles and two of our species – sand lizard and smooth snake – are essentially restricted in southern England to heaths. Then there are the speciality birds that include the Dartford warbler, hobby, woodlark and nightjar, all of which have their British strongholds on heathland. Invertebrate life abounds too – notably dragonflies, beetles and spiders – and for the botanist boggy areas are a rich hunting ground for sundews, bog asphodel and, in a few locations, the diminutive bog orchid.

For many, heathland is one of our most precious habitats, the characteristic wide-open vistas creating an effective impression of wilderness in southern Britain. The habitat is also one of the most vulnerable. Ironically, neglect can be as much of a problem as intervention in some senses, since natural vegetation succession leads to encroachment by birch and sometimes conifer scrub. Unless checked, the heaths eventually revert to scrub and then woodland.

Bell heather favours dry areas of heathland with free-draining soils. Spikes of purple flowers appear in the summer.

oped in Britain. Nonetheless, it includes some of the richest areas for coastal wildlife in the country.

Where the coastal plain between Portsmouth and Selsey Bills looks across to the Bambridge cliffs on the Isle of Wight, it is dissected by the drowned valleys of Langstone and Chichester harbours. In winter these extensive intertidal mudflats, beds of cord-grass and saltmarsh support huge flocks of waders and wildfowl, including large numbers of brent geese from Siberia.

Between Arundel and Pulborough the River Arun meanders through a broad flood plain that reaches its greatest extent at Amberley Wild Brooks. This 360ha (889 acre)-area of grazing marsh and meadow, dissected by an intricate pattern of drainage dikes, still floods most winters, providing refuge for the beautiful Bewick's swans, fresh from their Arctic tundra breeding grounds. Large areas of grazing marsh are now almost confined to the Norfolk Broads and the Somerset Levels: one of the few exceptions are the flood plains of the Sussex rivers. Astonishingly, the drainage dikes of the Wild Brooks contain more than 60 per cent of the total British aquatic flora, including such rarities as the sharp-leaved and hairlike pondweeds and rice-grass. The aquatic invertebrates are no less exciting, especially the water snails and dragonflies.

From Brighton eastwards, the coastal plain gives way to the chalk cliffs, culminating in the Seven Sisters and Beachy Head. Those to the west of Newhaven, with their capping of dark-coloured sands of Reading beds, have recently been colonised by nesting fulmars, so completing one of the most astonishing southward expansions ever recorded in the breeding range

Wherever they occur in the New Forest, ponds act as magnets for wildlife. Look closer for treats!

As its name suggests, the bog orchid grows only in the wettest situations, often on floating bogs among sphagnum mosses.

have been reintroduced and roe deer have expanded here as in much of the rest of the country. In the south of the forest is a small herd of sika deer, introduced from Beaulieu.

ALONG THE COAST
The New Forest meets the Solent between the Lymington and Beaulieu Rivers. Bucklers Hard, on the lower reaches of the Beaulieu River, developed as an important shipbuilding centre in the 17th century, exploiting its ready supply of forest oaks. Between the Fawley oil refineries and Southampton in the west and the North Foreland in the east, the south-eastern coast has the dubious distinction of being the most devel-

SOUTHERN ENGLAND HABITATS

Discover urban wildlife

With the majority of the British population living in towns or cities, for most us the countryside is a place to be enjoyed on weekend visits. However, most urban areas in Britain are surprisingly rich in wildlife if you look hard enough. Indeed, many budding naturalists gain their first insights into the subject by discovering and exploring the plants and animals in gardens, parks or urban wetland sites.

Visually, mature gardens obviously have a lot in common with woodland clearings or natural scrubby areas, although they are more manicured and frequently comprise mainly alien

To encourage small tortoiseshells into your town or city garden, grow plenty of nectar-rich flowers in the borders and leave patches of stinging nettles for the caterpillars to feed on.

species of plant. The choice of non-native species may give the gardener more scope for colour

Nature reserve status protects habitats for wild flowers and insects at London's Camley Street and allows the capital's schoolchildren to experience at taste of the wild just north of King's Cross station!

Amberley Wild Brooks is a wonderful mosaic of wetland habitats that supports a wealth of marsh-loving wildlife.

Outside the holiday season, popular beaches such as this one at Compton offer fabulous opportunities for exploration.

of a bird. Up until the beginning of the last century they were confined in the eastern Atlantic to St Kilda and Iceland. Peregrines have also begun to return to the cliffs sites that they occupied before agricultural pesticides drove them to the verge of extinction in the 1960s.

Between Eastbourne and Bexhill is the broad expanse of the Pevensey Levels, an ancient grazing marsh protected from the sea by the flimsy strip of shingle fronting Normans Bay. Similar in its natural history to Amberley Wild Brooks, but more than 10 times the size, the Levels can pro-

duce a real feeling of timelessness as you stop and listen to the wigeon calling out of the mist on a January morning.

East of Hastings, the rocks of the central Weald meet the sea in a short range of cliffs, which abut the western corner of the marshes and shingle of Romney Marsh and Dungeness. This is a coast redolent in history and dramatic change, brought about at the whim of the sea. The town of Old Winchelsea was totally destroyed by a storm in 1287, and the population moved to a new cliff-top site. In 1539,

Henry VIII built Camber Castle on the seaward shingle ridge to Rye Bay, but today it stands isolated 1.5km (1 mile) from the sea. Romney Marsh itself has long been reclaimed and drained, and Dungeness is the largest shingle foreland in Europe. Here it is possible to see what shingle vegetation looked like before the beaches were invaded by people. In June the shingle is purple, white and yellow with sea pea, sea-kale and the special prostrate form of broom. At the same time, the air is full of the screeching of nesting terns, and the sharp-eyed can spot the

and variety but, unsurprisingly, fewer species of insects are likely to find the foliage palatable. This has a knock-on effect upon insect-eating animals, especially birds. Nevertheless, unless heavily sprayed, most gardens will support thriving invertebrate communities and birds such as robins, blackbirds and starlings at the very least.

A number of opportunistic creatures have taken advantage of the spread of urban development and followed us into towns and cities. Butterflies such as small

tortoiseshells and large whites, for example, are just as common in towns as they are in the countryside, and plants such as Oxford ragwort flower along roadsides and railway tracks. Even a few species of animal seem to be close to making the break from being truly wild. The prospects for hedgehogs, for example, are closely linked with humans and these charming animals are far more widespread in gardens than they are in areas away from settlement. House martins and swifts, too, are

Collared dove

Streptopelia decaocto

Strange as it may seem, the collared dove was unknown in Britain until 1955, since when it has spread across the entire country. It seems to favour urban gardens and is often seen perched on television aerials, uttering its *oo-OO-oo* call. London's parks and formal gardens are also good for this species. It is a pinkish-buff bird with a relatively long tail which bears a broad, white band. Collared doves usually feed on the ground searching for grain and seed and are often seen in pairs.

See also page 240

Although the species is now widespread in Britain, the collared dove is invariably associated with people, favouring farms as well as towns and villages.

Hedgehogs probably reach their highest densities in Britain on the fringes of urban areas and are frequent visitors to gardens throughout the summer months, when many are busy raising young.

closely tied to people, nesting almost exclusively on or in buildings.

Some of the animals and plants with which we share our lives are less welcome than others. Fortunately, however, there are far more species that have a positive benefit in the garden and we can do plenty to encourage

them. A small pond will very quickly become a restful haven for aquatic creatures, and frogs and toads will consume large numbers of pests. Hedgehogs too feast on invertebrates and can be encouraged by the creation of refuges in the shape of partly hidden boxes lined with straw or log piles.

The mistle thrush is a widespread species in the south. It often nests in parks and gardens as well as rural woodlands. Listen for its distinctive song in suitable places.

beautiful Mediterranean gull nesting among the black-headed gulls. Dominating the whole wonderful area is the huge eerie hulk of the Dungeness power station.

The Kent coast, from Deal to the North Foreland and west to Whitstable, is almost wholly built up, except for the marshes, sand dunes and mudflats of the Stour Estuary and Sandwich Bay. Here golf links and nature reserve co-exist on the best stretch of sand dune in the south-east, famous for its lizard orchids and the strange, parasitic bedstraw broomrape. Tradition has it that the Saxon Hengist arrived here in around 449, and it was here that St Augustine

Ancient oaks in Windsor Great Park support thriving populations of beetles and other invertebrates, some of which are found nowhere else in Britain.

landed in 597, on his mission to bring Christianity to the English.

THE THAMES VALLEY

Between the North Downs and the Chilterns the chalk dips below the sands and clays of the Thames Valley. The river carves its way through the gorge of the Goring Gap, between the Berkshire Downs and the Chilterns, towards

Pangbourne and Reading, where it forms the northern boundary of Berkshire. Windsor Great Park is the sole remaining fragment of the ancient royal forest of Windsor which, in the Middle Ages, stretched 64km (40 miles), as far west as Hungerford. The 6,000ha (14,800 acres) of old deer forest are famous for their ancient oaks and beeches – and for the beetles, fungi and lichens that depend on them.

Parkland estates are also a feature of the intensively farmed countryside of Hertfordshire, but some heathland remnants do still survive on the more acid sands, usually as a result of the survival of commoners' rights. On the heavier soils,

SOUTHERN ENGLAND HABITATS

Reading the landscape

Country cottages are often built from local timber – invariably oak – and have roofs made from reed or straw thatch.

Chalk downs are a reminder that sheep-grazing once dominated large areas of land.

The White Cliffs of Dover were traditionally the traveller's first sight of Britain. Although a soft limestone, the chalk resists the weathering that has worn away weaker rocks around it, so the downs stand out as a framework to the landscape of southern England.

The rocks of this part of Britain were thrown into gentle folds by the outer ripples of the collision between Europe and Africa that formed the Alps. A long fold runs like an upturned gutter from the Berkshire Downs to the Channel coast of Kent and Sussex. The crest of the eastern part of this has eroded away, leaving the chalk escarpment of the North and South Downs as a sharp rim, cut by the sea near Dover and at Beachy Head. Within this rim, the lower-lying country of the Wealden clays and sands carry fine tracts of ancient woodland. Resistant sandstones stand up as

Even in London, ponds and woodland such as these in Highgate offer refuges for a fantastic range of plants and animals.

large areas were traditionally managed as oak-hornbeam woodland. The latter was coppiced, chiefly for fuel, while the former provided mature timber. Commercial coppicing has now declined, as there is little call for the hornbeam, but when these woodlands do survive they provide a vivid display of spring-time flowers as well as a refuge for dormice and the typical woodland birds.

Dominating the whole region is the nation's capital, with a population of 6.7 million within its 1,580sq km (610 square miles). In spite of motorways, suburban growth and high-rise estates, London has a surprisingly rich natural history – and not only in the traditional remnants of its once rural margins, such as Hampstead Heath and Wimbledon Common, or in the descendants of the old royal parks,

The Thames, once the lifeblood of the city of London, is now a focus for recreation. It is cleaner now than it has been for at least a century, and many species of bird and fish are once again finding a home in this broad and beautiful river.

such as St James. Newly created oases, such as cemeteries and reservoirs, canal-sides and dockland, gravel pits and railway sidings, have all been colonised by a unique range of plants and animals. Staines Reservoirs boast one of the largest concentrations of wintering wildfowl anywhere in the British Isles, and the Thames itself is at last beginning to feel the benefit of pollution control legislation: salmon once again successfully navigate what was originally one of the prime salmon rivers of Europe.

On the continent, robins are shy, woodland birds. But, luckily for us, in Britain they are generally bold. The 'gardener's friend' is found even in city-centre parks and gardens.

tracts of often heathy country with acid, leached soils, as on the lower greens and at Hindhead and Leith Hill, and the older rocks of the High Weald in the hilly country east and west of Ashdown Forest.

Downfolds to the north and south formed shallow basins – London lies in one, Southampton and Bournemouth in the other – which became filled in by younger deposits. In south Hampshire, sands and gravels form the acid heathland soils of the New Forest and its surroundings; bands of clay often impede the drainage and the valley bogs are a characteristic feature. The line of chalk hills across the middle of the Isle of Wight forms a southern rim to the basin, broken at the sea stacks of the Needles, but continued on the other side of Poole Bay in Purbeck.

To the north, much of the London basin is occupied by the

London clay, tenacious and impermeable – ideal for the construction of London's underground railways, but the heavy soils are less popular with suburban gardeners. The clay is relieved here and there by gravels, and gives way westwards to the gravels and sands of the heathy country of Surrey, north Hampshire and Berkshire.

North and west of London the dip-slope of the chalk rises gently to the long escarpment of the Chiltern Hills and the Berkshire Downs, a prominent feature as you approach by road from the north.

Beyond these hills, bands of successively older rocks strike diagonally across the country – soft clays from Oxford to Bedfordshire (where the country around the brickworks rivals Fenland in its flatness), giving way to the Jurassic limestones of the Cotswold dip-slope in north Oxfordshire.

So long as disturbance and pollution are controlled, canals such as the Basingstoke Canal are superb wildlife habitats, noted for their dragonflies in particular. Nature is a wonderful adaptor, and the fact that canals are manmade poses no barrier to their being a fantastic haven for all manner of plants and creatures.

WHERE TO GO

Southern England

Visitors to the south are fortunate to have a wealth of sites to visit on top of those covered in the region's main section, on the pages that follow. The places featured here are all great for a day out – and this list is by no means exhaustive!

1. BEACHY HEAD AND SEVEN SISTERS

To appreciate their beauty, Beachy Head and the Seven Sisters are best viewed from the sea: the sheer white cliffs tower to some 150m (500ft) at their highest point. On the landward side of the cliffs, the chalk downland supports a rich population of flowers and butterflies. The latter include marbled white and no fewer than five species of blue. Areas of scrub are rewarding places to find migrant birds in spring and autumn – remember that for many small migrant birds, autumn passage starts in early August. Sea-watching can be good in the spring from Birling Gap.

2. BLEAN WOODS

These extensive woodlands to the north and west of Canterbury owe their survival to the poor underlying soil of gravel on London clay. Blean is one of the most ancient deciduous woodlands in southern England, with extensive areas of oak together with stands of sweet chestnut coppice. Breeding birds include nightingales, redstarts and wood warblers, but these woods are most famous for their colonies of heath fritillary butterflies, best seen in early July. This is one of our rarest and most localised butterflies: its caterpillars feeds on cow-wheat.

3. BOUGH BEECH RESERVOIR

This attractive lake in the Kentish Weald was first flooded in 1969. Since then it has been intensively scrutinised by bird-watchers, so few birds pass here unseen. More than 230 species have been recorded, including many rarities ranging from night herons to little crakes. It one of the most reliable sites in southern England to see ospreys and although they rarely pause for long in the spring, young birds may linger for days during the autumn. Autumn is also the best time to see passage waders as the water levels are invariably low, revealing muddy fringes to the lake.

4. GILBERT WHITE COUNTRY

Visit Selborne to enjoy the beauty of the hanging beech-woods that still dominate this quiet corner of Hampshire. This is where the celebrated naturalist the Reverend Gilbert White wrote *The Natural History of Selborne*, first published in 1789. Many of the creatures and plants that intrigued White can still be found here: the hanger above Selborne supports ferns such as hartstongue, hard fern and male fern, and wood warblers and nuthatches breed. Try and find time, too, to visit White's house, now the Gilbert White Museum.

Little has changed to the countryside surrounding Gilbert White's home at Selborne in Hampshire, and his famous zigzag path still allows access to the beech hangers which overlook this rural village.

5. LEE VALLEY

The River Lee flows directly south from Ware in Hertford-shire to join the Thames not far from Tower Hamlets. Along its valley are a number of notable sites for wildlife, including Walthamstow and the King George V reservoirs, the RSPB reserves at Rye Meads and Rye House Marsh, and the River Lee Country Park. The latter has numerous paths, and is a rewarding site year round. In winter, its Waverley Hide has a well-founded reputation for being the best place in Britain to see bitterns at close range.

6. PEVENSEY LEVELS

Once an area of tidal mudflats, the Pevensey Levels were reclaimed long ago to form a large area of low-lying grazed field dissected by dykes. A diverse floral and invertebrate community is a feature of these ditches – frogbit, bur-reed and reedmace are

The network of drainage ditches that criss-cross the Pevensey Levels are the haunt of numerous water plants and aquatic invertebrates. Bird-watchers too find plenty of interest at this wetland site throughout the year.

common, and this is one of the few sites where the rare great silver water beetle (Britain's largest water beetle) can be found. In spring, listen for drumming snipe and watch out for the lively displays of redshank and lapwing.

7. RYE HARBOUR

This extensive area of shingle is an excellent place to look for migrant birds, moths and butterflies. In the summer, nesting little and common terns are an attraction, while the series of flooded pits often hold interesting wildfowl and waders. The introduced marsh frog has made its way here from Romney Marsh, and the brown-tailed moth, a characteristic south-eastern species, is present. More than 300 species of flowering plants have been recorded, including shingle-loving species such as yellow horned-poppy and sea kale.

8. SANDWICH BAY

Back in 1784, the first definitive study of the sandwich tern was undertaken using a specimen collected from Sandwich Bay. Today, much of the bay is a private estate, best known for its celebrated links golf courses, Royal St George's and Prince's. The bay has always been famous for migrant birds, and a bird observatory was established here in 1961. Autumn is the most exciting time to visit, when departing warblers and flycatchers mingle with arriving finches and thrushes. Pallas's warblers from Siberia are almost annual visitors, usually in the last week of October. In the spring, a variety of orchids, such as southern marsh and pyramidal, can be found on the dunes and in the golf-course roughs.

9. STODMARSH

The biggest freshwater marsh south of the Thames, Stodmarsh was formed by mining subsidence in the Stour Valley, creating an extensive area of shallow lagoons and reed beds. A national nature reserve, with free access throughout the year on the Lampen Wall, Stodmarsh is an outstanding birding site.

Attractions include resident bearded tits, wintering wildfowl and hen harriers, and summering warblers and hobbies. Rarities are recorded frequently, and the chance of such an encounter adds spice to each visit. The dykes contain bogbean, water forget-me-not and the insectivorous greater bladderwort, which catches insects in its tiny underwater bladder-shaped traps.

10. SURREY HEATHS

Thursley, Hankley and Frensham Commons are made up of several habitats. Their wet and dry heaths, sphagnum bogs, acidic grassland and deciduous woods all support a diverse and specialist flora and fauna. The dry heather is coloured with heather, bell heather and gorse, while the wet heath is characterised by purple moor-grass. Birds include nightjars, woodlarks and Dartford warblers, while the butterflies range from silver-studded blue to purple emperor. Smooth snakes and sand lizards are not uncommon, and the nationally rare large marsh grasshopper and white-faced darter also occur.

11. THE SWALE

Internationally important numbers of wildfowl and waders can be found every winter on the Swale, the broad, tidal channel that separates the Isle of Sheppey from the Kentish mainland. Peak counts of up to 1,400 white-fronted geese, 1,600 dark-bellied brent geese and 10,500 wigeon are typical, along with large numbers of grey plover, oystercatcher, curlew and redshank. Many of the Swale birds also use the Thames Estuary and the Sheppey reserves of Elmley and Shell Ness. Plants such as yellow horned-poppy and sea-lavender add colour in the summer.

12. TEST VALLEY

Famous as one of England's great chalk streams, the Test winds its way through some of the most picturesque countryside in Hampshire. Its cool, clear waters hold not only grayling, wild brown trout and migratory salmon, but also water voles and water shrews. In recent years

otters have reappeared, but they are rarely seen, just leaving tracks and spraints as evidence of their presence. Kingfishers, little grebes and grey wagtails are the most typical birds of the Test, but where there are watercress beds, look out for water rails and, in the winter, green sandpipers.

13. TRING RESERVOIRS

In recent years the importance of the Tring reservoirs for birds has declined, but these 19th-century man-made lakes remain one of the most productive birding areas in a part of England with few large bodies of open water. Migratory and wintering wildfowl and waders are a feature, while birds such as black terns and ospreys are recorded annually. The diversity of flora and fauna at Tring is also impressive: the site is noted for its leeches (seven species), dragonflies and bats.

14. WINDSOR GREAT PARK AND VIRGINIA WATER

Once a royal hunting forest, Windsor Great Park is famous for its ancient oak trees, many reputed to be more than 500 years old. These stag-headed, hollow monuments to the past support a fascinating variety of fungi and insects: there are rare species of Boletus fungi, while an astonishing 2,000 species of beetle have been identified here. The park has long been famed for its birdlife, and hole-nesting

Although created by man, the reservoirs at Tring in Hertfordshire are fringed with reedbeds in places. They offer a refuge for waterbirds galore.

species, such as woodpeckers, nuthatch, treecreeper, redstart and little owl, also use the old trees. Nearby Virginia Water is not only a local beauty spot, but is famed for its wildfowl. Look out for mandarin ducks – the lake is a stronghold for this beautiful exotic from China.

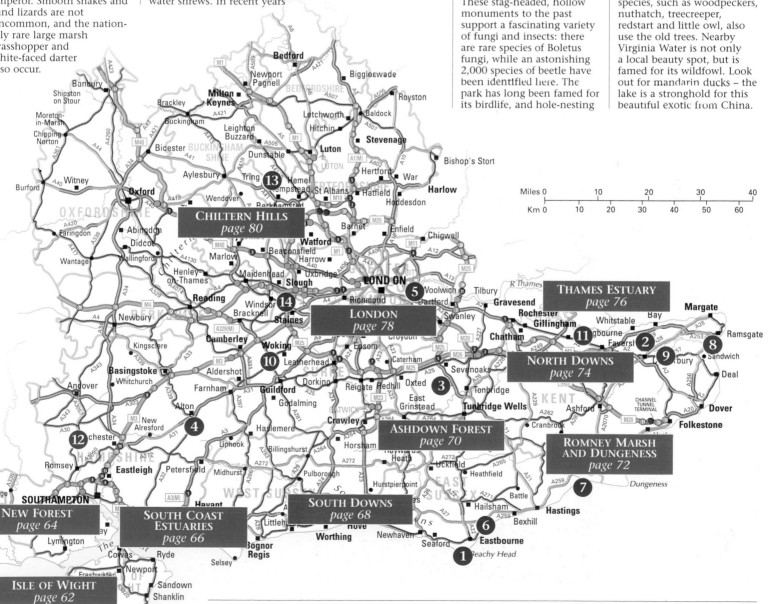

Isle of Wight

The Island, as it is referred to by both residents and visitors, has often been described as a microcosm of lowland England: it certainly has a remarkable diversity of landscapes, often on an intimate scale.

On the Isle of Wight red squirrels are found in deciduous woodland – especially oak – whereas in other parts of their range they favour conifers.

I N WINTER, WILDFOWL congregate on the estuaries and shores of the northern coast. Visitors arriving at Ryde Pier can often see flocks of brent geese feeding on the eelgrass beds at low tide and a walk along the esplanade eastwards to Seaview should reveal sanderling, bar-tailed godwit and other waders. Bembridge Harbour and the Medina Estuary have good public access, while the Newtown Estuary is a classic example of a small, natural estuary.

Winter is also a good time to look for red squirrels. Sadly lost from almost all other parts of England and Wales, they thrive here in the complete absence of greys and can be found in most woodlands.

Spring comes early to the Island, particularly along the sheltered under-cliff on the south coast. A visit to Ventnor Botanic

Gardens will show the potential of this area for tender plants. St Catherine's Point, at the southern-most tip, has early spring flowers and migrant birds.

SPRING FLOWERS

As the year progresses the woods become carpeted with primroses, wild daffodils, wood anemones, lesser celandines and, later, bluebells.

Most of the ancient woodlands grow on the heavy clay soils of the northern half of the Island and it is here that a particular speciality can be found – the rare and showy narrow-leaved lungwort, a distinctive plant with blotched hairy leaves and heads of intense blue flowers. Look for it in Firestone Copse or in the northern half of Parkhurst Forest.

Along the slumped cliffs

Small flocks of bar-tailed godwits can be found on the Island's estuaries from September to March.

of the south-western coast, silken webs in the grass contain masses of the black, bristly, red-faced caterpillars of the Glanville fritillary. By the end of April they will have dispersed from their webs and, in a good year, swarm across the vegetation and paths looking for a place to hibernate. The beautiful adult butterfly, with its orange-and-black chequerboard wings, flies in late May or June, feeding on nectar from the pink thrift and yellow bird's-foot trefoil. The butterfly is not found in mainland Britain.

By early summer the first broods of downland butterflies are flying, taking full advantage of the rich variety of chalkland flowers

At Freshwater Bay, the pastel colours of thrift and other clifftop flowers complement the colours of cliff and sea to create a stunning setting.

Sea campion

Silene maritima

Sea breezes cause the showy white flowers of sea campion to nod continually in the wind, the movement serving to increase their attraction for pollinating insects.

Invariably growing within sight of the sea, large clumps of sea campion are a familiar sight around Britain's coasts, either on sea cliffs or stable shingle ridges above the tide line. The plant often grows alongside other maritime, salt-spray-tolerant species such as thrift. The flowers, which appear from May to July, comprise five white petals, each deeply divided and slightly overlapping. Like its inland relative, bladder campion, the base of the flower, called the sepal tube, is inflated to form a conspicuous bladder that hides the seed capsule.

beginning to emerge. A chalk ridge runs across the middle of the Island and terminates impressively as high white cliffs at either end. Again the Island has a speciality here: the diminutive and exquisite early gentian opens its flowers in abundance in good years. Found only in Britain, it is perhaps commoner on the Island than anywhere else. Later visitors will catch the second brood of common, adonis and chalkhill blues in August and September.

Above Ventnor, a dark, dense forest of evergreen oaks clings to the steep slope. Here the National Trust keeps a herd of feral goats to browse the trees and check their spread. A thriving colony of wall lizards sunning themselves on rocks and walls around the town adds to the Mediterranean feel.

During autumn the weather remains mild and frosts are rare. There is still much to be discovered in rock pools on the beaches, while butterflies, grasshoppers and bush crickets continue to be active. Autumn lady's-tresses, the latest orchid to flower, can be found on the downs.

Purple sheets of sea lavender on the north coast saltmarshes attract painted ladies and other butterflies. As the leaves begin to turn, the fiery reds of wild service trees along the northern coasts are most impressive.

The Glanville fritillary is found on the cliffs and landslips of the Island's south coast. Its only other British site is in the Channel Islands.

Great black-backed gull

Larus marinus

Standing the size of a small goose, the great black-backed gull is the largest of its kind to be found In Britain and is easy to see along the whole of the south coast. During the breeding season, pairs nest in isolation on sea cliffs and offshore islands, driving other great black-backs from their territory. At other times of the year, they are more usually encountered around ports or on estuaries where they generally consort with others of the same species. Great black-backs, like other gulls, are essentially scavengers and have benefited greatly from the presence of man. During the breeding season, however, they become active predators of seabirds such as kittiwakes and razorbills.

see also page 237

Great black-backed gulls can be identified by their dark upperwings and wingtips. Unlike the smaller lesser black-backed gulls, they have pink, not yellow, legs.

AND ALSO LOOK OUT FOR...

- shelduck - ringed plover - whitethroat - meadow brown
- dog rose - kidney vetch - common sea-lavender
- autumn gentian - golden samphire - pyramidal orchid

ISLE OF WIGHT HIGHLIGHTS
Brent geese and waders **between Ryde and Seaview** in winter. Red squirrels in **Parkhurst Forest.** Early spring flowers and migrant birds at **St Catherine's Point.** Narrow-leaved lungwort at **Firestone Copse** or northern part of **Parkhurst Forest.** Blue butterflies and early gentian on the **chalk downs.** Glanville fritillary butterflies on **south-west coast.**

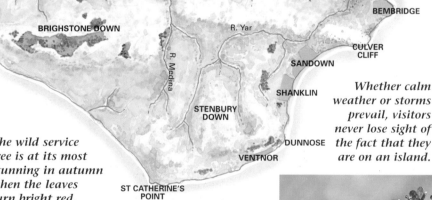

Miles 0 ... 5
Km 0 2 4 6 8

COWES
THE SOLENT
THE SOLENT
NEWTOWN ESTUARY
PARKHURST FOREST
RYDE
SEAVIEW
NEWPORT
BEMBRIDGE HARBOUR
BEMBRIDGE
FRESHWATER
ATTOW DOWN
BRIGHSTONE DOWN
R. Yar
THE NEEDLES
R. Medina
CULVER CLIFF
SANDOWN
SHANKLIN
STENBURY DOWN
DUNNOSE
VENTNOR
ST CATHERINE'S POINT

Whether calm weather or storms prevail, visitors never lose sight of the fact that they are on an island.

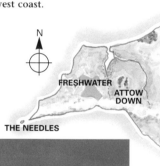

The wild service tree is at its most stunning in autumn when the leaves turn bright red.

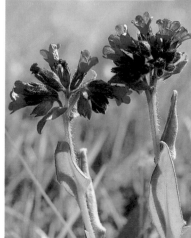

The narrow-leaved lungwort occurs locally in woods and on verges, flowering in early spring. The Isle of Wight is a stronghold for the species.

New Forest

There is nowhere quite like the New Forest, the largest area of uncultivated land in lowland England; it consists of heathland, valley bogs and ancient woodland – all moulded by traditional practices.

THE CHARACTER OF the forest is intimately bound up with the traditions of 'commoning', such as Common of Turbary (turf cutting) and Common of Mast (allowing pigs to forage acorns and beech mast) . The 'commoners' who live there have turned their animals out to graze for centuries and as well as the familiar New Forest ponies, you may also see cows, sheep, donkeys and pigs at large.

In late summer, the heathlands put on a magnificent show of flowers across thousands of hectares. The purple of the heathers is broken up by the yellow of gorse, which gives shelter to Dartford warblers and acts as a look-out point for stonechats. Unique to the New Forest is the reddish-purple wild gladiolus, which grows on grass heath close to the woodland edge.

Overhead you may glimpse the agile hobby hunting large day-flying insects. Much easier to see are the clouds of butterflies. In good years these can be extraordinarily abundant, particularly on areas where the heather is young and vigorous. Most dramatic are the silver-studded blues – forming carpets over the heaths on hot summer days.

Dotted among the

Butcher's-broom grows under mature trees, protected from grazing by its spiny, leaf-like shoots.

heaths lie bogs – the dramatic red, green and purple of the sphagnum mosses contrasting strongly with the heather. On the edge of paths, insectivorous plants such as sundew can be found – you need to look closely, as a whole plant is often smaller than a 10p coin. These bogs are important for dragonflies and damselflies, and sometimes the small red damselfly can be seen trapped in the sticky leaves of a sundew.

PROTECTED WOOD
The ancient, grazed wood pastures are protected by laws passed in Victorian times, and roe, fallow and red deer also graze here. Few flowers or shrubs survive, except species such as holly, butcher's-broom and wood spurge, which are unpalatable to the animals. However, the forest is renowned for its abundant non-flowering plants – lichens, fungi, mosses and liverworts.

The ancient trees provide ideal roosts for bats and 13 of the 15 British species have been recorded; chief among them being Natterer's, whiskered, serotine and long-eared, as well as the ubiquitous pipistrelle. Enormous (but relatively harmless) hornets nest in the old hollow trees, and the plentiful dead wood

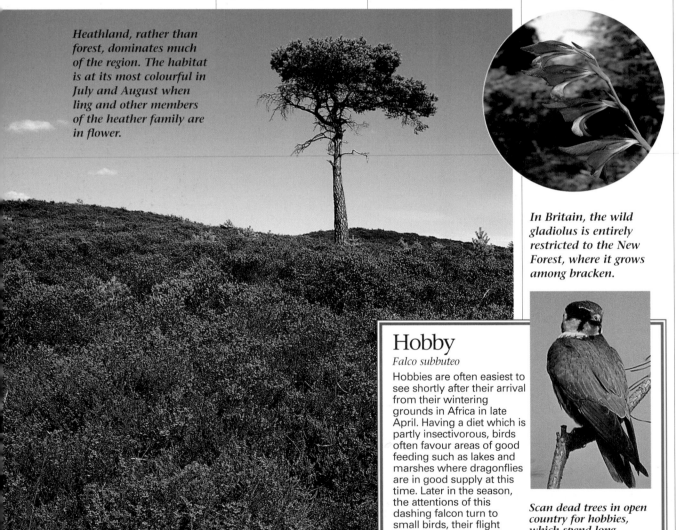

Heathland, rather than forest, dominates much of the region. The habitat is at its most colourful in July and August when ling and other members of the heather family are in flower.

In Britain, the wild gladiolus is entirely restricted to the New Forest, where it grows among bracken.

Hobby
Falco subbuteo

Hobbies are often easiest to see shortly after their arrival from their wintering grounds in Africa in late April. Having a diet which is partly insectivorous, birds often favour areas of good feeding such as lakes and marshes where dragonflies are in good supply at this time. Later in the season, the attentions of this dashing falcon turn to small birds, their flight being swift enough to enable them to capture swallows and martins. The hobby is often thought of as a classic heathland species and indeed there are few examples of this habitat in southern England that are not graced by these elegant birds. It is, however, also widespread in areas of farmland, so long as scattered woodlands are present for breeding.

see also page 230

Scan dead trees in open country for hobbies, which spend long periods perched and scanning the terrain.

Extensive areas of beech woodland provide a sanctuary for woodland birds such as wood warbler and redstart.

Porcellain fungus can be found growing on dead and dying branches, especially those of beech.

AND ALSO LOOK OUT FOR...

- fox ● badger ● fallow deer
- honey buzzard ● woodlark
- sparrowhawk ● stonechat
- snipe ● black-headed gull
- Dartford warbler ● broom
- ● spotted flycatcher
- ● marsh St John's-wort
- ● heath spotted orchid

Coral-necklace
Illecebrum verticillatum

For botanists, one of the highlights of a trip to the New Forest in August or September is the chance to see the delicate and charmingly named coral-necklace, the area being the species' stronghold in Britain. Its English name is indeed apt since along the trailing, reddish stems are borne whorls of coral-white flowers, set like clusters of jewels against rosettes of fresh green leaves. Coral-necklace thrives on the margins of shallow, summer-drying pools and, since it is easily crowded out by more vigorous plants, it would appear to benefit from the over-grazing by ponies, cattle and deer to which much of the commonland of the New Forest is subjected.

Where conditions suit it, coral-necklace forms spreading clumps which carpet the damp, marginal soils around shallow ponds.

of the best places for beetles and other insects. These include the spectac-ular stag beetle and the goat moth, whose enormous larvae spend three to five years feeding in dead stumps. In summer, you can hear the purring song of wood crickets, and the New Forest cicada, Britain's only member of this group, is still found in

Temporary, seasonal pools are home to many creatures, including these delicate fairy shrimps.

Although New Forest ponies are small, they are hardy animals; this even applies to the foals.

one of the old woods.

Although patches of woodland are scattered all over the forest, most are 'inclosures' planted for timber production. Sika deer, which escaped from Beaulieu, particularly like this younger, mainly coniferous, woodland.

The commons are sur-rounded by small farms, lanes and village greens. Take a walk over a green to see the mass of daisy-like flowers of wild chamomile with its

The large marsh grasshopper – the largest of its kind in Britain – thrives on floating bogs.

pungent, pineappley smell. If the weather has been wet, look for fairy shrimps swimming in the puddles. Their eggs spend most of the year in dusty hollows that only turn to puddles in the wettest months. They can reach full-size in a few weeks.

© Crown copyright

NEW FOREST HIGHLIGHTS
Grazing New Forest ponies and pigs. Hobbies hunting for insects on summer evenings. Clouds of silver-studded blue butterflies flying over **heather**. Tiny sticky leaves of sundew in **bogs**. Bats leaving their daytime roosts. Numerous fungi in autumn. Village greens of wild chamomile. Fairy shrimps in **water-filled hollows**. Buttercups and oxeye daises in **fields** at the Forest edge.

Miles 0 — 4 — 8 — 12
Km 0 — 5 — 10 — 15 — 20

N

REDLYNCH
R. Blackwater
R. Test
FORDINGBRIDGE
TOTTON
SOUTHAMPTON
R. Avon
LYNDHURST
HYTHE
RINGWOOD
BURLEY
BEAULIEU
BROCKENHURST
NEW MILTON
LYMINGTON
HIGHCLIFFE
CHRISTCHURCH
THE SOLENT
BOURNEMOUTH
MILFORD ON SEA
ISLE OF WIGHT

South coast estuaries

The sheltered natural harbours and estuaries centred on the Solent provide rich feeding grounds for hundreds of thousands of shorebirds. They are both a destination – for wintering species – and a staging post for tired and hungry migrants.

Yellow wagtails breed in small numbers at a few sites but many more pass through on migration.

Little tern

Sterna albifrons

Visit the south coast in spring and you are sure to see good numbers of terns, summer visitors to the region. Of the five species that breed here, the little tern is the smallest, recognised not just by its size but also by its striking yellow bill. Like its relatives, it nests on sand and gravel banks, making it vulnerable to predation and disturbance. Active conservation measures, such as the creation of artificial nesting sites, allow the little tern to flourish, however, and breeding colonies can be found along the coast from Dorset to Kent.

see also page 238

Arriving from West Africa in April, the little tern indulges in noisy courtship flights before laying its camouflaged eggs in a shallow unlined scrape.

SOUTH COAST ESTUARIES HIGHLIGHTS
Wintering flocks of black-necked grebe at **Langstone Harbour**. Brent geese on playing fields around **Portsmouth**, along with teal, shoveler and pintail. Breeding lapwing and redshank on **wet cattle-grazed fields**; also corky-fruited water-dropwort. Passage and wintering waders and wildfowl at **Pagham Harbour**. Little egrets at northern end of **Thorney Island**.

ALONG THE SOLENT coast large areas of saltmarsh with their associated mudflats, sandbars and shingle beaches provide safe roosting for thousands of wintering birds, and in summer they support large colonies of black-headed gulls. Where there is shingle terns will nest, and there are colonies of Sandwich, common and little terns in the area.

In the winter the most numerous of the waders is the dunlin, which feeds in loose flocks on the mud at low tide. As the tide turns the birds form tight, wheeling flocks that move up to roosting sites clear of the rising water. Thousands of curlews,

A group of mute swans glides effortlessly through the channels at Farlington Marshes. The reedbeds are home to a host of smaller birds.

grey plovers and oyster-catchers are attracted to the mudflats, too.

The sandier parts of the harbours are preferred by bar-tailed godwits, while their relative the black-tailed godwit stays on the

mudlands or wet fields. The latter are all from the small Icelandic population; they stay from about mid-July to late April, and are often in their brick-red breeding plumage when they arrive and leave.

Several predators target the wader flocks. The power and tremendous speed of a peregrine is always compelling to watch, as is the dashing agility of a merlin. Both birds used to be winter visitors only, but the peregrine can now be seen year round.

Much of the coast is protected by sea walls and at several sites fields and

Black-tailed godwits do not nest on the south coast but overwinter there from late summer to spring.

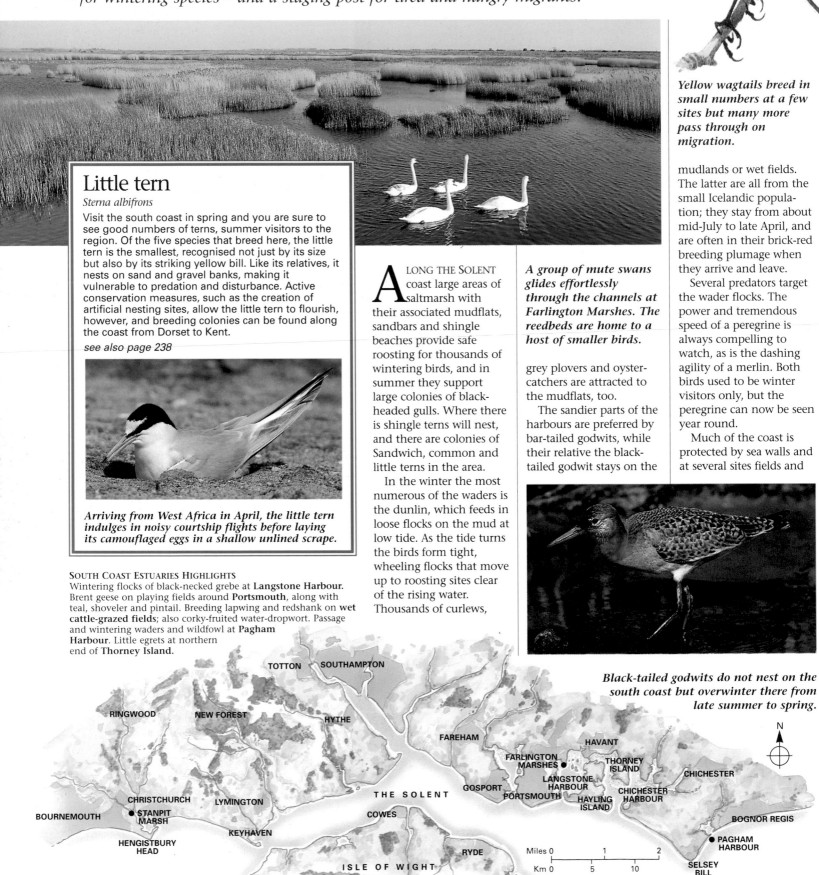

TOTTON SOUTHAMPTON

RINGWOOD

NEW FOREST

HYTHE

FAREHAM

HAVANT

FARLINGTON MARSHES

THORNEY ISLAND

CHICHESTER

GOSPORT

LANGSTONE HARBOUR

CHICHESTER HARBOUR

CHRISTCHURCH LYMINGTON

PORTSMOUTH

HAYLING ISLAND

BOURNEMOUTH

STANPIT MARSH

THE SOLENT

COWES

BOGNOR REGIS

KEYHAVEN

HENGISTBURY HEAD

RYDE

PAGHAM HARBOUR

ISLE OF WIGHT

Miles 0 1 2

Km 0 5 10

SELSEY BILL

N

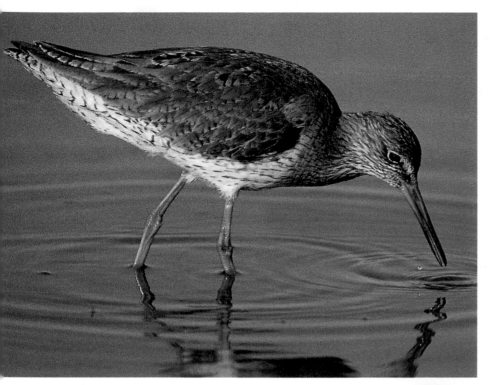

see also page 224

Brent goose
Branta bernicla

October sees the arrival of flocks of brent geese on the estuaries of southern and eastern Britain, flying in from their breeding grounds in the high Arctic. Their barking calls are distinctive and very much a part of winter sounds on the estuary. Seldom seen on their own, groups of 100 or more often gather together to feed on eelgrass or other saltmarsh plants. At high tide, the geese are pushed off their feeding grounds and often fly to coastal grassland to graze. By early April, the birds begin to leave the estuaries and start on their long flight northwards.

Brent geese are the smallest widely occurring geese in Britain. What they lack in size, however, they more than make up for in terms of numbers.

With its red bill and legs, the redshank is easy to identify. It is known as 'the warden of the marshes' because it is often the first bird to sound the alarm.

low-lying marshlands now exist where once there was mudland. Marshy fields, grazed in summer by cattle, provide ideal winter areas for brent geese and wigeon, both of which eat grass. These same marshes attract flocks of teal, shoveler and pintail.

SUMMER BIRDS
In summer, when most of the ducks and waders have departed to the north and east, the coastal marshes are home to other birds. Skylarks are still common on the traditionally managed fields. Meadow pipits nest in the long grass on the slopes of the sea walls, and at one or two places, such as Farlington Marshes, yellow wagtails breed.

The same wet fields provide nest sites for lapwing and redshank. Both these species have extravagant and noisy display flights which go on for much of the spring and early summer. Lapwings will defend their young from predatory crows and magpies by dramatic dive-bombing.

Some of these fields are rich in flowers, with species such as marsh-orchids, vetches and yellow-rattle. A particular feature of early summer is the frothy cream flowers of the corky-fruited water-dropwort. This wonderfully named plant is nationally rare but has its stronghold on the Solent coast.

Such an abundance of flowers is great for butterflies and, while there are no rarities, the numbers of some of the common grassland species are spectacular. Meadow browns and gatekeepers are everywhere, and small and Essex skippers are common.

WHERE TO GO
There are many places where the passage of wintering waders and wildfowl can be seen. Pagham Harbour offers a wide range of habitats, including some open coast and sea-watching at nearby Selsey Bill.

Chichester Harbour offers several viewpoints, while the 11-km (7-mile) walk around Thorney

Despite its name, the Essex skipper is widespread along the south coast.

Island probably offers the best bird-watching. At the northern end of the island is a roost of little egrets.

Langstone Harbour can be viewed from points on Hayling Island, with North Hayling Halt, beside the old oyster beds, being the best place to see Britain's largest black-necked grebe flock.

The marshes at Lymington and Keyhaven offer long walks with a good range of birds on both sides of the sea wall, the landward pools being especially good for scarce waders during autumn migration. Stanpit Marsh and Hengistbury Head to the west both have a reputation for attracting scarce and rare species.

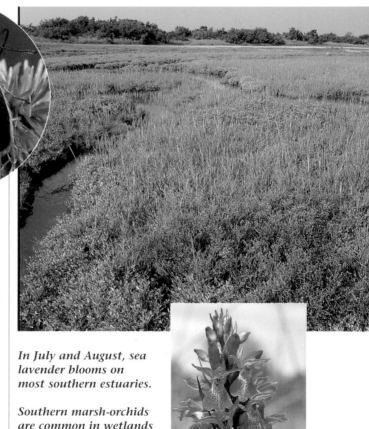

In July and August, sea lavender blooms on most southern estuaries.

Southern marsh-orchids are common in wetlands along the south coast.

AND ALSO LOOK OUT FOR...
- cormorant ● grey heron
- goldeneye ● grey plover
- short-eared owl ● lugworm
- common cockle
- celery-leaved buttercup
- field bindweed ● ragwort
- spear thistle ● sea wormwood
- glasswort ● golden samphire

South Downs

Between the white cliffs of the Seven Sisters and Butser Hill, in Hampshire, the downland swoops along in a series of rounded curves. The bridleway along the crest gives views of the Weald and the sea.

Throughout the year, the song of skylarks fills the air. During the winter months, the birds form flocks which feed in the stubble and short grass.

Marbled whites are locally abundant on the South Downs and their presence on the wing is one of the best indicators that summer has really arrived.

Greater knapweed

Centaurea scabiosa

With its large, showy flowers, greater knapweed would not look out of place in the herbaceous borders of a mature garden. As it is, the species is one of the most attractive elements of our native grassland flora, flourishing especially well on lime-rich soils; it is one of the most characteristic plants of chalk downland. Like other members of the daisy family, the purple heads of greater knapweed comprise a large number of smaller flowers. They are extremely popular with bees, hoverflies and butterflies and bloom from July to September. The hard, rounded remains of the flower heads persist well into the autumn along with the highly divided leaves.

see also page 305

Chalk or limestone soils are essential for greater knapweed to flourish. It grows along the entire length of the South Downs and can also be found on roadsides and in rough grassland. A lowland plant, it is rare in Scotland.

THE DOWNS CAME from the sea 60 million years ago, originating from shell and sponge, shark and sediment which fell to the ocean floor and formed a great chalk deposit. Later the sea-bed bulged up into a great dome, the crest of which was eroded away leaving a steep scarp slope – the North Downs – and a dip slope facing the sea – the South Downs.

About 6,000 years ago the first settlers arrived on the downs, preferring the drier, safer hills to the Weald below, with its swamps and bogs, wolves and bears. Much of the woodland was cleared

The view from Butser Hill in the Queen Elizabeth Country Park is stunning, the grassland in the foreground being studded with chalk-loving flowers.

away and the land cultivated with flint implements dug from mines and amazing vertical shafts, sometimes nearly 200m (650ft) deep. Often you can find flints that were shaped 4–5,000 years ago, easily identifiable by a small, smooth white bulge where the blow was struck to break it off the core. Occasionally a smooth axe is found; sometimes flake knives with chipped

saw-teeth. Flints used to heat water for cooking are easy finds, being dark grey and deeply cracked.

During the Iron Age, secure hilltop fortresses were built and the great earthworks at places such as Cissbury and Chanctonbury are testament to the engineering skills of that time.

Centuries later the downs were cropped by huge flocks of sheep. Some say that the wealth of Britain was built upon the back of sheep, each area evolving its own breed. The Southdown, first bred by a Wealden farmer's son in the 19th century, was highly prized for both its meat and soft

Squinancywort is a member of the bedstraw family and a typical downland plant, found only on chalk and limestone soils.

The corn bunting is one of the few birds which tolerates or even thrives where arable fields have replaced open downs.

Adonis blue
Lysandra bellargus

Few small butterflies are held in higher regard than the adonis blue, males having iridescent, electric-blue upperwings reminiscent of a species from the tropics; in common with many other species of blue, females have brown upperwings relieved by orange spots on the margins. Like its relative the chalkhill blue, the range of the adonis blue – it is restricted to southern England – is at least partly determined by the distribution of its larval foodplant, horseshoe vetch, a plant of chalk and limestone downs. Where it does occur, it is usually relatively common and appears in two broods, one flying in May and June, the second in July and August.

see also page 263

No British butterfly can match a male adonis blue for the sheer vibrancy of colour. Even its relative the common blue looks dull by comparison.

wool. Later, rabbits were farmed in vast banked enclosures from which they escaped and bred wild. Thus both sheep and rabbit ensured the sward was tightly grazed.

Today, agricultural practices have changed yet again and much of that grassy downland has gone under the plough, but where it does remain its wealth of flowers is bewildering.

DOWNLAND GLORIES
Aromatic plants such as wild thyme form dense cushions of stems as their shoots are bitten off. Clusters of horseshoe vetch and bird's-foot trefoil create brilliant yellow patches, while blue bugle, dark pink calamint, pale pink squinancywort, sky-blue speedwell and the delicate white fairy flax form displays of colour as good as any alpine meadow.

Of the 300 or so species of low-growing herbs and flowers to be found on the undisturbed downland, over 20 are orchids: bee, burnt-tip and early spider are among the species that grow there.

In winter, wandering flocks of skylarks, linnets, yellowhammers and corn buntings keep hen harriers fed. Kestrels ride the flowing air like gliders. In summer, hobbies cut the air with scything wings and power-dive on butterflies in mid-air.

The South Downs are home to about three-quarters of Britain's butterfly species and in July and August the air shimmers with dancing blues, notably adonis and chalkhill, while fritillaries make zig-zag orange lines of speed and marbled whites, with their distinctive black-and-white markings, and their relative the meadow brown, rest on knapweed and thistle flowers.

YEW FOREST
Blocks of ancient woodland have survived here and there, and on Kingley Vale's steep slopes, near Chichester, stands of evergreen yew form the finest yew forest in Europe. Nothing grows under their dense shade. Some may be 2,000 years old, their deep-red trunks, branches and shallow roots twisted into monstrous shapes and gargoyle faces.

SOUTH DOWNS HIGHLIGHTS
Adonis and chalkhill blue butterflies along with tapestries of flowers on **springy downland turf**. **Winter flocks** of skylarks, linnets and yellowhammers providing food for hen harriers. Burnt-tip and early spider orchids on **East Sussex downs**. Ancient yew woods at **Kingley Vale**. Stone Age flint mines at **Birling Gap**.

While in bud, the diminutive burnt-tip orchid bears a fanciful resemblance to a glowing cigarette butt; the similarity disappears once the flowers open fully.

AND ALSO LOOK OUT FOR...
● common shrew ● harvest mouse ● brown hare ● badger
● cuckoo ● turtle dove ● dunnock ● whitethroat ● goldfinch
● yellowhammer ● meadow brown ● small copper
● grizzled skipper ● 5-spot burnet ● common green grasshopper
● meadow grasshopper ● old man's-beard ● salad burnet
● dog rose ● restharrow ● autumn gentian

Ashdown Forest

Formerly part of a huge forest, Anderida, that stretched across south-east England, Ashdown Forest today is an area of commonland made up largely of heathland, with scattered patches of woodland. It was the setting for AA Milne's Winnie the Pooh.

Stonechats are relatively easy to see as the birds – especially in spring – often perch on posts or bushes.

Bell heather and gorse are the characteristic plants of heathland.

F ROM THE MIDDLE Ages onwards much of the oak woodland was cleared to supply the Wealden iron industry. Enclosure reduced the Forest to its present area – 2,600ha (6,420 acres) – between East Grinstead and Uckfield. Many of the local villages, such as Chelwood Gate and Chuck Hatch, take their names from the old 'gates' (for vehicles) and 'hatches' (for pedestrians) into the Forest.

Today about 40 per cent of Ashdown Forest is managed as heathland – the largest area of heath in south-east England – characterised by heather, acidic grassland, bracken and gorse.

The most common and widespread of the three heathers is ling, whereas cross-leaved heath with its grey foliage and pale pink flowers is generally confined to the wetter areas, and bell heather with its dark green, red-tinged leaves is found on drier parts. Purple moor-grass covers large areas in summer.

Bracken, which grows in the Forest in profusion, encroaches on to the heathland and creates a high fire risk in the spring when the previous year's

One of the habitat's most widespread reptiles is the adder; although poisonous, it is very nervous of man.

growth provides a considerable amount of highly combustible material.

Gorse can be seen in flower practically all year round, giving rise to the old saying, 'kissing is in season when gorse is in flower'. Most of the gorse is the more robust European species, which provides an important habitat for heathland birds such as the stonechat, easily recognisable by its call resembling the sound of two stones being knocked together.

In early summer, silver-studded blue butterflies can be found on the mown rides; adders bask on the sandy soils; and emperor moths, with

their bright eye-spots, fly during the day. As summer progresses, the streams and bog pools in the valley bottoms come alive with dragonflies and damselflies hovering above round-leaved sundew, cottongrass and marsh clubmoss; and, at dusk, nightjars fill the air with their churring.

WOODLANDS
Much of the wooded area of the Forest is silver birch woodland which has invaded the heath – and here the red fly agaric toadstool proliferates – but there are also stands of mature sweet chestnut, alder, hazel and oak.

The largest beech woods were devastated during the 1987 storm but a good number of old pollarded trees survive, particularly around the Forest boundaries. Here many interesting species

Fly agaric
Amanita muscaria

Without doubt, this is the most familiar species of toadstool to most people. The underground fungal threads, which form the bulk of the body of the fungus, grow mainly in association with birch trees and, as a result, fly agarics are invariably found growing on heaths and commons where this tree species occurs. This is an easy toadstool to identify since it is the only one which has a bright red cap dotted with white flecks. The stem is pure white with a ring just below the level of the gills.

see also page 314

Look and admire but do not touch fly agarics as these toadstools are poisonous. In medieval times an infusion made from fly agarics was used to repel flies – hence the name. This fungus appears from August to November.

Fox

Vulpes vulpes

For an animal that is so shy and retiring in the countryside, the urban fox is a bold character. Many town-dwellers on the fringes of the Ashdown Forest, for example, can relate tales of nocturnal raids on dustbins, the target being the remains of a chicken or some other tasty morsel. Foxes will also readily come to food put out for them and will sometimes tolerate human observers watching from behind a window. In spring, when the cubs are born in underground earths, foxes become extremely secretive and wary.

see also page 219

During the day, foxes often doze above ground, basking in the sunshine or hiding in undergrowth.

of fungi can be seen in autumn, including the distinctive white porcellain fungus.

Deer are abundant across the Forest area. Most are fallow, the bucks having large, flattened palmate antlers – unlike the spiky headgear of red deer. There are also roe deer, usually seen in twos or threes rather than herds, a feral herd of sika and occasional muntjac.

Animals regularly cross the Forest roads and it is as well to remember that if you see one deer, another is likely to follow

For the first few days after its birth, the roe deer fawn spends much of the time crouched motionless among the bracken until its mother returns.

close behind. The woods are also home to foxes, badgers and a range of woodland birds, including all three species of woodpecker.

Commoners' cows and sheep now graze a much reduced area of the Forest because of the need to restrain the stock with fencing in order to prevent road traffic accidents. However, there is free public access to the fenced areas. To learn more about the Forest, visit the information barn situated a mile east of Wych Cross.

> AND ALSO LOOK OUT FOR...
> ● wood mouse ● pipistrelle bat ● sparrowhawk ● kestrel
> ● tree pipit ● common lizard ● grayling ● green hairstreak
> ● bog asphodel ● lousewort

The broad-bodied chaser is just one of a dozen or more dragonflies and damselflies that are common in the area.

The gold and brown of birch and bracken make autumn a particularly colourful season in the Ashdown Forest.

© Crown copyright

ASHDOWN FOREST HIGHLIGHTS
Silver-studded blue butterflies along **heathland rides**. Emperor moths over **heather**. Dragonflies and damselflies around **bog pools and streams**. Stonechats on tops of **gorse**. Wide variety of fungi in **beechwoods**. All three woodpeckers in **wooded areas**. Four possible species of deer – mainly fallow, with occasional roe, sika and muntjac.

Romney Marsh & Dungeness

With its broad, sweeping landscape dominated by huge skies, Romney Marsh is more reminiscent of East Anglia than south-east England. Originally saltmarsh, the area was long ago reclaimed from the sea and protected by sea walls. Dungeness spit is an extraordinary shingle desert.

Following their release into a garden pond on the fringes of Romney Marsh in 1935, marsh frogs have become firmly established in the area.

The open landscape, seen here around Fairfield Church, is criss-crossed by a system of drainage dikes and marshy fields that characterises much of Romney Marsh.

ONE OF THE WORLD'S best-known breeds of sheep, the Romney Marsh, evolved here, and flocks of these white-faced sheep are still to be seen. During the last 20 years, however, much of the marshland has been deep-drained and fields of winter cereals have replaced the grazing meadows, sadly destroying the traditional landscape in the process.

Where the grazing pastures have been retained, flocks of wintering lapwings and golden plovers are a familiar sight. In recent years, increasing numbers of Bewick's swans – migrants from Siberia – have been wintering on the marshes. As winter reluctantly

Warm weather and a southerly airflow in early summer sees the arrival of migrant butterflies such as this clouded yellow from mainland Europe.

gives way to spring, the lapwings start displaying. Their glorious, tumbling display flight, accompanied by ecstatic calls, is one of the most stirring reminders of the changing season.

This is the time when flocks of migrant fieldfares and redwings crowd the pastures, preparing for their return to breeding grounds in Scandinavia and continental Europe. As the thrushes slip away, so the first of the summer migrants arrive. Swallows swoop low along the dikes, while flocks of bright

yellow wagtails appear like magic. By the third week of April the woods surrounding the marshes vibrate with the songs of scores of nightingales – nowhere else in England do these elusive songsters breed at greater densities.

Summer is relatively quiet on the marsh, but it is a time when the drainage ditches and dikes that criss-cross the area are bright with water-crowfoot. From the dikes you are sure to hear the powerful croaking of introduced marsh frogs. Almost as big as a saucer, they are all descended from 12 individuals released at Stone-in-Oxney in 1935. The frogs were quick to colonise and are now common throughout Kent.

UNEXPECTED HAVENS
The great shingle spit of Dungeness, deposited by the sea over a period of 4,000 years, adjoins Romney Marsh but

presents a very different landscape; its great size, dryness and lack of vegetation calling to mind a desert. Sadly, today the area has lost its sense of wilderness, for the scene is dominated by a huge nuclear power station, while extensive flooded gravel pits bear witness to decades of commercial gravel extraction.

Ironically, these water-filled pits are now Dungeness's most important bird habitat, attracting a rich variety of wildfowl and waders throughout the year. Many are managed by the RSPB. In winter, they are one of the most reliable sites in Britain for smew, while divers and grebes are often present. Crowds of gulls and terns nest here as well. Look carefully among the nesting black-headed gulls for the larger, dark-hooded Mediterranean gull: several pairs usually nest here, one of their few sites in Britain.

Black redstart
Phoenicurus ochruros

Though they breed at Dungeness, black redstarts are mainly winter visitors to coastal Britain. Any robin-sized bird with a red tail seen near the sea is likely to be this species, which is present in small numbers between October and March. Black redstarts feed on insects and are often seen around the strandline. They are also not averse to human habitation, and coastal gardens, lighthouses and harbours provide alternative sites.

see also page 248

A few pairs breed each year in Britain, usually favouring crevices in buildings and other man-made sites such as gas works and power stations.

Painted lady
Vanessa cardui

In most summers, from June onwards, painted lady butterflies can be seen around the coast. Although this species does not survive the winter in Britain, each year thousands of individuals from the Continent migrate northwards to our shores. The upperwings are a beautiful shade of orange, with black and white markings; the underwings are a more subdued version of the colour and patterning of the upperwing. Powerful fliers, they move swiftly between flower heads to feed.

see also page 261

Look for newly arrived migrant painted lady butterflies feeding on wayside flowers. After spending a few days on the coast, many continue their journey and head inland.

Even the power station has played a role in enhancing Dungeness's ornithological riches. Black redstarts breed among the buildings and kestrels perch on the pylons, while the cooling-water outflow (known as the Patch) provides a constant source of food for gulls and terns.

Jutting out as it does into the English Channel, Dungeness is an important migration watchpoint. The start of the spring passage of birds comes in mid-March, with the main rush in April and early May. In summer, Dungeness can be a great place to witness the arrival of hordes of painted lady or clouded yellow butterflies. Autumn bird passage begins in late July and continues right through to November. Rarities such as Pallas's warblers and red-breasted flycatchers are recorded annually – invariably blown off-course by strong easterly winds.

Dungeness is much more heavily vegetated than it was a century ago, when goats and sheep helped keep the vegetation in check, and the flora of the shingle is surprisingly varied with over 400 recorded species. Look, especially, for the bright carpets of thrift, stonecrop and sea campion on the open shingle.

Shortly after their arrival in early April, Sandwich terns start courting one another prior to mating and nest-building. Here, the male is presenting the female with a sand eel as a gift for her favours.

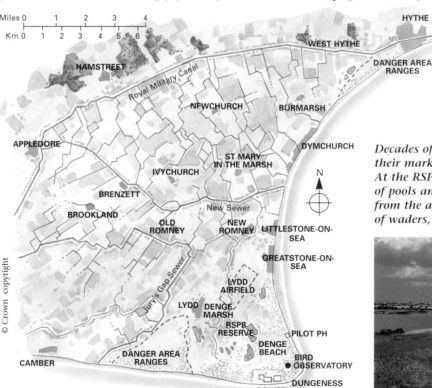

© Crown copyright

ROMNEY MARSH & DUNGENESS HIGHLIGHTS
Wintering flocks of lapwing, golden plover and Bewick's swans on the **marsh**. Singing nightingales in **woods around marsh**. Croaking marsh frogs in **ditches**. Smew, divers and grebes at **Dungeness**. Nesting Mediterranean gulls among black-headed gulls. Breeding black redstarts and kestrels around **power station**. Summer migration of painted lady and clouded yellow butterflies.

Mediterranean gulls breed in small numbers among the black-headed gull colonies, and can be distinguished from their commoner cousins by their black rather than brown hood and white wingtips.

AND ALSO LOOK OUT FOR...
● fox ● water shrew ● garganey ● oystercatcher ● swift
● sea sandwort ● yellow horned-poppy ● silvery moth
● hare's-foot clover ● rock samphire

Sea-kale is one of a number of plants adapted to life on the shingle beach. Sizeable clumps grow at Dungeness.

Decades of gravel extraction have left their mark on the Dungeness landscape. At the RSPB reserve, however, a mosaic of pools and islands has been created from the aftermath, to the great benefit of waders, terns and other waterbirds.

North Downs

Rarely higher than 200m (650ft), the North Downs form the backbone of Surrey and Kent, their chalk vertebrae glinting among the mosaic of woodland and downland that runs along their length.

THE NORTH DOWNS have had a chequered history. Originally, all but the steepest scarps would have been covered with dense woodland, predominantly ash, hornbeam, beech and yew, and the river valleys – formed where the scarp is breached by the Stour, the Medway and the Darenth – would have been wet and marshy.

Changes came with early settlement when the marshes were drained and the woodlands cleared to expose grazing land. Much later, at the height of the wool trade in the Middle Ages, huge tracts of the downs would have been grazed by innumerable sheep.

Today, much of the scarp slope has been recolonised by woodland as the demand for sheep grazing has waned. The remaining grassland is distributed along the length of the downs, with the greatest concentration at the eastern end between Ashford and Dover. The thin chalky soils are a botanical wonderland, with as great a variety of flowers as any other British habitat.

Orchids are the speciality, with common species such as pyramidal and fragrant orchids interspersed with such rarities as man orchid and late spider-orchid. There are also colourful displays of yellow trefoils, rock-roses and hawkbits.

Perhaps the best time to visit the downs is mid-August, when the pinks and blues of the scabious and knapweed families predominate, and a diligent search can reveal autumn gentian and the tiny twisted spikes of autumn lady's-tresses.

BLUE BUTTERFLIES

Since most slopes face south, the combination of sunshine and short turf provides conditions that are ideal for warmth-loving butterflies, especially the colourful blue family. Again, mid-August is the best time to see clouds of chalkhill and common blue butterflies, and on a few sites the second brood of adonis blues will be on the wing. On nature reserves there can be literally thousands of butterflies in the air, creating an unforgettable spectacle.

Slightly earlier in the year, marbled whites are abundant and, especially in Surrey and west Kent, dark green fritillaries can be seen gliding over the grassland in search of the violets on which their caterpillars feed.

The woods are at their best for flowers in May, with drifts of violets, primroses and stitchwort, and maybe a chance of the lady orchid, one of our largest species.

Wherever mature trees are present, hole-nesting birds such as woodpeckers and nuthatches can be seen, and badger setts are easily located by the great mounds of white chalk deposited at the entrances. These chalk dip-slope woods have abundant hazel and honeysuckle, both important for dormouse;

Using updraughts off the slopes, kestrels are frequently seen hanging on the wind, scanning the ground below for mice, voles and other small mammals.

The lady orchid is a tall, handsome species which is found only on the North Downs in Britain. It flowers from mid-May to early June in woodland or scrub.

Angley Woods is typical of many downland woods, with stands of mature beech trees forming a complete cover by midsummer. Orchids flower before the canopy closes over.

The distinctive and chirpy song of the male yellowhammer can be heard in areas of scrub and mature hedgerows throughout the North Downs.

Yellow-rattle is a semi-parasitic plant that gains part of its nutrition from the roots of grasses. It is common on chalk grassland.

Under a covering of winter snow the downs look starkly beautiful and footprints indicate which animals have been active.

Long-tailed tit

Aegithalos caudatus

Parties of half a dozen or so long-tailed tits are a familiar sight, the birds being most active and obvious during the winter months. At a glance they resemble animated feather dusters, with their compact bodies and extremely long tails. They announce their presence with a wren-like rattle and high, thin notes. Their nests, held together with spiders' web, are almost spherical.

see also page 250

Look for long-tailed tits in patches of scrub. Gorse, bramble and blackthorn are favoured for winter feeding and for nest sites in spring.

NORTH DOWNS HIGHLIGHTS
Pyramidal and fragrant orchid along with rarer orchids in summer on the **downland**. Mid-August for autumn gentian and autumn lady's tresses. Mid-August also for chalkhill, common blue and other blue butterflies. Dark green fritillaries in **Surrey** and **west Kent**. Carpets of spring flowers in **woodlands**. Mounds of white chalk by badger setts. Kittiwakes at **St Margaret's Bay**.

LONDON · THAMES ESTUARY · DARTFORD · GRAVESEND · ROCHESTER · SHEPPEY · CHATHAM · WHITSTABLE · HERNE BAY · MARGATE · RAMSGATE · SITTINGBOURNE · FAVERSHAM · R. Darenth · NORTH DOWNS · R. Medway · NORTH DOWNS · R. Stour · CANTERBURY · WOKING · R. Mole · MAIDSTONE · DEAL · R. Wey · DORKING · REIGATE · SEVENOAKS · R. Beult · GUILDFORD · R. Eden · TONBRIDGE · DOVER · FARNHAM · CRAWLEY · ASHFORD · ST MARGARET'S BAY

N

Miles 0 · 10 · 20
Km 0 · 10 · 20 · 30

this tiny nocturnal rodent is widely distributed in south-east England, but rarely seen.

Access to the downs is greatly helped by the North Downs Way, a long-distance footpath running their whole length. On open ground you might be accompanied by the trilling song of a skylark on the wing, or the 'little-bit-of-bread-and-no-cheese' song of the male yellowhammer, easily distinguished by his bright yellow head and underparts.

At the eastern end of

At dusk, rabbits can be seen on the downs in their dozens. Their grazing helps keep chalk grassland free from encroaching scrub.

the downs there is a magnificent cliff-top walk along the coast from Dover to St Margaret's Bay. All the chalk grassland flowers are here, the views over the Channel are spectacular,

and the cliffs have the only breeding colony of kittiwakes in south-east England. To top it all, peregrine falcons have recently returned to breed here after an absence of over 40 years.

AND ALSO LOOK OUT FOR...
● short-tailed vole ● fox ● grey partridge
● woodpigeon ● chaffinch ● brimstone ● meadow brown
● common green grasshopper ● lady's-bedstraw ● great mullein

Chalkhill blue

Lysandra coridon

As its name implies, the chalkhill blue is entirely restricted to areas of chalk and limestone grassland where its larval foodplant – horseshoe vetch – flourishes. The species is relatively easy to see on the North Downs where undisturbed examples of the habitat still remain untouched by the plough. The male butterfly can easily be distinguished from other superficially similar species by the sky-blue colour of the upperwings.

see also page 263

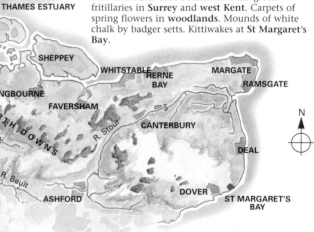

Chalkhill blues are often easiest to observe well in late evening. Prior to roosting for the night, they frequently bask in the dying rays of the sun.

Thames Estuary

Every year, tens of thousands of waders arrive to overwinter along the estuary, as the mud is a rich source of food. As the tide rushes in, knot and dunlin wheel in tight flocks, appearing like plumes of smoke.

DOTTED ABOUT THE Thames Estuary are patches of eelgrass which act as a magnet for the thousands of dark-bellied brent geese that arrive from their breeding grounds in western Siberia each autumn. Their large chattering flocks commute up

From October onwards the mudflats of the estuary resound to the cackling calls of brent geese, the smallest goose species to regularly visit Britain.

and down the estuary during the winter. Towards the end of the season they can often be found grazing on the marshes and farmland.

Throughout the area, whether in urban pockets, on marshes or near the coast, the ubiquitous black-headed gull is likely

Black-headed gulls are present throughout the year, although it is only in spring and summer that they possess their diagnostic chocolate-brown hood.

to be present. Only the breeding adult has the dark hood but at other times the species can be recognised in flight by the white leading edge to the wings. What little saltmarsh remains supports a very specialised community of plants, including the attractive sea-lavender, sea arrow-grass and thrift. In winter, roving finch flocks forage, particularly linnets and their very similar cousins of the uplands, twites. Take a walk through

the saltmarsh in summer, and you may notice the silken tents of the caterpillars of the rare ground lackey moth. In undisturbed areas of grazing marsh rich communities of grasses and herbs flourish, attracting butterflies such as the common blue, meadow brown, and the migrant painted lady. Much more scarce, being confined to coastal areas in south-east England, is the Essex skipper butterfly.

LIFE ON THE MARSHES
The dykes dissecting the marshes support a rich aquatic community; one of their most vociferous inhabitants, the introduced marsh frog, has spread north through east Kent from the south coast. These in turn can fall prey to the herons that stalk the dykes.

Ditches with plenty of cover provide nest sites for ducks such as the elusive garganey. In

Small flocks of snow buntings can be seen in the winter months, searching for seeds just above the high-tide line.

summer, the marshes echo to the drumming of snipe and the calls of redshank and lapwing, three waders which all nest here.

On the RSPB reserve of Elmley, floods have been created that attract a variety of breeding wildfowl and waders. In spring and autumn, migrant waders flying between Africa and their northern breeding grounds are present. Greenshank and the elegant spotted redshank rub shoulders with the tiny little stint, while the aggressive avocets chase intruders from their territories.

The Isle of Sheppey is noted for the variety of birds of prey that overwinter. Short-eared owl

Common sea-lavender

Limonium vulgare

Common sea-lavender is one of the more showy plants associated with, and characteristic of, saltmarshes. Around the south coast of Britain it is found along the margins of tidal stretches of rivers as well as on estuaries. It is normally found on the upper, drier parts of the saltmarsh but is invariably inundated with seawater on many tides, to which it is tolerant. Individual plants can appear rather straggly with narrow, spoon-shaped leaves and branched stems. When in flower en masse, however, common sea-lavender is a spectacular sight. The flowers are carried in terminal, one-sided clusters which often appear flat-topped. Lavender-blue in colour, they can appear pinkish-lilac in some lights.

see also page 296

Common sea-lavender puts on a colourful show in August and early September and is one of the most distinctive members of the saltmarsh community.

Greenshank

Tringa nebularia

Although known as a rare breeding species in Britain, the greenshank is more familiar as a migrant and winter visitor in small numbers to the estuaries and coasts of the south. The birds occur mainly in spring and autumn on migration between their breeding grounds in northern Europe and their wintering quarters in Africa; a few remain for the winter in sheltered areas. At a distance and in strong light, greenshank can look almost black and white. At close range, however, delicate patterning can be seen on the back and mantle.

see also page 235

Similar to redshank and other medium-sized waders, the greenshank has dull greenish-yellow legs and a long, robust bill with a slight upturn.

Autumn sees the arrival of thousands of waders, including the diminutive little stint, en route from its Arctic breeding grounds to its winter quarters in Africa.

The ground lackey moth flies in July. It lives only on our southern estuaries, probably because foodplants such as sea-lavender grow there.

Lesser marsh grasshoppers are found in coastal grassland and invariably occur within a few hundred yards of the sea. A good place to look for them is in clumps of rushes.

and hen harrier quarter the fields, and merlin and peregrine can be expected, while marsh harriers both breed and winter. Capel Fleet and Elmley are both excellent sites for raptors. In the far south-east corner of Sheppey lies Kent's best-kept secret, the Swale national nature reserve. As at Elmley, there are hides here and a similar variety of birds on the floods and bordering saltmarsh.

SHELL NESS

Jutting out into the Swale is Shell Ness, one of a number of shellbanks found throughout the Thames Estuary. Created from cockle shells washed up from the cockle beds offshore, this unusual habitat is constantly moving and so provides little opportunity for plants other than annuals, such as the yellow horned-poppy, to colonise.

A few birds attempt to breed on these banks, notably ringed plover and a few little terns. Twittering snow buntings are regular inhabitants in winter, occasionally joined by the scarcer shorelark. The tip of Shell Ness is used by knot and oystercatchers as a high-tide roost; other impressive wader roosts can be found off Foulness.

A few shorelarks forage along the tide line during the winter and, by early spring, are often in breeding plumage.

THAMES ESTUARY
HIGHLIGHTS
Brent geese on **eel grass**. Essex skipper and migrant painted lady butterflies on **Isle of Sheppey**. Breeding avocet and passage greenshank and spotted redshank at **Elmley**. Birds of prey on **Isle of Sheppey**.

FOULNESS

ASOUTHEND-ON-SEA

FOBBING MARSHES
CANVEY ISLAND
STANFORD-LE-HOPE

BARKING
ROMFORD

THAMES ESTUARY

GRAYS
YANTLET CREEK
CLIFFE MARSHES
TILBURY
CLIFFE POOLS
SHEERNESS

DARTFORD
GRAVESEND
ISLE OF SHEPPEY

RIVER MEDWAY
CAPEL FLEET
ROCHESTER
ELMLEY RSPB RESERVE
SWALE NNR
SHELL NESS

GILLINGHAM
CHATHAM

FAVERSHAM

Miles 0 2 4 6 8
Km 0 2 4 6 8 10 12

N

London

There is a surprising amount of wildlife to be found throughout the city, and even in the heart of the capital it is now commonplace to see a heron, flapping lazily over the rooftops of Oxford Street to its nest in Regent's Park.

Gravel pits and ponds attract a wide range of waterbirds, with largest numbers in winter.

Grey herons nest in Regent's Park, Battersea Park and Richmond Park, and there are four new heronries on the Thames in West London.

When songbirds discover a roosting tawny owl in the daytime, they mob it relentlessly, hoping to make it fly away.

F RAGMENTS OF THE original countryside survive in the outer suburbs with fine ancient woodland at Epping, Hainault and Ruislip. These woods are rich in hornbeam, trees often grossly contorted as a result of centuries of pollarding. Fine oakwoods occur too, especially around the southern fringe of London.

Kings Wood in Croydon is one of the capital's most beautiful bluebell woods, while Lesnes Abbey Woods in Greenwich are famous for their fine displays of wild daffodils.

Other ancient landscapes include the wooded pasture of Richmond and Bushy Parks, where ancient oaks are riddled with holes occupied by jackdaws. Nowadays they compete for sites with newcomers like mandarin ducks and ring-necked parakeets!

OPEN SPACES

London's heaths and commons provide some of its most famous open spaces. Wimbledon Common still has its areas of wet heath and even a patch of bog where sundew survives among the cross-leaved heath. The hay meadows of Totteridge Fields in Barnet provide a spectacle in early summer with their mixture of yellows and blues; a landscape which has survived the gradual encroachment of the outer suburbs.

London is particularly famous for the variety of unlikely places that have been colonised by nature. Although most of the post-war bomb sites with their host of wild flowers have long since gone, other new habitats continue to develop in all sorts of odd corners. They vary in size from tiny patches of wasteland, often vigorously defended by local residents, to extensive tracts of open land associated with sand and gravel workings in the outer suburbs. These unlikely areas now provide some of the most important oases for people to enjoy wildlife in the capital.

Disused Victorian cemeteries, such as Highgate, Abney Park and Nunhead are another of London's special features. These are town woodlands of a very special kind, where tawny owls hoot at night and speckled wood butterflies bask in the sun. Urban foxes also thrive among the tombstones, often venturing into back gardens to scavenge for food.

For many people, London's parks are the great attraction. A springtime walk from Holland Park to Westminster via the royal parks is pure delight. Green and great spotted woodpeckers, goldcrest and nuthatch may well be seen in the wooded parts, while the park lakes are home to a great variety of waterbirds, including herons, cormorants and great

Garden tiger moth

Arctia caja

Search beneath streetlights or outdoor lamps during July and August and you stand a good chance of finding a garden tiger moth. These amazingly attractive insects are drawn to the light after dark and sometimes remain in the vicinity, resting on walls and the like, during the daytime. At rest, the forewings, which are chocolate brown with white crazy-paving markings, conceal the hindwings. When alarmed, the forewings are opened to reveal the orange hindwings bearing bluish spots. The hairy caterpillars of this moth feed on all manner of herbaceous plants and are popularly known as 'woolly bears'.

see also page 265

Garden tiger moths are usually extremely docile during the hours of daylight and can be viewed at close quarters. If the insect is disturbed, it exposes its vividly marked hindwings.

The brown rat is found not only in sewers but by rivers and canals and in derelict buildings.

LONDON HIGHLIGHTS

Waterfowl in **St James's Park**. Ancient woods of **Epping**, **Hainault** and **Ruislip** rich in hornbeam. Nesting mandarin duck and ring-necked parakeets in ancient oaks of **Richmond Park**. Tawny owls hooting in the cemeteries of **Highgate**, **Abney Park** and **Nunhead**. Large flocks of gadwall, pochard and shoveler on **Lea Valley** and **West London reservoirs**.

Foxes have successfully colonised the suburban fringes of London and are regularly seen in gardens and parks after dark.

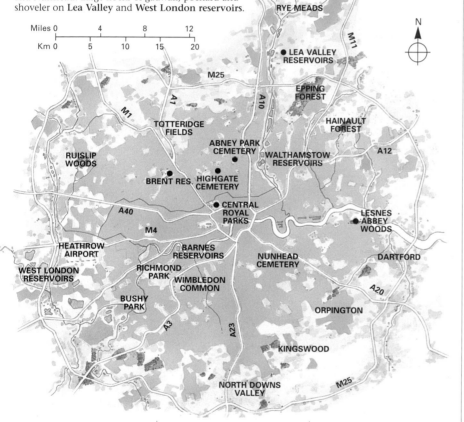

Canada goose
Branta canadensis

Flocks of Canada geese are now a common sight in parks In and around London, the birds swimming on ornamental lakes or feeding at the margins. They are usually bold enough to leave the water and graze the grass. Although this natural scene is a delight to many, their droppings, of which they produce copious quantities, are often less welcome. Canada geese have grey-brown plumage with a conspicuous white patch under the tail. The neck and head are black except for a white patch running upwards from the throat.
see also page 224

As its name suggests, the Canada goose is not native to Britain. It was introduced here from North America and is now firmly established.

Further north, near Waltham Abbey, the wetland at Rye Meads offers fine views of kingfishers, and bitterns are frequently seen in winter.

London's wildlife is being further enhanced by the creation of ecological parks. One of the best known is Camley Street, near King's Cross Station, where a tiny pocket of wild provides an outdoor classroom for local schools. More ambitious is the new WWT wetland centre being built next to the Thames at Barnes, providing public viewing points and a rich array of wetland habitats.

Despite their alien origins, ring-necked parakeets have become established in many parts.

crested grebes, whose springtime displays are not to be missed.

Central London parks are important nesting areas for pochard and tufted ducks, and even dabchicks have nested in St James's Park, where the waterfowl collection is a must for any visitor.

Although nightingales have long gone from Berkeley Square, goldfinches, blackcaps and spotted flycatcher may well be seen in the leafy squares of Belgravia.

The London area is particularly renowned for its reservoirs which provide feeding and roosting areas for large numbers of waterfowl. The Lea Valley and West London reservoirs are internationally important for their winter duck populations, and tufted duck, gadwall, pochard and shoveler all occur in large numbers, together with the less common goosander and smew. Bird-watching on these reservoirs is always unpredictable, with

rarities such as great northern divers and red-necked phalaropes turning up at one time or another.

The wetlands of the Lea Valley are especially good for birds, with a huge heronry of more than 100 pairs on an island in the Walthamstow reservoirs.

Cormorants are most numerous during the winter on rivers, reservoirs and lakes in and around London. They now breed at Walthamstow reservoirs.

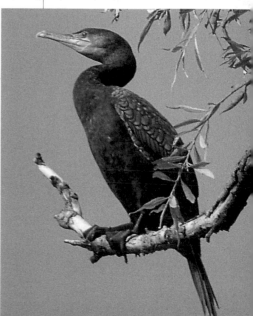

AND ALSO LOOK OUT FOR...
● hedgehog ● badger ● pipistrelle bat ● mute swan
● mallard ● kestrel ● woodpigeon ● pied wagtail
● chaffinch ● robin ● peacock ● small tortoiseshell
● oak bush-cricket ● common lime ● fly agaric

Chiltern Hills

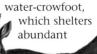

Lying just to the north-west of London, this chalk ridge stretches from the Goring Gap, on the River Thames, to Dunstable in Bedfordshire. It rises dramatically to a height of some 300m (986ft) from the Vale of Aylesbury.

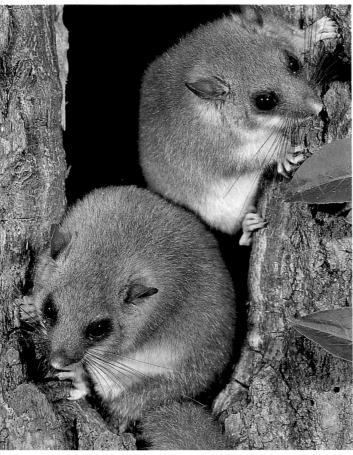

Edible dormice are considerably smaller than their grey squirrel cousins, but they do look similar.

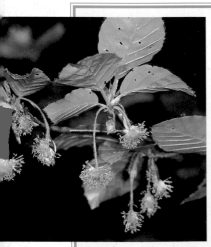

Beech

Fagus sylvatica

A fully mature beech is a stately tree and, when growing as a continuous stand, provides something of interest throughout the year. Even in winter when the leaves are off, the grey bark and spreading form of the trees is attractive, especially when set against a carpet of reddish-brown leaves. In spring, the newly formed leaves are a beautiful pale green, while in late summer and autumn the reddish-golden colours can be stunning. Beech leaves are oval and shiny with a wavy margin.

see also page 280

The autumn harvest of beech nuts – known as mast – is relished by many species, including birds and small mammals.

THE UNDERLYING chalk of the Chilterns was formed some 70 to 95 million years ago in the warm, shallow, lime-rich seas which covered most of England at that time. Today, its gleaming whiteness can be seen where the M40 carves its way through the escarpment at Aston Rowant or in quarries, such as at Chinnor and Pitstone, from which it has been excavated for cement. On higher ground the chalk is often covered by a heavy clay, but over much of the area the soils are light and shallow.

The Chilterns are one of the most heavily wooded parts of England, comparable in extent to places such as the Weald, the New Forest and the Wye Valley. Many of the woods are ancient in origin with a complex history of management resulting in a wide variety of plant and animal life.

While beech is dominant in much of the woodland, due to planting or selection to provide timber for a once-thriving furniture industry centred around High Wycombe, it is often the woods with oak and ash as well as beech which are the more valuable for wildlife.

A host of different orchids can be found here that occur nowhere else in Britain and species such as the enigmatic ghost orchid and the attractive red helleborine are carefully protected. Other characteristic plants of the woodlands include familiar garden shrubs such as box and the spring-flowering, sweet-scented mezereon, while in early summer bluebells, wood vetch, cow-wheat and coralroot are all widespread.

Most special of all, however, is the edible dormouse. Only occasionally seen elsewhere, this grey, long-tailed creature was regarded as a delicacy in Roman times. It was introduced into Britain in 1902.

RICH GRASSLAND

Besides their woodland, the Chilterns are characterised by relatively small patches of flower-rich chalk grasslands, found on the scarp and along the sides of many of the dry valleys. This grassland has a very distinctive character and supports many plants and insects which are uncommon elsewhere in southern England.

The short, springy turf produced by centuries of rabbit grazing is of special interest for its wide diversity of herbs and its rich communities of mosses and liverworts. As well as the wealth of orchids which grow in the grasslands, three rare gentians – the early, fringed and the autumn-flowering Chiltern gentian – are all found here, along with the more

The muntjac, Britain's smallest deer, escaped from Woburn Park around 1890 and now lives wild. It is seen in pairs or family groups.

Following recent reintroductions, red kites have now become established in the Chilterns. Look for the forked tail and white underwing patches.

common autumn gentian, yellow-wort and pink-flowered centaury.

A recent addition to the wildlife of the Chilterns is the red kite, which has been reintroduced by English Nature in conjunction with the RSPB. Today there is a thriving population centred around the Stokenchurch area to the west of High Wycombe. These magnificent birds of prey can easily be identified by their distinctive forked tail and attractive russet colouring.

CHALK STREAMS

Many of the chalk streams flowing off the Chilterns are spring fed and the upper sections, which run dry during the summer, are known as winterbournes.

The streams and their muddy margins provide an important habitat for many plant and animal species, including bullheads (otherwise known as miller's thumb) and sticklebacks. In the early summer the surface may be covered with the white flowers of water-crowfoot, which shelters abundant

Pasque flower
Pulsatilla vulgaris

Chalk grassland flowers have a necessarily modest range in Britain, given the fragmented distribution of the habitat itself. Among the most restricted of all is the pasque flower which only occurs in a few sites, the Chilterns being the species' stronghold. It favours short-cropped turf, and the showy, nodding flowers appear in late April and May. Although pale forms do occur, the flowers are usually an intense purple colour. The pasque flower likes southern slopes and cannot tolerate soil disturbance or undue competition.

Once fairly common on downland in the Chilterns, the pasque flower – Easter flower – now flourishes on just a few protected sites.

insect life, while water-cress, yellow iris and marsh-orchids line the edges. The fast-flowing waters are home to brown trout, dace and grayling, as well as crayfish intro-duced from France.

These streams were once exploited by local communities, and the remains of water mills and watercress beds can still be found.

Today, much of the Chilterns is covered by arable farmland, and in these areas there has been a decline in wildlife interest in recent years. Yet, even here, small pockets of land have survived which, because of their thin friable soils, support now rare cornfield plants such pheasant's-eye and ground-pine.

Glorious autumn colours on the slopes of the Ivinghoe hills. Mixed deciduous woodlands are very much a feature of the Chilterns' landscape.

The elusive ghost orchid puts in a brief appearance in July or August, but only in years of high rainfall.

Holly blue butterflies thrive where holly and ivy occur. Adults rest on the leaves of these plants, and caterpillars feed on the shoots, flowers and berries.

Famed for its autumn colour, Burnham Beeches is popular with naturalists and ramblers alike.

CHILTERN HILLS HIGHLIGHTS
Orchids, such as ghost orchid, along with bushes of wild box and sweet-scented mezereon, in **mixed beech woods**. Yellow-wort, pink-flowered centaury and rare gentians on **chalk grassland**. Red kites around **Stokenchurch**. White sheets of water-crowfoot in spring, covering **chalk streams**. Trout and grayling with occasional Atlantic crayfish in **fast-flowing waters**.

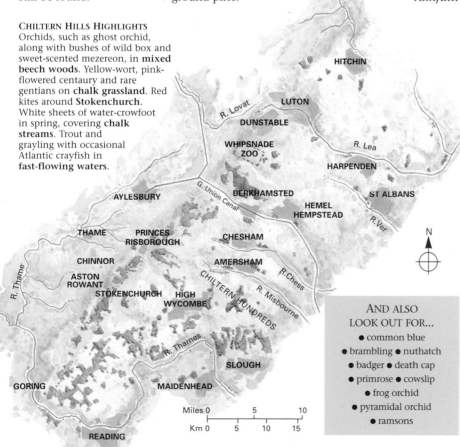

HITCHIN

R. Lovat

LUTON

DUNSTABLE

R. Lea

WHIPSNADE ZOO

HARPENDEN

G. Union Canal

BERKHAMSTED

ST ALBANS

AYLESBURY

HEMEL HEMPSTEAD

R. Ver

THAME

PRINCES RISBOROUGH

CHESHAM

CHINNOR

AMERSHAM

R. Chess

ASTON ROWANT

STOKENCHURCH

HIGH WYCOMBE

CHILTERN HUNDREDS

R. Misbourne

N

R. Thame

R. Thames

SLOUGH

GORING

MAIDENHEAD

Miles 0 5 10

Km 0 5 10 15

READING

AND ALSO LOOK OUT FOR...
- common blue
- brambling ● nuthatch
- badger ● death cap
- primrose ● cowslip
- frog orchid
- pyramidal orchid
- ramsons

Wales & the Borders

Wales is a small country, no more than 208km (130 miles) from north to south and barely an hour's drive across its narrow waist from the Shropshire Marches to the shores of Cardigan Bay. Notwithstanding this, the Principality boasts a greater variety of countryside than any comparative part of the British Isles, much of it completely unspoilt, remote and sparsely populated. Within its three national parks alone are high, snow-capped mountains, glorious coastal scenery and wild uplands that stretch for miles without sight or sound of human habitation.

Deciduous native woodland cloaks the slopes of many Welsh river valleys, and the enchanting scene at Fairy Glen, near Betws-y-Coed, is an aptly-named example. Woods such as this harbour fascinating birds, mammals and plants, while the flowing waters are rich in fish and invertebrate life.

A whole host of different landscapes lie cheek by jowl, juxtaposed one against the other to produce a continually changing mosaic of ancient woodland, wild upland, sinewey valleys, high crag, and everywhere the velvet green of sheep-grazed pastures.

With the mountains of the Lleyn Peninsula in the distance, the North Wales coast invites exploration in search of exciting birds and seashore life.

Beaches at Marloes Sands are typical of many in the region, unspoilt, almost deserted and framed by rugged, flower-covered cliffs.

LAND OF THE SEA

Wales is a land which is bound to the sea. Only one of its modern counties, Powys, has no coastline, although even here the tidal waters of the Dyfi Estuary push into the farming flatlands of its hinterland at Machynlleth. On three sides the waters of the Atlantic Ocean and the Irish Sea pound against the great cliff coastlines of Pembrokeshire, Anglesey and Lleyn, and flood over the wide saltmarshes of Gower, Gwent and Deeside. Only on its eastern flank, from north to south through the Marches, is Wales land-locked, the modern boundary roughly following the line of the 8th-century earthwork built by Offa, King of Mercia, to hold back the marauding Welsh.

To stand on the heights of the Precipice Walk above the stern, blue-grey town of Dolgellau and look seawards down the serpentine length of the estuary of the River Mawddach is to view one of the finest scenes in all Wales. On a warm summer's evening the heady scent of gorse rises up the mountainside; buzzards circle and mew; tree pipits parachute into the rowan trees on the scree slope below; and whinchats, meadow pipits and willow warblers fill the air with their song. On a clear winter's day the low sun electrifies the ebbing water in each successive fold of the hills all the way to the sea and sets the sands ablaze with light. About 200m (650ft) below, in the uppermost part of the estuary, a thousand runnels and cut-offs gleam on the saltmarsh, footprints of the falling tide.

OFFSHORE ISLANDS

It surprises many people that there are some 40 or so isles and islets dotted round the Welsh coast. The half-mile-long silhouette of Flat Holm sits in the Bristol Channel, 5km (3 miles) offshore, home of a former cholera hospital and the site from which the first radio message was transmitted over water.

WALES AND THE BORDERS HABITATS

Discover rivers and streams

During the summer months, water levels in rivers can often drop, exposing the waterworn stone along the banks.

Running water holds a fascination for most outdoor enthusiasts and the sound of constantly trickling water mingling with the song of birds and the buzzing of insects has a soothing quality treasured by many. Much of this habitat's wildlife interest derives from the wealth of plants and animals found on or beneath the water's surface, with many flowing-water species occurring nowhere else.

By way of a bonus for the naturalist, however, rivers and streams serve as magnets for the wildlife of the surrounding countryside, with many land-based birds and mammals paying regular visits to bathe or drink.

Although most of us can picture how a stream might differ from a river, the distinction is a rather arbitrary one, based more on appearance than actual differences. If a body of flowing water is viewed along its course, a stream is usually taken to be the stretch of fast-flowing headwaters near the source. Thereafter, further down its course, it becomes a river; this gradually increases in volume along its length while the flow slackens as the gradient becomes less steep.

Several physical factors influence the range of life that any given stretch of flowing water can support. The speed of the current has an obvious impact on any sedentary plant or animal's ability to retain a

All the sizeable islands of Pembrokeshire (save Caldey with its monastery) are nature reserves on account of the enormous seabird and seal colonies that they support. The populations of Manx shearwaters, gannets, puffins, guillemots, razorbills and grey seals are of high international importance.

Ramsey, queen of the Pembrokeshire islands, has fewer seabirds but high botanical richness and the finest cliff scenery in Wales, alive with tumbling choughs – those wild, red-billed and red-legged crows; a Celtic bird, still to be found here and on other cliffs on the western fringes of Britain. The long subterranean sea caves and inaccessible storm beaches of Ramsey are nurseries too for large numbers of grey seals for which Pembrokeshire is again famous. Scattered in the sea around Ramsey are many tiny islets; the Bishops and Clerks, Ynys Bery and, far out in the west, the dangerous rocks of the Smalls and the low hump of Grassholm, snow-white with its massive colony of gannets.

Off the coast of the Lleyn Peninsula in north-west Wales are the little island groups of the Gwylans and St Tudwal's and, more famously, the sacred island of Bardsey, standing fast in the tide races which boil and swirl off the cliffs of Aberdaron Head. Here are the remains of an Augustine monastery, and it is the alleged resting place of 20,000 saints. Modern visitors come here for the peace and solitude and to share the lonely island with peregrine, chough, Manx shearwater and the summer wailing of gulls.

Then of course there is Anglesey, the largest island off Wales by far and a county in its own right. Mam Cymru it is called, the Mother of Wales, in recognition of the ancient rocks which underlie its gently rolling topography,

A trip to Anglesey requires just that little bit more effort but its dramatic coastline makes the journey worthwhile.

Grey seals occur around much of the Welsh coast but reach their highest density around Pembrokeshire where they breed.

scraped, gouged, flattened and eroded by more than 100 million years of geological processes. The coast is punctuated with a litter of small islets and skerries, from Llanddwyn off the south-west point to The Skerries in the north.

Two famous bridges span the narrows which separate Anglesey from the mainland of Wales. Thomas Telford's great iron suspension bridge was the first of its kind in the world and has been the island's road artery to the mainland

ever since 1826. About 1.6km (1 mile) to the west is Robert Stephenson's equally impressive Britannia Tubular Bridge, carrying the railway to the Irish railhead at Holyhead, and now supporting a second deck which takes the rerouted A5 towards the same destination. Peregrines and ravens nest on Stephenson's bridge, Arctic terns breed on islets below, and mergansers feed in the food-rich waters of the Menai Strait.

HILLS FULL OF SHEEP

Wales is a green country, but a land whose yield is constrained by poor soils, generous rainfall and steep contours. Except for the fields of early potatoes in Pembrokeshire and Gower, and small areas of cereals or roots in some of the lowland areas, grass is the universal crop; the only one that will prosper well in the mild

Brown trout

Salmo trutta

The brown trout is one of the most attractive of our native fish. The base colour of the flanks is indeed brown but an array of brightly coloured spots enhances its appearance. In Wales, there are both river and lake-bound populations of brown trout. In late autumn and early winter the fish spawn, either moving upstream in the case of river populations or into the feedstreams in the case of lake trout. In shallow, gravelly areas, where the water is fast-flowing, the female excavates a depression known as a redd. Present throughout the process, the male trout readily fertilises her eggs, after which she covers them with gravel.

see also page 257

Experienced fishermen can predict the places along a river that will be favoured by brown trout. These include deep pools, under weirs and in shaded overhangs.

beds of gravel and boulders, while slower reaches have sand or silt on the bottom. It is hardly surprising that the nature of the river bed has a profound bearing on which species occur.

In a pond or lake, microscopic algae live in suspension and form an important basis for the complex food webs that develop. In flowing water, these tiny plants would soon get swept away, so much of the primary input of food comes from detritus washed down from further upstream. As a consequence, many of the smaller river creatures, particularly from fast-flowing reaches, are either filter-feeders and detritivores or carnivores feeding upon them.

Further up the food chain in flowing water we find the fish, most of which are predatory, and above them the birds which have

a spectrum of diets that includes everything from invertebrates to fish.

Given the importance of fish in flowing water, it is hardly surprising that freshwater biologists traditionally categorise the different stretches of a river system according to the species of fish that occur there.

The dipper's rotund, dumpy profile and habit of perching on boulders in fast-flowing streams make it unmistakable.

foothold on the stream or river bed. Of equal importance is the amount of dissolved oxygen contained in the water; fast-flowing, turbulent waters harbour more of this essential gas than sluggish stretches.

The nature of the river bed will also vary along the length of any stretch of flowing water. As a general rule, the swifter the current the larger the particles that get swept away and so fast-flowing stretches generally have

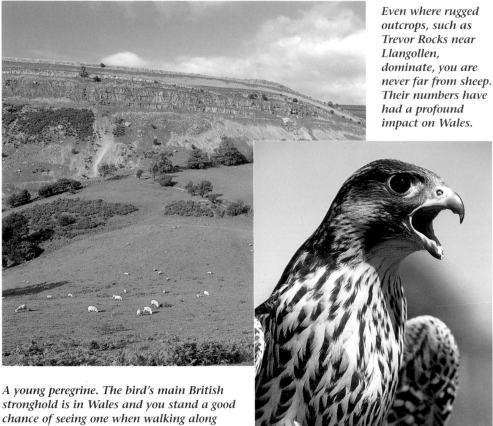

A young peregrine. The bird's main British stronghold is in Wales and you stand a good chance of seeing one when walking along coastal cliffs or through craggy inland terrain.

Even where rugged outcrops, such as Trevor Rocks near Llangollen, dominate, you are never far from sheep. Their numbers have had a profound impact on Wales.

patterns and the intervening woodlands and copses are much as they were and hedgerows, unlike those in many other parts of Britain, remain largely intact, serving as field boundaries and as narrow bands of shelter for sheep.

Some 11 million sheep graze the Welsh countryside, from the saltmarshes of the larger estuaries to the highest pastures of the Snowdonia mountains. Sheep dominate the landscape and govern the lives and livelihood of most of the rural population. Farming in the unforgiving conditions of the marginal hill lands is a hard business and wildlife too has paid a heavy price for the intensity with which this farming system has had to operate.

The enclosed fields have become a monoculture of improved grasses, robbing them of the traditional meadow flowers, butterflies and other flying insects. Lapwings and curlew are scarce birds now, and even the once ubiquitous skylark is absent from wide swathes of country.

Old hay meadows are few and far between, and are greatly valued where they still occur; most of the grass grown for winter fodder is cut for silage and stored in the fields in large black plastic sacks. In May and June the countryside becomes a patchwork of colour, the pale yellow of cleared fields alternating with various greens.

THE FFRIDD

Many of the valley sides in hill areas are too steep to cultivate and remain as rough pastures. This is the ffridd, the land which lies between the enclosed fields of the valleys and the open moorland above. Whole hillsides are dominated by bracken or gorse, studded with rowan, holly or hawthorn, to form a vital component of the landscape. The gorse is a golden yellow

moist conditions which define much of the Welsh climate. Thus Wales is a stock-rearing country par excellence. Here sheep alone outnumber people by more than four to one. Dairy herds characterise much of the farming in the lowland areas of the south-east, south-west and

north-east, but everywhere – and exclusively in the hills and uplands – the sheep is king.

The countryside is an ancient tapestry of fields which form the heartland of a pastoral system of stock grazing. Visually little has changed over the past 50 years or more. Field

WALES AND THE BORDERS HABITATS

Discover wetlands

As any naturalist will tell you, an interest in freshwater life embraces far more than just a study of those plants and animals that occur beneath the surface of the water. Water margins are wonderful places to explore; as well as being more accessible, they often harbour a far greater variety of life than either open water or dry land. Sometimes when soil and climatic conditions permit, sizeable areas develop, comprising a mosaic of habitats including pools, partly inundated marshy soil and drier ground.

Collectively these are often referred to as wetlands, but this broad generalisation covers a wide variety of visibly different habitats, the precise nature of

Where conditions are not too acidic, common reeds can form extensive stands along the edges of standing or flowing water.

which is often strongly influenced by the chemical nature of the underlying soil.

The physical appearance and ecology of any wetland habitat inevitably changes with time and, were it not for the intervening activities of man, almost every freshwater location would show a gradual shift from open water to dry land over a period of a century or so. This slow but dramatic process, generally referred to as succession, is a natural one; silting up gradually allows more plant cover to take hold, the final

Southern marsh-orchid is found in southern England and Wales, growing in calcareous or base-rich marshes, fens, dune slacks and wet meadows.

Short, grassy turf in upland areas can be surprisingly rich in flowers, especially where sheep-grazing is restricted or the terrain limits their ability to crop the vegetation. One of the most attractive flowers in these settings is the mountain pansy, which blooms in late spring.

Once threatened with extinction, polecats are now relatively common in Wales. Broken ground with stone walls, plenty of scrub cover and nearby woods is an ideal habitat for these relatives of the weasel.

and the autumn bracken a rich red-brown, staying that way through the winter until the vivid green of new growth emerges in May. On some slopes carpets of bluebells indicate where a wood once stood, and here and there the beautiful yellow mountain pansy can still be found. Badger, polecat and fox thrive on these hills, and the ffridd is a hunting ground for buzzards – the most numerous bird of prey in Wales – kestrels and sparrowhawks.

These are bird-rich habitats, alive with the springtime song of redstart, tree pipit, whinchat, wheatear and willow warbler. Meadow pipits are the most numerous birds in many areas and the most frequent host for cuckoos, which are commoner here than anywhere else.

The Irfon valley, near Builth Wells in Mid-Wales, is typical of many watercourses in the region. The slopes are covered with a mosaic of sparse deciduous woodland, bracken and grassland, with recent conifer plantations growing on the hilltops.

Lesser spearwort

Ranunculus flammula

Lesser spearwort is very variable in size and habit. It often creeps or trails over damp ground, rooting at nodes along its length. It is a typical plant of riversides and lake margins, growing on gravel, among boulders or on muddy ground. The stems are often reddish and carry leaves which vary in shape from almost oval to lanceolate.

see also page 285

Lesser spearwort is a common wetland plant and has small, buttercup-like flowers from June to October.

stage being colonisation by trees once dry land is established.

Were it not for the pressures of limited space and competing land use, succession could be allowed to follow its natural course. As it is, most wetland areas are managed in some way to preserve the existing proportions of terrestrial and watery habitats.

Classic wetlands occur in locations where, whether through natural geography or the actions of man, drainage is restricted and the ground remains permanently wet. Where this happens, debris that occurs after natural plant death and from the annual dieback of herbaceous species is not washed away and does not decompose fully. This leads to sediment layers of peat building up.

Skilled ecologists can detect a whole range of subtly different wetland habitats but, although it might be considered an oversimplification by some, most people choose to categorise them into two broad types.

In areas where the underlying soil and ground water are acid and nutrient-poor, the wetland habitat that develops is referred to as a bog; this is characteristic of waterlogged areas of lowland heath but is perhaps more typical of upland terrain. A range of bog moss species (*Sphagnum* species) is characteristic of this habitat, as are specialised flowering plants such as bog asphodel, butterworts, bladderworts and sundew species. These last three all supplement their nutrient input with an insectivorous diet.

Soils and overlying groundwater that are alkaline and mineral-rich support a wetland habitat known as fen, in which the vegetation is visibly more lush and diverse than that of any bog. Large numbers of herbaceous plants, many of them rare, can be found in the best sites. Various grasses often predominate and, in some areas, species such as common reed are actively encouraged and harvested on a regular basis.

Grey wagtails are year-round residents on many streams and rivers. In winter they also visit watercress beds and marshes.

ECHOES OF THE PAST

Sad groups of old sycamores on lonely terraces or in hidden cwms are monuments to those who failed to eke out a living on these hills and whose dwellings are now no more than stumps of grey stone walls or shapeless grassy mounds.

In some areas, more extensive signs of man's struggles with this raw environment are found, for the hills contain meagre seams of lead, silver, gold and copper, which have been exploited in past centuries. The legacy of this work, in areas such as the Plynlimon massif in central Wales, is evident in hillsides riddled with shafts, terraces of deserted miners' cottages high in the hills, the remains of former workings and lines of old trackways.

Trackways of diverse origins and many ages are everywhere: a lacework of human progress and intent. In the lowlands many of these ancient routes are long since subsumed in changing land-use and urbanisation, or have

Much of the Welsh coastline is blessed with well-marked trails and paths, as here in the Pembrokeshire Coast National Park.

The Welsh people make good use of local building materials. Here in Snowdonia a slate fence is used as a barrier to prevent sheep roaming.

become tarmac carriageways now identifiable only by the deeply sunken lanes in which they lie. But in the hills the signs are everywhere. The scars of the rash of Euro-funded farm roads gouged into the hills in the 1980s are obscene in their disregard for contours and landform. They cleave into the very heart of the hills and will take many years to soften.

Much gentler and more sensitive are the older trackways where lines are often only subtly traced on the ground like crop marks in the fields below: ancient routes of drovers, London-bound with cattle, sheep or geese, finding the easy routes, as water does, through the folds of the hills. Even older routes are there – dim shadows sometimes – leading to the outline of old

WALES AND THE BORDERS HABITATS

Discover uplands

Eroded by wind, rain and ice over countless millennia and scarred by glaciation, upland regions are arguably the most inspiring places in Britain to visit, generating a scenic beauty and climate all of their own. They are also among the most challenging of environments, both for the wildlife that survives there and for the people who visit. The term uplands includes not only mountain and hill tops but the lower slopes as well.

It comes as a surprise to many people to discover that, even though they may appear wild and untamed, our upland regions have felt the impact of man over the centuries and the landscape is often far from

A dusting of snow on the peaks of Snowdonia heralds the early arrival of winter, while the autumn colours of bracken still adorn the lower slopes.

In the right conditions, purple moor-grass can be dominant over large areas of moorland.

natural. Steep and rugged they may be, but most British uplands are not high enough for their summits to extend beyond the tree line, and studies of fossil records in peat deposits confirm that most of our mountains, and certainly their lower slopes, were wooded from the end of the last Ice Age some 10,000 years ago until comparatively recent times.

gateways to forgotten forts whose rampart lines still leave their signature on the summits of innumerable hills; medieval monks' paths etched on the landscape, and the more recent wearying uphill tracks of miners' daily journeys from mean dwellings in sheltered cwms to candle-lit working caverns deep in the mountains above. Here and there, too, is evidence of the military straightness of a Roman presence.

The process continues today as the growing crowds of ramblers and walkers slowly wear the bedrock routes to Pen y Fan, Cadair Idris and the mountains of Eryri, or plod the long-distance paths of Offa's Dyke, Glyndwr's Way or the Pembrokeshire coast.

Welsh slate blasted from the quarries and mines of Snowdonia is famous the world over as the finest roofing material available. It doubles too for sills and thresholds on many Welsh houses. In parts of Snowdonia, cut slabs of slate used vertically and interwoven with strong wire form unique and distinctive field divisions, an alternative to the more traditional drystone walls of the mountain regions.

Just as slate is the roofing material for older buildings – and many modern ones in North Wales – so stone was the material for the buildings themselves before the use of brick. Dressed stone gives style and squareness to many of the countryside houses just as uncut stone, often in huge blocks, gives ruggedness and solidarity. Other houses, mills and barns are built of rounded water-worn stones lifted straight from the rivers and streams. Thus many buildings in the countryside spell out great age and continuity. They sit as rock-solid and grey as the rocky hillsides into which many of them are securely built.

Although small numbers of goosander breed in the region, this fish-eating duck is commonest in winter, occurring on larger lakes and reservoirs, sometimes in sizeable flocks.

Spectacular waterfalls, such as this one on the Afon Mellte in the Brecon Beacons, are a widespread feature of watercourses throughout much of the upland region of Wales.

WATER, WATER, EVERYWHERE

There is plenty of rain and it is greatest in the hills, declining from west to east. Wales is a country of hills and mountains which spawn 10,000 streams and rivers. Many of these, both large and small, have carved deep, steep-sided dingles, ravines and valleys, often completely disproportionate to their size, most numerously in the softer shales of Mid Wales and the coalfields of South Wales. The rivers and streams have lyrical names – Pysgotwr, Dwyfor, Hafren, Sirhowy and Syfynwy. Hafren is the name give to the upper reaches of the Severn as it eases its way towards the English border from its origins on the Plynlimon plateau, a few miles from the source of that other great Welsh river, the Wye; they meet again at the head of the Severn Estuary.

These Welsh rivers are jewels in the landscape, crystal waters cascading from the hills in myriad cataracts and falls. The most stupendous waterfall is the famous 70m- (230ft-) drop at Pistyll Rhaeadr, where the River Rhaeadr

The dotterel is a scarce summer-visiting wader, breeding only on high tops. The male incubates.

Only where the terrain was too steep or the soil too unstable was tree cover absent.

Clearance of the forests for fuel and to allow sheep grazing effectively eliminated our upland forests, and continued overgrazing by sheep does nothing to encourage natural regeneration.

Today, the lower slopes of most mountains are covered with grassland or heather moorland, except where scree slopes prevent

successful colonisation by plants. Only at high elevations on the highest mountains does this vegetation give way to communities of true mountain plants, low-growing species adapted to living in nutrient-poor, stony ground where temperatures can vary wildly, even on an hourly basis, and frost and snow are part of everyday life, even in summer.

In sheltered areas where sheep grazing is prevented either by the terrain or by their deliberate exclusion, surprisingly lush vegetation often develops. The chemistry of the underlying rock has a profound influence on the plant species that occur. The extent to which the plants flourish is often encouraged by springs and water seepages.

Upland animals are necessarily hardy creatures adapted to survive the extremes of a mountain climate. A surprising

Short-eared owl

Asio flammeus

Unusually for owls, this one is often active by day. Short-eared owls favour rough grassland and feed in a highly characteristic manner. Using their long, rounded wings, they fly in a leisurely fashion low over the ground, quartering the terrain and doubling back if they detect something. If a mouse or vole is unfortunate enough to rustle or move while the owl is overhead, the bird will drop down on the creature and grasp it with its talons.

see also page 241

Short-eared owls tend to nest on the ground in upland areas of Britain, including Wales, choosing areas of thick heather moorland or young conifer plantations.

number of insects and other invertebrates can be found, enough to support populations of breeding birds. Some of these species, including waders such as dotterel and golden plover, are summer visitors to our uplands, while the resilient ptarmigan is a year-round resident, able to forage even when snow blankets the landscape. Both ptarmigans and mountain hare, the latter also a permanent resident of the hostile environment, fall victim to golden eagles where the range of predator and prey overlap.

In their first few years of life, conifer plantations on upland moors are ideal breeding sites for several raptor species, including the graceful hen harrier.

Mountain lakes are often nutrient-poor but are home to specialised plants – like water lobelia here – invertebrates and various fish.

Although regimented and of uniform age, mature conifer plantations harbour a few interesting plants and animals.

tumbles off the flanks of the Berwyn Mountains. The most beautiful one may well be Henrhyd Falls in the upper valley of the River Neath, an area blessed with other lovely falls.

Apart from being scenic highlights, these watercourses are rich in wildlife. They abound with brown trout and are nurseries for Atlantic salmon and sewin (sea trout). They support dipper, kingfisher, goosander and common sandpiper, and their tree-lined riversides are important corridors for many other birds and mammals. Otters – populations are expanding in Wales now – have their holts here, the invasive mink abounds and the inoffensive but

threatened water vole manages to survives.

In a land of hills and valleys where rainfall is high, lakes and pools are numerous. Many are up in the hills and are cold and hold little wildlife. A few have Arctic char, occasional sandpipers or small colonies of water lobelia and quillwort. Of the lowland lakes, Llangorse in Powys, reed-clad and much used for recreation, is one of the best and rich in wildlife. Bala Lake in Gwynedd is the largest in Wales and the only place in which the unique gwyniad is to be

found (unique too as the fish with a Welsh name only). It lives deep in the waters and feeds on small shells and the leaves of water lobelia.

The majority of natural waters are not easily reached by road, but the numerous reservoirs, almost without exception, are more accessible and many of them lie in valleys which are spectacular – forest-clad Lake Vyrnwy in the Berwyn Mountains, a beautiful series in the Elan Valley, remote Nant-y-Moch in the Plynlimon Hills and Claerwen on the Dyfed/Powys border.

WALES AND THE BORDERS HABITATS

Reading the landscape

Most of Wales is high, rolling terrain on hard, 400–500-million-year-old Ordovician and Silurian rocks, a varied mix of shales, slates and grits. The nature of the rocks, together with the high rainfall, has led to thin acid soils, poor in plant nutrients. The higher ground is generally covered by hill grasslands, long given over to sheep, sometimes with deep peat on the flatter tops.

Better pasture occurs in the valleys in the enclosed fields around farms. Often there are patches of oak and birch wood on the valley sides; wonderful mossy oak woods grace the wet rocky valleys around Devil's Bridge and the valleys and ravines of southern Snowdonia.

Slate meets the eye almost

The Devil's Kitchen at Llyn Idwal is one of Snowdonia's most dramatic locations and a great spot for mountain plants.

WOODLAND OLD AND NEW

The uplands of Wales are now bare of the native oaks and birches that once clothed them. Where the hills are not planted with blocks of modern conifers, they are open sheep walks and heather moor. Curlew and red grouse inhabit these moorlands; the rarer black grouse lives at the edges where the moors meet the forests. Hen harriers and merlin are present in modest numbers, preying on voles, meadow pipits and skylarks. The new conifer forests cover some 25 per cent of the uplands of Wales and although they often seem dark and forbidding they do in fact support a growing range of wildlife. Fallow deer herds graze some of the forests, red squirrels maintain a toe-told, as does the pine marten, while crossbill, siskin, goshawk and nightjar (now a regular breeding bird in cleared areas) would be far scarcer without the forests.

In woodland terms, however, it is the glorious oakwoods of the valley sides for which Wales is rightly famed. These trees are not the tall straight pedunculate oaks of lowland Britain, but the tough, rugged sessile oaks that prosper in the thin soils and humid climate of the West. Given a chance they will grow as straight as the lowland specimens but the best have been felled and used long since, extracted for building, smelting, fencing or burning: they have been valued by men such as Nelson and Rodney whose ships would have always been made of Welsh oak. The framework of many of the old houses, farms and barns in lower areas are enduring testimony to the timber's hardness and durability.

These woods are at the very heart of the Welsh countryside, the essence of so much of its

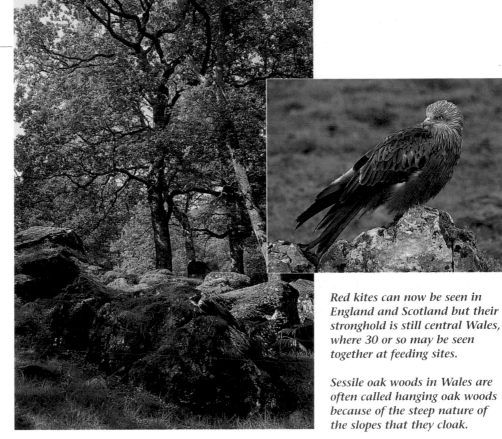

Red kites can now be seen in England and Scotland but their stronghold is still central Wales, where 30 or so may be seen together at feeding sites.

Sessile oak woods in Wales are often called hanging oak woods because of the steep nature of the slopes that they cloak.

life and wildlife. In spring, they burst into colour with soft green carpets of foliage, underlain with mats of sorrel and wood anemone and swathes of bluebells and dog's mercury. Then they resound with the songs of pied flycatcher, redstart, tree pipit and wood warbler. The trunks and boughs are tattooed with multicoloured lichens and festooned with epiphytic ferns.

In many steep-sided woods, the ancient twisted trees have forced their way up among massive boulders, each clothed in its own summer green, a silent magical world, seemingly untrodden and secret. This must be the home of the Twlwyth Teg, the Little People!

These remote valleys are certainly the heartland of barcud, the red kite – one of the rarest and most cherished of our birds of prey – snatched back from the brink of extinction (a handful of pairs) and guarded here in its final haunt: the symbol of wild Wales. The living essence of a glorious Celtic countryside.

everywhere, especially around the old quarries, now mostly derelict, at places such as Corris, Blaenau Ffestiniog and Bethesda. Slate is the traditional building material of Mid and North Wales; in its heyday, Welsh slate roofed much of Britain.

Around this central core Wales is remarkably diverse. The coal of the South Wales valleys was for a long time the economic mainstay of the region, but coal-mining is now fast receding into history. The Carboniferous limestone around the edge of the coalfield creates some magnificent landscapes, in the cliffs of Gower, the crags above Crickhowell and Merthyr Tydfil, and the waterfalls and gorges around the head of the Vale of Neath.

Although older and geologically lower than the limestone, the sandstone summits of the Brecon Beacons, just to the north, tower above it. The south Pembrokeshire

coast is again limestone. West Pembrokeshire recalls Cornwall, but has its own character.

In North Wales, the Carboniferous limestone reappears in the Eglwyseg Rocks north of the A5 at Llangollen and in Great Orme's Head at Llandudno; there are smaller outcrops from Flintshire to Anglesey. Snowdonia,

Slate is the most popular roofing material because it is widely available across Wales.

with the highest peaks in Britain outside the Scottish Highlands, was one of the first places where the evidence of former glaciation was recognised. It is easy to see the cwms on the mountainsides that

once held the heads of glaciers, ice-smoothed rocks, and glacially deepened U-shaped valleys (Nant Ffrancon and the Llanberis Valley are classic examples). The glaciers piled up morainic debris, and carried boulders to places where we now see them as 'erratics'.

Anglesey, across the Menai Strait, is a low, glacially smoothed island. Its limestone, sandstone, glacial drift and shell-rich sand dunes, as well as some of the oldest rocks in Wales, produce striking contrasts.

Wales has some of the finest coastal sand dunes in Britain, and the islands off the coast are famous for their seabirds.

The Marches, where the Midlands meet Wales, are geologically complex and scenically beautiful. The Pre-Cambrian Malvern Hills and Long Mynd, and the igneous sugarloaf summits of Craig Breidden, are three landmarks among many.

WHERE TO GO

Wales and the Borders

As well as a rich cultural and linguistic history, Wales has a wealth of different habitats and wildlife. There is plenty to discover: the grand mountain scenery of Snowdonia, plush green valleys inland and rocky seacliffs to the west.

1. BERWYN MOUNTAINS AND LAKE VYRNWY

The Berwyn Mountains are the most important remaining area of heather moorland in Wales and the last stronghold in the Principality for red grouse and hen harrier. Peregrine, merlin, short-eared owl and ring ouzel also occur, together with a few black grouse. Rare cloudberry and lesser twayblade are two of the most notable plants, and large heath butterflies are occasionally found together with the ubiquitous fox and emperor moth. The woodlands around Lake Vyrnwy are excellent for siskins and crossbills. The lakeside has breeding common sandpipers, grey and pied wagtails, goosanders and great crested grebes.

2. BREIDDEN HILLS

Straddling the border between England and Wales, the Breidden Hills rise steeply and abruptly from the floor of the Severn Valley to a height of 365m (1,200ft) at Rodney's Pillar, a monument commemorating the fact that Admiral Rodney insisted his ships were made of Montgomeryshire oak. The blackish dolerite rock supports important wildfowl communities and makes Breidden one of the classic botanical sites in this area. Common rock-rose, bloody crane's-bill, meadow saxifrage and narrow-leaved bitter-cress are some of the notable plants, but the real rarities date back to the 17th century when Edward Lluyd discovered western spiked speedwell, sticky catchfly and rock cinquefoil, for which the hills have remained famous ever since.

3. BURRY INLET AND PENCLACWYDD

The Burry Inlet is an estuary of enormous low-tide sandflats and wild creeks, dissected by saltmarshes. The flats on the south of the river channel are renowned for the harvesting of cockles, but most famous are the huge populations of wintering wildfowl and waders. Oystercatcher flocks alone can be as large as 20,000. The best viewing is from the Wildfowl and Wetlands Centre at Penclacwydd, Llanelli. Birds are to be found in abundance; little egret are numerous recent arrivals and many other species can be seen at close quarters. The development of the Millennium Coastal Park along the adjacent coastline will make this one of the great bird-watching places in Britain.

4. DEE ESTUARY

The Dee Estuary is famous for the numbers and variety of passage and wintering birds that it supports. It is also well known for the grey seal colonies on Hilbre Island and West Hoyle bank. Bird-watching can be rewarding on either the Welsh or English banks, but the latter is considered best. On the highest winter tides, when the vast saltmarshes are completely covered, huge flocks of waders fly restlessly up and down. Herons wait to prey on escaping water rails, and short-eared owls, hen harriers, merlins and peregrines will be in the air in considerable numbers.

5. GREAT ORME

The splendid Carboniferous headland at the Great Orme above Llandudno has long been famous among botanists for its special plants, and with bird-watchers for the seabird colonies and its importance as a migration site. Bloody crane's-bill, two rock-roses, spring squill and wild cabbage are just some of the flowers, while a rare wild cotoneaster is thought to be a relict from 6,000 or 7,000 years ago when the area enjoyed a warmer, more Mediterranean climate. Apart from the usual seabirds, migrants such as wheatear, whinchat, snow bunting, ring ouzel and golden plover are regular visitors. Seabird passage off the headland is often impressive with kittiwakes, Manx shearwaters, gannets and skuas predominating.

6. GWENT LEVELS

Bordering the north side of the Severn Estuary, the Gwent Levels comprise one of the most extensive areas of reclaimed wet pasture in Britain. The pattern of ancient fields, rhynes and ditches and isolated hamlets is a landscape that has developed over the past 2,000 years or more. The rhynes are of high national interest for their flower and invertebrate life. Good numbers of shorebirds and wildfowl characterise the foreshore. The wildlife of the area is benefiting from the construction of a new 400ha (1,000 acre) nature reserve, a complex of wet pastures, lagoon and reedbeds.

7. KENFIG POOL AND DUNES

More than 500 species of plant, including favourites such as wild pansy, evening-primrose, autumn lady's-tresses, marsh orchids and wintergreen, grow in the dunes at Kenfig. The weed-fringed pool supports

Kenfig Pool lies at the heart of a vast and largely unspoilt area of stabilised, vegetated sand dunes.

breeding sedge, grasshopper and reed warblers, tufted duck and great crested grebe. The area is well known to bird-watchers and, in addition to a long list of regular migrants and winter wildfowl, it has produced a trickle of extreme rarities such as pied-billed grebe and little whimbrel.

8. LLEYN AND BARDSEY

The wild headlands of Aberdaron at the tip of the Llyn peninsula look across the dangerous tide races to the island of Bardsey (called Ynys Ennli in Welsh). These remote cliff coasts are home

to chough, peregrine and raven. The coastal paths are bright with gorse in summer and studded with primrose, bluebells and squill earlier in the year. Stonechats and yellowhammers can be found, together with whitethroats and cuckoos in their season. Seabird colonies occur on headlands such as Carreg y Llam and Cilan Head. Bardsey – which is open to day-visitors – is famed as a landfall for migrating birds, as well as for supporting good populations of seabirds, including Manx shearwaters and storm-petrels.

9. MALVERN HILLS

The Malvern Hills form the border between the old counties of Worcestershire and Herefordshire and were once part of the royal forest of Malvern Chase. Today much of the area is open commonland. The tops are clothed in acid grassland scattered with heath bedstraw and harebells, while the woodland at the southern end is mainly sessile oak, with wood sorrel, yellow archangel and ramsons in spring. The hills are excellent for butterflies, including pearl-bordered fritillaries. Skylarks sing high overhead, while tree pipits drop like mini-parachutists during their display flight.

Great Orme's Head is a landfall for migrant birds in spring and autumn and has considerable botanical interest throughout the summer months.

10. STRUMBLE HEAD

Strumble Head is without doubt the most exciting place to watch birds out at sea. Local breeding birds arrive from the middle of March and intensity increases in June and July as the adults – razorbills, guillemots, puffins, gannets and Manx shearwaters – forage to feed their young. Through late summer and autumn, northern species of Leach's petrel, skuas and terns pass through on their way to oceanic wintering grounds. Birds from the south and east also appear – Mediterranean shearwaters or little gulls, together with occasional rarities from the southern oceans.

11. TYWI VALLEY WOODLANDS

Few woods in Wales can match those in the spectacular valley of the upper Tywi and its tributaries north of Llandovery, Carmarthenshire. These sessile oak woods are best in spring with

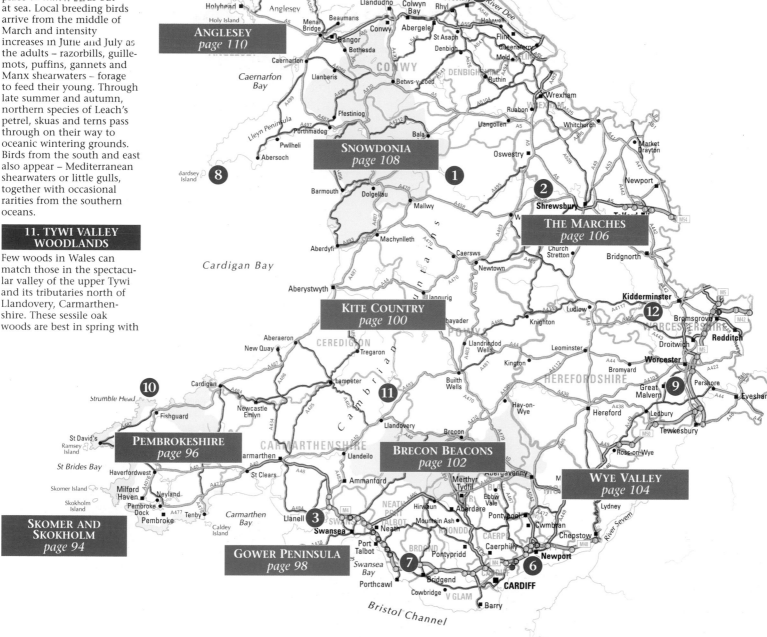

the bursting canopy of new growth and misty carpets of bluebells. Red kites live here and float over the valleys in company with ravens and peregrines. The woods themselves are especially noteworthy for great numbers of summer visitors – redstarts, pied flycatchers, wood warblers and tree pipits. Dipper, grey wagtails and goosanders feed on the cascading watercourses.

12. WYRE FOREST

Although much of Wyre Forest is woodland, it incorporates unimproved meadows, small mires and streams and even a disused railway line. The woods on the plateau contain sessile oak, birch and rowan –

similar to the woodland of the Welsh valleys – and there are also areas of pedunculate oak like those of the Midlands. The varying habitats encourage insects of every shape and size, from the only land-living caddis fly larvae to southern aeshna dragonflies. All three species of woodpecker nest, along with nuthatch, tawny owl and other hole-nesters; woodcock are another speciality.

Easily accessible to the energetic walker, the Malvern Hills offer stunning views over rolling English countryside with distant Welsh mountains looming to the west.

Skomer & Skokholm

Stand at Wooltack Point, in west Pembrokeshire, and ahead is the massive bulk of Skomer, separated from the mainland by the turbulent waters of Jack Sound. To the south-west are the red sandstone cliffs of Skokholm, another prime bird island.

Puffin
Fratercula arctica

The puffin's most distinctive feature is its triangular bill, coloured red, blue-grey and yellow. Chicks emerge with a small grey bill but by their first winter it has started to become recognisably puffin-like. The adult's beak is at its brightest in spring and summer, when birds perform a 'billing' display, touching beaks as part of their courtship and greeting ceremonies. But it is on fishing trips that the bill really comes into its own: on a single dive the bird can catch several fish, holding them crosswise in its bill – one Scottish bird returned with a staggering 62 fish in its bill. Puffins nest in burrows, often using those abandoned by rabbits. Adults are most in evidence early in the morning or in the late afternoon when returning with fish for their chick.

see also page 239

Puffins are present in the region from April to August, after which they head away from land to spend the winter at sea.

ALTHOUGH THE island year commences well before Christmas, when fulmars, guillemots and razorbills visit the cliffs, it truly begins in late March with the arrival of the puffins. These endearing birds nest in thousands in burrows on the cliff slopes. During April the tasks of courtship and preparing the underground nest begin in earnest. After the single egg hatches in early June, the adult birds can be seen winging in with

In late May and early June, the cliffs are transformed into natural rock gardens by the appearance of hardy coastal flowers.

beakloads of sand eels to feed the chicks.

The kittiwake, that most dainty of gulls, occupies many of the Skomer cliffs. It is named after its raucous call, *kittee-wake, kittee-wake.*

SEABIRD CITY
Guillemots in their hundreds nest on the narrowest ledges, while razorbills choose crevices and niches for comparative safety. Fulmars often nest higher up, and are best seen in flight as they sweep effortlessly along the cliffs. To stand above the great chasm of The Wick, one of the world's great seabird 'cities', is an experience of a lifetime.

Inland, great black-backed gulls stand sentinel on some of the higher rocks, while lesser black-backed gulls nest in huge swathes on the plateau. The piping calls of oystercatchers fill the air, and on Skomer the curlew nests at what is now its only locality in south-west Wales.

Red campion flowers in the shelter of rocky outcrops and stone walls on both islands.

You may be fortunate enough to see a short-eared owl hunting low over the bracken and heath. Among its prey is the Skomer vole, a race of bank vole found only on the island; although prolific, it is rarely seen.

Two of the most numerous seabirds nesting on the islands – the Manx shearwater (commonest on Skomer) and the storm-petrel (commonest on Skokholm) – are also seldom seen by the day visitor. Shearwaters, very much birds of the sea, are vulnerable to predators on land due to their ungainly gait and do not come ashore until after dark. At dusk, they gather in their thousands in rafts offshore before flying to their nesting burrows and crevices, uttering strangled, caterwauling calls to each other.

SPRING COLOUR
In spring, carpets of pink thrift and white sea campion cover the cliff slopes, while much of the interior seems to be clothed in the blue haze of bluebells throughout May and early June, often followed by belts of red campion. Later in the year, the purple heathers, and, on Skokholm, goldenrod and ragwort predominate.

Although most of the

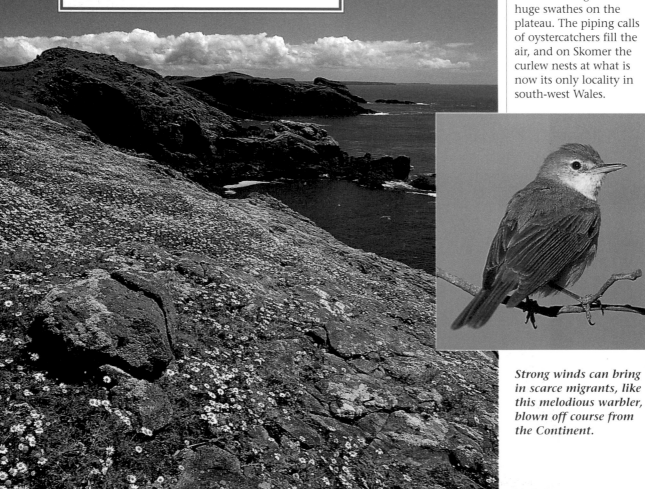

Strong winds can bring in scarce migrants, like this melodious warbler, blown off course from the Continent.

seabirds depart in early August there is still much to see and enjoy. Grey seals become more numerous as they prepare for the autumn breeding season, and small migrants, such as redstart and pied flycatcher, warblers, chats and wagtails, pause briefly on their passage to wintering grounds in Africa. Then there is always the chance of the more unusual visitor – barred, icterine or melodious warblers, hoopoe or wryneck – or even truly rare vagrants, such as the isabelline and desert wheatears that paid brief visits to Skokholm in the autumn of 1997.

Skokholm and Skomer, nature reserves of the Wildlife Trust for West Wales, are accessible by boat from April to October, weather permitting. Limited accommodation is available.

Some 70 years ago the pioneer naturalist Ronald Lockley went to live on Skokholm with his family, working as a shepherd and studying the migration of birds. He wrote several books and articles about the island and its wildlife, all of which make interesting and entertaining reading.

> **AND ALSO LOOK OUT FOR...**
> - grey seal - buzzard
> - kestrel - oystercatcher
> - herring gull
> - sedge warbler - tormentil
> - common limpet
> - edible crab
> - beadlet anemone
> - common scurvy-grass

Miles 0 — 1
Km 0 — 1 — 2

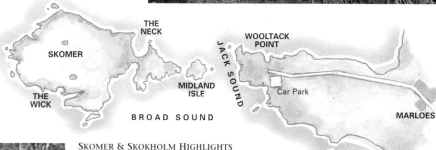

THE NECK
WOOLTACK POINT
JACK SOUND
SKOMER
MIDLAND ISLE
Car Park
THE WICK
BROAD SOUND
MARLOES

N

SKOMER & SKOKHOLM HIGHLIGHTS
Porpoises feeding in **Jack Sound**. Fulmars scything through the air on straight wings. Puffins buzzing back and forth from **clifftop burrows**. Guillemots and razorbills nesting on narrow **cliff ledges**. Constant raucous calls of kittiwakes. Lesser black-backed gulls nesting among bluebells. Piping call of oystercatchers. Stone walls, hut sites and cairns of early island-dwellers.

THE STACK
MAD BAY
SKOKHOLM

Although superficially gull-like, fulmars fly on stiffly held wings. They have unusual, tube-shaped nostrils.

Mists and rough weather only serve to enhance the rugged appeal of Skokholm's wave-battered shores.

Storm-petrels nest in rock crevices and under boulders. They spend their days far out at sea, but can occasionally be seen at dusk when they return to gather near their nest sites.

Razorbills can be found all round the islands, favouring boulder slopes and protected rock crevices for their nest sites. Both parents share the task of incubating the single egg. Like puffins, they carry sand eels back to their young in their beaks.

Shag

Phalacrocorax aristotelis

Although at a distance the shag looks uniformly dark, in good light and at close range its plumage has an oily sheen giving it a bottle-green appearance. Shags are a common sight off rocky coasts in the West Country, often appearing indifferent to the raging forces of the sea. They dive well, searching for fish as they swim underwater. Although they are true seabirds, shags do not have plumage which is entirely waterproof. When not in the water, they can often be seen perched on rocks, sometimes with their wings outstretched to dry in the wind.

see also page 223

Shags build untidy, bulky nests of seaweed and sticks, lined with grass, on ledges and in sea caves on rocky coasts around western and northern Britain. They defend their nests aggressively.

Pembrokeshire

From a spectacular coastline and wild hills to a tangle of estuaries and ancient woodland, the Pembrokeshire Coast National Park – one of the most protected areas of Europe – is a landscape of surprises.

Small numbers of Cetti's warbler can be found in a few wetlands and are generally detected by their loud song.

frequently seen basking in the sun on offshore rocks or swimming in the waters, often surfacing to breathe and survey their surroundings with a doe-eyed curiosity. The pupping season lasts from September to November.

This coastline bears witness to the violent forces that formed the earth's surface, and the geology is spectacular in its variety. The volcanic ridge of the St David's Peninsula in the north stretches inland, visible in a series of outcrops, while in the south the sea has carved arches, caves and blowholes out of the limestone cliffs. Near Cemaes Head folds of rock have buckled under

SPRING COMES EARLY to this western edge of Wales. Around the coast, white-flowering sea campion mingles with pink thrift and sweet-scented gorse. Bluebells on the Marloes Peninsula reflect those of Skomer Island; a carpet of mauve visible beyond the clear-blue tidal races. Red campion and kidney vetch soon follow in a profusion of native flowers that flourish in the clear, Atlantic-borne air. Rock-clinging lichens, those most sensitive barometers of pollution-free air, thrive.

COAST PATH
You can join the 298-km (186-mile) coast path, one of 12 national trails in Britain, almost anywhere along its length and walk to sandy beaches, cliffs, harbours and inlets.

The rare chough and peregrine breed along the coast, and the huge variety of seabirds that breed on the offshore islands, including razor-bills, kittiwakes and guillemots, can be sighted from the mainland.

To see that streamlined predator of speed, the gannet, arc from on high to clutch a fish from below the water's surface, or Manx shearwaters making for the islands in a pattern of black-and-white crosses against an evening sky can be delightful experiences. Particularly good areas for watching seabirds include Strumble Head, St David's Head and the Marloes Peninsula.

Porpoises, bottle-nosed dolphins, minke whales

PEMBROKESHIRE HIGHLIGHTS
Manx shearwaters, gannets and other seabirds from **Strumble Head**, **St David's Head** and **Marloes Peninsula**. Chough riding updraughts along **coast**. Grey seals basking on **offshore rocks**, pups from September onwards. Summer warblers in **inland valley woods**. Buzzard and merlin in the **Preseli Hills**. Overwintering wildfowl and waders at **Daugleddau Estuary**. Cetti's warblers at **Welsh Wildlife Centre, Cilgerran**.

The Pembrokeshire coast is a haven for grey seals which can be seen from most cliffs and headlands.

and even leatherback turtles are sighted by those at sea. Grey seals gather in small coves along the coast. They are

In Pembrokeshire, gannets breed only on the remote island of Grassholm.

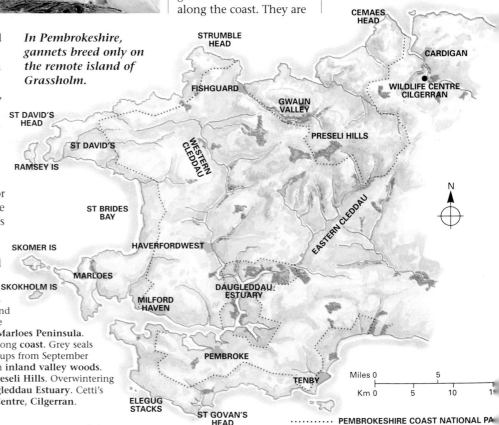

CEMAES HEAD

STRUMBLE HEAD

CARDIGAN

FISHGUARD

WILDLIFE CENTRE CILGERRAN

GWAUN VALLEY

ST DAVID'S HEAD

PRESELI HILLS

ST DAVID'S

WESTERN CLEDDAU

RAMSEY IS

ST BRIDES BAY

EASTERN CLEDDAU

SKOMER IS

HAVERFORDWEST

MARLOES

DAUGLEDDAU ESTUARY

SKOKHOLM IS

MILFORD HAVEN

N

PEMBROKE

TENBY

Miles 0 5

Km 0 5 10 1

ELEGUG STACKS

ST GOVAN'S HEAD

········· PEMBROKESHIRE COAST NATIONAL PA

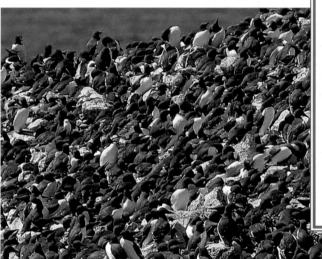

Spring squill
Scilla verna

Colourful, rounded flowering spikes of spring squill are an attractive sight on many sea cliffs in western Britain, bejewelling the grassy turf. It also occurs at a few sites in north-eastern Britain. The pale blue

flowers, which have six petals and open out to a star-shaped outline, appear in May and June. There are usually six or so flowers per plant which are produced from a rosette of wiry, grass-like leaves that precede the flower's appearance by at least a month. After flowering has finished, the dried remains of both flowers and leaves last several months.

In sites where conditions suit it, spring squill is often locally abundant. The plant generally grows on areas of short, dry grassland near the sea.

The rugged cliffs of Ramsey Island are typical of much of the Pembrokeshire coast. A grey seal colony can be seen on the island shores.

Chough
Pyrrhocorax pyrrhocorax

With its red legs and long, downcurved red bill, the chough is a rather aristocratic member of the crow family and can be distinguished at a glance from its cousins. It is still fairly common in Pembrokeshire, mostly seen in small flocks flying aerobatically around the cliffs and gullies, or feeding in short turf. Both in flight and on the ground, members of a flock utter loud and distinctive '*chough*' calls. They use their long bills to probe the ground in search of insects and other invertebrates. Several stretches of the Welsh coast are

important strongholds for the chough, which is absent from England and much of Scotland. This lively and sociable bird is protected, and may not be disturbed in any way when it is near the nest.

see also page 254

Like other crows, the chough is an intelligent and observant bird, quick to take advantage of any new feeding opportunities.

immense pressure to form night-sky rainbows in the cliff face; the Elegug Stacks are sea-sculpted precipices of rock, a stone's-throw from land and home to colonies of razorbills and guillemots.

Inland lies valley woodland where the sweet songs of warblers can be heard. Some 11km (7 miles) long, the Gwaun Valley is lined with oak woods that are home to woodpeckers, pied flycatchers, the rare dormouse and a host of native wild flowers.

PRESELI HILLS
In the Preseli Hills you can follow in the footsteps of pilgrims and tradesmen along prehistoric trade routes. This wild landscape of rugged outcrops and open moorland contains many burial sites and settlements from the Bronze and Iron Ages. With the occasional merlin and buzzards gliding in the wind-draughts above a landscape patterned with gorse and heather, and breathtaking views of fields and homesteads, it is an invigorating place.

The Daugleddau Estuary, an entrancing area of creeks, inlets and hamlets which provide important overwintering

From the mainland, with the aid of binoculars or a telescope, the guillemots on Elegug Stacks can be seen nesting shoulder-to-shoulder.

areas for waders and wildfowl, is often referred to as Pembrokeshire's 'Secret Waterway'.

Farming is still the major industry in the county, and fields within and beyond the national park's boundaries are enclosed by hedgebanks. Built from stone, earth and turf, these traditional field borders, often centuries old, are increasingly precious as havens for native plants, small

birds and mammals.

Just outside the park, the Welsh Wildlife Centre, near Cilgerran, is well worth a visit. Surrounded by a wetland of marsh, reedbed and estuary, as well as woodland and meadows, the reserve is home to badger, dormice, mink and otter. For the bird-watcher there are hides, and the largest population of the rare Cetti's warbler in Britain.

At the height of summer the maritime heaths are a colourful delight for the visitor.

Famed for its white water-lilies, Bosherston Pool, near St Govan's Head, is also a haven for dragonflies and even the elusive otter.

AND ALSO LOOK OUT FOR...
● fulmar ● kestrel ● oysterctacher ● herring gull ● rock sea-spurrey
● great black-backed gull ● rock pipit ● whitethroat ● linnet
● wild carrot ● bell heather ● emperor dragonfly ● restharrow

Gower Peninsula

Recognition of the Gower's national importance came in 1956 when it was designated Britain's first Area of Outstanding Natural Beauty. Today, despite outside pressures, it remains separate and special.

HEADING WEST OUT of Swansea, the outskirts of the city soon thin out and give way to villages and great tracts of common-land. The peninsula becomes increasingly wild until, at its extreme western edge, it termi-nates abruptly at Rhossili

Down and plunges into the great sweep of Rhossili Bay, guarded by the rocky high-tide islets of Worms Head: the name 'Worms' comes from the Norse word for serpent.

The southern coastline, between Mumbles Head and Worms Head, is par-ticularly beautiful, with

dramatic limestone cliffs, sandy beaches and rocky coves all rich in marine life. Brown seaweeds grow luxuriantly on the sheltered west sides of the rocky bays, while on the east sides, exposed to the prevailing south-westerlies, bare limestone supports carnivorous dog whelks that prey on the accompanying mussels and acorn barnacles.

Bracelet and Langland Bays, easily reached and

A view from the flowery clifftops northwards along Rhossili Bay, with Rhossili Down at right.

with good parking, yield a wide variety of wildlife. Here you may be lucky and find a painted topshell, conical and beautifully coloured; its relatives the grey and purple topshells are much commoner.

Sandy bays have different attractions. These are the places to look for shells – razor, necklace, trough and cockle – and other jetsam such as

Among flocks of common species of gull, rarities such as the ring-billed gull from North America may turn up.

jellyfish, mermaid's purses and cuttlebones.

At Swansea Bay a vast expanse of sand is revealed at low tide; Black Pill is good for gull-watching. Oxwich Bay is another huge tract of sand. West of the stream flowing into the bay is a national nature reserve, a dune system backed by saltmarsh, open water and fen. The road to Oxwich passes between lakes and through large reedbeds.

There is another fine sandy beach at Port-Eynon; look on the dunes for sea stock, a plant which disappeared but is locally common again.

CLIFFTOP FLOWERS
Behind the old lifeboat station a path leads up to the headland, the start of a stretch of lovely cliffs terminating at Rhossili. In the early part of the year these are a mass of flowers. Yellow whitlow-grass, at its northernmost outpost in Gower, forms splashes of yellow in March, later rock-roses – both common and the

GOWER HIGHLIGHTS
Good rock pools and shore life at **Bracelet** and **Langland Bays**. Rich variety of shells on sandy bays such as **Swansea Bay**. Fine dunes at **Oxwich Bay** and **Whiteford Point**. Sea stock in dunes at **Port-Eynon**. Flower-covered coastal cliffs towards **Rhossili**. Fine displays of spring flowers in **Bishopston, Ilston** and **Caswell Valleys**. Eider ducks on **Loughor Estuary**. Oystercatchers at **Whiteford Point**.

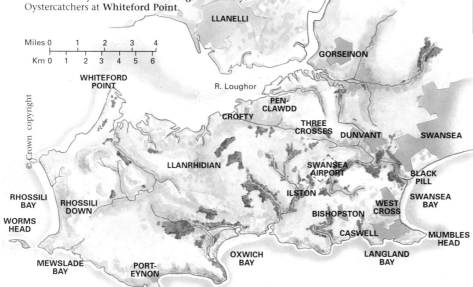

Miles 0 — 1 — 2 — 3 — 4
Km 0 — 1 — 2 — 3 — 4 — 5 — 6

© Crown copyright

LLANELLI

GORSEINON

WHITEFORD POINT

R. Loughor

PEN-CLAWDD

CROFTY

THREE CROSSES

DUNVANT

SWANSEA

LLANRHIDIAN

SWANSEA AIRPORT

ILSTON

WEST CROSS

BLACK PILL

SWANSEA BAY

RHOSSILI BAY

RHOSSILI DOWN

BISHOPSTON

CASWELL

MUMBLES HEAD

WORMS HEAD

MEWSLADE BAY

PORT-EYNON

OXWICH BAY

LANGLAND BAY

Sea stock is one of the most attractive plants found along the seashore. It is able to colonise sand dunes soon after they have been stabilised by the underground stems of marram grass.

Stonechat
Saxicola torquata

For all its small size, the stonechat is an attractive and distinctive bird. In the breeding season, males have a black head and back, orange-red breast and white on the neck and vent; females and winter birds are more subdued in appearance. The male makes himself conspicuous by perching on prominent look-outs such as sprays of gorse or bramble, or fence posts. When alarmed, stonechats utter a sharp call that sounds like two stones being struck together.

see also page 248

Stonechats nest on bramble- and gorse-covered slopes but, outside the breeding season, they range more widely around the coast.

rarer hoary with its felted leaves and sulphur-yellow flowers – carpet the rock along with horseshoe vetch and squills. Bloody crane's-bill and ox-eye daisies follow on, but by midsummer the cliffs are relatively bare, except for bracken and gorse on areas of deeper soil.

Whitethroats are common summer visitors here, while colonies of seabirds breed in Mewslade Bay and peregrine, raven, chough, jackdaw and flocks of finches inhabit the cliffs on the outer part of Worms Head.

Open moorland grazed by ponies, sheep and cattle covers the sandstone hills of West Gower. Boggy areas here are interesting for sundews, bog myrtle and royal fern. Most of inland Gower is agricultural land,

Whitethroats are summer visitors to the region, present from April to August. They advertise their presence with a loud, scratchy song.

but the limestone is dissected by deep valleys of oak and ash, carpeted in spring with ramsons, bluebells and wood anemones. There are splendid walks along the Bishopston, Ilston and Caswell Valleys.

THE NORTHERN COAST
The Loughor Estuary lies on the north side of Gower, creating a very different coastline with extensive saltmarsh. The estuary is a bird sanctuary

In Britain, yellow whitlowgrass is found only on the limestone cliffs of the Gower's southern coast.

of international status, known for its resident population of eider duck, and migrant geese and ducks which overwinter. Huge flocks of oyster-catchers, often numbering over 10,000 birds, are regularly seen at Whiteford Point, along with similar numbers of dunlin and knot.

The dune system here is

noted for its wildflowers; saltmarsh and freshwater wetland plants occurring in close proximity.

Pen-clawdd is home to the cockle industry. Here these bivalves are picked from the estuary, processed, and sold in Swansea market where you can also buy laver-bread, another delicacy, made from a red seaweed.

Eiders nest on Gower's rocky coasts. The female lines her nest with eiderdown – feathers plucked from her breast.

AND ALSO LOOK OUT FOR...
● shag ● lesser black-backed gull ● common tern ● rock pipit
● green hairstreak ● common blenny ● common limpet
● masked crab ● shore crab ● heart urchin ● sea rocket ● wild carrot

Turn over the fronds of bladder wrack at low tide and you are sure to find collections of brightly coloured flat periwinkles.

Flat periwinkle
Littorina littoralis

One of the most common and distinctive shells of the seashore, the flat periwinkle is easily found on sheltered rocky shores around the south-west. It lives among bladder wrack and other seaweeds on which it feeds. The shell appears almost spherical at first glance but close examination reveals that the first smallest whorls are extremely flattened and reduced. Although the flat periwinkle's shell shape is fairly uniform, this cannot be said of their colour. Seemingly almost any colour variety can be found, ranging from red, orange and yellow to green and brown; they are sometimes even banded.

see also page 275

Mewslade Bay is often deserted early in the year but comes alive with colonies of seabirds and people in the summer.

Kite Country

There are few places in Britain which can be given the epithet 'wilderness'. In Wales it applies to the Cambrian Mountains, the Empty Quarter. Here you can walk all day and not see another person.

Red kites have been introduced to parts of England and Scotland, and have extended their range in Wales, but central Wales is still their stronghold.

THE CAMBRIAN Mountains are the wellspring of the major rivers of Wales – the Teifi, Tywi, Usk, Wye and Severn. They, along with a multitude of lesser rivers, rise in the wet bogs which lie across so many of the flat plateaux.

Here are the summer homes of dunlin, snipe and golden plover. Red grouse and merlin are found too, along with short-eared owls which can be seen by day flying low over the ground in search of rodents. The most numerous bird, though, is the raven. These spectacular crows – the largest in Britain – can be seen all year, sometimes in great numbers, feasting on carrion or gathering to roost on rocky crags in the evenings.

RIVER VALLEYS

The relatively soft shales of the mountains are deeply incised by the rivers. Their spectacular valleys have steep sides, spreading woodlands and a multitude of torrent streams. Many valley sides are too steep to cultivate and remain as rough *ffridd* land – bracken covered or gorse dominated – and wonderful reservoirs for wildlife. Other valleys have retained hanging oakwoods that are alive in summer with redstarts, willow warblers and pied flycatchers feeding off the multitude of insects.

These woods are home, too, to badger, stoat and weasel, as well as the endangered polecat and all manner of mice, voles and bats. The best known examples of these woods are at Devil's Bridge at the head of the Ystwyth Valley, a precipitous beauty spot.

RED KITES

North of Llandovery, at the confluence of the River Tywi and its tributary the River

Ravens use their massive bills to good effect when feeding on carrion, their main source of food during the winter.

Doethi, is the RSPB's notable Dinas Hill reserve. It was here, early in the 20th century, that the very last pairs of red kites clung on when the species had died out elsewhere in Britain through loss of habitat, changing agricultural practices and persecution.

The red kite is a glorious bird, graceful and agile in flight and sought after by bird-watcher and layman alike: its story is a legend in the annals of bird protection.

There is a network of Kite Country centres throughout Mid Wales, and large numbers of kites can be viewed at

Water is very much a feature of the landscape of the region and occasionally creates dramatic waterfalls such as this one at Pistyll Rhaeadr in Clwyd.

The conspicuous berries are readily visible to passing birds. In return for a meal, the tree has its seeds dispersed far and wide.

Mountain ash

Sorbus aucuparia

Also known as rowan, the mountain ash is a familiar and attractive tree that is widespread in upland Britain. Growing on hillsides or sometimes beside streams and rivers, the tree produces arrays of attractive white flowers in April and May. Rowan is at its most splendid, however, in late summer when the colourful berries often turn whole trees orange-red. Not surprisingly, these provide a feast for birds, attracting not only resident species such as blackbirds but also migrants passing through in the early autumn. The leaves of the mountain ash are similar to those of the lowland ash: oblong leaflets grow opposite each other along the leaf stem in 10 to 12 pairs. A mature tree can reach a height of 15m (49ft) but most are considerably smaller.

see also page 281

Sessile oak
Quercus petraea

The sessile oak often grows on surprisingly steep and sometimes dramatic slopes, giving rise to a recognised type of forest called hanging oak woodland. Although tree-felling down the centuries has removed a considerable amount of native deciduous woodland in western Britain – the main range of the sessile oak – sizeable pockets still remain. The typical oak-shaped leaves are carried on short stalks, unlike the stalkless (sessile) acorns, which appear in the autumn. In the case of its close relation, the English oak, the reverse is true. Where woodlands comprise mature and gnarled old oak trees and a limited understorey, pied flycatchers and redstarts are sure to occur.

see also page 280

During the spring and summer the leaves of sessile oak provide food for moth caterpillars, which in turn are eaten by woodland birds.

extremely close quarters throughout the winter months at feeding stations at Tregaron Bog national nature reserve and Gigrin Farm near Rhayader.

Tregaron (*Cors Goch*, in Welsh, which means 'red bog') is one of the largest raised bogs in Britain. As well as red kites, winter visitors such as hen harriers and short-eared owls, plus whooper swans, goosanders and other wildfowl can be

Caban Coch Reservoir in the Elan Valley is a focal point for many visitors to the region. Birds of prey are frequently seen on the surrounding slopes.

seen. Breeding birds include teal and snipe.

One of the most impressive visitor facilities in the area is located in the Elan Valley, famous for its chain of four huge reservoirs and massive dams managed by the Welsh Water Authority. Before the reservoirs were built in the late 19th century this was one of

the most remote areas of Britain, and even now the high open moors are particularly wild and beautiful, and are sometimes referred to as 'the great desert of Wales'.

Gilfach Farm, a traditional Welsh longhouse near St Harmon, has been restored by the Radnorshire Wildlife Trust for use as a visitor centre.

AND ALSO LOOK OUT FOR...
- fox ● black grouse ● merlin
- grey wagtail ● dipper
- wren ● rowan ● sheep's-bit
- scabious ● foxglove
- bilberry ● ling ● herb robert
- lesser spearwort
- tormentil
- lousewort ● sharp rush

The whinchat is a summer visitor to the region, present from April to August.

On calm, mild evenings from spring to autumn, long-eared bats can be watched feeding along wooded streams at dusk, catching insects that fly above the water.

KITE COUNTRY HIGHLIGHTS
Ravens, grouse and merlin in **Cambrian Mountains**, with dunlin, snipe and golden plover in summer. Hanging sessile oak woodland at **Devil's Bridge**. Pied flycatchers, redstarts and wood warblers nesting at **Dinas Hill**. Red kites at winter-feeding sites at **Tregaron** and **Rhayader**.

R. Severn
NEWTOWN

DEVIL'S BRIDGE

ST HARMON

RHAYADER

ELAN VILLAGE

LLANDRINDOD WELLS

TREGARON

R. Doethi

LAMPETER

BUILTH WELLS

LLANWRTYD WELLS

DINAS HILL

R. Teifi

R. Wye

N

R. Tywi

LLANDOVERY

R. Usk

© Crown copyright

| Miles 0 | 4 | 8 | 12 |
| Km 0 | 5 | 10 | 15 | 20 |

Despite its small size, the weasel is a voracious predator which will tackle small mammals and birds. Although unobtrusive, it is common and widespread in the region.

Brecon Beacons

Despite lying within an easy drive of the cities of the West Midlands and South Wales, the Brecon Beacons National Park contains some of the quietest and most remote countryside in southern Britain.

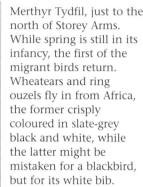

Polecat

Putorius putorius

Wild ancestors of the familiar ferret, polecats are fairly common in remoter parts of Wales. The species' precise status is difficult to assess because this secretive and largely nocturnal member of the weasel family can be very difficult to see, let alone survey accurately. The polecat is a good swimmer, able to catch eels and frogs. Polecats are sometimes confused with ferrets that have escaped to the wild. Dark fur and the presence of a dark 'mask' on the face are good indicators of a genuinely wild animal.

see also page 218

The polecat is a skilled predator, feeding on mice, rabbits and birds. It may paralyse frogs, storing them as a winter food supply.

Llyn y Fan Fach, a corrie lake, nestles at the base of glacially eroded cliffs and adds to the breathtaking views characteristic of upland parts of the region.

THE PARK EXTENDS from the Black Mountains in the east to Mynydd Du in the west, with a weathered swathe of rich-red sandstone rocks dominating the central spine. Rising to 886m (2,914ft) on Pen-y-Fan, the north-facing slopes of the mountains drop steeply in a series of dramatic cliffs and escarpments.

These crags are the most southerly home in Britain of Arctic–alpine plants and animals. As the icicles of winter melt from the cliffs in the first warm days of spring, the otherwise dead-looking vegetation sparkles into life with brilliant patches of purple saxifrage.

Craig Cerrig Gleisiad national nature reserve lies close to the road between Brecon and Merthyr Tydfil, just to the north of Storey Arms. While spring is still in its infancy, the first of the migrant birds return. Wheatears and ring ouzels fly in from Africa, the former crisply coloured in slate-grey black and white, while the latter might be mistaken for a blackbird, but for its white bib.

The cliffs are rich in summer flowers, too, and there is nowhere better to admire the delicate silken yellow petals of the Welsh poppy or the white starry flowers of the mossy saxifrage growing alongside fragrant thyme.

VISITOR CENTRE

On the northern flank of Mynydd Illtyd, near the little village of Libanus, is the national park's visitor centre. It is surrounded by sheep-grazed common-land dotted with sedge-rich pools and wetlands, home of the palmate newt and saw-sedge.

To the south of Crickhowell, in the east of the park, is the spectacular limestone amphitheatre at Craig-y-Cilau national nature reserve. Many of its ledges are inaccessible to the otherwise ubiquitous sheep and are home to wild lily-of-the-valley, angular Solomon's-seal and the rare lesser whitebeam.

Peregrines and raven nest on these ledges, often as quarrelsome neighbours, shrieking and croaking at one another through the breeding season. Buzzards too can be seen soaring on the thermals. Below the cliffs a network of more than 27km (17 miles) of caves

Purple saxifrage is an Arctic-alpine plant which has its southernmost British site in the Beacons.

provide a winter-roost site for one of the largest populations of lesser horseshoe bats in Europe.

IN THE VALLEYS

In contrast to the wide, windswept uplands are the deep-cut, limestone valleys, characterised by tumbling waterfalls. The most spectacular falls are on the rivers Fechan, Mellte and their tributaries on the edge of the South Wales coalfield, between Ystradfellte and Pontneddfechan. A series of footpaths from car parks at Porth-yr-Ogof, Pont Melin Fach and Pontneddfechan lead to these wooded gorges.

Shady woodland provides the ideal habitat for lily-of-the-valley, whose white bell-shaped flowers are at their best in May.

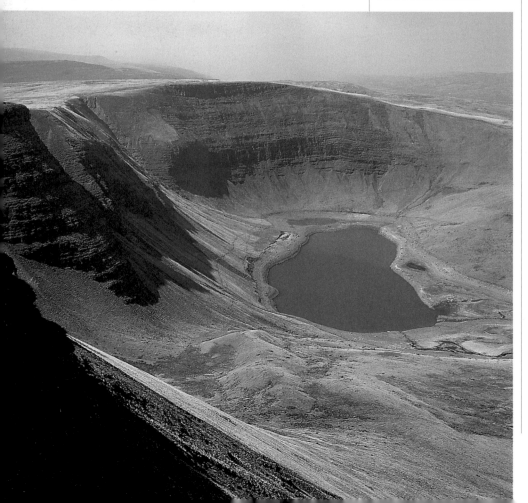

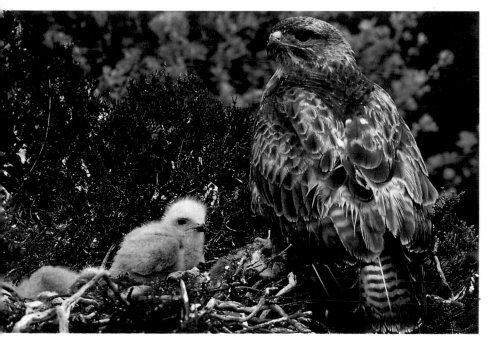

Inaccessible rocky ledges are favoured nesting sites for buzzards, which raise between one and three chicks to fledging, depending on the availability of food.

BRECON BEACONS HIGHLIGHTS
Arctic-alpines such as purple saxifrage on **Pen-y-Fan** in early spring, along with returning wheatears and ring ouzels. Welsh poppy at **Craig Cerrig Gleisiad NNR**. Wild lily-of-the-valley and angular Solomon's-seal at **Craig-y-Cilau NNR**. Dippers around spectacular waterfalls on **Rivers Fechan, Mellte and Hepste**. Beds of white, yellow and fringed water-lilies on **Llangorse Lake**.

During the winter months, snow frequently settles on higher slopes such as Garn Fawr, providing a challenge for both ramblers and wildlife.

Spectacular waterfalls interrupt the course of the River Mellte to the south of Ystradfellte.

The dipper lives on fast-flowing streams and rivers. It feeds on aquatic invertebrates.

At Scwd-yr-Eira, on the River Hepste, the path leads behind the falls and the river can be crossed dryshod. From here you get a dipper's-eye view of the world. This semi-aquatic little bird hunts for food in the torrential streams and often nests in mossy banks behind the waterfalls.

Ferns thrive in the humid air, with filmy ferns tucked into the shadier recesses and royal ferns and green spleen-wort clinging to the cliffs.

But the Brecon Beacons are not all mountains and torrents. There is rich and

fertile farmland in the Usk and Wye valleys, and the towpath of the Brecon and Abergavenny Canal provides an easy route through the wooded Usk Valley.

Between the Wye and the Usk lies Llangorse Lake, the largest natural lake in Wales and a major recreational centre. It is best visited from its southern shore at

Llangasty-Talyllyn where, in summer, a footpath takes you west along its reed-fringed margin through fields of wild-flowers. The lake has beds of white, yellow and fringed water-lilies, with breeding mute swans, great crested grebes, coot and moorhen; a far cry from the wide, wild expanses of the hills of the Brecon Beacons.

AND ALSO LOOK OUT FOR...
- short-tailed vole ● fox ● sparrowhawk ● short-eared owl
- meadow pipit ● grey wagtail ● willow warbler ● redstart
- rowan ● lesser spearwort ● Welsh poppy ● tormentil ● broom
- tufted vetch ● herb robert ● ling ● bell heather

Palmate newt
Triturus helveticus

Stand at the margins of a weedy lake in spring and you may be lucky enough to see palmate newts walking and swimming over the bottom. During the breeding season, males are well marked, the orange belly bearing dark spots; a needle-like point projects from the tip of the tail and the hind feet are webbed. Female palmates are rather plain by comparison, although the belly is also orange and spotted; the throat in both sexes is unspotted. After breeding, the newts leave the water and can be found under stones during daylight.

see also page 256

In spring, palmate newts lay their eggs in water and feed on aquatic life, including worms and the tadpoles of frogs.

Wye Valley

As it flows from its source on the Plynlimon summits in Mid Wales to the Severn Estuary, the beautiful River Wye cuts through high limestone cliffs, ancient woodland and pastoral fields, past bankside alders and willows.

Overhanging branches provide ideal perches for the colourful kingfisher which is common but easily overlooked.

estuarine species such as glasswort start to become increasingly obvious.

NATIVE TREES
Most of the Wye woodland is a mixture of lime, oak, beech, ash and wych elm, largely preserved by traditional coppicing to fuel the local iron- and tin-works. The limestone cliffs are marked by groves of yew growing under the beech, together with some rare native species of whitebeam. Ancient woodland species such as wild service tree and small-leaved lime complete the picture, with clouds of white wild cherry blossom in spring.

Throughout the spring there is a succession of

BETWEEN FOWNHOPE and Goodrich the Wye swings in grand curves to and fro across its wide plain, the landscape to either side gently rolling. Downstream of Goodrich, however, the scene changes and the river cuts through 200m- (658ft-) deep gorges and loops round the base of the fabulous viewpoint of Symonds Yat Rock, where nesting peregrines have become a prime attraction. Below Monmouth, the river flows in a deeply

incised valley to its estuary below Chepstow, skirting grand limestone crags at Tintern and Wyndcliff.

During the 18th century the Wye Valley was a popular tourist draw. Visitors would board a boat in Ross and drift downstream to Tintern. There they would view the ruins of the Cistercian abbey. Indeed, the ruins survive in such an impressive form partly because their owners, the Dukes of Beaufort, were quick to recognise their

appeal and took pains to preserve them.

Many of today's visitors choose to follow the Wye Valley Walk, a well-sign-posted route between Hereford and Chepstow.

The Wye is one of the cleanest of Britain's major waterways, a factor which has given rise to its fame as a salmon river. Clear and nutrient-rich, it supports a wealth of underwater life, including pollution-sensitive mayflies and stoneflies, and in late summer is carpeted with huge

The tawny owl is a nocturnal hunter, heard far more often than it is seen. Occasionally one may be glimpsed in the headlights of a car.

flexing trails of water-crowfoot.

Kingfishers, dippers, grey wagtails and herons all thrive here, and undercut banks provide homes for colonies of sand martins. Mink occur, and the otter is making something of a comeback.

Below Bigsweir the river is tidal and consequently

Migrant sand martins breed in sandy banks, excavating long tunnels in which they can nest in comparative safety.

Welsh poppy

Meconopsis cambrica

Although not exclusive to Wales, this attractive plant has a distinctly western distribution in Britain. It favours shady lanes and damp woodland rides, but its precise distribution in the wild is clouded by garden escapes, this being a popular plant in cultivation. The flowers, which appear from June to August, are around 2.5cm (1in) across and comprise four petals; the green sepals that envelop the buds fall off as the flowers open. After pollination, a bright green, egg-shaped seed pod is produced. The deeply divided leaves are typical of the poppy family in outline.

see also page 286

Although never as abundant as its common red cousin, Welsh poppy thrives in many parts of Britain, particularly in the west, and the stunning bright yellow flowers are always a welcome sight.

Symond's Yat affords the visitor one of the most spectacular views of the Wye Valley. A watchpoint offers the chance to observe peregrines at the nest.

Silver-washed fritillary
Argynnis paphia

The grace and ease of the flight of this handsome butterfly is often what first attracts the attention of the observer. At one moment gliding slowly along a sunny woodland ride, it can, at a whim, fly at great speed and ascend to the top of the tallest tree in seconds. With care, silver-washed fritillaries can be observed at close range while feeding on the flowers of bramble, or sunbathing on the leaves. Its English name comes from the silvery-metallic markings on the underwings. Adults are on the wing in July and August and the caterpillars, which feed on violets, are most conspicuous in spring.

see also page 262

The silver-washed is the largest of the British fritillaries – a family of predominantly orange and brown spotted butterflies, taking their name from the speckled flowers that they resemble. Most live in areas of open woodland.

Despite its fearsome appearance, the scorpion-fly is entirely harmless to humans.

wood anemone, wood sorrel, dog's mercury and violets on the woodland floor, along with ramsons, bluebells and early-purple orchids. In the Tintern area you may well spot the martagon lily, or Turk's hat (more familiar as a garden plant but growing naturally here), the northern bellflower, or even broad-leaved spurge, locally known as Tintern spurge.

A summer's day brings out numerous butterflies, including the silver-washed fritillary, the holly blue, and the more easily found speckled wood.

Summer migrants such as warblers keep company with resident woodpeckers and the handsome hawfinch, and after dark you will almost certainly hear the familiar hoot of the tawny owl, predator of the many rodents on the forest floor.

INTIMATE LANDSCAPE
Above Goodrich much of the valley is intensively farmed, but it remains attractively studded with willow, oak and ash, and partitioned by clipped hedges. Alluvial grassland survives at the magical

Sellack Common, north-west of Ross and, higher up on a tributary, are the Lugg Valley Meadows, where the snake's-head fritillary grows.

Away from the river, however, the essence of the Wye Valley is the intimate mixture of woods, pastures, villages, farms, hedges and secluded lanes.

Nowhere is this more apparent than on the old commons, such as those at St Briavels and Hewelsfield, where tiny, irregular fields are divided by thick hedges, high stone walls and spreading oak, beech and lime trees. Bluebells spread colour not just through the woods, but along hedges and under bracken.

In some small fields still cut for hay you can find yellow-rattle and common spotted-orchids growing in a mixture of wild grasses, a scene that has long since ceased to be common.

AND ALSO
LOOK OUT FOR...
● buzzard ● sparrowhawk
● pied flycatcher ● redstart
● wood warbler ● tutsan
● orange-tip ● oak bush-cricket
● cuckooflower ● selfheal
● herb bennet ● bugle
● foxglove ● cow-wheat

LEOMINSTER

R. Wigg

R. Wye

HEREFORD

● LUGG MEADOWS

WYE VALLEY

● SELLACK COMMON

ROSS-ON-WYE

R. Monnow

● GOODRICH CASTLE

● SYMONDS YAT
● HIGHMEADOW WOODS

MONMOUTH COLEFORD
FOREST
OF
DEAN
ST BRIAVELS
COMMON

HEWELSFIELD
COMMON

TINTERN ●

WYNDCLIFF ●

CHEPSTOW

© Crown copyright

N

Miles 0 4 8 12
Km 0 5 10 15 20

As their name suggests, common spotted-orchids are among the most widespread and numerous of their kind in the region; they are found in short grassland.

Several species of water-crowfoot can be found along the length of the Wye, most thriving in shallow, marginal waters.

WYE VALLEY HIGHLIGHTS
Herons and kingfishers joined by nesting sand martins in summer. Floating carpets of water-crowfoot in late summer. Glasswort on the mud banks at **Bigsweir**. Ancient woodlands full of flowers along valley scarps between **Chepstow** and **Symonds Yat**. Snake's-head fritillaries on **Lugg Meadows**. Flower-rich fields at **St Briavels Common**.

The Marches

These are the borderlands of England and Wales. The boundary is marked by Offa's Dyke, an earthwork built by King Offa to protect the fertile valleys of the kingdom of Mercia from attack by the Welsh.

Wheatears, one of our earliest migrants, are present from early April to September. They are often seen perched on boulders or stone walls.

Bog rosemary, with its purple nodding heads, is one of the most charming flowers of the region's wetlands.

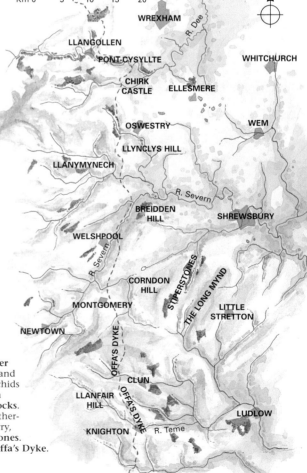

flowers. The orchids at Llynclys Common are of special interest: in spring, look for the deep hues of the early-purple orchid; in June, the paler common spotted-orchid and the distinctive flowers of the bee orchid. In autumn, especially in the 'amphitheatre' at Llanymynech Hill nature reserve to the south, you may find the tiny autumn lady's-tresses.

The Breidden Hills rise steeply to the east and a strenuous walk to Rodney's Pillar (a column commemorating Admiral Rodney) provides distant views. Far below is the spectacular sight of the

A T LLANGOLLEN THE River Dee flows round great boulders before it tumbles into a deep wooded valley; from the bridge in the town dippers and grey wagtails can be seen flitting among the rocks below. To the south, Telford's aqueduct at Pont-Cysyllte crosses high above the valley floor and from here a walk along

Despite its size – nearly that of a spread hand – the raft spider is easily overlooked when resting on waterside vegetation.

The Long Mynd is arguably the best-known site in the region, and the rolling heather moorland is extremely popular with walkers.

the dyke will bring you close to the stark ramparts of Chirk Castle, built by Edward I to control the northern Marches.

The hills to the west of Oswestry mark the beginning of wild Wales, but to the east the land falls quickly away towards the rich agricultural fields of north Shropshire. The glaciers of the last Ice Age

scooped out massive hollows and while some have remained as open water to form meres, others have filled with vegetation and the rich peatlands now support many fascinating creatures and plants.

The rare raft spider, one of the longest spiders in Britain, may be spotted lurking on the surface of bog pools. More easily seen are the star-burst yellow flowers of bog asphodel and the purple blooms of bog rosemary.

ON HIGH GROUND South of Oswestry are the Oswestry uplands, limestone hills with craggy outcrops. Up here are many small-holdings with traditionally managed fields filled with wild

THE MARCHES HIGHLIGHTS
Dippers and grey wagtails on **River Dee** at Llangollen. Bog asphodel and bog rosemary on the **mosses**. Orchids at **Llynclys Hill reserve**. Autumn lady's-tresses at **Llanymynech Rocks**. Ring ouzel and stonechat on heather-clad top of **Long Mynd**. Crowberry, cowberry and curlews at **Stiperstones**. Grassy earth bank and ditch of **Offa's Dyke**.

Miles 0 4 8 12
Km 0 5 10 15 20

WREXHAM
R. Dee
LLANGOLLEN
PONT-CYSYLLTE
WHITCHURCH
CHIRK CASTLE
ELLESMERE
OSWESTRY
WEM
LLYNCLYS HILL
LLANYMYNECH
R. Severn
BREIDDEN HILL
SHREWSBURY
WELSHPOOL
R. Severn
STIPERSTONES
THE LONG MYND
CORNDON HILL
LITTLE STRETTON
MONTGOMERY
NEWTOWN
OFFA'S DYKE
CLUN
OFFA'S DYKE
LLANFAIR HILL
LUDLOW
KNIGHTON
R. Teme

Jay

Garrulus glandarius

Although seldom permitting prolonged views, jays can be recognised in an instant – even when glimpsed only fleetingly – because they are the only medium-sized species with a white rump. This conspicuous feature is most noticeable in flight and is often seen when birds are disturbed while feeding on roadside verges. The jay is the most colourful British member of the crow family and is essentially a woodland bird. Its role in the continued survival and expansion of oak woodland in Britain is often underestimated: vast numbers of acorns are buried by jays each autumn in countryside caches and those which remain undetected later in the season stand a good chance of germinating and creating a new generation of oak trees.

In autumn, the raucous calls of jays fill the air as they search excitedly for acorn-laden oak trees, then disperse – their crops bulging with their prize.

see also page 254

Although usually rather shy and retiring, polecats occasionally become oblivious to onlookers when preoccupied with rough-and-tumble play.

River Severn as it meanders to its confluence with the Vyrnwy.

South Shropshire is a landscape of green hills and valleys. These are A E Housman's 'Blue remembered hills', a pastoral landscape as peaceful today as it was in his day. The Long Mynd's heather moorland top contrasts with the agricultural land, and here are some of the last regional strongholds for red grouse, ring ouzel, stonechat and snipe.

Many footpaths twist to the top of the ridge through the folds in the hillside where whinchat and wheatear breed, and dippers hunt the rushing streams. There is a visitor centre (National Trust) at Carding Mill Valley.

The Stiperstones are a long line of jagged tors emerging from heather- and bilberry-clad slopes, with crowberry and cowberry sometimes thrown in for good measure; above, the drifting call of the curlew fills the air. Beyond are hills stretching into Wales – the Kerry Ridgeway, Corndon Hill and many others – and a climb to the top is rewarded with extensive views.

HILL STREAMS
These hills feed many streams and swift, clear little rivers: the Clun, Camlad, Onny and Teme flow through wooded valleys and water-meadows banked with alder and willow. Rabbits, introduced to Britain well after Offa's time, are a familiar sight. Above, the buzzard's circling cries contrast with the throaty call of the raven.

In spring, the woods are carpeted with white mats of anemone and wood sorrel, followed by bluebells. The border counties are one of the few strongholds in Britain of the polecat, which favours woodland areas.

Between Newcastle in the valley of the Clun and Knighton on the Teme, Offa's Dyke provides wonderful vantage points before it reaches the lower lands of Herefordshire.

AND ALSO LOOK OUT FOR...
● weasel ● fox ● pipistrelle ● pheasant ● tree pipit ● wren
● grasshopper warbler ● whitethroat ● dark green fritillary
● primrose ● ling ● hedge bedstraw ● harebell ● birch polypore

Early-purple orchids are a characteristic sight in open woodlands and on roadside verges, the flower spikes appearing in April and May.

Rabbits are ever-alert to danger, using their keen senses of smell and hearing. They need to be wary as they are eaten by a wide range of predators.

Bird's-foot-trefoil

Lotus corniculatus

This creeping, low-growing plant is common in most parts of lowland Britain, including the Welsh borders. Bird's-foot-trefoil prefers grassy, rather bare, slopes and is often seen growing beside paths and tracks. From May to August, heads of attractive yellow flowers, sometimes tinged with red, are produced and carried on long stems; there are usually five or so flowers per head and these are arranged in a radial manner. The flowers mature and ripen into elongated seed pods and it is at this time of year that the reason for the 'bird's-foot' part of the plant's name becomes obvious.

When not in flower, bird's-foot-trefoil is easily overlooked as it straggles through grassy meadows and roadside verges.

see also page 290

Snowdonia

When the traveller and essayist George Borrow toured Wales in 1854, he wrote of Snowdonia: 'Perhaps in all the world there is no region more picturesquely beautiful'.

THE SNOWDONIA National Park is Britain's second largest, after the Lake District, and within its 217,000ha (535,802 acres) rise several mountain ranges, including Wales's highest summits. There are wide moorland skylines too, and dense swathes of forest. The most frequented peaks are Snowdon in the north of the park and Cader Idris in the south. This is

Purple saxifrage often appears in flower in early April, despite the fact that it grows on mountain ledges.

mountaineering country, where the conquerors of Everest trained. Today's hillgoers need to lace expeditions with due caution, whatever the season. Rain, wind and mist often besiege the tops and winter snows can linger as late as May in some years.

Snowdonia's savagely beautiful upland landscapes owe their forms to glacial ice which scoured the region's ancient volcanic geology during the last Ice Age. Grinding inexorably downhill, the glaciers left behind them a remarkable legacy of U-shaped valleys, lumpy

hills of moraine debris and brooding crags above skirts of scree and boulders. High up beneath the summit ridges, steeply hollowed rock amphitheatres known as 'cwms' cradle jewel-like lakes.

HARDY SHEEP

Apart from wild ponies roaming the northern Carneddau Hills, and scattered herds of Welsh Black cattle, only the hardy Welsh Mountain sheep can withstand the inhospitable upland climate and convert rough grazing into profit for farmers.

The region is at its most dramatic in winter and snow may lie for months. Llyn Can on Cader Idris lies in a typical 'cwm'.

Various songbirds, including chaffinches, are found on the lower slopes and all are subject to periodic attacks by the resident sparrowhawks.

After lambing around Eastertime, the ewes and their offspring are driven up the mountainside to fend for themselves until shearing in June and July. September sees the flock gathered and female lambs put to overwinter on kinder pastures while their male counterparts are destined for slaughter. Older ewes run with the rams in October, starting the breeding cycle afresh.

Snowdonia's army of

nibbling sheep keeps many upland plant species in check, but in some high locations beyond their reach Arctic–alpines such as rose-root and purple saxifrage flourish. In summer, mossy saxifrage scatters its white flowers over mountainsides, for all the world like unseasonable snowfall.

One special flower – the Snowdon lily – grows nowhere else in Britain save on inaccessible ledges in the Glyder and Snowdon massifs.

Snowdon lily

Lloydia serotina

In Britain, this plant is known only from the Snowdonia region. In part due to grazing pressure, it is now restricted to a very few sites, most of them on ledges inaccessible to sheep at heights between 640 and 730m. It is therefore something of a challenge for botanists to see it well. When not in flower, this is a very difficult plant to detect because its leaves are slender, grass-like and small in number. In May, a single delicate miniature lily flower is produced, borne on a slender stalk; it is very pale pink in colour with delicate, purple veins. This is one of Snowdonia's most special plants.

Despite its rather unprepossessing appearance, the Snowdon lily arouses intense interest among botanists who visit the region in search of mountain speciality species.

The migratory ring ouzel is the mountain counterpart of the blackbird and is present from April to August.

However, it is not always necessary to scale the heights to appreciate the mountain environment. Even from below, cliffs echo to the croaking 'kronk kronk' call of ravens and to the buzzard's plaintive mewing. In summer, the carrying song of the ring ouzel can be heard, though you are less likely to spot this shy bird.

There are hovering kestrels, peregrine, dashing sparrowhawks and red-billed choughs that sometimes nest in abandoned copper mines. Mountain hares, still white in their winter coats, remain incongruously conspicuous for a time during early spring.

WOODLAND POCKETS
Sessile oak once clothed Snowdonia's hillsides but here, as elsewhere in Britain, early man's appetite for timber and land clearance decimated the natural broad-leaved woodlands. Some glorious remnants remain, however. They occur mainly in valleys such as those in Nantgwynant and around Betws-y-Coed, while isolated trees sprout defiantly from crags and lakesides.

Grasses, heather and bilberry provide the usual ground cover, but bracken on deeper soil and ferns near bubbling streams and in damp hollows support rich populations of insects. Small mammals and birds, including the pied fly-catcher, thrive in these quiet pockets of unspoiled woodland. Oak acorns sustain jays, squirrels, mice and voles; the latter two fall prey to tawny owls.

Planting of commercial conifer forests began in the early 20th century, controversially transforming the character of many a hillside. The most common species are Sitka spruce and larch, but among others appear Douglas fir, Corsican pine and lodgepole pine. Snowdonia's three principal evergreen forests are Gwydyr around Betws-y-Coed, Coed y Brenin (The King's Forest) north of Dolgellau and the Dyfi Forest north of Machynl-

High-pitched calls and songs alert birdwatchers with good hearing to the presence of goldcrests in the conifer forests.

The rainbow leaf beetle has its sole British location on patches of thyme on Snowdon's highest slopes.

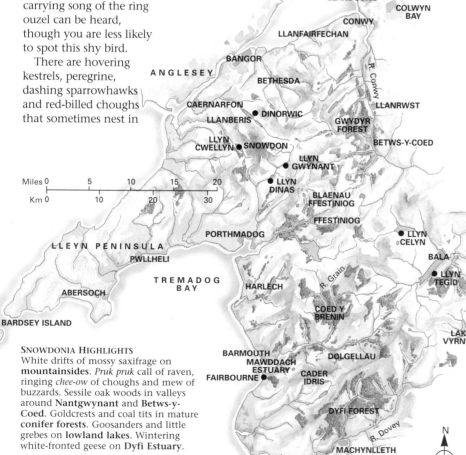

Miles 0 5 10 15 20
Km 0 10 20 30

LLANDUDNO
COLWYN BAY
CONWY
LLANFAIRFECHAN
BANGOR
ANGLESEY
BETHESDA
CAERNARFON
DINORWIC
LLANBERIS
LLANRWST
GWYDYR FOREST
LLYN CWELLYN SNOWDON
BETWS-Y-COED
LLYN GWYNANT
LLYN DINAS
BLAENAU FFESTINIOG
FFESTINIOG
PORTHMADOG
LLYN CELYN
LLEYN PENINSULA
PWLLHELI
BALA
TREMADOG BAY
HARLECH
R. Grain
LLYN TEGID
ABERSOCH
COED Y BRENIN
BARDSEY ISLAND
LAKE VYRNWY
SNOWDONIA HIGHLIGHTS
White drifts of mossy saxifrage on **mountainsides**. *Pruk pruk* call of raven, ringing *chee-ow* of choughs and mew of buzzards. Sessile oak woods in valleys around **Nantgwynant** and Betws-y-Coed. Goldcrests and coal tits in mature **conifer forests**. Goosanders and little grebes on **lowland lakes**. Wintering white-fronted geese on **Dyfi Estuary**.
BARMOUTH
MAWDDACH ESTUARY
DOLGELLAU
FAIRBOURNE
CADER IDRIS
DYFI FOREST
R. Dovey
N
MACHYNLLETH
DYFI ESTUARY

Parsley fern
Cryptogramma crispa

Parsley fern is a characteristic upland plant that is locally common in Snowdonia. It favours damp rock faces and stable scree slopes where it grows among the boulders; shady ravines through which the Snowdon railway line passes are among the best sites for this species. Unfortunately, trampling and grazing have eliminated it from many areas. As its name suggests, the plant bears more than a passing resemblance to its namesake culinary herb. The fronds are a fresh green colour and divided in a parsley-like manner. Parsley fern forms dense and sometimes sizeable clumps; the fronds wither and turn brown during the winter months.

see also page 311

Parsley fern thrives on scree slopes in Snowdonia. The shifting, unstable substrate of this precarious habitat is too challenging for most other plant species to gain even temporary purchase.

Native sessile oak woodland still cloaks many of the slopes, as here at Conway Falls. They are graced by breeding birds such as pied flycatcher and redstart, and a wealth of insect life can be found on the leaves.

Peregrine
Falco peregrinus

The peregrine is Britain's largest resident falcon and the species is relatively common in Snowdonia. Using binoculars, scan inaccessible rocky crags to find perched or nesting birds.

Few birds can raise the pulse of a keen bird-watcher to the same extent as the peregrine. This supreme bird of prey is certainly one of the most magnificent sights to be seen in upland areas of Britain, although to see one requires both sharp eyesight and a degree of luck. Once seemingly in terminal decline due to the effects of pesticide residues, peregrines now enjoy a much more healthy position. Resident pairs hold territories on many rocky outcrops and cliffs in Snowdonia, catching smaller birds such as jackdaws and pigeons on the wing. During the winter months, the birds often move to the coast to hunt, and the sight of a peregrine 'stooping' at great speed on an unsuspecting bird will stay in the memory for a long time.

see also page 230

leth. Details of forest trails are available from visitor centres.

New plantations can be extremely interesting places. More open conditions there, free from sheep, encourage songbirds such as yellowhammers, whinchats, tree pipits and willow warblers. Older established conifer forest may seem claustrophobic and lifeless, yet even here some species do well. Coal tits and goldcrests are much in evidence, while in summer the yellow and black siskin may be spotted.

LAKES AND RIVERS
As much as 470cm (185in) of rain has been recorded on the Snowdonia mountains in one year; even in a drought year just under half that amount is not uncommon. Little wonder, then, that water features so prominently in the Snowdonia landscape.

On calm days the lakes assume an almost mystical tranquillity, only the wakes of little grebe disturbing their glassy surfaces. But in stormy weather waves lash against their shaly beaches with a fury reminiscent of the sea, and the feeder streams and waterfalls froth white with run-off from the bare slopes above.

Winter sees the arrival of wildfowl on the region's marshes and lake margins. Among the highlights are white-fronted geese.

Some lakes – Llyn Gwynant and Llyn Dinas beneath Snowdon's southern flank spring to mind – are among the most exquisite and accessible in Britain; others lie unseen and rarely visited among the hills.

Many and varied are their shapes, colours, moods and legends, the loveliest of all unfettered by hydro-electric schemes or forestry. Most are best seen in winter when the ubiquitous green of fescue grass and bracken gives

The reed-fringed margins of sheltered lakes support breeding wetland birds such as the little grebe which builds a floating nest.

way to burning shades of gold and ochre. And when all around is snow-clad, the lakes sulk beneath sinister shields of black ice – any remaining patches of water attracting small groups of wildfowl such as goosanders and whooper swans.

While watersports are permitted on some larger lakes, others are the preserve of anglers and the occasional passing walker. The rare Welsh or Arctic char, a red-bellied alpine trout known locally as torgoch, resides in Llyn Cwellyn to the west of Snowdon, and perhaps in other lakes too. It is believed to be under threat from artificial increases in brown trout introduced for the benefit of fishermen.

At the extreme end of the park, Llyn Tegid has been renowned for its gwyniad, a unique alpine

Golden-ringed dragonflies are the largest of their kind in the region. In the nymphal stages they spend several years feeding in fast-flowing streams and rivers.

The autumn colours of the mountains are reflected with mirror-like perfection in the waters of Llyn Padarn.

fish species resembling the whiting. Among other fish found here are roach, rudd, chub, pike and the rarer grayling.

On their journey to the sea, streams draining the peaks and high lakes amalgamate into swiftly flowing torrents, providing a challenge to whitewater canoeists and excitement for coarse fishermen. Plunging through tree-stepped gorges and bursting as waterfalls over rock ledges, these turbulent water-courses finally broaden and slow into reed-fringed estuaries bound for the coast. Here all manner of water-loving and wading birds may be seen.

The Dyfi Estuary's special species is the Greenland white-fronted goose. It arrives in mid-

Goosanders breed beside rivers and streams in the region, using natural tree holes in which to nest. In late spring, family parties of ducklings can be seen resting on strategic fallen logs.

October and stays until mid-April – this is its only Welsh wintering place.

THE SEASIDE
Snowdonia's coastline extends north from the Dyfi Estuary round the Lleyn Peninsula to the River Conwy. In no other part of Britain are lofty mountains and splendid bucket-and-spade seaside resorts found in such close proximity.

The biggest beaches tend to fringe the estuarine bays but river-mouths can be breezy, exposed places and blown sand creates dune systems such as those at Fair-bourne on the Mawddach

Estuary in Tremadog Bay. Over time, marram grass and eventually heathland stabilise the shifting sandhills, despite the onslaught of winter storms. Moist hollows, or 'slacks', form, providing ideal conditions for dis-tinctive plants such as creeping willow, butter-wort and orchids.

In other locations, shoreline cliffs provide nesting sites for a wide variety of sea and land birds, and migrant birds drop by.

Sea fishing for mackerel, plaice, whiting and dab has declined over recent years so that today fewer fishing boats crowd the quaysides of the little ports around the coast. Instead, flotillas of sailing dinghies from marinas at Conwy, Caernarfon, Pwllheli and other sheltered moorings dot the summer sea.

AND ALSO LOOK OUT FOR...
- polecat ● fox ● grey heron ● black-headed gull ● whinchat
- siskin ● linnet ● jackdaw ● common frog ● palmate newt
- small copper ● marsh pennywort ● bog pimpernel
- marsh St John's-wort ● tormentil ● lesser spearwort
- cuckooflower ● bilberry ● lousewort ● goldenrod ● shoreweed

Arctic char
Salvelinus alpinus

This attractive cold-water fish is very much a speciality of Snowdonia. It is found in two lakes in the region with other isolated populations occurring in northern and upland lakes elsewhere in northern Britain and Scotland. The Arctic char is referred to by biologists as a glacial relict species, as it was more widespread in Britain at the end of the last Ice Age. As temperatures warmed following the glacial melt, so the Arctic char retreated to cold, deep lakes. It is an extremely attractive fish, trout-like in appearance with a bright-red belly. The Welsh name for this species, torgoch, does in fact mean red belly.

Its streamlined appearance and a small adipose fin on the back betray the relationship of the Arctic char to salmon and trout. Unlike its relatives, in Snowdonia it is only found in lakes.

Anglesey

Linked to the mainland by two bridges across the Menai Strait, the island has a beautiful and incredibly diverse coastline, ranging from rugged cliffs and rocky shores to saltmarsh and sand dunes, with lakes and heaths inland.

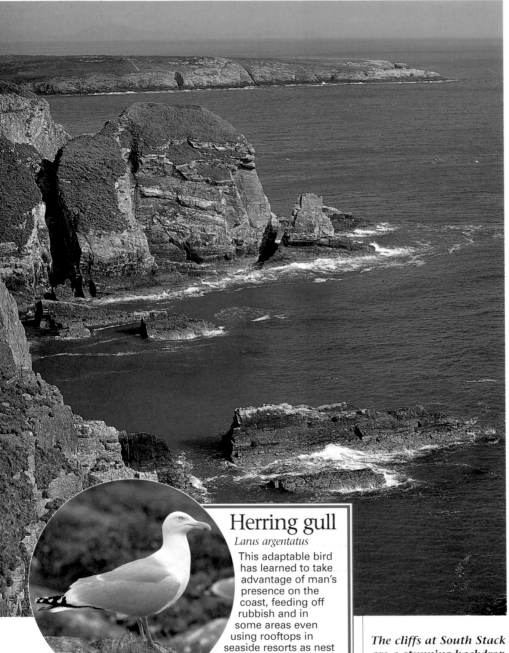

DURING A VISIT TO Anglesey you would be unlucky not to see a chough or peregrine, or one of the rarer orchids during a spring visit, and a walk alongside the Strait at any time of the year provides excellent opportunities for observing seabirds and marine life. The lakesides and marshes are the best places to look for any of the island's two dozen species of orchid.

EXCITING ORCHIDS

In spring and summer marsh helleborine, lesser butterfly-orchid and fragrant and green-winged orchids, as well as both heath and pale dog-violets, can be seen at the Wildlife Trust reserve of Cors Goch. Summer migrants – sedge warblers and cuckoos – will be in residence, and the rare hairy dragonfly patrols its territory. A boardwalk gives views of the wildlife.

One of the rarer plants of the island, the spotted rock-rose, can be found along the coast. The varied flora of the limestone rocks, including the beautiful bee orchid, is home to the silver-studded blue butterfly which is

While walking coastal paths, keep your eyes peeled for peregrines, which engage in spectacular 'stooping' dives on their prey.

common on Holy Island.

Penmon, the most easterly tip of Anglesey, offers splendid views across to Snowdonia and is good for bird-watching, with fulmars, puffins (especially offshore on Puffin Island) and even breeding black guillemots.

In the north, in early summer, the lagoon at Cemlyn echoes with the deafening cries of terns (including a few roseates) nesting on the saltmarsh islands. Point Lynas, further east, is a popular point for watching migrant seabirds such as skuas and gannets.

No trip to Holy Island would be complete without visiting South Stack, famous for its contorted rock formations and numerous seabirds – guillemots in their thousands, razorbills, peregrine, raven and chough – which congregate here in spring and summer. Floral interest on the cliffs includes sea

Herring gull

Larus argentatus

This adaptable bird has learned to take advantage of man's presence on the coast, feeding off rubbish and in some areas even using rooftops in seaside resorts as nest sites. In winter, refuse tips inland are favoured hunting grounds and attract large flocks. Adult birds have blue-grey backs and pink legs, features not shared by other gull species. Juveniles, by contrast, are mottled grey-brown; they acquire adult plumage gradually over a period of several moults. Away from human habitation, herring gulls nest in loose colonies on seabird cliffs and islands.

The herring gull is the commonest of the large gull species and its loud, harsh cry is a familiar coastal sound. Its diet includes fish, shellfish, small mammals and birds.

see also page 237

The cliffs at South Stack are a stunning backdrop for some of Wales's most accessible seabird colonies. Sightings of dolphins and grey seals are not uncommon in calm weather.

To see spotted rock-rose at its best you need to find it early in the morning – the flowers usually shed their fragile petals by midday.

campion, rock sea-spurrey and spring squill. Inland, western gorse, bell heather and tormentil create a mass of colour. On calm days the mournful call of grey seals can be heard from the bay between South Stack and North Stack, one of their few safe hauling-out places on this rocky coast.

NATURE RESERVE
Newborough Warren national nature reserve on the southern side of Anglesey has well-marked paths through the sand dunes. In spring and summer it is hard to miss the abundant marsh helleborines, grass-of-Parnassus and round-leaved wintergreen, among many other species, while butterflies include graylings and dark green and pearl-bordered fritillaries.

Nearby Newborough Forest has the largest winter raven roost in Europe; in the damper areas there are orchids and a host of other plants. Small heaths, dingy skippers and common blues flit around the clearings and, if you are lucky, you may see one of the few red squirrels that still occur on Anglesey.

A toll road passes through the forest to a car park from where you can walk to Llanddwyn Island

Ravens are a familiar sight around the cliffs of Anglesey; their presence is often detected by the loud 'cronking' calls so characteristic of the species.

(in fact a peninsula cut off only during very high tides). Here the Pre-Cambrian green 'pillow lava' rocks, over 600 million years old, are of interest, while there are always terns, gulls and, offshore, shearwaters and gannets to be seen.

Nearby is the wide estuary of the River Cefni and the adjacent Cob Lake; both are magnets for birdwatchers at any time of the year, with flocks of winter pintail and spring migrants such as black-tailed godwit and spotted redshank.

AND ALSO LOOK OUT FOR...
● shag ● meadow pipit ● stonechat ● wheatear ● small copper ● common scurvy-grass ● bird's-foot trefoil ● hare's-foot clover ● English stonecrop ● sea ivory lichen ● *Xanthoria* lichen

Miles 0 5 10
Km 0 5 10 15

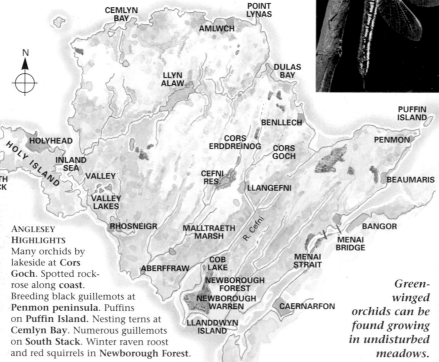

CEMLYN BAY
POINT LYNAS
AMLWCH
N
LLYN ALAW
DULAS BAY
HOLYHEAD
BENLLECH
CORS ERDDREINOG
CORS GOCH
PENMON
HOLY ISLAND
INLAND SEA
VALLEY
CEFNI RES.
PUFFIN ISLAND
SOUTH STACK
VALLEY LAKES
LLANGEFNI
BEAUMARIS
RHOSNEIGR
MALLTRAETH MARSH
R. Cefni
BANGOR
MENAI BRIDGE
ABERFFRAW
COB LAKE
MENAI STRAIT
ANGLESEY HIGHLIGHTS
Many orchids by lakeside at **Cors Goch**. Spotted rock-rose along **coast**. Breeding black guillemots at **Penmon peninsula**. Puffins on **Puffin Island**. Nesting terns at **Cemlyn Bay**. Numerous guillemots on **South Stack**. Winter raven roost and red squirrels in **Newborough Forest**.
NEWBOROUGH FOREST
NEWBOROUGH WARREN
CAERNARFON
LLANDDWYN ISLAND

The dune system at Newborough Warren is one of the finest in Britain and supports a vast array of plants in its wet and dry slacks.

In certain lights, the downy texture of the hairy dragonfly can be seen to good effect. It emerges in early May.

Green-winged orchids can be found growing in undisturbed meadows.

Heart of England

This region of arbitrary boundaries covers a huge variety of landscapes, extending from the Essex marshes, across East Anglia and the Fens, into the Midlands and up to the fringes of the Pennines. Within this area are chalklands, clays, sands and peatlands. In north Staffordshire the region crosses the greatest division of all English landscapes, entering the Highland zone, where the hard rocks and forbidding mountains signal a radical change in scenery and in the way of life.

Sun-dappled woodland rides, such as this one at East Wrexham in Norfolk, are a delight for walkers and a focus for the activities of forest birds and mammals.

*A*s in the rest of the country, there are two main types of ordinary landscape in the Heart of England: Ancient Countryside, the result of stability or piecemeal change down the centuries; and Planned Countryside, which was created by the enclosure of each parish with straight roads and regular fields.

LANDS ANCIENT AND MODERN

Essex is a land of Ancient Countryside, with hamlets, greens and commons, ancient timber-framed farms, sunken winding lanes, thick mixed hedges, hedgerow trees and a lack of straight lines. The earliest maps of 400 years ago show it much as it is now. Ancient Countryside is typical also of south-east Norfolk, Warwickshire and Staffordshire. Cambridgeshire, in contrast, is a land of big villages, modern brick farms in fields, straight roads and flimsy hawthorn hedges in straight lines. This is Planned Countryside, deliberately set up as an Enclosure Act for each parish, mostly between 1760 and 1840. Previously most of the land had been farmed in thousands of half-acre strips belonging to different owners (as still happens in much of France). The Midlands, Breckland, most of the Fens and north-west Norfolk are also Planned Countryside – but the division is not as simple and does not follow county boundaries.

Planned Countryside contains fragments of hedges, lanes and pollard trees which enclosure commissioners failed to destroy, and occasionally even fragments of the prehistoric landscapes that preceded the cultivation strips. Conversely, there are many modern features and patches of reorganisation in Ancient Countryside.

THE BEGINNINGS OF THE COUNTRYSIDE

The creation of a landscape that we would recognise began in the Neolithic period, some 6,500 years ago. Farmers grubbed out wildwood and made fields in which to grow crops and keep

Poppies and other wild flowers flourish when fields are set aside for fallow, an approach that is much more sympathetic to wildlife.

introduced livestock. A fairly-well-preserved Neolithic landscape still exists in Breckland. By the last few centuries BC, most of the wildwood has been turned into pasture or arable. People were adopting fixed field boundaries – banks or hedges – and the remaining wildwood was being taken into management.

The Romans added main roads, whose straight lines still dominate most maps. They also extended farming into the Fens, helped by a retreat of the sea, and they dug the Car Dyke, a great canal from Lincoln to near Cambridge.

HEART OF ENGLAND HABITATS

Discover estuaries

*A*t first glance, the vast expanse of an estuary may seem an unpromising destination for the naturalist. Of course this is far from the truth, for beneath the surface of the mud live incredible densities of marine invertebrates that in turn support huge populations of birds. Estuaries are not without botanical interest either – flourishing saltmarsh communities develop around the more stabilised margins of these splendid locations.

Estuaries form where river meets sea, the silt and organic debris that is deposited creating vast expanses of mud, through which the flowing freshwater meanders at low tide. Although they are affected by the tides that

In summer, the subtle lilac flowers of sea-lavender adorn the extensive areas of saltmarsh on the North Norfolk coast.

In winter, grey plovers appear a uniform grey at a distance. At close range however, their upperparts appear spangled with white and black markings.

bathe the entire British coastline, the waters that cover the mudflats at high tide are usually brackish at best. At certain states of the tide and in the higher reaches of the estuary, however, they can be almost fresh.

The range of salinities experienced by creatures living beneath the surface of the mud is extreme compared to that experienced in the sea, but their physiology is obviously tolerant, as many marine molluscs and worms thrive here at almost

Ordinary Ancient Countryside is very difficult to date. The average Essex lane and its hedge came into being before the 13th century: some sunken lanes are already called 'holloway' in Anglo-Saxon charters. In places there are even remains of a much earlier organised system, probably Iron Age.

Originally, Planned and Ancient Countryside were probably much the same, until strip-fields were created as a sort of collectivisation of agriculture in the mid to late Anglo-Saxon period (8th–11th centuries) – a great and mysterious change which involved redistributing land, removing hedges, moving people from their farms into villages and persuading them to take up communal practices. This was nearly completed in areas such as Cambridgeshire, but never got far in most of Essex. It created a vast difference between hedged and open country, very prominent in the 16th century and still recognisable today.

Landscapes and human activities have had their ups and downs. In the 18th and 19th centuries, nearly all the strip-cultivation and most of the remaining heath, grassland and fen were abolished and made into ordinary farmland. Some of this went out of cultivation in the ensuing agricultural depressions. The pattern of strips may be preserved in ridge-and-furrow in what is now grassland or woodland.

A greater onslaught than ever on the remaining roughland, especially woodland, came between 1950 and 1975, when it was thought that every inch of land ought to be put to good use. At the same time, most of the hedges were destroyed, especially in eastern England.

A few new habitats have been added in the 20th century. Forestry plantations have usually

Woodland can be found across the region. At Thetford Warren, typical Breckland Forest is birch growing on sandy soil.

Small colonies of red squirrels can be found in some conifer woods in the Heart of England, although luck is needed to see them.

been destructive, preserving, at best, scraps of the heath and woodland that they replaced. Those in the Breckland, however, are the last mainland stronghold of the red squirrel in England. Derelict land is a valuable and little-known habitat, all too often swept away in the name of tidiness or urban renewal. Occasionally, as in Langdon Hills County Park, Essex and Sandwell Valley, west of Birmingham, it is recognised as an amenity in its own right.

Flounder
Platichthys flesus

Although essentially marine fish, flounders can live in brackish water and often venture up estuary channels.

Like other flatfish, the flounder's body is compressed laterally, the animal lying on its left-hand side. To compensate for this, the structure of the head alters during development so that both eyes lie on the fish's right-hand side, facing upwards. Flounders are perfectly suited to living on a sandy seabed. Not only does their coloration blend in with the substrate, but, with a quick quiver of their fins, they can flick up sand to cover all but their eyes. They are occasionally found in shallow pools on sandy estuaries.

see also page 260

unbelievable densities.

During the winter months in particular, bird-watchers gravitate towards our splendid estuaries – and not without good reason. From August onwards almost all Britain's estuaries attract vast numbers of waders and wildfowl, most of which will have migrated here from breeding grounds further north in Europe or even farther afield in the Arctic. Some species pause only briefly to feed and rest before continuing their journey southwards for the winter. Hundreds of thousands of birds remain around the coasts, however, making Britain one of the most important sites in Europe for these winter visitors. Study the birds on an estuary for long enough and you become aware that each species feeds in a subtly unique manner, the shape and size of the bill being crucial in minimising undue competition for food.

Visit an estuary during the summer months and the somewhat limited bird-watching interest will be eclipsed by the sight of saltmarsh plants growing in profusion, many in full bloom. Like the invertebrates that live under or at the surface of the mud, the highly specialised plants that thrive here have to cope with environmental extremes that would kill their terrestrial or freshwater counterparts. On a twice-daily basis they are immersed in water, either fully or partly depending on the cyclical state of the tide.

The salinity of this water might be close to that of seawater in the summer but almost fresh during periods of autumn or winter rain. Add to this problems associated with exposure to the elements at low tide – wind, rain or snow – and you have some extremely tough and resilient plants.

Characteristic among these are glasswort, sea purslane, seablite, sea-lavender, sea aster and golden samphire.

Late summer on many estuaries is marked by the appearance of stunning spikes of golden samphire, a member of the daisy family.

Within the Heart of England are several hundred ancient woods, mostly scattered among farmland, though some are within the borders of expanded towns. These woods often have a recorded history going back to the 13th century, and a few are mentioned in Anglo-Saxon charters of a thousand years ago. Before that, they have a long, dim, history going back to the prehistoric wildwood. For example, Haley Wood (now owned by Cambridgeshire Wildlife Trust) belonged to the Bishops of Ely, and Bradfield Woods (Suffolk Wildlife Trust) to the Abbey of Bury St Edmunds.

Woodland may now seem to be little-used places where nature takes its course, but for most of their history they were very actively used. The normal practice was coppicing; every six to 25 years most of the trees were felled to produce underwood – rods, poles and logs used for many purposes, but especially for fuel. Most native trees – ash, hazel, maple, hornbeam, lime – survive being cut down and sprout from the base, or stool, to produce more crops of poles. A scatter of timber trees, mainly oaks, would be left to grow to sizes suitable for planks and beams. Trees were self-replacing and new ones were rarely planted.

Coppicing began in the Neolithic era and went on into the 20th century; in a few woods, such as Bradfield, it never ceased. Over the centuries woodland ecosystems became adapted to the periodic fellings. Plants such as primrose and oxlip flower profusely with the extra light.

Dormice and nightingales favour particular stages of regrowth, and the flowers attract hoverflies, butterflies and other insects. Coppicing has been revived over the past 30 years, and can be seen in most woodland nature reserves, such as Norfolk Wildlife Trust's Wayland Wood.

Although it may seem drastic, coppicing trees such as small-leaved lime – seen here – prolongs their life and benefits other wildlife.

Ancient woodlands can be recognised by their irregular outlines and their names – such as Wayland or Hayley. Woodland was valuable land and was carefully defined and guarded, and these woods are still surrounded by big banks and ditches that are about a thousand years old. Ancient woods contain a great mixture of trees and shrubs, including small-leaved lime in some

Dormice are one of the key species to benefit in carefully managed woodland. Their status is being monitored by English Nature and other conservation bodies.

areas, such as the Marshall Woods in Essex, and service, found in Hockley Wood. Coppice stools live indefinitely, and ancient examples can be seen in most woods.

Ancient woods also have a special flora, including plants that do not easily invade newly formed woodland, such as oxlip in East Anglia and Essex. Anemone, lily-of-the-valley and herb paris are among the many ancient-woodland plants.

Innumerable timber-framed buildings, especially in Suffolk and Essex, contain the products of woodland. The timbers show that there was a rapid turnover of small oak trees, each beam representing one tree. Coppiced underwood is sometimes revealed between timbers during repairs. The great barns of Cressing Temple owned by Essex County Council, demonstrate the largest sizes to which ordinary trees would grow.

Not all woodlands are ancient. Almost any piece of land, if not ploughed or grazed, turns into a wood – but a peculiar kind of wood, often of oak or hawthorn, beneath which little but brambles grow. New woods are slow to acquire the full woodland flora, but often have remains of the previous flora and signs of previous land use – especially old industrial land. Nearly all of

HEART OF ENGLAND HABITATS

Discover farmland

Farming in its various guises is by far the most dominant form of land use in lowland Britain, and our perception of the countryside is to a large degree based on a legacy of centuries of agriculture. Indeed, the quintessentially British mosaic of fields, hedgerows and copses has been created almost entirely as a result of farming activities. In areas where large-scale agri-business dominates the scene, the wildlife interest is likely to be minimal. Where mixed farming prevails, however, there is generally something to be found throughout the year – although those native plants and animals that survive generally do so in spite of farming and not

The use to which any given area of farmland is put is determined as much by available subsidies as by food requirements.

In Britain, the stone-curlew is found on downland and areas of arable farmland.

because of it, except where they are actively encouraged and exploited.

From the naturalist's point of view, the greatest variety of wildlife is likely to be found where small farms dot the landscape and land use comprises a mixture of arable and livestock farming. In the West Country, for example, a patchwork of fields defined by mature hedgerows and studded with small copses provides habitats for nesting songbirds, butterflies, other insects and wayside flowers. Where pesticides, herbicides and fertilisers are used, our native

Once widespread, the fritillary is now restricted to a few undisturbed and unploughed water meadows.

the Mousehold Heath, Norwich, has become woodland within the last 100 years, as has most of Holme Fen near Peterborough. This has happened at various times in down the centuries. At Gamlingay Wood, Cambridgeshire, the woodbank originally excluded a prehistoric earthwork, now well within the wood. At Swithland Wood, Leicestershire, nearly a whole ancient wood contains ridge-and-furrow from earlier ploughing; big stools of small-leaved lime grow on the baulks between blocks of ridges.

In the 20th century, woods suffered many vicissitudes. Coppicing fell into neglect, and between 1950 and 1975 woods were made into the arable land, often set-aside today. There was also a short-lived fashion for felling and poison-

The natural succession of vegetation can be seen in all its stages at Holme Fen, from open water through to mature woods.

ing ancient woods, and replacing them with planted trees. Recent changes include a run of dry summers, which has hastened the demise of planted conifers and the multiplication of deer. There are now more deer loose in the region – seven species – than for a thousand years, and they are a severe limitation on coppicing, or indeed to any woodland management.

PASTURE AND MEADOW
Grassland traditionally includes both pasture, which is grazed, and meadow, which is cut for

hay. Ancient grassland is full of wild flowers; for example, fritillary in damp meadows, pasqueflowers on dry chalkland, sheep's bit and harebell on acid healthy grassland, and an alternation of cuckooflower and buttercup on the ridge-and-furrow of medieval ploughland. These contrast with the standard 'improved' farm grassland of cock's-foot, rye grass and the occasional thistle, which is almost as much an arable crop as wheat. Amenity grassland, too, is disappointing – even poverty does not prevent councils from fertilising, weedkilling and mowing public lawns into an imitation of plastic grass.

Chalk downland once covered much of the east of the region, but almost all of it north of Luton was destroyed in the 19th century. Meadows and old pasture were thickly scattered almost everywhere, but nearly all succumbed to the fashion for improving every scrap of land in

wildlife inevitably suffers.

In a quest for greater efficiency in areas of arable farming, hedgerows are often grubbed out to make way for larger fields. Unsurprisingly, wildlife interest has generally declined in these areas, although birds such as partridges and woodpigeons still thrive, and stone-curlews find the wide open vistas much to

The showy flowers of silverweed betray its allegiance to other members of the rose family. The species thrives on bare, trampled ground.

their liking. In recent years, crop planting has switched from spring to winter on many farms, with the result that stubble and spilt grain does not persist throughout the winter months. It is no coincidence that the numbers of buntings, finches, skylarks and tree sparrows have declined as winter visitors to arable land over the last decade.

There is a feeling among many in the rural community that farmers are largely responsible for the guardianship of the countryside. While it is true to say that they wield power over the fate of the land, this does not mean that the needs of conservation and wildlife necessarily have any bearing on the way in which the land is used. A relatively harmonious relationship may have existed between farmers

Lapwing
Vanellus vanellus

Rough grassy fields make ideal nesting sites for the lapwing, an attractive wader which is fairly common throughout Britain. At a distance the bird can look black and white, but in good light the greenish-purple sheen on the back feathers is revealed. The lapwing's upturned crest is distinctive and, in flight, the black and white rounded wings and diving display-flight make it easy to identify. Its call is a choked and drawn-out scream which gives the bird its other name of peewit. Outside the breeding season, lapwings are found in flocks feeding in fields.
see also page 233

As a ground-nesting species, the lapwing is vulnerable to foxes and feral cats, as well as to disturbance by human activities.

and wildlife a century ago, but the same can seldom be said today. Most aspects of modern farming do little to encourage native plants and animals, and often agricultural activities are at

odds with the needs of British wildlife. Food production is vital to the nation's well-being, but the downside of modern farming for conservation and wildlife should not be forgotten.

Etched in hoar frost, heathlands can be as dramatic in winter as in summer, although the range of wildlife is more restricted.

the mid-20th century. Old grassland is now quite rare: the two largest areas are inaccessible in the Stanford military area in Norfolk, and on Newmarket Heath. Small fragments survive on ancient earthworks, however, such as Fleam Dyke and the Devil's Ditch in Cambridgeshire, and on the sites of castles and deserted medieval villages.

County Wildlife Trusts have a number of grassland reserves, notably Barnack building-stone. There are many small meadow reserves, such as Mickfield and Framsden Meadows (Suffolk Wildlife Trust), both sites for fritillary.

HEATHLAND

Heathland appeared at various times from the Bronze Age onwards. When wildwood on infertile soil was converted into pasture, sometimes via an arable stage, it was often taken over by heather and other plants of such soils. Heaths were not underused land; heather, grasses and

In summer, heathlands become a mosaic of purple, green and yellow as the flowers of dwarf gorse merge with those of ling.

even bracken were useful plants. Heaths were grazed and cut for various purposes, but not normally burnt. Over the centuries they developed their own ecosystem of plants and animals. They were recognised by poets, artists and naturalists – in this region, John Clare the poet, the painter Crome, the Norwich writer George Borrow and the Breckland scholar W G Clarke – as beautiful places and symbols of freedom.

In the 18th century heaths became unfashionable, when technology made it possible to turn them into ordinary, albeit rather poor, farmland or conifer plantations. By the 1960s most of the remaining areas were too small to be easily maintained. They turned into rather commonplace woodland, especially after rabbits – the last grazing animals – were almost exterminated by myxomatosis in the 1950s.

Heathland was once scattered all over this part of England, as place-names such as Heath and Hatfield (which means 'heath-field') show. There were three big areas: Sherwood Forest, the Breckland and Sandlings.

Any sizeable heath has many different plant communities: the heather itself, areas of acid or chalky grassland, furze and the special small

Discover deciduous woodland

Deciduous woodland harbours a wealth of plants and animals, and possesses a unique scenic beauty. Although Britain is one of the least wooded countries in Europe, few people live far from an area of woodland and many have fabulous sites right on their doorstep.

In Britain, ancient deciduous woodland has a timeless quality that belies its chequered history and its ever-changing nature. In geological terms its occurrence is fairly recent. Broad-leaved trees only spread across the region after the last Ice Age, replacing the pines which colonised in the wake of the retreating glaciers. Deciduous woodland has been

When oak and hazel woods are managed sympathetically, a carpet of bluebells can result.

dramatically affected by man over the centuries, and the impact was most destructive in the latter half of the 20th century.

Over the centuries, almost every area of deciduous woodland in Britain has been managed for its timber products. By and large, those species of plant and animal that thrive in deciduous woodland today are those which can either tolerate woodland management or those whose well-being is actually encouraged by its actions. Today,

Look for the tall spikes of foxgloves in woodland clearings and glades in June.

plants of sandy, trodden places. In boggy valleys, plants of acid wetlands occur. Heaths are often diversified by remains of former cultivation, archaeology from Neolithic sites to relics of World War II, and natural features, such as fossil sand-dunes and the holes left by melting ice at the end of the Ice Age.

FENS

Fens are permanently wet places, where the remains of vegetation does not rot completely, but build up to form a layer of peat. They are unsuitable for conventional agriculture, but they used to support a distinctive economy based on hay and pasturage, as well as sales of reeds, eels, ducks and many other useful things.

The history of most fens is determined by the relative levels of land and sea. When sea-level fell in the Roman period people took to living in the The Fens, which are the combined delta of the Great Ouse, Nene, Welland and other rivers. They were flooded out when sea level rose in Anglo-Saxon times, but just before the Norman Conquest the sea-level dropped again relative to the land, and people returned to live and farm in the area. To do so involved constructing great works of engineering to keep out exceptional tides from the sea, and floods coming off the land. Much of this work was organised by the fenland abbeys. It was such a success that by the 14th century The Fens had become the most prosperous part of England (the great fenland churches are a legacy of the period). The work of creating new farmland was not complete until the 19th century, and has overlapped with the ever more difficult task of sustaining the land against a renewed rise of sea-level.

A similar story is told of other fens connected

Managed by the National Trust, Wicken Fen in Cambridgeshire is one of the finest and most accessible wetlands in Britain.

to the sea, such as the Norfolk Broads and the Essex coastal marshes.

Fens now seem to be dull flat places, where the most utilitarian kind of arable farming is precariously sustained by technology against the threat of rising sea-level.

A few patches of fen remain from the lost age

Tall and imposing spikes of butterbur can be found in early spring in wetland areas, sometimes growing in shallow water.

– Dersingham Fen in Norfolk, and Wicken, Woodwalton and Holme Fens in Cambridgeshire. The Ouse Washes are the one large area representing the pastures of medieval fenland. A better survival is the fens of the Norfolk Broads, the Essex coast, and many small fen nature reserves scattered over the region. Suffolk Wildlife Trust's reserve, Redgrave and Lopham Fens, is famous for the great raft spider, Britain's largest spider, which lives in the water-filled craters produced by peat diggings. One of the most interesting areas is the Wildlife Trust's Flitwick Moor reserve, Bedfordshire, with its remains of modern commercial peat-pits.

The remaining fens are threatened by drying out, especially in hot summers. If they become too dry, trees invade and the sites turn from distinctive fenland into nondescript woods.

MEDIEVAL PARKLAND

The idea of parks was introduced around the time of the Norman Conquest, along with the rabbit, the pheasant and the fallow deer. A park was a deer farm, on which deer – originally the native red and roe, later fallow – were kept

traditional woodland practices such as coppicing and pollarding are seen as the way forward for woodland conservation, as they create a mosaic of micro-habitats.

Although a wide range of native deciduous trees are found in Britain, mature, natural woodland is dominated by just a few. Oaks favour acid or neutral soils, the English or pedunculate oak prevailing in the east and the sessile oak occurring in the wetter, western half of the region. Neither oak species thrives in calcareous conditions, the dominant tree species on lime-rich soils being ash in the north and west, and beech in

Badgers spend the day in their underground setts, emerging just after sunset to forage for earthworms, insects, bulbs, roots and shoots.

the south and east.

The true distribution of many of our native trees is clouded by man's influence. Ash, for example, has been widely encouraged in many southern woodlands, as it is a quick-growing, regenerative species. It responds well to woodland management and provides a valued crop of timber for fuel and fencing.

Deciduous woodland can be viewed as a series of layers. The foliage and branches of mature, dominant trees make up the upper, canopy layer. Beneath this is the shrub layer, comprising

Great spotted woodpecker

Dendrocopus major

As its name suggests, woodland is the primary haunt of the great spotted woodpecker, a widespread resident in most parts of Britain. Throughout the winter months, however, gardens stocked with peanut feeders or fat can often attract this elegant species during particularly cold spells. Their arrival normally causes great excitement among bird-watchers viewing their garden birds from the comfort of an armchair. The distinctive calls and springtime drumming of male birds can be heard in most woodlands in the Heart of England.

see also page 242

The bill and skull are specially strengthened to withstand the impact of its drumming activities.

species such as hawthorn and hazel, plus a range of small tree species and the saplings of larger ones. Lower still is the herb layer where herbaceous plants such as bluebells, foxgloves and wood anemones grow. Finally there is the ground layer where lower

plants and fungi grow, often carpeted with a layer of leaf litter.

Although some woodland creatures move freely between the layers, many are tied to one particular level. These ties and relationships only strengthen the need for careful management.

Despite their size, fallow deer can be surprisingly unobtrusive when lying up in the cover of bracken.

instead of, or as well as, sheep and cattle. Parks reached their heyday in about 1300, when there were at least 150 in Essex alone. They were usually private wood-pasture enclosed by a deer-proof fence, called a pale. The trees were either fenced off after every coppicing or treated as pollards – cut well above ground so that deer could not eat the young shoots.

There was a revival of parks in Tudor times, especially under Henry VIII and Elizabeth I, who were both great hunting sovereigns. This time

With their skeletal structure exposed, the woodlands at Bradgate Park, Leicestershire, are worth exploring in winter, as the absence of leaf cover makes birds easier to find.

parks had additional functions as the scene for ceremonial hunts and the formal setting for palaces. Parks as beautiful landscapes came into fashion again with designers of the 18th-century school of landscape design.

Removed from the usual pressures of com-

mercial agriculture, parks are preservers of antiquities, especially of ancient trees, grassland or heath. It is here, and not in ancient woods, that we find vast, wonderful, bizarre pollard oaks and other ancient trees which are a special feature of England. It is now appreciated that these, and only these, are the habitats of many plants and animals, from the lichens on old dry bark to the mistletoe on ancient hawthorns and maples.

The Heart of England is well provided with parks, although many are private. About a third of Bradfield Woods is a medieval coppiced park, with its internal subdivisions; and a good example of the open type of medieval park, with thousands of scattered pollard oaks, is Bradgate Park, Leicestershire. The oldest, largest and

HEART OF ENGLAND HABITATS

Reading the landscape

Some of the most elegant timber-framed buildings are found in the Heart of England.

This is a region of gentle relief, often pleasantly undulating, but with few striking hills. The underlying geological strata lie in orderly sequence, the uppermost – which are among the youngest in Britain – in East Anglia; the oldest and lowest in the Midlands. The harder rocks form low, west-facing escarpments; that of Jurassic limestone, with its attractive stone-built villages, connects the northern Cotswolds to the prominent ridge on which Lincoln stands.

The chalk scarp, hardly apparent in East Anglia, becomes noticeable again in Lincolnshire. In the Midlands, 'new red' rocks, the legacy of a 250-million-year-

old desert, give rise to attractive hilly countryside. Carboniferous rocks reach the surface in country that was the cradle of the 18th century Industrial Revolution. In the two centuries that followed, this area built its prosperity and blackened its landscape on coal.

The Midlands and East Anglia are traditionally farming country, with deep fertile soils and ancient oak woods. These provided wood for timber-framed buildings (including the glories of the octagon of Ely Cathedral) and the small timber necessary for the diverse needs of rural life, such as hurdles and firewood. The livestock-fattening pastures of the East Midlands were famous.

Most of East Anglia and the Midlands was covered by ice at the height of the glaciations, which left behind a blanket of

In ancient hedgerows, blackberries, the red berries of black bryony and other fruits and nuts produce a rich harvest in autumn.

grandest of the surviving designer parks from the 17th century is at Grimsthorpe, south-west Lincolnshire; the original oaks overlie a savanna landscape of yet more ancient pollards. Nearly as grand is the National Trust Property as Ickworth, Suffolk: it was 'laid out' from 1701 onwards, over a fossilised 17th-century landscape with marvellous hedgerow and field trees.

HEDGES AND PONDS

Ancient hedges are common in Suffolk, Essex, south Norfolk and Warwickshire, and scattered examples occur among modern hedges over most of the region. Typically they are a colourful mix of trees and shrubs – dogwood, hazel, maple, spindle, blackthorn and many others, but often not much hawthorn. They are formed of massive, centuries-old coppice stools, often set in wandering lines. Hedges of the 18th century or later run in straight lines, and are made of just one or two species, especially hawthorn. In the east Midlands, a typical Enclosure Act road has wide, straight verges between two simple hedges.

Grass fields often preserve the ridge-and-furrow of medieval strip-cultivation, even where the grassland is no longer old. On the edge of a village there may be 'humps and bumps' showing where the village was once bigger, sometimes with a few old trees left over from gardens.

Ponds often have a short life, and many have been filled in or have disappeared naturally with the growth of vegetation, but ancient ponds do still exist. They may once have been fishponds, moats around houses or marl pits in fields, but

Showy spikes of wood sage appear in open woodland, hedgerows and along roadside verges from June to September.

many are of unknown origin. New ponds have arisen abundantly from gravel-diggings, as at Ferry Meadows in Peterborough and Brandon Marsh in Warwickshire. These develop more quickly than most other habitats, acquiring trees and a full set of water plants in a few decades. They are good sites for birds, which is partly why waterbirds have prospered in the 20th century.

boulder clay, or 'till'. Sometimes this is chalky and clayey, yielding fertile but heavy soils – as in south Cambridgeshire. At times it is sandy, as in the Suffolk Breckland, where the dry soils once bore little except heath and poor grassland.

East Anglia brings to mind the Fens and the Norfolk Broads. Following the last glaciation around 10,000 years ago, the sea rose until, 4,000 to 5,000 years ago, it flooded much of the fenland basin. This created a shallow expanse of water which was later filled in with silt, followed by reed and fen peat. Although there were minor incursions of the sea in Roman times, by the Middle Ages the Fens were a vast tract of marsh, reed and water. Drainage began in earnest in the 17th century, and was effectively completed by the mid-19th century, after steam-powered pumps were

introduced. Only fragments of undrained fen remain.

In Broadland, peat growth generally kept pace with rising sea level, and by medieval times the valleys were deeply filled. The Broads (lakes) are flooded medieval peat-diggings, now a wonderful area for wildlife. Interplay of land and sea is seen too in the saltmarshes, dunes and shingle of the East Anglian coast.

The windswept coast at Spurn Point provides a refuge for migrant birds in spring and autumn.

Harvesting reeds for thatching is a traditional craft that continues to this day in East Anglia.

Heart of England

*The Heart of England is a playground for the nature lover and harbours
a wide range of lowland habitats. With windswept coasts, superb woodlands and
extensive tracts of heath and grassland on offer, there is little need to leave the region.*

1. ABBERTON RESERVOIR

Two roads cross the southern end of Abberton Reservoir on raised causeways, both giving fine views over this extensive shallow lake, the largest area of freshwater in Essex. Throughout the winter more than 20,000 wildfowl of a variety of species can be seen here, with peak numbers sometimes twice this. The most numerous species are coot, wigeon, teal, pochard and tufted duck, but up to 500 goldeneye also occur, along with smaller numbers of goosanders and a few smew. Check out the surrounding pastures for wintering flocks of lapwing and golden plover. Abberton's colony of 200 pairs of tree-nesting cormorants are a spring attraction.

2. BLACKWATER ESTUARY

The Blackwater is the largest of the Essex estuaries north of the Thames, and forms part of an extensive area of inter-tidal mudflats, saltmarshes and grazing meadows. Ditches in the grazing meadows support several

Cannock Chase lies within easy reach of tens of thousands of outdoor enthusiasts but the naturalist can still find deserted stretches of heath and forest.

interesting dragonflies, including ruddy darter, scarce emerald damselfly and hairy dragonfly, and there are also several rare species of water beetle. However, it is the wintering flocks of wildfowl and waders that are the chief attraction, in particular the dark-bellied brent geese numbering 20,000 to 25,000 – 13 per cent of the world population. Raptors can be numerous, with hen harriers, merlins, peregrines and short-eared owls present throughout the winter.

3. CANNOCK CHASE

Late summer is the best time to visit Cannock Chase, when green swathes of bracken curve up to the purple-topped heather plateau. A royal forest in Norman times, by the end of the 17th century much of the woodland had been felled

for iron-smelting and was open heathland. Where cowberry and bilberry grow near by they hybridise, producing the Cannock Chase berry. The heath is also

important for nightjars. The late 20th century has seen a fall in grazing and the Chase is reverting to wood with birch spreading and pines seeding from the plantations. As befits a royal forest, deer are numerous, mainly fallow but also red, roe and sika.

4. DANBURY WOODLANDS

To the east of Chelmsford, and to the north of the village of Danbury, lie a group of woodlands with a surprising variety of habitats. Lingwood Common, The Backwarden, Pheasanthouse Wood, Woodham Walter Common, Poors Piece and Danbury Common all offer attractions as diverse as their names. There are spectacular bluebell woods, carpets of wood anemones, areas with lily-of-the-valley, as well as coppices of hornbeam, hazel, sweet chestnut and even oak. The area is rich in breeding warblers, and nightingales are also present.

5. DEDHAM VALE

The lower reaches of the Stour Valley – the Vale of Dedham – were immortalised by the paintings of John Constable. Today this area still retains much of its great

natural beauty, and an impressive range of wildlife. Kingfishers are often seen on the river, while the marshes below Flatford Mill are good for snipe and redshank. Flatford Mill is owned by the National Trust: it houses a Field Studies Council Centre that makes an ideal base for discovering the wildlife of the surrounding countryside.

6. FINGRINGHOE WICK

On a warm May morning, there is no better place in Britain to listen to nightingales than this Essex Wildlife Trust reserve. Nightingales are declining fast in England, mainly due to loss of habitat, but Fingringhoe offers them plenty of suitable nesting areas in its disused, overgrown gravel pits bordering the River Colne. Hides overlook the foreshore, giving fine views of the large numbers of wildfowl and waders that feed on the estuary. The reserve is also noted for its butterflies, including the local Essex skipper.

Spring and autumn are the prime seasons to visit Gibraltar Point whose strategic location attracts migrant birds in good numbers.

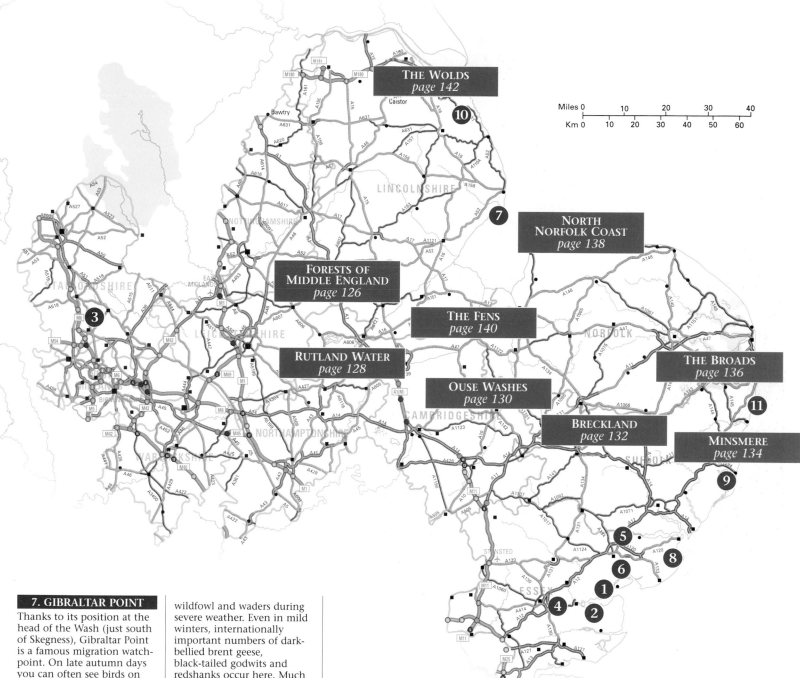

THE WOLDS
page 142

10

Miles 0 10 20 30 40

Km 0 10 20 30 40 50 60

NORTH
NORFOLK COAST
page 138

7

FORESTS OF
MIDDLE ENGLAND
page 126

THE FENS
page 140

3

RUTLAND WATER
page 128

THE BROADS
page 136

OUSE WASHES
page 130

11

BRECKLAND
page 132

MINSMERE
page 134

9

5

8

6

1

4

2

7. GIBRALTAR POINT

Thanks to its position at the head of the Wash (just south of Skegness), Gibraltar Point is a famous migration watch-point. On late autumn days you can often see birds on the move: flocks of finches and thrushes, flying in from the North Sea, and packs of brent geese, moving south along the coast. Easterly winds at this time of the year may bring the unexpected – perhaps a red-breasted fly-catcher or a Pallas's warbler all the way from Siberia. In spring, the lime-rich dunes (sea-shell fragments provide the lime) are carpeted with wild flowers, including cowslips, lady's bedstraw and pyramidal orchids. Common seals are a year-round attrac-tion at the Point.

8. HAMFORD WATER

Thanks to its sheltered position, this large, shallow, estuarine basin to the south of Harwich frequently supports tens of thousands of wildfowl and waders during severe weather. Even in mild winters, internationally important numbers of dark-bellied brent geese, black-tailed godwits and redshanks occur here. Much of the area is saltmarsh, and it is the abundance of inver-tebrates found in the saltmarshes that supports the wintering armies of waders. Several uncommon saltmarsh plants can be found, including rock and lax-flowered sea-lavender. The brent geese and wigeon graze on the mudflats on narrow-leaved and dwarf eelgrass.

9. HAVERGATE ISLAND AND ORFORD NESS

Just a short boat ride from Orford, Havergate Island is one of the RSPB's oldest reserves. Avocets first started nesting here in 1947, and the reserve was established soon afterwards to help protect them. Today, Havergate still has a large colony of avocets, but its other attractions include noisy nesting colonies of Sandwich and common terns and black-headed gulls. Short-eared owls usually breed here. To the north of Havergate is the long shingle spit of Orford Ness. Here sea-kale, sea pea, yellow horned-poppy and yellow vetch grow in profusion, and herring and lesser black-backed gulls nest in good numbers.

10. SALTFLEETBY DUNES

Few English counties have as unspoilt a coastline as Lincolnshire. At Saltfleetby Dunes, not far as the duck flies from the mouth of the Humber, is a fine example of coastal transition. Here the shingle banks of the North Sea are backed by saltmarsh and sand dunes, with fresh-water marsh beyond. The stable, older dunes are notably rich in flowers, including dewberry, viper's-bugloss and common bird's-foot trefoil. The fresh-water marshes are equally interesting botanically, with bog pimpernel and autumn gentian growing alongside early and southern marsh orchids. This is the only site in Lincolnshire for the natter-jack toad. Breeding birds include shelduck, skylark and redshank.

11. SUFFOLK SANDLINGS

The Sandlings of Suffolk are a remnant of the extensive but narrow coastal heaths that once existed between Kessingland in the north and Felixstowe to the south. The Suffolk Wildlife Trust has played a major role in ensuring the survival of the remaining heaths, even managing them in the tradi-tional manner with a flock of sheep. The Sandlings are acid heathland, dominated by heather and gorse. Here the common birds are stonechats, yellowhammers and linnets, while in summer the evocative churring of nightjars is a familiar sound. On sunny summer days, look out for basking adders and common lizards.

Forests of Middle England

William the Conqueror first 'created' Forests by establishing tracts of land as royal hunting grounds where deer were protected. More were declared by later kings and nobles, especially after fallow deer were introduced around 1100.

A Forest was rather like a National Park. The king's deer were added to land that was already used for pasturage, woodcutting and even farming, and the animals would be hunted, killed and eaten. Like modern National Parks, Forests preserved old-fashioned practices. However, in the 18th and 19th centuries, they fell foul of 'improvers', and many Forests were destroyed. It has been left to the modern conservation movement to discover how Forests had really operated, and to treat the survivors with appropriate care and respect.

Hatfield Forest in Essex is the most complete – it is the only Forest where, with a little imagination, one can step back into the Middle Ages to see a Forest in use. Managed by the National Trust, it has deer, cattle, sheep, coppice woods, grassland, ancient trees, fen and a medieval Forest lodge – a

Small numbers of redpolls breed, but the species is better known as a winter visitor.

true microcosm of English history.

Hatfield Forest is part woodland and part grassland. Regrowth was slow because of the deer, but the woods are home to herb paris and violet helleborine, and the sweet song of the nightingale can be heard. The grassland is scattered with pollard trees, some of vast size and surreal shape, the home of rare and specialised insects.

Epping Forest, on the other hand, is very different to Hatfield, being mostly wooded with close-set pollarded beeches, hornbeams and

Wood mouse

Apodemus sylvaticus

Despite its common name, the wood mouse is by no means restricted to woodland habitats. Hedgerows, mature gardens and scrub are all perfectly suitable for this adaptable and inquisitive little rodent. Sit still at a suitable site for long enough and you stand a good chance of seeing one scurrying around in search of food. Dusk is the best time to look, but they often venture out during daylight hours too. Large ears, beady eyes and a keen sense of smell ensure that they remain alert to the possibility of danger. Nevertheless, they feature heavily in the diets of most British predators.

see also page 217

The wood mouse is the most common and widespread of its kind, foraging on woodland floors across the whole of middle England. Its diet comprises mainly seeds, nuts and berries.

Epping's status as a royal hunting forest has ensured a continuity of stately trees, particularly hornbeam and beech.

The introduced muntjac deer is charming to look at but it has a ravenous appetite for our native trees and shrubs.

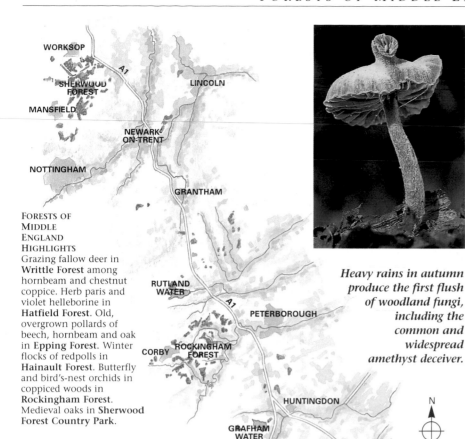

**FORESTS OF
MIDDLE
ENGLAND
HIGHLIGHTS**
Grazing fallow deer in
Writtle Forest among
hornbeam and chestnut
coppice. Herb paris and
violet helleborine in
Hatfield Forest. Old,
overgrown pollards of
beech, hornbeam and oak
in **Epping Forest**. Winter
flocks of redpolls in
Hainault Forest. Butterfly
and bird's-nest orchids in
coppiced woods in
Rockingham Forest.
Medieval oaks in **Sherwood
Forest Country Park**.

*Heavy rains in autumn
produce the first flush
of woodland fungi,
including the
common and
widespread
amethyst deceiver.*

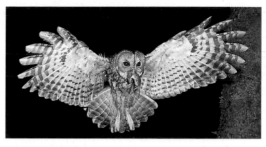

Tawny owl

Strix aluco

Although this owl is unobtrusive during the daytime
and for much of the year, the nocturnal calls of
tawny owl pairs between late autumn and early
spring announce their presence in an area. The
duets (the female's 'kewick' complementing the
male's 'too-whooo') can be heard in many of the
leafy suburbs of our towns and cities, as well as
areas of native, deciduous woodland. Tawny owls
usually nest in holes in large tree trunks and lay
their eggs quite early in the year, sometimes in
April. They specialise in catching small mammals
such as mice and voles but will also take rats or
even frogs if the opportunity arises.

see also page 241

*Although its night vision is good, the tawny owl's
hearing is the most important sense for hunting.
Specially modified wing feathers result in near-
silent flight, enabling it to pounce without warning.*

oaks. Since 1878 it has
survived in the care of the
City of London Corpora-
tion. Unfortunately
pollarding was discontin-
ued and grazing declined,
and the Forest became
very shady. Many open
areas were lost, and the
Forest became dissected
by busy roads. Lately, the
Corporation has set about
protecting the remaining
open areas and restoring
pollards.

Also close to London is
Writtle Forest. It is a small
private Forest, protected
by an ancient and appre-
ciative family, but public
rights of way allow access
to this wild and lovely
place, complete with
fallow deer, hornbeam
woods, heathland,
pollards and alder valleys.

Further north in
Northamptonshire is
Rockingham Forest. Little
survives of this site except
a rather dense scatter of
coppice-woods, many of
which have been invaded
by conifers. Nonetheless,
small-leaved lime,
butterfly and bird's-nest
orchids can be found, as
well as purple hairstreak
and white admiral butter-
flies. The Forest character

survives through the
profusion of deer.

Sherwood Forest in
Nottinghamshire was
once a vast tract of heath
and bracken, dotted with
red deer. Within it were
several woods, some of
which provided extra-
long timbers for Lincoln
and Ely Cathedrals. Time
has hit Sherwood hard,
and barely a scrap of
heath is left. Two of the
woods – Birkland and
Bilhaugh – were preserved
for their ancient trees,
which were thought to be

typical of the whole
Forest, but even these
were encroached upon by
coal-mining and forestry.

Part of Birkland
remains as Sherwood
Forest County Park, with
hundreds of wonderful
medieval oaks. On this
sandy site their long lives
have been an intermittent
struggle against drought,
but they are a famous
habitat for the insects
of ancient trees and for
noctule bats. The area is
now being rehabilitated
by Forest Enterprise.

*The green woodpecker
drills a nest hole in an
old tree trunk. The first
sign of its presence is
often its 'yaffle' call.*

AND ALSO
LOOK OUT FOR...
- pipistrelle ● sparrowhawk
- great spotted woodpecker
- fox ● blackcap ● nuthatch
- ● spotted flycatcher
- orange-tip ● herb bennet
- ● green-veined white
- angelica ● Dryad's saddle
- ● common spotted orchid
- ● oyster fungus

*Speckled wood butterflies
are often one of the first
butterflies to appear in
spring. Two broods later,
they are still on the wing
in late summer.*

*Herb paris is a distinctly local woodland flower that
appears in early spring. It favours calcareous soils.*

Ouse Washes

Away from the busiest estuaries and seabird cliffs, few places have such a concentration of birds and wildlife as the Ouse Washes. The land is mostly flat, barely rising above the level of The Wash downstream.

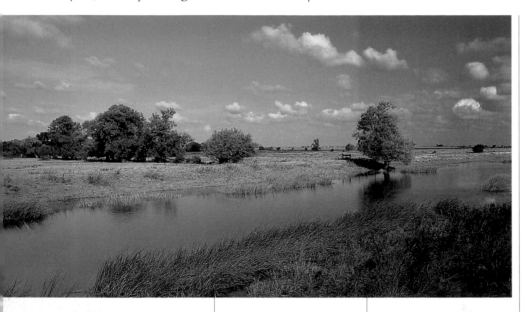

THE WASHES LIE between two parallel channels and take surplus water which would otherwise spill on to the whole of the Fens, limiting the flood to a narrow strip between Downham Market and Earith. Deeper pools close to Welney, in front of the Wildfowl and Wetlands Trust hides, attract thousands of ducks and swans. There are three kinds of swan here: resident mutes and two winter-visiting species from the far north – whooper and Bewick's swans. The musical Bewick's can be seen all along the Washes, with big concentrations on RSPB land south of Welney. Each winter, thousands arrive from Siberia, feeding on fields several miles either side of the Washes proper and returning to the safety of the Washes to roost. At Welney they are fed and floodlit at night, creating an extraordinary sight.

Most of the tens of thousands of ducks are wigeon, always in colourful, busy flocks which dabble in the shallows and graze the pastures. Long lines fly over the Washes, often high in the air, wary of the gunners who wait in those areas not in conservation ownership. The air rings to the bright, emphatic whistles of the males.

Passing great black-backed gulls create havoc, hunting sick coots or diving optimistically into groups of teal. True predators include peregrines, generally sitting on some stump or post for hours on end, and hen harriers, which float magically above the longer grass. A merlin might dash by, or a sparrowhawk make a pass at the finches foraging on the water's edge where the wind drifts seeds and stems into ragged strand-lines. Now and then a fox trots by, and the undulating form of a stoat may be seen in partial white 'ermine'.

SPRING ARRIVALS

The Washes are famous for winter wildfowl but, come the spring, most swans and ducks are gone. Flocks of waders arrive: black-tailed godwits, a few score ruffs, dunlins and redshanks. Some of the godwits stay to breed if the conditions are right. The RSPB does all it can to make sure they are, controlling water levels and farming the land to create the perfect mix of tussocky swards and pools, but a late spring flood may undo the good work overnight.

Lapwings tear the air with their broad wingtips as they display; copper-coloured godwits perform high, rolling flights. Dotted here and there all along the Washes, snipe fly in switchbacks, more often heard than seen as their stiff tail feathers produce bursts of strange vibrations as the birds dive earthwards. This unique 'drumming' serves as territorial song.

The place is full of life. Swallows, martins and swifts concentrate in the insect-rich air above the wet meadows. Sedge warblers and reed buntings sing from dense

Drainage channels such as the New Bedford River allow water levels to be controlled; they also provide a haven for water-loving species of plant and animal.

The wetlands encourage numerous insects, which are snapped up by insect-eating birds such as the swallow. This migrant is present in good numbers from April to September.

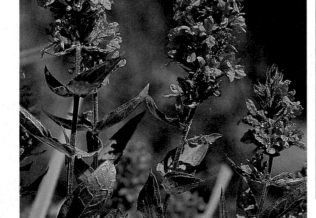

Worthy of any herbaceous border, dense stands of purple loosestrife are a conspicuous and attractive feature of many water margins.

Common toad

Bufo bufo

Although retiring and unobtrusive by day, toads are active after dark and can sometimes be picked out by torchlight as they trundle through the damp undergrowth. Like common frogs, they mainly eat invertebrates such as slugs and beetles, and consequently are a benefit to the gardener. Males hug females for long periods while mating. Unlike frogspawn, which is produced in a mass, the spawn

of the common toad is laid in long strands and becomes entwined with water plants. In their early stages, the tadpoles of the common toad are difficult to distinguish from those of the frog.

see also page 256

In early spring, these fascinating amphibians gather in ponds and lakes – used traditionally year after year – to mate and spawn.

Bewick's swan
Cygnus columbianus

Few sights are more heartening on a cold winter's day than that of a flock of swans gracefully winging their way through the skies. Look carefully at the birds because, although resident mute swans are frequently encountered, the birds could be whooper or Bewick's swans, both species being winter visitors to Britain from their Arctic breeding grounds. Bewick's are the smallest of all and can be recognised by their black and yellow bills; the yellow is less extensive than on the beaks of whooper swans. Several thousand Bewick's swans occur in Britain between October and March, with a significant proportion of the birds favouring the Ouse Washes. Refuges provided by the Wildfowl and Wetlands Trust and the RSPB benefit the birds.

see also page 224

The distinctive markings on the wedge-shaped bill of the Bewick's swan make it easy to recognise. The birds return year after year to the same wintering sites, and the exact shape of the yellow on the bill allows individuals to be identified.

Weighing just a few grams, the harvest mouse is Britain's smallest rodent. Its prehensile tail acts as a fifth 'limb', allowing it to move rapidly through meadow vegetation.

OUSE WASHES HIGHLIGHTS
Whooper, Bewick's and mute swans at **Welney**. Numerous wigeon dabbling in shallows or grazing on **pasture**. Hen harrier floating over **fields**. Breeding ruff and black-tailed godwits. Sedge and reed warblers singing in reeds at edge of **ditches**. Nesting little and barn owls in **pollarded willows**. Water voles swimming along **ditches**, with dragonflies and damselflies flying above.

(map)

NORDELPH

DOWNHAM MARKET

R. Wissey

WELNEY

New Bedford River

R. Great Ouse

HIDES

MANEA

Old Bedford River

GOLD HILL

N

WELCHES DAM

Miles 0 1 2 3 4 5
Km 0 1 2 3 4 5 6 7 8

OXLODE

MEPAL COVENEY

EARITH

R. Great Ouse

vegetation along the edges of open channels. Among the plant stems, ball-like nests of woven grasses indicate the presence of the nocturnal harvest mouse. Frogs and toads revel in the fresh, clean pools.

Pollarded crack willows provide ideal cavities for nesting little owls, barn owls and stock doves, while taller willows contain a heronry and attract breeding turtle doves, redpolls and goldfinches. Coots and moorhens nest in the osiers that sweep low over the water.

Otters pass through (though are seldom seen), while water voles, now remarkably rare national-ly, have a stronghold here. Short-tailed voles attract the attention of weasels, kestrels and short-eared owls.

In summer, the ditches

The ruddy darter, just one of a dozen or so dragonfly and damselfly species that are common in the region.

and wet meadows are full of flowers. Wetland species include familiar examples such as purple loosestrife and yellow iris, while scarcer plants, including the slender spike-rush and yellow fringed water-lily, need

AND ALSO
LOOK OUT FOR...
● pintail ● teal ● mallard
● green sandpiper
● reed bunting
● hemlock water-dropwort
● great willowherb
● water boatman
● broad-bodied chaser
● southern hawker

searching out.

The unpolluted water supports several species of dragonfly, including good numbers of scarce chasers and ruddy darters, as well as red-eyed damselflies and other insects.

The Washes are the prime British site for breeding ruff. The extraordinary courtship antics of these well-named waders can be seen in May and June.

Thousands of Bewick's swans, pochards and tufted ducks gather at the wildfowl refuge at Welney to supplement their grass diet with the grain provided daily for their benefit.

Breckland

Battlefield of Queen Boudicca and onetime haunt of the extinct great bustard, the area takes its name from the word 'brecks' – patches of exhausted land – and is home to some rare birds and flowers.

A S LONG AGO AS THE Middle Ages, the shallow soil of Breckland had become nutrient-poor due to over-grazing, by sheep in particular, and farmers moved to richer pastures, leaving a windswept waste of sandy heathland.

In the 19th century some effort was made to reclaim the land, and belts of conifer forest – what is now Thetford Forest – were planted to stabilise the soil and act as wind-

Low, close-cropped vegetation made up of ling and short grasses is the most typical vegetation of the region.

breaks. Elsewhere, large areas have been irrigated to grow crops of sugar beet and carrots, and lack of proper grazing has led to valuable grassland being encroached by pine and birch scrub. Yet more heathland has been lost to military training grounds and air bases.

The wide open spaces that characterise Breckland are ideal for the brown hare, an animal which likes to be able to see danger coming at a distance.

The few remaining heaths that have survived are a very special habitat. Predominantly acid grassland, with small areas of heather, these open spaces are the summer home of about 90 per cent of Britain's stone-curlews. Other notable birds include ringed

plover, curlew, woodlark and wheatear.

If you look hard enough, species of wild-flowers that are extremely rare elsewhere in Britain – Spanish catchfly, spiked speedwell and Breckland thyme – can be found. These characteristic plants attract a wonderful range of butterflies, including the Essex skipper and holly blue.

Rabbits, which overran the heath prior to devasta-tion by myxomatosis in the 1950s, are once again well established. Much less common is the brown hare, distinguishable by its longer legs and ears.

The Norfolk Wildlife Trust reserve at Weeting Heath, near Brandon, where there are hides to observe the range of breeding birds, is an excellent example of this heathland habitat.

The rough tracks and arable edges of the region

Roe deer are best looked for at dawn. Although wary if caught in the open, they are often bold when seen in woodland.

are home to many scarce plants. Spring speedwell and grape hyacinth brighten many a stroll along ancient byways where once Anglo-Saxon villages stood.

A chalk pit near Mildenhall, the Rex Graham nature reserve of the Suffolk Wildlife Trust, provides the largest of only two sites in Britain for the elegant military orchid. (It has one open day in early June.)

EVERGREEN WOODS Although there are still a few areas of deciduous woodland with popula-tions of redstarts and hawfinches, the relatively sterile coniferous forest predominates. More enlightened management

Stone-curlew
Burhinus oedicnemus

Secretive and at least partly nocturnal, the stone-curlew is more often heard than seen, its wailing calls carrying over a considerable distance on calm nights. When seen well, the species is unmistakable with its streaked-brown plumage and staring yellow eyes. In flight, it shows black and white wingbars and, thanks to the long-winged appearance, bears a passing resemblance to an immature gull. Stone-curlews are summer visitors to Britain, arriving in March and departing again in September or October. The arable lands of East Anglia and southern England are the stronghold for the species, although the few remaining tracts of true Breckland habitat are also graced by its presence.

see also page 232

With its nocturnal habits, preference for farmland and bizarre appearance, the stone-curlew is a rather atypical wader. The best place to see it is in Breckland.

The tree pipit is a summer visitor, present from April to August. Males usually sing from bare branches.

Military orchid has one of its British strongholds in a single woodland in the region.

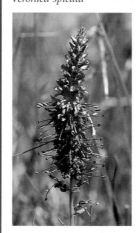

Spiked speedwell
Veronica spicata

Among the list of Breckland floral specialities, spiked speedwell is surely the most attractive with its tall spikes of bluish-purple flowers adorning the few remaining examples of the habitat left undisturbed by the plough. In bloom from July to September, they are frequently visited by insects in search of nectar and pollen. Rabbit grazing is without doubt a problem for the species. Ironically, however, this same pressure also stands to benefit the plant since it exerts a degree of control on rank, widespread plant species whose growth could potentially swamp that of the speedwell. Conservation of spiked speedwell is not straightforward.

Gardeners will be familiar with many of the relatives of spiked speedwell grown in cultivation, but this attractive plant is native and grows wild in a few grassy Breckland habitats.

BRECKLAND HIGHLIGHTS
Repeated *kur-ee* of stone-curlews on **arable areas** at dusk. Ringed plover, curlew and wheatear on **open heath**, with tree pipits and woodlarks in the **scrubby patches**. Essex skipper and holly blue butterflies on **grass heath**. Crossbills in **pine plantations**. Red squirrels on road between **Brandon** and **Elveden**. Gadwall and little grebe at **Ringmere** and **Langmere**.

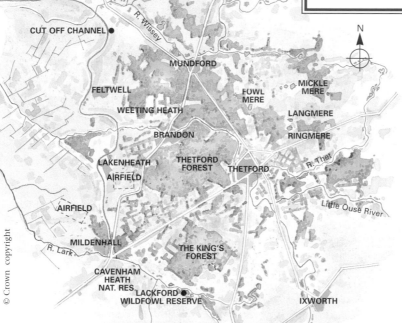

SWAFFHAM

CUT OFF CHANNEL

R. Wissey

R. Wissey

MUNDFORD

FELTWELL

MICKLE MERE

FOWL MERE

WEETING HEATH

LANGMERE

BRANDON

RINGMERE

LAKENHEATH AIRFIELD

THETFORD FOREST

THETFORD

R. Thet

AIRFIELD

Little Ouse River

MILDENHALL

R. Lark

THE KING'S FOREST

© Crown copyright

CAVENHAM HEATH NAT. RES.

LACKFORD WILDFOWL RESERVE

IXWORTH

Miles 0 2 4 6 8
Km 0 2 4 6 8 10 12

BURY ST EDMUNDS

in recent years by the Forestry Commission has seen the diversity of wildlife improve, however, and if you sit quietly by a pond on a warm dry spring morning much will be revealed: a party of thirsty crossbills, a sparrowhawk in need of a bathe or perhaps a roe deer coming for a drink.

SUMMER SOUNDS
Summer days echo with the sweet song of tree pipits, which accompanies their descending display flight, in chorus with the beautiful fluty notes of woodlarks. Siskins, goldcrests and sometimes firecrests can be found by careful searching, and occasionally a goshawk may pass overhead.

Red deer and the introduced muntjac abound in the forest, but the red squirrel, which was so often associated with this area, is now almost extinct in East Anglia, although a reintroduction programme is under way in Thetford Forest.

Despite the fact that Breckland is one of the driest areas of Britain,

meres – which can vary from small ponds to largish lakes – occur throughout the area. Ringmere and Langmere, two of the finest, are situated in the Norfolk Wildlife Trust's East Wretham reserve just north-east of Thetford.

These areas of freshwater vary in their levels as water rises up from the underlying chalk, and sometimes they dry up completely. Gadwall,

pochard and little grebes are attracted to the shallow water and their marshy margins.

The Suffolk Wildlife Trust's Lackford wildfowl reserve, near Bury St Edmunds, has a series of recently dug gravel pits. Here large numbers of wildfowl breed, as well as kingfishers, and on a summer evening a hobby might be seen hunting for dragonflies.

Breckland mugwort – one of the specialities of the region – still survives in a few pockets of unspoilt Breckland habitat.

AND ALSO LOOK OUT FOR...
● grey squirrel ● badger
● red-legged partridge
● turtle dove
● green woodpecker
● blackcap ● common lizard
● small heath ● small copper
● elephant hawkmoth

A few pairs of firecrests breed in mature conifers; listen out for their song.

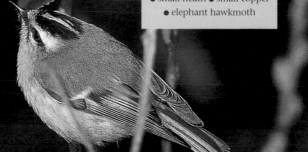

Minsmere

Often referred to as the 'jewel in the crown' of RSPB reserves, Minsmere has almost every typical lowland habitat, including man-made lagoons that are home to Britain's largest colony of avocets.

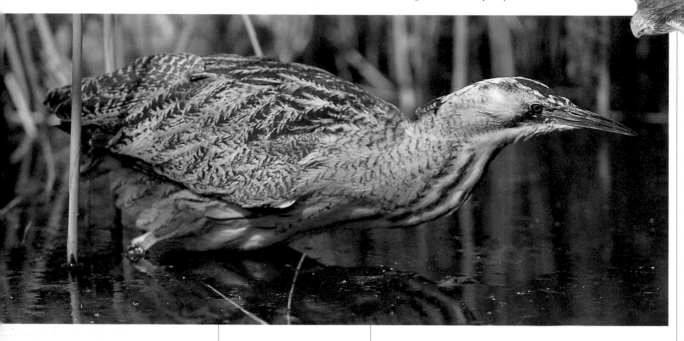

Marsh harriers fly low over the reedbeds, ever on the look out for prey. Males are particularly attractive, thanks to their strikingly patterned wings.

redshanks and black-tailed godwits are just two species to look out for.

NIGHTLIFE
At the close of the day, the eerie 'churring' of nightjars can be heard on the heath; you might even catch a brief glimpse of one hunting for moths low over the heather, and the path may be bordered with pin-pricks of light from glow-worms.

In autumn, the Scrape is again used as a stopping-off spot by migrating waders on their way to Africa, and the bushes bordering the coast provide food and cover for flycatchers, warblers and wheatears.

As winter approaches,

WITH ITS MIX OF seashore, dunes, grazing marshes, reedbeds, heathland, woodland and farmland, Minsmere is rich in wildlife: around 100 species of bird breed here; there are 650 species of plant; 35 species of mammal; 33 species of butterfly; 460 species of moth – the list goes on and on.

The reserve is at its very best from mid-April to mid-June when the

activity of the breeding birds is at a peak and migration is in full swing. One of the best ways to experience the magic of Minsmere is to join one of the popular dawn-chorus walks, starting at 3:30am, when resident birds are joined by a host of migrants – chiffchaff, blackcap, garden warbler, redstart and, master of them all, the nightingale. When the sun rises, more and more birds join in until there is a wonderful

Although Minsmere is one of the best places in Britain to see a bittern, luck and patience are still needed to spot this large, heron-like bird because it is extremely well camouflaged as it wades among the reeds.

cacophony of song.

As the day wears on, other sounds and sights fill the air. From the depths of the reedbed the strange, haunting 'boom' of the bittern, one of Britain's rarest breeding birds, may be heard, and the reeds seem alive with warblers. High overhead marsh harriers perform

their spectacular 'sky dancing' displays, and a harsh, metallic 'pinging' alerts you to the presence of a bearded tit flying low over the reed tops with its fast, whirring flight.

In the distance, from the Scrape, come the raucous cries of black-headed gulls and the ringing *kluut, kluut* of up to 1,000 breeding pairs of avocets. With their bold black-and-white plumage, upturned bill, long blue legs and elegant courtship display, these waders can fascinate for hours.

The Scrape is also a vital refuelling spot for migrating waders on their way to Arctic breeding grounds – spotted

Kingfisher
Alcedo atthis

This jewel of a bird is widespread on rivers, lakes and gravel pits throughout most of southern and central Britain, and is particularly easy to see at East Anglian wetland reserves such as Minsmere. Kingfishers occur wherever small fish such as minnows or sticklebacks can be found in good numbers, and where overhanging branches provide perches from which to fish. Seen well, the kingfisher is a dazzling bird with an orange breast, blue upperparts and an iridescence on its back; this latter feature shows up particularly well when the bird is viewed flying low over the water. Kingfishers nest in burrows excavated in sand or earthen banks beside rivers or standing water.

see also page 242

Kingfishers often spend extended periods perched on branches or reeds, scanning the water below for the slightest signs of fish activity before diving in pursuit.

Despite their name, glow-worms are in fact beetles. It is the females that glow, their bioluminescence serving to attract their winged male partners.

Avocet

Recurvirostra avosetta

The RSPB could hardly have chosen a more fitting symbol for itself than the avocet, given the ease with which the species can be seen at the society's flagship reserve at Minsmere and the organisation's historical association with the bird's conservation. It is a most distinctive wader, having black and white plumage, long bluish legs and a long upcurved black bill, the latter being swept from side to side as the bird feeds in shallow muddy lagoon margins. Avocets breed successfully at Minsmere and at other reserves on the Suffolk and Norfolk coasts.

see also page 233

In winter, many avocets leave Britain and fly south, although good concentrations remain on a few estuaries in south and south-west England.

wildfowl arrive from northern Europe and Russia – wigeon and teal are the most numerous – and skeins of brent geese pass offshore on their way south. By November, white-fronted geese have arrived on the marshes and their numbers gradually increase to over 200 early in the new year. In recent years over 1,500 wintering red-throated divers have been counted out on the sea.

Although Minsmere is best known for its birds, it has plenty of other wildlife interest too. In spring, bluebells carpet some of the woodland rides, while in late summer the heath is a stunning mixture of purple heather and yellow gorse. Rutting red deer are a spectacular sight in the autumn – the bellowing roar of the stags resounds through the woods and heath at dawn and dusk – and otters can occasionally be seen on the Island Mere.

BUTTERFLIES

In summer, dragonflies and butterflies patrol or sun themselves along the paths and ditches. The reserve's proximity to the east coast means that there are invasions of Continental species such as painted ladies, and these, together with resident tortoiseshells and peacocks, can be seen in numbers on the buddleia by the visitor centre.

Interest at Minsmere does not fade as the sun sets. In summer, bitterns boom across the reedbeds and nightjars call on heaths.

- - - - - - RSPB'S MINSMERE RESERVE

DUNWICH

WESTLETON

DUNWICH HEATH (NT)

Car park

MINSMERE VISITORS' CENTRE

THE SCRAPE

● HIDES

SLUICE

The New Cut

EAST BRIDGE

To Leiston

© Crown copyright

N

NORTH SEA

Miles 0 1/2 1
Km 0 1 2

SIZEWELL POWER STATION

AND ALSO LOOK OUT FOR...

- water rail ● reed bunting
- wood sandpiper
- common tern
- common sympetrum
- common reed ● yellow iris
- southern marsh orchid
- common spotted orchid

MINSMERE HIGHLIGHTS
Breeding avocets and black-headed gulls on **The Scrape**. Nightingales singing in **thick scrub**; bearded tits pinging and bittern booming in **reedbeds**. Marsh harriers 'sky dancing' over **reeds**. Migrating spotted redshank and black-tailed godwits feeding on **The Scrape**. Churring nightjars and glow-worms on **heathland**. Red-throated divers wintering off **coast**.

Known affectionately to bird-watchers as 'pingers' on account of their flight calls, bearded tits are present at the reserve all year.

Against the backdrop of the North Sea, the purple flowers of ling provide an attractive contrast to the yellow gorse – both are at their best in high summer.

The Broads

Sandwiched between Norwich and the coast of Norfolk, the area known as Broadland is one of winding rivers, tawny, wind-waved reedmarshes and open marshland, with here and there a red-brick, white-sailed windmill.

Marsh harriers are relatively easy to see in the region, occasionally perching to eat a frog or small mammal plucked from the reedbeds.

Tall spikes of marsh-mallow grace river banks and wet meadows, providing a rich source of nectar for pollinating insects.

NATURAL AS IT MAY seem, the landscape of the Broads is, in fact, largely man-made, the result of turf- and peat-digging in medieval times. (It was not until about 50 years ago that this came to light through records made at the Benedictine abbey of St Benet's in the marshes south of Ludham.) Peat was an important source of fuel for the expanding city of Norwich, and large-scale extraction continued until the Middle Ages when a rise in sea level caused widespread flooding and the diggings filled up to form today's shallow lakes.

The Broads Authority displays information about the Broads in a former eel-catcher's cottage, known as Toad Hole, at the How Hill reserve, near Ludham.

Although only 12m (39ft) above sea level, the hill is one of the highest points in the area and there are lovely views from here. The variety of Broadland habitats here can be explored in summer.

At Ranworth Broad, to the south, a duckboard trail leads through wetland woodland and fen to the Broadland Conservation Centre, where there is an exhibition about the Broads and their wildlife.

One of the most pressing problems facing the Authority is pollution. The major rivers – the Bure, the Yare and the Waveney, and their tributaries the Ant, the Thurn and the Chet – drain two-thirds of Norfolk and a substantial part of north Suffolk and the nitrates and phosphates from fertilisers off the farmland and from sewage works encourage the growth of algae, which has slowly choked the once-clear waters of the Broads.

However, successful restoration programmes at places such as Cockshoot and Barton Broads have been undertaken with the aim of returning the water to its former clarity. Here water-lily and holly-leaved naiad thrive, along with water-soldier, an aquatic perennial that remains underwater for much of the year, and a range of wildfowl that includes great crested grebe and tufted duck.

Kingfishers and herons are commonly seen on or by the water's edge on many of the rivers, and a special treat would be a glimpse of an otter.

HICKLING BROAD

The reserve at Hickling Broad, one of the largest areas of open water in the south of England, is among the best places for bird-watching, with shelduck, shoveler and pochard, and many other species thriving on the wetland fringes.

As well as the broads and rivers, the other major elements of the landscape are dykes and fens, marsh, reedbed and carr woodland. All rich in wildlife, these delicately balanced habitats require careful managment. The woodland, a mixture of

The colourful marsh-marigold is one of the most characteristic spring flowers in the region. It favours river margins, damp woodlands and wetland meadows.

alder, sallow and birch, represents the final stage of colonisation of water by vegetation.

Alder usually predominates as it is quite happy growing with its feet in the water, whereas birch requires drier ground. In winter, members of the finch family, siskins and redpolls in particular, can often be seen feeding here in small flocks.

The grazing marshes, with their complicated network of dykes, are important for overwintering flocks of lapwing, redshank and snipe, while the reed and sedge beds, still cut annually for the famous Norfolk thatch, are the haunt of the shy bittern, the bearded tit and the dashing marsh harrier.

Plant life of international importance includes orchids, ferns, yellow iris and marsh-

Bittern

Botaurus stellaris

Once a widespread and familiar sound, the booming call of the bittern is no longer heard resonating round the marshlands and fens of East Anglia. Today, only a handful of pairs breed in Britain and extensive reedbed reserves in Suffolk and Norfolk offer the only reasonable chance of encountering the species. Bitterns only occasionally venture into the open, spending much of their time among the reeds where their plumage affords them astonishingly good camouflage. Now and again, however, one will cross a wetland channel. In flight its broad, round wings and leisurely flight pattern call to mind an outsized owl.

see also page 223

Bitterns, like other members of the heron family, have a dagger-like bill for catching fish and amphibians, and long wading legs.

Delicate yellow spikes of bladderwort appear in early summer. The plant is carnivorous, catching tiny invertebrates in its underwater bladders.

In Britain, the Norfolk aeshna dragonfly is entirely restricted to the Norfolk Broads, where it is on the wing in June and early July.

This idyllic scene at How Hill on the River Ant shows the Broads at its best, a quiet and beautiful haven for wildlife.

© Crown copyright

Early April sees the arrival in the region of migratory garganey, small ducks that fly in from their wintering grounds in Africa.

marigolds, and you may be lucky enough to spot the rare Norfolk aeshna dragonfly or the unmistakable swallowtail butterfly, Britain's largest.

NORFOLK WHERRIES

There are over 200km (125 miles) of navigable waterways in the Broads, and unquestionably one of the finest ways to appreciate this special landscape is by boat. As well as modern motor-cruisers and sailing boats, Norfolk wherries – broad-beamed, black-sailed cargo boats which plied the rivers for 200 years – are now used for pleasure.

AND ALSO LOOK OUT FOR...
- water shrew ● water vole
- harvest mouse ● snipe
- sedge warbler ● water rail
- long-eared bat ● wren
- pink-footed goose
- green sandpiper ● marsh tit
- common tern ● reed bunting
- yellow wagtail ● reed warbler
- short-eared owl
- common frog ● common toad ● pike ● rudd ● alder
- osier ● puss moth
- white ermine moth
- common sympetrum

THE BROADS HIGHLIGHTS
Bird's-eye view of Broadland from **How Hill**. Alder woodland bordering **River Ant**. Courtship display of great crested grebes. Swallowtail butterfly and Norfolk aeshna dragonfly. Colonies of water-lily and holly-leaved naiad at **Cockshoot Broad**. Wintering flocks of lapwing, redshank and snipe. Restored eel-catcher's cottage at **Toad Hole**. Reed cutting for thatch.

NORTH WALSHAM
R. Ant
STALHAM
BARTON BROAD
HICKLING BROAD
HOVETON
HOW HILL
LUDHAM
ST BENET'S ABBEY
R. Thurn
HEMSBY
ORMSBY ST MARGARET
CAISTER-ON-SEA
NORWICH
ACLE
R. Bure
BRUNDALL
BREYDON WATER
GREAT YARMOUTH
R. Yare
FRITTON LAKE
LODDON
R. Chet
R. Waveney
LOWESTOFT
N
BUNGAY
BECCLES

Miles 0 — 4 — 8
Km 0 — 5 — 10 — 15

Swallowtail

Papilio machaon britannicus

Few British butterflies have as restricted a range as the swallowtail. Found in East Anglia only, it is confined to a few protected marshes and fens, particularly in the Norfolk Broads. One of its main strongholds is Hickling Broad where it can be seen on the wing in May and June; the second brood flies in August. Fortunately for the butterfly enthusiast, at sites where it does occur, the species is not particularly difficult to see since it is large and colourful and frequently alights on flowers to feed on nectar. The swallowtail's range is defined at least in part by the distribution of its larval foodplant, milk parsley, a rare member of the carrot family.

Thanks to conservation measures aimed at encouraging its larval food plant, the swallowtail still thrives in a few broads and fens.

The Wolds

The chalk uplands of the Lincolnshire Wolds explode the myth that all Lincolnshire is flat. In fact, at 170 m (559 ft) above sea level, Normanby Top is the highest point in eastern England south of the Humber.

Goldfinch

Carduelis carduelis

Wayside ground with plenty of weeds is the place to look for goldfinches. These delightful birds finds the seeds of teasels and thistles almost irresistible and the narrow, pointed bill is ideally suited to the purpose of extracting seeds from prickly seedheads. They also use the thistledown for nest building. Goldfinches are invariably seen in small flocks which, when disturbed, fly off uttering high-pitched, musical tinkling calls. In cold winters, they will sometimes visit garden flower borders. Seen well, the bird is beautifully marked with a red, black and white face, buffish body feathers and black and yellow wings.

As befits such an attractive and colourful bird, flocks of goldfinches are referred to as 'charms'.

see also page 252

To APPRECIATE THE open rolling landscape – with sweeping views west to the towers of Lincolnshire Cathedral silhouetted on the skyline, and east across the low-lying marsh to the coastal fringe – take to the high roads. These are prehistoric trackways, forged on safe, dry, elevated ground: the High Street follows the western crest; Bluestone Heath Road the central scarp; and Barton Street takes the line of the ancient sea cliff to the east.

Roads from the coast – followed by medieval salters and later by cattle drovers – cross the high Wolds from west to east. One of the most attractive swoops like a switchback from Bluestone Heath Road towards Hallington with a view of Louth, a lovely Georgian market town marked by the spire of St James's Church.

FAST DISAPPEARING

By the middle of the last century most of the open downland of the high Wolds had succumbed to the plough and only fragments of permanent grassland now remain – on steep hill slopes, around prehistoric earthworks and along the wide verges of the ancient trackways and ruler-straight enclosure roads, several of which are protected under a joint scheme of the Lincolnshire Trust for Nature Conservation and the county council. Gone forever are the medieval sheepwalks, the rabbit warrens, the nesting great bustard (extinct in Britain since the 1830s) and the stone-curlew. At night, though, the ghostly outline of the barn owl – a scarce bird in most areas now – may be seen quartering the roadside verges for small mammals.

At Red Hill nature reserve, near Goulceby, some 3ha (7 acres) of this now rare grassland support rock-rose and yellow-wort, autumn gentian and pyramidal orchid. The 'brown' family of butterflies is well represented, along with small skipper and common blue, and handsome six-spot burnet moths cluster on scabious and knapweed in July.

Birds are mainly of scrub and hedgerow habitats and include dunnock, yellowhammer and whitethroat. Badger, too, are resident here. On the cliff face below the old quarry is a striking outcrop of red chalk, stained by iron-rich mud deposits around 100 million years ago.

Although they are moths, six-spot burnets are active by day. They are often seen on knapweed and scabious.

Many valleys dissecting the area are now dry, but the headwaters of some streams flowing east – the Waithe Beck, the Lud and the Calceby Beck – have cut deep through the chalk. On these wooded slopes there are bee and pyramidal orchids, and salad burnet. On the marshes below, early and southern marsh orchids, and local species, such as marsh arrowgrass, thrive.

STREAMS

These stream systems follow meandering courses: the most spectacular examples are at Round Hills, near Hatcliff, Hubbard's Hills, Louth (a public park) and at Swaby (a nature reserve with a public footpath).

Four of the nature reserves in the Wolds are old chalk quarries, on the

Yellow-wort is easily overlooked as the flowers only open fully in bright sunshine.

A visit to Snipe Dales will soon dispel any mistaken belief that Lincolnshire is entirely flat. The gently rolling slopes are cloaked in scrub and pockets of deciduous woodland with a carpet of foxgloves.

Barn owls are often associated with churchyards since these sites are relatively undisturbed and often rich in small mammals.

Giant bellflower certainly lives up to its name, the flower spikes standing more than a metre tall.

eastern edge. The best is Mill Hill, at Claxby by Alford, opened to extract stone for marshland tracks, and burnt lime for use as a fertiliser (two of the kilns survive). Today, the quarry floor is covered with turf where cowslips and marjoram, purging flax and giant bellflower, common spotted-orchid and the rarer bee orchid thrive. Spotted flycatchers flit among the ash and beech, and bumblebees warm themselves on the south-facing slopes.

Near by, the crystal waters of Claxby spring emerge, flowing past Hoplands Wood, a reserve of mixed oak and ash. Traditional coppicing has produced a shrub layer of hazel and field maple, dogwood and guelder-rose, and in spring primroses and early-purple orchids abound. Woodpeckers and woodcock are among the breeding birds.

AND ALSO LOOK OUT FOR...
- short-tailed vole
- brown hare
- sparrowhawk
- grey partridge ● gatekeeper
- mistle thrush
- marbled white ● dog rose
- wild mignonette

Common blue

Polyommatus icarus

Wherever the larval foodplants, which include bird's-foot-trefoil and other members of the pea family, abound, you are likely to come across the common blue butterfly. Only the male has the iridescent blue upperwings so characteristic of the species, the female being chocolate-brown with orange spots on the wing margins. The underwings of both sexes are buffish and covered with a complex pattern of black and white spots. Common blues are on the wing from May to September, the species usually having two or three broods which occasionally overlap. As dusk approaches, look for them resting with their wings closed on grass stems.

see also page 263

This species is the most common and widespread of all our native blue butterflies.

LINCOLNSHIRE WOLDS HIGHLIGHTS
Panoramic views from **Normanby Top**. Rock-rose and yellow-wort, autumn gentian and pyramidal orchid at **Red Hill reserve**, along with six-spot burnet moth. Outcrop of red chalk on cliff face below quarry, **Red Hill**. Cowslips, giant bellflower and bee orchid at **Mill Hill**. Primroses and early purple orchids at **Hoplands Wood**. Ramsons beside **Tennyson's Brook**.

As its name suggests, marsh arrowgrass is a plant of damp grassland and river margins.

Miles 0 — 2 — 4 — 6 — 8
Km 0 — 2 4 6 8 10 12

CLEETHORPES
N
BEELSBY
WAITHE BECK
NETTLETON
ROUND HILLS
NORMANBY LE WOLD
CLAXBY
NORMANBY TOP
WOLD NEWTON
LUDBOROUGH
BINBROOK
UTTERBY
Louth Canal
NORTH WILLINGHAM
LUDFORD
BURGH ON BAIN
LOUTH
HUBBARD'S HILLS
TATHWELL
Great Eau
RED HILL RESERVE
GOULCEBY
R. Barn
BURWELL
TETFORD HILL
SWABY
ALFORD
TETFORD
SOMERSBY
MILL HILL
HORNCASTLE
LANGTON
WILLOUGHBY
CLAXBY
HOPLANDS WOOD
R. Lynn
PARTNEY
WILLOUGHBY WOOD
CANDLESBY

© Crown copyright

Pyramidal orchids, plants of chalk grassland, are so called because of their triangular flowerheads.

Northern England

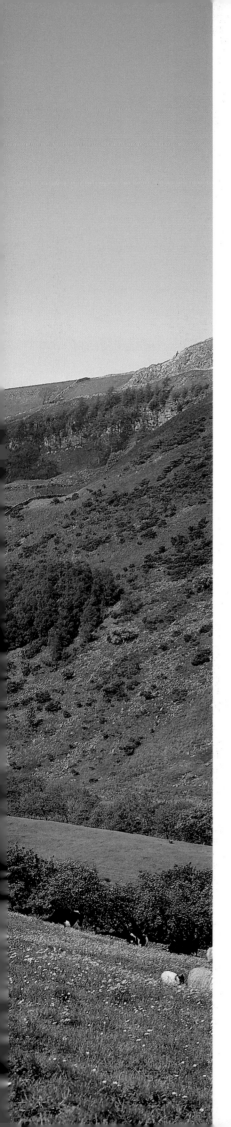

Where is the North of England? In physical terms, it includes the Lake District, the North York Moors and Wolds, the Northumberland Moors and Cheviots, the Vale of York, the Cheshire Plain, and the Fylde and Mersey Basin of Lancashire – all of which have their own proudly distinct characters.

Northern England is sterner, colder, and in many ways more dramatic than the south. Running through the heart of the region, and giving it much of its rugged identity, is the Pennine chain.

An idyllic rural scene on Swaledale in the Yorkshire Dales. Traditional barns and stone walls nestle alongside flower-filled hay meadows full of breeding birds and insects, while uncultivated slopes serve as a backdrop and a reminder of the untamed wilderness that lies off the beaten track.

The Elizabethan historian William Camden described the Pennines running 'like as the Apennine in Italy, through the middest of England, with a continued ridge, rising more and more with continued tops and cliffs one after another ever as far as Scotland'.

BACKBONE OF ENGLAND

The Pennines have long been known as 'the Backbone of England', and this well-worn metaphor has strong physical and cultural claims to the truth. This 400km- (250 mile-) long ridge of millstone grit and limestone, running north from the Peak District to the Cheviots and the Scottish Borders, gives much of northern England its gritty character.

The mineral wealth of these hills, particularly lead, was first exploited by the Romans and later became a major industry in the Peak District and the Yorkshire Dales. The fast-running Pennine streams and rivers were harnessed by pioneers such as Arkwright and Hargreaves to provide power for the Industrial Revolution, and the resulting great industrial cities of the north-west and Yorkshire gave the nation the economic might needed to found and maintain the Empire.

In Victorian times, the coalfields of Teeside, Durham, Derbyshire and Yorkshire east of the Pennines, became the source of power for industry, and remained so until the recent wholesale closure of the pits. The proximity of coal and iron reserves dictated the location of the steelworks and ship-building yards of Teeside and Tyneside, while the western-facing ports of Merseyside became the gateway to trade with the New World.

Culturally, too, northern England has contributed enormously to the nation's persona and consciousness. The Lakeland school of poets, led by local boy William Wordsworth, first popularised an appreciation of the natural world; the Brontë sisters encapsulated the harsh Pennine moors around Haworth in their books, and

A winter view with the Cheviot Hills in the distance. In the north of England you are never far away from hills and uplands.

much of Poet Laureate Ted Hughes's work owes a debt to his Pennine roots, as did Henry Moore's monolithic sculptures.

NORTHERN VARIETY

The northern countryside ranges from craggy Cumbrian fells, the highest ground in England, to the lush dairy farms of the Cheshire Plain and the Vale of York; and from the bleak, boggy plateaux of the Pennines to the smooth, grassy tops of the Howgill Fells, the rolling Yorkshire Wolds that end in chalk cliffs at Flamborough,

NORTHERN ENGLAND HABITATS

Discover sandy shores and beaches

On sandy shores, unlike rocky coasts, marine creatures have few opportunities to attach themselves, so most life occurs beneath the surface of the sand and out of reach to all but the serious marine biologist; naturalists on a sandy shore generally do better to turn detective and look for tell-tale remains along the tide-line. The real fascination for the wildlife enthusiast, however, comes from exploring the beach above the strandline where a remarkable collection of specialised plants and animals thrives.

Given the shifting nature of the substrate and the erosive powers of the wind, it is a

Even in mid-winter, sand dunes stabilised by marram grass have a lively, windswept beauty.

wonder that any plants can grow on sandy beaches. Look along the high-tide line, however, and you will begin to see the early stages of dunes in formation.

Chief among the plants that colonise the shifting sands is marram grass, a tough, wiry species that is able to grow up through the sand that inevitably collects around its leaves and stems through wind action. Its spreading roots further stabilise the sand and a dune is born.

Other plants then move in, including sea couch grass, sea sandwort and sea holly. Away from the sea, on more mature and stable dunes, attractive and distinctive plants such as sea bindweed and sea spurge appear.

As dunes are formed by the actions of tide and wind, the youngest ones are those nearest

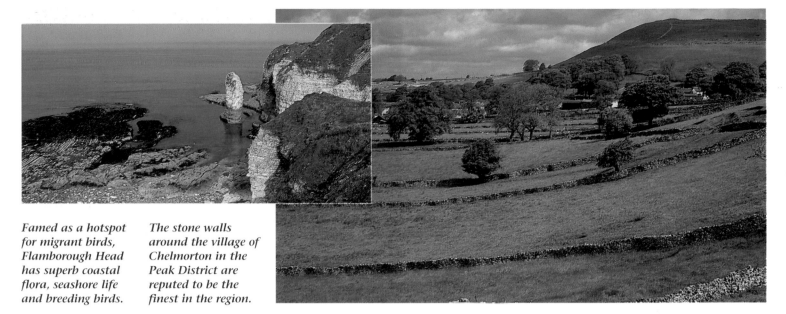

Famed as a hotspot for migrant birds, Flamborough Head has superb coastal flora, seashore life and breeding birds.

The stone walls around the village of Chelmorton in the Peak District are reputed to be the finest in the region.

and the heather-clad North York Moors.

It is a countryside of ever-changing moods, where all the seasons of the year can often be experienced in one day, winter or summer. This landscape is both challenging and comforting, accessible yet remote. Some of the wildest country in England can be found less than 32km (20 miles) from the centres of some of its largest and most industrialised cities, providing a vital escape and re creation – to use the word in its true sense – for their teeming populations.

THE LIVING LANDSCAPE

Geology has shaped the character and natural history of northern England's landscape, and the way it has been exploited and adapted by

man over perhaps 10,000 years. It is reflected in the buildings of the region, from the blackened, millstone grit terraces and mills of many Pennine towns and villages, to the pale, almost white walls of the limestone cottages of the Dales and the green, slate-clad roofs of the Lake District. One of the most striking features of the north, especially to visitors coming from the south, are the drystone walls which climb up hill and down dale. These reflect the underlying geology of the area and, just like the barns and buildings, seem to grow organically from the landscape.

The typical Pennine landscape is of broad, U-shaped glaciated valleys, known here almost exclusively by the Old Norse name of 'dales',

with terraces, or 'scars', of gleaming white limestone, topped by succeeding, stepped layers of shale and grit and capped with an impervious layer of millstone grit on the windy summits.

This series of rocks, all of which date from the Carboniferous period (around 350 million years ago), were laid down when the area was a few degrees north of the Equator, and enjoyed a semi-tropical climate. In these conditions, generations of tiny sea creatures lived and died over millions of years in shallow lagoons fringed with reefs of harder, coral-like formations. These 'reef limestones' give us the upstanding pinnacles of Dovedale and prominent, pointed hills around Burnsall in Wharfedale. Harder bedding planes of limestone also created the splendid series of

Sandy shores and estuaries are the haunt of the ringed plover, a small, stubby, well-marked wader.

the sea. Walk away from the sea and, in terms of dune structure, you are taking a trip back in time, the system becoming progressively older further inland. Eventually, when the dunes become fully stabilised, marram grass and its associate colonisers cease to

Tough and resilient, sea sandwort can be found on most sandy beaches and is recognised by its succulent leaves.

predominate and a more varied community of plants becomes established.

Where the sand is composed largely of shell fragments or other calcareous material, flowers of chalk or limestone grassland grow, whereas acid sand encourages the formation of coastal heathland.

Where sandy beaches and their associated dunes are protected from undue disturbance during the breeding season, colonies of terns and gulls prosper, the birds sometimes nesting alongside oystercatchers and ringed plovers.

Away from the sea, on stabilised dunes, a surprising array of invertebrates can be found, including spiders, beetles and snails.

Although marram grass

Marram grass
Ammophila arenaria

Marram grass is without doubt the most important plant to be found on any sand-dune system around the British coast. This amazing plant is able to colonise the shifting sands on the upper beach and its roots help stabilise the ground, enabling other maritime plants to become established; the floral community of the dunes can then flourish. Apart from its growing position on the

As it puts down long roots to secure its position, hardy marram grass can tolerate salty spray and withstand 'sandblasting', strong winds and a lack of fresh water.

shore, marram grass can be recognised by the greyish-green colour of the leaves and the fact that they bear a sharp point and have inrolled margins that help reduce water loss. The flowering spike, which appears from June to August, is carried on a tall stem.
see also page 310

and the succession of plants which colonise subsequently do much to ensure the stability of dune systems, catastrophes do occur. Natural 'blow-outs' can result after severe gales, but it is

human trampling that often starts the process of sand erosion. Consequently, great efforts are put into dune restoration and to ensure that visitors stick to boardwalks or designated paths.

The intriguingly named Cow and Calf Rocks near Ilkley are typical of the rocky outcrops found on many upland areas in the north.

waterfalls such as those at Hardrow and Aysgarth in Wensleydale.

Later in the Carboniferous period, the enormous beds of white limestone – up to 600m (1,974ft) thick – were overlaid by the coarse grits and mudbanks brought down by huge river systems flowing from ancient mountains in the north. These created the shales and harsh, abrasive sandstones of the millstone grit series, which have weathered to create the distinctive tors and edges of Brimham Rocks in Nidderdale and the eastern moors of the Peak District, and the peat bog moorland of the heights above.

Tremendous earth-movements uplifted this sedimentary landscape, which was later eroded and planed by ice and meltwater from Ice Age glaciers into roughly its present shape. The crushing power of the ice and the rushing glac-

Colonising plants growing from the limestone rocks at the renowned Malham Cove in the Yorkshire Dales near Skipton.

ier meltwater created the dales we see today, as the prominent moraines which they left behind in places such as Ribblehead in the Yorkshire Dales still testify.

The porous limestone, split by numerous cracks and fissures and easily dissolved in the slightly acidic rainwater, gives the Yorkshire Dales and Peak District their famous subterranean landscapes of caves, caverns and pot-

holes. The best-known of these are in the Ingleborough area of the Yorkshire Dales and around Castleton in the Peak District, where well-lit show caverns are open to the public. Early man used these natural caves at places such as Victoria Cave, near Settle, and Thor's Cave, in the Manifold Valley of the Peak District, leaving behind their flint tools.

RICH WILDLIFE OF THE LIMESTONE
The limestone pavements of Malham and Ingleborough were exposed at the last glaciation, which ended about 10,000 years ago. This

NORTHERN ENGLAND HABITATS

Discover grassland

Grassland flourishes across large parts of Britain and is such an integral part of the landscape that it is often difficult to grasp that its origins are entirely linked to man. Like many of our inland habitats, the origins of grassland start at the end of the last Ice Age some 10,000 years ago. Deciduous woodland came to dominate in the wake of the retreating ice but, over the millennia that followed, early man effectively removed the tree cover.

Grazing by sheep and cattle prevented recolonisation by trees and actively encouraged plants tolerant of constant nibbling. Few plant groups are more suited

Traditional hay meadows still survive in areas where fertilisers and herbicdes are not used.

The common blue butterfly is widespread in unimproved grassland throughout the region.

to grazing than grasses and so British grasslands were born.

In lowland Britain, grassland can be split into two broad categories according to use: areas cut for hay are referred to as meadows and grazed fields are called pastures. Traditionally, meadows harboured a rich array of colourful grassland flowers in addition to grass species, and would have been grazed after the

scraped off the overlying rocks to provide wonderful rock gardens for rare plants such as lily-of-the-valley and hart's-tongue fern.

The Yorkshire and Peak District dales are among the richest wildlife habitats in northern England: their lime-rich pastures support a marvellous variety of wildflowers, including orchids, thyme and vetches, which in their turn play host to a wide range of insect and bird life. Typical species are summer visitors such as the wheatear and spotted flycatcher; the pure, clear-running rivers are home to kingfisher, dipper and grey wagtail.

The ashwoods of the limestone dales are internationally famous, especially Grass Wood in the Yorkshire Dales and Dovedale and Lathkill Dale in the Peaks. These are home to rare woodland plants, such as the pink-flowered mezereon, and many woodland birds and mammals. The limestone plateaux above, criss-crossed by mile after mile of drystone walls, support lapwings, curlews and other waders.

Compared with the riches of the limestone dales, the gritstone moors of the Pennines are a wildlife desert. The waterlogged peat bogs – formed after countless generations of sphagnum moss and other moorland plants died and were compressed into this soft, acidic blanket – are very low in the essential nutrients required by most plants. Some, such as the insectivorous sundew and butterwort, actually devour insects to obtain the necessary sustenance, while the delicate yellow stars of the bog asphodel add a welcome splash of summer colour to many a dank moorland.

Showplace of Pennine moorland flora is undoubtedly Upper Teesdale, a national nature reserve which supports a unique reminder of Ice

A limestone pavement below Ingleborough in the Yorkshire Dales. This habitat is a national treasure, holding a rich variety of plants that root in the eroded channels.

Bloody crane's-bill is one of the most attractive plants to thrive in limestone areas.

Age Britain in its range of rare Arctic and alpine flora. Here, in what is left after the flooding of the upper valley for the Cow Green Reservoir, above the impressive waterfall of Cauldron Snout, can be found spring gentian, bird's-eye primrose, mountain saxifrage and alpine bistort, all of which were blooming here at the end of the Ice Age 10,000 years ago.

THE HUMAN FACTOR

Man's influence is not confined to drystone walls: some of the finest monuments left by prehistoric man are found in the 'lows' (usually Bronze Age burial mounds) that punctuate so many skylines in the Peak District, the Yorkshire Dales and the North York Moors. The bumps and humps left behind by generations of lead

Short-tailed vole

Microtus agrestis

These voles flourish on all types of grassland. Hillsides, meadows and even roadside verges provide ideal habitats for this small rodent, which can become very common in some years. Short-tailed voles can be told from bank voles by their sandy brown, rather than chestnut, fur. Short-tailed voles build runs through the grass, close to the surface. Nests of woven grass are often under sheets of corrugated iron or debris.

see also page 217

Often abundant, short-tailed voles can have a profound impact on the grassy habitats where they live. The species is eaten by many predators.

cutting of hay in summer.

Upland areas of grassland comprise an entirely different array of plant species and are more appropriately dealt with in the moorland section.

Soil type has a profound influence on the ecology of grassland. Grassland on neutral soils is widespread and supports a rich array of species, including plants such as dandelions, several species of thistles and cow parsley, as well as butterflies such as meadow browns, ringlets and large skippers. In terms of wildlife diversity, however, grassland on chalk or limestone is the richest.

Paradoxically, for all their rich biodiversity, chalk grasslands are among the poorest in terms of the nutrients and water available to the plants that grow there. Typical species that thrive include quaking grass, salad burnet, rock-rose and wild carrot, not forgetting a sometimes spectacular array of orchids.

Equally well known are the butterflies of calcareous grassland, which include adonis and chalkhill blues and Duke of Burgundy fritillary. In addition, visitors cannot fail to notice the abundance of grasshoppers and snails which so characterise the habitat.

Today, existing areas of grassland face a number of threats to their long-term survival. Changes in land use obviously pose the most immediate problems for the habitat and unsuitable practices include ploughing, early cutting for silage, seeding with vigorous grass species and the use of herbicides to suppress species other than grasses.

The right level of grazing is also vital and a significant reduction can be damaging since it eventually leads to scrub encroachment and the demise of the grassland itself.

The tiny flowers of tormentil are a familiar sight in grassy areas. Unlike other members of the rose family, it has four, not five, petals.

Unseasonal snow fall in early summer can leave the mountain hare looking conspicuous – it is only in winter that the animal acquires a white coat.

From April to August, golden plovers can be found on upland moors, often nesting on relatively bare or recently burnt patches of ground.

Yeavering Bell in the Cheviots, seen from Humbleton Hill. There are Iron Age hill forts and remains of the Anglo-Saxons' capital.

miners – generically known as 't'owd man' – who plumbed the depths in their search for mineral wealth are prominent features in the Yorkshire Dales, the North Pennines and the Peak District.

The Pennine moors were blessed with a kinder climate during the Bronze Age, and many upland areas were cultivated by the first farmers. Their hut circles, field systems and stone circles are still visible in a considerable number of places, outlined under the rank moor grass and heather.

The drier moorlands of the Pennines and North York Moors are dominated by the purple-hued heather, a glorious sight in late summer and early autumn. Northern England's wonderful expanses of heather moorland are largely due to the requirements of one bird – the red grouse, Britain's only exclusive gamebird. The management regime of the heather moors is also incidentally beneficial to other forms of wildlife, from the predatory merlin and hen harrier to the handsome golden plover – 'the guardian of the moors' – and winter coat-changing mountain hare.

The bald, grassy summits of the Cheviot Hills of Northumberland were the result of a later volcanic interlude of perhaps 380 million years ago, when liquid magma welled up through the strata to form the distinctive domed summits that were subsequently eroded by ice and frost to reveal their granite cores. This was known as 'the debatable land', where reivers (raiders) and moss-troopers waged almost constant warfare across the Border for nearly 300 years in the late

NORTHERN ENGLAND HABITATS

Discover coniferous forest

For a brief period – in geological terms – following the end of the last Ice Age, conifers would have been widespread across Britain, perhaps even dominating the landscape in places. As the climate improved, however, they were replaced throughout lowland Britain by deciduous forest, and conifers were largely restricted to parts of Scotland.

In common with other woodland types in Britain, the coniferous forests of Scotland were effectively cleared by man over the centuries, with the result that native Scots pines are now confined to remnant pockets of Caledonian forest in the Highlands. Conifer forest elsewhere in Britain is not natural in occurrence and forestry plantations are widespread. They seldom comprise native species and invariably look artificial, although when sufficient mature trees are

Conifer plantations are often too dense and uniform to attract wildlife but improve with age.

In many parts of its range, the red squirrel is fairly indifferent to people and will often sit and feed.

Well fortified sites such as Bamburgh Castle on the Northumberland coast reflect the rugged terrain and the often turbulent past.

Middle Ages. Evidence of this bloody past can still be seen in the numerous defensive pele towers (such as the classic at Elsdon) and bastle houses – fortified barns – where the populace would retire in times of trouble.

Volcanic movement was also the cause of one of the most famous landscape features of the north of England – the Whin Sill: an intrusion which forced its way to the surface some 295 million years ago. This hard, dark grey rock created the ridge of upstanding rock which the Roman Emperor Hadrian used as the foundations of his great wall in AD 122, marking the northern boundary of his Empire. Hadrian's Wall, with its forts and milecastles, runs for 117km (73 miles) across the neck of England, between the Solway and the Tyne, and remains the most impressive example of Roman military architecture in north-west Europe.

The Whin Sill also created the hills or 'heughs' on which the medieval coastal castles of Dunstanburgh and Bamburgh were built, and it runs out into the North Sea to form Cuthbert's holy island of Lindisfarne and the low-lying Farne Islands, famous for their colonies of seabirds and seals.

THE LAKE DISTRICT

The tremendous abrasive power of Ice Age glaciers put the finishing touches to the Lake District of Cumbria – perhaps the best-loved of all the landscapes of northern England. Glaciers scooped out the corries and valleys which were later filled by the lakes which radiate – as Wordsworth was the first to point out – like the spokes of a wheel from the central fells.

The rocks of the Lake District are generally much older than those of the Pennines. The oldest are the Skiddaw slates of the smooth-sided northern fells, such as Skiddaw and Blencathra, which were laid down during the Ordovician period, some 500 million years ago. These mudstones and fine grits were squeezed to give the easily split green Lakeland slates, quarried for centuries at places such as Honister.

Further south, the craggy rocks of the Borrowdale series have a volcanic origin and give us the knobbly outline of the Central Fells, while the Silurian slates of the southern Lakes, such as the copper-rich hills around Coniston,

Crested tits breed only in native Caledonian pine forests in Scotland and excavate nest holes in rotting stumps.

present, young saplings often colonise land adjacent to the plantation itself. This invasion is a threat to areas of southern heathland.

The native pine forests of Scotland, such as Abernethy and Rothiemurchus in the Cairngorm region, are dominated by Scots pine trees, many of which are gnarled and ancient, with juniper forming a shrub layer.

The habitat offers the chance to see some specialised forms of wildlife, including Britain's sole endemic bird, the Scottish crossbill, found nowhere else in the world and with a bill adapted to extract the seeds of Scots pine. Other creatures have their British strongholds in this habitat too, notably crested tit, capercaillie, red squirrel and pine marten.

Conifer plantations have far less wildlife diversity than native Scots pine forests. The problems stem from the use of non-native tree species and the fact that they are usually grown in single-species stands of uniform age.

Thankfully, there are some wildlife benefits to conifer plantations. In their infancy, they provide nesting sites for hen harriers and short-eared owls in upland areas and for woodlarks and nightjars in the south.

Mature pine plantations sometimes take on the appearance of natural woodland, especially if sympathetic

Pine marten

Martes martes

Wherever red squirrels are seen in northern Britain, there is a good chance of pine martens, as the squirrels are a favourite prey. Pine martens are tree-climbers that feed on smaller mammals, as well as birds, seeds and fruits. The species occurs sparingly across large areas of northern Britain, but is shy, at least partly nocturnal and hard to see. In places, pine martens visit bird feeders or raid litter bins at dusk.

see also page 219

Pine martens are essentially nocturnal and spend much of the day in their underground lairs. Just occasionally, one can be found resting at the entrance to its retreat as dusk approaches.

thinning has created clearings and the appearance, if not the reality, of age structure.

Birdlife associated with mature plantations is generally limited but crossbills, coal tits, goldcrests and great spotted woodpeckers often occur, while a notable range of fungi thrives in the deep carpet of fallen needles.

The scenic beauty of parts of the Lake District such as Derwent Water is unsurpassed anywhere in the north.

A few pairs of golden eagles nest each year in the Lake District, the only site south of the border where the species occurs on a regular basis.

and the lower landscapes of Windermere and Grizedale, originate from a more settled, sedimentary period about 400 million years ago.

Lake District wildlife is similar to that of the upland Pennines, but Borrowdale's marvellous oakwoods, some of the finest in Britain, echo to the song of pied flycatcher, redstart and wood warbler, while in isolated Mardale, the golden eagle occasionally passes over the fells.

The rugged Lake District hills have been little altered by man, although the Romans reached here, as the dramatically sited little fort over-looking the Esk Valley at Hardknott illustrates. Agriculture, especially sheep-raising, has been the major industry for centuries, and the sturdily built statesmans' houses, such as Town End near Grasmere, show a certain rural prosperity.

YORKSHIRE UPLANDS
The Jurassic rocks forming the self-contained eastern outlier which is now the North York Moors are, in geological terms, some of the youngest uplands in Britain. They were laid down under the huge delta of rivers flowing from Scandinavia a mere 210 million years ago, to be uplifted by later earth movements to their present ice-sculpted, heather-clad escarpments.

Younger still is the chalk of the gently-swelling Yorkshire Wolds, which reach the North Sea in the towering cliffs of Bempton and Flamborough Head – two major bird reserves noted for their colonies of guillemots, gannets and gulls. The chalk was laid down under the sea during the Cretaceous period, around 140 million years ago.

But the youngest landscape of all in the North

NORTHERN ENGLAND HABITATS

Reading the landscape

Remains of the Roman granary at Housesteads Fort on Hadrian's Wall are a reminder of Britain's history of settlement.

The North is dominated by the Pennines, a broad but gentle upfold of Carboniferous rocks. On the higher ground the strata lie almost flat, like the layers of a cake. Around Penyghent and Ingleborough, in Yorkshire, the massive limestone base is overlain by varied thinner strata, shales alternating with harder rocks to produce a noticeably stepped landscape around the heads of the Dales.

The summits are capped by the thick, hard millstone grit, and glacial boulder clay is plastered indiscriminately over everything. The coal-bearing rocks that lay above the grit were eroded from the tops of the Pennines, but underlie industrial Lancashire, Yorkshire and Tyneside on either side.

Limestone and millstone grit make most impact on the Pennine landscape. The Derbyshire and Yorkshire Dales are limestone country; the grit (often covered with dark moorland peat) dominates the south Pennines from Manchester and Sheffield northwards, reappearing in the Bowland fells beyond Preston. The geology is often as apparent in buildings and drystone field walls as in natural outcrops.

Limestone is slowly but steadily dissolved by rainwater that percolates into fissures in the rock. Consequently, most water drains underground; the area is famous for potholes such

Bearded tits have their only breeding site in the north at Leighton Moss in Lancashire, the RSPB reserve famed for its reedbeds and nesting bitterns.

of England is the strange, end-of-the-world peninsula of Spurn Head, which hooks out into the Humber Estuary like the tail of Yorkshire. Here is a fluid landscape of shifting shingle, constantly being formed and reformed by the North Sea tides, and always threatening to isolate the small community of coastguards who live precariously at its tip.

THE LOWLANDS

As in many other areas of Britain, the landscape of the lowlands – the Vale of York, the Cheshire Plain, the Mersey Basin and the Fylde of Lancashire – has changed from marshland to farmland over the centuries. Despite what most history books say, prehistoric man did not ignore these marshy areas, as the discovery of the well-preserved body of Lindow Man in a peat bog near Wilmslow in 1984 has proved.

North of Lancaster, the great 'wet Sahara' of Morecambe Bay is an internationally important feeding ground for over-wintering wildfowl, and its treacherous sandbanks and quick-

sands are a reminder that there is wildness even here. The RSPB reserve at nearby Leighton Moss, whose reedbeds support Britain's largest colony of bitterns, show us what much of the lowland landscape once looked like, as does the reserve in the flooded watermeadows of Fairburn Ings near Castleford in Yorkshire.

Large expanses of open water and well managed reedbeds can be found at Leighton Moss.

Estuaries in the north are a haven for wintering waders such as these oystercatchers.

THE NORTHERN LEGACY

It has been said that the North of England is as much an attitude of mind as a place, and there is more than a little truth in this. An ancestry which goes back to the first British settlers and the first Norse and Anglian raiders can still be traced in its placenames. Most river and hill names have probably been in use since before the Roman legions arrived, while words such as 'gill' (narrow valley), 'thwaite' (clearing), 'force' or 'foss' (waterfall), 'fell' (mountain side), and 'dale' (valley) all come straight from the Old Norse or Old English tongue of the first settlers.

The fierce independence of the Northerner owes much to that ancestry, and to a landscape where the past is never far below the surface.

as Gaping Ghyll and Alum Pot, and has the most extensive cave systems in Britain.

Major geological faults have created striking features in the landscape. Along the A65 between Settle and Ingleton, the limestone is juxtaposed against grit country to the south; near Penrith the M6 gives fine views of the fault scarp bounding this highest part of the Pennines.

East of the Pennines, the landscape reflects the countryside of the south. The Yorkshire Wolds have much in common with the chalklands of Dorset and Wiltshire, and the country east of Thirsk is akin to south Somerset, which is geologically similar. But the Jurassic rocks here include thick beds of hard sandstone, and the resulting high, heathery tract of the North York Moors, with its steep westerly scarp, has no parallel farther south.

West of the Pennines, low-lying country on soft 'new red' rocks gives way north of Lancaster to the Carboniferous limestone that forms a broken rim round the Lake District, which itself has much in common with Snowdonia. Hard grits and shales form the Howgill Fells, astride the M6

near Tebay. The northern Pennines broaden and merge into the Border country.

A feature here is the Great Whin Sill, a layer of hard igneous rock seen in the dark crags and waterfalls of upper Teesdale, the sharp north-facing escarpment along Hadrian's Wall, and Farne Islands' cliffs.

Builders of Hadrian's Wall used both the local building materials and the lie of the land – the Whin Sill seen here – to good effect.

In limestone country streams often disappear underground, the water filtering away through rock fissures.

WHERE TO GO

Northern England

The north is a region of rugged beauty with a wealth of natural history interest. Many of the best wildlife sites are on a grand scale, from the bays and marshes along the coast to the upland crags, moors and forests.

1. ALDERLEY EDGE, CHESHIRE

The Alderley Edge escarpment, near Wilmslow, is a landscape embued with myth and legend. King Arthur and his knights are said to lie entombed beneath the rocks, ready to come to the nation's aid in time of peril. The Edge is a red sandstone escarpment honeycombed with old copper and mineral mines. The views westwards across the Cheshire Plain are outstanding, and the birdlife of the semi-natural woodlands includes warblers and woodpeckers.

2. ARNSIDE AND SILVERDALE, CUMBRIA

Situated in the north-east corner of Morecambe Bay, the 73 sq km (28 sq miles) Arnside and Silverdale Area of Outstanding Natural Beauty (AONB) offers a range of scenic contrasts – from the expansive sands of Morecambe Bay to the reed and willow marshes of Leighton Moss and the grey

The coastline near Silverdale on the shores of Morecambe Bay offers superb opportunities for combining walking with the observation of wildlife.

limestone crags and pavements of Arnside Knott (159m/521ft). Sheltered by the Lake District hills, the climate of the AONB is noticeably milder, enabling it to support a wide range of plant and animal life. The RSPB reserve at Leighton Moss is one of the few places in Britain where it is possible

Arnside Knott, which overlooks Leighton Moss and Morecambe Bay, is a superb area of limestone pavement harbouring rare plants in its weather-worn fissures, which are partly overgrown with scrub.

to hear the booming call of the bittern, and the reedbeds are also home to bearded tits and marsh harriers.

3. CASTLE EDEN DENE, DURHAM

'Dene' is the local name for a deep valley. Castle Eden Dene is a well-wooded, ravine in the Magnesian limestone near Peterlee, and is now a national nature reserve covering 200ha (500 acres). The extensive woodlands mainly comprise oak, ash and alder. The acid-loving flora includes heather, milkwort and tormentil. In spring, the woods are carpeted with wood anemones, bluebells and primroses. Orchids and crane's-bills abound. Castle Eden Dene is the normal northern limit for the nuthatch, and a range of woodland birds means it resounds with birdsong in spring and early summer.

4. CRESWELL CRAGS, DERBYSHIRE

This small Magnesian limestone gorge on the borders of Derbyshire and Nottinghamshire, near Worksop, is best-known for the prehistoric remains discovered in the series of caves that mark its length. Ice Age hunters used the caves for shelter up to 45,000 years ago. The crags are festooned with ivy, and plants such as comfrey and monkeyflower grow by the man-made lake in the valley bottom, while birds including spotted flycatcher and pied wagtail feed on the insects.

5. DRURIDGE BAY, NORTHUMBERLAND

The wide sweep of Druridge Bay, stretching between Amble-by-the-Sea and Lynemouth, is perhaps best-known for its birdlife, which includes roseate terns, ruff, black-tailed godwit,

whimbrel and knot. To the north on Coquet Island there is a well-established puffinry, as well as colonies of eider ducks. Ladyburn Lake in the Druridge Bay Country Park hosts flocks of red-breasted merganser and smew in the winter. The sand dunes of the bay support burnet rose, bloody crane's-bill, viper's bugloss and grass-of-Parnassus, all of which have returned after the restoration of disused open-cast coal-mining sites.

6. FOREST OF BOWLAND, LANCASHIRE

The Forest of Bowland is usually overlooked by holidaymakers streaming north on the motorway to the Lake District and Scotland, but this isolated mass of gritstone moorland is an Area of Outstanding Natural Beauty and has important populations of curlew, golden plover, merlin and peregrine. Bowland is used mainly for sheep grazing and grouse rearing, but 13 per cent of the area is designated as Sites of Special Scientific Interest, mainly because of their ornithological interest. The deeply incised river valleys of the Hodder, Wyre and Hindburn support some mixed woodland, but there are blanket conifers around the Stocks Reservoir, near Tosside.

7. HAMSTERLEY FOREST, DURHAM

At first sight, the forest, near Barnard Castle between Teesdale and Weardale, looks like yet another Forestry Commission conifer factory. But Hamsterley is different, with many sunlit glades where wildflowers such as foxglove, lady's-mantle, bush vetch, bluebell, ramsons and wood sorrel flourish. The Pennington beechwood, at 300m (1,000ft), is one of the highest in Britain, and in the valley of the Bedburn Beck old meadows support cowslip and primrose, yellow rattle and meadowsweet. Roe deer, red squirrel and badger inhabit the forest, and the birdlife includes crossbills, goldcrests and siskins.

8. HARBOTTLE CRAGS, NORTHUMBERLAND

Centrepiece of the Harbottle Crags nature reserve is Harbottle Lough, an exposed, acidic tarn in among the low scarps of gritstone rock and wide areas of heather and bilberry moorland and sphagnum bogs, known here as 'mosses'. The lough attracts a wide range of wildfowl, ranging from teal and tufted duck to winter-visiting whooper swan, greylag geese, goosander and goldeneye. Moorland birds include both red grouse and black grouse, summer-visiting ring ouzel, short-eared owl and the occasional merlin.

ISLE OF MAN
page 168

9. MARTIN MERE, LANCASHIRE

This low-lying area of marshland and lagoons, north of Ormskirk, is a Wildfowl Trust reserve famed for its spectacular range of overwintering wildfowl. Up to 10,000 pink-footed geese migrate here annually from Greenland and Iceland, along with whooper and Bewick's swans from Iceland and Russia. Wintering ducks include teal and pintail, plus many other species that gather in this sheltered spot from all over western, northern and eastern Europe. Martin Mere also supports the largest wintering population of ruff in Britain, and other waders such as dunlin, bar-tailed and black-tailed godwit, and golden and grey plover. Predators include hen harriers, as well as both Montagu's and marsh harriers.

10. UPPER TEESDALE AND COW GREEN, DURHAM

Part of the North Pennines Area of Outstanding Natural Beauty, Upper Teesdale is a national nature reserve

famed for its Arctic/alpine flora. Flowers such as the bird's-eye primrose, spring gentian, alpine bartsia and Teesdale violet thrive on the turf created by the unique 'sugar' limestone which was created when the volcanic intrusion of the Whin Sill – seen to best advantage at the nearby Cauldron Snout and High Force waterfalls – 'baked' the surrounding rocks. All this was threatened by the construction of the huge Cow Green Reservoir in the 1970s, but much is still left and can be explored by

following the Widdybank Fell nature trail. Breeding birds include ring ouzel, dipper, curlew, snipe and the ubiquitous meadow pipit.

11. FAIRBURN INGS AND THE LOWER DERWENT VALLEY, YORKSHIRE

Coal-mining subsidence created the extensive – 275-ha (680 acre) – low-lying area of Fairburn Ings near

Doncaster. The permanent lakes here are popular with flock of wintering whooper swans, wigeon and goldeneye, and resident flocks of mute swans and Canada geese. Passage migrants include up to 20,000 swallows, which descend on the area every in

autumn. The Lower Derwent Valley is a national nature reserve with etensove areas of flood meadows, marshes and pastures around the River Derwent and Bielby Beck near Selby. Wintering populations of Bewick's swans, teal and wigeon are of international importance.

The Dark Peak

The Dark Peak is the alter ego of the White Peak, sterner and more uncompromising. Like an upturned horseshoe, the high, peaty, gritstone moors enclose the gentler limestone scenery to the south.

Red grouse are a familiar sight on the moors, the birds take to the wing in alarm when approached too closely.

LAID DOWN OVER THE limestone by huge rivers during the Carboniferous period, the sandstones and shales of the millstone grit have been eroded away from the central core by aeons of wind, rain and ice, leaving a landscape of rocky escarpments and upstanding tors with moors around the edges.

The area is well named, because the overall impression of this peat- and heather-covered wilderness is of dark moorlands above the reservoir-filled valleys.

The names of some of the major hills give a clue to their uncompromising nature: Kinder Scout, Bleaklow and Black Hill, and they mark the first stage of Britain's toughest long-distance footpath, the 432-km (270-mile) Pennine Way.

Even this apparently untamed landscape has largely been created by

Derwent Edge is at its most splendid in July and August when moorland flowers such as ling are in bloom.

Mountain hares change their coats to suit the time of year: in the summer the blue-grey matches the colours of the moors while the white winter coat blends in with the snow.

human activities. During the Middle Stone Age, the earliest visitors to the Dark Peak moors, whose tiny flints are still occasionally found in the peat, would have seen an entirely different landscape, covered with trees and rich in the game they hunted.

But gradual 'slash and burn' deforestation robbed the high ground of its trees, and the lower, more sheltered parts of the moors were cultivated by Bronze Age farmers.

Modern farmers retain a centuries-old grazing regime with their sheep, which prevents regeneration of woodland. Sheep farming is by far the most important form of agriculture on the Dark Peak moors, and local breeds, such as the Derbyshire gritstone and white-faced woodland, are famed for their hardiness.

MOORLAND

Most of the purple-hued heather moorland which is such a glory in late summer and early autumn is equally unnatural. These moors are managed almost exclusively to raise red grouse for shooting after

Bracken

Pteridium aquilinum

Bracken is an extremely important plant in Britain and is by far and away the most common fern in the region. It grows in a wide variety of places including woodland glades, roadside verges and open hillsides; on upland slopes, in particular, it can cover large areas and often appears to grow to the exclusion of other plants. Bracken dies back in the winter but, in spring, young shoots push through the ground. Initially coiled like a spring at the tip, these gradually unfurl to reveal small fern fronds.

see also page 311

Bracken is seemingly unpalatable to most creatures and as a consequence this robust fern flourishes unchecked in many parts of Britain.

the 'Glorious Twelfth' of August each year.

The cackling grouse is the most typical bird of the moors, and its *go-back, go-back, go-back, back, back* calls act as a warning to intruders and somehow personify the character of these wild uplands. Peregrines and hen harriers fly over the heather, quartering the moorland.

Other moorland wildlife includes waders such as curlew, golden plover and snipe, while the reintroduced mountain hare, which changes its coat to white in winter, is increasingly seen on the high moors. In the rocky 'cloughs' (stream valleys) the strident call of the ring ouzel can be heard marking its territory,

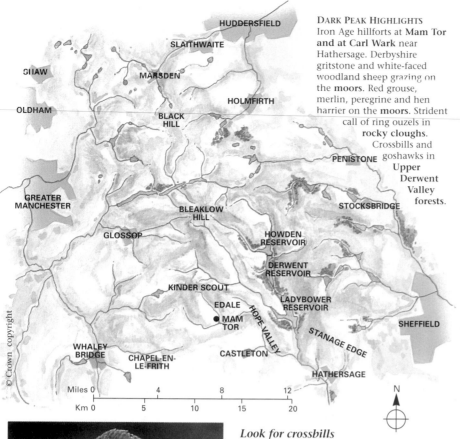

© Crown copyright

Miles 0 4 8 12

Km 0 5 10 15 20

DARK PEAK HIGHLIGHTS
Iron Age hillforts at **Mam Tor** and at **Carl Wark** near Hathersage. Derbyshire gritstone and white-faced woodland sheep grazing on the **moors**. Red grouse, merlin, peregrine and hen harrier on the **moors**. Strident call of ring ouzels in **rocky cloughs.** Crossbills and goshawks in **Upper Derwent Valley forests.**

Curlew
Numenius arquata

The lonely and haunting call of the curlew is surely the most evocative sound of the wild uplands of Britain. Not only is the call diagnostic but, when seen well, this is one of the easiest birds to identify. The long, downcurved bill, used to good effect when probing the ground for invertebrates, is unique among the region's resident birds. Curlews have long, bluish legs and mottled-brown plumage. They are summer visitors to their nesting grounds in the uplands. In his display flight, the male flutters up, hovers, then parachutes down while calling.

see also page 235

Curlews are present in upland areas of Britain such as the Peak District only during the breeding season. At other times of the year, most move to the coast where they feed on estuaries and marshes.

Look for crossbills wherever pine and larch trees are mature enough to bear cones. The bill of this bird is adapted to extract the seeds from the cones.

AND ALSO LOOK OUT FOR...
● fox ● mallard ● tufted duck ● goosander
● sparrowhawk ● merlin ● curlew ● black-headed gull
● meadow pipit ● redstart ● redpoll ● herb robert ● ling
● cross-leaved heath ● lousewort ● goldenrod

The marsh cinquefoil is widespread in northern and upland areas. It grows in bogs and around upland pools, flowering from May to July.

while the golden hues of invasive bracken mask the moorland slopes in autumn.

The moors of the Dark Peak end abruptly in short but steep escarpments of naked rock, known locally as 'edges', which frown down on the valleys. These are popular with climbers and at places such as Stanage, above Hathersage, there are up to 500 climbing routes.

RESERVOIRS
About 50 reservoirs have flooded the valleys of the Dark Peak, providing freshwater supplies to the surrounding ring of industrial towns. While

not providing anything like the richness of wildlife habitat of the limestone dales, these reservoirs do provide a vital softening element to the harsh landscape.

Reservoirs, such as the Howden, Derwent and Ladybower which fill the Upper Derwent Valley near Bamford, are ringed by dense conifer forests, planted in the interests of water purity. Although often claimed to be wildlife deserts, these forests support the last few red squirrels in the Peak, as well as crossbills and goshawks. Mergansers and sandpipers can be seen on the reservoirs.

Bogbean thrives in the shallow margins of peaty pools and its leaves are similar to those of broad bean.

Mature conifer plantations are the haunt of goshawks, large birds of prey that specialise in catching woodpigeons and other medium-sized birds on the wing.

East Coast

From the towering cliffs of Flamborough, blinding white in the summer sunshine, to the endless gun-metal mudflats of Spurn, shimmering in the pale winter light, you can scarcely imagine a coastline of such stark contrasts.

THE CHALK SWEEP of the Yorkshire Wolds meets the sea in the great white cliffs, arches and pinnacles of Flamborough Head, 140m (460ft) high. For a few months each summer these heights are home to hundreds of thousands of nesting seabirds.

Britain's only mainland nesting gannets torpedo into the sea below for fish; while fulmars glide past on stiff wings like miniature albatrosses – in contrast to the guillemots and razorbills whose short, stubby wings flap nineteen to the dozen as they hurtle up to their nesting ledges. Puffins, some 14,000 of them, fly constantly to and fro with beaks full of fish for chicks in the cliff-top burrows.

The grasslands can be a riot of colour with bluebells, red campion, thrift, bright yellow kidney vetch and several different orchids. Peregrines are a regular sight, making an easy living off the many feral pigeons. There are even cliff-dwelling foxes, which scavenge dead seabirds, chicks and eggs.

ANCIENT MERE

A few miles south of Flamborough down the great sandy sweep of Bridlington Bay is the small seaside town of Hornsea, with Hornsea Mere tucked away behind. This shallow 120ha (296 acre) lake is the last great remnant of the once extensive post-glacial lakes and marshes of Holderness. Ringed by large reedbeds and pastureland, it is good for bird-watching all the year.

Search among the winter flocks of black-headed gulls for sightings of the tiny and rather scarce little gull.

In summer, mute swan, gadwall, pochard, tufted duck and shoveler all nest here. Great crested grebes perform their elaborate courtship dances, and reed warblers fill the reedbeds with their incredibly noisy and not very tuneful songs. In late summer spectacular numbers of swallows and starlings gather before settling down for the night in their reedbed roosts. Also at this time of year important numbers of the world's smallest gull, the little gull, gather to feed on the mere before continuing their migration south.

Wintertime brings several thousand duck from breeding grounds all over Europe; these include mallard, teal and wigeon in the shallows, and diving ducks such as goldeneye, tufted duck and pochard. In some years, waxwings from north-eastern Europe turn up in search of berries.

South of Hornsea the low boulder-clay cliffs of Holderness sweep on; the dozens of drowned villages lying offshore are evidence of one of the fastest-eroding coastlines

Dramatic cliffs such as those at Bempton harbour seabird colonies and offer vantage points for watching migration.

in the world. Standing sentinel at the very end of Holderness and guarding the mouth of the great Humber Estuary is the strange and beautiful Spurn peninsula. This low spit of clay, shingle and sand dunes, which at high tide is only a few metres

Thrift

Armeria maritima

Also known as sea pink, thrift is arguably the most familiar and characteristic cliff-top plant in the region. On many coasts around Britain, especially on west-facing slopes where salt spray inhibits the growth of other species, this plant often grows to form a carpet. In May and June the display of flowers is unforgettable. From the dense clumps of wiry leaves arise tall stems on which heads of pink flowers appear.

see also page 296

Thrift is a hardy plant capable of growing in shallow, free-draining soil and tolerant of both salt spray and strong winds.

Lesser black-backed gull
Larus fuscus

The lesser black-backed gull is seen in greatest numbers in the region during the summer months when small colonies breed on inaccessible cliffs and islands. In the winter months many depart our shores for more southerly quarters. The lesser black-backed gull is an elegant bird: unlike the great black-back, the back is smoky-grey, this contrasting with the jet-black wingtips. The legs are a striking yellow colour. Many of our gull species are essentially coastal in distribution but the lesser black-back will feed far out to sea, sometimes out of sight of land altogether.

see also page 237

Lesser black-backed gulls usually nest in a single-species colony, the group often abutting colonies of other seabird species. At all times the combination of dark mantle and yellow legs is diagnostic.

Newly arrived from mainland Europe, these winter-visiting waxwings are feasting on berries to replenish their reserves.

Botanical interest is not confined to spring and summer – autumn gentian puts on a good show in August and September.

wide, is constantly eroding and reforming, always somehow managing to hang on to the rest of Holderness.

Winter sees tens of thousands of waders feeding out on the vast mudflats, mainly knot, dunlin, redshank and curlew. Summertime brings harbour porpoises offshore and grey seals in the estuary. One of the many special plants at Spurn – and one of the most obvious along the roadside and in the sand dunes – is sea-holly.

Good numbers of wildfowl including shoveler arrive in autumn, many spending the winter in the region.

EAST COAST HIGHLIGHTS
Numerous kittiwakes, along with puffins, guillemots and razorbills on **Flamborough Head**. Diving gannets out **at sea**. Courtship dances of great crested grebes at **Hornsea Mere**. Flocks of starlings and swallows coming in to roost in **reedbeds** in late summer. Dunlins, redshank and curlew feeding on **mudflats off Spurn**.

AND ALSO LOOK OUT FOR...
- cormorant ● fulmar
- black-necked grebe
- red-throated diver
- grey plover ● redshank
- common gull ● rock pipit
- whitethroat ● silver y
- sea buckthorn ● silverweed
- sea sandwort ● thrift
- sea plantain ● wild carrot

Although windswept, the coastal vegetation offers a refuge for tired migrant birds that have crossed the North Sea in September.

MIGRATION
Spurn is also internationally famous as a bird migration watchpoint, and spring, summer and autumn can produce huge movements of many different birds. These include swifts and swallows, skylarks and meadow pipits, thrushes and finches, passing north or south in their thousands.

Migration is not just confined to the birds. In some years huge numbers of butterflies pass along the peninsula having crossed the North Sea; mainly small tortoise-shells and members of the white family, but clouded yellows are spotted most years and sometimes the purple and yellow Camberwell beauty.

Map labels:
SCARBOROUGH
FILEY
THE WOLDS
BEMPTON CLIFFS
BEMPTON
FLAMBOROUGH
FLAMBOROUGH HEAD
BRIDLINGTON
BRIDLINGTON BAY
GREAT DRIFFIELD
HORNSEA
HORNSEA MERE
ALDBROUGH
BEVERLEY
HOLDERNESS
KINGSTON UPON HULL
WITHERNSEA
River Humber
BARTON UPON HUMBER
IMMINGHAM
SPURN HEAD
GRIMSBY
Miles 0 4 8 12
Km 0 5 10 15

Morecambe Bay

Set against the backdrop of the Lakeland fells, the bay is an ever-changing world of water and sand, moulded by the tides. Home to one of the largest concentrations of birds in Europe, thousands of waders feed there.

WHAT IS IT THAT attracts so many birds to Morecambe Bay? Principally, its sheer size – 507sq km (195sq miles), of which 310sq km (120sq miles) are intertidal sand and mud – and the abundance of food. Under water with each tide, these sands are extremely fertile, holding vast numbers of a limited variety of invertebrates.

One of the commonest is the minute laver spire shell, which can reach densities of 10,000 per square metre (950 per sq ft). It is the major food of the handsome shelduck

Whimbrels can be told from curlews by their smaller size and the head markings; the seven-whistle call is also distinctive.

that collects its share by scything its bill through the wet sand. Another abundant inhabitant of the sandflats is the Baltic tellin shell. This delicate rose-pink creature, about the size of a finger nail when full grown, lives in

the sand in densities reaching 50,000 per square metre (4,700 per sq ft). It sustains the large flocks of knot and dunlin which probe with frantic speed into the soft sand as the tide retreats. These waders occur in vast wintering and passage flocks, and provide one of the great spectacles of the estuary as they twist and turn against a wintry sky like animated smoke.

Immense numbers of mussels settle on the rocky outcrops, known locally as 'skears', providing the major food source for many tens of thousands of oystercatchers. To feed, the birds either wade in the shallow water and lever the relaxed bivalve open or, when the tide is out, puncture the tightly closed shell by a series of sharp blows to the side.

Those with longer bills

A few pairs of little terns, present from April to August, nest alongside their larger cousins at protected sites around the bay.

– bar-tailed godwit, curlew and, occasionally, whimbrel – are able to exploit the rich supply of marine worms that live deeper in the sand.

WADER ROOSTS
To experience the true wonder of Morecambe Bay make for any of the headlands, islands or larger saltmarshes (such as Walney or Foulney, Hest Bank, Middleton or Pilling) around two hours before a high spring tide any time between late July and late May.

Waders assemble at the roost site in a strict order dictated by the distribution of their food resource. Oystercatchers

The pale, clean-looking plumage of the sanderling becomes reddish-brown in breeding birds, and this is sometimes seen in spring and autumn.

Sanderling
Calidris alba

Small flocks of sanderling can be seen on almost any undisturbed sandy beach between September and March. During this period the overall appearance of the birds seen in bright light is strikingly white, with the back seeming slightly darker than the rest of the body; the bill and legs are by contrast jet black. The plumage and their habit of running along the shore in a line right where the waves are breaking, as though propelled by clockwork, make them relatively easy to identify. When alarmed, the whole flock will take to the wing, resembling a small cloud of snowflakes.

see also page 234

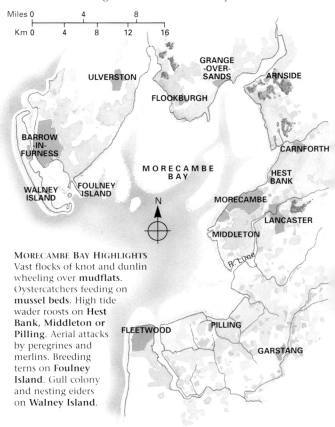

MORECAMBE BAY HIGHLIGHTS
Vast flocks of knot and dunlin wheeling over **mudflats**. Oystercatchers feeding on **mussel beds**. High tide wader roosts on **Hest Bank, Middleton** or **Pilling**. Aerial attacks by peregrines and merlins. Breeding terns on **Foulney Island**. Gull colony and nesting eiders on **Walney Island**.

Turnstone
Arenaria interpres

Those with only a passing interest in bird-watching might be forgiven for failing to notice turnstones as they feed on the rocky shores and beaches around the British coast. These rather unobtrusive birds have mottled grey, brown, black and white plumage for the period they visit the region (September to April) and this helps them blend in extremely well with the seaweed and rocks among which they feed. Seldom was a bird more appropriately named than the turnstone. In search of sandhoppers and other small creatures of the shore, they do indeed turn stones, flicking them over with their stout and chisel-like bill. Turnstones are usually seen in small flocks and are rather reluctant to fly, preferring to walk away from approaching observers.

see also page 234

The turnstone's reddish legs and triangular-shaped bill help distinguish it from other waders. The birds feed quietly among debris on the strandline.

Although the setting sun marks the end of the day for many animals, the activity of the thousands of birds that winter on Morecambe Bay is driven more by the state of the tide than by daylight.

Although small and insignificant, the laver spire shell is one of the most important food organisms for winter wildfowl and waders.

Once used in glass-making, hence its name of glasswort, this a saltmarsh plant that can be pickled and eaten. It grows on open sandy mud.

Dainty common gulls nest in small numbers on protected sites around Morecambe Bay. Their breeding season extends from April to July.

The fragile saltmarsh communities that fringe the upper reaches of sheltered parts of the bay are home to vast numbers of marine invertebrates.

and curlews arrive early, their feeding grounds on the skears and lower sandflats being covered first. They are followed in turn by clouds of knot, redshank, bar-tailed godwits and, last of all, dunlin and ringed plover, which feed mainly on the upper shore. At higher tides, the waders crowd together on to the last available space, producing an unforgettable spectacle of sight and sound that is heightened when a plundering peregrine or merlin launches an attack, creating havoc.

Two of the bay's five islands are the focus of breeding bird activity in the spring. Foulney Island supports a mixed colony of Sandwich, common, Arctic and little terns that fish in the waters off Barrow-in-Furness. Terns are among our most accomplished migrants, wintering along the coasts of Africa, but Arctic terns can move as far south as the Antarctic or Australia.

At south Walney you can walk among the largest ground-nesting gull colony in Europe – but do not forget to take some head covering as the adult gulls will divebomb any intruder.

Gulls often take the eggs and young of other birds, so it is perhaps surprising that among the tens of thousands of pairs of gulls on Walney a thriving colony of eider ducks exists. The female lines her nest with down and incubates on her own – the colourful male would be too noticeable to undertake such duties. By June, large numbers of chicks are on the water, often in crèches attended by several females.

AND ALSO LOOK OUT FOR...
● cormorant ● grey heron ● black-necked grebe ● wigeon ● teal ● shelduck ● grey plover ● ringed plover ● redshank ● greenshank ● bar-tailed godwit ● flounder ● common cockle ● shore crab

Yorkshire Dales

It is limestone that makes the Dales so special; creamy-grey rock that gleams bone-white in sunlight, spectacularly so where exposed crags form great walls and shattered turrets.

Globeflower

Trollius europaeus

Few plants have such an accurately descriptive name as the globeflower. From May to August, this large and robust member of the buttercup family produces flowers which are almost spherical. Measuring about 3cm (1in) across, they are bright yellow and comprise ten sepals; most other flowers, including other members of the buttercup family, have flowers comprising both petals and sepals. The leaves are hand-like and deeply divided in the manner of many buttercup leaves. Globeflower grows in damp soils and is locally common in marshy ground or beside rivers. Grazing pressure excludes it from many suitable sites.

see also page 285

Where conditions suit it, the globeflower can be locally abundant. Hay meadows in the Yorkshire Dales are an ideal habitat, especially where the soil is damp and marshy.

Alighting near its nest, the lapwing shows the broad, rounded wings that so characterise the species.

THE CENTRAL Pennines – that immense line of hills and moors which creates the spine of northern England – are fractured by ancient fault lines of primeval movement of the earth's crust, exposing underlying rock like the layers of a contorted, neatly cut cake.

Running at a gentle tilt from west to east across the Dales, huge cliffs of exposed Carboniferous limestone have been shaped and carved over millennia by frosts and the erosive action of water to form dramatic natural features such as Malham Cove, Gordale and Attermire Scars.

On the high plateaux above the scars the thin peaty soils have been washed away to produce areas of limestone pavement, an extraordinary, lunar landscape of deep, ankle-twisting fissures – known as clints and grykes – where wind-twisted juniper and hart's-tongue fern flourish. At least half the limestone pavement of Britain is to be found in the Yorkshire Dales.

CHALKLAND FLOWERS
Flowers flourish on sweet alkaline soils. In damper places, and in the few but precious areas of limestone woodland, you will find a wide variety of orchids, as well as globeflower, crane's-bills, wood anemone, water avens, and shrubs like mezereon and guelder-rose.

In June the high pastures are dotted with bird's-eye primrose, cowslip and pansies, including the mountain pansy. If you know where to look on the high Yoredale limestone near the summits of the higher fells, you might find the rare, pre-glacial purple saxifrage, a jewel of the high crags.

Nor is this remarkable limestone landscape confined to the surface. The porous rock is honey-combed with water-carved caves and potholes, some of them, such as Gaping

Flower-filled hay meadows are one of the delights of the Dales with crane's-bills growing side-by-side with buttercups and other grassland species.

Snipe breed in damp meadows, and the nest is often built at the base of a clump of rushes.

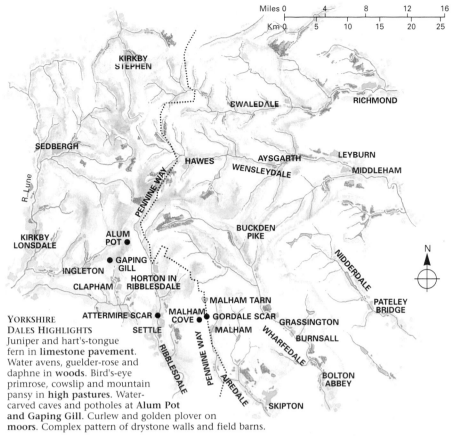

Miles 0 4 8 12 16
Km 0 5 10 15 20 25

KIRKBY STEPHEN

SWALEDALE RICHMOND

SEDBERGH

AYSGARTH LEYBURN
HAWES WENSLEYDALE MIDDLEHAM

R. Lune

KIRKBY LONSDALE ALUM POT

BUCKDEN PIKE

GAPING GILL NIDDERDALE
INGLETON HORTON IN RIBBLESDALE
CLAPHAM

MALHAM TARN PATELEY BRIDGE

ATTERMIRE SCAR MALHAM COVE GORDALE SCAR GRASSINGTON
SETTLE MALHAM BURNSALL
WHARFEDALE

RIBBLESDALE PENNINE WAY AIREDALE
BOLTON ABBEY
SKIPTON

N

YORKSHIRE DALES HIGHLIGHTS
Juniper and hart's-tongue fern in **limestone pavement**. Water avens, guelder-rose and daphne in **woods**. Bird's-eye primrose, cowslip and mountain pansy in **high pastures**. Water-carved caves and potholes at **Alum Pot and Gaping Gill**. Curlew and golden plover on **moors**. Complex pattern of drystone walls and field barns.

Mountain avens
Dryas octopetala

Although it does not reach any great height, this upland plant can form sizeable but compact clumps in those areas where grazing does not affect it. The broadly oval leaves have lobed or toothed margins and are dark green above and silvery-grey beneath. The attractive flowers, which appear from May to July, have eight or more white petals surrounding a

dense cluster of yellow stamens. Intriguingly, in order to catch the maximum amount of warmth from the sun, the flowers follow its progress during the day. Having set seed, fruits are produced which bear white, feathery styles that disperse them on the wind.

Mountain avens is a plant with an Arctic or alpine distribution but it has outposts on calcareous soil in a few sites in northern England.

Merlins are easiest to see in the Dales during the breeding season when they take a toll of small birds such as meadow pipits.

The berries of guelder-rose are eaten by birds and mammals which scatter the seeds with their droppings.

The rushing waters of The Strid, a section of the River Wharfe near Bolton Abbey.

Gill or Alum Pot, of huge proportions, others forming a network of narrow passageways and subterranean caverns.

The summits of the fells are not high, even by British standards, with few peaks reaching more than 700m (2,303ft). They are dominated on the drier, eastern side by heather moorland, much of it managed for grouse shooting, but on the higher fells of the west

there is rough pasture with extensive areas of boggy Sphagnum, sedge and cotton-grass.

These are the wild places, haunted not only by nesting curlew, snipe, lapwing and golden plover, but by increasing numbers of birds of prey – kestrel, peregrine, merlin, hen harrier, buzzard – as well as the occasional fox, hare or roe deer.

DOWN IN THE DALES
The deep river valleys contain the characteristic dales. Countless small waterfalls, often concealed within narrow gullies or

gills where ash and rowan flourish, are a haven for ferns, grasses and flowers such as primrose and harebell. There are badger setts in many of the smaller woods, and otters have been recorded on some rivers.

It is the contrast between the bleak, brown upland moorlands and the soft, green pastures of the valleys, dotted with ancient stone farmhouses and barns, and compact villages, that gives the Dales their charm.

This is a man-made landscape whose ancient

forest and scrub cover was replaced by a complex pattern of drystone walls enclosing fertile pastures, with rough grazing land up the steep valley sides. Many of the old herb-rich meadows of the upper Dales – gold with butter-cups in spring – are now formally protected.

AND ALSO LOOK OUT FOR...
● brown hare ● cuckoo
● stock dove ● skylark
● willow warbler ● blackcap
● green-veined white
● white bryony ● ragged robin ● cuckooflower
● yellow archangel
● hedge woundwort

North York Moors

Wave upon wave of rolling moorland, the faint buzz of bees, and that wonderful aroma of heather in bloom. These are the North York Moors in their full summer glory – the largest area of upland heath in England.

Continual managment is required to keep the open, heather-clad appearance of the moors.

Boggy areas are favoured by cranberry, and its flowers resemble miniature fuchsias.

Although well camouflaged, the hairy caterpillars of the emperor moth can still be found feeding on ling.

CREATED IN THE Jurassic seas and rivers more than 160 million years ago, uplifted gradually over many more millions of years, scoured by glaciers, eroded by wind and rain and finally clothed in vegetation, the moors appear to be a changeless landscape at first sight.

Cross-leaved heath likes its feet in water and grows best in permanently wet bogs.

But nature and man have combined to continually transform the picture. When these hills were first occupied, more than 7,000 years ago, the people would have been hunter-gatherers, wandering through natural woodland, hunting the wild deer and cutting occasional clearings in which to build burial mounds. Later, more forest would be cleared to make way for agriculture, and later still, as the climate changed and the high tops were abandoned, heath began to invade the early farm and woodland. The moors were starting to evolve.

GROUSE AND SHEEP

Today, the moorland is managed for the sport of red grouse shooting (unlike other native gamebirds, grouse cannot be bred in captivity, hence the need to maintain their natural habitat) and for sheep, both an essential part of the modern moorland economy. This is done by carefully burning the old, woody stems of the heather on a rotation basis, thus creating a patchwork of new stems (on which the sheep and grouse feed) and old growth (needed for nesting and cover).

If disturbed, the grouse bursts from the heather, flying fast and low while uttering its rapid 'go-back, go-back, go-back' call – a sound evocative of the high moor, along with the song of the curlew.

Cuckoo

Cuculus canorus

Heralding the arrival of spring, cuckoos usually appear in Britain in the last week of April after migrating from their wintering grounds in Africa. Heard more than they are seen, in flight cuckoos are superficially bird-of-prey-like in appearance, with narrow, pointed wings and a long tail. The fact that they are brood parasites of songbirds is well known, and in upland areas of Britain meadow pipits are perhaps the commonest host species to young cuckoos. The familiar 'cuck-oo' call is uttered only by the male; the female has a distinctive, bubbling call. Cuckoos feed mainly on hairy caterpillars, a diet not shared by other British birds.

see also page 240

Cuckoos bear some resemblance to birds of prey and they also elicit mobbing behaviour in songbirds.

Other waders that summer here include the smaller dunlin. By contrast, the fast-flying predatory merlin is tiny, only a little bigger than a blackbird; it has one of its strongest footholds here on the North York Moors.

A CLOSER GLANCE

At first glance the heather appears to be a monoculture, but closer scrutiny reveals three differing species. The first to flower, in late June and early July, is the royal purple bell heather. As its flowers begin to fade the pale pink florets of the damp-loving cross-leaved heath appear, followed quickly by heather or ling. It is ling, in its various hues, which is responsible for the purple wash to the hills throughout August.

Smaller patches of bright green bracken and bilberry dominate many of the steeper slopes, and close examination may reveal occasional pockets of the rarer cloudberry and crowberry, or the delightful white flowers of dwarf cornel. Look out for the vivid green-and-black caterpillars of the magnificent emperor moth, which feed on heather shoots. Less obvious but equally interesting are the caterpillars of the northern eggar – large, rusty brown and very hairy!

Common though seldom seen is the adder or viper, a beautifully patterned poisonous snake which feeds on small mammals, birds and eggs. This much-maligned creature is very sensitive to vibration and is usually long gone by the time any human arrives. You will also have to be very quick to spot the common lizard – unless you chance on one sunning itself on a rock.

Beware of walking on flat, bright green mats of moss. Sphagnum or bog moss absorbs water like a sponge and often covers very wet holes. Scattered among it you will find the delicate discs of the common sundew. No more than 10mm (0.5in) across and fringed with hairs, these attractive plants are deceptive – an unwary fly or midge alighting on the sticky discs will not escape, as the hairs close over and engulf it.

As autumn arrives the bracken turns a golden brown, the heather fades and the moors take on the more sombre colours that gave them their old name, Blackamore.

The fruits of the bilberry seldom persist for long as they provide a nutritious feast for birds.

see also page 244

Meadow pipit
Anthus pratensis

Perhaps on account of its rather uniform plumage, the meadow pipit is often largely ignored by bird-watchers. Open, sheep-grazed fields and moorland slopes are home to this species, which is common in upland areas of Britain. Its drawn out 'pip-pit' call is a familiar sound to hill walkers. Meadow pipits are insect feeders and present in varying numbers throughout the year. In spring, tussocks of grass or clumps of rushes are chosen as nesting sites, the actual structure being well concealed and difficult to find.

Meadow pipits are common during the breeding season but most disperse to the coast in winter.

Damp grassland with lush vegetation is the preferred nesting habitat of the curlew.

AND ALSO LOOK OUT FOR...
● fox ● stoat ● short-tailed vole ● kestrel ● wheatear ● linnet
● ring ouzel ● tormentil ● petty whin ● lousewort ● bog asphodel
● hare's-tail cottongrass ● Yorkshire fog ● stagshorn clubmoss

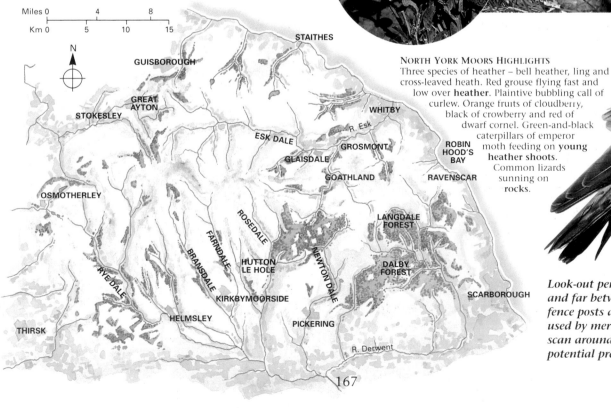

Miles 0 4 8
Km 0 5 10 15

N

STAITHES

GUISBOROUGH

GREAT AYTON

STOKESLEY

WHITBY

R. Esk

ESK DALE

GROSMONT

GLAISDALE

ROBIN HOOD'S BAY

GOATHLAND

RAVENSCAR

OSMOTHERLEY

LANGDALE FOREST

FARNDALE

ROSEDALE

BRANSDALE

NEWTON DALE

DALBY FOREST

RYE DALE

HUTTON LE HOLE

SCARBOROUGH

KIRKBYMOORSIDE

THIRSK

HELMSLEY

PICKERING

R. Derwent

NORTH YORK MOORS HIGHLIGHTS
Three species of heather – bell heather, ling and cross-leaved heath. Red grouse flying fast and low over **heather**. Plaintive bubbling call of curlew. Orange fruits of cloudberry, black of crowberry and red of dwarf cornel. Green-and-black caterpillars of emperor moth feeding on **young heather shoots**. Common lizards sunning on **rocks**.

Look-out perches are few and far between and so fence posts are regularly used by merlins as they scan around for potential prey.

Isle of Man

Legend has it that the island was originally cast into the sea by an Irish giant, Finn MacCoole, after he snatched a lump of Ireland from Lough Neagh and threw it at an English adversary.

The water rail's long, trailing legs are best seen in flight. A few pairs breed on the island but more occur on migration in autumn.

Although small in stature, the intricate flowers of the dense-flowered orchid certainly repay close scrutiny.

Yellow iris

Iris pseudacorus

Where conditions suit, yellow iris – also known as yellow flag – forms dense, almost regimented stands comprising clumps of strap-like leaves standing shoulder to shoulder. The leaves are grey-green in colour and often wrinkled at the margins. The plant favours damp soils

Showy yellow flowers attract the attention of visitors and pollinating insects alike.

and thrives at the margins of ponds and lakes as well as in marshes and ditches. From spring to early summer clusters of two to three yellow flowers – each up to 10cm (4in) across – are produced on tall stems; they are visited by all manner of insects, especially small beetles. Yellow iris is widespread throughout most of lowland Britain.

see also page 306

IN FACT, THE ISLE OF Man was separated from Ireland about 15,000 years ago and finally from mainland Britain some 6,000 years later. However, as with Ireland, there are no snakes and several other common species, such as badgers, woodpeckers and newts are lacking.

The central hills, known locally as mountains (Snaefell is the highest at 621m/2,043ft), offer some of the wildest landscapes on the island. This is the breeding area of 10 per cent of the British hen harrier population, as well as curlew, skylark, meadow pipit and wheatear. In the autumn the resident harriers are joined by

Bathed by the Irish Sea, the coast – such as here at Maughold Head – supports a rich variety of intertidal life. Rock pooling can be a rewarding pastime.

migrants from Scotland and elsewhere; they gather in evening groups of as many as 100 individuals, making the largest winter roosts in Western Europe.

On the northern plain is a large area of wetland, Ballaugh Curragh, which dates back to the last Ice Age when lakes were formed in the area. It has been drying out ever since, and, where in the 1800s there were sheets of open water, there is now willow carr. The boggy areas are rich in purple moor-grass, bog myrtle and marsh cinquefoil, while common spotted-

and heath spotted-orchids, yellow iris, devil's-bit scabious and ragged-robin add colour to the marshy grassland. Water rail and little grebe skulk in the reeds, but short-eared owls are easier to see as they quarter the area for small mammals.

At the northern tip is a 10km (6 mile) stretch of shingle beach and sand dune, known as The Ayres. Arctic, common and little terns find suitable nest-sites here, as do oystercatcher, ringed plover and shelduck, the latter using the numerous rabbit burrows. The dunes are stabilised by whip-like marram grass with clumps of pink sea bindweed and blue-grey sea-holly; while behind is a fascinating heathland where lichens, more usually found on trees, grow on the ground. The

many tiny flowers are a feature of this area: blue forget-me-nots, pink crane's-bills, orange trefoils and the Manx cabbage – a small, yellow-flowered crucifer. Orchids also flourish, including the insignificant looking dense-flowered orchid, found nowhere else in the British Isles save for the west coast of Ireland.

COASTAL GLORIES

It is the coast of Man that has some of the finest wildlife and most spectacular scenery. The circular Raad ny Foillan (the Road of the Gull), a footpath around the isle, can be joined at numerous points. Most of the cliffs are Manx slate – Spanish Head in the south being a particularly fine example.

Manx shearwater
Puffinus puffinus

When autumn gales blow or as dusk approaches, lines of Manx shearwaters can sometimes be seen from headlands, especially off the west coast of Britain. These well-adapted seabirds spend most of their lives far from land, only venturing in during the breeding season and then only at night. Shearwaters nest in rabbit burrows and are rather ungainly on land, the combination making them vulnerable to predators. Not surprisingly, they nest only on offshore islands such as the Calf of Man and even here they were almost wiped out by introduced rats. When seen well, Manx shearwaters are distinctive: black upperparts alternate with the white underparts as they fly low over the water with stiff, outstretched wings.

see also page 223

In order to see Manx shearwaters on land you need to visit a colony after dark, preferably on an overcast, moonless night.

Meadow pipits nest in good numbers in grassland and are present throughout the summer months.

Just west of Castletown is a small area of limestone, noted for its geology and in particular the 'stack', a large mass of columnar basalt similar to that found on the Giant's Causeway in Ireland. Spring squill creates a blue sheen on the coastal grassland, along with carpets of pink thrift, white sea campion and yellow lady's bedstraw. This is the only place in Britain where the endemic lesser mottled grasshopper is found.

Summer boats trips run to the Calf of Man set up as a bird observatory in 1959. Auks and other seabirds nest on the cliffs, and Manx shearwaters come ashore at night to their nesting burrows. The coastal heath is grazed by the brown-fleeced, multi-horned Manx loghtan sheep.

Grey seals breed around the Calf and also off Maughold Head. The snowy white pups are born in late autumn but adults can be seen all year round, along with dolphins and porpoises. , One of the most impressive animals however, the basking shark, is sighted only in the summer. Special boat trips are available to see these leviathans of the deep.

The rugged Snaefell mountains allow visitors with stamina to see breathtaking panoramic views of the island.

ISLE OF MAN HIGHLIGHTS
Hen harriers on the central hills. Orchids at **Ballaugh Curragh**, along with short-eared owls. Nesting terns at **The Ayres**. Lichens growing on ground on heathland behind **The Ayres**. Cliff-nesting seabirds at **Spanish Head**. Spring squill on coastal grassland at **Castletown**. Manx loghtan sheep on **Calf of Man**. Basking sharks out at sea.

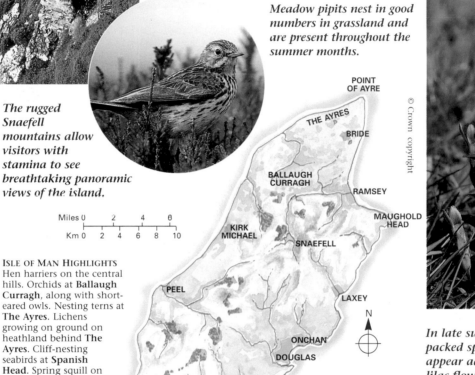

Miles 0 2 4 8
Km 0 2 4 6 8 10

POINT OF AYRE
THE AYRES
BRIDE
BALLAUGH CURRAGH
RAMSEY
MAUGHOLD HEAD
KIRK MICHAEL
SNAEFELL
PEEL
LAXEY
ONCHAN
DOUGLAS
PORT ERIN
CASTLETOWN
DERBY HAVEN
CALF OF MAN
SPANISH HEAD
LANGNESS

© Crown copyright

In late summer, the tightly packed spikes of field gentian appear adorned with bluish-lilac flowers.

AND ALSO LOOK OUT FOR...
● fulmar ● shag ● lapwing ● turnstone ● swallow ● whinchat ● willow warbler ● chough ● reed bunting ● red campion ● sea rocket ● tormentil ● wild carrot ● eyebright ● goldenrod

Despite its cavernous mouth and frightening appearance, the basking shark is entirely harmless to people – its diet comprises tiny planktonic animals which are filtered from the water with its gill-rakers.

Lake District

Nearly 200 years ago, when it was first discovered by tourists, Wordsworth called the Lake District a 'sort of national property'. Today, despite its popularity, the area is unsurpassed in terms of landscape, wildlife and heritage.

Alpine catchfly grows in a few undisturbed spots on the high tops. Look out for the flowers in June and July.

As their name suggests, tree pipits are associated with wooded habitats. They are summer visitors, present from April to August.

THE MARVELLOUS variety of the lakeland scenery largely results from the nature of the underlying rocks and successive geological processes. In the north, a band of Skiddaw slates, which break down readily, have produced a landscape of smooth slopes and clear-cut edges, as on Skiddaw itself and the outlying peak to the south, Black Combe. The harder Borrowdale volcanics, characterised by rock-strewn slopes and jagged ridges, comprise the central area, while in the south are the eroded grits and shales of Silurian rocks; lower, gentler hill country that peaks at 333m (1,095ft) on Kirkby Moor.

Over millions of years, buckling and folding from pressure by movement of the earth's crust and subsequent erosion raised the rocks into a dome and created the radial pattern of rivers evident today. Glacial action during the Ice Ages gouged deep, smooth U-shaped valleys – some, such as above Red Tarn, with cliffs at the head –

Autumn is arguably the best time of year to visit the region. Here, the slopes of Helvellyn are mirrored to perfection in Thirlmere Reservoir.

and deep tarn basins. Some higher tarns are dammed by glacial deposits, including Windermere, England's longest lake at 17km (11 miles).

THE HIGH FELLS
The mountains reach a mere 978m (3,210ft) on Scafell Pike, England's highest peak, but their location on Europe's western edge ensures an extreme climate on the summits that makes for harsh conditions. In the north-eastern corries about Helvellyn snow can lie until June, though nowhere is it permanent.

These summits are hostile places in which to live and have sparse plant life; lichens, woolly hairmoss, a little dwarf willow and stiff sedge may be all that survives. Sheep-

grazing and associated burning have had a massive impact and consequently the upper slopes have lost much of their heather and bilberry, so although the sward left on the broad sweep of fellside makes for easy walking, it is impoverished. There are glorious rock gardens of Arctic–alpines, however, on the richer cliffs around Helvellyn, Pillar and Scafell. Perhaps the most famous of the species found here is the Alpine catchfly, on Hobcarton Crag. Among a long list of others are moss campion, hoary whitlowgrass and purple saxifrage.

Above 300m (987ft) the raven is ever present and there is a small lakeland population of golden eagles, focused around

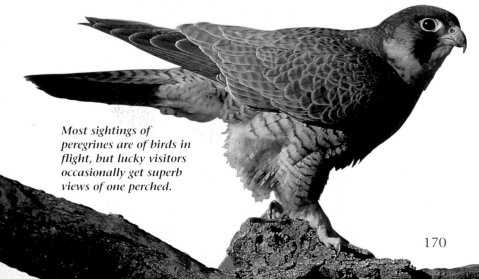

Most sightings of peregrines are of birds in flight, but lucky visitors occasionally get superb views of one perched.

Emperor moth
Saturnia pavonia

The striking emperor moth is easy to identify both by its appearance and by the fact that it flies by day. Both sexes have beautifully marked upperwings showing conspicuous eye marks. The female, which has greyish wings, can sometimes be seen resting on clumps of heather in April or May. She releases a scent which lures the orange-brown males to her. On sunny days, males fly at great speed across open ground while attempting to track down the source of their interest. The caterpillar of the emperor moth is an attractive shade of green and is covered with clusters of black bristles. It blends in surprisingly well with the leaves of heather on which it feeds.

see also page 267

This moth's eye markings are presumed to serve a defensive function, scaring off birds.

Moss campion

Silene acaulis

Although this plant seldom reaches any great height, it makes up for its diminutive stature by forming broad, cushion-like mounds up to 20cm (8in) across with a thick growth of wiry, deep-green leaves. From June to August these become studded with bright pink flowers which comprise five petals, each slightly notched at the tip. Despite its compact appearance and its ability to survive the most severe of winters, moss campion is vulnerable to damage by sheep and boot erosion. Consequently, it is usually found in upland areas that are comparatively inaccessible to both walkers and grazers.

see also page 284

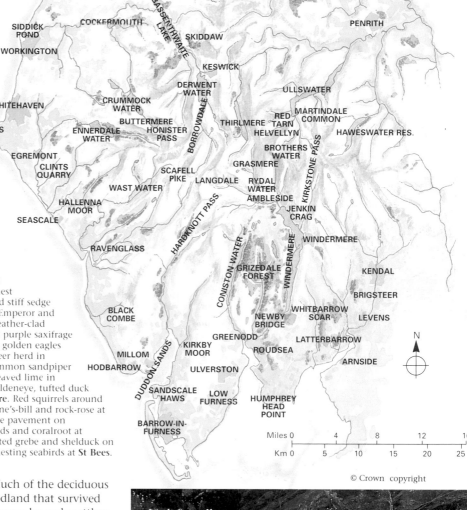

Moss campion is one of the most attractive of our so-called Arctic-alpine flowers and is locally common in this area.

Map lichen often lives up to its name, creating the illusion of a colourful map painted on the rocks.

LAKE DISTRICT HIGHLIGHTS
Scafell Pike, England's highest mountain. Dwarf willow and stiff sedge near summit of **Helvellyn**. Emperor and northern eggar moths on heather-clad fellsides. Moss campion and purple saxifrage on higher peaks. Displaying golden eagles around **Haweswater**. Red deer herd in **Martindale**. Dipper and common sandpiper by mountain becks. Small-leaved lime in woods east of **Coniston**. Goldeneye, tufted duck and pochard on **Windermere**. Red squirrels around **Derwent Water**. Bloody crane's-bill and rock-rose at **Humphrey Head**. Limestone pavement on **Whitbarrow**. Natterjack toads and coralroot at **Sandscale Haws**. Great crested grebe and shelduck on pools at **Hodbarrow**. Cliff-nesting seabirds at **St Bees**.

© Crown copyright

Haweswater Reservoir. February is the time for their courtship display and the young fledge in June. The crags are also the refuge of peregrine, the population of which has more than doubled since the 1950s. More widely found on the fells are wheatear, ring ouzel and tree pipit. Mammals, with the exception of foxes and short-tailed voles, are few and far between on this high ground.

The ice-cold, fast-flowing high mountain tarns and becks have sparse wildlife, but lower down dipper, common sandpiper and oyster-catcher often breed. In a few lower tarns the rare medicinal leech still survives, and here and there, in the richer becks, crayfish occur.

HEATHS AND WOODS

On the middle fellsides, easily reached from passes such as Honister, Hardknott and Kirkstone, the emperor moth is attracted to the heather in spring, as is the northern eggar later in the year. Former woodland areas here are often covered with bracken, and, in spring, bluebells.

Northern eggar caterpillars feed on ling. Their coating of irritating hairs deters most predators, except cuckoos.

Much of the deciduous woodland that survived clearance by early settlers is found in the valley bottoms or lower fellsides, although the ancient wood of Keskadale in Newlands Valley is a fine exception. This native woodland is largely National Trust or Park property, and there is easy access to it in Borrowdale and around Rydal. Most is comprised of sessile oak and birch, with alder and willow in the wetter bottoms, and ash, hazel and elm, as well as natu-ralised beech, on less acidic soils. Ungrazed woodlands usually have an understorey of lush wood-rush and bilberry with scattered holly and yew; the northern outpost of small-leaved lime occurs east of Coniston. Native juniper occurs widely and many of the conifer plantations –

Look for yellow mountain saxifrage growing beside water; the plant thrives in settings where fairly constant humidity is maintained.

Northumberland

From the top of Windy Gyle in the Cheviot Hills, it seems as if the whole world is laid out before you. The Border Ridge wends its way north and south, castles punctuate the Northumbrian coast, and Scotland lies just over the fence.

THE JOURNEY FROM north to south through Northumberland, much of which is embraced by the national park, reveals lonely, remote landscapes. Beefstand, Russell's Cairn, Bloodybush Edge, Cushat Law and Comb Hill lie within easy striking distance of Windy Gayle. These softly rounded lava flows from a long-dormant volcano form a ring around The Cheviot, Northumberland's highest hill at 815m (2,681ft).

The walking is wild and strenuous but not precipitous, and in summer you can keep company with skylarks, meadow pipits, curlews, golden plovers, wheatears and, occasionally, ring ouzels. Sections of the ridge, in parts followed by the Pennine Way, are paved with massive sandstone blocks from derelict Lancashire cotton-mills to prevent erosion of the soft carpet of cottongrass, crowberry, bilberry and heather.

OVER THE RANGE

To the south is the impressive sandstone ridge known as the Simonside Hills, at their best in August when purple heather or ling and magenta bell heather are in full flower. On the higher slopes is the stag's-horn clubmoss, found only on mountain moors and heaths. Its fruiting 'cones' grow in pairs and bear a faint resemblance to a stag's horn. Throughout the year, you will be warned to *go-back, go-back, go-back* by red grouse standing their ground.

West of the Simonsides is the Otterburn Training Area. This is out of bounds for most of the year and red flags indicate the no-go areas. The clear, fast-flowing Upper Coquet, which divides the range, is important for salmon, and otters are regular visitors although they are rarely seen.

Traditional hay meadows on the range

Kielder Lake is a man-made reservoir, fringed with forests that are home to birds such as crossbills and goshawks.

In such a rugged landscape, feral populations of goats do not seem out of place.

near Alwinton contain a wealth of flowers. The right of way through Angryhaugh leads on to a boggy hillside where there is bog asphodel, cross-leaved heath and sweet gale – its aromatic leaves and flowers were once used to flavour beer.

In contrast to the species-rich meadows, the wild moorland of the

Cross-leaved heath thrives in damp, acid ground and flowers during the summer months.

Redstart

Phoenicurus phoenicurus

Named after the striking orange-red tail, seen in both sexes, which is continually flicked up and down when the bird is perched. The redstart is a migrant visitor to Britain; it arrives in April and early May and has departed by August. Male redstarts are striking birds with steel-grey upperparts, red underparts, a black face and a white splash on the forecrown; females have subdued, reddish-brown plumage. Areas of mature oak woodland where there is little undergrowth are favoured by this species, which nests in holes in tree trunks. They are also found in more open terrain, sometimes around houses, where stone walls are a common nesting site.

see also page 248

The redstart is a welcome summer visitor to Britain, occurring mainly in the north and west of the region. Open wooded areas in the Northumberland National Park are ideal for the species.

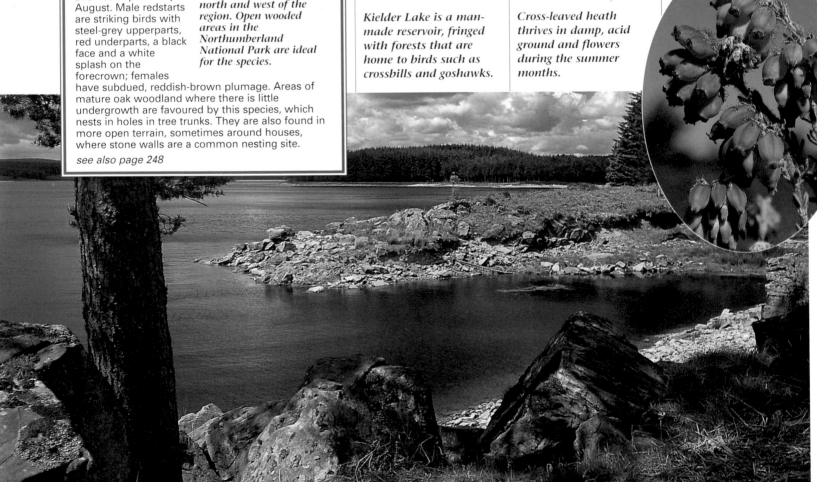

Starry saxifrage
Saxifraga stellaris

This delightful, delicate little plant is the most common upland saxifrage in the region and typically grows in damp, open places. A favourite site would be beside a stream where the humidity was high and drops of water splashed onto the plant. The leaves of starry saxifrage are produced in a basal rosette; individually, they are oval in shape with toothed margins. From June to August a tall and slender flowering shoot is produced. This branches at the end and carries arrays of delicate, star-shaped flowers which comprise five white petals, off-setting the deep-red anthers in the flower centre.

The word 'saxifrage' might be loosely translated as 'stone-breaker', a name which reflects the predilection this plant group has for stony habitats. Starry saxifrage invariably grows alongside mosses on the stony margins of streams.

Golden plovers nest on the open moors, their plaintive calls being one of the most evocative sounds of the region.

training area provides an ideal habitat for various waders, including curlew, snipe and lapwing. Black grouse are a speciality.

KIELDER AND BEYOND
The Reivers' Trail, running beside Tarsetburn in the Upper North Tyne Valley, leads to five ruined bastle houses (a style of fortified dwelling unique to the area that developed when the area was ruled by outlaws called reivers.) Follow the trail from Sidwood in early summer, when herons, dippers and grey wagtails feed along the river and the banks are studded with marsh-marigolds.

From the valley the

Black grouse begin displaying at their communal leks before winter has fully retreated.

park boundary meanders south, passing the eastern edge of Kielder Forest, Europe's largest man-made forest. Although impenetrable, the sitka spruce and Scots and lodgepole pines provide a sanctuary for many mammals, including red squirrels, foxes, voles, weasels and mice, together with an accompanying array of predators such as tawny and long-eared owls, goshawks, sparrowhawks and

Hedgerows and verges are full of the flowers of wood crane's-bill in late spring and early summer.

kestrels. More unusually, on the edges of the forest, wild goats can be seen, while in forest glades the nibbled young trees betray the presence of roe deer.

Leaving the forest behind, our final encounter is with Hadrian's Wall, the most grandiose feature of the park, marking its southern border. All is quiet here on a summer's evening when the sad calls of curlew and the drumming of snipe focus the mind on the enduring nature of this landscape. On the crags is a natural rock garden of bell heather, rock-rose, wild thyme and tormentil.

The rocky outcrops of Peel Crag near Hadrian's Wall, are a good place to search for unusual plants and are often the haunt of ring ouzels and jackdaws.

NORTHUMBERLAND HIGHLIGHTS
Skylarks, meadow pipits and ring ouzels along the **Border Ridge**. Stag's-horn clubmoss on higher slopes of **Simonside Hills**. Traditional flower-filled hay meadows near **Alwinton**. Bog asphodel and bog myrtle in **wet areas around Angryhaugh**. Herons, dippers and grey wagtails beside **Tarsetburn**. Goshawk and sparrowhawks around the **forestry plantations**. **Hadrian's Wall**, a World Heritage Site.

AND ALSO
LOOK OUT FOR...
● merlin ● kestrel ● buzzard
● common sandpiper
● short-eared owl
● grey wagtail ● goldcrest
● coal tit ● redpoll ● siskin
● wheatear ● emperor moth
● rowan ● globeflower
● petty whin ● field gentian
● lousewort ● eyebright
● harebell ● fly agaric

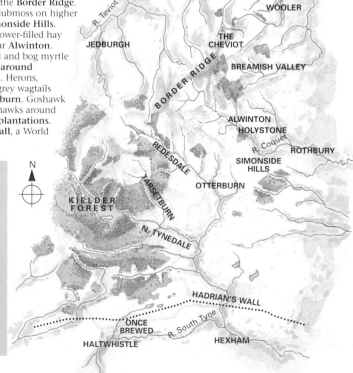

The Farnes & Holy Island

Cuthbert was Bishop of Lindisfarne and a hermit on Farne. He had a special love of the birds and animals of his adopted islands and drew up rules for their protection, making Farne the first nature reserve. The islands are still wild places.

The kittiwake's name derives from its distinctive call which is heard throughout the breeding season.

Boat trips allow superb close-up views of the seabird stacks, the sight, sound and smell of which create a lasting memory for visitors.

THE SWEEP OF COAST between Seahouses and Holy Island is made up of low rocky headlands, wide sandy bays and mudflats. The headlands, and the nearby gorse-covered ridges, are part of the Whin Sill, a volcanic intrusion of hard, fine-grained dolerite. This is the dark grey rock that outcrops as the Farne Islands, and makes the platform for the castles of Bamburgh and Lindisfarne.

From late winter to early summer the cliffs and grassy tussocks that deck the Farnes are alive with seabirds. Fulmars and guillemots, kittiwakes and shags are the main cliff-dwellers, with a scatter of razorbills and cormorants. Eiders (Cuthbert's favourites – local people still call them cuddy ducks) choose any nook or cranny for their downy nests; puffins by the thousand dig out little tunnels on Inner Farne; and the terns (common, Arctic, Sandwich and a few rare roseates) settle in among the tussocks.

Turnstones, like this one in winter plumage, can be seen around the coast hunting sandhoppers.

The other main attraction of the Farnes is the colony of grey seals. They breed in the early winter, but on any sunny summer day can be seen basking on the rocks. Regular boat trips leave from Seahouses between Easter and the end of the summer, landing at one or other of the main islands (which are managed by the National Trust) or doing a circuit to see the seals.

Back on the mainland and a short drive up the coast from Seahouses are Bamburgh and Stag Rock, a good spot for seabird-watching. Late summer brings skuas, and winter turns up grebes, divers and long-tailed duck.

DUNE FLOWERS

Just beyond Bamburgh, in the shadows of the great castle, and around the headland of Black Rock, there are some wonderful sand dunes. During the summer the upper dunes become a tapestry of flowers. Cowslips are still

Arctic tern

Sterna paradisea

Among British birds, the Arctic tern is a true record breaker, the birds flying greater distances than any other between their breeding grounds in the northern hemisphere and their Antarctic wintering quarters. As a consequence of their travels, they experience more hours of daylight than almost any other animal on earth. Although they can be seen in many places around the British coast, one of the best places to view them is on the Farne Islands where birds nest close to paths and trails. Although the terns are not put off their nests by the visitors, they are notoriously aggressive and will dive-bomb intruders, sometimes even drawing blood with their sharp bills; sensible bird-watchers at a tern colony wear hats.

see also page 238

Arctic terns can be distinguished from their close relatives by their blood-red bills and short red legs. In subdued light, a distinction can be seen between the pure white throat and soft grey underparts.

Dark green fritillaries are fast fliers but pause now and again to feed on the nectar of dune flowers.

Lindisfarne's sand dunes harbour a wealth of plant life, including northern marsh-orchids and several other species of orchids.

Eider
Somateria mollissima

One of the highlights of a trip to the coasts of northern Britain is the prospect of seeing eiders. These stoutly built seaducks are widespread and are often seen swimming buoyantly in even the roughest of seas, or resting on rocks. Male eider look strikingly black and white at a distance, while females are mottled brown. When sitting on eggs, the female is remarkably well camouflaged and will usually sit tight even when viewed from extremely close quarters, confident in her disguise. After the eggs hatch, the ducklings are led to the sea where they live in creches comprising several broods.

see also page 227

Despite plumage differences, both male and female eiders can be recognised by their dumpy bodies and large, wedge-shaped bills. They move awkwardly on land but are buoyant and confident at sea.

THE FARNES & LINDISFARNE HIGHLIGHTS
Black and white male eiders bobbing on sea around **Farnes**. Puffins flying to and fro to their nest burrows. Guillemots, kittiwakes and shags on **cliffs**. Common and Arctic terns on **Inner Farne**. Grey seals basking on **rocks** around islands. Divers and long-tailed duck from **Stag Rock** in winter. Cowslips on the upper dunes at **Black Rock**.

© Crown copyright

AND ALSO LOOK OUT FOR...
- harbour porpoise ● fulmar
- ● great black-backed gull
- ● rock pipit ● common limpet
- ● shore crab ● edible crab
- ● dog whelk ● sea urchin
- ● sea sandwort ● sea rocket
- ● rock samphire ● marram grass
- ● sea lyme grass ● egg wrack
- ● serrated wrack ● spiral wrack
- ● bladder wrack ● kelp
- ● crab-eye lichen

Roseate terns breed among colonies of other terns but prefer less open sites, usually nesting among vegetation or in the shelter of a rock.

as common here as they once were in village England, and there are special communities of bloody crane's-bill and the most prickly, but superbly scented of all wild roses, the burnet rose. This is also the place for sand-wasps and cinnabar moths, and the dark green fritillary butterfly.

Black Rock looks out over a unique seascape. Away to the right are the Farne Islands, and the Longstone lighthouse. To the left is the broad expanse of Budle Bay, and ahead, over a fast-running channel and beyond the sweep of Ross Back Sands (which must be the most deserted few miles of beach in England), lies

Holy Island. This magical island is only cut off for a few hours at high tide; monks used to cross the Fenham mudflats on foot, but these days people drive across the causeway from Beal, a few miles to the north. Although there is a car park in the village, the only way to get around is by walking – a circuit takes a couple of hours. To the north and west of the island a long drift of dunes leads to the Snook. These dunes, and the damp slacks or hollows between them, are renowned for midsummer wild flowers; carpets of northern and early marsh-orchids, and

a sprinkling of coralroot and dune helleborine.

Perhaps the best time to be on Holy Island is in the depths of winter, on a frosted-glass morning. Rafts of scoters and long-tailed ducks bob in the swell. Purple sandpipers and turnstones patter around the rock pools, and low over the dunes a merlin dashes after pipits. In the far distance a skein of pale-bellied brent geese pass the Snook and pitch in to land on the saltings.

Scotland

Lochs and mountains, heather moors and rugged coasts are some of the features that spring to mind when Scotland is mentioned. But this small country, at the north-western edge of Europe, is much more varied than the traditional perception from beyond its borders might suggest. Scotland is a place of enormous contrasts – between regions, seasons, places and people – and all the richer for that.

Framed by native Scots pine trees, Loch Maree in Wester Ross is at the heart of prime Scottish walking country in the Highlands. The open moors, once cloaked in forests, now afford the rambler spectacular vistas which are home to exciting plants and animals.

I t is virtually impossible to define any one person or locality as typically Scottish. The different histories and cultures of a borderer and a Hebridean; the contrasting experiences of Shetlanders and city-dwellers of the central plain, all serve to emphasise the astonishing variety of this country, in its society and speech, as well as in its scenery.

LANGUAGE OF THE LAND

A borderer, growing up among the rounded inland hills that look towards England, has little in common in speech or environment with an islander from the Outer Hebrides, where the sea and the Gaelic language shape life and culture; and as you travel from place to place, you encounter a host of local dialects and regional speech variation. Picts, Celts, Vikings, Anglians from Northumbria, lowland speakers of 'Broad Scots' and others besides have left their marks, both visible and audible, on the land, a multilingual legacy which has been boosted further through influences from recent Irish, Italian, Polish and Asian immigrants.

Look at any map sufficiently detailed to show local features in any part of Scotland, and the placenames reveal something of the country's rich human and natural history: 'Moss' names, which give echoes of peatlands now perhaps long-vanished; names with the prefix 'Pit' or 'Bal', showing where those shadowy Dark Age people, the Picts, had their heartlands; Gaelic names full of descriptions of species and natural colours, such as the Monadhliath (the Grey Hills), which face the Cairngorms (the Blue Hills) across the floodplain of the River Spey. Such are the layers of meaning added to Scottish places by the hundreds of generations who have

Mature pine forests and the snow-flecked tops of the Cairngorms are reflected in the tranquil waters of Loch Morlich, the haunt of goldeneye, red-throated diver and osprey.

lived here in the last few thousand years.

If differences and cultural complexities such as these are true of Scotland's people, then variety in communities of wildlife is just as pronounced. At 77,700 sq km (30,000 square miles), Scotland could fit into Brazil over 100 times with room to spare. But Scotland has a

SCOTLAND HABITATS

Discover cliffs

S et against a backdrop of open sea, the cliffs which fringe the British coastline produce what is arguably the most dramatic scenery in the land. In rough weather the scene can appear positively elemental, with waves pounding seemingly impregnable rock faces. Revisit the site in spring, however, and the chances are the cliffs and sea will have assumed a more benign quality, the relative tranquillity reflected in displays of colourful flowers and an abundance of breeding seabirds.

A cliff-top walk during a winter storm is an invigorating experience and it is not hard to grasp the fact that cliffs are formed where sea erodes land. The height of any cliff reflects the

Seabird colonies can be remote, but are easily seen at the RSPB's Fowlsheugh reserve in Grampian.

Although forced to return to land each spring to breed, guillemots, like many seabirds, are far more at home in the air and on water.

topography of the land that is being eroded, but the gradient, and the way in which it erodes, depends largely on the type of rock involved and the relative exposure of the site to prevailing winds and tides.

It is hardly surprising, therefore, that cliffs are not universally good for wildlife; for example, the best floral displays are often found on relatively gently shelving slopes, while cliffs of hard, stratified rocks often

large surface, borne up obliquely in the corrugations of its many mountains, and a coastline so deeply indented and studded with islands that a lifetime can seem too brief to do it justice.

SPRING JOURNEY

Imagine taking a spring journey, from the eastern lowlands between the rivers Tay and Dee, overlooking the North Sea, across the hills to the west coast and out to the islands. Spring comes to the lowlands not with the call of the cuckoo, but with the 'birl of the peesie'. Lapwings, peewits, teuchits, peesies – call them what you will – the sound of their territorial cries is particularly welcome to those who come from places where the crops have changed to winter-sown and these waders have vanished. The black and white birds fly over the red earth of farms in Tayside and Grampian, where some barley or grass is still sown in the spring.

Move inland from the Howe of the Mearns, near Stonehaven, and savour the extra sounds of the Grampian foothills. Redshank and oystercatcher near noisy spate rivers, snipe in the rushy corners and curlew on the drier ground make a squeaking, piping chorus, joining the sound of rooks in the tall plantations of pine. Beyond, the Cairngorms stretch

Their camouflaging plumage renders snipe difficult to spot when feeding or nesting in grassland. The long bill is used to probe damp ground for worms.

away in a series of high-level plateaux.

At first sight, this largest continuous chunk of mountain ground in Britain and Ireland seems unexceptional, its outer ramparts rather uniform. But push on and the true glories gradually unfold. There may be vast views or no views at all, as the mist or blizzard clamps down on the tops. Mountain flowers cling to scraps of soil at the fringe of steep crags; fell-fields of shattered stone lie among late snowbeds; the whole area has a true sense of wildness.

Down and westwards, many glens, lochs and river courses point towards the farther seaboard. But first, there is the watershed to cross, the major divide of mountain ground that separates the Highlands into two quite distinct parts. The

Lapwings can be found nesting on moors and open grassland throughout the region. Birds on high ground move to lower, milder areas in winter.

Wintry and quite magnificent, this is the broad valley of Glen Feshie in the Cairngorms. The river is flanked by Caledonian pines.

harbour the best seabird colonies.

Plants that grow on coastal cliffs live in a harsh environment, having adapted to thrive in conditions that exclude vigorous, but less hardy, inland species. Cliffs are windy more often than not and salt spray is an ever-present factor with which plants have to contend. Rainfall is high relative to inland sites, especially so on the west coast of Britain, but what little soil is present is usually very free draining and so freshwater is at a premium.

On the positive side, the presence of the sea exercises a moderating influence on climatic extremes so that summers are relatively cool, while prolonged frost and snow are rare near the sea in winter.

Plants that are truly salt-tolerant tend to be most prolific low down on any cliff, characteristic species including thrift, sea campion, sea plantain

Gannet

Sula bassana

The gannet is the largest British seabird. Its cigar-shaped body, long pointed wings and distinctive black and white plumage make it unmistakable. Breeding colonies are dotted around northern and western coasts – one of the most important on the Bass Rock. Wide-

At a large gannet colony, thousands of birds sit on nests that are built at regimented distances from one another.

ranging for food, gannets are a common sight away from their colonies in summer and can be seen off most headlands down the west coast; they pass close to land when there are strong onshore winds. They are at their most dramatic when plunge-diving after fish such as mackerel. When feeding is good, huge numbers gather in one spot.

and rock samphire. Further up the cliff, where the effects of salt spray are moderated, more generalist plants such as gorse and bell heather may appear if soil conditions permit.

For many cliff-top visitors it is the prospect of seeing seabirds that is the main attraction. Dramatic colonies are few and far between – Scotland holds many of them – but they provide a true

spectacle of numbers. Nesting seabirds need certain conditions: the cliff must be inaccessible to land predators and free from human disturbance, the rock structure must provide a range of nesting sites from ledges and rock crevices to gently shelving areas, all the better if there is sufficient soil for burrowing to take place; lastly, there must be good feeding close to shore.

Most good seabird colonies are protected and typical breeders include puffin, razorbill, guillemot, fulmar, kittiwake, herring gull and great black-backed gull.

Tussocks of colourful thrift are a feature of many sea cliffs and are often at their best in June. They can tolerate the sea's salt spray.

Although unobtrusive and largely nocturnal, wildcats are sometimes seen by lucky observers during the daytime, often resting near their lairs in rocky or wooded areas.

Grazing pressure results in slow regeneration of native forests but mature Scots pines still dot the margins of Loch Tulla, Argyllshire.

main part of the mountain spine that runs up the country from Loch Lomond to Durness rises just inland from the coast. Some 120 tops of more than 914m (3,000ft), with many more just below that altitude, are deeply separated by steep-sided glens. These mountains draw in a huge rainfall from the Atlantic-driven clouds – 500cm (197in) a year is not uncommon, and more than that on the major peaks such as Ben Nevis, the highest mountain in Britain.

Along this west Highland backbone, rivers flowing west drop steeply to the sea, while those flowing east have a shallower, longer run. Apart from the Clyde, which runs south–east to north–west for part of its course, all major Scottish rivers flow eastwards.

WEST AND EAST

Along the west coast, more than 80 sea lochs push deep inland between the hills. Ice Age glaciers left more obvious sculpting on the Scottish landscape than most earlier earth- and rock-moving processes, and they gouged out the sea lochs, dumping sills of rocky moraine at their entrances. Lochs differ but typically they have broad, deep basins and narrow, shallow mouths. Thanks to them, the warming influence of the sea can penetrate far inland.

These fjord-like sea lochs are a distinctive west Highland feature. Along the western shore, from Assynt to Argyll, spring comes later than in the east, and more quietly. A pastel unfolding of primroses on warm banks in silent oakwoods, when lichen-smothered trunks are still fogged with frost, gives a promise of new life, long before leaf-burst on the boughs above.

Watered by the copious western rains, the oakwoods along this fringe are a kind of temperate rainforest, richer in their variety of damp-loving mosses, lichens and liverworts than any other woods in Europe. Later, when

SCOTLAND HABITATS

Discover still water

The sound of running water may have a soothing effect, but if it is tranquillity you are after then few things can rival the still water of a lake on a warm summer's evening. The mirror-like surface reflects the lush surrounding vegetation and clouds of small insects take to the wing – a food source for their larger cousins, the dragonflies, along with swallows, martins and other insect-eating birds. The peacefulness of the scene belies the activity of life in the water below, this being every bit as prolific as that in the air above.

In lowland Britain, bodies of still water are categorised broadly according to their size and depth: ponds are relatively small and shallow and lakes are larger and deeper. In Scotland, these are often referred to as lochans and lochs respectively. Scottish stillwaters, however, often harbour different species.

Water chemistry has a strong bearing on the ecology of any water system: nutrient-rich and neutral to base-rich systems are generally more productive than acid, nutrient-poor conditions.

White water-lilies flourish in calm, tranquil waters and flower in mid-summer.

Undisturbed lakes and lochs support a lot of invertebrate life, as well as submerged and emergent vegetation.

summer comes, wood warblers, redstarts and tree pipits will call from their groves, where wildcats and pine martens still hole up under fallen trees or make their dens in rock piles.

THE ISLANDS

Beyond the coast, two lines of islands – the Inner and Outer Hebrides – extend offshore along almost the entire length of the western mainland, from Kintyre in the south to Cape Wrath in the north.

Push westward from island to island (each one different from its neighbours) and the contrast in wildlife from the mainland coast becomes more and more pronounced. Apart from tantalising, distant outliers such as St Kilda, the Outer Hebrides are mainly one long chain of islands, and each part can be a pleasure in itself. Begin, for example, in the north and work your way southwards, starting at Stornoway Harbour, where grey seal bulls compete to grab offal from fishing boats. It's not far from there, by foot or cycle, to moors and peat-banks, waving with cotton grass and haunted by diver and raven calls.

A bus ride brings you to the rocky barrens of the Harris tops, where grey hills rise beyond white dunes and cool, blue waters. Car ferries cross the magnificent lagoon shallows of the Sound of Harris, watched by black guillemots on the channel buoys and seals on the skerries, to the loch-studded flatlands of North Uist, hunting waters for many otters.

Walk on southwards, over the machair grasslands of Benbec-ula and South Uist's Atlantic edge, busy with redshank, dunlin, oystercatchers and other waders. Formed on

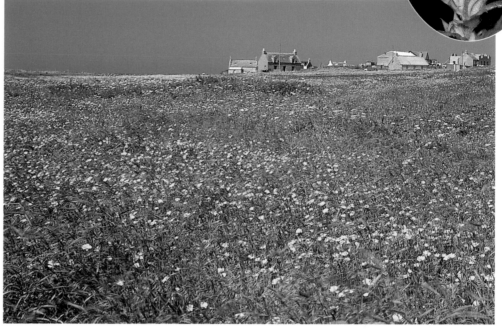

A view across Balranald RSPB reserve in North Uist. Hay meadows and the colourful 'machair' are characteristic of Hebridean islands and are reminders of a landscape that has gone from many parts of Britain.

Eyebright is a flower characteristic of short turf and is semi-parasitic on the roots of grasses and other plants.

A grey seal yawning. The species is generally common and widespread along rocky stretches of the Scottish coast.

Lochans and lochs north of the border are normally acid, nutrient-poor and have limited wildlife diversity, but this masks the fact that many of their plants and animals are unique.

Sunlight cannot penetrate water to any great depth and so the growth of aquatic plants is generally limited to the top few metres. Ponds, on the whole, are shallow enough for plant life to flourish throughout the water column, with open-water species, such as water-lilies, rooted in the mud at the bottom. This sediment supports a wealth of invertebrates including molluscs, crustaceans and the nymphs and larvae of insects; a similar diversity is often found among the marginal vegetation as well. Small species of fish, such as sticklebacks, often thrive in ponds, and amphibians are drawn to them each spring to spawn.

Although the margins of lakes have a lot in common with those of ponds, their open waters are strikingly different. With waters too deep to support anchored or rooted plant life, photosynthesis is often carried out by planktonic algae. In undisturbed lakes there

Shore-weed

Littorella uniflora

But for the shape of its flowers and the fact it grows along freshwater edges, this curious plant could easily be passed over as a tuft of grass. It is actually a member of the plantain family, as indicated by the projecting stamens seen in male flowers. As its name suggests, shore-weed is a plant of lake margins, generally growing on shingle and gravel at, or just below, the water line. As the summer months progress and the water level drops, the plant is often exposed to the air. Shore-weed forms tufted rosettes of tough, grass-like leaves which are flat on one side; these are dark green, sometimes with a reddish tinge.

Spiky rosettes of shore-weed form areas of 'turf' around the shores of many shallow lochs and lochans.

see also page 309

Red-throated divers swim low in the water. Their streamlined profile speeds progress during dives for fish. On land they shuffle awkwardly.

Summer

Winter

is a stark difference between the temperature of the shallow surface layer and that of the water below. This has a profound bearing on the activity of the animals of the lake and their position in the water column.

Man-made water bodies such as reservoirs and flooded gravel pits are generally less productive than more natural waters. Although this often reflects their relative infancy, the steep profile and underlying soil is also influential. Human activities such as fishing continue to effect the ecology of these, and more natural bodies, of still water.

Meadow crane's-bill flourishes in hedge bottoms and in undisturbed grassland. Absent from northern Scotland, its showy flowers appear elsewhere from June to September, attracting bees.

The call of the corncrake is now a rare sound but can still be heard on many Hebridean islands.

calcium-rich shell sand, blown inland from Hebridean strands, the machair has been shaped for millennia by sea winds, and for centuries by a particular pattern of agriculture, somewhat akin to the seasonal movement of livestock on traditional lowland hay meadows.

This has produced a cornucopia of floral brilliance. Crane's-bills, wild carrot, yellow-rattle, meadow rue, eyebrights and violets are some of the flowers which may mix in profusion in a

single machair sward. On both Outer and Inner Hebrides, the cultivated ground fringing such areas is a European stronghold of the globally threatened corncrake. Now, thanks to partnerships between the crofters, who work this land, and bodies such as the RSPB, corncrake numbers are rising in the Hebrides.

EMPTY COUNTRY

Mainland Scotland is only 442km (274 miles) long, from Cape Wrath in the north-west to the Mull of Galloway in the extreme south-west. From east to west, Scotland is a mere 250km (155 miles) at its broadest. Scotland's shores are richly indented, producing a mainland coastline of some 4,000km (2,485 miles), while nearly 800 islands have a coastline of around 6,000km (3,728 miles).

Only 126 Scottish islands are inhabited, and only about one-tenth of the coast is used on a regular basis for work, homes and leisure. Huge stretches of the Scottish coast are scarcely visited, and the potential for quiet encounters with wildlife here is enormous. What applies to the coast also holds true for many parts away from the sea. A few places are hotspots, such as readily accessible high mountains and watchable osprey nests, but many areas are trodden by relatively few residents or visitors.

This offers fine opportunities for undisturbed

Few sights are more dramatic than that of an osprey snatching a fish from a loch.

wildlife-watching. But the peace, in some places, can be bittersweet. Especially in the northern and western Highlands, the lack of people stems in part from massive depopulation in the 19th century with the notorious 'Highland Clearances'. At that time, thousands of glen-dwellers were forced to emigrate or move to smallholdings on the coast.

Part of the reason was that the population, as in Ireland, had grown larger than the land could support, and was vulnerable to sudden food shortages, such as those caused by failures of the potato crop. But much of the exodus and

SCOTLAND HABITATS

Discover moorland

Grass moorland at Kintyre, with areas of heather and stumps of previous heather burnings.

The term moorland is used to denote the wide, open terrain that characterises so much of upland Britain. Little of it is cultivated but activities including sheep grazing, grouse shooting and forestry all have an impact on moorland wildlife as a whole.

Except where the terrain or climate dictated otherwise, the original, natural vegetation of our moorland areas would have been woodland. Over much of the region this comprised deciduous species such as downy birch, sessile oak and rowan, while in the Highlands of Scotland the native Scots pine would have predominated. Clearance by man over the

centuries created the open landscape we see today.

Apart from a few pockets of upland broad-leaved woodland and remnants of the old Caledonian pine forests in Scotland, upland forests seen today have been planted in recent times and often comprise rows of same-age, alien conifers.

Compared to its lowland cousin, the blackbird, the ring ouzel is a shy bird, confined to rugged and isolated rocky outcrops in the hills.

resettlement came from the decision by owners of large tracts of land – the lairds – that sheep would be more profitable than peasant rents on their extensive holdings.

Scotland has the most polarised system of land ownership in western Europe, with much of it, especially in the uplands, under the control of a few hundred people. Major tracts of country of prime value for wildlife, scenery and local communities, can be traded to the highest bidder on the international property market.

This seems set to change. Buoyed up by successful, community-linked purchases of estates in the west, including the island of Eigg and the mainland crofting area of Assynt, a groundswell of current opinion suggests that the new Scottish parliament may revise antiquated laws on landholdings, some of which have remained unchanged since the Middle Ages.

This, in turn, could benefit wildlife, since recent community land purchases have seen conservation of both natural and human heritage as central parts of their mission. The future pattern of landholdings in the Scottish uplands could be very different, not only because of reform, but also in response to changing pressures on agriculture and rural enterprise.

NATURAL BOUNDARIES

In addition to the major feature of the western mountain watershed, a long-established, threefold division of the Scottish mainland into Highlands, Central Lowlands and Southern Uplands recognises some of the most fundamental landform and geological differences in the country. Beginning with the southernmost of these, a major faultline is associated with the Solway Firth – that huge, soft-edged arm of the

Barnacle geese are winter visitors to the region, flocks arriving from their high Arctic breeding grounds in October.

sea which has its southern shore in England and its north in Scotland. This fault marks the boundary between two ancient continents: Laurentia, in the north, and Avalonia, in the south. About 500 million years ago, these continents lay further apart than Britain now does from North America, separated by the great Iapetus Ocean. When the ocean crust between them was swallowed into the earth through continental drift, Iapetus vanished and the continents collided. The sustained shock of this monumental impact thrust the Southern Uplands into being and united the previously separate landmasses of Scotland and England.

The Firth, which straddles the scene of these earth-shaking events, seems peaceful enough at a distance. Closer up, it teems with wildlife. Its shores hold tens of thousands of birds at times of peak autumn and spring movements, and are used regularly by 19 kinds of wader and 18 species of wildfowl. Scotland's only sizeable wintering flock of pintail and the entire Svalbard breeding population of barnacle geese, many of them wintering at the Wildfowl and Wetlands Trust reserve at Caerlaverock, are the wildfowl highlights.

Saltmarsh on the Solway Firth attracts vast numbers of wildfowl and waders from autumn to spring.

Factors such as soil type, climate, drainage and altitude have a strong bearing on the nature of any stretch of moor. In many areas, grasslands predominate, and the species that occur are largely influenced by rainfall and altitude.

Purple moor grass and species of fescues are common, with mat grass typical of higher slopes. Sheep can upset the natural balance and heavy grazing often leads to the predominance of unpalatable rushes.

Bog asphodel grows where the ground is wettest. It tolerates extremely acid soils.

From a visual point of view, heather moorlands, which prevail over large areas of upland Britain, are the most attractive – certainly during the summer months when the vegetation is in bloom. In many ways, heather moorland is the upland counterpart of heathland and it is characterised by many of the same species, notably ling, bell heather and cross-leaved heath.

Large tracts of heather moor in northern Britain are managed for red grouse, and systematic and periodic burning is used to promote a constant regrowth of heather shoots.

Where the terrain or geology prevents adequate drainage, neither heather moorland nor grassland can successfully colonise, and these boggy areas become the domain of sphagnum mosses and a few specialised flowers such as bog asphodel and insectivorous

butterwort and sundews.

In places, bogs may be restricted to small pockets such as valley bottoms, but in parts of Scotland, notably the Flow Country of Caithness and

Sutherland, they blanket vast areas. Such habitats are, by their very nature, inaccessible and the lack of disturbance results in large numbers of breeding waders and wildfowl.

Cowberry

Vaccinium vitis-idaea

This low-growing relative of the bilberry is characteristic of upland areas in Britain. The leaves of cowberry are broadly oval and leathery, with a glossy, waxy surface. The small but attractive flowers recall miniature bellflowers, but are pale pink. They are carried in clusters at the ends of leafy shoots, the tips of which are often slightly drooping. The flowers appear from May to July in succession and, when fertilised, form berries which ripen bright red. Birds of the region, and passing migrants too, find them a welcome feast. Cowberry is typically seen creeping over the ground or among low vegetation.

The textured leaves and luscious-looking berries of cowberry are often best appreciated on a dull day, on account of the highly reflective surfaces of both structures.

see also page 296

THE SOUTHERN UPLANDS

From the border with England northwards, typical Southern Uplands scenery comprises rounded hills with smooth slopes. The valleys cut in the Ordovician and Silurian rocks here are usually narrow, deep and steep-sided; the surface shaping of the rolling green hills is a legacy of long-vanished glaciers. In the west, isolated granite outcrops, volcano-forged, give a contrast to the dominant whaleback relief of the borderlands in the high ground at Criffel, Cairnsmore of Fleet and the Merrick (the highest point in Scotland south of the Highlands).

East of these granite lumps, stranger forces are said to have formed the three most prominent but smaller volcanic necks of the Eildon Hills, which tower over a loop of the river Tweed between the old abbeys of Melrose and Dryburgh. Legend has it that Michael Scott, a scholar and astrologer from the Borders, and one of the most famous magicians in Europe in the Middle Ages, cleft Eildon in three in a single night. Whether that disturbed the repose of the sleeping King Arthur and his knights, also said by some to lie there, is not recorded.

THE CENTRAL LOWLANDS

The junction of the Southern Uplands with the central plain beyond runs south-west from the North Sea coast near Dunbar to meet the outer reaches of the Firth of Clyde, south of Ballantrae. In the east, this boundary is marked by abrupt descents from high ground to low along the line of the South-

Chickweed wintergreen belongs to a select group of flowers whose distribution in Britain is centred on Scotland.

River Teith near Callander, Central region. Manty rivers are fringed with marshes, the haunt of waders and wetland flowers.

ern Uplands Fault, but in many places this feature is much less distinct than its northern counterpart along the boundary of the Highland line.

The land between these faults probably formed far to the west, at the fringe of Laurentia, and then was shunted into Scotland along the Highland faultline. Later, volcanoes added punctuation marks of steep relief to the plain, so that here, as throughout the country, you are never far from a good-sized hill.

The great majority of Scotland's 5.1 million people live in this region, which includes the cities of Glasgow and Edinburgh, and whose mines, ironworks, factories and shipyards were powerhouses of earlier industry. Many of these activities have given way to newer technology,

SCOTLAND HABITATS

Reading the landscape

Dramatic black basalt columns at Fingal's Cave on Staffa in the Hebrides inspired Mendelssohn, Keats and many other artists.

The landscape of Scotland overlies some of the most complex geology in the world. The Southern Uplands, the Highlands and the country in between are geologically and scenically very different; the far west offers yet more contrasts.

The Southern Uplands are geologically similar to Wales, and this is reflected in the landscape; sheep farming and forestry largely dominate the rural scene.

The lower belt of country, which includes Glasgow and Edinburgh, is a rift valley, similar to – but much older than – the great rift valley of Africa. Some 300–400 million years ago, old

Unlike many streams in the south, most Scottish burns continue to flow all the year.

red sandstone and Carboniferous rocks were laid down on its floor, and at the same time lava erupted spasmodically, producing such hills as Arthur's Seat in Edinburgh, the Campsie Fells near Glasgow and the Ochills

but the aftermath of the old ways is still highly visible – in the spoil heaps or 'bings' that rise above towns and farmland; in the canal which joins the rivers Forth and Clyde; in the many reservoirs constructed to meet urban needs; in the network of current and old railways, and in the dense concentration of housing. Features like these can now be a boon to wildlife, from rare orchids on bings to waterfowl on reservoirs.

THE HIGHLANDS

To stand on the Menteith Hills, or many other places along the Highland Boundary Fault not far from the industrial hub, can give an awesome overview of a chunk of the nation. To the south, the productive plain, city and seascapes stretch towards the distant uplands. To the north, the quartzite and granite hills are heaped like waves of stone to the horizon.

The mountains are divided by sea lochs that gouge deep into the land; icy streams tumble through wooded glens; and there are large inland lochs. There are few people but the Highlands have a distinctive wildlife, typified by the golden eagle, red deer and salmon.

Each glen between these Highland hills is different, its individual sculpting owing much to the cut, thrust and smoothing of Ice Age glaciers which gripped the land a mere eyeblink of Earth history ago. Within recorded history, each major fold of these uplands, each fertile floodplain or 'strath', each old woodland and each mountain pass influenced the ways in which men worked the land. Now such features and more besides are what makes each Highland community distinctive from its neighbours.

Across the nation as a whole, the possibilities for exploration among the massed mountains,

Heathers, tormentil and coltsfoot enliven the grassland and sedges of Glen Torridon in this view up to the stark outcrop of Liathach.

Red deer are most visible and vocal in autumn, when rutting is in progress.

lochs, glens, moors, bogs, farmlands, islands and shores are legion. Those, and the perspectives, accents and outlook of the people, are all part of Scotland's glorious diversity.

Welcome to the big country.

between Stirling and Perth.

The Highland Boundary Fault runs from Loch Lomond, past Crieff and Blairgowrie to Stonehaven south of Aberdeen; beyond it you are in a different world. The Highlands are carved from an earlier mountain range, which now lies in fragments in Scotland, Scandinavia and Greenland, but was one of the greatest ranges on earth 400 million years ago. The fault dividing the Highlands along the Great Glen, from Fort William to Inverness, is an ancient feature.

Even now, the Highlands are not trivial mountains – unlike the Alps, they start from sea level. The legacy of glaciation is all-pervading. Glacial corries facet the peaks ('corrie' from Gaelic *coire* and 'cwm' from the Welsh are now interchangeable international terms); ice-scoured valleys are punctuated by lakes; and glacier-borne rocks and

moraine are everywhere. Some 20,000 years ago, ice covered the central Highlands as it covers Greenland now; it then spilled out down valleys such as Glencoe, carving out sea lochs which were then drowned by the rising sea when the ice receded.

Climate has played its part in diversifying the Scottish landscape. During the glaciations, snowfall and ice movement (and erosion) were greatest near the sea. Nowadays a corresponding climatic gradient determines the contrast between the heathery slopes of the eastern Highlands, and the wet peaty soils and soft greens and browns of the mild, humid west.

The Highlands were thrust over rocks of even greater antiquity, exposed in a knobbly, bare-boned landscape in the far north-west. The oldest of these Lewisian rocks, over 2,500 million years old, are among the

The Pictish Broch on Mousa in the Shetlands is a reminder of Scotland's long history of settlement by man.

most ancient known anywhere. In part they are covered by sediments. The Torridonian sandstone, over 700 million years old, forms spectacular mountains such as Beinn Eighe and An Teallach, while the long

outcrop of the Durness limestone (some 550 million years old) contrasts startlingly with the rocks around it.

Farther south, and only tens of millions of years old, are the volcanic rocks of the terraced landscapes of Skye and Mull, the Cuillin peaks and the fantastic pinnacles of the Storr on Skye, and the basalt columns of Fingal's Cave on Staffa.

WHERE TO GO

Scotland

Large areas of mainland Scotland and the islands are untamed and sparsely populated countryside. Much of the region qualifies as wilderness and wildlife interest is widespread, but there are a few hot-spots that are well worth adding to your itinerary.

1. BASS ROCK

Bass Rock in the Firth of Forth is renowned for its colony of breeding gannets, holding some 12 per cent of the 186,500 pairs in Britain and Ireland. Indeed, the species' scientific name, *Sula bassana*, reflects the gannet's centuries-long links with the rock. A boat trip out to Bass Rock in spring or summer is spectacular whether you manage to land or not as, apart from being surrounded by gannets diving spectacularly for fish, you will be able to enjoy the rock's breeding colonies of kittiwakes, puffins and guillemots.

2. BEN NEVIS AND GLEN COE

Britain's highest mountain and arguably its most dramatic glen are, not surprisingly, good places to go for a chance to see upland birds and mammals. Golden eagle, ptarmigan and raven live among the tops, and dotterel have been recorded. Glen Coe is particularly good for ring ouzel, which can be found both in the high corries and further down the slopes. A small group of whooper swans provide wildlife interest in winter, and in the autumn the sound of the red deer rut is heard.

3. FAIR ISLE

Fair Isle is only a tiny dot on the map between Orkney and Shetland, but it makes a welcome landfall for migrants in late spring and autumn, and they arrive in amazing numbers and variety. Rarities are blown in, too, and these are monitored

Clear days may be few and far between on the west coast but when they do occur, the views from the summit of Ben Nevis are stunning.

at the island's bird observatory, which also provides accommodation. Even in summer the bird-watching is excellent, with plenty of breeding waders, auks and skuas.

4. THE FLOW COUNTRY

Peatland pitted with bog holes – known in Gaelic as *dhu loch*, or 'black lochs' – make up this extraordinary blanket bog at the northern extreme of mainland Britain. Naturally treeless, it is alive with the cries of breeding greenshank, dunlin and black-throated diver, which share the waters with the showy pink plant bog bean and a variety of insectivorous plants, including sundews. It is prime country for birds of prey such as the ground-nesting hen harrier and the diminutive merlin. To visit the Flow Country is to experience one of the last true wildernesses in Britain.

5. ISLE OF MAY

Situated in the Firth of Forth, the Isle of May is famed for its 12,000 pairs of puffins that arrive on the island in early spring to breed. Tens of thousands of other seabirds – kittiwakes, guillemots and razorbills – lay their eggs on ledges on the steep cliffs. Common terns, Arctic terns and shags are also common on the island, as are grey seals, which can be observed swimming or hauled up at low tide at many points around the shore. In fine weather, the island can be reached by boat from Crail or Anstruther, both in Fife.

6. YTHAN ESTUARY AND SANDS OF FORVIE

A large dune system, the Sands of Forvie supports a breeding colony of eider ducks, as well as sandwich and Arctic terns and an important colony of little terns. Waders frequent the

Preserved from the threat of blanket afforestation, the Flow Country of Caithness and Sutherland is of international importance as a haven for northern breeding birds, especially divers, waders and wildfowl.

Ythan Estuary, and in winter golden plover, ruff and bar-tailed godwit can be seen alongside more common waders. Winter is also a good time for pink-footed geese and a wide range of ducks.

7. LOCH OF LOWES

Ospreys have bred at the Loch of Lowes near Dunkeld, Perthshire, since 1969, and it remains one of the best places in Scotland to see them. They winter in Africa and arrive each year within two days of 1 April, leaving again at the end of August or the beginning of September. The Scottish Wildlife Trust

has established a visitor centre and, nearer to the loch, an observation hide equipped with powerful telescopes. The visitor centre also contains displays and interactive material for children.

8. LOCH OF STRATHBEG

On the tip of Scotland's north-east region of Grampian, the Loch of Strathbeg is only separated from the sea by sand and grass, and is a magnet for many a weary bird, as well as resident species. Tens of thousands of greylag and pink-footed geese and hundreds of swans fly in for the winter, while in summer water rail, shelduck and sparrowhawk breed. Regular passage migrants include ruff, black-tailed godwit and marsh harrier. Even spoon-bills have been recorded! There are also excellent opportunities for sea-watching, with divers, shearwaters, skuas, scoters and other sea ducks passing in spring and autumn.

9. MONTROSE BASIN

Wintering waders and wildfowl are the big attraction at the Montrose Basin in Tayside, where the River South Esk opens out into extensive mudflats. Flocks of common waders rub shoulders with more unusual passage migrants, such as spotted redshank and curlew sandpiper. The estuary attracts large numbers of wildfowl, including pink-footed and greylag geese, mute and whooper swans and a variety of ducks. It is also worth going down the estuary to the coast for good sea-watching, with a chance of spotting skuas and shearwaters.

10. MORAY FIRTH

This big east coast firth just outside Inverness has become famous for its resident population of dolphins, but in the bird-watching world it is celebrated for its huge colonies of sea ducks. Up to 15,000 long-tailed duck – three-quarters of the total for Britain and Ireland – winter in the Firth, and common and velvet scoters from Scandinavia, Russia and Siberia mingle with the occasional grebe. There are boat trips, a bridge and coastal roads to make the wildlife watching easy and rewarding.

11. WESTER ROSS

This spectacular area is dominated by remote and rocky upland habitats, home to both golden and white-tailed eagle, as well as the elusive wildcat, otter and pine marten. Wester Ross is also famed for its remnants of ancient Scots pine forest, which can be seen in a well-managed state at Beinn Eighe NNR and the nearby islands in Loch Maree – these can be easily admired from the main road. Oak and ash woods can also be found, and they are of particular interest because they are at their northern limit.

OUTER HEBRIDES
page 208

SHETLAND
page 212

ORKNEY ISLANDS
page 210

SKYE AND THE SMALL ISLES
page 206

CALEDONIAN FOREST
page 204

THE CAIRNGORM MOUNTAINS
page 202

ARGYLL AND ARDNAMURCHAN
page 198

TAYSIDE
page 200

LOCH LOMOND
page 196

ISLAY
page 194

THE BORDERS
page 192

NORTH SOLWAY COAST
page 190

Miles 0 10 20 30 40
Km 0 10 20 30 40 50 60

Shaped by erosion over countless millennia, Torridon's sandstone summits afford the energetic walker superb views over Wester Ross and the Highland coast.

Border Country

From a viewpoint on the Eildon Hills, just outside Melrose, much of the Borderland can be seen spread out around you. To the south-east, the ramparts of the Cheviot Hills form the boundary with England.

Rocky coasts are the haunt of black guillemots whose plaintive whistling calls can be heard in the breeding season.

Black grouse

Tetrao tetrix

In recent years the range of the black grouse has contracted and its numbers decreased. This is due in the main to changes in land use. This distinctive gamebird is still relatively widespread, however, in parts of Scotland, and the Scottish Borders hold good numbers of the species. Black grouse favour a mosaic of habitats comprising grassy heather moors for feeding and areas of woodland – small conifer plantations often suffice – for nesting. Equally important is the presence of comparatively bare, open areas where the males can gather at leks to display and attract females. Lekking generally occurs at first light and traditional sites can sometimes be observed beside moorland roads from the comfort of a car.

see also page 231

A magnificent displaying male black grouse fans out his tail, and spreads and curves his wings to create a lyre-shaped outline.

THE COURSE OF THE River Tweed, the area's outstanding natural feature, can be picked out as it runs eastwards towards its estuary on the North Sea at Berwick. Looking across the Tweed to the north, the land rises gently, almost in waves, to the heathery Moorfoot and Lammermuir Hills. Far away to the east, running down to the coast, is the rich agricultural land of the Berwickshire Merse.

Not surprisingly, this is an area of rich and diverse habitats. The Cheviot Hills, magnificent walking country, are characterised by rough grassland and craggy outcrops. They are the domain of upland birds such as the curlew, a welcome summer visitor, wheatear, golden plover and, in spring, the skylark with its glorious song.

The whole of the Tweed basin is designated as a Site of Special Scientific Interest. Near the salmon-rich river the otter is making a comeback, waterbirds include a large heron population and rather fewer kingfishers, while the spring flowers form a mass of colour on the banks. Much of central Tweeddale is forested and here you can see buzzards and hooded crows, and mammals including foxes, badgers and roe deer.

Large sheets of water are rare in the Borders – St Mary's Loch in the Yarrow Valley and, nearer to the Cheviots, Hoselaw and Yetholm Lochs, are exceptions. The latter two, both nature reserves, have good winter populations of pink-footed and greylag geese, mallard and wigeon. Din Moss at Hoselaw is an important peatland area with a rich fen vegetation and also crowberry, bilberry and cranberry.

At Duns Castle reserve there is an artificial lake, called the Hen Poo, with water-lilies on the surface and iris and reedmace on the margins. The surrounding mixed woodland has been supplied with nest-boxes which attract tits and pied flycatchers.

Above Selkirk lies the small but very attractive Lindean Reservoir where more than 200 flowering plants have been recorded, including grass-of-Parnassus and the beautiful northern marsh orchid. Many ducks winter here, and songbirds, including linnets, breed in summer.

BY THE SEA

Although short in extent, the Borders' coastline offers a treasury of delights. At Pease Dean, near Cockburnspath, the Southern Upland Way path runs through the reserve's lovely mix of old woodland. Among the

Walks along grassy clifftops are often accompanied by the incessant song of the skylark.

St Abb's Head is home to many seabirds during the breeding season, and the rocky shore is a haven for birds, seals and rock-pool enthusiasts all the year.

Crowberry
Empetrum nigrum

Crowberry is generally found as a low-growing, creeping perennial and is most often encountered in mountain grassland. Although not a member of the heather family, the plant is superficially similar to ling and has stems which are densely cloaked in short, spiky leaves; these are dark green and shiny. The tiny flowers, pink with six petals, appear during April and May. Following fertilisation, fruits are formed that are initially green but eventually ripen black. Not surprisingly, these are popular with migratory birds which find the late summer bonanza of food a welcome source of energy.

see also page 296

Although they may look good enough to eat, these berries are not to be recommended for human consumption!

A blanket of snow is not uncommon on high ground during the months of January and February. This makes evidence of mammal activity easy to spot.

ash, elm and sycamore can be found ancient groups of sessile oak, and paths follow the Tower and Pease burns.

Further south is perhaps the greatest glory of the Scottish Borders, the national nature reserve at St Abb's Head, managed jointly by the National Trust for Scotland and the Scottish Wildlife Trust. From April onwards the magnificent cliffs here are inundated with an extraordinary mass of birds, wheeling and calling as they fly to and from their nests. More than 10,000 guillemot breed here, along with thousands of kittiwakes, razorbills, fulmars, gannets and small numbers of puffins. The reserve also includes steep grassland which becomes ablaze with vast banks of thrift in June, a delight for butterflies, including migrants such as painted ladies.

Other reserves worth a visit include Bemersyde Moss, which draws thousands of pairs of noisy black-headed gulls; St Ronan's Wood at Innerleithen, owned by the Woodland Trust, with fine beech, sweet chestnut and Scots pine; and Whitlaw Wood, with its rowan trees, woodpeckers and rich carpet of flowers.

Sometimes misleadingly referred to as 'heather', ling is one of the dominant plants of the region. In July and August the flowers attract many insects such as honey bees.

The delightfully named grass-of-Parnassus likes damp grassland. Look out for it near the coast.

AND ALSO LOOK OUT FOR...
● cormorant ● herring gull ● lesser black-backed gull ● merlin
● stonechat ● gorse ● red campion ● herb robert ● wild carrot
● lady's bedstraw ● sheep's-bit scabious ● goldenrod

Hooded crows replace their all-black counterparts from southern Britain and are easily recognised by their grey and black plumage.

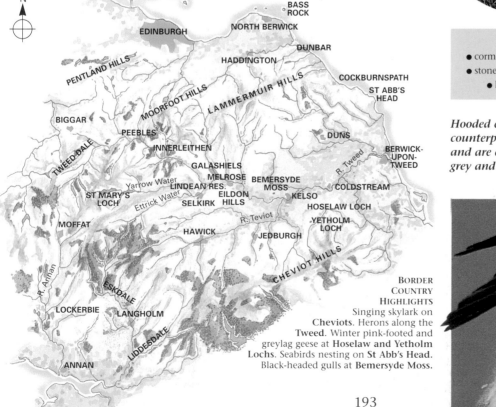

BORDER COUNTRY HIGHLIGHTS
Singing skylark on **Cheviots**. Herons along the **Tweed**. Winter pink-footed and greylag geese at **Hoselaw and Yetholm Lochs**. Seabirds nesting on **St Abb's Head**. Black-headed gulls at **Bemersyde Moss**.

Islay

When the Vikings first landed on Islay they called it 'the green, grassy Isle', a description still applicable today. The island is blessed with substantial areas of farmland, full of grazing cattle and sheep – and geese.

Spring squill, a tiny relative of the bluebell, grows in coastal grassland and appears in May and June.

ISLAY IS THE WINTER home of the one of the greatest concentrations of wild geese in Britain. Every October, more than 30,000 barnacle geese and 12,000 Greenland white-fronted geese arrive from their Arctic breeding grounds. With each dawn, noisy flocks leave their night-time roosts to

The placid waters of Loch Gruinart provide a safe haven for flocks of wintering barnacle geese, a spectacle which it is well worth visiting the island for.

graze along with the livestock in the fields, returning in the evening. To stand under a flight-line as dusk approaches and watch the clamouring skeins pour overhead and then, above the roosting area, tumble out of the sky in spirals of wheeling birds, is an unforgettable sight. With luck, the scene will be set against the glorious backdrop of a flaming Hebridean sunset. The largest numbers of geese, in flocks several thousand

Although introduced, the spotty-coated fallow deer blends in well on Islay.

Barnacle goose

Branta leucopsis

Britain has a global responsibility for the barnacle geese that visit its shores between October and March from their high Arctic breeding grounds. There are only three known nesting populations and two of them winter in Britain. Birds from Greenland can be found on Islay and other islands in the Hebrides, and off north-west Ireland; the Svalbard population winters on the Solway Firth. Like many other species of wildfowl, barnacle geese are usually found in flocks sometimes numbering several hundred individuals. Birds graze on arable land as well as occasionally on the seashore and the sight of a flock taking to the wing is one of the greatest wildlife spectacles in Britain.

see also page 224

Barnacle geese appear essentially black and white although a close view reveals a barred grey back.

strong, feed within a few miles of the two major barnacle goose roosts, Loch Indaal and Loch Gruinart, the latter of which is an RSPB reserve.

OTHER BIRDLIFE

But it is not only geese that winter here. A flock of at least 1,000 scaup lives on the sheltered waters of Loch Indaal, along with eider ducks, scoters, divers and grebes, while the sandflats swarm with feeding waders. The bird-watching opportunities are particularly good here and special laybys

have been created at prime spots around the head of the loch.

By the time the geese are leaving in April the first summer migrants are arriving, while some resident birds have already begun nesting, including the red-billed and red-legged chough. Traditionally breeding in caves in sea cliffs, the choughs of Islay have, in recent decades, taken to

Flocks of scaup are winter visitors found both at sea and on a few lochs.

nesting in old buildings well inland.

By April, too, golden eagles are already nesting on the sea cliffs, while inland, over the heather-covered moorland, hen harriers will be indulging in their dramatic pairing

ISLAY HIGHLIGHTS
Barnacle and Greenland white-fronted geese grazing in fields around **Loch Indaal and Loch Gruinart**. Scaup on **Loch Indaal**, along with eider, scoter, grebes and divers. Choughs nesting in **old buildings** inland. Golden eagles soaring above **sea cliffs**. Displaying hen harriers on the **moorland**. Snowdrops in **woods** at end of January.

N

AND ALSO LOOK OUT FOR...
● red-throated diver ● cormorant
● curlew ● grey heron ● oystercatcher
● redshank ● short-eared owl ● thyme
● marsh marigold ● eyebright
● edible crab ● edible periwinkle

Black guillemot
Cepphus grylle

Unlike other members of the auk family, black guillemots can be found scattered around the inshore waters of northern Britain throughout the year. During the breeding season these charming birds can sometimes be seen carrying fish to their nests, which are placed under boulders and in crevices on rocky coasts. When swimming and in flight, the white panel on the wings shows up extremely well against the otherwise sooty black plumage. Occasionally, birds loaf around on rocks close to the water and their bright red legs and gape can then be observed. In winter, the black guillemot's plumage changes dramatically, becoming greyish on the upperparts and white on the underparts. The white wing patch is still evident, although the contrast between it and the rest of the plumage is obviously less marked than in summer.

see also
page 239

Black guillemots breed in loose colonies on the cliffs of northern coasts.

Choughs are sociable birds, and are invariably seen in small but noisy flocks. Listen out for the calls that led to their onomatopoeic name!

broadleaved and coniferous, while over 200 lochs of all shapes and sizes are scattered across the island. Many of these are in the hills, which rise to nearly 500m (1,645ft). Cliffs and rocky shores guard much of the coastline but there are also sandy beaches and numerous sheltered coves.

There are red, roe and fallow deer on the land, and both grey and common seals breed round the coasts. Otters are widespread along the shore and also occur in some of the larger lochs. For many visitors, though, it is the wild flowers that are outstanding.

The winters are generally mild, if sometimes windy and wet, and by the end of January snowdrops are carpeting the woods, to

be replaced in turn by primroses and bluebells. Spring is also signalled by the yellow flowers of gorse creating great splashes of colour along the sides of the roads, the heady scent filling the air. Summer is when species of spotted-orchid and marsh-orchid flower profusely on the wetter moorland and on the dunes. The final colour of the year is the purple of the heather moors as autumn arrives, heralding the return of the geese.

It can come as a surprise to visitors to discover beautiful wild primroses in many of Islay's woods.

display in which the slim, grey and white males fling themselves in wild looping dives in order to attract the larger, brown females to their territories.

For many islanders, summer begins not so much with the return of the swallow, but when the harsh double call of the corncrake rises up from a patch of irises or nettles in an undisturbed

field corner. Although these curious birds are much rarer on Islay than they used to be, several pairs can still be found on the west side of the island.

ON THE GROUND
The variety of Islay's birdlife – there are more than 100 breeding species – reflects the diversity of habitats. These include woodlands, both

In contrast to the rolling farmed areas, many of Islay's sea cliffs are rugged and dramatic.

Loch Lomond

Fringed with wooded shores and dotted with tree-clad islands, Loch Lomond is Britain's largest freshwater lake – 37km (23 miles) long and 8km (5 miles) across at its widest point – and a renowned beauty spot.

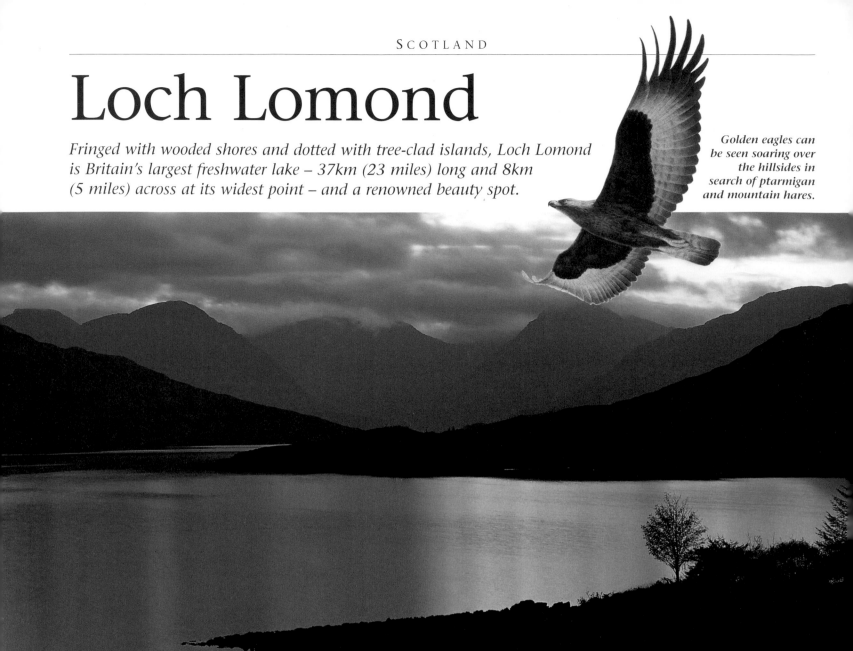

Golden eagles can be seen soaring over the hillsides in search of ptarmigan and mountain hares.

On a calm summer's evening, it is easy to see how Loch Lomond has acquired such a romantic image in both literature and song.

O N A CLEAR DAY THE sight of a golden eagle majestically soaring above Rowardennan Forest on the eastern shore is a sight never to be forgotten. Look for the long, gliding flight with the wing tip 'fingers' splayed out and upturned. The eagle, usually seen in the more upland areas above the tree line, is not to be confused with the buzzard, a bird of the woods, which can be seen patrolling the tree tops and is easily identified by its distinctive, high-pitched 'mewing' call.

Loch Lomond's other raptors include the peregrine and Europe's smallest bird of prey, the merlin, often seen streaking across the hills in pursuit of small birds. Look out, too, for the hen harrier, especially in spring when the male takes food to the female nesting in the open heather.

Islands in the loch are home to the capercaillie. On the islets off Luss, 30 pairs of these massive 'turkeys of the forest' are breeding successfully. Although foxes have been known to swim to the islands, it would take a brave animal to tackle a mature male. In the spring these huge birds, nearly a metre tall, have been known to attack anything that moves, including vehicles! The strong plier-like beak, which is used to crack open conifer cones, is a formidable weapon.

The capercaillie's close cousin the blackcock, or male black grouse, can be seen in large numbers in spring and autumn performing its early-morning ritual dance at communal display grounds, or 'leks'. Look for patches of clear ground in the area around Rowardennan Forest.

Northwards, the Ptarmigan mountain is aptly named, as it is a good place to spot its namesake. Pure white in winter, this small grouse can bear extremes of cold due to its hollow feathers. Look, too, for the mountain hare, which also turns white in winter.

WOODLAND & WATER
The lakeside oak wood of the RSPB reserve at Inversnaid is one of the most important wildlife sites in Europe. You may be lucky enough to catch a glimpse of the pine marten, known to live in the area. North of the reserve, reached by following a section of the West Highland Way, is Rob Roy's Cave, where outlaw and Jacobite supporter Rob Roy MacGregor used to collect protection money from local farmers. On the way you might see willow warbler, tree pipit, grey wagtail, chaffinch, redstart and dipper. Look out too for red and roe deer; in bad weather large groups come down from the mountains to shelter

in the area. If you are really lucky, you might catch sight of a wildcat sunning itself on a rock. Although resembling very large tabby cats, they are not closely related. Once rare, wildcats are increasing in numbers – possibly due to the population of feral goats; the kids are a good source of food.

Loch Lomond is internationally important for powan, a close relative of salmon and trout. This is a relic of the last Ice Age, when breeding populations were left isolated in freshwater lochs. Pike can also be found here; the fish holding the British record of 21.6 kg (47 lb 10 oz) was caught on the loch. Otters are often seen along the burns and rivers that feed the loch. Look for spraint (droppings) on a distinctive rock or large log; lush vegetation, due to the extra fertility from the partly digested fish, can indicate a site.

If you are very, very lucky, the 'Urisk' may make an appearance. He is the spirit of the forest, often reported on Loch Lomondside; half human, half goat, with long teeth, claws and hair.

Emergent plants such as mare's-tail can be found all around the undisturbed fringes of the loch.

LOCH LOMOND HIGHLIGHTS
Golden eagle soaring above **Rowardennan Forest**. Merlin and hen harrier on **open hills**. Black grouse lekking displays in open clearings of **forest**. Capercaillie on the **islands off Luss**. Ptarmigan on **Ptarmigan mountain**. Nesting pied flycatchers in **woods at Inversnaid**, also occasional pine marten. Red and roe deer along **West Highland Way**.

Scottish dock
Rumex aquaticus

Wellington boots are handy for appreciating Scottish dock at close range as the species thrives with its roots in water. It grows on the loch's south-east and west banks.

This robust plant only occurs north of the border, and its alternative name of Loch Lomond dock indicates its extremely limited range more accurately. Scottish dock is a perennial plant which grows on damp ground at the margins of Loch Lomond and its feeder rivers. Like other dock species, the leaves are largest towards the bottom of the plant, where they are rather oval in outline, broadest at the base and have a crinkly margin. Clusters of seed-like flowers appear in July and August and are borne in whorls on tall spikes. A botanical background and a hand lens are needed to separate this species from some of its close relatives with absolute certainty, as docks are very similar and can hybridise.

Tufted duck
Aythya fuligula

Few ducks are as easy to identify as the drake tufted duck. His plumage is mostly jet black, but pure white flanks provide a striking contrast. As the name suggests, there is a conspicuous black tuft of feathers on the head which normally droop downwards. The female tufted duck is a sombre brown colour but a short, tufted crest is usually conspicuous; both sexes have beady yellow eyes. Tufted ducks are diving birds that disappear for up to 20 seconds at a time in search of small molluscs and other invertebrates. The species is most numerous in Britain during the winter months.

see also page 227

Numbers of wildfowl, including tufted duck, build up on Loch Lomond and other Scottish water bodies during the winter months. The birds tend to form single-species flocks.

In early spring, male capercaillies gather at traditional lekking sites where they compete for the attentions of the smaller females.

AND ALSO LOOK OUT FOR...
● grey heron ● greylag goose ● goldeneye ● osprey
● common sandpiper ● black-headed gull ● redstart
● ring ouzel ● golden-ringed dragonfly ● downy birch
● lesser spearwort ● marsh marigold ● bilberry
● melancholy thistle

The Scotch argus is a speciality butterfly of the region, favouring grassy rides in open woodland. It only flies on calm, sunny days which can be few and far between.

Many visitors from the south will be familiar with siskins as winter visitors to their gardens but in Scotland this finch breeds in the pine forests.

197

Argyll & Ardnamurchan

This little-known landscape is one of great drama: huge sea lochs and bays set against a stunning backdrop of hills and ancient woodland, with high mountains and large expanses of wild terrain inland.

NOWHERE IN ARGYLL are you far from the sea. From the long stretches of white beach near Campbeltown, to the dramatic rocky shores further north, some of the most fascinating wildlife is found in and around the water. Sea-going shearwaters, turnstones on the shore and curlew probing the mud or keeping lapwings company in the fields – all hug the coast. A sea journey from any point along the coast might bring you alongside a minke whale as it rises to blow. Special boat trips can be taken from Mull, and Ardnamurchan lighthouse, the most westerly point on the British mainland, is now an observation centre for minke and killer whales,

In winter, Britain's smallest bird of prey – the merlin – moves from its moorland breeding habitat to the coast

varying species of dolphin and porpoise, and even the huge basking shark.

Where the Gulf Stream washes the western coasts the climate is warm and damp, producing great swathes of ancient broadleaved trees hung with the feathery lichens that indicate more clearly than any scientific test that this is clean air. From the reserve of Taynish in Mid Argyll to Ariundle in Ardnamurchan, the woods are alive with birds – from tiny goldcrests, treecreepers and long-tailed tits to great spotted woodpeckers, predatory sparrowhawks and buzzards. The butterflies and moths frequenting the sunny glades have

The sheltered waters of Loch Leven support a rich growth of seaweeds and a wealth of animal and bird life.

turned Argyll into a mecca for lepidopterists, with the rare chequered skipper drawing enthusiasts from all over the world. Along the burns and in the boggy, damp hollows damselflies and dragonflies flit among asphodel, sundew and many species of orchid.

FLOWER GARDENS
Flowers of all kinds are a hallmark of the west, and patches of machair – the grassy swards dotted with eyebright, trefoil and wild pansy – can be found up and down the coast. A speciality is the tiny fairy foxglove that clings to the stone Atlantic Bridge crossing the sea to the Isle of Seil, but most dramatic of all are the displays of rhododendrons that burst out of the wooded slopes come springtime.

In the 19th century Argyll landowners turned

Non-intensive, small scale, arable farming is perfect for wild pansies – seen in early summer.

to plant collecting and created many superb gardens, some of which are open to the public. Local wildlife finds a happy home among the sub-tropical bamboo and pal in jewels such as Arduaine, or Crarae.

In Ardnamurchan, you barely set foot off the

Black-throated diver
Gavia arctica

In the summer, a few large, undisturbed lochs still echo to the haunting and evocative calls of black-throated divers. For many people, these sounds have come to symbolise the wild, untamed nature of the region. Like other divers, black-throats swim buoyantly but low in the water. Striking black and white markings adorn the neck and back in breeding plumage, becoming more uniformly grey and white in winter. As its streamlined appearance suggests, the black-throated diver is a consummate swimmer, able to dive for long periods in search of fish.

see also page 222

Black-throated divers grace the waters of fish-rich lochs from April to July. The calls of these elegant birds are one of the most haunting Scottish sounds.

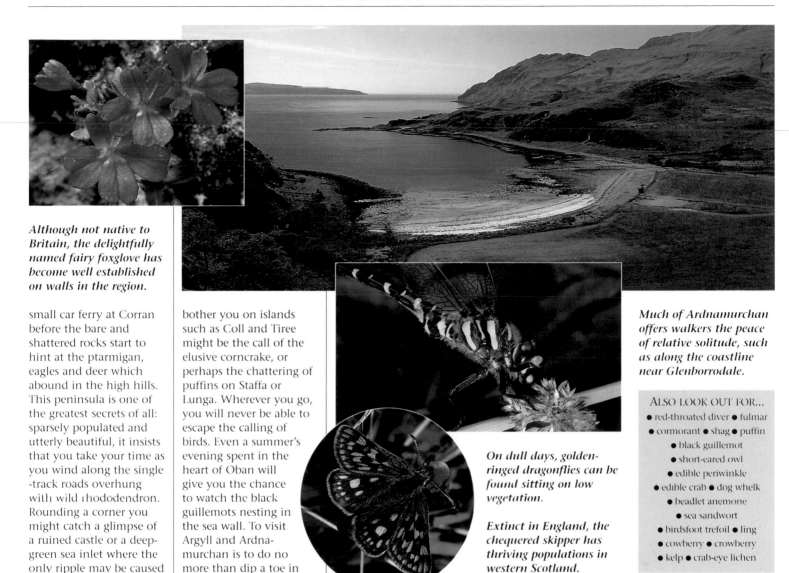

Although not native to Britain, the delightfully named fairy foxglove has become well established on walls in the region.

small car ferry at Corran before the bare and shattered rocks start to hint at the ptarmigan, eagles and deer which abound in the high hills. This peninsula is one of the greatest secrets of all: sparsely populated and utterly beautiful, it insists that you take your time as you wind along the single-track roads overhung with wild rhododendron. Rounding a corner you might catch a glimpse of a ruined castle or a deep-green sea inlet where the only ripple may be caused by an otter slipping away.

Opportunities for solitude are many: the only sounds likely to

bother you on islands such as Coll and Tiree might be the call of the elusive corncrake, or perhaps the chattering of puffins on Staffa or Lunga. Wherever you go, you will never be able to escape the calling of birds. Even a summer's evening spent in the heart of Oban will give you the chance to watch the black guillemots nesting in the sea wall. To visit Argyll and Ardnamurchan is to do no more than dip a toe in the clear, cool water.

On dull days, golden-ringed dragonflies can be found sitting on low vegetation.

Extinct in England, the chequered skipper has thriving populations in western Scotland.

Much of Ardnamurchan offers walkers the peace of relative solitude, such as along the coastline near Glenborrodale.

ALSO LOOK OUT FOR...
- red-throated diver ● fulmar
- cormorant ● shag ● puffin
- black guillemot
- short-eared owl
- edible periwinkle
- edible crab ● dog whelk
- beadlet anemone
- sea sandwort
- birdsfoot trefoil ● ling
- cowberry ● crowberry
- kelp ● crab-eye lichen

ARGYLL & ARDNAMURCHAN HIGHLIGHTS
Whales, dolphins and porpoises or even basking sharks from **Ardnamurchan lighthouse.** Trees festooned with feathery lichens in **woods.** Eyebright, trefoil and wild pansy in the **machair.** Flowering rhododendron on **wooded slopes.** Fairy foxglove on bridge to **Isle of Seil.** Black guillemot at **Oban.** Little grebes on **Loch Etive.**

Minke whale
Balaenoptera acutorostrata

In the past, most records of whales around the British coast came from chance observations by seabird enthusiasts or from beached corpses. In the last decade, however, sightings in certain areas have become regular and reliable thanks to a growing army of cetacean enthusiasts creating an awareness of the possibilities for whale- and dolphin-watching. The comparatively sheltered waters around the Inner Hebrides arguably provide the best opportunities for observation in Britain, the minke whale being the main attraction.

see also page 221

The minke whale may be the smallest of the baleen whales, but at a length of some 10m (33ft), an adult is often larger than the boat from which it is being observed. A white spot on the flipper is a diagnostic identification feature.

Tayside

Salmon are widely regarded by fishermen as the 'King of Fish', and the sight of one leaping the rapids is indeed majestic. The River Tay and its tributaries are renowned strongholds for this and other wildlife.

A FEW CENTURIES AGO, most of Britain's larger rivers would have been graced by a migratory, clean-water fish – the salmon. Today many rivers are unsuitable for its requirements and the fish's name has become synonymous with the Scottish waters in which it now thrives. The River Tay is arguably the quintessential example.

Salmon are truly remarkable fish, not only because of the size they attain but also on account of their life history. Spawning takes place in the gravel shallows of the river's upper reaches in late autumn and early winter, the adult fish having migrated from the sea earlier in the season.

The eggs are placed in depressions – known as redds – in the river bed and then covered with small stones. The work of excavation and the subsequent breeding behaviour of the fish can sometimes be witnessed from the river bank by discrete observation.

So demanding are the exertions associated with spawning that few of the adult fish survive long enough to make the return journey to the sea.

Over a period of two or three years, the young fish that emerge from the eggs as fry grow and pass through developmental stages where they are known as 'parr' and then 'smolt'; growth is linked with a gradual move downstream and eventually the smolts move out to sea where they feed and mature into adult salmon.

Almost any sidestream or feedstream on the Tay where the water is less than 15cm (6in) deep over gravel is a potential spawning ground, and juvenile salmon are relatively easy to see in the crystal waters of their nursery streams.

Look for common sandpipers at the water margins. They often perch on rocks or feed in the shallows.

The dipper is a familiar sight, perched on stones in mid-stream as it hunts for insects.

It is more difficult to see the adults except when they leap from the water to free themselves of parasites or to escape capture by anglers. However, in the autumn, when fish are desperate to get upstream to their spawning grounds, they will often leap substantial waterfalls. Migrants can also be seen from the viewing chambers on fish passes, constructed to allow them to circumnavigate hydro-electric dams; the Pitlochry Dam on the River Tummel

Salmon

Salmo salar

Most large rivers across Scotland play host to adult salmon during the winter months, the fish visiting the waterways where they were hatched in order to spawn. They usually arrive when the river is in spate, the rise in water level assisting their progress. After spawning in the headwaters the exhausted females try to return to the sea. Those that make it, swim far out into the Atlantic, feeding up for a number of years before returning as truly massive fish to spawn again. Mature males generally die on the spawning grounds. Most young fish migrate to the sea, where they grow into mature adults, but some male parr remain in freshwater all their lives and compete with the large returning males, successfully fertilising some of the eggs.

see also page 257

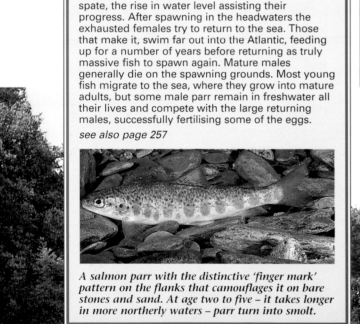

A salmon parr with the distinctive 'finger mark' pattern on the flanks that camouflages it on bare stones and sand. At age two to five – it takes longer in more northerly waters – parr turn into smolt.

offers good salmon-viewing opportunities, as does the Aigas Dam on the River Beauly further north.

OTHER WATERLIFE
Unsurprisingly, the Tay supports not only healthy populations of salmon but also a wealth of other aquatic life, including waterplants, freshwater invertebrates and birds (although management by the vested interests of fishing enthusiasts can threaten those birds and mammals competing with man for the fish).

Due to the high flows and constantly eroding rocky beds the upper stretches of the river support few submerged plants, other than mosses. Snapping up flies at the surface, salmon live in these fast-flowing headwaters alongside brown and sea trout, eels and stickle-backs.

Further downstream up to 20 fish species occur, including coarse fish such as roach and dace. Many of the larger fish are essentially piscivorous – they eat other fish – but younger, smaller fish of all species are likely to include freshwater invertebrates such as caddis larvae and mayfly

Salmon wait until the rivers are in spate before attempting to overcome obstacles such as rapids and waterfalls.

nymphs in their diet.

Parts of the Tay are very restricted, but walk along the banks of accessible stretches and you should come across a selection of water-loving birds. Where the bankside vegetation is lush and undisturbed, waders such as common sandpipers may nest.

Dippers and grey wagtails are frequently encountered perched on

mid-stream boulders and are fairly indifferent to the presence of humans. Far more wary, however, are the region's goosanders and red-breasted mergansers, fish-eating ducks which are discouraged by water baillifs.

Similarly wary are the otters and escaped North American mink, but a degree of luck is needed to see these shy animals.

TAYSIDE HIGHLIGHTS
Leaping salmon at **waterfalls**. Migrating salmon at viewing chambers at **Pitlochry Dam** on River Tummel or **Aigas Dam** on the Beauly. Dipper, grey wagtail and common sandpiper on **fast-running water**. Occasional goosander or red-breasted merganser. Signs of otter or mink.

Grey wagtails are year-round residents of rivers and perch conspicuously, bobbing their tails up and down.

Melancholy thistle often grows along river banks where the terrain is rough and grassy. It flowers in mid-summer.

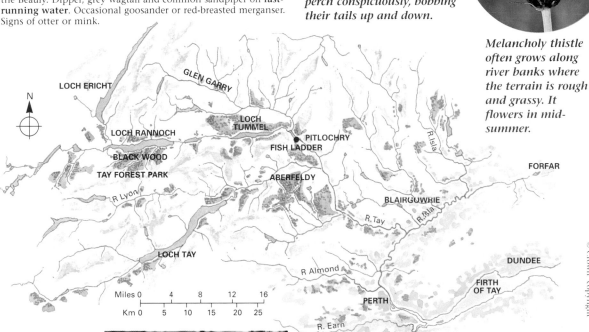

The large heath is a distinctly local butterfly and usually favours damp meadow grassland, often close to running water.

AND ALSO LOOK OUT FOR...
- osprey ● oystercatcher
- redshank ● sand martin
- willow warbler
- golden-ringed dragonfly
- rowan ● marsh-marigold
- globeflower
- lesser spearwort
- cuckooflower
- water avens ● butterwort
- butterbur ● angelica

Hare's-tail cottongrass

Eriophorum vaginatum

It is during the summer months, when the seed heads of this wetland grass bear their conspicuous, cotton-like hairs, that this plant gets noticed. Earlier on in the year, when it is flowering, it is relatively easy to overlook, as the inflorescences are brownish green and compact. When the plant is not in flower or fruit, the wiry, dark green leaves are almost impossible to detect among the other grasses with which this species grows. The white hairs of the seed head, which give the plant its common name, eventually get caught by the wind and disperse the seeds to new areas.

see also page 309

The delightfully named hare's-tail cottongrass is a common and widespread plant in Scotland, flourishing particularly well in damp ground along the margins of rivers.

The Cairngorm Mountains

Rounded and gentle from a distance, the Cairngorms are a southern outlier of the Arctic, with the most extensive area of land over 1,000m (2,290ft) in Britain. Their local name – Monadh Rhuadh (red mountains) – comes from the pink feldspar.

Ospreys can be seen feeding in many of the region's lochs from May to August.

THESE HIGH TOPS are home to dotterel, ptarmigan and golden eagle, along with snow buntings. One of Britain's hardiest birds, ptarmigan moult into white plumage for the winter and eke out a living on tiny plants exposed on windy ridges.

In summer, pink cushions of moss campion add colour to the high plateaux, and dotterel nest among the woolly fringe moss.

Alpine lady's-mantle and starry saxifrage grow alongside least willow in the snow hollows, and purple saxifrage, alpine saw-wort and a range of hawkweeds find rootholds on the precipitous rock walls of corries.

The views from the ski road are spectacular, a succession of glens and mountain ranges stretching to the horizon. A herd of reindeer introduced in the 1950s grazes on the appropriately named 'reindeer moss' on the northern slopes, not far from the access road.

MOORLAND LIFE

The moorlands surrounding the Cairngorms are at their most beautiful in August when the blooming of the purple heather is at its peak. These moors are home to red grouse, red deer and mountain hare.

Red deer are now plentiful; living on the high tops in summer with their new-born calves, they come into the glens in winter.

October evenings can resound to the noise of the rutting stags. Even better, listen to their roaring under the moonlight. Here in northern Scotland, the night skies are at their very best and sometimes are aglow with the northern lights, or aurora.

The native forests of Scots pine in the Cairngorms add to the distinctly Scandinavian feel of the landscape and climate. Goldeneye, with their pretty black and white ducklings are found on most of the woodland lochs, as well as the rivers. The first pair nested in 1970 and now there are about 150 pairs.

Scots pine forests are also important for Scottish crossbills, crested tits and

Although it may be just a few centimetres tall, mountain willow is still classified as a tree. The plant covers large tracts of upland terrain.

If the winter weather has been harsh, a blanket of snow may persist well into April.

Golden eagles are the dominant predators in the region but may be reduced to scavenging at carcasses in winter.

Dotterel

Charadrius morinellus

Small parties of migrating dotterel sometimes stop off at traditional resting sites in England. These parties, known as trips, seldom stay long and in spring soon head on north to breeding grounds in Scotland and mainland northern Europe. Unusually, males rather than females incubate the eggs and are duller than their mates. The Cairngorm plateau is one of the strongholds for the species and these dumpy, confiding birds are generally indifferent to observers so long as they do not feel threatened.

see also page 233

The dotterel is one of several species for which the Cairngorm region of Scotland is famous. This plump wader only nests on the highest plateaux. It is the female who displays over the territory.

Introduced herds of reindeer live in the Cairngorms. Their diet is supplemented at feeding stations.

Trailing azalea is widespread in the region and grows on bare, stony ground on high plateaux.

capercaillie; all special species of the Cairngorm forests. Whereas the diminutive crested tit with its distinctive crest and purring call is relatively easy to find, the capercaillie, or in Gaelic 'the horse of the woods', is often elusive.

Males are as big as turkeys and utter a strange bubbling call. In winter, they feed on Scots pine needles, but in summer they feast on many plants, including the succulent blaeberries. Red squirrels are common in these woods, while fox, badger, wild cat, otter and pine marten all live here.

OSPREYS RETURN

This area is famous for ospreys. Since 1954, a pair has nested beside beautiful Loch Garten. There the RSPB set up its observation hide and over the decades nearly 2 million people have enjoyed watching these breeding birds. Nowadays, the number of ospreys has increased, and they can often be seen fishing at the Rothiemurchus fish farm. In winter they migrate to West Africa.

The birchwoods, crofts

and farmlands, lochs, rivers and marshes create a rich mosaic of beautiful countryside where wildlife and people live and work in harmony. Running through it is the Spey, a famous salmon river.

On its 265 km- (107 mile-) journey to the sea it meanders through the Insh Marshes, a superb area of marshlands and lochs that acts like a gigantic sponge. It is an important RSPB reserve for wildfowl and wading birds, while in winter it is home to whooper swans.

Map scale:
Miles 0 4 8 12
Km 0 5 10 15 20

© Crown copyright

GRANTOWN-ON-SPEY
TOMINTOUL
LOCH GARTEN
ABERNETHY FOREST
AVIEMORE
GLENMORE FOREST PARK
LOCH AN EILEIN
GLEN AVON
CAIRN GORM
KINGUSSIE
INSHRIACH FOREST
BEN AVON
NEWTONMORE
INSH MARSHES
CAIRN TOUL
R. Dee
DALWHINNIE
BRAEMAR
LOCH ERICHT
LOCHNAGAR
BEINN DEARG
GLEN GARRY
LOCH TUMMEL PITLOCHRY

CAIRNGORMS HIGHLIGHTS
Snow buntings on **high tops**. Purple saxifrage on **rock walls of corries**. Reindeer from the **access road**. Rutting red deer stags in October. Goldeneye on **woodland lochs**. Purring call of crested tits in **Scots pine**. Ospreys at **Loch Garten** and **Rothiemurchus fish farm**. Whooper swans at **Insh Marshes** in winter.

AND ALSO LOOK OUT FOR...
● Slavonian grebe
● red-breasted merganser ● buzzard
● peregrine ● merlin ● red grouse
● golden plover ● ring ouzel ● redpoll
● siskin ● raven ● tormentil ● ling
● map lichen ● hoof fungus ● fly agaric
● chanterelle

Ptarmigan

Lagopus mutus

This true mountain species rarely occurs below 700m (2,303ft). Its dense plumage and feathered toes suit it to a cold environment but its most striking adaptation is its changing plumage. In summer, when snow is rare, the ptarmigan has mottled grey-brown plumage; feeding birds blend in with the lichen-covered rocks and birds on eggs are almost impossible to spot. In preparation for the winter snows, ptarmigan become pure white; only their black eyes and bills being at all conspicuous.

see also page 231

Whatever the season or the weather, the plumage of the ptarmigan always helps it blend in with its surroundings. The birds are unobtrusive but generally not especially wary of human visitors to their mountain terrain.

Caledonian Forest

Only in the Scottish Highlands do fragments remain of the vast conifer forests that once covered much of Britain. Pine trees loom all around, massive trunks red-brown and flaky, tops a fuzz of bottle-green needles.

THE ANCESTRY OF ancient Caledonian forests – the only native conifer woodland in Britain and a far cry from the relatively sterile plantations planted this century – stretches back more than 8,000 years, to when Scots pines and other native trees took hold of the open, tundra-like ground after the last glaciers had retreated. With the warmer climate

A prime example of the open nature of native conifer forest, with silver birch and a wealth of plants at ground level.

that followed, the woods were eventually replaced by broadleaved trees, save in the cooler climes of the Highlands.

Later, during the land clearances of the 18th century, felling and burning took their toll, reducing these northern forests to the few isolated relict pockets we see today. However, many of these remnants are now nature reserves and active conservation and the revival of traditional woodland practices augurs well for their future and expansion.

Unlike the plantation

forests, where regimented rows of conifers form a dense canopy, plenty of light penetrates these woods, allowing a rich mix of species to flourish. Birch, aspen and rowan grow among the great

Generally shy, the wild cat is not uncommon. Bigger than domestic cats, it is ferocious if cornered.

pines (some rising over 28m/88ft), with juniper, bracken, bilberry and ling in the understorey.

SPECIAL SPECIES
Specialities among the midsummer ground flora include twinflower, a delicate, creeping perennial found only in these native woods; wintergreens, including 'St

The Scottish crossbill has a large crossed beak. It lives in the Caledonian forests, occurring nowhere else in the world.

Olav's candlesticks', named for Norway's patron saint; and the orchids lesser twayblade and creeping lady's-tresses.

Mosses and lichens thrive too on the pine-scented forest floor and on fallen trunks, thanks to the pure, damp air borne in from the Atlantic Ocean.

Long gone now are brown bear and beaver, wild boar, lynx and wolf (though some, such as beaver, are being reintroduced). Still here, in their British strongholds, are red deer, wild cat, pine marten and red squirrel, golden eagle, crested tit and Scottish crossbill.

Pine martens spend

Capercaillie

Tetrao urogallus

Once hunted to extinction, this magnificent gamebird was reintroduced in the 19th century and has now become successfully established in many locations in Scotland. It is a bird of pine woods, and the shoots and buds of the trees are important in its diet. The remaining pockets of Caledonian pine forests, such as Rothiemurchus and Abernethy, are traditional strongholds but mature conifer plantations also provide a suitable habitat for the birds. Male capercaillies can look all-dark in dull conditions but sunlight reveals a shiny iridescence to much of their plumage; females are marbled and mottled grey-brown and white, the pattern of the plumage affording them excellent camouflage when sitting on eggs.

see also page 231

Male capercaillies are huge, turkey-sized birds which display to attract females at 'lek' sites in woodland clearings. To the sound of popping and wheezing calls, the males will strut up and down with the tail fully fanned.

CALEDONIAN
FOREST HIGHLIGHTS
Red squirrels feeding in
Scots pines, and signs of pine
marten and wild cat. Crossbills up in
the pines removing seeds from cones; listen for dropping
cones. Twinflower, wintergreens and creeping lady's-
tresses on **forest floor**. Breeding goosanders on **Loch
Affric and Loch Beinn á Mheadhoin in Glen Affric**.
Fine ancient trees in **Glen Strathfarrar**.

Areas of forest are shown as
dark green. Ancient forest,
often contained within
newer plantings, is less
extensive than appears here.

*Single-flowered
wintergreen is a
speciality plant of
the forests, growing in
the thick carpet of pine
needles on the ground.*

*Red squirrels are
generally not as bold as
their grey cousins but can
usually be found by
scanning mature trees.*

much of their time in
treetops (often chasing
red squirrels) and are
rarely seen by day, but
you may find a dropping,
full of part-digested
rowan berries, glistening
on a track. Also largely
nocturnal is the tabby-like
wild cat, emerging at dusk
to hunt for small rodents,
rabbits and birds.

FINEST FORESTS
Glen Strathfarrar is the
largest surviving remnant
of Caledonian forest in the
west, with massive pines
up to 300 years old. These
huge, gnarled trees have
open, flat crowns and
deeply fissured bark.

Another remnant, Glen
Affric, is a gorgeous blend
of loch, wood and hill,
which reaches westward
almost to the coast. The
forest lies along the
southern side of lochs
Affric and Beinn á
Mheadhoin, with
breeding goosanders and
plenty of red squirrels.

*The northern eggar moth
occurs wherever the
larval foodplant –
bilberry – is common.*

Beinn Eighe, further
north-west, was Britain's
first national nature
reserve, established to
safeguard the fragments
of forest on its north-east
slopes running down to
the shores of Loch Maree.

Other areas of the old
forest include Abernethy
Forest in Strathspey (see
map on page 203), a
mixture of forest, plateau
and moorland, and the
heartland of the Scottish
crossbill – the only species
of breeding bird unique
to Britain; Glen Tanar in

Deeside, haven for the
great grouse of the
northern woods – caper-
caillie – as well as black
grouse and siskin; and the
Black Wood of Rannoch
in Tayside (see map on
page 201), internationally
important for insects of
ancient pine-wood –
beetles, flies and bugs, as
well as moths such as the
Rannoch looper moth.

AND ALSO LOOK OUT
FOR...
● sparrowhawk ● tree pipit
● woodcock
● common wintergreen
● hoof fungus ● bay bolete
● cep
● yellow stagshorn fungus

Crested tit

Parus cristatus

As its name suggests, the black and white crest of
this engaging little bird is its most distinctive
feature, especially if the bird is seen in silhouette. In
Britain, its range is entirely restricted to the conifer
woodlands in Scotland but it is not hard to see in
the remaining remnants of Caledonian pine forest
and is often particularly obliging at the RSPB's Loch
Garten reserve (see the map on page 203). Crested
tits are year-round residents and, like their more
widespread relatives, feed on a mixture of insects
and seeds. One of the most important requirements
for the birds is the presence of old, rotting pine
stumps in which they can excavate nest sites.

see also page 250

*When feeding a brood of young in the nest, sited in
a rotten pine stump, crested tit parents are on
almost constant duty, bringing supplies of
caterpillars to feed their hungry offspring.*

Skye & the Small Isles

From every direction the jagged Cuillin Hills of Skye and the mountains of Rum dominate these islands. In winter the snow-capped peaks sparkle, while in summer the croak of the raven can be heard.

Grey seal
Halichoeras grypus

Whether seen basking on a rock or bottling – floating in an upright position – seals are an engaging sight. The grey seal is the larger of the two British species and is generally the more widespread of the two in western Britain. The coat is rather variable in colour but usually dappled grey with darker spots and patches. The pups, which are born in the autumn, are white in their early weeks.

see also page 219

During the summer months in particular, grey seals spend a considerable period of the day hauled out on rocks or resting on beaches. They tend to be quite wary of approaching humans.

SKYE AND THE SMALL Isles to the south – Rum, Eigg, Muck and Canna – lie at the northern end of the Inner Hebrides. As well as mountains (with the exception of Muck and Canna, which are low-lying), they have rocky shores, extensive peatland and bog, and maritime heaths.

Otters frequent the shores of loch and bay, and great northern divers winter in some lochs and at sea around the Small Isles. Common seals haul out mainly on Skye and Canna, while the Roman-nosed greys are on Rum and Canna.

At sea you may spot black guillemot, eider or red-breasted merganser. Dolphins are also about, and harbour porpoises can be spotted in more sheltered areas. Minke whales also come close to the coast, and if you are lucky you may see a pod of orcas (killer whales).

MOORLAND LIFE
Birds of prey from hen harriers down to the tiny merlin inhabit the ubiquitous moorland, and you may glimpse the silhouette of a golden eagle on the skyline. As well as skylarks and meadow pipits, there are nesting snipe, golden plover, dunlin and oystercatcher. Sometimes the moorland slopes gently to the sea, but elsewhere it terminates in spectacular sea cliffs, such as those at Neist, Duntulm and Staffin on Skye.

Rivers and burns are plentiful on all the islands, but large freshwater lochs are confined to Skye. During summer the shores of these

Seashore enthusiasts are in their element on the rocky shores of the Isle of Canna. Clean waters – indicated by a profusion of seaweeds – support a wealth of marine life.

Fortunate visitors can sometimes see common dolphins bow-riding ferries as they cross between the islands.

resound to the call of the common sandpiper, while red-throated divers breed on moorland lochs and feed at sea. The lower reaches of the bigger rivers have dipper and goosander, and wherever there is tall vegetation or scrub by stream or loch, look for sedge warblers or reed buntings.

In Sleat on Skye you can find fine natural woodland, both near the coast and also inland. Birch, hazel, ash and oak, with abundant willow, predominate. In north Skye, hazel woodlands grow in the shelter of coastal cliffs, while on Eigg the woodland nestles beneath the inland cliffs; look also for occasional wych elm and goat willow where it is particularly sheltered, or on Eigg for blackthorn.

The woodland fringes are good for birds, including woodland warblers, thrushes,

Better known as a North American species, in Britain pipewort can only be found growing in a few freshwater lochs on the island of Skye.

buntings, finches and tits, as well as treecreeper and great spotted wood-pecker. Buzzards mew and soar overhead, and careful searching may reveal tawny owl and sparrowhawk, while woodcock are numerous in winter. On Skye foxes skulk between woodland and moorland.

ISLAND VARIETY

The larger the island, the greater the variety of wildlife, but each has something special. On Skye, visit Torrin and Trotternish, where banks of yellow saxifrage and lawns of alpine lady's-mantle flower on the limestone, and pipewort is a speciality in lochans near Sligachan. On Rum visit the hills to see the Scottish asphodel and cyphel. Mountain avens thrives on limestone heath on both islands, and montane flowers, such as moss campion and purple saxifrage, can be found even at sea level. Orchids abound on all the islands, including fragrant, and greater and lesser butterfly. Look also for eyebrights on coastal pastures, bogbean in lochans and yellow iris in wet places.

On Rum 60,000 pairs of Manx shearwaters nest in burrows among the hills and feed in rafts just off the coast at dusk. The best places for seabirds on Skye are close to Neist Point or Duntulm, and on Canna there is a nesting population of around 800 pairs of shag, as well as guillemot and razorbill.

> AND ALSO LOOK OUT FOR...
> ● grey heron ● gadwall ● goldeneye ● ringed plover ● lapwing
> ● dunlin ● Arctic tern ● pied wagtail ● butterfish
> ● edible periwinkle ● common mussel ● edible crab ● dog whelk
> ● sea urchin ● sea sandwort ● marsh marigold ● silverweed

Hay meadows are a haven for breeding waders such as oystercatchers, which can be seen in May and June.

Rock pipit
Anthus petrosus

During the breeding season, rocky coasts and sea cliffs are the haunt of the rock pipit, the birds nesting in crevices between rocks. Often seen perched on lichen-covered boulders, this is the only small, brown British bird whose distribution is almost entirely restricted to the coast. Even in the winter, when the cliffs become rather inhospitable, the birds remain near to the sea, usually moving to sheltered coves or feeding along the strandlines of sandy beaches. Their food includes insects and sandhoppers. Once learned, the call of the rock pipit, a loud and fairly distinctive *pheet*, is unmistakable, while in the spring the bird also utters an engaging, accelerating little song.

see also page 244

Rock pipits feed actively along the shoreline, probing under stones and among tideline debris for insects. The adults and larvae of kelp flies are extremely important in their diet.

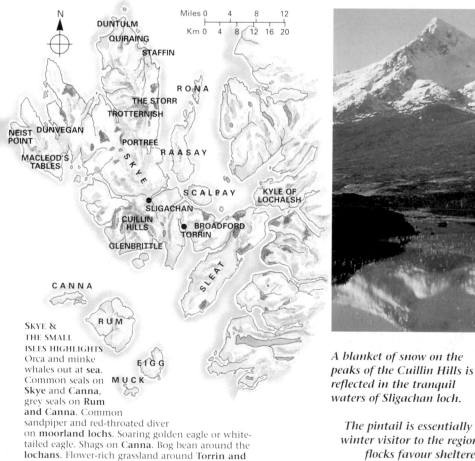

SKYE & THE SMALL ISLES HIGHLIGHTS
Orca and minke whales out at sea. Common seals on Skye and Canna, grey seals on Rum and Canna. Common sandpiper and red-throated diver on moorland lochs. Soaring golden eagle or white-tailed eagle. Shags on Canna. Bog bean around the lochans. Flower-rich grassland around Torrin and Trotternish, Skye.

A blanket of snow on the peaks of the Cuillin Hills is reflected in the tranquil waters of Sligachan loch.

The pintail is essentially a winter visitor to the region; flocks favour sheltered shores and shallow lochs.

Outer Hebrides

Otherwise known as the Long Island, the Outer Hebrides stretch in a ragged chain from the Butt of Lewis to Barra Head. Here corn buntings, corncrakes and corn marigolds, all but disappeared from mainland farms, thrive.

Corn marigold puts on a fine display in the hay meadows which are such a feature of the islands. May and June are the best months to see the flowers.

Corncrake

Crex crex

The story of the corncrake in the 20th century is a sorry tale, the species' range and numbers having declined catastrophically. Changes in agricultural practice are without doubt to blame and these extraordinary birds are now found regularly in reasonable numbers only on the western isles of Scotland. Corncrakes favour damp hay meadows, and early cutting all too often results either in the destruction of the nest or the death or maiming of both adults and chicks. Once heard, the corncrake's call is easily learnt and seldom forgotten, not least because the rasping, repetitive 'crek-crek' call is often uttered continuously for hours on end, most frequently after dark. Because it favours dense vegetation, the species is difficult to observe even when a bird is heard calling during the hours of daylight. Just once in a while, however, the caller may crane its neck up to survey its surroundings, allowing the observer a brief glimpse.

Present from April to August, corncrakes can still be found in hay meadows on the islands.

see also page 232

CROFTING AND fishing are the main occupations on the islands, of which 14 are inhabited. Lewis is the largest and a quarter of the 32,000 population lives in Stornoway, on the east coast.

The sandy, fertile, flower-studded pasture known as machair on the low-lying western seaboard – so typical of Harris, the Uists and Benbecula – plays an important part in the economy of the islands as cattle feed. It also supports nearly a third of all dunlin and ringed plover breeding in Britain, and lapwing and oyster-catcher are numerous too.

Further inland, a jigsaw of lochs studs both the machair and the moorland. Snipe, redshank and Arctic tern nest along the water margins, while the resident waterfowl are joined every winter by flocks of migrant ducks, geese and swans from more northern climes.

Mute swans breed commonly in the Uists but, surprisingly, are absent from Lewis and Harris. Whoopers are, however, regular winter visitors throughout the Hebrides, with barnacle geese preferring the undisturbed islands offshore. A relict population of native greylag geese, now numbering several thousand, refrain from flying north every spring and remain to breed throughout the island chain.

The wet, boggy moorland – making up so much of the interior of Lewis in particular – provides peat for fuel. It is also home to an abundance of waders – redshank, red-necked phalarope, golden plover and dunlin, as well as merlin, raven, skuas and two species of diver.

MAMMALS

Birdlife, including many ground-nesting species since there are almost no trees in the Outer Hebrides, has flourished in the absence of mammal predators. No foxes, stoats and weasels have managed to reach these islands, though in recent times polecat-ferrets (in a vain attempt to control rabbits) and feral cats have been introduced. Mink, too, escaped from captivity some years

Shallow lochs stud the landscape and are often fringed by flower-rich grassland habitat known as 'machair'.

ago and spread through-out Lewis and Harris; an annual trapping programme is striving to prevent these aquatic carnivores from reaching the Uists where they would do untold damage to breeding waders, waterfowl, gulls and terns.

Red deer, field voles, mice and brown rats are common, with black rats only on the Shiant Islands. Otters are probably the only land mammal to have reached the Outer Hebrides under their own steam, however. While they are to be found in freshwater lochs and rivers, they are especially abundant along the seashore; anywhere

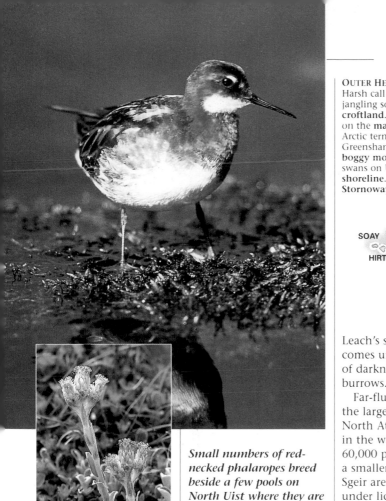

OUTER HEBRIDES HIGHLIGHTS
Harsh call of corncrake and jangling song of corn bunting on **croftland**. Ringed plover and dunlin on the **machair**. Snipe, redshank and Arctic terns around **lochs**. Greenshank and golden plover on **boggy moorland**. Breeding mute swans on **Uists**. Otters feeding along **shoreline**. Risso's dolphins off **Stornoway harbour, Lewis**.

BUTT OF LEWIS

FLANNAN ISLES

CALLANISH STORNOWAY

LEWIS

N

Miles 0 5 10 15 20
Km 0 5 10 15 20 25 30

HARRIS

SHIANT ISLANDS

BORERAY
SOAY
ST KILDA
HIRTHA

LOCHMADDY
NORTH UIST

MONACH ISLANDS CARINISH

BENBECULA

SOUTH UIST

ERISKAY

BARRA

MINGULAY

BERNERAY

Small numbers of red-necked phalaropes breed beside a few pools on North Uist where they are protected by the RSPB.

Minch, and bottlenose and white-beaked dolphins, orcas (killer) and other whales occur further out to sea. There is an old whaling station at Bunavoneadar in Harris.

SEABIRD COLONIES
The smaller islands support huge colonies of puffins and other auks, fulmars, shags and kitti-wakes, while the rare

Leach's storm-petrel comes under the cover of darkness to its nest burrows.

Far-flung St Kilda has the largest colony of North Atlantic gannets in the world – some 60,000 pairs. Young from a smaller colony on Sula Sgeir are still harvested under licence by the men of Ness in Lewis.

St Kilda also has its own sub-species of wren and field mouse, although its unique house mice became extinct when the islanders left in 1930. There are even flocks of wild Soay sheep, found only on Hirta and Soay.

Flocks of Soay sheep still survive on St Kilda, the island from which this dark-fleeced and hardy breed originated.

Mountain everlasting – also known as cat's-foot – can be found growing in short turf at scattered locations throughout the islands.

on the east coast is best and they are regularly seen in broad daylight. Common seals are even easier to observe, while grey seals tend to confine their activities to the exposed Atlantic coasts of the west. Every autumn, thousands gather on the inaccessible Monach Isles national nature reserve where they constitute the second largest colony in the world.

Whales and dolphins might be seen from boats or the inter-island ferries, while Risso's dolphins seem to be resident off Stornoway harbour. Porpoises and minke whales are regular in the

AND ALSO LOOK OUT FOR...
● Manx shearwater
● common sandpiper
● common gull ● wheatear
● sea sandwort ● yellow iris
● eyebright ● marsh-marigold
● northern marsh orchid
● crab-eye lichen ● sea ivory

Successfully reintroduced, white-tailed eagles can now be seen on rugged stretches of the coastline.

Bogbean
Menyanthes trifoliata

The boggy margins of nutrient-poor lakes are often colonised by this wetland plant, which can sometimes be seen growing partly submerged in the shallow waters. As its name suggests, its leaves, which are divided into three, comprise rounded, shiny lobes giving them the appearance of broad bean leaves. Robust spikes of attractive flowers appear from April to June and if you happen on a sizeable colony it is a stunning sight. Individual flowers have a five-lobed petal tube which is white, flushed with pink at the margins and fringed with hairs. Insects find the flowers attractive.
see also page 296

In sites where conditions suit it, such as shallow pools, bogbean forms dense colonies.

Orkney Islands

The islands have been described as 'sleeping whales, peaceful mounds', a true reflection of their appearance. They are renowned for their seabirds and swards of flowers.

EACH OF THE 75 OR SO islands of the archipelago (only 19 are presently inhabited) has its own distinctive character – the landscape, the wildlife, the accent of the local folk – but they all have one thing in common, the sea. Between them they possess miles of rocky coastline – a tangle of seaweed seething with shorebirds at certain times of the year, while on the northern isles in particular you can walk alone along mile after mile of dazzling white, shell-sand beaches.

Both grey and common seals can be seen in their hundreds hauled out on beach and skerry on virtually any island. Otters too are common around the coast, searching for food among the kelp. Avid sea-watchers may be rewarded not only with stunning views of seabirds – a million are thought to nest in Orkney, and the Noup Cliffs on Westray, with tens of thousands of nesting guillemots, are arguably the most densely populated in Britain – but perhaps a glimpse or more of one of the whales and dolphins that cruise the warmer waters around the islands.

In recent years the rearing of beef cattle has been the mainstay of the agricultural economy and much of the low-lying land on Mainland, South Ronaldsay, Shapinsay, Stronsay, Westray and others is therefore given over to grass. The scene is a typical pastoral one, with cattle lazily grazing green fields and here and there a field of barley that will later serve as winter feed. During the summer months you may hear the strange, rasping call of the shy and scarce corncrake nesting in undisturbed hay fields.

Many of the wet hollows have recently been drained, but those which remain, along with the damp, rank loch margins, are a wonderful sight in April and May when the dazzling, golden displays of marsh-marigolds are unparalleled. Overhead, the sky comes to life with the display flights of waders such as redshank, snipe, curlew and lapwing.

HEATHS AND CLIFFS

On higher ground there are large tracts of heather moorland, and those of Mainland, Hoy and Rousay are the haunt of hen harrier, merlin, red

Scottish primrose has small but thriving colonies on the islands. The plant also grows in north-east mainland Scotland, but nowhere else in the world.

Grey seals occur in good numbers on the islands and can be found hauled out on rocky shores in sunny weather.

grouse and Arctic and great skuas, all of which breed here. Over 2,000 pairs of great skuas, or bonxies, nest on Hoy alone. They make their presence felt in no uncertain terms as any unwary hillwalker who approaches egg or chick will quickly discover, with a painful clatter around the ears at worst, or a terrifying whoosh of wings at best. From the

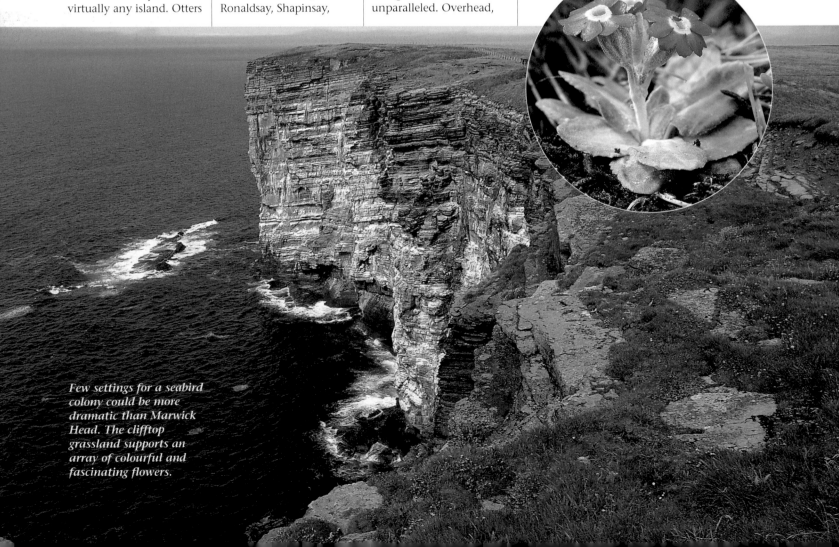

Few settings for a seabird colony could be more dramatic than Marwick Head. The clifftop grassland supports an array of colourful and fascinating flowers.

towering cliffs, peregrines plunge seaward to snatch a puffin off Britain's highest rock stack, the Old Man of Hoy (140m/461ft).

The summit plateaux ring with the eerie calls of red-throated divers, the evocative song of the golden plover, the trill of the dunlin or the song of the skylark.

One of the most fascinating habitats on the islands is the maritime heath, and the largest single area in Britain occurs on the RSPB's North Hill reserve on Papa Westray. The heath, developed due to a combination of exposure, salt spray and grazing, consists of a mosaic of up to 50 species of flowering plants, including the endemic Scottish primrose, a tiny pink gem.

Berriedale Wood on Hoy, a relict of the huge areas of woodland which existed before the arrival of neolithic man, is a jewel of a birch wood and the most northerly native wood in Britain.

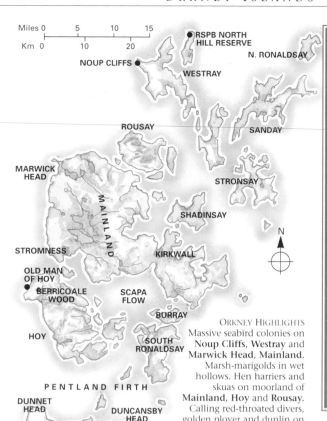

Miles 0 — 5 — 10 — 15
Km 0 — 10 — 20

RSPB NORTH HILL RESERVE
N. RONALDSAY
NOUP CLIFFS
WESTRAY
ROUSAY
SANDAY
MARWICK HEAD
STRONSAY
MAINLAND
SHADINSAY
STROMNESS
KIRKWALL
N
OLD MAN OF HOY
BERRICOALE WOOD
SCAPA FLOW
BURRAY
HOY
SOUTH RONALDSAY
PENTLAND FIRTH
DUNNET HEAD
DUNCANSBY HEAD

ORKNEY HIGHLIGHTS
Massive seabird colonies on **Noup Cliffs**, **Westray** and **Marwick Head**, Mainland. Marsh-marigolds in wet hollows. Hen harriers and skuas on moorland of **Mainland**, **Hoy** and **Rousay**. Calling red-throated divers, golden plover and dunlin on summit plateaux. Scottish primrose on maritime heath of **North Hill reserve**, **Papa Westray**. Birch wood at **Berriedale, Hoy**

AND ALSO LOOK OUT FOR...
- red-throated diver ● fulmar
- cormorant ● shag ● puffin
- black guillemot ● short-eared owl
- edible periwinkle ● edible crab
- dog whelk ● beadlet anemone
- sea sandwort ● bird's-foot trefoil
- ling ● cowberry ● crowberry ● kelp
- crab-eye lichen

Ditches and wet meadows are adorned with the bright yellow flowers of marsh-marigold in spring, the islands offering some of the finest displays of this wetland plant in the British Isles.

Hen harrier
Circus cyaneus

Moorlands and uplands are home to Britain's hen harriers during the summer months and Scotland is especially important for the species. Orkney is a particular stronghold, with reserves providing safe havens for the birds. In flight, the hen harrier is one of our most graceful raptors, quartering low over the ground at a leisurely pace in search of small mammals and birds. Males have essentially pale blue-grey plumage relieved by a white rump and belly and dark wingtips; females have barred and streaked brown plumage with the same conspicuous white rump. Hen harriers are present on their breeding grounds from April until September.

see also page 230

Being ground-nesters, hen harriers are potentially vulnerable to disturbance by ground predators. While the female is incubating the eggs, the male spends much of his time patrolling and scanning for danger.

Arctic skuas breed in considerable numbers on the islands. These aerobatic pirates specialise in harassing other seabirds into disgorging their last meal.

Orkney's guillemot colonies are among the finest in the world and many keen birdwatchers pay a visit to witness this spectacle at least once in their lifetime.

Razorbill
Alca torda

Similar in appearance to its close relative the guillemot, the razorbill is an attractive bird with strongly demarcated black and white plumage. When seen through binoculars or at close range, the bird's powerful bill, which is indeed flattened and razor-like, is evident. Although fairly common, razorbills are usually rather thinly scattered among other seabirds in a colony and are rarely seen in dense ranks. They are noisy and quarrelsome at the nesting colony, growling at each other. They are present on nesting cliffs from around April to August; thereafter, they disperse to sea for the winter. Young birds leave the nest at two and a half weeks, before they can fly, jumping and fluttering to the sea.

see also page 239

Razorbills feed on a variety of small fish, diving from the surface and swimming strongly to catch them. Prey is carried in the bill back to the nest site on a cliff ledge or crevice, or among boulders.

Shetland

The Shetlands are the northernmost islands in Britain, lying where the Atlantic Ocean floods into the North Sea. The long winters are made up for by the glorious summer days, when the sun scarcely sets.

Nerves of steel and a keen head for heights are needed to view the gannet colony at the Noup of Noss. The Isle of Noss itself harbours some of the best seabird colonies in Britain.

THERE ARE MORE than 100 islands in the Shetland archipelago, running in a chain from Fair Isle in the south to Unst in the north. The landscapes are of rolling, short-cropped hills of heather and grasses, almost devoid of trees and bounded by low rocky shores, towering sea cliffs and unspoilt sandy beaches.

Set in some of the richest waters in the world, it is no wonder that Shetland's wildlife and people owe much of their existence to the sea.

In the spring and summer, the islands provide safe nest sites for a million seabirds, including the comical puffin and northern specialities such as great and Arctic skuas. Otters and seals forage close to the shore and whales can be sighted offshore.

Snowy owls occasionally summer on Shetland and have bred on Fetlar. In recent years, female snowy owls have been present but no males.

Inland, the grasslands and moorlands hold remarkable numbers of breeding waders, including the rare red-necked phalarope and whimbrel, while red-throated divers nest beside many of the lochs. During spring and autumn easterly winds can divert thousands of migrant birds (and sometimes butterflies and moths) from the Continent to seek shelter on the islands.

In winter, many of the breeding birds and the whales depart for southern latitudes, but great northern divers, whooper swans, greylag geese and long-tailed ducks arrive from their Arctic breeding grounds.

PRIME SPOTS

Fair Isle, lying between Shetland and Orkney, is world famous for attract-

Shetland mouse-ear chickweed grows only on the island of Unst, and even here it is restricted to small areas where a rock known as serpentine breaks the surface.

ing rare migrant birds from as far afield as Siberia and North America. At the southern tip of Mainland is the RSPB nature reserve of Sumburgh Head, where you can watch at close range the antics of puffins. There is also a chance of seeing the minke and killer whales that sometimes approach close to the shore.

Mousa, lying east of southern Mainland, is a low-lying island with hundreds of basking common seals, a few grey seals, plus many terns, skuas and black guillemots. The island holds the best-preserved Iron Age broch (stone tower) in Britain, home to thousands of tiny storm-petrels. These minute seabirds spend the daylight hours far out at sea, but special boat trips are run on summer evenings so that they can be watched as they return to their nests.

The Isle of Noss national nature reserve lies to the east of Shetland's capital, Lerwick. Here, from a distance, the breathtaking sea cliffs appear white, but as you approach more closely the snow-white slopes resolve into thousands of squabbling gannets. Puffins waddle between the entrances of

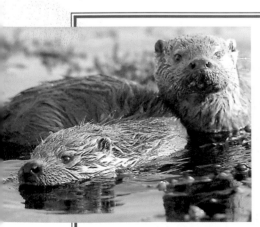

Sit for long enough on a deserted stretch of Shetland coastline and you stand a good chance of seeing a wild otter.

Otter

Lutra lutra

Throughout the 20th century the otter slowly disappeared from most parts of England and Wales, due to persecution and habitat destruction. Thankfully, the animal is now staging something of a comeback in parts of southern England, while in the Scottish isles it has never really faced problems to the same extent as its southern counterparts. The Shetland Isles are a particular stronghold and also provide the best opportunities for observing the animals since they feed on the seashore. Droppings and piles of smashed urchin and mollusc shells indicate their presence.

see also page 219

their nesting burrows at the top of the cliffs, and great skuas aggressively defend their nests.

Part of Fetlar is an RSPB nature reserve, which holds Britain's largest colony of breeding red-necked phalaropes. These attractive little wading birds are extraordinary, in that the smaller and less brightly coloured male incubates the eggs and tends the young. The serpentine heaths of Fetlar resemble the Arctic tundra and, during the long summer days, resound with the trilling calls of whimbrel.

The island of Unst at the very north of Shetland has two national nature reserves. One, Keen of Hamar, provides a glimpse of what Britain might have looked like just after the last Ice Age. The gently sloping screes are sparsely covered by some of Britain's rarest plants: the white flowers of the Shetland mouse-ear chickweed and Arctic sandwort sprout among the yellow serpentine rocks. The spectacular sea cliffs of Herma Ness hold vast numbers of puffins and gannets, and the predatory great skuas swoop menacingly across the mossy peatlands. From the towering cliffs you can look across to Muckle Flugga and beyond to Out Stack, the most northerly isle.

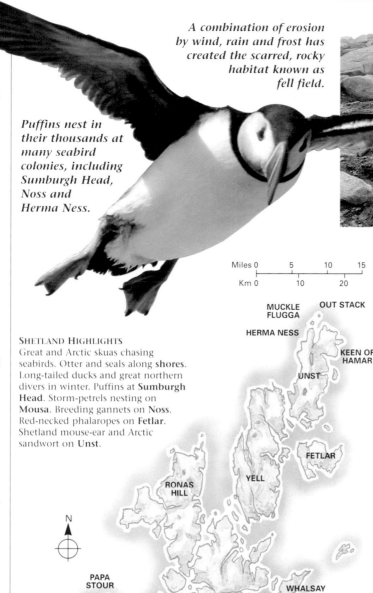

Puffins nest in their thousands at many seabird colonies, including Sumburgh Head, Noss and Herma Ness.

A combination of erosion by wind, rain and frost has created the scarred, rocky habitat known as fell field.

SHETLAND HIGHLIGHTS
Great and Arctic skuas chasing seabirds. Otter and seals along **shores**. Long-tailed ducks and great northern divers in winter. Puffins at **Sumburgh Head**. Storm-petrels nesting on **Mousa**. Breeding gannets on **Noss**. Red-necked phalaropes on **Fetlar**. Shetland mouse-ear and Arctic sandwort on **Unst**.

Miles 0 5 10 15
Km 0 10 20

MUCKLE FLUGGA
OUT STACK
HERMA NESS
KEEN OF HAMAR
UNST
FETLAR
YELL
RONAS HILL
N
PAPA STOUR
WHALSAY
MAINLAND
FOULA
LERWICK
NOSS
MOUSA
SUMBURGH HEAD
FAIR ISLE

Small lochans dot the landscape and the marginal vegetation provides nesting sites for birds such as snipe, dunlin and – on Fetlar – the rare red-necked phalarope.

Red-throated divers nest beside surprisingly small lochans, flying off to fish at sea. As the birds are awkward and ungainly on land, the nest itself is built close to the water's edge.

AND ALSO
LOOK OUT FOR...
● glaucous gull ● curlew
● eider ● dog whelk
● shore crab ● sea urchin
● roseroot ● red campion
● grass-of-Parnassus

Great skua
Stercorarius skua

Although it bears a superficial resemblance to an immature gull with its chocolate-brown plumage, the great skua's bold and aggressive nature, along with its stout build, soon dispel any doubts as to its identity. This robust seabird has its stronghold on Scotland's northern isles and is present in the region from May to August, moving south for the winter months. Although it can catch food for itself, the great skua specialises in parasitising other large seabirds such as gannets, chasing and harrying them until they regurgitate their catch. Smaller birds fare less well and the skuas take a heavy toll of kittiwakes and puffins, especially the inexperienced young.

see also page 238

Shetland's 5,000 or so breeding pairs of great skuas represent some 40 per cent of the world population. Known to Shetlanders as bonxies, these vicious birds do not tolerate intruders into their territories.

Identifying wildlife

It is really satisfying to be able to name the wildlife you come across. This section of the book will help you to identify the plants and animals you see on a trip to one of the wildlife havens featured in this book, or even in your own garden or local town centre.

Most of us are familiar with a number animals and mature specimens in the case of plants, unless otherwise indicated. Birds often have different plumages, depending on the time of year and the sex of the bird. Male birds are usually brightly coloured in the breeding season, and winter plumages are often duller than summer plumages; these differences are clearly indicated in the text.

The butterfly illustrations show the upper wing on the left and the under wing on the right, so you can see what both sides of the species look like.

SPEEDY ID

Sometimes nervous creatures allow only a fleeting glimpse before disappearing so it is important to note any striking features which will help with identification; in the case of deer, for example, the presence of a tail is important, as is the pattern of markings around it. Some birds show a white rump or wings bars as they fly away, and, with practice, it soon becomes a

Shore lark

Eremophila alpestris

Normally seen in Britain in winter when adults have brown upperparts with darker mottlings, a dark tail with white outer feathers, a pale underside with darker streaks on the flanks and a black bill and legs. The most striking features are the yellow face, black moustachial stripes and black chest band; in summer plumage these features are very bold and there are also two black tufts on the head, giving this bird its alternative name of 'horned lark'. Females are duller versions of the male with darker streaks; juveniles are similar but without the face pattern. In flight, the underwings look pale, and the chest band is very prominent. May mix with other larks and pipits but it can be distinguished by its more crouching posture.

SIZE Length 14–17cm
NEST Depression on ground under overhanging plant or rock
BREEDING Lays 2–4 whitish eggs with pale brown spots in April–June
FOOD Seeds and insects in summer; mostly seeds in winter
HABITAT Breeds on Arctic tundra and mountain plateaux; overwinters on coasts
VOICE Quiet musical warblings
DISTRIBUTION Winter visitor to North Sea coasts, sometimes in large flocks

of the common species of birds, mammals or wild flowers, and would have no trouble in recognising a robin or a dandelion, but going beyond this can sometimes be a little tricky.

WHAT'S THAT CREATURE?

This identification guide is set out in several different sections, so birds are grouped separately from mammals, for example. Within these sections the individual species are grouped in families, so all the gulls appear together, as do the carnivorous mammals and seashore molluscs, for example. The photographs and artists' illustrations show adults in the case of

Red deer

Cervus elaphus

Britain's largest native land mammal. Mature stags have well-developed branching antlers, becoming larger each year. Females are smaller than males. In summer the coat is rich reddish-brown, but in winter it is grey-brown. In autumn males defend harems by roaring and fighting.

SIZE Shoulder height 115–120cm
BREEDING Single fawn (rarely twins) born in May–June
FOOD Grasses, sedges and rushes, low-growing shrubs and trees
HABITAT Moorland, open woodland, farmland with copses
VOICE Males make deep roaring bellows in October, females and young can make short bleats
DISTRIBUTION Widespread and common in Scotland, and present in many other areas of Britain and Ireland in more isolated populations

habit to note the key features which are referred to in the text.

Plants should not present such a problem as they cannot escape! The rule should always be: 'Take the book to the plant, and not the plant to the book'. There is no need to pick the plant in order to name it. The illustrations nearly always show flowers, but many species have distinctive seed pods or leaves, or may be rather prickly or hairy; if these features are important for correct identification they are referred to in the text.

Giving correct flowering times can be a

Red admiral

Vanessa atalanta

WINGSPAN 60mm
Upperwings are mostly black with a pattern of red bands and white spots. The underwings are a mottled smoky-grey. Small numbers hibernate, but the main influx is of summer migrants. Caterpillars feed on nettles. Very common and widespread in good summers.

problem. Across the whole of the British Isles the flowering period of a common flower such as the bluebell can vary enormously; spring arrives early in the south-west and advances slowly across the country before reaching the Shetland Islands. Also, our variable weather means that in some years spring arrives later than in others. The months given for flowering or appearance are only an indication of when flowers or fungi can be found, and there are always going to be exceptions.

SPECIAL NAMES

Scientific names are used for all living things and always follow the same style. Each plant or animal has a two-part name, unique to that species and recognisable anywhere in the world. Thus, the blackbird, which is 'Merle noir' in France

Bramble ①

Rubus fruticosus agg

HEIGHT Up to 3m
A very variable, prickly shrub with long trailing stems which root when they touch the ground. The white or pink flowers open in early summer and are followed by edible blackberries in late summer and autumn. Extremely common and widespread.

extinct in Britain now were far more common 150 years ago.

Today there is no need to collect specimens, as photography provides an excellent means of keeping a record of wildlife sightings and reliving exciting experiences. Also, there is no need to take things home (which usually end up dead) in order to identify them, as comprehensive and highly portable field guides make identification easy. If you don't have a field guide with you, taking notes in the field, making sketches or taking photographs will allow you to check on the identity later without harming the species you are interested in.

Watching wildlife is an increasingly popular pursuit but it is important not to disturb animals or endanger rare plants. Beware of scaring birds when they are nesting. Species which appear to be 'tame' are often in reality reluctant to leave their eggs or chicks and will stay close to them even when people are nearby. Watch out also for delicate plants which may be trampled underfoot when you are looking for other species.

Where possible, keep to paths and tracks and avoid disturbing species in the breeding season. The quiet, careful observer will in any case see far more wildlife than the noisy, clumsy one – good luck with your fieldwork!

Greenbottle

Lucilia caesar

BODY LENGTH 9mm
Body is metallic green or bronzy-green, gleaming in sunlight when the fly is basking. Eyes are red-brown. Common in wide range of habitats, feeding on flowers, carrion and detritus. Larvae feed on carcasses.

and 'Amsel' in Germany, has the scientific name of *Turdus merula* in all countries. Scientific names are usually derived from Latin, and sometimes Greek, and are normally descriptive of the creature.

Occasionally they honour the name of a scientist. The first name describes the genus the creature belongs to, in this case the Thrushes, or *Turdidae*, whilst the second name describes that precise species. The blackbird's close relative, the song thrush, is therefore *Turdus philomelos*, for example. Some species, such as caddis flies, do not each have their own English name, and are given a group English name – caddis flies – whilst still having individual scientific names.

LOOKING AND LEAVING

In the 19th century, collecting butterflies, birds' eggs and stuffed birds, or pressing wild flowers and seaweeds were common pursuits and there was little concern for safeguarding rare species. Indeed, many plants and animals which are almost

Yellow stagshorn fungus

Calocera viscosa

HEIGHT Up to 7cm
An easily recognised fungus with bright yellow, much branched fruiting bodies, which have an antler-like appearance. Widespread and quite common in coniferous woodlands, growing on dead stumps and twigs. Appears in late autumn.

MAMMALS

INSECTIVORES
- Sharp teeth ● Eat small invertebrates
- Highly active and aggressive

Hedgehog
Erinaceus europaeus

An unmistakable mammal with a body covering of tough spines. The upperparts are protected by the spines which stick out in all directions. The flanks, head and underparts are covered with tough, brownish hair. The ears are prominent and hairy, the eyes are black and the snout is black and usually looks wet. Will roll up into a spiny ball if alarmed, but can run and climb through undergrowth with ease. Hibernates in winter in leafy nest in undergrowth. Prone to being killed on roads.

LENGTH 16–26cm (i.e., body, not including tail unless stated)
BREEDING Produces litters of 4–6 in June–August
FOOD Wide range of invertebrates, sometimes carrion, scraps, plant material
HABITAT Gardens, hedgerows, woodlands where badgers are scarce, sand dunes, scrub
VOICE Usually silent, but may make snuffling sounds, and sometimes squeals when attacked
DISTRIBUTION Widespread across most of Britain and Ireland, apart from some offshore islands

Mole
Talpa europaea

Presence of molehills indicates where moles are active. Body shape compact, with very short legs and short stiff tail. Front legs strong with spade-like paws for digging. The minute eyes are hidden beneath the dense black fur, but the nose is prominent and bright pink. The sexes are alike and very difficult to distinguish. Moles are aggressive towards each other and apart from mating, lead solitary lives in their own semi-permanent system of burrows.

LENGTH 11–16cm
BREEDING Produces litters of 3–4 young in May–June
FOOD Soil invertebrates, principally earthworms
HABITAT Woodlands, pastures and habitats where earthworms are abundant
VOICE Usually silent but can make shrill screeching sounds
DISTRIBUTION Widespread in Britain and most islands, absent from Ireland

Pygmy shrew
Sorex minutus

A very small mammal with dense, short brownish-grey fur, darker on the upperparts than the underside. The snout is long and pointed, and the eyes and ears are small. The tail is more than half the length of the body and appears relatively thick due to a covering of hairs. The small sharp teeth have red tips. Very active, constantly searching for invertebrate food. Our smallest mammal.

LENGTH 6cm
BREEDING Produces litters of 4–7 once or twice a year from April–August
FOOD Small invertebrates, especially woodlice, spiders, beetles
HABITAT Areas with thick ground cover, scrub patches, hedgerows, shrubby gardens
VOICE Shrill squeaks, almost inaudible to humans
DISTRIBUTION Widespread in Britain, apart from some offshore islands

Common shrew
Sorex araneus

A very small mammal with a tri-coloured appearance; fur on upperparts is dark brown, on the flanks is lighter brown and on the underside it is greyish-white. The tail is relatively hairless and about half the length of the body. As in pygmy shrew the snout is pointed, and the eyes and ears are small. Very active when searching for food and sometimes heard squabbling with other shrews.

LENGTH 7.5cm
BREEDING Produces litters of 6–7 young at intervals between April–September
FOOD Small invertebrates, especially earthworms, slugs and beetles
HABITAT Scrub, hedgerows, woodland edges, well vegetated ditches, roadside verges
VOICE Shrill squeaks and twittering sounds
DISTRIBUTION Widespread across mainland Britain, absent from Ireland

Water shrew
Neomys fodiens

Larger than common and pygmy shrews with a 'keel' of silvery hairs on the tail to aid swimming and a fringe of bristly hairs on the hind feet. Looks black above and white below when on land, but silvery when swimming underwater due to trapped bubbles in the dense fur. Head, snout, eyes and ears similar to other shrews with prominent whiskers. Swims readily, but also very active on land using narrow runways in thick cover.

LENGTH 10cm
BREEDING Produces 2 litters of 6–12 young between April–September
FOOD Aquatic and terrestrial invertebrates; sometimes small fish and amphibians
HABITAT Normally near water; watercress beds, ditches, clear streams, seashores, wet, scrubby areas
VOICE Very vocal with variety of loud squeaks and squeals
DISTRIBUTION Widespread across most of mainland Britain, absent from Ireland

RODENTS
- Well-developed feet and claws for climbing and scrambling
- Chisel-shaped incisors for gnawing ● Good hearing

Dormouse
Muscardinus avellanarius

A secretive and very scarce nocturnal mammal, rarely seen in the wild unless disturbed. Fur is rich bright orange and very soft, although young animals are greyer. The tail is bushy, unlike any other mice, and 1 in 10 have a white tip. The muzzle is short with long whiskers, and the eyes are large and black. The ears are prominent and rounded. Very agile, spending most of its life in the tree canopy, coming to the ground only to hibernate in small nest for around 6 months in winter.

LENGTH 8cm
BREEDING Produces single litter of 4–7 young in July–September
FOOD Fruits, seeds, nectar-rich flowers, some invertebrates; hazel nuts are most important food
HABITAT Ancient woodlands with hazel and honeysuckle, connecting hedgerows, copses
VOICE Normally silent, but can make quiet purring sounds and faint squeaks
DISTRIBUTION Very rare and mostly restricted to suitable in southern England

Edible dormouse
Glis glis

Resembles small grey squirrel with mostly grey fur above and white underside. The tail is long and bushy, but the small hind feet help distinguish it from young squirrel. May occur in small colonies in suitable habitats, hoarding food and hibernating communally in underground burrows. May enter buildings to take stored food. Once eaten by the Romans – hence the English name. Introduced into Hertfordshire and now naturalised, but spreading slowly to surrounding areas.

LENGTH 12–15cm
BREEDING Produces a litter of up to 9 young in June–August
FOOD Wide range of fruits and seeds, stripped bark, fungi, insects, eggs and nestlings of woodland birds
HABITAT Mixed deciduous woodland, orchards, large gardens
VOICE Loud squeals and grunts
DISTRIBUTION Introduced into southern England and common in a very local area

Harvest mouse
Micromys minutus

A very small mouse with reddish-brown upperparts, a white underside and a very long, almost hairless tail with a prehensile tip. The muzzle is short and the ears are rounded and hairy. When moulting the upperparts appear patchy with grey areas showing through. Very agile and able to climb through thin grass stems with ease. Usually feeds at night. Tiny woven nests in grasses and brambles are good field sign. The smallest European rodent.

LENGTH 6–7.5cm
BREEDING Produces litters of 5–8 young several times a year between May–October
FOOD Tiny seeds, fruits and berries, green shoots and buds, small insects
HABITAT Long grass, reedbeds, bramble patches, unkempt cereal fields
VOICE Normally silent, but can make some very shrill squeaks
DISTRIBUTION Widespread but thinly scattered across England and Wales

Bank vole
Clethrionomys glareolus

Fur is reddish-brown and glossy above, and greyer on the flanks in adults. Juveniles are greyer overall. Dark brownish-grey underside. The tail is short, but longer than in the short-tailed vole. The eyes are black and the ears are rounded, but not as prominent as in mice. Nibbles hazel nuts, leaving neat round hole with no surrounding tooth marks, and hoards food under logs. Favourite prey of owls. Usually lives on the ground but can climb well.

SIZE Length 9–11cm
BREEDING Produces litters of 3–5 young, up to 4 times a year in April–October
FOOD Nuts, seeds, berries, roots and shoots; some small invertebrates
HABITAT Deciduous woods, scrub, hedgerows and bramble patches
VOICE Shrill chattering and squeaking, some inaudible to humans
DISTRIBUTION Widespread in mainland Britain, increasing in Ireland, but still local

Short-tailed or field vole
Microtus agrestis

Fur is dark grey-brown above, and a dull creamy-grey below, and looks less sleek than that of the bank vole. It is thicker in winter after an autumn moult. The tail is very short, and the eyes and ears are also slightly less prominent. Adult males kept in close confinement produce an unpleasant smell. Active in open grassland, sometimes creating a network of tunnels among the roots from which animals are occasionally heard squabbling.

SIZE 10–12cm
BREEDING Produces up to 6 litters of 4–6 young in April–September
FOOD Roots and shoots of grasses, may gnaw bark in hard winters
HABITAT Grassland, rough pastures, heaths, young plantations and road verges
VOICE Various shrill, short squeaks and chattering sounds
DISTRIBUTION Widespread in mainland Britain, absent from Ireland

Water vole
Arvicola terrestris

A large vole with shaggy blackish-brown fur; Scottish animals are darker than those from further south. Similar in size to brown rat, but the muzzle is blunt and the tail is far shorter. Swims readily and is rarely found far from water. Clues are piles of green droppings near bankside runways, remains of white pith from inside rushes and grazed 'gardens' on river banks near entrances to burrows.

SIZE 18–22cm
BREEDING Produces 3–4 litters of up to 5 young in March–September
FOOD Grasses and sedges, emergent plant roots and tubers, riverside plants; rarely takes animal food
HABITAT Well-vegetated river banks with scope for burrowing
VOICE Usually silent but can make squeaking, disyllabic alarm call
DISTRIBUTION Widespread but declining in mainland Britain, absent from Ireland

Yellow-necked mouse
Apodemus flavicollis

A large mouse with a very long tail and large ears and eyes when compared with similar wood mouse. Best identification feature is yellowish-orange neck collar across white underparts. Upperparts are a rich brown and clearly demarcated from the clean white underparts. A very lively and agile mouse, and aggressive when captured. Climbs trees with ease, and collects food which is taken to safe hiding place. Will use nesting boxes.

SIZE 9–12.5cm
BREEDING Produces up to 3 litters of 4–5 young in April–October
FOOD Seeds, berries, shoots and buds, sometimes invertebrates
HABITAT Ancient woodlands, thick hedgerows, copses, gardens adjoining woodlands
VOICE Usually silent, but makes high-pitched squeaks if provoked
DISTRIBUTION Confined to suitable habitats in southern England and Wales

Wood mouse
Apodemus sylvaticus

A sleek, mostly brownish-grey mouse with a pale grey underside. There is a variable patch of yellow-orange on the throat between the front feet, often no more than a thin line. Juveniles are greyer than adults. The tail, eyes and ears are all comparatively smaller than in the yellow-necked mouse. A common and widespread mouse found in most habitats, including houses in towns. Nibbles holes in hazel nuts leaving neat round hole with surrounding tooth marks.

SIZE 7.5–11cm
BREEDING Produces 2–3 litters of up to 9 young in March–October
FOOD Fruits, seeds, nuts, buds and shoots, fungi and some invertebrate food
HABITAT Woodlands, hedgerows, scrub, gardens; any habitat with good vegetation cover
VOICE Various shrill squeaks
DISTRIBUTION Common and widespread throughout Britain and Ireland

House mouse
Mus musculus

A mostly grey-brown mouse with fairly uniform colouring above and below. The eyes and ears are large, but not as prominent as in the wood mouse and the tail is the length of the body and mostly hairless. This species is most likely to be associated with humans, although it is far less common than it used to be. Can be very destructive to fabrics, stored food, timbers, etc. Field signs are droppings left near food and small entrances to tunnels. Leaves a striking 'mousy' smell where it has been feeding.

SIZE 7.5–10cm
BREEDING Produces up to 6 litters of 6–8 young throughout year if in suitable buildings
FOOD Wide variety of foods including stored grains and flour; occasionally fruits
HABITAT Buildings, especially those storing food, farmyards and adjoining scrub patches
VOICE Various high-pitched squeaks
DISTRIBUTION Widespread across Britain and Ireland but declining in range and abundance

Red squirrel
Sciurus vulgaris

Fur is warm reddish-brown, becoming darker in winter; underside is mostly white. Bushy tail and tufted ears, although the latter feature is not always very obvious. Smaller than the grey squirrel; the two species do not usually occur in the same area. Builds a drey of twigs, with a soft lining, over 6m up in mature tree.

SIZE 20–28cm
BREEDING Produces 1–2 litters of up to 5 young in April–September
FOOD Pine seeds, acorns, nuts, fungi, bark and sap; rarely birds' eggs or chicks
HABITAT Pine forests and parks and gardens with suitable trees
VOICE Chattering calls, often accompanied by tail flicking
DISTRIBUTION Restricted mainly to Scotland and Ireland with isolated populations in Wales and parts of England

Grey squirrel
Sciurus carolinensis

Fur is mostly grey, but paler on the underside. Some individuals show some red on the flanks. The tail is very bushy, but there are no ear tufts. Builds large leafy dreys with outer structure of twigs high in trees, often in fork near main trunk. Spends more time on ground than red squirrel, usually looking for food stored in previous year. In autumn may be seen burying nuts or acorns. Frequently enters gardens to raid bird feeders. Introduced in Britain from North America.

SIZE 25–30cm
BREEDING Produces 1–2 litters of 3–5 young in April–September
FOOD Nuts, seeds, berries, bark and sap; occasionally birds' eggs and chicks
HABITAT Mixed woodland, gardens and hedgerows
VOICE Scolding, chattering calls sometimes accompanied by tail flicking and stamping
DISTRIBUTION Widespread and common on southern Britain and parts of Ireland, spreading north

Brown rat

Rattus norvegicus

Fur is mostly brown and paler on the underside, although can be variable. Tail is thick and mostly hairless, and ears are short and rounded. When running on soft ground tail leaves a trail between paw prints. Holes and burrows usually marked by oily stains and regularly used tracks are very clear due to oily deposit. Usually associated with human activity, especially grain stores, farmyards and refuse tips, but also occurs in more open country. Not native to Britain, but widespread.

SIZE 22–27cm
BREEDING Produces several litters per year of up to 9 young if food is plentiful
FOOD Wide range of animal and vegetable foodstuffs, including scraps and refuse, plus live food such as invertebrates, eggs and chicks
HABITAT Human habitation, farmland, crop fields, ditches and seabird colonies
VOICE Shrill chattering calls and defiant screams if threatened
DISTRIBUTION Widespread across most of Britain and Ireland

RABBIT AND HARES
● *Large hind feet* ● *Long ears*
● *Chisel-shaped incisor teeth*

Rabbit

Oryctolagus cuniculus

A common, widespread and very familiar mammal, only possible confusion likely with larger hare. Fur is mostly brown, turning to grey underneath. Behind the ears there is a rufous patch, and the short, dark tail shows white on the underside when the rabbit is fleeing. The ears are brown and shorter than the head. Field signs include extensive warrens in banks and on open ground, and piles of droppings in prominent places. Introduced into Britain in Middle Ages, becoming very common. Vulnerable to myxomatosis, but some show resistance.

SIZE 35–40cm
BREEDING Produces up to 6 litters of 3–6 young from February–October
FOOD Grasses, shoots of crops and herbaceous plants, bark and bulbs; re-ingests droppings
HABITAT Grassland, hedgerows, woodland margins, dunes, heathlands and cliffs
VOICE Usually silent, but stamps feet in alarm and squeals if threatened by predator
DISTRIBUTION Widespread and abundant across much of Britain and Ireland, including offshore islands

Brown hare

Lepus europaeus (capensis)

Larger than rabbit, with longer, black-tipped ears and longer legs. The fur is a yellowish-brown on the upperparts, but grey on the underside. Remains crouched on the ground if alarmed, only fleeing if approached very closely, and then always remaining above ground. Makes regular well-worn tracks and larger depressions, known as 'forms', in which to rest. Pairs engage in 'boxing' in spring, standing on hind legs and sparring with front legs, when disputing territories or repelling unwanted advances.

SIZE 60–70cm
BREEDING Produces up to 3 litters of 4 young in March–October
FOOD Grasses, meadow plants, some crops and bark in winter
HABITAT Open flat grassy country and open woodlands
VOICE Usually silent, but screams when under stress
DISTRIBUTION Widespread, but scarce in northern Scotland and rare in Ireland

Mountain hare

Lepus timidus

Smaller than brown hare and with a more compact shape; the legs and ears are shorter giving a slightly rabbit-like appearance. In summer the fur is blue-grey, leading to the alternative name of blue hare, but in winter the fur is all white apart from the black tips to the ears. Makes trails in heather which lead to the 'form', a sheltered depression in long heather. Irish race is slightly larger than Scottish race and does not turn fully white in winter.

SIZE 50–65cm
BREEDING Produces up to 3 litters of 3–5 young (leverets) in March–August
FOOD Heather, bilberry, gorse, willow in winter; grasses and herbs in summer
HABITAT Upland moors and mountain slopes, lowland areas where brown hare is absent
VOICE Usually silent, but screams when in distress
DISTRIBUTION Occurs in upland areas of Scotland, Wales and Pennines; widespread in Ireland and Isle of Man

MUSTELIDS
● *Slender, muscular bodies* ● *Sharp teeth for killing prey*
● *Produce strong 'musk' scents*

Stoat

Mustela erminea

Long and slender-bodied predator with rich brown fur and a short, black-tipped tail. The underparts are yellowish-white and the ears have a white edge. In winter northern animals may moult into white pelage, or at least become partly white; the tip of the tail always remains black. Uses narrow tracks in thick cover, but when chasing a rabbit emerges into open. Sits up on hind legs to look over tall vegetation. Very aggressive and usually solitary. Males larger than females. Prey is killed by a strong bite to the back of the neck. Heavily persecuted by gamekeepers.

SIZE 35–40cm
BREEDING Produces a litter of up to 10 young in May–June
FOOD Small mammals, rabbits and birds
HABITAT Wide range of habitats from sea level to mountainous regions, wherever there is cover and prey
VOICE Shrill chattering and 'kree kree' call notes
DISTRIBUTION Widespread across most of mainland Britain and Ireland

Weasel

Mustela nivalis

Smaller than stoat, with shorter tail lacking the black tip. Rich chestnut-brown fur above and white below, not quite as clearly demarcated as in the stoat. Aggressive and usually solitary, but females may sometimes be seen with young. Travels along small runways and burrows in thick cover; climbs well, but may run out into open in pursuit of prey.

SIZE 20–25cm
BREEDING Produces 1 or 2 litters of up to 7 young in April–August
FOOD Small mammals, especially mice, voles and rats; some small birds
HABITAT Wide range of habitats, where cover and prey can be found
VOICE Sharp, trilling alarm call and short yap and hissing sounds
DISTRIBUTION Widespread across most of mainland Britain, absent from Ireland

Polecat

Mustela putorius

Fur is mostly dark brown, but the face has a distinctive white snout and pale patches between eyes and ears, giving a masked effect. The outer edges of the ears are white and the flanks are usually paler than the upperparts. At times the pale yellow underfur shows through the darker outer coat. May be confused with escaped polecat-ferret, but these are much more variable in body colour and often lack face mask.

SIZE 45–55cm
BREEDING Produces 1 litter of up to 7 young in June–July
FOOD Amphibians, small mammals, birds, earthworms, carrion and beetles
HABITAT Lowland woodland, farmland with hedgerows, river banks and marshes
VOICE Growls and hisses when angry, plus some chattering calls
DISTRIBUTION Confined mainly to Wales

American mink

Mustela vison

Fur is usually glossy dark brown or black, although paler individuals do occur. There is normally a small patch of white on the chin and throat, and the underside may be mostly white. The feet are slightly webbed, as mink are partially aquatic and usually found close to water. Slightly bushy tail when dry, which is about half the length of the body. Males are slightly longer than females, but twice as heavy. Food may be stored in caches on river banks. An introduced species, and very destructive to native wildlife.

SIZE 42–65cm
BREEDING Produces 1 litter of up to 7 young in April–May
FOOD Fish, frogs, small birds and mammals, large insects and molluscs
HABITAT Well-vegetated river banks, lake margins, ditches, rocky seashores and estuaries
VOICE Purring sounds, plus shrill shriek when alarmed
DISTRIBUTION Widespread alien across large areas of Britain and Ireland, including offshore islands

Pine marten
Martes martes

Secretive and arboreal, but may be spotted when hunting red squirrels through branches of pine trees, the chase can be noisy and involve energetic leaping from branch to branch. Fur is rich reddish-brown, with creamy-yellow throat and chest. The tail is very bushy and the soles of the feet are covered in thick fur. Appears long-legged by comparison with other mustelids. Deposits twisted droppings in prominent places beside roads and streams.

SIZE 65–75cm
BREEDING Produces one litter of 3 young in April–May
FOOD Voles, rabbits, red squirrels, birds, carrion, amphibians and beetles
HABITAT Mature coniferous or mixed forests, rocky ground and inland cliffs
VOICE Usually silent, but makes cat-like calls in breeding season, plus growls and sharp scolds
DISTRIBUTION Patchy distribution across Ireland, Wales, northern England and northern Scotland

Otter
Lutra lutra

Large and sleek with short legs and a long, thick, tapering tail. Broad muzzle and small rounded ears. The front and hind feet are webbed and leave characteristic prints on wet mud. Fur mostly dark brown above and pale below. Swims very well on the surface and under water; equally at home on the seashore and in freshwater. Leaves droppings (spraint) with pleasant musky smell in prominent places on river banks, and makes well worn 'slides' on steep river banks.

SIZE 95–130cm, including tail
BREEDING Produces one litter of 2–5 young in April–September
FOOD Mostly fish, plus some amphibians, small birds and mammals, crustacea
HABITAT Freshwater systems with plenty of food and hiding places and remote
seashores
VOICE Usually quiet, but makes low whistle and quiet chattering and 'yikkering' calls
DISTRIBUTION Occurs in small numbers across much of Britain and Ireland; commonest in west and north

Badger
Meles meles

An easy mammal to recognise with its striking black and white face pattern, but due to its nocturnal habits and fear of humans it is quite difficult to observe in the wild. There is no variation in markings between the sexes or juveniles and adults, although adult males have broader heads than females and are larger. The white parts of the face may be coloured with soil, and can vary according to local soil types. Typical home is a large sett, identified by earth mounds outside tunnel entrances. Large numbers are killed on roads each year.

SIZE 80–95cm
BREEDING Produces single litter of up to 5 cubs in February
FOOD Earthworms, slugs, wide range of invertebrates, small mammals, carrion, fruits and scraps
HABITAT Woodland, farmland with
hedgerows and large suburban gardens
VOICE Usually silent, but young make *yikkering* calls; adults make growls and other calls
DISTRIBUTION Widespread across most of mainland Britain and Ireland

CARNIVORES
● *Powerful teeth and jaws*
● *Good hearing and smell for hunting* ● *Mostly nocturnal*

Wildcat
Felis sylvestris

Bears resemblance to large tabby cat, but has far bushier, blunt-ended tail with several dark rings and dark tip. Body is marked with dark stripes, never irregular blotches. The eyes are amber-green and the nose is pink. Very secretive and largely nocturnal, but camouflage is excellent and may be overlooked in woodland habitat when prowling at dawn and dusk. Small prey eaten whole, but larger prey such as rabbits may be skinned and turned inside out. Hybridises with domestic cat.

SIZE 75–105cm
BREEDING Produces one litter of 3–4 young in April–September
FOOD Small mammals and birds, some amphibians, fish, and grass to prevent hair balls
HABITAT Forest margins, scrub and
new plantations
VOICE Cat-like calls, purrs and mews
DISTRIBUTION Largely confined to forests and scrub in Scottish Highlands, decrease in persecution leading to slight increase in range

Fox
Vulpes vulpes

Unmistakable shape and demeanour; colours may vary, but thick coat is normally rich reddish-brown with dark backs to the sharply pointed ears. Throat and chest may be white or grey. Long bushy tail; some may have a white tip. The muzzle is pointed with a shiny black nose. Winter coat is thicker and greyer than summer coat. Twisted droppings left in prominent spots and strong musky smells mark well-used tracks. Wary of humans;long history of persecution.

SIZE 100–120cm
BREEDING Produces one litter of 4–5 cubs in March–May
FOOD Small birds, mammals, amphibians, carrion, beetles, earthworms and refuse
HABITAT Complete range of habitats, including city centres
VOICE Blood-curdling screams from vixen, and many barks and shrieks
DISTRIBUTION Widespread across most of mainland Britain and Ireland

SEALS
● *Limbs reduced to flippers* ● *Streamlined bodies*
● *Thick blubber layer under skin*

Common seal
Phoca vitulina

Our smallest seal, with a varied coat colour and pattern of spots. Best identification feature is the rounded, dog-like head with a short muzzle and nostrils which are close together and form a 'V' pattern. From a distance a dry animal may look rather silvery; at closer range the coat is seen to be mottled with darker spots. The sexes are very similar and juveniles resemble adults, apart from the smaller size. Usually hauls out on sandbanks or in sea lochs, and can dive for up to 10 minutes at a time.

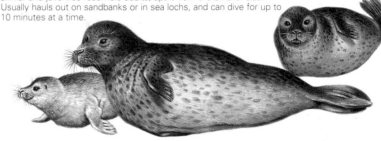

SIZE 1.8–2m
BREEDING Produces single pup in June–July
FOOD Fish, crustaceans and large molluscs
HABITAT Sheltered coastlines with
access to safe hauling-out sites
VOICE Normally silent, but can'make gruff barking calls
DISTRIBUTION North Sea coasts, sheltered parts of north and west Scotland, Ireland

Grey seal
Halichoerus grypus

A large seal with mostly grey colourings. Adult males have a long muzzle and an arched nose; this is less pronounced in females and young, but never concave as in the common seal. Males are much larger than females. The nostrils are widely separated and more parallel. Adults often bear deep scars, either from fighting between males, or acquired during mating if on the backs of the head of females. Newly born pups are silvery white at first, moulting into their mottled grey coat after weaning. Often seen 'bottling' in deep water, with the head at the surface and the body hanging vertically below.

SIZE Length 2.5–3m
BREEDING Produces single pup in October–November
FOOD Fish and squid
HABITAT Open sea, rocky coasts, estuaries; breeds on remote rocky shores
VOICE Mournful howling calls, especially from females; young make sad crying calls
DISTRIBUTION Widespread around coasts of Britain and Ireland, apart from SE England

BATS
● *Acute hearing* ● *Forelimbs adapted for flight*
● *Hibernate in winter*

Lesser horseshoe bat
Rhinolophus hipposideros

A medium-sized bat with distinctive 'nose leaves', the fleshy lobes on either side of the nose which help in its echo-location. The ears lack the tragus, or pointed flap of tissue inside the ear opening, found in most other bats.
The fur is soft and greyish-brown, becoming paler on the underside.
Lives in colonies, preferring caves and tunnels, but will use barns and attics in summer. Feeds by 'gleaning', or picking prey items off foliage.

SIZE Wingspan 22–25cm
BREEDING Produces single young in June–July
FOOD Night-active insects, especially craneflies, moths, beetles
HABITAT Open wooded country, mostly in limestone regions
VOICE Ultrasonic chirps and barks
DISTRIBUTION Very rare in Britain and declining; mainly in limestone areas of SW England and Wales

Greater horseshoe bat
Rhinolophus ferrumequinum

A large bat with horseshoe shaped 'nose leaves' and no tragus in the ear. The fur is soft and mostly dark brown with a reddish tinge on the back, and greyish-white on the underside. The wing membranes and ear lobes are a light grey-brown. Lives in colonies and makes audible chattering sounds, especially in breeding colonies. Remains of insect prey may accumulate beneath favourite roosts.

SIZE Wingspan 34–39cm
BREEDING Produces single young in June–July in large colonies
FOOD Large night-flying insects, e.g., cockchafers, moths
HABITAT Wooded areas with caves for roosting near by
VOICE Chirping and scolding calls, mostly inaudible to humans
DISTRIBUTION Very rare in Britain, confined to a few sites in SW England and south Wales

Daubenton's bat
Myotis daubentoni

A medium-sized bat with brown fur tinged with grey, or sometimes bronze on the back. The underside is grey and there is usually a well-defined border between the grey and the brown fur. Juveniles have a black spot on the chin, but lose this after one year. The ears are relatively short and have a small tragus, or flap of skin at the entrance. Usually found near water, and hunts low over the water for emerging insects. Roosts in tree holes or rock crevices.

SIZE Wingspan 23–27cm
BREEDING Produces single young in June–July
FOOD Caddis flies, mayflies, small pond beetles
HABITAT Open woodland near water, farmland
VOICE Ultrasonic calls
DISTRIBUTION Widespread across large areas of Britain and Ireland, including southern Scotland

Serotine bat
Eptesicus serotinus

A large bat with dark brown fur on the back, but paler colouration on the underside. The ears are comparatively large and the tragus is well developed. Roosts in buildings, leaving clues in the form of droppings near the entrance hole and making audible squeaks before emerging. Hunts along woodland edges and rides, making slow powerful wingbeats. May share roosts with other species.

SIZE Wingspan 36–38cm
BREEDING Produces single young in June–August
FOOD Flies, moths, beetles caught on the wing
HABITAT Open wooded country, parklands, farmland
VOICE Audible squeaks and chirps from roost, plus ultrasonic calls
DISTRIBUTION Confined to SE England

Natterer's bat
Myotis nattereri

A medium-sized bat with wings which look pale in flight. The fur is light brown on the back and white below; the face is hairless and pink and the limbs and wing membranes are hairless. There is a fringe of hairs on the trailing edge of the wing membrane. The ears are comparatively long and narrow and have a long narrow tragus. Takes insects on the wing or by gleaning from foliage, sometimes using its tail to flick them into the mouth.

SIZE Wingspan 25–30cm
BREEDING Produces single young in June–July
FOOD Small insects, flies, beetles, caddis flies
HABITAT Open woodland, farmland, marshy areas, parks and gardens
VOICE Ultrasonic calls, plus squeaks and chirps
DISTRIBUTION Widespread across much of Britain and Ireland, apart from north

Long-eared bat
Plecotus auritus

Best identification feature is very long ears, more than half the length of the head and body, with well-developed tragus; ears can be visible in flight in good light. A small bat with brown fur on the back and paler brown fur below, but avoid confusion with very rare grey long-eared bat which is similar but with grey fur. May land on ground to catch food. Can tolerate colder conditions than many other species so is found further north. Roosts in caves, buildings and tree holes.

SIZE Wingspan 23–28cm
BREEDING Produces single young in June
FOOD Small beetles, moths, flies
HABITAT Woods and copses, farmlands, gardens
VOICE Quiet high-pitched clicks and ultrasonic calls
DISTRIBUTION Widespread and common across most of Britain and Ireland

Noctule bat
Nyctalus noctula

A large bat with reddish-brown fur on the back and slightly paler fur on the underside. The fur is relatively short and smooth. The ears are broad and lobed and dark brown like the wing membranes. A strong flier which may emerge just before sunset, flying over the tree canopy and making frequent twists and turns to catch prey. Favourite tree-hole roosts are marked by oily stains. Also roosts in buildings, bridges and rock crevices.

SIZE Wingspan 32–39cm
BREEDING Produces single young in June–July
FOOD Large flying insects caught on the wing, plus some smaller prey
HABITAT Open woodland, parks and gardens
VOICE Sharp metallic flight calls, ultrasonic calls
DISTRIBUTION Widespread but uncommon in England and Wales

Pipistrelle bat
Pipistrellus pipistrellus

The smallest British bat and the one most likely to be seen by casual observers. The fur is normally brown but can vary; most individuals have rich dark brown colourings with darker ears, nose and wings. The ears are short and far apart and the face is small and rounded. The flight pattern is jerky and erratic, but may follow a set route. Frequently roosts in houses, sometimes in large colonies.

SIZE Wingspan 19–25cm
BREEDING Produces single young in June–July
FOOD Small flying insects, up to 3,000 per night by a single bat
HABITAT Parks and gardens, open countryside with buildings
VOICE High-pitched twitterings and scolding sounds, ultrasonic calls
DISTRIBUTION Widespread and common throughout Britain and Ireland, apart from far north

DEER

- New antlers grow each year
- Males have antlers • Cloven hooves

Fallow deer

Dama dama

Adult males have palmate antlers. Coat colour variable, ranging from black with paler spots through browns and buffs to very pale buff with darker spots. Conspicuous white rump has inverted dark horseshoe pattern. Males make belching sounds in the mating season.

SIZE Shoulder height 85–95cm
BREEDING Produces 1 (rarely 2) fawns in June–July
FOOD Wide range of plant material, especially grasses, but will nibble shoots on trees
HABITAT Parkland, open woodland, farmland, shelter belts
VOICE Gruff alarm 'bark' from females and roaring calls from male
DISTRIBUTION Introduced into Britain and widespread in the south with isolated populations in Scotland and Ireland

Red deer

Cervus elaphus

Britain's largest native land mammal. Mature stags have well-developed branching antlers, becoming larger each year. Females are smaller than males. In summer coat is rich reddish-brown, but in winter it is grey-brown. In autumn males defend harems by roaring and fighting.

SIZE Shoulder height 115–120cm
BREEDING Single fawn (rarely twins) is produced in May–June
FOOD Grasses, sedges and rushes, low-growing shrubs and trees
HABITAT Moorland, open woodland, farmland with copses
VOICE Males make deep roaring in October, females and young can make short bleats
DISTRIBUTION Widespread and common in Scotland, and present in many other areas of Britain and Ireland in more isolated populations

Sika deer

Cervus nippon

Summer coat is reddish-brown with white spots; this becomes much greyer in the winter. Males have pointed, branching antlers, smaller than red deer. Rump shows brown and white horseshoe pattern.

SIZE Shoulder height 75–80cm
BREEDING Produces single fawn in June–July
FOOD Wide range of grasses, rushes, bramble, low-growing shrubs
HABITAT Mature woodlands with undergrowth, farmland, parkland
VOICE Harsh screams if alarmed and whistling calls in breeding season
DISTRIBUTION Introduced from Japan in 1860 and now naturalised at many scattered localities in Britain and Ireland

Roe deer

Capreolus capreolus

A small and attractive native deer with a rich reddish-brown coat in summer; in winter the coat is a grey-brown providing excellent camouflage in woodlands. The rump is white and there is no tail, but females have a small tuft of white hair on the rump. Males have small antlers with knobbly bases and up to three points. They are shed in November and start to regrow early the following year.

SIZE Shoulder height 65–70cm
BREEDING 1, sometimes 2 fawns born in May–June
FOOD Wide range of shoots, leaves, buds, plus acorns, beech mast, fungi in season
HABITAT Woodlands with dense undergrowth, copses, farmland with thick hedgerows
VOICE Gruff bark if alarmed
DISTRIBUTION Widespread in Scotland and southern England, spreading to other areas, absent from Ireland

Muntjac deer

Muntiacus reevesii

The smallest deer found in Britain, recognised by its small size, hunched posture and a ginger tail which is held up showing the white underside if the deer is alarmed. The coat is mostly chestnut-coloured above.

SIZE Shoulder height 45–48cm
BREEDING Single young can be produced at any time of year
FOOD Wide range of herbs, shrubs, fruits and berries, buds and shoots
HABITAT Coppiced woodland, shrubby gardens, areas with thick cover
VOICE Gruff barks, sometimes repeated for over 30 minutes; shrill screams
DISTRIBUTION Introduced, and now spreading in southern England

WHALES AND DOLPHINS

- Thick blubber layer beneath skin for insulation
- Streamlined bodies • Nostrils form blowholes on top of head

Minke whale

Balaenoptera acutirostrata

The smallest of the baleen whales. Appears all black on upperparts. Dorsal fin is hooked and head is triangular in outline with a distinct ridge running to the snout. If seen from a boat the dorsal fins show large white patches on the upper surface. Feeds near surface.

SIZE Length 8–10.5m
BREEDING Single calf produced in December–January
FOOD Small fish and squid, shrimps
HABITAT Coastal waters
VOICE Mostly silent, but can make grunts and clicks
DISTRIBUTION Frequently seen around coasts of Scotland and Ireland, occasionally elsewhere

Common dolphin

Delphinus delphus

Not common, but may be seen from coasts and ferries. Back is mostly black but flanks show hourglass pattern of yellow at head end and grey near tail. At close range undulating white lines may be seen on flanks. The dorsal fin is triangular and slightly hooked.

SIZE 1.8–2.5m
BREEDING Single calf born in June–September but not every year
FOOD Fish, sometimes small squid
HABITAT Open sea, some coastal waters
depending on food supplies
VOICE Inaudible clicks
DISTRIBUTION Could be seen at any point around British coast, but most likely in north and west

Bottle-nosed dolphin

Tursiops truncatus

Large dolphin with fairly uniform dark grey colourings, paler on the underside. 'Beak' or 'bottle nose' can be seen when the dolphin is at the surface. Dorsal fin is tall and sickle shaped, and the tail is broad and notched. The skin is sometimes marked with scars and scratches. Usually seen in small schools at regular feeding areas.

SIZE Length 2.8–4m
BREEDING Produces single young in summer in alternate years
FOOD Fish and squid
HABITAT Coastal waters
VOICE Various squeaks and clicks and ultrasonic calls
DISTRIBUTION Still widespread but declining due to fouling in fishing nets and over-fishing

Harbour porpoise

Phocoena phocoena

The smallest cetacean. Mostly black on upperparts, grading into white on belly. Snout is short and blunt and the dorsal fin is triangular with a slightly concave trailing edge. Body is compact and rounded. Does not breach or bow ride.

SIZE Length 1.3–1.9m
BREEDING Produces single calf in May–July in alternate years
FOOD Fish, especially herring and mackerel, squid
HABITAT Coastal waters, large estuaries, sea lochs
VOICE Usually silent
DISTRIBUTION Widespread but declining around British and Irish coastlines

BIRDS

DIVERS AND GREBES

- *Excellent divers and swimmers* • *Legs set well back on body*
- *Nests often floating on water*

Black-throated diver

Gavia arctica

Large diving bird with mainly black and white plumage. Sexes alike. In summer head and nape are blue-grey, throat black and sides of neck striped black and white. Chequerboard black and white back contrasts with pure white underside. In winter bird is mostly plain black above with white underside and whitish 'thigh' patch showing at waterline.

SIZE Length 60–70 cm
NEST Platform of vegetation at water's edge on isolated lakes and tarns
BREEDING Rare breeder in Britain; lays 1–2 eggs in April–May in nests on remote Scottish lochs
FOOD Mainly fish caught by diving in sea or freshwater lochs

HABITAT Isolated freshwater lochs in summer, moves to coasts and large inland reservoirs in winter
VOICE Far-carrying, mournful *kloweee-kow* and some chattering sounds
DISTRIBUTION Scarce breeding bird in Scotland, winter visitor to coasts and inland lakes

Red-throated diver

Gavia stellata

Slender diving bird with slightly upturned, pointed bill. Sexes similar. In summer red throat patch contrasts with slate-grey head and face and black and white striped nape. Winter plumage is plainer with mostly grey upperparts and white underparts; at close range a pattern of pale speckles may be seen on back.

SIZE Length 55–65 cm
NEST Platform of vegetation at water's edge
BREEDING Lays 1–2 eggs in April–May
FOOD Mainly fish caught by diving in sea or lochs

HABITAT In summer, upland lochs and tarns in Shetland; moves to coasts and reservoirs in lowlands in winter
VOICE A goose-like cackling flight call, and a long mournful *a-rooo*, said to predict rain
DISTRIBUTION Orkney, western Scotland and NW Ireland, south Britain in winter

Great crested grebe

Podiceps cristatus

Slender diving bird with long thin neck and long pointed pinkish-buff coloured bill; for most of year looks black and white at a distance, but in summer acquires orange ear tufts and black crest. Upperparts mainly grey-brown, sexes alike. Engages in elaborate courtship display in which birds carry out 'penguin' dance on water, with offerings of pond weed.

SIZE Length 50 cm
NEST Floating nest of vegetation among water plants
BREEDING Lays 2–7 eggs in April–May
FOOD Mainly fish caught by diving
HABITAT Freshwater lakes, reservoirs and large rivers; may move to coasts and estuaries in winter
VOICE Usually silent, but can make harsh cackling calls
DISTRIBUTION Found throughout British Isles, apart from northern Scotland

Red-necked grebe

Podiceps grisegena

Mainly black and white in winter, but smaller than great crested grebe and has yellow bill with black tip and no white eye-stripe. Not a British breeding species, but may sometimes be seen in summer plumage with brick-red neck, white cheeks and black cap.

SIZE Length 45 cm
NEST Nests on margins of well-vegetated lakes
BREEDING Breeds in northern and eastern Europe; lays 4–5 eggs on floating nest

FOOD Mainly fish, caught by diving
HABITAT Winters on sheltered coasts, reservoirs and lakes
VOICE Harsh squealing and stuttering calls
DISTRIBUTION Winter visitor to coasts and freshwater lakes

Slavonian grebe

Podiceps auritus

Small, rather plump grebe with short straight bill. In winter looks black above and white below, with more noticeably white face than other small grebes; flat black head gives 'capped' appearance. Striking plumage in summer with reddish neck and underparts, black head and yellow ear tufts.

SIZE Length 35 cm
NEST Nest of floating vegetation on margins of small well-vegetated lakes
BREEDING Lays 4–5 eggs in April–May; confined to Scottish Highlands in Britain in nesting season
FOOD Mainly fish and invertebrates caught by diving
HABITAT Isolated upland lochs in summer, moves to coasts and estuaries in winter

VOICE Weak, trilling calls heard near breeding sites in spring
DISTRIBUTION Scarce breeding bird in Scotland, winter visitor to coasts in south

Black-necked grebe

Podiceps nigricollis

Small, compact grebe with small upturned bill. In winter looks black and white, and differs from slavonian grebe in having more pointed head and greyer sides to neck. In summer plumage neck is black with contrasting yellow ear tufts and underparts are chestnut.

SIZE Length 28 cm
NEST Nest of vegetation in well-vegetated lakes, often colonially and sometimes near black-headed gulls
BREEDING Lays 4–5 eggs in April–May on a few remote lakes in Scotland and Northern Ireland
FOOD Mainly fish caught by diving
HABITAT Lakes in summer; moves to sheltered coastal waters in winter
VOICE A few quiet whistling calls

DISTRIBUTION Winter visitor to coasts and estuaries

Little grebe

Tachybaptus ruficollis

The smallest British grebe, with plain brownish coloration above and pale buff below. Dark head contrasts with paler neck. In summer cheeks and neck are chestnut and base of bill has bright lime-green spot. The commonest and most widespread of the grebes.

SIZE Length 25 cm
NEST Nest of vegetation floating among marginal plants
BREEDING Lays 4–6 eggs in April–July; quickly covered with nest material if bird leaves nest
FOOD Mainly small fish and invertebrates caught by diving
HABITAT Large ponds, canals and slow-flowing rivers; may disperse to sheltered

coastal waters in hard winters
VOICE Shrill whinnying sounds in breeding season
DISTRIBUTION Widespread on sheltered freshwater areas, visits coasts in winter

FULMARS, PETRELS & GANNET
● *Gliding flight* ● *Winter mainly at sea*
● *Catch food at sea surface*

Fulmar
Fulmarus glacialis

Gull-like seabird, but with gliding, stiff-winged flight, and habit of riding on updraughts by cliffs. Tube nostrils and bill plates give bill a stocky appearance. Plumage predominantly white, but wings and back a soft blue-grey. Dark smudge next to eye. A very long-lived seabird, some recorded reaching 50 years of age, which pairs for life and uses the same cliff nest site year after year.

SIZE Length 45cm
NEST Scraps of vegetation on cliff ledge, usually in colonies
BREEDING Lays single egg in April–May
FOOD Fish, invertebrates collected from sea surface during gliding flight
HABITAT Open sea; sea cliffs in breeding season
VOICE Harsh cackling calls, especially when greeting mate at nest
DISTRIBUTION Widespread breeding bird, mainly on north and west coasts

Manx shearwater
Puffinus puffinus

Appears black and white at a distance; groups usually seen in long lines gliding over the waves when long black wings show white undersides as birds bank from side to side. Completely nocturnal on land, coming ashore only in darkness to remote islands to breed in rabbit burrows. Strange cackling, wailing calls can be heard at breeding colonies which often number many thousands of pairs.

SIZE Length 30–38cm
NEST Abandoned rabbit burrow, little or no nesting material
BREEDING Lays single large white egg in May–June
FOOD Small fish, squid, caught at surface during gliding flight
HABITAT Open sea, far from land, breeds only on offshore islands
VOICE Hoarse, rhythmic cackling calls heard at breeding colonies
DISTRIBUTION Breeds on islands in north and west Britain

Storm-petrel
Hydrobates pelagicus

A very small almost all-black seabird with a characteristic flight pattern, most often seen in small flocks fluttering over the waves delicately picking food from the surface. Will sometimes follow fishing boats. The all-black plumage is broken by the white rump patch and pale band on the underside of the wings. The tiny black bill has tube nostrils, and the black legs and feet trail in flight.

SIZE Length 14–18cm
NEST In a rock crevice or small burrow on remote islands
BREEDING Single egg laid in April–June
FOOD Collects plankton, from sea surface
HABITAT Open sea, far from land, breeds on isolated cliffs and islands
VOICE A purring, rhythmic call, often heard from nesting holes
DISTRIBUTION Breeds on islands in north and west Britain

Gannet
Sula bassana

Europe's largest breeding seabird, appearing gleaming white at a distance with pointed black wingtips at the end of long slender wings. The torpedo-shaped body, with its pointed tail and long bill, is designed for diving from a height to catch large fish, and gannets can often be seen in feeding flocks plunge-diving into shoals of mackerel or herring. Large numbers can be watched flying powerfully past cliffs and headlands during migration in autumn. Juveniles are grey-brown and spotted with white.

SIZE Length 87–100cm
NEST Pile of seaweed and other debris in large colonies on cliffs and islands
BREEDING Lays single pale blue egg in April–June
FOOD Large fish caught by plunge-diving
HABITAT Open sea, but breeds on remote cliffs and islands
VOICE Guttural cackling calls on breeding sites
DISTRIBUTION Abundant breeding birds on rocky islands in north and west Britain

CORMORANT AND SHAG
● *Excellent divers and swimmers* ● *Mostly black plumage*
● *Long, slightly hooked bills*

Cormorant
Phalacrocorax carbo

A large, almost all-black seabird with broad wings, robust body and a powerful beak with a slightly hooked tip. In water resembles a diver, swimming low with its head held slightly upwards. Cormorants dive frequently, and can stay under for a long time; they surface holding a fish which is tossed and gulped down. Often roost with wings outstretched.

SIZE Length 80–100cm
NEST Platform of seaweed and debris on cliffs or islands, sometimes in trees
BREEDING Lays 3–4 large white eggs in April–May
FOOD Large fish caught by deep dives
HABITAT Mainly on coasts, but also large lakes, reservoirs and inland rivers
VOICE Harsh, guttural croaks
DISTRIBUTION Widespread on most coasts, and on some large inland waters

Shag
Phalacrocorax aristotelis

Appears all-black at a distance, but plumage is dark glossy green in breeding season, duller at other times. Adults have crest in breeding season and yellow gape. Less stocky than cormorant with shorter, more rounded wings, faster wingbeats and more slender appearance. Adults lack white 'thigh' patch of breeding cormorant. More restricted to coastal waters, especially rocky habitats, and does not migrate in winter. Juveniles are pale brown with white patch under bill.

SIZE Length 65–80cm
NEST Large pile of seaweed and other debris, with new material added daily
BREEDING Lays 3 eggs in March–April, nests on cliffs and islands
FOOD Fish caught by diving
HABITAT Rocky coasts
VOICE Harsh, guttural calls heard at breeding colonies
DISTRIBUTION All British coasts

HERONS AND RELATIVES
● *Dagger-like bill* ● *Long legs and toes*
● *Catch fish by wading*

Grey heron
Ardea cinerea

A large, long-legged grey and white bird, often seen standing motionless in shallow water, or wading purposefully in search of fish which are caught with a stab of the large powerful bill. Juveniles resemble adults, but have more black and white markings and greyer underparts.

SIZE Length 90–98cm
NEST Large platform of twigs and vegetation in tree, often in colonies
BREEDING Lays 4–5 eggs in Feb–April
FOOD Fish, frogs, small aquatic life including birds and mammals
HABITAT Wetlands, mainly freshwater but sometimes sheltered coasts
VOICE A harsh and resonant *craank*, young in nest make squealing sounds
DISTRIBUTION Throughout Britain

Bittern
Botaurus stellaris

A well camouflaged and very secretive bird, mostly confined to dense reedbeds where its cryptic markings and quiet habits make it almost impossible to see. The male's strange booming call can be heard from reedbeds in the spring, and occasionally a bird may be seen flying low over a marsh, when its rounded wings and brown plumage are reminiscent of an owl. Freezing conditions may force it to feed in more open water. A scarce bird with only a few breeding sites in Britain.

SIZE Length 70–80cm
NEST Platform of vegetation on ground in reedbed
BREEDING Lays 5–6 brownish eggs in April–June
FOOD Mostly fish, some frogs, newts
HABITAT Dense reedbeds
VOICE Silent, apart from male's booming calls in breeding season
DISTRIBUTION Scarce breeder in English reedbeds

SWANS

● *Large size* ● *Webbed feet*
● *Feed on submerged plants*

Mute swan

Cygnus olor

A very large all-white waterbird. The sexes are almost identical, apart from the black knob at the base of the orange bill which is larger in the male. Males are aggressive in the breeding season, keeping rivals away from their mates and predators away from the cygnets. The very long neck, held in an S-shape when swimming, allows swans to feed on submerged pondweeds; by up-ending they can reach plants beyond the range of smaller geese and ducks. Juveniles are buff-brown with a flesh-coloured bill.

SIZE Length 145–160cm
NEST Large mound of plant material close to water
BREEDING Lays 5–8 eggs in March–May
FOOD Mostly submerged water plants, may take some invertebrates

HABITAT Lakes, rivers and canals, flood meadows, sheltered coasts and estuaries
VOICE Silent, apart from hissing sounds when angry
DISTRIBUTION Widespread on lakes, rivers and coasts

Whooper swan

Cygnus cygnus

Pure white with a straighter neck than the mute swan. The black bill has a yellow base, and the legs are black. The sexes are alike. Juveniles are a warm buff colour and the bill is flesh-coloured with a black tip. Often flies in large noisy flocks in 'V' formation and family groups remain together during migration and through the winter. Will feed in water and graze in fields. A winter visitor to Britain from the Arctic, sometimes occurring in very large flocks.

SIZE Length 145–160cm
NEST Pile of vegetation with lining of downy feathers
BREEDING Lays 3–5 white eggs in April–June
FOOD Submerged aquatic vegetation and grain in stubble fields
HABITAT Breeds in the far north; winters in flooded meadows, lochs and marshes
VOICE Far-carrying trumpeting calls, especially in flight
DISTRIBUTION Winter visitor to wetlands

Bewick's swan

Cygnus columbianus

The smallest European swan, with pure white plumage, black legs and feet and a black bill with a patch of yellow at the base. The shape of this patch, smaller than that of the whooper swan, is unique to each bird so that individuals can be recognised. Juveniles are greyer than adults and have pinkish bills with black tips. Family groups stay together through the winter, and Bewick's always feed in large flocks in traditional overwintering sites. This is a winter visitor to Britain from remote Arctic breeding grounds.

SIZE Length 115–125cm
NEST Pile of vegetation on raised site on tundra
BREEDING Lays 3–5 white eggs in May–June
FOOD Aquatic plants, roots and shoots of meadow plants; spilled grain

HABITAT Breeds on Arctic tundra; overwinters on flood meadows, marshes and shallow lakes
VOICE Trumpeting calls often given in flight
DISTRIBUTION Winter visitor to wetlands

GEESE

● *Large size* ● *Webbed feet*
● *Fly in formation in large flocks*

Brent goose

Branta bernicla

A small, compact goose appearing very dark at a distance. Head and neck are all black apart from a white neck patch. The back and wings are dark greyish-brown, but the flight feathers are black. In flight the striking V-shaped white rump shows clearly. Juveniles lack the white neck, and the pale feather-edges on the back give a scaly appearance. A winter visitor to Britain from its Arctic breeding grounds, occurring in large flocks on estuaries and coastal fields and marshes.

SIZE Length 55–60cm
NEST Pile of vegetation on island or tussock in water
BREEDING Lays 3–5 whitish eggs in May–June
FOOD Eelgrass in winter, plus other plant material on meadows and marshes

HABITAT Arctic tundra in summer, coastal marshes in winter
VOICE A cackling bark, frequently heard when flocks are nervous
DISTRIBUTION Winters in south and east

Barnacle goose

Branta leucopsis

A small goose with a black neck and white face, a grey and black barred back and white underparts. Juveniles have a blotchy face and a brownish tinge to the back and greyer underparts. In flight, adult barnacle geese look strikingly black and white, and there is a conspicuous V-shaped white rump. They feed in large noisy flocks and fly at dawn and dusk from their roosting areas to feeding grounds.

SIZE Length 60–70cm
NEST Mound of plant material on cliff ledge or rocky island
BREEDING Lays 4–5 greyish eggs in May–June
FOOD Plant material, especially roots and shoots, and some seeds

HABITAT Breeds on Arctic tundra; overwinters on coastal marshes and meadows
VOICE Sharp barking calls, usually uttered in chorus in large flocks
DISTRIBUTION Winter visitor to north and west coasts and marshes

Canada goose

Branta canadensis

Europe's largest goose, recognised by its black head and neck with large white face patch, and contrasting brown plumage. Black and white tail pattern shows clearly in flight. Juveniles are very similar to adults, but with duller plumage. Introduced to Europe in the 17th century and now very well established; occurs in city parks with large lakes. Remains in family groups, even in large flocks, and is aggressive towards rivals.

SIZE Length 90–100cm
NEST Large pile of vegetation, near water or hidden in tall reeds
BREEDING Lays 5–6 creamy-white eggs in March–May
FOOD Aquatic plants, roots, shoots and seeds of waterside and meadow plants

HABITAT Lakes, parkland, gravel pits and meadows
VOICE Far-carrying honking calls and a two-note barking sound
DISTRIBUTION Common breeding bird in southern Britain

Greylag goose
Anser anser

A large and robust grey goose with an orange bill and large pale patches on the wings, visible only in flight. The short, rounded tail is pale grey with a white patch and the lower belly and undertail are white. The sexes are alike, and juveniles are similar to adults but more barred on the upperparts and rather duller in colour. Greylags are nervous birds, very wary of human approach, and will take off in a noisy flock if danger threatens.

SIZE Length 75–90cm
NEST Secluded hollow among tall vegetation with downy lining
BREEDING Lays 4–6 creamy-white eggs in April–May
FOOD Grasses, roots and shoots and spilt grain
HABITAT Marshy arable land and lake margins
VOICE Wide range of typical goose calls, including chattering flight call
DISTRIBUTION Widespread, but not common, in northern Scotland, Scandinavia, Iceland and eastern Europe; introduced elsewhere, including Britain

Pink-footed goose
Anser brachyrhynchus

A relatively small goose with a shorter neck and smaller bill than other grey geese. The dark bill has a pinkish band near the tip, and the legs and feet are pink. The head and neck appear dark brown, contrasting with the paler brown flanks and white lower belly. In flight the back and wings show grey areas with dark flight feathers. Seen in Britain in winter in large flocks on coastal grazing marshes.

SIZE Length 60–75cm
NEST Pile of vegetation on tussock or rock ledge
BREEDING Lays 3–5 white eggs in May–June
FOOD Roots and shoots, winter stubble
HABITAT Arctic tundra in summer, coastal marshes and lake margins in winter
VOICE Musical honking calls and a high-pitched disyllabic call
DISTRIBUTION A winter visit to Britain and NW Europe from its Arctic and Icelandic breeding grounds

Bean goose
Anser fabialis

A medium-sized goose which appears mostly brown at a distance. The dark bill has a variable orange band near the tip and the legs and feet are noticeably orange. In flight the wings and back look dark above, apart from the paler tail with a terminal white band and white rump patch. A very wary bird which usually feeds in large flocks in open fields where it can keep an eye open for danger and take flight easily; the almost vertical take-off is characteristic of this species.

SIZE Length 65–80cm
NEST Pile of vegetation with down-lined hollow
BREEDING Lays 4–6 buff coloured eggs in May–June
FOOD Grasses and spilt grain
HABITAT Breeds on Arctic tundra and in open forests; overwinters on fields in central and southern Europe, including eastern Britain
VOICE Many calls, including cackling sounds
DISTRIBUTION A winter visitor to Britain in small numbers; two races occur in northern Europe, nesting on either tundra or in forests

White-fronted goose
Anser albifrons

A large grey-brown goose with a white patch on the face and orange legs and feet. The underside is variably marked with dark bands and patches, and the undertail is white. In flight the wings show dark flight feathers and paler forewings, and the dark tail has a prominent terminal white band and white rump patch. Very nervous birds, ready to take flight at the slightest hint of danger, flying off in large noisy flocks, often in 'V' formation. Skilled fliers, white-fronts are able to make twists and turns in flight before landing.

SIZE Length 65–78cm
NEST Hollow lined with vegetation on raised tussock
BREEDING Lays 5–6 pale buff eggs in April–June
FOOD Roots and shoots
HABITAT Arctic tundra, often wetter areas; overwinters farther south, including Britain, on coastal marshes and inland watermeadows
VOICE Quarrelsome yapping calls on ground, musical honking calls in flight
DISTRIBUTION A winter visitor to Britain in large flocks

DABBLING DUCKS
● *Bills adapted for sieving mud* ● *Feed by up-ending*
● *Sexes usually look different*

Shelduck
Tadorna tadorna

Both sexes appear to have black head and neck, black on back and a chestnut breast band; plumage otherwise white. In good light, black elements of plumage show a green iridescence. Both sexes have reddish-pink legs and red bill; male only show red knob at base of bill; female usually has some white at base of bill.

SIZE Length 60–70cm
NEST Usually in rabbit burrow
BREEDING Lays 8–10 eggs, mainly May
FOOD Mainly marine invertebrates sieved from mud
HABITAT Coastal marshes and estuaries
VOICE Male utters whistling call; female utters nasal quacks
DISTRIBUTION Locally common around suitable areas of coast

Mandarin
Aix galericulata

Exotic-looking and attractively marked duck, male having orange neck, brown mane and conspicuous white supercilium. Shows orange on flanks and orange 'sails' at rear of flanks. Plumage otherwise essentially brown with white stern. Bill orange-pink. Female has grey-brown plumage with large, white spots on breast and flanks and white 'spectacle' around eye. Bill dark.

SIZE Length 40–48cm
NEST In tree hole
BREEDING Lays 10–12 eggs, mainly May
FOOD Plant shoots and aquatic invertebrates
HABITAT Wooded lakes
VOICE Mostly silent
DISTRIBUTION Introduced from Asia; feral populations mainly in southern England

Mallard
Anas platyrhynchos

Britain's most familiar duck. Often becomes quite tame in urban sites, especially when fed. Breeding male has iridescent green head, dark chestnut breast and grey-brown body. Stern is black with contrasting white tail. Bill yellow and legs orange. Female has mottled brown plumage and dark orange bill. Eclipse male similar to female but has yellow, not orange, bill. In flight, both sexes show blue speculum defined by white border on leading and trailing edges.

SIZE Length 50–65cm
NEST In a depression among vegetation
BREEDING Lays 9–12 eggs, mainly April–May
FOOD Omnivorous, taking seeds, shoots and small aquatic animals
HABITAT All sorts of freshwater habitats during the breeding season; also occurs near coasts in winter
VOICE Female in particular utters the familiar quack; male's call is more subdued
DISTRIBUTION Widespread and common in most of Britain throughout the year

Gadwall

Anas strepera

Compact duck with rather subdued markings. Forms flocks on open water outside the breeding season and frequently associates with coots and pochards. At first glance, adult male appears rather sombre, but in good light fine, intricate markings can be seen on the grey flanks. Plumage otherwise rather uniformly grey-brown except for prominent black stern and dark bill. Adult female recalls female mallard with mottled brown plumage but dark bill shows

characteristic orange band along side. Male in eclipse plumage resembles female. In flight, both sexes show conspicuous white patch on upper side of rear inner wing; this is bordered on its leading edge by a black band.

SIZE Length 45–55cm
NEST On ground, among vegetation
BREEDING Lays 8–12 eggs, mainly May–June
FOOD Seeds, shoots and insects
HABITAT Freshwater wetlands during breeding season; lakes and flooded gravel pits in winter

VOICE Male has a nasal call; that of female is a soft quack
DISTRIBUTION Scarce breeding species but widespread and locally common in winter

Pintail

Anas acuta

Distinctive, long-bodied duck. Often seen in loose flocks in winter on estuaries or around margins of flooded wetlands. Adult male is unmistakable with chocolate-brown head and white neck and breast; white extends as narrow band up side of neck. Body plumage mainly grey with fine markings; stern marked with black and yellow-buff on rear of flanks. Elongated central tail feathers often held erect. Bill grey and legs dark. Female has mottled buff-brown plumage and always looks long-necked and long-bodied compared to other female ducks. Bill and legs dark grey. Male in eclipse plumage resembles female. In flight, male has greenish speculum while that of female is brown; both sexes show striking white trailing edge to inner flight feathers.

SIZE Length 50–60cm
NEST Placed in fairly open site among wetland vegetation
BREEDING Lays 7–8 eggs, mainly April–May
FOOD Seeds, plant shoots and insects

HABITAT Breeds on undisturbed wetlands; winters on lakes and estuaries
VOICE Male utters soft whistling calls; female utters short quacks
DISTRIBUTION Scarce breeding species; locally common winter visitor

Garganey

Anas querquedula

Small, attractively marked duck. Usually seen in small parties during spring and autumn migration when they favour flooded wetlands with plenty of emergent vegetation. Adult male is unmistakable with reddish-brown head and neck and strikingly white, crescent-shaped supercilium. Breast is warm brown and rest of body plumage is essentially greyish-brown with elongated feathers on scapulars forming white stripes on back. Female recalls female teal with mottled brown plumage but note the dark cheeks and eye-stripe and pale spot at base of bill. In flight, both sexes show pale blue panel on leading edge of inner wing; in male, this is separated from green speculum by white band while in female these colours are more subdued.

SIZE Length 37–40cm
NEST On ground, in waterside vegetation
BREEDING Lays 7–9 eggs, mainly April–May
FOOD Aquatic plants and insects
HABITAT Flood meadows and wetlands

VOICE Male utters diagnostic rattling call; female utters soft quack
DISTRIBUTION Rare breeding species; scarce but regular passage migrant in spring and autumn

Shoveler

Anas clypeata

Attractive duck which forms small flocks during the winter months on wetlands and estuaries. Easily recognised in all plumages by the disproportionately long and broadly flattened bill which gives the bird its name. Adult male is beautifully marked with greenish head and neck, white on breast and rear of flanks, reddish-orange belly and black stern. Bill black and legs orange. Female has mottled reddish-brown plumage. Bill dark with orange sides and dull orange legs. Male in eclipse plumage similar to female. In flight, male shows pale blue inner forewing separated from green speculum by white band. Wing pattern of female similar to that of male but colours duller.

SIZE Length 45–50cm
NEST In depression among wetland vegetation
BREEDING Lays 9–10 eggs, mainly April–May
FOOD Small aquatic invertebrates and plant shoots

HABITAT Shallow lakes, flooded meadows
VOICE Male utters soft *tucc*; female utters soft quacks
DISTRIBUTION Scarce breeding species but locally common winter visitor

Wigeon

Anas penelope

Widespread and familiar winter visitor to coasts and extensive and undisturbed wetland areas. Feeds both in shallow water and walks confidently on land when feeding on grain or grazing plant shoots. Adult male has orange-chestnut head with striking pale yellow blaze on forehead. Breast pinkish and body plumage otherwise grey and finely marked. Black and white pattern on stern conspicuous even in swimming birds. Female has grey-brown, marbled plumage with striking white belly and darker patch around eye. Male in eclipse plumage similar to female but plumage warmer brown. All birds have dark-tipped grey bills. In flight, male shows striking white patch on leading half of inner wing; speculum is green but can look all-dark in poor light. Female lacks male's white patch on inner wing, this instead appearing pale brown.

SIZE Length 45–50cm
NEST On ground, in cover of vegetation
BREEDING Lays 6–12 eggs, mainly June; incubation takes about 25 days
FOOD Mainly plant material; eelgrass favoured on estuaries

HABITAT In breeding season, favours tundra and moorland; in winter occurs on estuaries and lowland wetlands
VOICE Male utters diagnostic *whee-ooo* call; female utters grating purr
DISTRIBUTION Rare breeding species but locally common winter visitor

Teal

Anas crecca

Britain's smallest duck and one which is generally quite common and widespread. Usually seen in flocks outside the breeding season; these can be several hundred strong in good feeding areas. Adult male has chestnut head and neck; green patch around eye is demarcated by narrow yellow border. Body plumage essentially grey but close inspection reveals fine, intricate markings. Stern buffish-yellow, this colour defined by black borders. Bill and legs dark grey. Female has grey-brown, mottled plumage. Bill dark grey with dull orange-yellow patch at base. In flight, both sexes show green speculum, defined on leading and trailing edges by white lines.

SIZE Length 34–38cm
NEST On ground, in deep cover
BREEDING Lays 8–10 eggs, mainly May
FOOD Seeds, plant shoots and invertebrates
HABITAT Freshwater wetlands during breeding season; occurs on estuaries and flooded grassland in winter

VOICE Male utters a high-pitched *kriik*; female utters soft quacks
DISTRIBUTION Locally fairly common breeding species; widespread and sometimes numerous in winter

DIVING DUCKS
- *Compact body shape* ● *Feet set at rear of body to aid swimming underwater* ● *Spend most of time on water*

Tufted duck
Aythya fuligula

The male tufted duck is one of the most distinctive small ducks with striking black and white plumage and a prominent black crest on the head. At close range the golden eye and pale bill with its black and white tip are easily seen. The female is mostly brown with a paler belly; the bill and eye colours are very similar, but there is only a short tuft on the head. There may be a white patch at the base of the bill. In flight, both male and female show a white wingbar. Usually seen in large flocks on open water, diving frequently and for long periods.

SIZE Length 40–47cm
NEST Near water, usually hidden by ground vegetation
BREEDING Lays 8–11 greenish-grey eggs in March–May
FOOD Aquatic molluscs and insects caught by diving, some plant matter

HABITAT Large bodies of open water, including wide rivers
VOICE Variety of harsh, low calls
DISTRIBUTION Widespread in Britain and increasing in areas where new reservoirs and gravel pits are created

Scaup
Aythya marila

Male scaup bears a slight resemblance to male tufted duck, but the head is dark glossy green, there is no tuft, and the back is grey with a delicate pattern, not black. The female scaup is mostly brown with a paler buff back and flanks and has a prominent white patch around the base of the bill. Both sexes show white wingbars in flight and have a golden eye. Usually seen in winter in large flocks in shallow coastal waters.

SIZE Length 42–51cm
NEST On ground near pools on Arctic tundra
BREEDING Lays 8–11 pale grey eggs in May–June
FOOD Molluscs, caught by diving

HABITAT Arctic tundra near coast in summer; winters on shallow coastal waters.
VOICE Harsh *karr karr* flight call
DISTRIBUTION A winter visitor to coastal waters in Britain, sometimes found inland

Pochard
Aythya ferina

The male is a small colourful duck with a reddish-orange head and neck, a black chest and a pale grey back with a delicate pattern of fine lines. The relatively large black bill has a broad grey band across the middle. The female is mostly mottled grey-brown, with paler greyish markings on the back. The bill shape and markings are similar to the male's, but there is a pale 'spectacle' around the eye, and in flight the belly of the female is paler than the upperparts. Males in flight show a strong contrast between the dark chest and white underparts. A skilled diver, most often seen in large flocks on open water.

SIZE Length 42–49cm
NEST Concealed on ground near water, uses leaves and grasses
BREEDING Lays 8–10 greenish eggs in April–May
FOOD Aquatic invertebrates, pondweeds and seeds, taken by diving

HABITAT Open water in winter, smaller well-vegetated pools in summer
VOICE Guttural growling calls
DISTRIBUTION A winter visitor to Britain in large numbers from central and eastern European breeding sites; breeds in smaller numbers in northern Britain

Eider
Somateria mollissima

A large duck with a wedge-shaped bill. Males are distinctive with their black and white pattern and lime-green patch on the neck. Females are mottled brown and appear barred at close range. Usually seen in large flocks in shallow coastal waters, diving frequently. Flocks fly low over the water in long lines, looking rather heavy with drooping necks and slow wingbeats. Females gather in large flocks with the chicks whilst males move off shore to moult.

SIZE Length 50–70cm
NEST On ground near shore, depression lined with down
BREEDING Lays 4–6 greenish eggs in May–June
FOOD Marine molluscs, especially mussels, taken by diving

HABITAT Coastal waters, mainly northern Britain, but straying further south in winter
VOICE Males make *ah-ooooo* calls in breeding season, otherwise silent
DISTRIBUTION Breeds around coasts of northern Britain, winter visitors arrive from farther north to join residents

Common scoter
Melanitta nigra

At long range the scoter looks all dark, but the black male has a large yellow patch on the bill and the female is dark brown with pale cheek patches which can be seen easily at a distance. In winter scoters are found in large flocks on coastal waters, but usually not where conditions are very rough. They swim buoyantly and dive well, frequently in search of molluscs. They fly in large flocks, often in straight lines, but sometimes in a tight flock with a few stray birds following behind.

SIZE Length 44–54cm
NEST Depression on ground near water
BREEDING Lays 6–8 cream eggs in April–June
FOOD Aquatic molluscs in winter, freshwater insect larvae in summer
HABITAT Winters around coasts; upland moors and tundra in summer

VOICE Mostly silent, but males make quiet whistling calls in breeding season
DISTRIBUTION Winter visitor in large numbers to coastal waters, disperse to moors and tundra in summer and are very secretive; scarce breeding bird in Britain

Velvet scoter
Melanitta fusca

Superficially similar to smaller common scoter, but male has white eye and white eye patch and large yellow patch on bill. Female is almost all dark brown but with two white patches on head. Both sexes show broad white wingbar in flight. Sometimes found in small flocks of 20–30 birds, they occasionally mingle with much larger flocks of common scoter when they are slower to take flight. Stray birds may turn up on inland lakes.

SIZE Length 51–58cm
NEST Depression on ground near water
BREEDING Lays 7–9 buff eggs in May–June
FOOD Aquatic molluscs and crustaceans

HABITAT Coastal waters in winter, moors and tundra in summer
VOICE Usually silent, but male makes quiet whistling calls in breeding season
DISTRIBUTION A winter visitor to Britain, mainly along North Sea coasts

Goldeneye

Bucephala clangula

Distinctive small diving duck with peaked head. The male has a glossy green head with a gold eye and white cheek, otherwise is mostly white with a dark back. The female is almost all grey with a reddish-brown head, gold eye and pale patch at tip of bill. Most common in winter when large numbers visit coastal waters and large lakes, swimming buoyantly and diving frequently. A few breed in Scotland, nesting in holes in trees and sometimes using nest boxes.

SIZE Length 42–50cm
NEST Hole in tree, sometimes quite high up
BREEDING Lays 8–11 bluish-green eggs in April–May
FOOD Aquatic invertebrates caught by diving

HABITAT Winters on lakes, reservoirs and very sheltered coastal waters
VOICE Normally silent, rattling display call in spring
DISTRIBUTION A winter visitor to Britain; a small but increasing number breed in pine forests in Scotland

Red-breasted merganser

Mergus serrator

Rather grebe-like in profile when viewed at a distance, with its slim build, slender bill and untidy crest. Males are most striking with red bill, eyes and legs, white collar, glossy black and white upperparts and grey underparts with fine striations. Females are paler all over, especially below, with a reddish head and smaller crest. Normally seen on coastal waters in winter, sometimes standing on exposed shingle bars. Persecuted in places for its fish-eating habits.

SIZE Length 52–58cm
NEST Well concealed on ground near water
BREEDING Lays 8–10 buff-olive eggs in April–May
FOOD Mainly fish

HABITAT Winters on coastal waters and estuaries, sometimes large lakes; breeds near northern lakes and rivers
VOICE Mostly silent
DISTRIBUTION Breeds in NW Britain; winter visitor from Scandinavia to most of British coastline

Long-tailed duck

Clangula hyemalis

A small sea duck most likely to be seen in winter in small flocks off northern and eastern coasts, often in areas of very rough water and diving and surfacing together. The winter male has a long pointed black tail and mostly black and white plumage, but in summer the back and chest are brown. The black bill has a broad pink band. The female lacks the long tail and has an all-grey bill with variable brown and white plumage; both sexes have large dark cheek patches in winter.

SIZE Length 40–47cm (not including male's tail)
NEST Depression on ground near water
BREEDING Lays 6–9 greenish-buff eggs in May–June
FOOD Aquatic insect larvae in summer, molluscs in winter

HABITAT Winters on sea coasts, rarely inland; breeds on Arctic tundra
VOICE Many musical calls, uttered frequently in breeding season
DISTRIBUTION A winter visitor to Britain from its Scandinavian breeding grounds

Smew

Mergus albellus

A small sawbill duck, appearing mostly white at a distance. The male has a black eye patch and black lines on the body, and fine grey lines on the flanks. The greyer female is more grebe-like in appearance with a reddish-brown cap, dark eye patch and white cheeks. Juveniles resemble females, and most birds seen in the winter in Britain are 'redheads' (females or juveniles), and they often associate with goldeneyes. Both sexes show white wingbars in flight and both have narrow bills with a serrated edge.

SIZE Length 38–44cm
NEST Tree holes, but will use nest boxes
BREEDING Lays 7–9 pale buff eggs in April–May
FOOD Mostly small fish, some aquatic insect larvae

HABITAT Wooded lakes in far northern Europe, Russia and Siberia in summer; winters on large lakes, reservoirs, sheltered coasts and estuaries
VOICE Mostly silent
DISTRIBUTION A scarce winter visitor to Britain, occurring mainly in the east

SAWBILL DUCKS
● *Serrated bills to grip fish* ● *Excellent swimmers*
● *Arctic breeders*

Goosander

Mergus merganser

A large sawbill duck which can look black and white at a distance. The male has a white body suffused with pink and a dark glossy green head. The female is mostly grey, paler below, and has a high-browed reddish-brown head. Moulting males resemble females. In flight the male shows broad bars of white on the wing while the female shows a large white speculum. Both have slender bills with serrated-edged mandibles.

SIZE Length 58–66cm
NEST Hole in tree, nest box or sometimes rock crevice
BREEDING Lays 8–11 whitish eggs in April–May
FOOD Fish
HABITAT Lakes, gravel pits and large

rivers in winter; breeds beside northern lakes and rivers with trees near by
VOICE Normally silent, but male makes loud ringing calls in spring
DISTRIBUTION Breeding bird in northern and western Britain, large numbers arrive in Britain in winter

STIFFTAIL DUCKS
● *Upright tail* ● *Dives for its food*
● *Very aggressive male*

Ruddy duck

Oxyura jamaicensis

A small diving duck which resembles a little grebe at a distance due to its compact shape and frequent short dives. At close range the male is very distinctive with its bright blue bill, white cheeks and black head and neck. Females are mostly grey-brown with a darker head.

SIZE Length 35–43cm
NEST Hidden on the ground in waterside vegetation
BREEDING Lays 6–10 whitish eggs in April–May
FOOD Aquatic insect larvae, seeds and grain

HABITAT Ponds, lakes and large rivers with rich plant life
VOICE Mostly silent
DISTRIBUTION Native to North America; naturalised in Britain after escaping from Slimbridge, Gloucestershire; well established in southern Britain

LARGE BIRDS OF PREY
- *Powerful talons and beaks* ● *Excellent eyesight*
- *Strong fliers, often good at gliding and soaring*

Osprey
Pandion haliaetus

A large raptor with relatively long wings and pale underparts. The back and upperwings are brown, while the dark primaries and carpal patches give the underwings a striking barred pattern. Both sexes have a brownish breast band, but it is more prominent in the female. Juveniles resemble adults but have more spotted upperparts. An osprey seen circling over a lake may resemble an immature gull, but its dramatic dive onto a fish will dispel any doubts. If successful, it flies off to a feeding perch carrying the fish in specially adapted talons.

SIZE Length 55–69 cm
NEST Large platform of twigs and branches in top of conifer
BREEDING Lays 2–3 whitish eggs blotched with red-brown in April–May
FOOD Fish
HABITAT Rivers, lakes and shallow coastal areas
VOICE Shrill yelping and whistling calls
DISTRIBUTION A summer visitor to Scottish Highlands, migrating to Africa in winter. One of the most widespread birds of prey in the world

Red kite
Milvus milvus

A large raptor with mainly red-brown plumage and a markedly forked tail. The head is pale grey, as are the undertail and underwing coverts; the tips of the primaries are black and separated into 'fingers' in flight. As the red kite twists and turns in its buoyant flight the contrast between the orange-red uppertail and grey undertail shows clearly. Much time is spent in the air searching for carrion, but red kites will also use high perches in tall trees, where they are less conspicuous. Introductions have helped them increase their range in Britain, but they are still at risk from poisoning.

SIZE Length 60–65 cm
NEST Large platform of sticks and vegetation in tall tree
BREEDING Lays 3–4 whitish eggs with blotches in March–April
FOOD Small mammals, carrion, earthworms and birds
HABITAT Wooded valleys, farmland and moorland edges
VOICE A high-pitched whinnying
DISTRIBUTION A stronghold in Mid Wales, with smaller numbers introduced to England and Scotland where they are now breeding successfully

Sparrowhawk
Accipiter nisus

There are a number of differences between the male and female sparrowhawk, one of the most striking being the small size of the male. The male has blue-grey upperparts and a pale underside with strong red-orange barring. The larger female is grey-brown above with grey-brown barring on the pale underside. Both sexes have long yellow legs and claws, a black-tipped yellow bill and a barred tail with a pale underside. Juveniles resemble females but have streaked undersides. The preferred method of hunting is to use a concealed perch and make a surprise attack, or fly close to a woodland edge and capture startled birds.

SIZE Length 30–40 cm
NEST Platform of twigs high in tree, often an abandoned crow's nest
BREEDING Lays 4–5 whitish eggs in March–April
FOOD Small birds caught on the wing
HABITAT Mixed woodland, farmland, hedgerows, town parks and gardens
VOICE Harsh, far-carrying *kek kek kek*
DISTRIBUTION Resident and widespread throughout Britain, though still persecuted and recovering from use of pesticides

Goshawk
Accipiter gentilis

A large, powerful hawk, the female being the size of a buzzard and capable of taking prey such as pigeons or squirrels. In spring, pairs soar over their territory in display in the early mornings, otherwise they are fairly secretive, remaining on a concealed perch before making a rapid flight, with long glides, in pursuit of prey. The female is larger than the male, but plumages are similar with both sexes having grey-brown upperparts, pale undersides with dark barring and fluffy white feathers at the base of the tail. Similar in silhouette to the sparrowhawk, but with a bulkier body, relatively longer wings and a shorter tail.

SIZE Length 50–60 cm
NEST Large platform of twigs high in tall tree
BREEDING Lays 3–4 bluish-white eggs in March–April
FOOD Medium-sized birds such as pigeons; small mammals
HABITAT Large forests, especially conifers
VOICE Mostly silent, but a gruff *gek gek gek* uttered sometimes at nest
DISTRIBUTION Resident in suitable habitats in Britain but thinly scattered over a very large area. Heavily persecuted by gamekeepers

Buzzard
Buteo buteo

The characteristic soaring flight of the buzzard on broad, outstretched wings, sometimes accompanied by 'mewing' calls, is familiar in spring in many parts of western and northern Britain. The sexes are similar, although females are larger, but there is always some variation in the markings on the underwings, which are normally pale with darker brown carpals. The upperparts are mostly brown and the broad tail is barred. Some birds can be almost all white, and some have a distinct brownish chest band. Buzzards often use a prominent perch such as a roadside post where they sit watching for prey.

SIZE Length 50–55 cm
NEST Large platform of sticks in tree or on rock ledge, lined with fresh leaves every day during breeding season
BREEDING Lays 2–3 whitish eggs in April–May
FOOD Rabbits, carrion and earthworms
HABITAT Hilly farmland and moorland edges near woodland
VOICE Mewing calls
DISTRIBUTION Widespread resident across most of Britain, apart from the east. Heavily persecuted by gamekeepers, so spreading its range only very slowly

Honey buzzard
Pernis apivorous

In the breeding season honey buzzards spend much time soaring on broad outstretched wings, held much flatter than the common buzzard's shallow V-shaped wings. The upperparts are dark brown with slight dark bands on the tail and hindwings. The underparts are very pale with dark barring, especially around the trailing edge of the wing and the tail. The head is long and slender and the tail is relatively long. When not soaring, honey buzzards are very secretive, even when feeding on wasps' nests, their favourite food.

SIZE Length 50–60 cm
NEST Twig platform in tree, sometimes in old crow's nest
BREEDING Lays 2 whitish eggs with reddish blotches in April–May
FOOD Mostly wasp or bee larvae dug out of nests, but some other insects, lizards and small mammals
HABITAT Mature woodland, large undisturbed forests
VOICE Normally silent, occasional thin mewing call
DISTRIBUTION Rare breeding bird in Britain (10–15 pairs); summer visitor, but abundant in Europe, overwintering in Africa

Golden eagle
Aquila chrysaetos

When gliding or soaring the golden eagle may be mistaken for smaller buzzard, but broad wings are held in shallow 'V' and are usually much darker below, and tail is longer. A large, powerfully built bird with mostly dark brown plumage and a pale golden brown head; back and forewings are pale buff and grey-brown. Juveniles show large white wing patches and have a white tail with a dark terminal band; this darkens into full adult plumage after five to seven years. Covers huge areas in alternate gliding and wing-flapping flight, and makes steep dives and low-level glides after prey.

SIZE Length 76–89 cm
NEST Large platform of sticks on cliff ledge, sometimes in tree
BREEDING Lays 1–3 white eggs blotched with red-brown in April–May
FOOD Small mammals (hares, rabbits) and birds; some carrion
HABITAT Remote mountainous areas, large forests free of disturbance
VOICE Mostly silent, infrequent yelping calls
DISTRIBUTION Confined mainly to Scottish Highlands; heavily persecuted by farmers and gamekeepers

HARRIERS AND FALCONS
● *Dashing flight* ● *Take small live prey*
● *Many are long-distance migrants*

Marsh harrier
Circus aeruginosus

Usually seen floating low over a reedbed in effortless flight and occasionally dipping down to capture prey, but may also be observed perched on low bush or tree stump. In flight the wings are held in a steep 'V' and the feet usually trail below the body. The male has a grey tail, mostly blue-grey wings with black-tipped primaries, and a brown head, back and forewings. Females are mostly dark brown, but have pale buff cap and throat and pale edge to forewing; juveniles are similar but with less distinct, paler markings.

SIZE Length 50–55cm
NEST Platform of reeds and twigs concealed in reedbed
BREEDING Lays 4–5 bluish-white eggs in April–May
FOOD Small birds, mammals and amphibians
HABITAT Reedbeds, wetlands and farmland
VOICE A shrill *kweeeoo*
DISTRIBUTION A rare breeding bird of reedbeds in SE Britain, occasionally seen elsewhere on migration

Hen harrier
Circus cyaneus

Adult male is mainly pale grey with dark primaries; the underside and rump are white and, at close range, perched birds show yellow legs and black-tipped yellow bill. The larger female is mostly brown, but with a white rump and a dark-barred tail; juveniles are similar to females and both are called 'ringtails'. When perched the female shows an owl-like facial disc. Usual flight pattern is gentle wingbeats alternating with long glides, but rapid flight is possible. Often flies very low over ground in search of prey.

SIZE Length 45–50cm
NEST On ground, usually in heather, lined with soft vegetation
BREEDING Lays 4–5 bluish-white eggs in April–May
FOOD Small birds and mammals, insects and amphibians
HABITAT Breeds on upland moors and bogs; overwinters on lowland grasslands, often coastal areas
VOICE Silent for most of year; staccato *ke-ke-ke* uttered in nesting season
DISTRIBUTION Breeds in Scotland, NW Wales and Ireland; overwinters in southern and eastern Britain; many migrate to southern Europe

Montagu's harrier
Circus pygargus

Smaller, slimmer and longer-winged than the hen harrier, and most likely to be seen in very slow flight low over fields of crops, dropping occasionally on to prey. The male is mostly pale grey with a white rump, black wingtips and a single dark wing bar. From below the male shows more black on the wingtips, two black wingbars and indistinct red-brown wingbars. Females are mostly brown with a smaller white rump than hen harrier; juveniles resemble females but have reddish wing coverts.

SIZE Length 45–50cm
NEST Grass-lined hollow on ground, sometimes in crops
BREEDING Lays 4–5 pale bluish-white eggs in May
FOOD Small mammals, birds, reptiles and insects
HABITAT Lowland habitats, mainly drier areas such as heathlands and arable land
VOICE Silent for most of year, high *yik yik yik* in breeding season
DISTRIBUTION A rare breeding bird in SE Britain, migrating to Africa for winter

Merlin
Falco columbarius

Britain's smallest bird of prey. At rest, outline looks rather compact. In flight wings appear rather broad and short and tail appears relatively long and faintly barred in both sexes. Adult male has blue-grey upperparts and buffish-brown underparts with conspicuous dark streaks. Adult female and juvenile have dark brown upperparts and pale buffish-brown underparts with dark streaks. Legs and cere (bare skin at base of bill) dull yellow in all birds. Sometimes seen perched on posts or boulders which are used to survey surrounding land for prey. More usually encountered in low, dashing flight, often only a few feet above the ground.

SIZE Length 25–30cm
NEST On the ground among bracken and heather; occasionally in abandoned crow's nest
BREEDING Lays 3–5 eggs, mainly May–June
FOOD Small birds
HABITAT Upland moors during breeding season; coasts, heaths and lowlands at other times
VOICE Utters a shrieking *kek-kek-kek* in vicinity of nest; otherwise generally silent
DISTRIBUTION Uncommon breeding species; widespread but scarce in winter

Hobby
Falco subbuteo

Comparatively slim and elegantly proportioned falcon. At rest, looks rather slender and long-winged. In flight, recalls an outsized swift with narrow, pointed wings held swept back in crescent shape; tail appears relatively short in flight. Sexes similar, males being slightly smaller than females. Good views reveal the black moustachial stripes and white cheeks. Upperparts mainly slaty blue-grey and underparts pale but heavily marked with black streaks. Red vent and 'trousers' visible in good light. Juvenile bird is browner than adult, with pale feather-margins on upperparts and no red on vent and leg feathers.

SIZE Length 28–35cm
NEST Usually in abandoned crow's nest, high in tree
BREEDING Lays 3 eggs, mainly mid-June
FOOD Mainly small birds and large insects (notably dragonflies) caught in flight
HABITAT Open country; heathland and farmland with scattered trees
VOICE Shrill *kew-kew-kew* uttered in vicinity of nest; otherwise generally silent
DISTRIBUTION Local and rather scarce summer visitor mainly to southern England; present from May to August

Kestrel
Falco tinnunculus

Britain's most familiar and widespread falcon. Familiarly seen hovering over motorway verges or grassland. Also frequently perches for extended periods on branches, bridges, posts or pylons. Adult male has blue-grey head and tail and reddish-brown upperparts strongly marked with dark spots; underparts pale and streaked. Adult female has more uniform brown, spotted plumage, underparts being paler than upperparts. Juvenile similar to adult female but appears more streaked.

FOOD Mainly small mammals but also some birds and insects
HABITAT Open country of all kinds including farmland, roadside verges, grassland and coasts
SIZE Length 33–39cm
NEST In tree hole, abandoned crow's nest or cliff ledge; also nests on man-made structures such as buildings and bridges
BREEDING Lays 3–5 eggs, mainly mid-April–mid-June
VOICE Shrill *kee-kee-kee*
DISTRIBUTION Common and widespread resident

Peregrine
Falco peregrinus

A large and impressive falcon. At rest, adopts a rather upright posture. In flight, wings look rather broad-based and pointed and body looks powerfully built. Sometimes hangs motionless or soars on updraughts. In active, level flight, wingbeats look shallow and rapid. Also seen in high speed diving display or stooping on prey when wings often held in swept-back fashion. Sexes are similar in appearance, but females are larger than males. Adult has dark slate-grey upperparts and pale underparts marked with dark bars. Facial pattern is striking with black moustachial stripes. Legs and cere are yellow. Juvenile has browner plumage than adult with pale margins to feathers on upperparts and a dull cere.

SIZE Length 40–50cm
NEST Uses abandoned nests of other species on cliff ledge
BREEDING Lays 3–4 eggs, mainly May and early June
FOOD Birds (especially pigeons and doves), mostly caught on the wing
HABITAT Mainly coastal cliffs and rugged, mountainous districts
VOICE Shrieking *kek-kek-kek* heard throughout year
DISTRIBUTION Local resident, most widespread in coastal western and northern Britain

 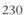

GAMEBIRDS
● *Plump bodies* ● *Short bills*
● *Reluctant to take flight*

Red grouse
Lagopus lagopus scoticus

A plump gamebird appearing all dark on the ground and in flight. At close range the male shows red wattles and white feathered legs; the female is a greyer brown with buff-coloured legs and no wattles. Juveniles resemble females but have pale feather-edges. Often seen in flight low over heather when disturbed; rapid wingbeats alternate with long glides and cackling call before birds drop out of sight into vegetation. Also occurs on moorland roads at dusk and dawn where it collects grit.

SIZE Length 37–42cm
NEST Shallow depression on ground under low vegetation
BREEDING Lays 6–9 yellowish eggs with brown mottling in March–May
FOOD Heather shoots, but some other plants and insects in summer
HABITAT Heather moorland, lower mountain slopes
VOICE A rattling *go-back go-back go-back*
DISTRIBUTION Endemic to Britain, confined to heather moorland in northern Britain

Ptarmigan
Lagopus mutus

In winter the male is all white apart from red wattles, black lores and bill and black outer tail feathers seen in flight. Females are also all white but without the red wattles. Through the spring and summer the plumage gradually changes to a mottled grey-brown, but the primaries and underside remain pure white. On the ground males look mostly grey, but in flight the white primaries show clearly as large wing patches. Females are browner and more mottled and juveniles are very similar. Both sexes have white feathered legs.

SIZE Length 34–36cm
NEST Shallow depression with moss and feather lining, sometimes in shelter of boulder
BREEDING Lays 5–8 dark red eggs with brown blotches in May–June
FOOD Shoots and buds, berries, some insects in summer
HABITAT High mountain slopes, open tundra
VOICE Rattling *karrrrrr kkkkkkk*
DISTRIBUTION Restricted to high mountains in Scottish Highlands, but widespread elsewhere in high Arctic

Black grouse
Tetrao tetrix

A chicken-sized gamebird with great differences between the sexes. The male is almost all black apart from red wattles, white wingbars and shoulder patches and white underwings and tail coverts. The unusual lyre-shaped tail is displayed in the communal 'lek' when males strut in front of females in open areas near woodlands. The female, known as the 'grey hen', is smaller, speckled brown above and grey-brown below; the tail is white below with a shallow fork. Juveniles are similar but duller and have a scaly appearance due to pale feather-centres.

SIZE Length 40–55cm
NEST Shallow depression with grass lining sheltered by bush
BREEDING Lays 6–11 buff or yellowish eggs with darker spots in April–May
FOOD Shoots and buds, seeds and berries; chicks take insects in summer
HABITAT Upland woodlands close to bogs and moorland
VOICE Females make cackling calls, males make *coo* sounds and a sudden *shoo-eesh* calls
DISTRIBUTION A declining species in Britain confined to Scotland, Wales and northern England

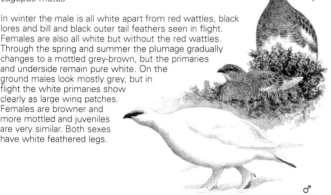

Capercaillie
Tetrao urogallus

A very large gamebird but often difficult to see because of its tree-roosting habits. The turkey-sized male has glossy black plumage with a dark green chest, brownish wings and white shoulder patch. The flanks and tail have white speckles and the undertail is white. Red wattles and a massive ivory-coloured bill add to the dramatic appearance. The smaller female is dark brown on the upperparts with a chestnut chest and a paler brown underside; most of the body is heavily barred with black and white. Juveniles resemble females but are smaller and duller. Easiest to see during spring courtship display when males gather in clearing emitting loud popping calls.

SIZE Length 60–87cm
NEST Shallow depression on ground; may use old crow nest in low tree
BREEDING Lays 7–11 yellowish-white eggs with brown streaks in May
FOOD Pine needles, leaves, shoots and berries
HABITAT Coniferous forests and shrubby forest margins
VOICE 'Drum roll' call and loud popping sounds, plus other grunting calls
DISTRIBUTION Restricted to pine forests in Scottish Highlands

Pheasant
Phasianus phasianus

A very common and widespread gamebird, originally introduced from Asia for shooting. Male has magnificent colourful plumage with green head and ear tufts, red face and white collar, purple-glossed underside and very long tail. Speckled appearance is due to each feather having a dark central spot. Many variations can be seen in male plumage, but females are more uniform with brown speckled plumage above and paler undersides. The barred tail is shorter than the male's. Juveniles resemble females but with duller colours.

SIZE Length 53–89cm
NEST Depression on ground beneath low vegetation
BREEDING Lays 8–15 olive-brown eggs in March–May
FOOD Seeds and shoots; insects eaten by chicks in summer
HABITAT Woodland, copses, farmland hedgerows, large gardens and parks
VOICE Male makes strident two-note crow, females quiet clucking sounds
DISTRIBUTION Widespread breeding bird in most of Britain apart from far north and offshore islands; many reared for shooting each year

Red-legged partridge
Alectoris rufa

A compact gamebird appearing mostly grey-brown at a distance but showing red legs and boldly striped flanks and head when viewed from the side. Red bill and white throat with a 'necklace' of black that meets over the eyes. The sexes are similar but males are larger. Juveniles lack the adult's striking markings. Its call often gives away its presence and it will sometimes sit in the open on posts. Both male and female can incubate separate clutches of eggs.

SIZE Length 32–34cm
NEST Shallow depression with grass lining under low vegetation
BREEDING Lays 10–16 yellowish eggs with red markings in April–May
FOOD Seeds, shoots and other plant material; some insects in summer
HABITAT Farmland, open grassland and dry heaths
VOICE Harsh *kchoo kchoo* repeated frequently
DISTRIBUTION Introduced to Britain in 18th century, now widespread in south and east but declining

Grey partridge
Perdix perdix

Appears very rounded in outline on the ground and its head is also markedly round. From the front males show a dark chestnut, inverted horseshoe patch on the chest and barred brown-grey flanks. The female has a less distinct patch and is slightly less grey. Both sexes have a brick-red face and show brown outer tail feathers in flight. At close range the plumage is seen to be finely marked with brown and buff barring. Juveniles have no horseshoe mark and are browner.

SIZE Length 29–31cm
NEST Shallow depression with grassy lining, usually sheltered by other vegetation
BREEDING Lays 10–20 olive-brown eggs in March–May
FOOD Seeds, leaves, shoots and buds; young take some insects
HABITAT Farmland, dry cultivated areas and open grassland
VOICE Harsh *keirr-ik* calls at night and *pitt pitt pitt* calls when alarmed
DISTRIBUTION Widespread but declining breeding bird in lowland Britain; absent from parts of far west and Ireland

RAILS AND CRAKES
● *Compact bodies* ● *Long legs and toes*
● *Shy and secretive*

Water Rail
Rallus aquaticus

A secretive waterbird, more likely to be heard than seen and usually confined to dense reedbeds. Its slim body enables it to walk between the reed stems and its colouring hides it extremely well. The upperparts are dark brown with darker brown feather-centres, the underside is slate-grey and the flanks are strongly marked with broken black and white bars. Short tail – white and buff below – is constantly flicked. Red, slightly downcurved bill. Females are a little smaller than the males and have a slightly shorter bill. Juveniles are browner below and have a brown bill. In flight the long legs trail behind the tail.

SIZE Length 22–28cm
NEST Cup-shaped nest on ground in thick waterside vegetation
BREEDING Lays 6–11 glossy white eggs with reddish spots in March–April
FOOD Aquatic invertebrates, insects and some plant material
HABITAT Reedbeds, well-vegetated marshes, lake and river margins
VOICE Harsh strangled squeals and grunts, plus nocturnal *kipp kipp* call
DISTRIBUTION Widespread but scarce breeding bird over most of Britain and Ireland in suitable habitat

Corncrake
Crex crex

The male's unique call is easily recognisable, but this is a very hard bird to spot, and very rare in Britain. In flight the corncrake shows long rusty-red wings and trailing legs. The upperparts are grey-brown with dark feather-centres that form a pattern of broken lines running along the body. The neck and supercilium are light grey and the underside is mostly buff with darker barring. Females and juveniles lack the grey on the face and neck.

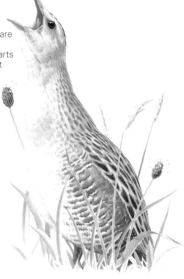

SIZE Length 27–30cm
NEST Shallow depression with slight canopy of overhanging grasses
BREEDING Lays 8–12 grey-green eggs with reddish spots in April–May
FOOD Invertebrates, some seeds and shoots
HABITAT Traditionally managed hay meadows and dry zones of marshes
VOICE Far carrying, rasping *crex crex* made by male in breeding season only
DISTRIBUTION Restricted mainly to western Ireland, Hebrides and Orkney, few records on mainland; overwinters in Africa

Moorhen
Gallinula chloropus

A very common waterbird which appears mostly black at a distance. When swimming it bobs its head and flicks its tail, constantly showing the white undertail feathers. The bill is bright red with a yellow tip and there is a red shield on the face. In good light the head and neck are seen to be black, the flanks are grey and the back and wings are dark brown, divided from the flanks by a horizontal white line. Out of water the yellowish legs with very long toes are striking. Can become very confiding in town parks.

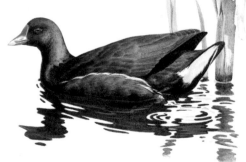

SIZE Length 32–35cm
NEST Platform of leaves with cup-shaped depression, sometimes floating on water
BREEDING Lays 5–9 buff-brown blotched eggs in March–June
FOOD Aquatic and terrestrial invertebrates, tadpoles and plant material
HABITAT Wide range of wetlands from large lakes to urban park ponds
VOICE Harsh *krrekk* and repetitive *kipp kipp kipp*
DISTRIBUTION Very common and widespread across most of Britain apart from far NW, but declining where waterways are damaged

Coot
Fulica atra

A compact, sooty-black waterbird with a white bill and face shield and bright red eye. The sexes are identical, but females are slightly smaller. Out of the water the coot shows its strangely lobed greenish-grey feet, and at close range the flanks are seen to be dark grey, rather than black. In flight the wings show a hint of a pale margin. A quarrelsome bird, defending its territory against any other waterbirds, and sometimes seen feeding in large flocks on land some distance from water. Large numbers sometimes arrive in Britain in winter from eastern Europe to escape harsh winter.

SIZE Length 36–38cm
NEST Platform of vegetation hidden among water plants
BREEDING Lays 6–10 buff eggs with darker speckles in March–May
FOOD Mainly aquatic plants taken by shallow dives; some invertebrates
HABITAT Large ponds, lakes and rivers; urban parks
VOICE An ear-splitting *pitt* and repetitive harsh *kowk*
DISTRIBUTION Widespread across most of Britain and Ireland apart from far north

WADERS
● *Long legs* ● *Plovers have short bills*
● *Avocets and oystercatchers have long bills*

Stone-curlew
Burhinus oedicnemus

Although classed as a wading bird, the stone-curlew is unlikely to be seen in water, preferring the driest of habitats for feeding and nesting. It has a slight resemblance to an immature gull with its mottled brown plumage, long black-tipped yellow bill and large yellow eye. In flight its wings show a strong black and white pattern; at rest there is a white wingbar visible. When motionless on the nest, it is extremely difficult to see against the stony ground it favours.

SIZE Length 40–44cm
NEST Shallow scrape with lining of tiny stones or rabbit droppings on open ground
BREEDING Lays 1–3 pale buff eggs with purplish markings in April–May
FOOD Mainly invertebrates; may also take lizards and small frogs.
HABITAT Dry, open grasslands and heaths
VOICE Shrill wader-like calls, uttered at night, and a curlew-like flight call heard in breeding season
DISTRIBUTION A rare breeding bird in SE England on suitable habitats; migrates to Mediterranean and North Africa for the winter

Oystercatcher

Haematopus ostralegus

A striking, large black and white wader with a long orange bill, red eyes and red-pink legs. The sexes are identical and in winter both acquire a white chin stripe on the all-black neck. Newly hatched chicks and juveniles have good camouflage.

SIZE Length 40–45cm
NEST Shallow scrape with lining of tiny shells or pebbles on open ground
BREEDING Lays 3 buff coloured eggs with darker blotches and lines in April–May
FOOD Marine invertebrates; earthworms for inland birds
HABITAT Rocky shores, estuaries, large stony rivers and lake shores in north

VOICE Far-carrying shrill piping calls, and a very loud *ku-beek* alarm call
DISTRIBUTION A widespread and common breeding bird around whole British coastline, and common inland in northern Britain

Golden plover

Pluvialis apricaria

A medium-sized rather plump wader with a rounded head, short bill and speckled golden-brown plumage. In summer the male has a black face and black underside with a white border. In flight, the white underwings contrast markedly with the black belly. Females have less black on the underside, an indistinct white border to the black area and a grey face. In winter the black is replaced by speckled golden-brown plumage on the neck and a white belly.

SIZE Length 26–29cm
NEST Shallow scrape on grassy open areas
BREEDING Lays 4 greenish or buff eggs with pattern of blotches in April–May
FOOD Mainly soil invertebrates, some seeds and berries

HABITAT Breeds on moorlands, bogs, mountain slopes; overwinters on lowland grasslands
VOICE A sad-sounding *pyuu-puu*
DISTRIBUTION A declining breeding bird in upland Britain; overwinters on lowland pastures

Avocet

Recurvirostra avosetta

A large black and white wader with a distinctive long upturned bill and long blue-grey legs. From a distance the avocet looks mostly white with a black head and nape and black panels on the wings. In flight the wings show large black wing tips and broad oval black panels. From below avocets look almost all white in flight. Juveniles resemble adults but have dark brown rather than black markings. Often seen in large feeding flocks on mudflats in characteristic stooped posture, sifting through mud with the upturned bill.

SIZE Length 42–46cm
NEST Shallow scrape on open ground near water, few shells or stones for lining
BREEDING Lays 3–4 pale buff eggs with brownish blotches in April–May
FOOD Small mud-dwelling invertebrates

HABITAT Estuaries, coastal marshes and shallow lagoons
VOICE A melodious *pleet pleet* and other harsh calls
DISTRIBUTION Confined to SE coast of England as breeding bird; overwinters on estuaries in SW

Grey plover

Pluvialis squatarola

A medium-sized wader with mostly dark grey speckled winter plumage, darker on the upperparts and grading to white on the belly. The bill, eyes and legs are black. In flight shows black 'armpits' contrasting with mostly white underside. In summer, when confined to the high Arctic, underparts are black and shoulders are white. Juveniles resemble adults, but have a buff tinge to the grey plumage.

SIZE Length 27–30cm
NEST Shallow scrape on open dry ground
BREEDING Lays 4 greyish eggs with darker blotches in April–May
FOOD Soil invertebrates on tundra, marine invertebrates in winter

HABITAT Breeds on Arctic tundra; overwinters around coastline of Britain and Europe
VOICE Far-carrying whistling *plee-oo wee*
DISTRIBUTION Common winter visitor to most of British coastline

Ringed plover

Charadrius hiaticula

A small, compact wader with a short, black-tipped orange bill, short orange legs and mostly plain grey-brown upperparts. The head is boldly marked with black and white bars and the underside is pure white. In flight the wings show prominent white wingbars against black flight feathers. The sexes are identical, but some females have less distinct black markings, and in both sexes the black fades in winter. Juveniles resemble adults but with a scalloped appearance on the upperparts due to white feather-edges.

SIZE Length 18–20cm
NEST Shallow depression on open ground near water, few pebbles or shells for lining
BREEDING Lays 4 buff eggs with black markings in April–May
FOOD Small invertebrates found in soft mud

HABITAT Sheltered seashores, estuaries, stony lake margins and tundra
VOICE Shrill, repetitive *tee-lee-a* alarm calls, and quieter whistles
DISTRIBUTION Widespread breeding bird around most of coastline and many stony inland sites; overwinters around coast

Dotterel

Charadrius morinellus

A slim, short-billed wader with a distinctive pattern. More likely to be seen on mountain tops and open ground than near water. Roles are reversed with the female having the more striking plumage. The upperparts are buff-brown with scalloped feather-edges, the face is mostly white and the neck is grey-buff separated from the chestnut breast by a black and white band. Juveniles and winter adults have more uniform faded plumage with a less obvious white supercilium.

SIZE Length 20–22cm
NEST Shallow scrape on open ground, sometimes near moss clump or boulder
BREEDING Lays 3 buff-green eggs with reddish-brown markings in May–June
FOOD Soil invertebrates, insects and spiders

HABITAT High open mountain grasslands in summer; overwinters in desert areas
VOICE Quiet *pweet pweet* flight calls and trilling contact notes
DISTRIBUTION A summer visitor to high mountains in Scotland and northern England

Little ringed plover

Charadrius dubius

A small, slim wader closely resembling the larger ringed plover, but with a prominent gold eye-ring; all-black bill and brownish legs. In flight, the absence of any wingbar is very noticeable. The head is strongly marked with a white line extending over the eyes and forehead. The sexes are identical; juveniles resemble adults but with less distinct markings. A secretive bird when nesting, but if discovered will make an elaborate distraction display, calling loudly and dragging its wings as if injured.

SIZE Length 14–15cm
NEST Shallow scrape on bare ground near water
BREEDING Lays 4 buff-coloured, brown-streaked eggs in March–May
FOOD Insects, spiders and aquatic invertebrates

HABITAT Dry open stony ground, gravely river beds and stony lake margins
VOICE A mournful *kreee-u* and a louder *kiu* flight call
DISTRIBUTION Summer visitor to inland sites in south and east Britain, widespread across Europe

Lapwing

Vanellus vanellus

Also known as green plover, this medium-sized wader has glossy green upperparts, white underparts and orange undertail coverts. There is a broad black chest band and a black crest, longer in the male, on the black head. In winter the feathers show pale margins that give a scalloped appearance and the cheeks are buff, not white. In flight lapwings look black and white, with very long, broad wings. Males make a dramatic display flight in spring, diving and calling with great skill.

SIZE Length 28–31cm
NEST Shallow scrape on open ground, sometimes slightly raised on tussock
BREEDING Lays 4 olive or brown blotched eggs in March–May
FOOD Soil invertebrates

HABITAT Marshes, pastures and open grassy areas
VOICE A shrill *peeoo-wit* and other harsher anxiety calls
DISTRIBUTION A widespread breeding bird across much of Britain; overwinters in large flocks in lowland marshy areas

Turnstone

Arenaria interpres

Usually seen in winter when upperparts are uniformly grey-brown, head and neck are grey, legs are dull orange and underside is white. The sexes are alike and juveniles resemble adults apart from scaly appearance due to pale edges on dark feathers. In breeding plumage the male is a striking bird with bold black and white facial markings, rich chestnut upperparts with dark bands, a pure white underside and bright orange legs. The female is a duller version of the male in summer. Most frequently seen on coasts in winter using short strong bill to flip stones over or probe among seaweeds on tide lines.

SIZE Length 21–24cm
NEST Shallow scrape on open ground, sometimes on slight mound
BREEDING Lays 4 buff eggs marked with darker blotches in May–June
FOOD Marine invertebrates, insects on tundra

HABITAT Arctic tundra in summer, coastal areas in winter
VOICE Short harsh alarm calls when feeding birds are disturbed
DISTRIBUTION A common winter visitor to most of British coastline from its Arctic breeding grounds

Temminck's stint

Calidris temminckii

A very small wader with short legs and bill, looking somewhat longer and thinner than the little stint. Breeding-plumage adults have greyish-buff upperparts with a mottled appearance due to some feathers having dark centres and chestnut margins. Winter adults have grey-brown upperparts and white underparts with the grey on the chest forming a more noticeable chest band than on the little stint. Juveniles are buff above with a scaly appearance due to pale feather-edges.

SIZE Length 13–15cm
NEST Shallow scrape on open ground
BREEDING Lays 4 greenish-grey eggs with brown spots in April–May
FOOD Small insects and soil invertebrates
HABITAT Breeds on tundra and

mountainous regions of Arctic; winters on seashores and marshes
VOICE A far-carrying *tirrr*
DISTRIBUTION A passage migrant in Britain, mainly found in autumn on coasts

Dunlin

Calidris alpina

A small, neat wader with mostly grey winter plumage; the underparts are pure white and there is slight streaking on the upper breast and crown. The legs and the medium-length, slightly down-turned bill are black. In summer adult males have a black belly, chestnut back with darker streaks and more distinct streaks on the neck and chest. Juveniles resemble moulting adults with dark streaks on the breast. May be present in flocks of thousands on suitable feeding grounds.

SIZE Length 16–22cm
NEST Shallow scrape with grassy lining on ground concealed by taller vegetation
BREEDING Lays 4 pale brown-olive eggs with dark blotches in April–May
FOOD Insects in summer on tundra or moors, marine invertebrates in winter
HABITAT Estuaries, sheltered shores, lakes in winter; tundra and moors in summer

VOICE Harsh *krrrreee* flight call
DISTRIBUTION A very common winter visitor to coastline; breeds in suitable habitats in northern and western Britain, mostly in Scotland

Knot

Calidris canutus

A medium-sized stocky wader with straight bill, thin white wingbars and a grey rump. Usually seen in large flocks on shorelines in winter when adults look mostly grey-buff above and white below. In summer plumage adults are strikingly coloured, brick-red below and buff above with chestnut and buff patches. Juveniles resemble winter adults with warmer buff colouration to the grey feathers. Always reluctant to move off the shore as the tide advances.

SIZE Length 23–25cm
NEST Shallow scrape on open ground near water
BREEDING Lays 3–4 green eggs with brown markings in May–June
FOOD Insects on tundra, marine invertebrates on seashore

HABITAT High Arctic tundra in summer; overwinters on sheltered coasts
VOICE A short nasal *knutt* in winter
DISTRIBUTION A common winter visitor to British coastline

Curlew sandpiper

Calidris ferruginea

A small but relatively long-legged wader with a downcurved bill. Mostly seen in juvenile or winter plumage; adults are pale grey above and pure white below with light streaking on the upper chest, juveniles have buff upperparts. Both show a white supercilium and a white rump in flight. In summer plumage, rarely seen in Britain, the adult is strikingly brick-red below with dark chestnut upperparts.

SIZE Length 18–20cm
NEST Shallow scrape on dry, open ground near water
BREEDING Lays up to 4 buff-brown spotted eggs in May–June
FOOD Insects on tundra, marine invertebrates on shore

HABITAT Arctic tundra in summer; overwinters on shores in tropical Africa; passage migrant in Britain
VOICE A shrill *krilleee*
DISTRIBUTION Small numbers are seen on coasts in autumn

Sanderling

Calidris alba

A distinctive small wader which looks all white at a distance and is usually seen running in and out of the surf pecking at tiny food items. At close range the upperparts are seen to be pale grey with white feather-edges; in flight the wings show white wingbars and in all plumages the bill, eyes and legs are black. Juveniles have more strongly marked, darker grey upperparts and a warm buff wash to the mantle and neck.

SIZE Length 20–21cm
NEST Small shallow dip in bare open ground
BREEDING Lays 4 greenish dark-spotted eggs in May–June
FOOD Small insects on tundra, tiny marine invertebrates and kelp flies on shore

HABITAT High Arctic tundra in summer; overwinters on sandy shores
VOICE A harsh *plitt* flight or alarm call
DISTRIBUTION A common winter visitor to British coastline

Little stint

Calidris pusilla

A very small wader with a short, dark bill which is used to pick tiny prey items from the surface of mud or plants. Usually noticed by its restless behaviour when running around after prey. In winter adults are mostly greyish-buff above and white below. Summer adults have rusty-red upperparts with dark feather-centres giving a mottled appearance and dark centre to the crown. Juveniles resemble adults, but seen from above show a white 'V' mark on the mantle. In flight the wings look dark, with a narrow white wingbar. The rump has a dark centre and white edges.

SIZE Length 12–14cm
NEST Shallow leaf-lined cup on open ground near water
BREEDING Lays 4 pale green eggs with dark blotches in May–June
FOOD Insects on tundra, very small invertebrates on shore

HABITAT Breeds on Arctic tundra; overwinters on Mediterranean coasts; passage migrant in Britain
VOICE A short, quiet *tip* contact note and a thin *svee svee svee* display call
DISTRIBUTION Passage migrant in small numbers around British coastline

Purple sandpiper

Calidris maritima

A plump, short-legged wader with dark plumage and a stocky, downcurved bill. The upperparts are dark grey in winter with some pale feather-edges; the underparts are paler with dark streaks on the breast grading to white under the tail. The bill is yellow-orange with a darker tip and the legs are greenish-brown. Summer adults are more strongly marked above with black, chestnut and yellow. Juveniles resemble winter adults but with more strongly marked feather-margins.

SIZE Length 20–22cm
NEST Small cup-shaped dip with mossy lining on open ground
BREEDING Lays 4 olive or buff eggs with dark blotches in May–June
FOOD Insects, spiders, some plant material on tundra and marine invertebrates on shore

HABITAT
Arctic tundra and moorland in summer; overwinters on rocky shores
VOICE Short *kewitt* calls if alarmed
DISTRIBUTION A common winter visitor to British coastline, preferring exposed rocky headlands

Redshank
Tringa totanus

Easily recognised in all plumages by the long orange-red legs and long mostly red bill. In summer adults have grey-brown plumage above, becoming paler below, but there is variation in the extent of dark markings on the feathers; birds from the far north of the range are darkest. In winter the plumage becomes a much more uniform grey-brown above and very pale below. Juveniles are paler with a scaly appearance due to pale feather-margins; the legs are red but the bill is darker. In flight adults show broad trailing white edges to the wings and an inverted V-shaped white rump.

SIZE Length 27–29cm
NEST Shallow scrape with sparse lining on open ground
BREEDING Lays 4 olive or pale green eggs with dark blotches in April–May
FOOD Marine invertebrates, earthworms and insect larvae
HABITAT Sheltered shores and estuaries in winter; coastal marshes and wet meadows in summer
VOICE A ringing *klu klu klu* and a disyllabic *tu hu*
DISTRIBUTION A widespread but declining breeding bird across much of Britain; common on sheltered shores in winter

Spotted redshank
Tringa erythropus

A slender wader with long red legs and long, mostly dark bill. The plumage is a very pale grey in winter, grading to white on the underside. It is best recognised by its characteristic 'stabbing' feeding method, often wading in quite deep water, and sometimes even resorting to swimming and up-ending like ducks. The sexes are almost identical; juveniles resemble adults but are browner above. In flight the dark, spotted wings with no wingbars and only a thin white rump patch make it easy to separate this bird from redshank. In summer the plumage is sooty-black all over with white speckled feather-margins.

WINTER

SIZE Length 29–32cm
NEST Shallow scrape lined with scraps of plant material on open ground
BREEDING Lays 4 olive-green eggs with brown blotches in May–June
FOOD Soil and freshwater insects on tundra in summer, marine invertebrates in winter
HABITAT Arctic tundra in summer, coastal areas and estuaries in winter
VOICE A shrill *chew-itt* alarm or flight call and a buzzing display call on breeding grounds
DISTRIBUTION A winter visitor to coastal areas in southern Britain in small numbers

Greenshank
Tringa nebularia

A predominantly grey wader with long green legs and a long, slightly upturned bill. In flight the wings look all grey and the wedge-shaped white rump patch extends up the back. The end of the tail shows a number of faint brownish-grey bars. In summer the upperparts have darker markings forming broken bands along the wings, and V-shaped markings along the flanks give a streaked effect. The sexes are similar and juveniles resemble adults but with browner plumage, neater streaks along the body and a slightly shorter, straighter bill.

SIZE Length 30–35cm
NEST Shallow scrape on ground near rock or grass tussock
BREEDING Lays 4 buff eggs with brown markings in April–May
FOOD Aquatic invertebrates, tadpoles and tiny fish
HABITAT Bogs and marshes in summer, sheltered coasts, estuaries and lake shores in winter
VOICE Far-carrying, ringing *chew chew chew*
DISTRIBUTION Scarce breeding bird in northern Scotland; fairly common autumn passage migrant, some overwinter in SW Britain

Green sandpiper
Tringa ochropus

A small nervous wader which looks black and white from distance. When feeding it appears restless, and takes flight readily if disturbed, showing dark wings with no wingbars, a white rump and a barred tail. The underside is white but the wings are dark below with speckled areas at the base. Juvenile has buff, not white, spots, and streaks on neck and chest. At close range the upperparts are seen to be dark olive-green with white spots grading to dark grey-green on the head. Usually solitary, preferring ditches and watercress beds, but several may be found in one area.

SIZE Length 21–24cm
NEST Uses abandoned thrush or wood pigeon nest
BREEDING Lays 4 cream eggs with reddish markings in May–June
FOOD Invertebrates, fish fry and emergent insects
HABITAT Breeds on boggy areas close to woodlands; overwinters on streams, lake margins and cress beds
VOICE A whistling three-note *tooeet-wit wit* given when flushed or in flight
DISTRIBUTION Breeds in northern and eastern Europe; winter visitor to southern Britain, mainly inland wetland sites

Wood sandpiper
Tringa glareola

A small, slim wader with relatively long legs. In winter adults look speckled brownish-grey above and white below with a white supercilium. In flight the barred tail and white rump show clearly and the underwings are white. Juveniles are browner than adults and have a more streaked neck, chest and flanks; they are most likely to turn up in Britain as passage migrants in autumn.

SIZE Length 19–21cm
NEST Sometimes in old tree, or on ground in dense vegetation
BREEDING Lays 4 greenish-buff eggs with dark brown blotches in April–May
FOOD Aquatic invertebrates, tadpoles and tiny fish; some plant material
HABITAT Open forests with boggy clearings, riversides and well-vegetated marshes
VOICE When flushed utters a whistling *chiff chiff*; trilling display call near breeding site
DISTRIBUTION A very scarce breeding bird in northern Scotland; passage migrant in autumn in small numbers, overwinters in Africa

Common sandpiper
Actitis hypoleucos

A small, short-legged wader, constantly bobbing up and down. From a distance looks sandy-grey above and white below; at close range upperparts are seen to be finely patterned due to pale feather-edges and darker centres. In flight the upperwings look dark with narrow white wingbars. Juveniles resemble adults but are more scaly-looking due to pale feather-edges.

SIZE Length 19–21cm
NEST Shallow cup-shaped nest on ground concealed by vegetation
BREEDING Lays 4 buff eggs with reddish markings in April–May
FOOD Insects and aquatic invertebrates
HABITAT Stony rivers, lake shores and sheltered coasts
VOICE When flushed utters a shrill *hee dee dee* call; display call is a rhythmic *will-ee-wicket*
DISTRIBUTION A widespread breeding bird in northern and western Britain in suitable habitats, moving south for the winter

Curlew
Numenius arquata

A large, long-legged wader with a very long, downcurved bill. The plumage is mostly speckled brown on the upperparts grading to white below the tail. In flight a long wedge-shaped white rump and barred tail show clearly. The sexes have identical plumage, but females are larger than males with longer bills. In winter the lower mandible is flesh coloured. Juveniles are very similar to adults. The haunting, rolling call of the curlew is one of the most evocative of wader calls, heard frequently on its moorland breeding grounds.

SIZE Length 50–60cm
NEST Large scrape, with grassy lining, on ground near tussock
BREEDING Lays 4 greenish-olive eggs with brown markings in March–May
FOOD Invertebrates on moorlands; marine worms, molluscs and crabs on seashores
HABITAT Breeds on upland moors and bogs; overwinters on sheltered coasts and marshes
VOICE A sad-sounding *cour-lee* and a beautiful bubbling trill when displaying
DISTRIBUTION A widespread breeding bird across much of northern and western Britain and Ireland, overwinters around coasts

Whimbrel
Numenius phaeopus

Smaller than the curlew but similar in appearance. The dark stripes on the head and pale supercilium show well at close range, and the plumage is more boldly marked overall with brown speckles. The bill is shorter and straighter than the curlew's; in flight the whimbrel looks smaller and has more energetic wingbeats. The sexes are very similar and juveniles resemble adults but have buff spots on the crown and wing coverts. Usually seen in small, nervous groups on passage.

SIZE Length 40–46cm
NEST Shallow scrape with plant lining on open ground
BREEDING Lays 3–4 olive-green eggs with brown markings in April–May
FOOD Invertebrates, insects, marine worms and small crustaceans
HABITAT Breeds on Arctic tundra, upland moors and bogs; overwinters on seashores
VOICE A seven-note trill in flight, and short curlew-like display call
DISTRIBUTION A scarce breeding bird in northern Scotland and Shetland; common passage migrant in spring and autumn; overwinters on African coasts

Black-tailed godwit

Limosa limosa

A large long-legged wader with a long straight bill. Breeding plumage is striking: the head and neck are brick-red; upperparts and chest are mottled grey with bold chestnut and black markings; underside is white. Females may be almost grey in summer, but most show some red colouration. Winter plumage is mostly grey. Juveniles are brown and buff above and yellowish-buff below. The bill is flesh-coloured at the base grading to black at the tip; the legs are black. The long bill is used to make hard downwards stabs into mud.

SIZE Length 36–44cm
NEST Shallow, grassy-lined scrape on open ground
BREEDING Lays 3–4 olive or brownish eggs marked with dark brown spots in April–June
FOOD Mud-dwelling invertebrates

HABITAT In summer lives on marshes, damp meadows, bogs; overwinters on estuaries, sheltered shores
VOICE Mostly silent, but makes harsh *kee wee wee wee* calls near nest
DISTRIBUTION A scarce breeding bird in scattered localities in Britain and Ireland, common winter visitor to the coast

Bar-tailed godwit

Limosa lapponica

Very similar to black-tailed godwit, but slightly smaller with shorter legs and marginally shorter bill which tilts upwards. In summer the male is dark red on the whole of the underside and dark mottled chestnut and brown on the upperparts. Females, which are larger than the males, are warm buff below and paler above. In winter both sexes are buff-grey above and pale grey to white below. The upperparts have a slightly scaly or streaked appearance due to dark feather-centres. Often mixes with small groups of curlew, looking smaller and paler than them.

SIZE Length 33–42cm
NEST Shallow scrape on dry open area of marsh
BREEDING Lays 3 or 4 greenish eggs with brown markings in April or May
FOOD Insects, soil invertebrates on tundra, marine invertebrates on seashores

HABITAT Arctic tundra in summer, sheltered muddy seashores in winter
VOICE Usually silent, but makes nasal *kee-vuu* calls in flight
DISTRIBUTION A fairly common winter visitor and passage migrant to many sheltered coasts

Grey phalarope

Phalaropus fulicarius

An unusual small wader, more likely to be seen swimming than wading. Summer plumage only seen in the high Arctic: underparts brick-red, back and wings dark chestnut mottled with brown; face black and white. Roles are reversed in this species, with the female having the brightest plumage. Winter adults are pale grey above and white below with large black eye patches. Juveniles are similar but have a scattering of black and dark brown feathers on the back and wings. The bill is broad at the base and mostly yellow in summer.

SIZE Length 20–22cm
NEST Shallow cup of vegetation in taller plants near water
BREEDING Lays 4 olive, mottled eggs in May–June
FOOD Invertebrates taken from surface or plant stems in shallow water

HABITAT High Arctic tundra in summer; overwinters at sea in tropical regions
VOICE Usually silent, but can make brief *pik* alarm calls
DISTRIBUTION A passage migrant, usually storm driven; occurs in small numbers in autumn

Red-necked phalarope

Phalaropus lobatus

Feeds by spinning round and round in shallow water to stir up food. Uses slender bill to pick tiny prey items from the surface, and lobed feet help it swim well. In summer females have striking red necks and chests, grey heads and napes and a white throat; males have more subdued colouring. Winter adults look black and white at distance with dark grey upperparts and white underparts. Juveniles are similar but have more buff-brown in the upperparts. The more slender bill and spinning habit distinguish winter red-necks from grey phalaropes.

SIZE Length 18–19cm
NEST Shallow leaf-lined cup of leaves concealed on ground in taller vegetation
BREEDING Lays 4 olive eggs marked with a few spots in April–May
FOOD Invertebrates taken from water surface

HABITAT Open, wet tundra in summer; overwinters at sea in the tropics
VOICE Brief *kitt* or *kirritt* calls
DISTRIBUTION A very rare breeding bird in northern Scotland, and a scarce passage migrant in autumn

Ruff

Philomachus pugnax

The male is a spectacular wader in the breeding season with a large and conspicuous ruff, formed from greatly enlarged head and neck feathers around its warty orange face. Different colour combinations vary from black through browns and oranges to white. The females are smaller and mostly mottled brown above, warm buff and white below. Groups of males perform a lively display at a 'lek', showing off their ruffs to impress females. In winter both sexes are much plainer and juveniles resemble winter adults, but have warmer buff plumage.

SIZE Length Male 26–32cm; female 20–25cm
NEST Shallow scrape with plant lining usually under overhanging plants
BREEDING Lays 4 greenish eggs marked with brown blotches April–May
FOOD Soil invertebrates in summer;

marine worms, shrimps on coasts
HABITAT Swamps, marshes, lake margins, wet pastures
VOICE Mostly silent
DISTRIBUTION A scarce breeding bird in Britain, but more common passage migrant and winter visitor

Woodcock

Scolopax rusticola

A very secretive and unusual wader, rarely seen near water. Males emerge from their woodland haunts at night in spring and summer to perform the 'roding' display, when they fly on jerky wings around a set route making peculiar grunting calls and the occasional shrill whistle. On rare occasions the woodcock may be seen feeding on the woodland floor, probing its long bill into soft mud. In flight, in good light, the rich red-brown plumage and broad dark bars on the head and the broad wings show clearly. The markings make superb camouflage and nesting females are very difficult to spot on the woodland floor.

SIZE Length 33–35cm
NEST Shallow leafy cup concealed on woodland floor
BREEDING Lays 4 pale buff, blotched eggs in March–May
FOOD Soil invertebrates, especially earthworms

HABITAT Woodlands, especially with damp soils
VOICE A creaky *oo-ort* and a shrill squeak
DISTRIBUTION A widespread breeding bird in woodlands across much of Britain, and a winter visitor from the Continent

Snipe

Gallinago gallinago

A small wader with a very long bill which it uses to probe into soft mud with a jerky, vibrating action; sucks up its prey without needing to remove the bill. If disturbed, will fly off on an erratic flight path and then quickly drop to safety. In the breeding season males perform a conspicuous display flight, diving from a height and sticking out their tail feathers to make a bleating sound. Both sexes are mostly brown with paler stripes above and mottled grey below. Juveniles have white rather than buff feather-margins.

SIZE Length 25–27cm
NEST Small cup of woven leaves under taller plants
BREEDING Lays 4 green-olive eggs marked with dark blotches in March–May
FOOD Invertebrates
HABITAT Wet meadow, marshes, bogs,

salt marshes
VOICE A sneeze-like alarm when flushed, and a rhythmic *tick a tick a tick* on display, usually uttered from a perch
DISTRIBUTION A widespread breeding bird across much of Britain and Ireland, and winter visitor from the Continent

Jack snipe

Lymnocryptes minimus

A very secretive and solitary small wader, usually only spotted when flushed from rushes; it will then make a short escape flight and drop quickly back into cover, often making its brief 'sneeze' call as well. The bill is proportionately smaller than the snipe's and the upperparts more strikingly marked with pale yellow stripes running the length of the back. In good light the plumage has a greenish-brown tinge and the legs are blue-green. The sexes are very similar and juveniles cannot be distinguished. If seen feeding in the open, it adopts a crouching, bobbing posture, and seems to move rather nervously.

SIZE Length 17–19cm
NEST Shallow cup with grass lining on ground near water
BREEDING Lays 4 olive-brown eggs with darker markings in April–May
FOOD Small invertebrates taken from surface of mud and plant stems

HABITAT Breeds on boggy tundra; overwinters on lowland marshy areas
VOICE Mostly silent, apart from sneeze-like alarm call
DISTRIBUTION A winter visitor to Britain and Ireland from its Arctic breeding grounds, found in suitable habitats over a wide area

GULLS

- *Mainly white plumage* • *Webbed feet*
- *Usually found on coasts*

Black-headed gull

Larus ridibundus

Extremely common and widespread gull. In all non-juvenile plumages it shows a diagnostic white leading edge to the wing. Summer adult has chocolate-brown hood. In winter this is lost and replaced by dark smudges on face. All adult birds have red legs and a black-tipped red bill. Mainly coastal in breeding season but flocks widespread inland in winter. Utters loud, raucous calls.

SIZE Length 36–40cm
NEST Shallow scrape on bare, marshy ground; lined with feathers and twigs
BREEDING Lays 2–3 eggs, mainly June
FOOD Marine invertebrates, insects and worms but also scraps and refuse

HABITAT Estuaries, marshes, farmland and urban settings
VOICE Harsh, screaming *kaaarh-kaaarh-kaaarh*
DISTRIBUTION Common and widespread resident

Mediterranean gull

Larus melanocephalus

Superficially similar to black-headed gull with which it associates but adult birds have pure white wings (black-headed gulls have black on the wingtips). Adult in breeding plumage has a black hood and white 'eyelid' markings. In winter, hood is lost and replaced by dark smudges on the head. All adult birds have red legs and a proportionately large red bill. Immature birds take two years to reach full adult plumage.

SIZE Length 36–38cm
NEST Shallow scrape lined with feathers and twigs
BREEDING Lays 3 eggs, mainly June
FOOD Marine invertebrates, insects and worms but also scraps and refuse
HABITAT Coasts and urban settings
VOICE Mostly silent in winter but harsh

kow-kow-kow call occasionally heard
DISTRIBUTION Rare breeding species on south coast of England. More widespread outside breeding season but still scarce.

Herring gull

Larus argentatus

The commonest and most widespread of the larger gulls in Britain. Adult has silver-grey mantle and upperwings; the wingtips are black and flecked with white. Plumage otherwise white although head and neck have dark streaks in winter. Legs pink and bill yellow with orange spot near tip. Immature herring gull has mottled grey, brown and white plumage and gradually acquires adult plumage over three years.

SIZE Length 55–65cm
NEST Mound of seaweed and debris
BREEDING Lays 3 eggs, mainly May–June.
FOOD Fish and marine invertebrates but also carrion and refuse
HABITAT Coastal areas and urban settings

VOICE Distinctive and familiar mewing call
DISTRIBUTION Common and widespread resident

Lesser black-backed gull

Larus fuscus

Superficially similar to great black-backed gull but appreciably smaller and with yellow, not pink, legs at all times in adult birds. Mantle and upperwings of adult are dark slate-grey, this colour noticeably paler than the black wingtips. Plumage otherwise white. Immature birds are mottled grey, brown and white and acquire adult plumage over three years. Nests colonially, sometimes near herring gulls.

SIZE Length 55–65cm
NEST Mound of seaweed and debris, often partly hidden by vegetation
BREEDING Lays 3 eggs, mainly May–June
FOOD Fish and marine invertebrates; scavenges refuse outside breeding season
HABITAT Estuaries, marshes and farmland

VOICE Loud mewing call, deeper than that of herring gull
DISTRIBUTION Widespread and locally common resident and winter visitor

Great black-backed gull

Larus marinus

Large, goose-sized gull, the largest of its kind in Britain. Adult birds have black upperwings and mantle but otherwise the plumage is white. The massive bill is yellowish with an orange spot near the tip and the legs are pink. Immature birds have mottled grey, brown and white plumage at first and acquire adult plumage gradually over three years. Great black-backs are rather solitary birds, even outside the breeding season.

SIZE Length 65–75cm
NEST Mound of seaweed and other vegetation on seacliff or coastal marsh
BREEDING Lays 2–3 eggs, mainly June
FOOD Scavenges but also feeds on smaller seabirds, especially in breeding season

HABITAT Mainly coastal, but occasionally on inland reservoirs or refuse tips
VOICE Utters deep *kuk-kuk-kuk* call
DISTRIBUTION Widespread but never as numerous as other, smaller gull species

Glaucous gull

Larus hyperboreus

Large and distinctive gull. Adult looks very pale. The plumage, including wingtips, is essentially white except for the pale grey mantle and upperwings. Head and neck have dark streaks during winter months. Bill proportionately massive and pink. Immature is very pale with dark-tipped pink bill and pink legs. Glaucous gulls are usually rather solitary but will roost with other, commoner gulls in the winter months.

SIZE Length 63–67cm
NEST Mound of vegetation
BREEDING Lays 2–3 eggs, mainly June, but does not breed in Britain
FOOD Expert scavenger but also a predator of smaller birds

HABITAT Mainly coastal, especially harbours, but also visits inland refuse tips
VOICE Comparatively high-pitched *kew-kew* call
DISTRIBUTION Scarce winter visitor

Common gull

Larus canus

Widespread but, despite its name, not the commonest gull in Britain. Adult resembles small adult herring gull with mainly white plumage except for grey mantle and upperwings and black wingtips flecked with white. In winter, the head and nape have dark flecks. Adults have yellowish-green legs and bill at all times. Immature birds have grey, brown and white plumage; gradually acquire adult plumage over two-year period.

SIZE Length 38–43cm
NEST Shallow cup-shaped nest built on marshy ground and lined with plant debris
BREEDING Lays 3 eggs, mainly June
FOOD Mainly fish, marine invertebrates, insects and earthworms
HABITAT Coasts, marshes and farmland

VOICE Distinctive mewing call
DISTRIBUTION Locally common breeding species in northern Britain; widespread and fairly common throughout outside breeding season

Kittiwake

Rissa tridactyla

The most marine of all our gulls and only present near land during the breeding season. Superficially similar to common gull but more dainty and with more buoyant flight. Adult plumage mainly white except for grey mantle and upperwings and black wingtips flecked with white. Bill yellow and legs black at all times. Immature has distinctive black zigzag marking on upperwings. Frequently uttered calls are heard at breeding colonies.

SIZE Length 38–40cm
NEST Small mound of mud and seaweed on cliff ledge
BREEDING Lays 1–3 eggs, mainly June
FOOD Marine fish and invertebrates
HABITAT Breeds on seacliffs but otherwise found at sea
VOICE Utters screaming *kittiwake-kittiwake-kittiwake* call

DISTRIBUTION Locally common breeding species at seabird colonies; widespread at sea, particularly off west and north coasts

TERNS AND SKUAS
● *Skuas steal food from other birds* ● *Long-distance migrants*
● *Terns are expert fliers*

Sandwich tern
Sterna sandvichensis

A large pale tern with long, narrow wings and a short, deeply forked tail. Upperparts are pale grey with silvery-grey flight feathers. In summer the head is jet black with an untidy crest. The black bill has a yellow tip and legs and feet are black. In winter forehead becomes white and head is mottled. Juveniles resemble winter adults but have all-black bill.

SIZE Length 36–41cm
NEST Shallow scrape on shingle or among saltmarsh plants
BREEDING Lays 1–2 cream, blotched eggs in April–May
FOOD Fish, especially sand eels, caught near surface
HABITAT Sheltered coasts with shallow waters at close range
VOICE A harsh, grating *keerr-ikk*
DISTRIBUTION A summer visitor to most of coastline of Britain and Ireland

Common tern
Sterna hirundo

A medium-sized tern with mostly white plumage apart from grey flight feathers and a black cap. The bill is red with a black tip, and the legs and feet are red. In winter adults lose the black cap and develop pale panels on the wings. Juveniles resemble winter adults but have a ginger-buff wash and pale central panels on the wings.

SIZE Length 31–35cm
NEST Shallow scrape with sparse lining of shells or vegetation
BREEDING Lays 1–3 buff eggs with darker blotches in April–May
FOOD Fish and shrimps caught at surface
HABITAT Sheltered coasts, large lakes in summer, migrates south in winter
VOICE Persistent grating *kee-yah* calls
DISTRIBUTION A summer visitor to British and Irish coasts and many inland sites

Arctic tern
Sterna paradisea

Similar to common tern, but has shorter bill and head, longer deeply forked tail and shorter legs. The bill has no black tip and the overall impression of breeding plumage is paler than common tern with a very white tail and rump. From below the flight feathers look almost transparent. In winter plumage, usually not seen in Britain, the crown is speckled with white and the legs are darker. Juveniles have a white forehead and black cap, and are grey above, lacking the buff tints of other juvenile terns.

SIZE Length 33–35cm
NEST Shallow scrape on open ground
BREEDING Lays 1–3 buff eggs with darker blotches in April–May
FOOD Fish and shrimps caught at surface
HABITAT Rocky coasts and islands, large rivers and lakes
VOICE Grating disyllabic calls and many other display and contact notes
DISTRIBUTION A common summer visitor to coasts and islands in northern Britain and Ireland

Roseate tern
Sterna dougallii

A medium-sized tern with very long, trailing tail streamers. It has shorter wings than the common tern, which gives the impression of a slimmer bird. In breeding season adults have a pink flush to the underparts and a blue-grey tinge to the upperparts. Seen from below the flight feathers look translucent. The black cap extends down the nape, narrowing to a point. Bill is black with a small patch of red at the base. In winter the forehead becomes white and the pink flush becomes white. Juveniles have darker blotches on the plumage.

SIZE Length 33–38cm
NEST Shallow scrape, no lining; sometimes near rock or large plant
BREEDING Lays 1–2 cream-coloured eggs with darker blotches in April–May
FOOD Fish caught at surface
HABITAT Exposed coasts with tiny islands
VOICE Varied calls, including a grating *aakkh* and a whistling *chewit*
DISTRIBUTION A rare summer visitor to a few coastal sites in Britain and Ireland; overwinters on West African coast where it is heavily persecuted

Little tern
Sterna albifrons

A small tern with mostly white plumage and narrow wings with darker grey primaries. The black cap extends down the nape and through the eye, and the forehead is white. The slender yellow bill has a black tip, and the legs and feet are orange-yellow. In winter there is less black on the head and the bill is darker. Juveniles have a scaly, pale brown appearance on the upperparts and a pale cap. By comparison with other small terns they look compact and short-legged.

SIZE Length 22–24cm
NEST Shallow scrape on sand or shingle
BREEDING Lays 1–3 cream eggs with darker blotches in April–May
FOOD Small fish and shrimps caught at surface
HABITAT Sheltered coasts, large rivers and lakes with shingle and shallow lagoons
VOICE Rasping, shrill *keeirr-ink* calls
DISTRIBUTION A summer visitor to scattered localities around most of British and Irish coastline

Black tern
Chlidonias niger

A small tern with almost all-dark plumage in summer. The head and underparts are black, the wings and mantle dark ashy-grey. From below the underwing looks pale grey and the undertail coverts are white. The bill is black and the legs are dark red. In winter the plumage fades to paler grey upperparts and white underparts; there is darker patch at the shoulder. Juveniles resemble winter adults. Typical feeding habit is buoyant, with dipping flight over water to pick insects from surface.

SIZE Length 22–24cm
NEST Low pile of vegetation close to water
BREEDING Lays 2–4 cream, spotted eggs in April–May
FOOD Insects, aquatic invertebrates and tiny fish caught at surface
HABITAT Fresh or brackish lakes, usually with plenty of vegetation
VOICE Harsh *kik-keek* calls
DISTRIBUTION A passage migrant and accidental visitor in Britain, usually in late summer; very common in continental Europe

Great skua
Stercorarius skua

A large, aggressive seabird, resembling an immature gull but darker and with a heavier build. Plumage is mostly dark brown, but in flight and when displaying the wings show white panels. When standing the legs look short and the feet are small, but the bird itself appears very heavy. A buoyant swimmer and very powerful flier. Adults display by standing with wings raised, uttering a harsh call. Juveniles are similar to adults but darker. Skuas are usually noticed when they are pursuing other seabirds. Attacks people who stray near nests.

SIZE Length 53–66cm
NEST Shallow scrape with sparse plant lining
BREEDING Lays 2 brown eggs with darker spots in April–May
FOOD Fish stolen from other seabirds, plus eggs, chicks, carrion and fish from sea
HABITAT Seabird colonies on cliffs and islands in summer; overwinters at sea
VOICE Hoarse contact notes and a *tuk tuk* alarm call
DISTRIBUTION Summer visitor to northern Scotland where over half of world's population breeds; seen on all coasts on migration

Arctic skua
Stercorarius parasiticus

A falcon-like bird, normally spotted as it twists and turns after another seabird, uttering screaming calls. Darker birds are commonest in the south of the range, paler birds more common in the north. Dark-phase birds have sooty-brown plumage all over, but with a darker cap and cream face. Pale-phase birds are paler grey above, grading through grey to pure white on the underside, but they still show a dark cap. Both colour phases have dark legs and dark wings with pale flashes which show well in displaying birds. The tail is relatively long with central elongated tail feathers. Juveniles are very variable, but usually browner overall with no dark cap.

SIZE Length 46–67cm
NEST Shallow scrape on open ground with sparse lining
BREEDING Lays 2 olive-brown eggs with darker spots in May–June
FOOD Chases other birds to make them drop their food
HABITAT Breeds near seabird colonies; overwinters at sea
VOICE Harsh calls similar to kittiwake; short alarm calls
DISTRIBUTION Breeds in northern Scotland, Orkney and Shetland; seen on passage on all coasts

AUKS
● *Black and white plumage* ● *Short tails and narrow wings*
● *Deep swimmers*

Razorbill
Alca torda

An all black and white seabird. Plain colourings only relieved by the bright yellow inside of the bill, sometimes seen as a bird yawns. The whole of the upperparts are sooty-black but there is a white line from the eye to the bill, a thin white band across the bill and a thin white wingbar. The underside is pure white and the legs and feet are black. In winter the upperparts become greyer and the throat and upper chest are a grubby white. Juveniles are slightly browner than adults.

SIZE Length 37–39cm
NEST No nest; egg laid on rock in crevice or under boulder
BREEDING Lays single large pale egg with darker lines and spots in April–May
FOOD Marine fish
HABITAT Breeds on sea cliffs and islands; overwinters at sea, sometimes close to shore
VOICE Usually silent, but makes growling calls on breeding cliffs
DISTRIBUTION A summer visitor to coasts of Britain and Ireland, where half of world's population breeds; some overwinter close to SW coasts

Guillemot
Uria aalge

A compact seabird with a dark, pointed bill. Plumage appears all black and white at a distance, but is dark chocolate-brown in birds from southern Britain, and almost black further north. Whole of upperparts and throat are dark, with only thin white line across wings; underparts are pure white apart from brown streaks on flanks. A bridled form is found, mainly in the north, with a white eye-ring and thin white line behind the eye. In winter cheeks, neck and upper chest are white, and upperparts are greyer. At all times legs and feet are dark blue-grey. Juveniles resemble winter adults but have smaller bills.

SIZE 38–41cm
NEST No nest built; eggs laid on rock ledge
BREEDING Lays single large pointed egg, blue-green with blotches, in April–May
FOOD Marine fish, some larger invertebrates
HABITAT Breeds on sea cliffs; overwinters at sea, sometimes near SW coasts
VOICE Growling, guttural calls, sometimes uttered in chorus at breeding colonies
DISTRIBUTION A widespread and common breeding bird on all rocky coasts in summer

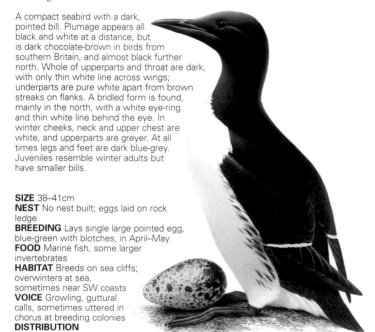

Puffin
Fratercula arctica

A compact auk with black and white plumage, a relatively large head and a large colourful bill. The face is pale grey and the dark eye is surrounded by a red ring and blue-grey wattles. The legs and feet are bright orange-red. The striking bill has a hooked tip and serrated-edged mandibles which help it catch and grip prey; it is also used to excavate nesting burrows. Winter adults have a less colourful bill and greyer plumage. Juveniles resemble winter adults and have flesh-coloured feet and legs and a smaller, darker bill.

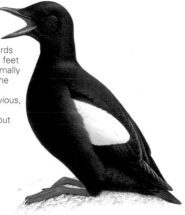

SIZE Length 27cm
NEST Chamber at end of burrow or under large boulder
BREEDING Lays single large white egg in April–May
FOOD Marine fish, some shrimps
HABITAT Breeds on rocky cliffs and islands; overwinters at sea
VOICE Usually silent, but makes deep laugh-like calls on nesting sites
DISTRIBUTION An abundant seabird at colonies on suitable cliffs and islands in north and western Britain and Ireland

Little auk
Alle alle

One of the smallest seabirds with smart black and white plumage, a short black bill and dark flesh-coloured legs and feet. The whole bird looks very compact, appearing to have no neck or tail. In summer plumage the throat and chest are black, but in winter this is replaced by white or smudged grey. Juveniles resemble winter adults but are browner. May be seen with other auks on migration when it looks markedly smaller. Underwing appears dark in flight. One of the most abundant seabirds in the world, but rarely seen close to land outside the breeding season.

SIZE Length 18cm
NEST Few pebbles arranged in rock crevice
BREEDING Lays single, pale greenish-blue egg in June–July
FOOD Mainly small shrimps caught near surface
HABITAT Arctic islands and cliffs in huge colonies; overwinters in cold seas
VOICE Shrill cheeping calls at nesting colonies
DISTRIBUTION A scarce passage migrant in Britain, usually storm-driven by autumn gales; Arctic nesting colonies number millions

Black guillemot
Cepphus grylle

A medium-sized auk with mostly black plumage in the breeding season. Large white wing panels show well in perched birds and are very obvious in flight. The legs and feet are bright red and the inside of the bill, normally only seen in display, is also red. In winter the black fades to a speckled grey and white, although the white wing panel remains obvious, and swimming birds then resemble small grebes. Juveniles similar to winter adults, but with darker mottled plumage.

SIZE Length 30–32cm
NEST No nest; uses crevices or gaps beneath boulders
BREEDING Lays 1–2 whitish, spotted eggs in May–June
FOOD Marine fish and crustaceans
HABITAT Breeds on sea cliffs and rocky islands; overwinters in shallow, sheltered coastal areas
VOICE A thin, plaintive whistle, described as sounding like a rusty hinge
DISTRIBUTION A common breeding seabird on NW British and Irish coasts; overwinters near breeding areas; occasionally seen elsewhere around coasts

PIGEONS AND DOVES
● *Sexes similar* ● *Short legs and bills*
● *Seed and plant feeders*

Rock dove/Feral pigeon
Columba livia

The rock dove is the wild ancestor of the feral pigeon and found only on remote coastal areas on NW Britain and Ireland. Feral pigeon is widespread throughout the country and generally associated with man. Typical rock dove has blue-grey plumage with two black bars across rear half of innerwing. Head and upper breast have greenish-purple sheen. In flight, the white lower back and underwing coverts are diagnostic; note also the black terminal band to the tail. Some pigeons are indistinguishable from rock doves but many show a range of colours from pale buff to almost black.

SIZE Length 31–34cm
NEST On ledge or in crevice; natural sites with rock dove, man-made structures with feral pigeon
BREEDING Lays 2 eggs March–October
FOOD Seeds, leaves and buds
HABITAT Rock dove favours rocky cliffs and coasts; feral pigeon occurs in urban and rural locations
VOICE Utters various cooing calls, typically *cooo-roo-cooo*
DISTRIBUTION Rock dove is local and rather scarce in NW Britain and Ireland; feral pigeon is widespread and common everywhere

Woodpigeon
Columba palumbus

Widespread and locally very common pigeon, the largest of its kind in the British Isles. Its song is a familiar sound in the countryside as is the clattering sound made by the wings on take-off, landing and in display. Gathers in large flocks outside the breeding season. The sexes are similar in appearance. Adult birds have essentially blue-grey plumage, pinkish on the breast, and a conspicuous white neck patch. In flight, white crescent on the wings are striking and a black terminal band to the tail can be seen. The bill is reddish with a yellow tip and the legs are pink. Juvenile birds are duller than adults and lack the white neck patch.

SIZE Length 40–42cm
NEST Loose collection of twigs arranged on branch or in tree fork
BREEDING Lays 1–2 eggs April–September
FOOD Mainly plant roots, leaves, shoots and seeds
HABITAT Open farmland and woodland edge; increasingly in urban settings
VOICE Familiar *coo-cooo coo coo cu*
DISTRIBUTION Widespread and generally common resident

Stock dove
Columba oenas

Medium-sized pigeon, appreciably smaller than woodpigeon with which it sometimes associates outside breeding season. The sexes are similar in appearance. Adult birds have essentially blue-grey plumage with a pinkish flush to the upper breast and a green sheen to the sides of the neck. In flight, the innerwing has a pale outer panel and shows two truncated dark bars at the base of the wing. The tail has a dark terminal band. The bill is dull yellow with a white patch at the base and the legs are pinkish. Juvenile birds are duller and browner than adults.

SIZE Length 32–34cm
NEST Nests in tree holes
BREEDING Lays 2 eggs, mainly May–August
FOOD Mainly seeds, leaves, shoots and flowers
HABITAT Open farmland and woodland edge
VOICE Repetitive *oo-look* cooing
DISTRIBUTION Fairly common but rather local resident

Collared dove
Streptopelia decaocto

Rather small and dainty dove with slender proportions. A familiar sight in most villages, towns and cities throughout the British Isles. The sexes are similar in appearance. Adult birds have warm pinkish-buff plumage on head, neck and underparts; a conspicuous white-edged black half-collar is striking. Back and inner upperwings are sandy-brown; in flight, shows dark primaries separated from innerwing by pale grey panel. Also in flight, undertail appears conspicuously white-tipped and uppertail is dark brown with pale tips to feathers; lower back is pale grey. The bill is dark, the eye is red and the legs are pinkish. Juvenile birds are duller than adults and lack the black half-collar.

SIZE Length 31–33cm
NEST Loose platform of twigs in tree
BREEDING Lays 1–2 eggs April–September
FOOD Mainly cereal grains and other seeds
HABITAT Gardens, farms and town parks
VOICE Repetitive cooing *coo-cooo cu*
DISTRIBUTION Widespread and locally common resident

Turtle dove
Streptopelia turtur

Attractive and well-marked dove, the smallest of its kind in the British Isles. The sexes are similar in appearance. Adult birds have blue-grey on head and warm pinkish neck and breast; belly is pale. Shows a conspicuous patch of black and white lines on side of neck. At rest, back and upperwings are attractively marked with dark-centred rufous-brown feathers. In flight, this feather area is bordered by blue-grey and the flight feathers are dark grey; the dark tail feathers are white-tipped. The yellow eye is surrounded by a red ring, the bill is dark and the legs are pinkish. Juvenile birds are duller than adults and lack the neck patch.

SIZE Length 26–28cm
NEST Loose construction of twigs in a hedge
BREEDING Lays 1–2 eggs June–July
FOOD Mainly seeds of arable and grassland 'weeds' and cereal grain
HABITAT Open farmland with hedgerows
VOICE Soft, purring *cooor*, often repeated for long periods
DISTRIBUTION Locally common summer visitor, present in southern Britain from late April to early September

CUCKOO
● *Summer visitor* ● *Male has distinctive cuckoo call*
● *Female lays eggs in other birds' nests*

Cuckoo
Cuculus canorus

Superficially falcon-like in flight, but with a straighter back and tail and weaker wing action. Seen in scrubby areas, near reedbeds and on moors and uplands. The call of the male is unmistakable, while the female utters bubbling calls from time to time. Adult male is slaty-grey above and on the neck and breast, and heavily barred with black and white below. Legs and feet are yellow. Females are similar but browner with a buff breast band. Juveniles are browner still with a barred throat and white nape.

SIZE Length 32–34cm
NEST Makes no nest; lays eggs singly in nests of dunnock, reed warbler or meadow pipit
BREEDING Lays up to 9 eggs, which closely resemble those of host bird
FOOD Hairy caterpillars and large beetles
HABITAT Woodlands, scrub, reedbeds, moors and heaths
VOICE Male makes *cu-coo*, sometime *cu-cuc-coo*, female makes bubbling calls
DISTRIBUTION Common summer visitor to most of Britain and Ireland, declining in areas where host species are declining

OWLS

- ● *Excellent night vision* ● *Accurate hearing*
- ● *Powerful talons*

Barn owl

Tyto alba

Seen on the wing at a distance, barn owls appear to be all white, but at closer range the upperparts are seen to be a warm yellow-brown with a delicate patterning of grey and brown spots. The tail has darker brown bars. The facial disc is heart-shaped and pure white.

SIZE Length 33–35cm
NEST On ledge in barn or quiet open building, sometimes in hollow tree
BREEDING Lays 4–7 white rounded eggs in March–May
FOOD Small mammals, some birds and amphibians
HABITAT Farmland, lowland grasslands, open country with hedges and heathland
VOICE Screeching, hissing and snoring calls mostly heard in breeding season
DISTRIBUTION A widespread but scarce and declining species over most of Britain; found in many countries around the world

Long-eared owl

Asio otus

A slender owl with remarkable camouflage. Its soft, mottled brown plumage is slightly rufous on the upperparts and a little paler below, and most of the feathers have pale edges. When sitting motionless in dense cover it is almost impossible to see, even at close range. It may occasionally open an orange eye and give the game away but it is very reluctant to take flight, even when approached closely. The long 'ear tufts' are for display and are not connected with hearing; an anxious bird raises them, but when it is relaxed they are lowered. In flight the ear tufts are not visible.

SIZE Length 35–37cm
NEST Uses abandoned crow's nest
BREEDING Lays 3–5 white eggs in April–May
FOOD Small mammals, some birds
HABITAT Mixed woodlands and scrub with open areas
VOICE Usually silent, but makes low *oo* calls at night
DISTRIBUTION Scarce breeding bird in scattered localities in Britain and Ireland; absent from SW, parts of Wales and NW Scotland

Short-eared owl

Asio flammeus

The owl most likely to be encountered in daylight, often seen flying on relatively long wings over open moorland, and sometimes in exciting display flight over nesting sites. When perched it adopts a horizontal posture; the eyes are bright yellow and the short ear tufts are usually held close to the head and are not often visible. The background colour of the plumage is warm yellowish-buff but it is heavily streaked with black on the upperparts, less so on the underside. The facial disc is striking with a pale border, buff cheeks and white crescents in the centre.

SIZE Length 37–39cm
NEST Shallow dip on rough ground with some lining, usually with overhanging vegetation
BREEDING Lays 4–8 white rounded eggs in April–May
FOOD Mostly small mammals, but some birds at times
HABITAT Open grasslands, moorlands and conifer plantations; coastal grasslands in winter
VOICE Hissing calls at nest, and occasional *hoo hoo hoo* calls
DISTRIBUTION Widespread but scarce breeding bird across northern and eastern Britain, very rare in Ireland; migrates south in winter, many found on south coast

Tawny owl

Strix aluco

The commonest owl is familiar through its hooting call; although primarily a woodland bird it can be found in most habitats where there are trees for nesting and small mammals to feed on. During the day tawny owls roost quietly in trees; if spotted, they look mostly mottled brown with a large head, a brown facial disc and no ear tufts. The eyes are black and have grey patches of feathers between them and the ivory-coloured beak. The rich brown wings have white lines along the scapulars. Juveniles newly emerged from the nest are grey and finely barred with darker lines.

SIZE Length 37–39cm
NEST Hole in tree, sometimes old bird's nest; will also use nesting boxes
BREEDING Lays 2–5 round white eggs in April–May
FOOD Small mammals, birds, amphibians, large insects and earthworms
HABITAT Woodlands, parks and large wooded gardens
VOICE Melodious hooting *huit-hoouu* and a shrill *ke-wick*
DISTRIBUTION Widespread across most of Britain; absent from Ireland and outer isles

Little owl

Athene noctua

A small, mottled, brown-grey owl with long white-feathered legs and staring yellow and black eyes. The upperparts are flecked with white spots which are finer on the head, and the tail has four grey-brown bars. The underparts are paler with brownish streaks on a pale background. Juveniles are similar to adults but paler overall. May be seen perched on low wall or stump near nest, and if alarmed flies low with woodpecker-like swoops. The spots on the wings and back form a pattern of broken lines.

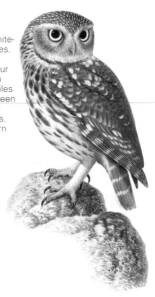

SIZE Length 21–23cm
NEST Hole in tree or stone wall, may use buildings
BREEDING Lays 2–5 white eggs in April–May
FOOD Large insects, especially beetles; some small mammals and birds
HABITAT Lowland farmland, moorland edges and open wooded country
VOICE Whistling calls, sometimes like lapwing or mewing cat
DISTRIBUTION Widespread breeding bird over most of England and Wales apart from far west; absent from Ireland and most of Scotland

NIGHTJAR

- ● *Superb camouflage on ground* ● *Feeds on wing at night*
- ● *Nocturnal calls*

Nightjar

Caprimulgus caprimulgus

A very secretive nocturnal bird of heaths and dry moorland. During the day it will sit tight on the ground, its dark brown, mottled plumage with finer grey and black patterning blending perfectly with a background of bare soil and dry leaves. At night it flies in search of insects such as moths, when it resembles a long-winged cuckoo. The wings are dark rufous brown and have white patches near the tip in males, buff patches in females. The long tail has dark bars, and there is a white 'moustache' on the head. The bill is very short, but the gape is enormous to help catch flying insects.

SIZE Length 26–28cm
NEST Shallow scrape on bare ground
BREEDING Lays 2 cream-coloured eggs with darker blotches in May
FOOD Night-flying insects, especially moths and beetles
HABITAT Lowland heaths, young conifer plantations and dry moorland
VOICE Persistent *churrrrr* and *kwa-ek* alarm calls
DISTRIBUTION Widespread summer visitor in small numbers across much of southern Britain in suitable habitats; very rare in Ireland

SWIFT

- ● *Spends most time in the air of all birds* ● *Most rapid flight*
- ● *Collects nest material on the wing*

Swift

Apus apus

Easily recognised by the essentially all dark plumage and long, narrow wings held swept-back in horseshoe-like outline. Even when beating wings in rapid, low-level flight, wings are always held stiffly and not folded. Looks short-headed and relatively long-tailed in flight; forked tail is often held closed. Adult plumage is very dark brown but usually appears black especially when seen against the light. Good views reveal pale throat. Juvenile similar to adult but tail shorter and feathers on upperparts have pale margins; these features seldom apparent except in grounded birds.

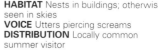

SIZE Length 16–17cm
NEST Cup-shaped construction of feathers and plant material held together with saliva and placed on level surface in loft space
BREEDING Lays 2–3 eggs, mainly June
FOOD Aerial insects
HABITAT Nests in buildings; otherwise seen in skies
VOICE Utters piercing screams
DISTRIBUTION Locally common summer visitor

KINGFISHER
- Bright-coloured plumage ● Nests in holes
- Dives from low perches

Kingfisher
Alcedo atthis

A small bird with a disproportionately large head and bill, short legs and a short tail. Its ungainly shape is ideal for diving and making short bursts of rapid flight. The whole of the upperparts are bright blue of varying shades; the wings are turquoise with pale blue spotting. The face, underparts and underwing coverts are orange-chestnut and the chin is white. There are white spots in front of the eye and on the neck. The bill is all-black in males, but has a red lower mandible in females. Often first noticed by shrill whistle as it darts along a river, looking mainly blue. If perched, orange is the main colour seen.

SIZE Length 16–17cm
NEST Long tunnel in high river bank, preferably of clay or sand
BREEDING Lays 6–7 round white eggs in March–May

FOOD Mostly fish, but some large aquatic insect larvae
HABITAT Nearly always on clear freshwater rivers, lakes and streams; may move to coasts in freezing conditions
VOICE Variety of whistling calls; hissing sounds from young in nest burrow
DISTRIBUTION Widespread breeding bird across most of Britain and Ireland, but absent from northern Scotland and outer isles

WOODPECKERS
- Long sticky tongues ● Harsh calls
- Stiff tails help support them on tree trunks

Green woodpecker
Picus viridis

A large woodpecker with predominantly green and yellow upperparts. When seen feeding on the ground the upperparts appear mostly green, but in flight the rump and lower back are bright yellow. The primary flight feathers are dark brown with cream spotting and the tail is greenish-grey with paler spots. The bright red crown extends down the back of the neck and the black moustachial stripes of the male have a red streak in the centre, although this is very hard to see at a distance. Juveniles are a dull version of the adults with more mottled upperparts and barred underparts.

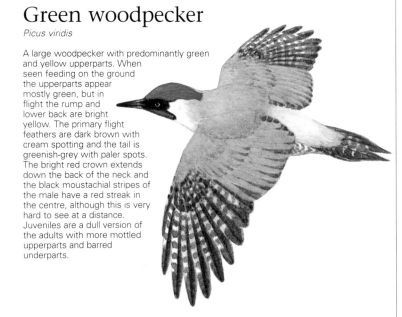

SIZE Length 31–33cm
NEST Hole excavated high up in tree
BREEDING Lays 5–7 white eggs in April–May.
FOOD Mostly ants taken from the ground and in ant hills, sometimes fruits and seeds

HABITAT Open deciduous woodland with clearings, large gardens, parks and heathlands
VOICE A ringing, laugh-like call called a yaffle, plus some shrill alarm calls
DISTRIBUTION A widespread breeding bird across most of England, Wales and southern Scotland, but absent from Ireland

Great spotted woodpecker
Dendrocopus major

A medium-sized, predominantly black and white woodpecker, but with a crimson nape in the male and rosy-tinted undertail and 'trousers'. The black upperparts are broken by two large white patches on the shoulders, white barring on the primaries and white areas on the neck and face. Females are very similar but lack the crimson nape patch. Juveniles have a red crown, grubby white underparts and more diffuse white barring on the wings. An active bird, which often perches on the topmost branches of tree giving its loud *tchicc* alarm call.

SIZE Length 22–23cm
NEST Hole excavated in tree
BREEDING Lays 4–7 round white eggs in April–May
FOOD Insect larvae excavated from trees, some fruits and seeds, eggs and chicks of tree-nesting birds; visits bird tables
HABITAT Mature deciduous woodlands, parks, large gardens and hedgerows with mature trees

VOICE Loud drumming for display, sharp *tchicc* alarm call
DISTRIBUTION Widespread breeding bird across most of Britain, but absent from Ireland and outer isles

Lesser spotted woodpecker
Dendrocopus minor

Our smallest woodpecker, about the same size as a house sparrow, and appearing all black and white at a distance. The back and wings are black and barred with white, but lack the broad white patches seen in the great spotted. The crown is red in the male and white in the female, and the undertail coverts are white with black spots in both sexes. Juveniles resemble adults, but have more streaked, less intensely white underparts. A secretive bird, hard to find in the tree canopy, but sometimes noticed in spring by its call, reminiscent of a distant sparrowhawk, or its quiet, high-pitched drumming.

SIZE Length 14–15cm
NEST Hole in tree, sometimes on underside of branch
BREEDING Lays 4–6 white eggs in April–May
FOOD Insect larvae pecked out of rotting wood
HABITAT Open deciduous woodland, parkland, orchards, large gardens, riverside alders and willows

VOICE Quiet whistling and persistent *pee pee pee*
DISTRIBUTION A scarce breeding bird across most of England and Wales, but very rare in some areas; absent from Scotland and Ireland

Wryneck
Jynx torquilla

A very secretive and remarkably well-camouflaged woodpecker, and now almost extinct in Britain, seen in small numbers while on migration flight. The mottled grey and brown upperparts with their delicate patterning help the wryneck blend with the bark of old trees and stony ground, where it prefers to feed. When seen perched the underparts look yellowish with dark bars on the throat, and arrow-shaped markings on the flanks. Juveniles are slightly paler than adults and with fewer bars and spots on the plumage.

SIZE Length 16–17cm
NEST Hole in tree or stone wall
BREEDING Lays 7–10 white eggs in May–June
FOOD Mostly ants, plus other small insects; occasionally takes berries
HABITAT Dry open woodlands, orchards, mature gardens and parks
VOICE Falcon-like, high-pitched *pee pee pee*

DISTRIBUTION One or two pairs may breed in Scotland, otherwise only a scarce passage migrant at coastal sites in spring and autumn

LARKS

- Feed on the ground ● Pointed, slender bills
- Attractive songs

Shore lark

Eremophila alpestris

Normally seen in Britain in winter when adults have brown upperparts with darker mottlings, a dark tail with white outer feathers, a pale underside with darker streaks on the flanks and a black bill and legs. The most striking features are the yellow face, black moustachial stripes and black chest band; in summer plumage these are very bold and there are two black tufts on the head giving this bird its alternative name of 'horned lark'. Females are duller versions of the male with darker streaks; juveniles are similar but without the face pattern. In flight, the underwings look pale, but the chest band is very prominent. May mix with other larks and pipits when it appears to have a more crouching posture.

SIZE Length 14–17cm
NEST Depression on ground under overhanging plant or rock
BREEDING Lays 2–4 whitish eggs with pale brown spots in April–June
FOOD Seeds and insects in summer; mostly seeds in winter

HABITAT Breeds on Arctic tundra and mountain plateaux; overwinters on coasts
VOICE Quiet musical warblings
DISTRIBUTION Winter visitor to North Sea coasts, sometimes in large flocks

Woodlark

Lullula arborea

A small compact lark with a very small crest. The upperparts are dark buff with heavy blackish streaks, the underparts pale buff with brownish streaks on the chest and flanks. There is a black and white wingbar just visible in perched birds, but more obvious in flight. The facial markings are more striking with a bold white supercilium meeting at the back of the neck, and brown cheeks. The sexes are very similar, but juveniles lack the bold facial markings. Flying birds appear to have a very short tail and rounded wings. Uses isolated trees as perches to sing its lilting song, but will also sing in descending flight.

SIZE Length 15cm
NEST Deep cup lined with vegetation in shelter of bush
BREEDING Lays 3–5 olive eggs with darker spots at one end in April–May
FOOD Insects in summer, seeds and small fruits at other times
HABITAT Lowland heaths and young conifer plantations
VOICE A melodious falling series of fluty notes

DISTRIBUTION Mainly confined to southern England where suitable habitats exist

Skylark

Alauda arvensis

The loud, persistent warbling flight song, delivered from high in the sky on fluttering wings, is how most skylarks are detected. On the ground, where they are less obvious and usually silent, skylarks look mostly buff with darker streaks on the upperparts and chest, and white below. There is a pale buff supercilium and border to the darker buff cheeks and a crest which is only visible when birds are alarmed. In flight skylarks look pale below and plain buff above with a thin white border to the plain tail. Juveniles are more speckled above with darker markings on the chest.

SIZE Length 18–19cm
NEST Shallow depression with grass lining in thicker vegetation
BREEDING Lays 3–5 greyish eggs with brown speckles in April–May
FOOD Insects in summer; seeds, small fruits and plant material at other times

HABITAT Open grasslands, rough farmland and mountain slopes
VOICE Loud warbling flight song; rich *chirrupp* contact notes
DISTRIBUTION A widespread and common breeding bird across Britain and Ireland

SWALLOWS AND MARTINS

- Catch food on the wing ● Colonial nesters
- Summer visitors

Swallow

Hirundo rustica

Familiar and welcome harbinger of spring. Often perches in pairs on wires in spring or gathers in large flocks in autumn. Sometimes congregates in considerable numbers to feed where flying insects are abundant. Adult has essentially dark blue upperparts; flight feathers are black. Tail feathers black with white subterminal white patches; outer feathers form streamers which are longer in male than female. Forehead and throat red and underparts white. Juvenile similar to adult but colours on face usually subdued and tail appreciably shorter.

SIZE Length 17-19cm
NEST Cup-shaped structure of mud and straw sited on ledge
BREEDING Lays 4–5 eggs, mainly June–July and often 2 broods
FOOD Aerial insects
HABITAT Farmland, marshes and meadows

VOICE Utters twittering, warbling song
DISTRIBUTION Common summer visitor throughout Britain

Sand martin

Riparia riparia

Widespread and familiar summer visitor. Adult is easily recognised by its uniformly sandy-brown upperparts and rather triangular-shaped wings. Underparts are white except for dark chest band, underwings and tail. Juvenile similar to adult but close view reveals that feathers on upperparts have pale margins giving scaly appearance.

SIZE Length 12cm
NEST In tunnel excavated in sand bank; breeds colonially
BREEDING Lays 4–6 eggs, mainly May-June, often attempting a second brood
FOOD Aerial insects
HABITAT Breeding colonies in sandy banks; often feeds over water
VOICE Quiet, twittering song and grating call
DISTRIBUTION Locally common summer visitor throughout Britain

House martin

Delichon urbica

Familiar and easily recognised summer visitor. Usually welcomed where it favours houses by nesting under the eaves. Sometimes nests in loose colonies and birds often seen sitting on nearby wires or circling overhead. Adult has mainly dark blue upperparts contrasting with pure white rump. Underparts white. Tail is slightly forked. Juvenile similar to adult but underparts often appear rather grubby.

SIZE Length 12.5cm
NEST Cup-shaped mud nest built under house eaves
BREEDING Lays 3–5 eggs, mainly May-June, sometimes with a second brood
FOOD Aerial insects
HABITAT Nests on buildings; often feeds over water
VOICE Utters quiet, twittering song
DISTRIBUTION Locally common summer visitor

PIPITS
● *Distinctive calls*
● *Insect feeders* ● *Slender bodies*

Tree pipit
Anthus trivialis

Probably best identified by its song flight, the tree pipit resembles other small pipits in having mostly buff upperparts and paler streaked underparts. The colours are warmer than in the other common pipits and the paler parts, such as the supercilium, have a yellow rather than a white tinge. The closed wing has a fairly distinct pattern due to the yellowish margins to the dark feathers. The legs and feet are flesh-pink and tree pipits usually sit in a more upright posture than the other species. Tree pipits use tree-top perches from which to launch themselves into their conspicuous song flight.

SIZE Length 15cm
NEST Shallow grassy cup with lining of fine mosses on ground
BREEDING Lays 2–6 variably marked and coloured eggs in May–June
FOOD Mostly insects; some seeds in winter

HABITAT Open, shrubby country, heaths, forest edges and young plantations
VOICE Loud, rich descending call with many churring and whistling notes
DISTRIBUTION A widespread breeding bird across mainland Britain, very rare in Ireland; migrates south in winter

Meadow pipit
Anthus pratensis

The upperparts are mostly greenish-olive or buff-brown with darker streaks on the crown and back; in flight there may be a pale bar visible on the upperwings, and the unstreaked olive-brown rump will show clearly. The underparts are pale olive on the chest grading to white below the tail, with dark spots and streaks fading towards the vent area. The legs are pinkish-buff and the bill is grey. Juveniles have darker streaking on the upperparts and warmer buff colours below.

SIZE Length 15cm
NEST Grassy cup lined with animal hair under overhanging plants
BREEDING Lays 3–5 variable eggs, mostly greyish background with darker spots, in March–May
FOOD Mainly small invertebrates, some seeds in winter

HABITAT Open, grassy areas, moorlands and tundra
VOICE Thin *tsip* calls and a quiet whistling song with descending notes
DISTRIBUTION A widespread and common resident across most of Britain and Ireland

Rock pipit
Anthus spinoletta

Larger and darker overall than the meadow pipit; mostly dark olive-grey upperparts with blackish streaks. The underparts are pale grey-buff with darker streaks, sometimes very heavily marked on the chest. The pale supercilium and pale grey wingbars show well on darker birds. The bill is dark greyish-brown and the legs are blackish-brown, all helping create the impression of a darker and heavier bird than the meadow pipit. Juveniles resemble adults but are more mottled above.

SIZE Length 16–17cm
NEST Cup of vegetation, hidden in hole or under overhang
BREEDING Lays 4–6 greyish eggs marked with darker spots in April–May
FOOD Mainly insects, often found on strandline seaweed; some seeds in winter
HABITAT Rocky coasts; may move to saltmarshes and estuaries in winter

VOICE Loud song uttered in conspicuous display flight; loud *tsup* contact note
DISTRIBUTION Breeds on most of coastline apart from eastern England

WAGTAILS
● *Long tails* ● *Bobbing habits*
● *Insect feeders*

Pied wagtail
Motacilla alba yarellii

Adult males have black upperparts, apart from white face and cheeks, white outer tail feathers and white wing patches. The underparts are mostly white. Females resemble males, but have dark grey rather than black backs and juveniles have a brown tinge to the whole plumage. In winter the black throat is just a narrow breast band.

SIZE Length 18cm
NEST Cup of vegetation lined with moss and hair, hidden in crevice
BREEDING Lays 5–6 white eggs with brown speckles in March–May
FOOD Small invertebrates
HABITAT Wide range of habitats,

especially watersides, farmyards, roadsides and open country; often close to human habitation
VOICE A sharp *chissik* and a quiet warbling song
DISTRIBUTION Widespread and common breeding bird in all regions

Grey wagtail
Motacilla cinerea

A colourful and conspicuous waterside bird with a lemon-yellow underside and yellow rump. Upperparts are mostly grey, with black flight feathers and a long, white-edged, black tail. Breeding male's throat is black and there is a thin white supercilium and moustachial stripe. Females and winter males lack the black throat. Juveniles are similar to non-breeding adults but with buff feather-fringes on the wing feathers. Often seen near running water, constantly bobbing the tail.

SIZE Length 18–19cm
NEST Grassy cup with moss lining in hole or crevice close to water
BREEDING Lays 4–6 creamy-buff eggs with grey markings in April–May
FOOD Invertebrates, sometimes aquatic larvae and tadpoles
HABITAT Rocky or man-made structures

near running freshwater, bridges and weirs
VOICE A sharp *tchee* contact note, and a rapid warbling song
DISTRIBUTION A widespread breeding bird in suitable habitats over most of mainland Britain and Ireland; scarce or absent in eastern England

Yellow wagtail
Motacilla flava

A widespread species across Europe showing great variation in head markings in males. The British race, 'flavissima', is all-yellow below and olive-yellow above with darker flight feathers barred with white. The tail is dark olive-grey with pale margins, and the legs and bill are black. Occasionally, Continental birds of different races appear with slaty-blue or black heads. Females are duller yellow than males with paler throats. Females of the different races are very difficult to separate. Juveniles are very similar to females but browner with a broken dark bib.

SIZE Length 17cm
NEST Grassy cup in hollow on open grassy ground
BREEDING Lays 4–6 whitish eggs with brown spots in April–May
FOOD Small invertebrates

HABITAT Lowland marshes and wet grassland areas
VOICE A sharp *pseep* call and a thin warbling song
DISTRIBUTION A summer visitor to suitable habitats in England; very scarce in northern and western Britain

Waxwing
Bombycilla garrulus

Upperparts are warm grey-buff on the mantle and plain grey on the tail, underparts are a rich pinkish-buff. The undertail coverts are a richer pink-orange and there are bands of yellow on the tail and wings, plus the bright red 'sealing wax' spots on the wing. The head has a large crest with a bold black bib and eye stripe. Females are very similar to males, with slightly less striking markings; juveniles are duller still, with slightly streaked underparts and no black bib.

SIZE Length 18cm
NEST Twiggy nest with moss and lichen lining
BREEDING Lays 5–6 blue-grey speckled eggs in April–June
FOOD Insects in summer, berries and fruits in winter
HABITAT Northern conifer forests in Scandinavia and Russia; moves into towns and gardens in winter

VOICE Quiet twittering calls, usually silent
DISTRIBUTION A winter visitor to towns and gardens in Britain, more common in east; abundant in some winters, scarce in others

SHRIKES
● *Powerful beaks* ● *Strong claws*
● *Harsh calls*

Red-backed shrike
Lanius collurio

A small bird with hawk-like habits; its usual hunting posture is to sit high on a prominent bush until prey is spotted and then dive on to it, sweeping back to the perch with the prey in its bill. Sometimes the prey is impaled on thorns for storage, or to hold it whilst it is being eaten. The male is a colourful bird with a rich chestnut back, blue-grey crown, nape and rump, and a black tail with white outer tail feathers. The underparts are mostly pale pinkish-buff. The head is very striking with a strong black mask and white throat. Females are rufous-brown above with a reddish tail and a scaly underside. Both sexes have a strong black bill. Juveniles are mostly brown above and pale below with a scaly appearance.

SIZE Length 17cm
NEST Cup-shaped, made of leaves and grasses secured in bush
BREEDING Lays 3–7 pale eggs with many spots and blotches in May–June
FOOD Mainly large insects; some small birds, mammals and lizards
HABITAT Open, bushy areas, heaths and dunes
VOICE Harsh *chack chack* calls and quiet mimetic song
DISTRIBUTION Very rare, possibly extinct breeding bird in England, otherwise scarce passage migrant in summer

Great grey shrike
Lanius excubitor

A habit of perching in the open on top of bushes or overhead wires makes this shrike easy to locate. From a distance looks black and white, but upperparts are grey, underparts are pure white and face mask, wings and tail are black. In flight, white wingbars are seen, and at close range white supercilium is more obvious. Females have faint brown barring on the chest in winter; juveniles a light brown wash on the paler areas with indistinct brown chest bars. The flight is low and undulating, ending in a swoop up on to the perch. Territories are maintained in winter, and impaled mammals and small birds may be found on a favourite bush.

SIZE Length 24–25cm
NEST Large nest of twigs and leaves high up in tree
BREEDING Lays 4–7 variably marked and coloured eggs in May–June
FOOD Small birds, mammals, reptiles and large insects
HABITAT Open country with scattered trees and shrubs
VOICE Harsh *scheck scheck* calls and quiet, mimetic song
DISTRIBUTION Scarce winter visitor to regular haunts over large areas of Britain

STARLING
● *Lives in large flocks* ● *Chattering calls*
● *Glossy plumage*

Starling
Sturnus vulgaris

A garrulous, noisy bird, familiar to both town- and country-dwellers. Winter plumage is glossy black with buff feather-edges giving a spotted appearance; the bill is grey-brown with a yellow base. In summer the bill becomes yellow and has a blue base, and the plumage looks more iridescent and richly coloured; the buff feather-edges wear away, leaving the bird looking far less spotted. Females have spots all year and are less glossy. Juveniles newly emerged from the nest are a greyish-brown, gradually developing the spotted plumage through autumn and winter.

SIZE Length 25cm
NEST Large untidy nest in tree hole, rock crevice or nest box
BREEDING Lays 5–7 pale blue eggs in March–May
FOOD Insects, soil invertebrates, seeds, fruits and scraps
HABITAT Wide range of habitats, including city centres; avoids high mountains
VOICE Lively mimetic song with whistling notes and many harsh calls
DISTRIBUTION A very widespread and common breeding bird across whole of Britain and Ireland

ORIOLE
● *Male has colourful plumage*
● *Male has melodious calls*

Golden oriole
Oriolus oriolus

Adult male is a stunning bird with duster-yellow head and body and black wings and tail. Bill is dark pink, legs are black and there is a black eye patch. Females, similar in size and shape, are yellowish-green with darker greenish-brown wings and tail. Juveniles resemble females but have brown eyes and grey bill.

SIZE Length 24cm
NEST Elaborate woven cup, suspended from fork in a tree
BREEDING Lays 3–4 white eggs with black spots in May–June
FOOD Insects; berries and fruits in autumn
HABITAT Open woods, with tall, well-spaced trees, large gardens and parks
VOICE Cat-like alarm squeals and melodious, rolling song, best heard at dawn
DISTRIBUTION A scarce summer visitor to eastern England where several pairs breed; others may turn up on coasts on migration

DUNNOCK
● *Secretive habits* ● *Use song perch in spring*
● *Complex breeding and courtship habits*

Dunnock
Prunella modularis

Adults have warm brown upperparts with darker brown streaks; face, throat and upper chest are slate-grey blending into a whitish belly with streaked flanks. Eye is red-brown and bill is mostly black. Sexes similar, but juveniles are more streaked.

SIZE Length 15cm
NEST Well-built cup of leaves and grass with fine lining, concealed in thicket
BREEDING Lays 4–6 blue eggs with red spots in March–May
FOOD Small invertebrates; seeds in winter
HABITAT Scrub, woodland edges, hedgerows, parks and large gardens
VOICE Sharp *tchik* contact notes, and a short warbling song
DISTRIBUTION Common breeding bird in most of Britain and Ireland

WREN
● *Secretive habits* ● *Loud rapid call*
● *Cocked tail*

Wren
Troglodytes troglodytes

A very small, compact bird with a short tail, sometimes held cocked upwards. Adults have rufous-brown upperparts and paler buff-brown underparts, with darker barring all over the body apart from the throat. There is a pale supercilium and lighter barring on the wings. The bill is long and slightly downcurved.

SIZE Length 9–10cm
NEST Domed structure of leaves lined with fine moss and feathers
BREEDING Lays 5–8 white eggs with speckles at one end in March–May
FOOD Small insects and spiders; some tiny seeds and fruits in winter
HABITAT Scrub, woodland edges, parks, gardens, hedgerows and streamsides
VOICE Loud, rapidly trilling song; sharper, scolding contact notes
DISTRIBUTION Common and widespread breeding bird in Britain and Ireland

DIPPER
● *Bobbing movements* ● *'Walks' under water*
● *Compact body*

Dipper
Cinclus cinclus

Adults have a dark brown head and neck, with remainder of upperparts being dark slaty-grey with darker feather-margins. Underparts are mostly white, but with some darker mottlings. Juveniles are very similar but without the dark head.

SIZE Length 18cm
NEST Domed structure of moss and leaves in crevice on river bank
BREEDING Lays 4–5 white eggs in April–May
FOOD Aquatic invertebrates taken from underwater; some small fish and worms
HABITAT Fast-flowing rivers with rocks, usually in upland areas
VOICE Harsh *tzitt* alarm calls, and a melodious, but quiet, warbling, barely audible over running water
DISTRIBUTION Widespread but declining species in suitable habitats in Britain and Ireland; absent from southern and eastern England

WARBLERS AND CRESTS
- Small size ● Insect feeders
- Slender, pointed bills

Grasshopper warbler

Locustella naevia

A small, secretive warbler, normally only detected when making its grasshopper-like, persistent call. Upperparts are olive-brown with spots and streaks of darker brown. At close range wings look darker and have buff fringes to the feathers, giving a slightly scaly appearance.

SIZE Length 12–15cm
NEST Cup-shaped structure of leaves with fine hair and grass lining, well concealed in thick vegetation
BREEDING Lays 6 white eggs with dark speckles in May–June
FOOD Mostly insects
HABITAT Dense undergrowth; often in marshy areas, thick hedges and young plantations
VOICE Short *pitt* contact notes, and a high-pitched, persistent trill, inaudible to some people
DISTRIBUTION A summer visitor to most of Britain and Ireland

Reed warbler

Acrocephalus scirpaceus

A very plain brownish warbler, usually concealed in dense reed beds but easy to locate by its prolonged chattering song. Adults are uniformly olive-brown above, with a slightly more rufous rump and darker flight feathers. The underparts are white, grading to buff under the tail and on flanks, and there is a faint off-white supercilium. The bill is dark with a pale base and the legs are greyish. The sexes are similar, but juveniles are brighter and more rufous than adults. This is a very agile bird, able to move freely through dense reed stems.

SIZE Length 13cm
NEST Deep cup of woven stems suspended from reed stems
BREEDING Lays 4 pale green, mottled eggs in May–June
FOOD Insects and spiders, sometimes other tiny invertebrates
HABITAT Reedbeds and adjacent dense vegetation
VOICE Harsh *churr churr* alarm calls, and a guttural, chattering song with long phrases
DISTRIBUTION A summer visitor to reedbeds in England and Wales, mainly in SE; very rare elsewhere

Marsh warbler

Acrocephalus palustris

A very similar bird in appearance to reed warbler, but at close range looks more compact and heavier with a shorter bill and rounded head. The overall impression is of an olive-brown, rather than rufous bird, and if observed in reeds it is far less agile when moving around. Best separated by song which is more musical and mimetic. More likely to occur in willows and other dense waterside vegetation than in reed beds. The sexes are alike and juveniles are difficult to separate from adults in the field.

SIZE Length 13cm
NEST Untidy cup-like arrangement of plant materials secured to plant stems
BREEDING Lays 4–5 pale green or blue eggs with darker spots in April–May
FOOD Insects and spiders; may take small snails and berries
HABITAT Dense, low riverside vegetation, withy beds
VOICE Loud *tchuc* and *chirr* alarm calls, melodious song with much mimicry
DISTRIBUTION A rare summer visitor to a few localities in SE England; occasionally singles occur elsewhere

Sedge warbler

Acrocephalus schoenobaenus

More strikingly marked than other warblers, the adult sedge warbler has a black-streaked crown and prominent white supercilium. The throat is white, contrasting with the darker cheeks, and singing birds show a red gape inside the dark bill. The rest of the upperparts are olive-brown with darker streaks grading into a plain brown rump. The underparts are white grading into more rufous flanks. Sedge warblers are more inclined to sing from open perches and will respond to calls of intruders very readily. The sexes are alike, but juveniles are yellower below with brown spots across the breast.

SIZE Length 13cm
NEST Untidy cup of grasses and leaves with soft lining, low down in dense vegetation
BREEDING Lays 5–6 greenish, heavily speckled eggs in April–May
FOOD Mainly insects and spiders
HABITAT Reedbeds, waterside scrub and other low, dense vegetation
VOICE Sharp *tuc* calls and long and varied song with alternating harsh and musical notes
DISTRIBUTION A summer visitor to most of Britain and Ireland

Cetti's warbler

Cettia cetti

A distinctive warbler when seen, but it usually remains in dense cover. Its explosive burst of song is the best way to locate and identify this species; this can be heard at any time of year. Adults are chestnut-brown above and mostly white below with a pale grey supercilium. The large tail has white tips to the undertail coverts which are visible when the tail is flicked. The sexes are similar, but males are larger than females. Juveniles closely resemble adults.

SIZE Length 13–15cm
NEST Cup-shaped nest of fine grasses with untidy outer layer
BREEDING Lays 4 bright red or chestnut eggs in March–May
FOOD Mainly insects and spiders, some small worms and larvae
HABITAT Dense scrub near water
VOICE Sharp *chip* alarm calls, and explosive snatch of loud song
DISTRIBUTION Resident in small numbers in wet areas in southern England and Wales

Willow warbler

Phylloscopus trochilus

A slim, delicate warbler with plain olive-green upperparts and yellowish-white underparts. Yellow supercilium and the chin is white or very pale yellow. The bill is brown and the legs are orange-brown. As summer progresses adults become browner above and whiter below through feather abrasion. Juveniles are much yellower than adults. May be seen hovering briefly to catch insects, otherwise keeps to shrubby areas searching for insects on leaves.

SIZE Length 10.5–11.5cm
NEST Grass cup with domed top, on ground in dense vegetation
BREEDING Lays 6–8 white, finely speckled eggs in April–May
FOOD Mainly small insects taken from leaves
HABITAT Open shrubby habitats, copses and hedgerows
VOICE Descending, musical song of whistling notes, mournful *hoo-eet* calls
DISTRIBUTION A very common summer visitor to most of Britain and Ireland

Chiffchaff

Phylloscopus collybita

Similar to the willow warbler, but easily separated by the *chiff chaff* sound of their song. Adults are dull brownish-olive above with pale yellow below merging into buff on the flanks, and there is a very pale supercilium. The dark legs help separate chiffchaff from willow warbler. The sexes are similar and juveniles resemble adults but are a little browner above with warmer yellow underparts. Migrant chiffchaffs from eastern Europe are much greyer than western birds.

SIZE Length 10–11cm
NEST Domed cup of grasses with fine lining, just above ground level in dense cover
BREEDING Lays 5–6 white, lightly spotted eggs in March–May
FOOD Small insects and spiders
HABITAT Open woodlands, copses and hedgerows
VOICE Persistent *hweet hweet* calls and *chiff chaff chiff* song
DISTRIBUTION A common summer visitor to most of Britain and Ireland, but less common in northern Scotland; small numbers overwinter in southern England

Wood warbler

Phylloscopus sibilatrix

A brightly coloured warbler with yellowish-green upperparts, a bright yellow supercilium, throat and upper chest and gleaming white underparts. The tail and wings are browner with yellowish feather-margins. The bill has a dark upper mandible and the legs are pale yellowish-brown. Juveniles resemble adults. The distinctive song, likened to a small coin spinning on a plate, is delivered from a high perch; males make wing-quivering displays on territory.

SIZE Length 12cm
NEST Domed cup of grasses and leaves on open ground in woods
BREEDING Lays 6–7 white, densely spotted eggs in May–June
FOOD Insects, larvae and spiders; some berries in autumn
HABITAT Open woods in hilly country, especially of beech and oak
VOICE *Pew pew* call notes and trilling song
DISTRIBUTION Summer visitor to woods mainly in northern and western Britain, very rare in Ireland

Goldcrest

Regulus regulus

The smallest European bird, with a tiny bill, short legs and wings, and a rounded, compact body. The upperparts are dull olive-green with darker flight feathers and two white wingbars. The underparts are very pale olive-green. The male has an orange-yellow crown with a black edging, but this is sometimes hard to see in the field unless it is raised in alarm. Females have a yellow centre to the crown. Juveniles are similar, but lack the crown markings. Feeding birds are sometimes very confiding, ignoring human observers.

SIZE Length 9cm
NEST Tiny platform of moss, lichens and cobwebs near end of conifer twig
BREEDING Lays 7–10 white, finely speckled eggs in March–May
FOOD Tiny insects, such as aphids
HABITAT Coniferous woods in breeding season; disperses widely in winter

VOICE High-pitched *tseee* calls and rhythmic trilling song, beyond range of hearing of some people
DISTRIBUTION A common and widespread resident across most of Britain and Ireland

Firecrest

Regulus ignicapillus

More brightly coloured than the very similar goldcrest with a boldly striped head. The golden-orange crown stripe is bordered with black; this contrasts with the broad white supercilium and thin black eye-stripe. The upperparts are a bright olive-green with bronze patches on the side of the neck, and the tail is a darker olive-brown. The underparts are a clean white. Juveniles are similar to adults, but lack the bright crown; they usually attain adult plumage early in the autumn.

SIZE Length 9cm
NEST Cup of mosses and lichens suspended beneath twig at end of branch
BREEDING Lays 7–11 pale buff eggs marked with red dots in March–May
FOOD Tiny insects, spiders and springtails
HABITAT Woodlands, gardens, heathland and scrub

VOICE High pitched *zit zit* calls, lower-pitched than goldcrest, song very rapid and shrill
DISTRIBUTION Mainly a winter visitor to southern England, with a scattering of breeding records in the SE

Dartford warbler

Sylvia undata

Normally a very secretive bird, keeping itself hidden in dense scrub, but males will display on sunny mornings by sitting on top of bushes with the long dark grey tail cocked up whilst they utter their scratchy, chattering song. Adult male is dark, grey-brown above with a slaty-grey head, dark brown wings, and rich red underparts. Early in the breeding season the throat has white spots, but these are lost by mid-summer; the orange-red eye-ring is present in all plumages. Females and juveniles similar to the male, but brown above and paler red below.

SIZE Length 12–15cm
NEST Cup of grass and soft materials, low down in dense bush
BREEDING Lays 4 white, lightly speckled eggs in April–May
FOOD Small invertebrates
HABITAT Heathlands and coastal scrub with dense scrub, especially gorse

VOICE Musical, chattering song, harsher *tuc* and *chirrr* alarm notes
DISTRIBUTION Resident in small numbers on heathlands in southern England, mainly Hampshire and Dorset

Whitethroat

Sylvia communis

A singing male is easy to recognise, attracting attention by its chattering song; it usually perches high on a bush, or makes short, fluttery display flights. The head and sides of the face are grey, but the throat is pure white, showing up well in singing birds. The upperparts are dull brown, contrasting with the pale buff breast and off-white underparts. The wings show a small rufous patch in good light. Females and juveniles are similar to males, but have less obvious white throat and browner upperparts.

SIZE Length 14cm
NEST Grassy cup with hair lining low down in thick vegetation
BREEDING Lays 4–5 pale greenish, finely speckled eggs in May–June
FOOD Mainly insects, but will take soft fruits in summer and autumn

HABITAT Open, shrubby habitats and bramble patches
VOICE Harsh *charr* scolding calls and a brief chattering song
DISTRIBUTION A common summer visitor to most of Britain and Ireland, commonest in east

Lesser whitethroat

Sylvia curruca

More secretive than the whitethroat, but betrays its presence with its churring song and harsh scolding calls. Adults are greyer than the whitethroat on the upperparts and whiter below, and there is no rufous panel on the wings. The head is grey and there is a diffuse black face mask above the white throat. In flight the primaries and tail feathers look browner than rest of upperparts. Male has bolder markings. Juveniles resemble females but are browner.

SIZE Length 12.5-13.5cm
NEST Cup-shaped structure of fine grasses, cobwebs and hairs, deep in thick cover
BREEDING Lays 4–6 white, lightly spotted eggs in May–June
FOOD Mostly insects and spiders, some small fruits and berries in summer

HABITAT Woodland edges, hedgerows and dense scrub patches
VOICE Harsh *tack* scolding calls and rattling song following a quiet warble
DISTRIBUTION A summer visitor to lowland habitats in England and Wales; scarce in the west and Scotland and absent from Ireland

Garden warbler

Sylvia borin

A plain-looking, medium-sized warbler with brown upperparts, darker on the wings, and pale buff underparts becoming white on the belly and undertail coverts. There is a pale eye-ring and the dark bill appears rather stout by comparison with other warblers. The sexes are very similar, but juveniles are a darker buff below and browner above. A persistent songster with a beautiful liquid song.

SIZE Length 14cm
NEST Cup of leaves and grass with fine lining low down in dense shrub
BREEDING Lays 4–5 off-white, speckled eggs in May–June
FOOD Mainly insects and spiders, but will take some small fruits and berries
HABITAT Open broad-leaved woodlands with thick undergrowth

VOICE Harsh *tac tac* scold notes, rich musical, warbling song
DISTRIBUTION Common summer visitor to Britain, scarce in Ireland

Blackcap

Sylvia atricapilla

Adult male easily recognised by neat black cap, ashy-brown upperparts and pale grey to white underparts. Females are similar, but have chestnut cap and browner upperparts. Juveniles resemble females but the cap is a dull brown. Rich song gives away presence, but may be confused with garden warbler; blackcap's is more varied, but sung in shorter snatches. Primarily a summer visitor, increasing numbers overwinter in gardens in southern Britain.

SIZE Length 13cm
NEST Neatly woven cup of fine grasses, cobwebs and hairs, hidden low down in bush
BREEDING Lays 5 off-white eggs with darker spots in May–June
FOOD Insects, plus fruits and berries in autumn and winter
HABITAT Open, mixed woodland and copses with undergrowth, large shrubby gardens
VOICE Loud *tac* contact notes and a rich warbling song
DISTRIBUTION A common summer visitor to most of Britain and Ireland, most abundant in the south

FLYCATCHERS
- *Catch insects in flight* • *Perch upright*
- *Most are summer visitors*

Spotted flycatcher
Muscicapa striata

Mostly plain grey-brown bird with pale underparts. At close range head is streaked with black; breast and flanks have dull brown streaks fading nearer the tail. Bill and legs are dull grey-brown. Juveniles are similar to adults but a warmer buff above with pale white spots, and spotted on underparts.

SIZE Length 13.5cm
NEST Deep cup of leaves, grasses and hair in tree fork or crevice
BREEDING Lays 4–5 pale blue, mottled eggs in May–June
FOOD Flying insects
HABITAT Woodland edges and clearings, orchards, parks and gardens

VOICE Short, scratchy song, *tzee-zuk-zuk* call notes
DISTRIBUTION A widespread but declining summer visitor to most of Britain and Ireland

Pied flycatcher
Ficedula hypoleuca

Breeding male is almost all-black above and white below with white forehead, white wing patches and white outer tail feathers. The female is a brown version of the male, but with smaller wing panels and no white forehead. Outside the breeding season male black areas are replaced by brown or grey. Juveniles are like non-breeding adults but have buff-coloured spots on the crown, mantle and breast.

SIZE Length 13cm
NEST Loose cup of grasses and leaves with soft lining in tree hole or nest box
BREEDING Lays 6–7 pale blue eggs in May–June
FOOD Flying insects, caterpillars and invertebrates on leaves
HABITAT Open deciduous woodlands, orchards and large gardens, mostly in hilly western areas

VOICE Rapid song of high notes, and sharp *whit* or *wee-tic* calls
DISTRIBUTION A summer visitor to western Britain; very rare in Ireland

CHATS
- *Often have upright posture* • *Sexes look different*
- *Feed on insects*

Stonechat
Saxicola torquata

Adult males are conspicuous as they sit upright, scolding noisily. The dark brown head and throat with its white neck patches contrast with the orange breast; this fades into greyish-white under the tail. Females are mottled brown above with buff underparts fading to white under tail.

SIZE Length 12.5cm
NEST Cup of leaves and grass with soft lining low down in dense vegetation
BREEDING Lays 4–6 pale, blue-green speckled eggs in April–May
FOOD Mostly invertebrates, seeds and tiny fruits in winter
HABITAT Dry, open scrubby areas, heaths, gorse-covered cliff-tops and young plantations

VOICE Sharp *tchack* calls and short scratchy song
DISTRIBUTION Widespread resident in most of western Britain and Ireland, scarce in lowlands in the east

Whinchat
Saxicola rubetra

Usually spotted perching upright on low bush or ant hill. Male has dark brown head with bold white supercilium, black cheeks and white moustachial stripes. The rest of the upperparts are dark brown with blackish streaks but the rump is paler and slightly rufous. Wings show a white bar contrasting with black panels. The underparts are warm orange fading to white under the tail. The female is a faded version of the male. Juveniles are an even more faded version of the female, with an indistinct face pattern.

SIZE Length 12.5cm
NEST Cup of leaves and grass with fine lining concealed on ground
BREEDING Lays 4–7 pale blue speckled eggs in May–June
FOOD Mostly small invertebrates, some seeds

HABITAT Open rough grassland and scrub, bracken slopes
VOICE Harsh *tzic* calls, varied tuneful and scratchy snatches of song
DISTRIBUTION A declining summer visitor to most of Britain and Ireland, scarce in the SE

Wheatear
Oenanthe oenanthe

Male wheatears are conspicuous birds as they perch on low mounds or fly low over the ground on uplands and cliff tops. The male's grey crown and back contrasts with the black mask and wings. In flight the rump and tail are white, but the tail is marked with an inverted black 'T'. The underparts are white but the chin and breast are pinkish-buff. Females are similarly marked but the dark areas are brown rather than black, and the paler areas have a warmer buff tone. In autumn, males lose the striking colours, looking more like females; juveniles have a scaly appearance and warmer buff tones.

SIZE Length 14.5–15.5cm
NEST Grassy cup with soft lining concealed in hole or rabbit burrow
BREEDING Lays 5–6 pale blue eggs in May–June
FOOD Mainly invertebrates collected from ground; some berries in autumn
HABITAT Open rough grassland, moorlands, cliff tops, dunes and mountain slopes

VOICE *weet chak chak* alarm calls and short warbling song
DISTRIBUTION A common summer visitor to most of western Britain and Ireland, common passage migrant on coasts in autumn

Redstart
Phoenicurus phoenicurus

In summer plumage the adult male looks orange-red below and grey above. At close range the grey head has a thin white forehead, and the face and throat are black. The flight feathers are dark blackish-brown and the tail and rump are a rich orange-red. The red on the belly fades to white below the tail. Females also have the rich tail colour, but the rest of the plumage is far duller than the male, and there is no black throat. Juveniles have the red tail, but are speckled buff and brown elsewhere.

SIZE Length 14cm
NEST Grassy cup with soft lining in tree hole or nest box
BREEDING Lays 5–7 pale blue eggs in May–June
FOOD Mainly insects, some small fruits in autumn

HABITAT Open deciduous woodlands, mostly in uplands
VOICE Mournful song with some *churring* notes and soft *tchuk* calls
DISTRIBUTION Common summer visitor to most of Britain, apart from SE; very rare in Ireland

Black redstart
Phoenicurus ochrurus

Adult male looks mostly black in summer; at close range wings are slightly browner with white panels. The rump and tail are rich chestnut, the vent and undertail orange; from above the tail shows dark brown centre. A lively bird which flicks its tail, making identification easy. Females are dull grey-brown all over with a less conspicuous orange tail and faint buff panels on the wing. Juveniles resemble females but are more speckled.

SIZE Length 13.5cm
NEST Loose cup of grasses and leaves with hair lining hidden in crevice
BREEDING Lays 4–6 pale blue or white eggs in April–June
FOOD Small invertebrates and tiny fruits
HABITAT Derelict urban sites and bare, rocky ground; coasts in winter

VOICE Scratchy, warbling song and *tzit* contact note
DISTRIBUTION Summer visitor in small numbers, mainly to southern England; some overwinter on southern coast

Robin
Erithacus rubecula

A very familiar garden bird. Males and females are similar, with olive-brown upperparts, a grey-brown rump and brown tail. The face, throat and breast are rich orange-red, separated from the rest of the upperparts by a band of pale blue-grey. The belly and undertail coverts are white. Juveniles have warm brown buff-spotted plumage above and paler buff, heavily spotted underparts.

SIZE Length 14cm
NEST Cup of fine mosses, grass and feathers hidden in crevice or hollow tree
BREEDING Lays 4–6 white, speckled eggs in March–June
FOOD Small invertebrates, plus fruits and seeds in autumn and winter
HABITAT Shady woodlands, hedgerows, parks and gardens
VOICE Mournful trilling song and sharp *tic* calls

DISTRIBUTION Widespread and abundant across most of Britain and Ireland

Nightingale

Luscinia megarhynchos

The adult is plain brown above with a rich chestnut-brown tail and a pale eye-ring. The underparts are a dull creamy-white with a hint of brown on the breast and flanks. The dark grey bill has a pale base and the legs are pale, fleshy-brown. Juveniles are very speckled at first with a reddish tail, but soon attain adult plumage. Best located by the rich, melodious song heard from thick cover by day and night.

SIZE Length 16.5cm
NEST Large, loose cup of leaves lined with feathers, in cover on ground
BREEDING Lays 4–5 pale blue speckled eggs in May–June
FOOD Insects and small invertebrates, some berries in autumn

HABITAT Dense scrub patches and coppiced woodland
VOICE Attractive, melodious song with many variations, including rattling and whistling notes
DISTRIBUTION Summer visitor to SE England

THRUSHES
● *Compact bodies* ● *Good songsters*
● *Often feed on the ground*

Blackbird

Turdus merula

The male should not be confused with any other bird; its glossy all-black plumage, yellow eye-ring and golden-yellow bill being unique among birds of this size. The female is basically dark brown with a rufous tinge to the dark-spotted underside. The bill, legs and eye-ring in the female are all dark brown. Juveniles are similar to females, but more heavily spotted and with a more rufous tinge. Males often sit on prominent perches to deliver their rich song.

SIZE Length 24–25cm
NEST Strong cup of grass and leaves with mud and grass lining in fork of branch
BREEDING Lays 4–5 light blue speckled eggs in March–May
FOOD Insects, earthworms, fruits and seeds

HABITAT Wide range of wooded habitats, including parks and gardens
VOICE Sharp chattering alarm calls and rich, fluty song
DISTRIBUTION Very common resident bird across whole of Britain and Ireland

Ring ouzel

Turdus torquatus

Rather secretive and easily scared, so sometimes overlooked on its breeding grounds, but males will sit on rocks and sing near territories. Male has scaly, black plumage due to pale feather-fringes, black head and a bold white crescent-shaped collar. The yellow bill has a black tip. Females are browner than males, but still have the scaly appearance; their neck collar is duller and reduced in size. Juveniles resemble females but have an indistinct collar.

SIZE Length 24cm
NEST Cup of grass and leaves in crevice among boulders
BREEDING Lays 4–5 blue-green speckled eggs in April–May
FOOD Mostly invertebrates, some seeds and berries in autumn

HABITAT Mountains and moorlands
VOICE Chattering alarm calls, blackbird-like song
DISTRIBUTION A summer visitor to mountains and moorlands in northern and western Britain and Ireland

Fieldfare

Turdus pilaris

A strikingly marked thrush with a slate-grey head, nape and rump and chestnut back. The flight feathers and the end of the tail are black, the underparts golden brown with bold black streaks. The sexes are similar but breeding males have a yellow bill. Juveniles lack the stronger colours, looking more like mistle thrushes with pale streaks on the back. In flight the underwing appears white.

SIZE Length 25.5cm
NEST Bulky nest of leaves and grass with mud and grass lining, in tree or on ground
BREEDING Lays 5–6 light blue, mottled eggs in April–June
FOOD Invertebrates, plus fruits and seeds in winter

HABITAT Open woodland, gardens, parks and open farmland
VOICE Chattering contact notes and a weak, warbling song with chattering notes
DISTRIBUTION A common winter visitor to much of Britain and Ireland; very rare breeding bird in northern Britain

Redwing

Turdus iliacus

The smallest thrush likely to be seen in Britain, and easy to recognise in flight because of the extensive red underwing. The upperparts are plain dark brown and the head is marked by a creamy-white supercilium and dark cheeks. The underparts are warm yellowish-brown with dark streaks, fading to off-white below the tail. The bill is dark brown and the legs are fleshy-brown. Juveniles resemble adults but have darker markings.

SIZE Length 21cm
NEST Cup of grasses and moss with mud and grass lining, may be high in tree
BREEDING Lays 4–5 pale blue or green speckled eggs in May–June
FOOD Invertebrates; fruits and berries in winter
HABITAT Open woods, scrub and birch thickets; open grassland in winter

VOICE Short, fluty song, plus *see-ip* call notes
DISTRIBUTION A common winter visitor to Britain and Ireland; small numbers breed in Scotland

Song thrush

Turdus philomelos

A rather shy thrush, but may be seen hopping on lawns in search of worms, or bashing snails on a favourite 'anvil'. Song at dawn and dusk gives away presence. Adults are warm brown above with a hint of a pale supercilium and moustachial stripe. The underparts are white with golden brown tinges on the flanks and throat and dark brown spots arranged in streaks. Juveniles are similar to adults but have pale streaks on the back.

SIZE Length 23cm
NEST Grassy cup with smooth mud lining
BREEDING Lays 4–6 bright blue, lightly spotted eggs in April–May
FOOD Invertebrates, including snails; fruits and berries in winter

HABITAT Mixed woodlands, parks, gardens and hedgerows
VOICE Various short alarm notes, including *tic tic tic*, and rich repetitive musical song
DISTRIBUTION A common and widespread breeding bird in Britain and Ireland

Mistle thrush

Turdus viscivorous

The largest thrush likely to be seen in Britain. In flight the bright white underwing region is diagnostic, and the white-tipped outer tail feathers may also show. At close range mistle thrushes look greyer on the upperparts than song thrushes, and whiter below with a more random arrangement of large, dark wedge-shaped spots. The flight is powerful and direct, not undulating as in other thrushes. Juveniles are like adults but have a white-spotted head, mantle and wing coverts.

SIZE Length 27cm
NEST Large cup of leaves and grasses with finer lining in high tree fork
BREEDING Lays 4–5 pale blue or greenish eggs with darker blotches in March–May
FOOD Invertebrates, plus berries and fruits in autumn and winter

HABITAT Open woodlands, parks and gardens, orchards and hedgerows
VOICE Harsh rattling alarm calls, short fluty song from high perch, often sung during storms
DISTRIBUTION A common and widespread breeding bird across mainland Britain and Ireland

TITS
● *Short bills* ● *Acrobatic habits*
● *Nest in holes*

Blue tit
Parus caeruleus

Distinguished immediately from its cousins by its bright blue crown. The white face is defined by dark blue lines and the wings and tail are blue; the remaining plumage is essentially yellow or yellowish-green. Often feeds high in the branches of trees, searching for hidden insect or their eggs and larvae.

SIZE Length 11.5cm
NEST Built in existing hole in tree or in nestbox; nest comprises base of moss, lined with hair
BREEDING Lays 6–15 eggs, mainly April–June
FOOD Mainly insects but also seeds, especially during winter months

HABITAT Almost any habitat with broad-leaved trees, including woods and gardens
VOICE Call a harsh *tsee-tsee*; song contains prolonged elements of call
DISTRIBUTION Common, widespread resident

Great tit
Parus major

Largest of the true tits and recognised by the bold black markings on its crown and throat and the thick black line down the breast; latter is broader in males than females. The cheeks are white while the remaining plumage is mainly yellow or yellowish-green. Takes precedence over most other small species at a bird feeder. Typical song is distinctive but the species' vocal repertoire is notoriously varied.

SIZE Length 14cm
NEST Built in existing hole in tree or in nestbox; nest comprises base of moss, lined with hair and feathers
BREEDING Lays 5–12 eggs, mainly April–June
FOOD Mainly insects and spiders but also seeds, especially during winter months

HABITAT Almost any habitat with broad-leaved trees, including woods and gardens
VOICE Call a harsh *tink-tink*; song typically *tcacha-teacha-teacha*
DISTRIBUTION Common and widespread resident

Marsh tit
Parus palustris

Common woodland tit, recognised by its black cap, white cheeks and essentially grey-brown upperparts and pale grey-buff underparts. Superficially very similar to willow tit but note the glossy cap, the small, neat black bib, the relatively slim neck and the absence of a pale wing panel. Best distinguished by learning the species' distinctive song and call. Sometimes visits bird feeders in the winter.

SIZE Length 11.5cm
NEST Placed in natural tree hole; nest composed of moss and lined with hair and feathers
BREEDING Lays 7–10 eggs, mainly April–June
FOOD Mainly insects and spiders in summer but seeds and nuts in winter

HABITAT Broadleaved woodland, especially oak or beech; despite English name, does not favour damp ground
VOICE Call a nasal *ptchoo* song a series of phrases on a single note
DISTRIBUTION Locally common resident in England and Wales; very local in southern Scotland

Willow tit
Parus montanus

Very similar to marsh tit, having black cap and bib, white cheeks, grey-brown upperparts and pale greyish-buff underparts. Useful features for separation from its cousin include the dull cap, the thick 'bull' neck, the rather diffuse bib and the presence on some birds of a pale wing panel. The harsh, nasal quality of the call is easily learnt. Seldom visits bird feeders.

SIZE Length 11.5cm
NEST Excavated in tree stump; nest composed of plant fibres and lined with hair
BREEDING Lays 6–9 eggs, mainly April–June
FOOD Mainly insects and spiders in summer but seeds and berries in winter

HABITAT Mixed or broadleaved woodland on damp ground
VOICE Calls include a nasal *tchee-tchee*; song a series of warbling phrases
DISTRIBUTION Locally common resident in England and Wales only

Coal tit
Parus ater

The smallest of the tits and one with distinctive plumage. The black head shows white cheeks and a white nape stripe. The upperparts are olive-grey, the pale underparts show a pinkish-buff hue on the flanks and two white wingbars are clearly visible. Regularly visits bird feeders in wooded areas. Often stores nuts in caches in late autumn for use later in the winter.

SIZE Length 11.5cm
NEST In hole in tree stump; nest composed of moss and lined with hair
BREEDING Lays 8–9 eggs, mainly April–June
FOOD Mainly insects and spiders in summer but seeds in winter
HABITAT Wooded areas, mainly coniferous but also mixed and broad-leaved

VOICE Call a piping *tsee*; song a loud *peechoo-peechoo-peechoo*
DISTRIBUTION Locally common resident throughout

Crested tit
Parus cristatus

The variegated black-and-white crest distinguishes this species from all other small British birds. Face conspicuously marked with black and white; upperparts otherwise grey-brown and underparts buffish-white. Entirely restricted to ancient forests of Scots pine in Scotland's Spey Valley but not uncommon there. The loud trilling call alerts observer to presence of species in suitable habitat. Often stores food in winter larders.

SIZE Length 11.5cm
NEST Hole excavated in tree stump; nest composed of moss and lined with hair
BREEDING Lays 6–7 eggs, mainly April–May
FOOD Mainly insects and spiders in summer but seeds outside breeding season
HABITAT Ancient Scots pine forests

VOICE Call a purring trill; song comprises repetition of call phrases
DISTRIBUTION Entirely restricted to the Spey Valley in Scotland

Bearded tit
Panurus biarmicus

Unmistakable small bird with orange-buff plumage and long tail. Adult male has blue-grey head with distinctive black 'moustaches'; undertail coverts black. Female similar to male but lacks distinctive head pattern. Entirely restricted to extensive reedbeds and seen in roving flocks outside breeding season flying short distances above vegetation. Often referred to by bird-watchers as 'pingers' on account of distinctive call.

SIZE Length 12.5cm
NEST Constructed low among reeds and composed of reed leaves, lined with reed flowers.
BREEDING Lays 4–8 eggs, mainly April–May
FOOD Mainly insects in summer but seeds in winter

HABITAT Extensive reedbeds
VOICE Call an explosive *ping*; song a subdued chattering
DISTRIBUTION Extremely local and found mainly in coastal, southern and SE England

Long-tailed tit
Aegithalos caudatus

Charming round-bodied, long-tailed bird which resembles an animated feather duster. Adult has essentially black upperparts, white underparts and crown, and pink rump and scapulars. Often seen in roving flocks in hedgerows and woods outside the breeding season; flock members keep in contact using their trilling calls. Despite the small, stubby bill the long-tailed tit is adept at catching small insects.

SIZE Length 14cm
NEST Rounded nest of moss, lichen and feathers, held together with spider silk
BREEDING Lays 8–12 eggs, mainly April–June
FOOD Mainly insects and spiders
HABITAT Broadleaved woodland, scrub and heaths

VOICE Call a trilling *tsirrup*; song a rapid series of call phrases
DISTRIBUTION Common and generally widespread throughout Britain

NUTHATCH
- Powerful bill ● Strong claws to hold on to bark
- Nests in holes

Nuthatch
Sitta europaea

A short-tailed, plump-bodied bird with a powerful, pointed, woodpecker-like bill. Adults have blue-grey upperparts and orange-buff underparts. The cheeks and throat are white and there is a bold black eye-stripe. The sexes are similar and juveniles resemble adults but are duller below. Usually first noticed by shrill calls or tapping sounds when feeding. Food is stored in bark crevices and opened nut shells often remain in thick bark. Birds pair for life and do not stray far.

SIZE Length 14cm
NEST Hole in tree, or will use nest box; makes large holes smaller with mud
BREEDING Lays 6–8 white eggs with fine speckles in March–May
FOOD Invertebrates, seeds and nuts; visits bird tables
HABITAT Deciduous and mixed woodlands, parks and avenues of trees
VOICE Loud *chwit chwit* calls and varied loud notes repeated for song
DISTRIBUTION Widespread resident bird in England and Wales

TREECREEPER
- Mouse-like plumage ● Delicate curved bill
- Stiff tail to give support on trees

Treecreeper
Certhia familiaris

A small brown and white mouse-like bird usually spotted creeping up the bark of a tree on a spiral track and then flying down to the base of another tree to start again. The upperparts are mottled brown above with pale spots which form streaks; there are buff and white wingbars, but the stiff tail is plain brown. The underparts are white, but may pick up some colouration from lichen-covered bark. The sexes are alike. Juveniles are very similar to adults but appear to be more spotted. The thin down-curved bill is almost unique in small birds in Britain.

SIZE Length 12.5cm
NEST Grassy cup-shaped nest often concealed behind loose bark
BREEDING Lays 5–6 white eggs with faint speckles in April–June
FOOD Tiny invertebrates found on bark, some small seeds in winter
HABITAT Mature broad-leaved woodlands, parks and large gardens
VOICE Thin, high-pitched *tseww* and brief, cascading song
DISTRIBUTION A common and widespread resident across most of mainland Britain and Ireland

BUNTINGS
- Short, seed-cracking bills
- Sexes different ● Form flocks in winter

Corn bunting
Miliaria calandra

A large, compact bunting with very plain and unremarkable plumage; the upperparts are buff-brown and heavily streaked with darker brown and black. The underparts are paler and also heavily streaked on the breast. The sexes are similar and juveniles are difficult to separate from adults. The bill is large and pinkish and the eye large and dark. Males sit on prominent perches uttering their jangling calls, and sometimes make fluttering song flights.

SIZE Length 18cm
NEST Untidy cup of grasses and leaves on ground in sparse cover
BREEDING Lays 3–5 pale, mottled eggs in April–May
FOOD Seeds and invertebrates
HABITAT Open farmland with hedgerows
VOICE Jangling song and low-pitched *kwit* calls
DISTRIBUTION A declining resident in eastern Britain, Hebrides and Orkney; very rare in Ireland

Yellowhammer
Emberiza citrinella

Adult males in summer are colourful with lemon-yellow heads and chestnut rumps. The upperparts are brown and streaked with black and dark brown, while the underparts are dull yellow with darker chestnut wash on breast. Females are much duller with greyish-green streaks on the head and chest, but the chestnut rump shows clearly in flight. Juveniles are very similar to females and non-breeding males. The distinctive song of the male is heard through the summer.

SIZE Length 16.5cm
NEST Flat arrangement of grass and straw low down in grass clump
BREEDING Lays 3–5 pale eggs with darker markings in April–May
FOOD Seeds, some invertebrates in summer
HABITAT Farmland, hedgerows, heathland and coastal scrub
VOICE Rasping song described as *a-little-bit-of-bread-and-no-cheese*
DISTRIBUTION A widespread and still fairly common resident across mainland Britain and Ireland

Cirl bunting
Emberiza cirlus

Similar to yellowhammer in size, shape and behaviour, but male has head pattern of bold black eye-stripe and chin on yellowish head. The underparts are mostly grey and yellow and the upperparts are chestnut, apart from dark tail and flight feathers and a grey-brown rump. Females resemble washed-out males and lack the head markings; the breast has dark, broken streaks and the rump is olive-grey. Juveniles are a buff-brown version of the females.

SIZE Length 16cm
NEST Tidy cup of moss and leaves concealed low down in cover
BREEDING Lays 3–4 bluish-white blotched eggs in April–May
FOOD Seeds and some insects
HABITAT Open, partly wooded habitats, gorse-covered slopes and hedgerows
VOICE Rattling, metallic, tuneless song
DISTRIBUTION Very scarce breeding bird, mainly confined to south Devon

Reed bunting
Emberiza schoeniculus

Male in breeding season has black and white head with white moustachial stripe. Rest of upperparts are brown with darker streaks, apart from the grey rump. The underparts are mostly white. Females lack the black head and grey rump; they have brown, streaked heads with buff supercilium and moustachial stripe. Juveniles resemble females, but have only faint head markings. Non-breeding males have faded appearance due to pale feather-tips.

SIZE Length 15–16cm
NEST Grassy nest concealed on ground
BREEDING Lays 4–5 pale blue-grey mottled eggs in April–May
FOOD Invertebrates and seeds
HABITAT Margins of wetlands with scattered bushes
VOICE Quiet *tseep* calls and short tinkling song
DISTRIBUTION A widespread but declining resident across all of Britain and Ireland

Snow bunting
Plectrophenax nivalis

Male in breeding plumage is easily recognised by its clean black and white plumage, and black bill, eyes and legs. Females in summer are brown where males are black and have an orange tinge to the white parts of the plumage. In autumn and winter plumage of both sexes is browner, bill is yellow and cap and cheeks show orange tinge. Juveniles are browner overall. Flying birds show large patches of white on the wings and tail at all times of year.

SIZE Length 16cm
NEST Mossy cup in rock crevice
BREEDING Lays 4–6 whitish eggs with brown blotches in May–June
FOOD Seeds and invertebrates
HABITAT Arctic tundra and high mountain plateaux; overwinters on coastal grasslands
VOICE Musical chirping calls and pleasant trilling song
DISTRIBUTION Winter visitor to coasts, mainly in south and east; scarce breeding bird in northern Scotland

FINCHES

- *Pointed bills for feeding on seeds*
- *Brightly coloured plumage* • *Form flocks in winter*

Chaffinch

Fringilla coelebs

The male has mostly pink underparts. Crown and nape are blue-grey, mantle is chestnut brown and rump is green. Wings strongly marked with black and white bars. Females and juveniles have same pattern but are olive-brown above and paler below.

SIZE Length 14.5cm
NEST Mossy cup with hair lining in fork of tree
BREEDING Lays 4–5 bluish or grey eggs with darker spots and scribbles in April–June
FOOD Mostly seeds, plus invertebrates in summer
HABITAT Mixed woodlands, farmland, parks and gardens
VOICE Sharp *chink* calls and trilling song with final flourish
DISTRIBUTION A very common and widespread bird over most of Britain and Ireland

Brambling

Fringilla montifringilla

Easily recognised in flight by white rump and salmon pink breast and shoulder patch of the male. Upperparts are very dark with scaly appearance caused by buff feather-margins. Yellow bill has a black tip. Females have the same bold pattern on the wings as the male, but are pale buff below, not pink-orange. Juveniles resemble females.

SIZE Length 14cm
NEST Cup of mosses and lichen in fork high in tree
BREEDING Lays 5–7 greenish-blue eggs with spots in May–June
FOOD Seeds, especially beech mast in autumn; invertebrates in summer
HABITAT Northern birch forests in summer; open ground and woodland edges in winter
VOICE Rasping *tsweep* calls
DISTRIBUTION A winter visitor to Britain in variable numbers depending on weather conditions and food supplies in northern Europe

Hawfinch

Coccothraustes coccothraustes

A large finch with a massive bill used to crack open cherry stones and other large seeds. In profile hawfinches look top-heavy, and in flight they appear to be very short-tailed; the wings show large areas of white in flying birds. Adults are mostly orange-buff and pink-buff, with darker flight feathers and a black-bordered tail. The white band on the wings shows clearly in sitting birds. The sexes are very similar, but females are duller than the male. Juveniles are browner and have spotted underparts.

SIZE Length 18cm
NEST Twiggy platform with sparse lining high in tree
BREEDING Lays 4–6 blue-green spotted eggs in April–June
FOOD Large seeds and fruit stones; insects in summer
HABITAT Mixed woodlands and parks
with mature trees
VOICE Loud, shrill *tic* calls
DISTRIBUTION A scarce breeding bird, usually found in small colonies, mainly in southern England; less common in Wales and northern England

Bullfinch

Pyrrhula pyrrhula

The male is a brightly coloured bird, nearly always accompanied by his rather duller mate. It is usually quite a difficult bird to see, however, preferring to remain in dense cover. When seen in flight the white rump is very distinctive. The male is mostly reddish-pink below and blue-grey above with a black cap and chin, black flight feathers and a black tail. Broad white wingbars show on the folded wings and in flight. The black bill is short and stubby. The female is patterned in the same way, but is mostly warm buff below and brownish-buff above. Juveniles resemble females but have no black cap.

SIZE Length 15cm
NEST Twiggy platform in dense bush
BREEDING Lays 4–5 greenish-blue eggs in May–July
FOOD Buds, berries and seeds; invertebrates in breeding season
HABITAT Thick scrub, woodland edges,
hedgerows, orchards and gardens
VOICE Thin, insipid *tseep*
DISTRIBUTION A widespread resident across most of mainland Britain and Ireland

Goldfinch

Carduelis carduelis

A very colourful small finch with a red and white face, black head, warm buff upperparts and black wings with broad yellow bands. The underparts are mostly pale buff or white. The sexes are similar, although males have a slightly longer bill. Juveniles resemble adults but do not have the head markings for the first two months after leaving the nest. Goldfinches form small foraging flocks in winter, sometimes mixing with other finches.

SIZE Length 12cm
NEST Tiny cup of moss and grass well concealed in dense bush
BREEDING Lays 4–6 pale blue, spotted eggs in April–June
FOOD Small seeds, especially teasels, dandelions and thistles
HABITAT Open country, gardens, parks, thickets of scrub and waste ground
VOICE Sweet-sounding *switt-witt-witt* and short musical song
DISTRIBUTION A widespread resident across most of Britain and Ireland apart from far north

Greenfinch

Carduelis chloris

A mostly olive-green finch with conspicuous patches of yellow in the wings and tail which show clearly in flight. The flight feathers and base of the tail are dark blackish-brown, and the tail is markedly forked. The bill is short but heavy and pale ivory. Females are similar to males but duller, with faint streaks on the crown. Juveniles are far less colourful and more heavily streaked. Usually found in noisy, chattering flocks. Males make a fluttering display flight near nest sites.

SIZE Length 15cm
NEST Large, untidy cup of grasses and mosses in dense cover
BREEDING Lays 4–6 greyish or blue-white lightly speckled eggs in April–July
FOOD Large seeds, some invertebrates; visits bird tables
HABITAT Mixed woodlands, hedgerows, parks and gardens
VOICE Twittering song and persistent, nasal, *breeeze* calls
DISTRIBUTION A common and widespread resident across most of Britain and Ireland

Siskin

Carduelis spinus

A small and rather dainty finch with black wings crossed by broad yellow wingbars. Males are yellow-green above with a black forehead, crown and chin. The black tail is forked and has bright yellow patches along the edges. The small yellowish bill is sharply pointed. Females do not have the male's black head markings, and juveniles are browner with more pronounced streaks on all parts. Very keen on red-coloured garden bird-feeders.

SIZE Length 12cm
NEST Tiny cup of twigs, mosses and grass high in conifer
BREEDING Lays 3–5 blue spotted eggs in April–June
FOOD Seeds, particularly spruce, birch and alder; visits bird tables
HABITAT Coniferous forests and riverside alders; gardens in winter
VOICE Thin *tsueee* calls and a pleasant twittering song
DISTRIBUTION An increasingly common resident over most of Britain and Ireland; commonest in north

Twite
Carduelis flavirostris

A rather plain finch with dark, streaked plumage and a short bill. May be overlooked as a female or juvenile linnet. The male's pink rump is diagnostic but is only seen well in flight; yellowish-white wingbars and outer tail feathers are also visible in good light. The sexes are similar, but females have a brownish rump. The bill is yellow in winter and grey in winter. Juveniles are similar to winter adults. Usually found in flocks in winter.

SIZE Length 14cm
NEST Cup of twigs and bracken hidden in deep crevice
BREEDING Lays 4–6 blue speckled eggs in May–June
FOOD Small seeds, usually collected from ground
HABITAT Treeless open country; overwinters on coastal marshes
VOICE Nasal *chweek* and twittering flight song
DISTRIBUTION Widespread breeding bird in Scotland, smaller numbers in northern England, Wales and Ireland; overwinters further south

Redpoll
Carduelis flammea

A rather plain finch, especially in winter plumage. The upperparts are brown and streaked and males have a black chin, red crown and partial white supercilium. The underparts are paler and streaked on the flanks, and in the breeding season males have a pink flush to the breast. Two white wingbars show best in flight. Females are similar to males but lack the pink breast and have a much smaller red cap edged with black, not white. Juveniles have no red cap and are more markedly streaked.

SIZE Length 13–14cm
NEST Cup of twigs and grasses high in tree
BREEDING Lays 4–6 blue speckled eggs in April–June
FOOD Mostly small seeds, especially birch and alder
HABITAT Birch and alder woods, conifer plantations and forest edges
VOICE High-pitched *chuchuchu* calls and flat, trilling song
DISTRIBUTION Widespread breeding bird across most of Britain and Ireland

Linnet
Carduelis cannabina

Male has chestnut upperparts, dark flight feathers and tail and a grey head with a crimson forehead. The chin is white and the breast is crimson, merging into the mostly white underparts. Females are browner above and plain below with no crimson areas. In flight both sexes show distinctive white wing and tail patches. Juveniles resemble females, but are more heavily streaked. Males acquire crimson patches after one year. May form large flocks in winter.

SIZE Length 12.5cm
NEST Cup of twigs and grasses low down in thorny bush
BREEDING Lays 4–6 pale blue, blotched eggs in April–June
FOOD Seeds
HABITAT Open country with scrub patches and hedgerows
VOICE Various quiet, twittering calls
DISTRIBUTION Widespread resident across most of Britain and Ireland apart from NW

Scottish crossbill
Loxia scotica

Male is bright red with darker flight feathers and tail, female is green, and also has darker wings and tail. The large bill has pointed tips to the mandibles which overlap. Juveniles resemble females but are grey-brown and heavily streaked. Found only in forests of Scots pine in northern Scotland, preferring mature trees; may be seen visiting puddles to drink. The only bird endemic to Britain.

SIZE Length 16cm
NEST Platform of twigs, usually near trunk
BREEDING Lays 4 whitish spotted eggs in February–May
FOOD Seeds of Scots pine
HABITAT Mature conifer forests
VOICE Loud *chip chip* calls
DISTRIBUTION Confined to pine forests in northern Scotland

Common crossbill
Loxia curvirostra

Adult males are bright red with darker wings and tail; the rump is brightest and shows well in flight. Females are green with darker wings and a brighter rump. Both have distinctive crossed mandibles and are usually spotted on the ends of conifer branches tackling pine cones. Juveniles are brown and heavily streaked and may show indistinct pale wingbars. Flight calls are best clue to their presence.

SIZE Length 17cm
NEST Twiggy platform near main trunk of tree
BREEDING Lays 4 whitish spotted eggs in February–May
FOOD Conifer seeds, spruce being the favourite
HABITAT Coniferous forests
VOICE Greenfinch-like calls and sharp *chip chip* flight calls
DISTRIBUTION Widespread, but not common, in conifer forests across Britain and Ireland

SPARROWS
● *Short bills* ● *Short, rounded wings*
● *Usually live in colonies*

House sparrow
Passer domesticus

The male is mostly brown above and grey below with a grey crown, black bib and eye-stripe and greyish cheeks. The wings are strongly marked with darker brown and the rump is greyish. The male's bill is black in the breeding season, grey at other times. Females are grey-brown, without any distinctive patterns apart from darker barring on the wings and a pale band over the eye. Juveniles resemble females, both having a grey bill and pink legs.

SIZE Length 14–15cm
NEST Untidy construction of grasses with soft lining
BREEDING Lays 3–5 white mottled eggs in April–June
FOOD Mainly seeds, some invertebrates; visits bird tables
HABITAT Almost always associated with people: gardens and farmyards
VOICE Persistent *cheep* calls
DISTRIBUTION A widespread and common resident across all of Britain and Ireland

Tree sparrow
Passer montanus

Separated from similar though slightly larger house sparrow by rich chestnut crown and nape and white cheeks; the black bib is much smaller but there is a black spot behind the eye, and the bill is black. The back and rump are yellowish brown and streaked with darker brown, and the underparts are pale buff, palest on the belly. Two thin, pale wingbars can be seen in flying birds. The sexes are very similar; juveniles resemble adults but are duller.

SIZE Length 14cm
NEST Untidy cup of leaves with soft lining, in tree hole or nest box
BREEDING Lays 4–6 whitish, mottled eggs in April–May
FOOD Seeds and invertebrates, mostly from the ground
HABITAT Farmland, woods, copses, parks and scrub
VOICE Repetitive *chet* or *tek* calls
DISTRIBUTION A declining species, mainly found in eastern Britain; scarce in Ireland

CROWS
- *Powerful bills* ● *Harsh calls*
- *Large size*

Jay
Garrulus glandarius

The most colourful member of the crow family with mostly pinkish-brown plumage. In flight the white rump shows clearly, and there are patches of white on the wings, under the tail and under the bill. Has thick black moustachial stripes. Sexes are alike and juveniles resemble adults with less streaking on the crown and redder plumage.

SIZE Length 34–35cm
NEST Twiggy nest with partial cover and dense lining of leaves and hair
BREEDING Lays 5–7 pale green or blue speckled eggs in April–May
FOOD Invertebrates, fruits, seeds and acorns
HABITAT Woodlands with dense canopy, thick hedgerows and mature parks
VOICE Harsh, screeching calls, varied according to what is being scolded
DISTRIBUTION Widespread resident over mainland Britain and Ireland, most common in south; absent from northern Scotland

Magpie
Pica pica

An easily recognised black and white bird with a very long tail. In flight the wings have white patches at the base, and black-bordered white primaries. Most of the upperparts are black, and the belly and flanks are white. In good light the black parts are seen to have a brilliant iridescence, purple on the head and body, green on the crown, blue-green on the wings and green and purple on the tail. The sexes are alike and juveniles are similar but have shorter tails and duller plumage with less iridescence.

SIZE Length 44–46cm
NEST Domed, twiggy nest with mud lining and soft inner layer
BREEDING Lays 5–7 blue or olive speckled eggs in April–May
FOOD Mostly invertebrates, plus seeds, scraps, carrion and small vertebrates
HABITAT Lowland farmland, woodland edges, copses, towns and gardens
VOICE Harsh rattling *chakka chakka chakka*
DISTRIBUTION A widespread breeding bird across most of Britain and Ireland; scarce in Scotland

Chough
Pyrrhocorax pyrrhocorax

An all-black corvid with a slight blue gloss to the plumage, apart from the tail and flight feathers which have a greenish gloss. The bill is red and downcurved, and the legs and feet are red with black claws. The sexes are alike and juveniles can be distinguished by their shorter, dull pink bills. The distinctive call is heard frequently when small flocks are feeding or flying. Birds calling from a perch will flick their wings and tails to help their display.

SIZE Length 39–40cm
NEST Twiggy platform with wool lining in cliff crevice
BREEDING Lays 3–5 pale buff or greenish mottled eggs in April–May
FOOD Invertebrates found in soil, seeds and berries in winter
HABITAT Coastal cliffs, inland rock faces and short, grazed turf
VOICE A harsh *cheeow* or *keeaa*
DISTRIBUTION Resident on coasts of Wales, Ireland, Isle of Man and SW Scotland

Jackdaw
Corvus monedula

From a distance, jackdaws look black with a grey nape; at closer range the black crown has a purple gloss, the wings a blue gloss and the underparts are a dark charcoal-grey. Adults have pale grey eyes which contrast with the black face. The legs and bill are black. The sexes are alike. Juveniles resemble adults, although are duller, with darker grey on the head; they have brown eyes which turn grey after a year.

SIZE Length 33–34cm
NEST Untidy pile of twigs with soft lining, built colonially
BREEDING Lays 4–6 pale blue or blue-green speckled eggs in April–May
FOOD Wide-ranging animal and vegetable diet, mostly collected from ground
HABITAT Sea cliffs, mountain crags, woodland edges with mature trees, towns and church towers
VOICE Harsh *jack* calls and many other contact calls
DISTRIBUTION Widespread resident across most of Britain and Ireland, rare in the far north of Scotland

Raven
Corvus corax

The largest corvid with all-black, iridescent plumage; the wings have a hint of purple and the tail is reddish-purple in good light. The bill is the most massive of all the corvids, looking very large when seen in profile; the shaggy neck feathers and large bill give the head a distinctive outline. In flight ravens are very agile, and the long wedge-shaped tail is diagnostic, avoiding confusion with the much smaller carrion crow. The sexes are alike and juveniles resemble adults.

SIZE Length 64cm
NEST Large pile of sticks with softly lined depression, on crag or large tree
BREEDING Lays 4–6 light blue-green speckled eggs in March–May
FOOD Carrion, seeds, fruits, young birds and mammals
HABITAT Open country with trees, coasts, mountains and moorlands
VOICE A deep *karronk* and hollow *toc toc toc* sounds
DISTRIBUTION Widespread in western Britain and Ireland, absent from the east

Carrion crow
Corvus corone corone

An all-black bird, including the bill and legs. The bill is more streamlined than the raven's, there are no untidy neck feathers, and the tail is square at the end, not wedge-shaped. Similar rook has white face and narrower bill. The sexes are alike and juveniles are similar to adults, staying with the parents for several weeks after leaving the nest. Crows are usually more solitary than rooks.

SIZE Length 45–47cm
NEST Large cup of twigs with soft lining, high in tree
BREEDING Lays 3–6 pale blue speckled eggs in March–May
FOOD Wide-ranging diet, including carrion, invertebrates, fruits and seeds
HABITAT Open country with scattered trees and hedgerows; increasingly in towns
VOICE Harsh *kawr*, sometimes repeated three times
DISTRIBUTION Widespread resident across most of Britain, apart from far north

Hooded crow
Corvus corone cornix

Distinguished from carrion crow, of which this is a sub-species, by its partially ashy-grey plumage. The head, neck, breast and wings are black, but the remainder of the body is grey. The bill, legs and feet are also black. The sexes are alike and juveniles resemble adults. Hybrids occur where hooded and carrion crow ranges overlap in a zone running across NW Scotland and these birds can show intermediate patterns in the plumage.

SIZE Length 45–47cm
NEST Large cup of twigs with soft lining, usually high in tree
BREEDING Lays 3–6 pale blue speckled eggs in March–May
FOOD Wide-ranging diet, including carrion, invertebrates, fruits and seeds
HABITAT Open country with scattered trees, moorlands, coasts, urban fringes
VOICE Harsh *kawr* calls
DISTRIBUTION Widespread in Ireland and NW Scotland, Orkney and Shetland

Rook
Corvus frugilegus

Normally found in large, noisy flocks, rooks can be separated from crows by their more slender bills, peaked heads and dirty white faces. In good sunlight the upperparts show a green and reddish-purple iridescence. In flight the tail looks rounded and the wings show distinct 'fingers'. The sexes are alike, and juveniles are similar to the adults, but on first fledging they have black bristles at the base of the bill and no white on the face.

SIZE Length 44–46cm
NEST Twiggy cup with mud and grass lining high in tree, colonial
BREEDING Lays 2–6 light blue or green speckled eggs in April–May
FOOD Soil invertebrates and seeds
HABITAT Lowland farmland with hedgerows and copses containing tall trees
VOICE Drawn out *kaah* calls
DISTRIBUTION Widespread and abundant across most of Britain and Ireland, absent from NW Scotland and outer isles

REPTILES

LIZARDS
- *All have limbs except slow-worm* ● *Can regrow damaged tails*
- *Bask in warm places such as walls and sandy patches*

Common lizard
Lacerta vivipara

Well camouflaged with mainly brown colourings and numerous darker irregular brown markings on the upperparts, with a pattern of paler stripes running along the body. The underside is much paler in females, but males have reddish colouration on the belly in the breeding season. If captured by the tail it will break off and twitch, distracting the predator long enough for the lizard to escape. A new tail will eventually grow back. Hibernates in winter.

SIZE Length 17cm
BREEDING Up to 10 young born live in late summer
FOOD Small invertebrates, mainly insects
HABITAT Grassy banks, heaths, marshy areas and cliffs
VOICE Always silent
DISTRIBUTION Widespread across most of mainland Britain and Ireland

Sand lizard
Lacerta agilis

Males are striking with green flanks that are brightest in the breeding season. Females are browner with darker blotches and pale stripes. Larger than common lizard with a noticeably large head. Enjoys basking in open sunny places near patches of mature ling on sandy heaths.

SIZE Length 15–22cm
BREEDING Lays eggs in shallow sand, relying on sun's heat to hatch them
FOOD Insects and spiders
HABITAT Sandy heaths with mature ling
VOICE Always silent
DISTRIBUTION Very rare in Britain, confined mainly to Dorset, Hampshire and Surrey

Slow-worm
Anguis fragilis

Snake-like at a quick glance, but is actually a legless lizard. Cylindrical body tapers abruptly into short tail, and there appears to be no neck; the head is fairly small. Colourings mostly bronze-brown above and paler below. Young are shiny and metallic in appearance. A few isolated populations are blue spotted. Sheds tail if captured and can grow a new one. Easy prey for cats in gardens.

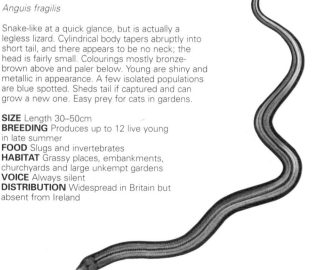

SIZE Length 30–50cm
BREEDING Produces up to 12 live young in late summer
FOOD Slugs and invertebrates
HABITAT Grassy places, embankments, churchyards and large unkempt gardens
VOICE Always silent
DISTRIBUTION Widespread in Britain but absent from Ireland

SNAKES
- *Complete absence of limbs* ● *Jaw can open to huge gape*
- *Belly scales enlarged into broad plates*

Grass snake
Natrix natrix

A long and slender snake with mostly olive-green colouration. The yellow neck collar with a black edge and the round pupil are good identification features. Flanks are usually marked with dark blotches along the length of the body. Often found near water and may be seen swimming. Piles of rotting vegetation, such as garden compost heaps, are used to incubate the eggs. Non-venomous, but releases foul-smelling liquid when threatened.

SIZE Length 70–150cm
BREEDING Lays 12–15 leathery eggs in June–July
FOOD Frogs, fish, small birds and mammals
HABITAT Damp grassy places, heaths, canals and lake margins
VOICE Always silent
DISTRIBUTION Widespread in England and Wales, but declining in range and numbers

Adder
Vipera berus

A short and rather plump snake with a short tail. Colourings are mostly grey-brown with a darker zig-zag pattern along the back. Some individuals may be all black or reddish-brown. At close range the vertical slit pupil may be obvious. Produces a poisonous venom which can be dangerous to humans; this is used to kill small mammals. Males compete for females to mate with in spring by fighting.

SIZE Length 50–65cm
BREEDING Produce 6–10 live young in late summer
FOOD Small mammals and lizards
HABITAT Dry heaths, woodlands, moorlands and cliff tops
VOICE Always silent
DISTRIBUTION Widespread across Britain in suitable habitats, but declining

Smooth snake
Coronella austriaca

A slender grey-brown snake which may be mistaken for an adder, but has a round, not vertical pupil, and an incomplete dark pattern along length of body. Usually found in same habitat as sand lizard which is its usual prey. Often restrains prey by coiling body around it. Enjoys basking on sunny banks or under sheets of corrugated iron.

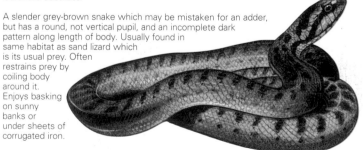

SIZE Length 55–75cm
BREEDING Produces up to 15 live young in late summer
FOOD Lizards, small birds and mammals, large insects
HABITAT Sandy heaths with open areas for basking
VOICE Always silent
DISTRIBUTION Very rare in Britain, restricted to Dorset, Hampshire and Surrey

AMPHIBIANS

NEWTS
● *Have long tails* ● *Legs short and feeble*
● *Skin not waterproof, so rarely seen in exposed positions*

Smooth newt
Triturus vulgaris

Female is brown with light specklings on upperparts. Male in breeding season has undulating crest along back with darker spots, an orange belly and a pale throat; the underside and throat also have darker spots. After the breeding season the male is similar to the female. Breeds in ponds, but spends much of year in damp places near water. Hibernates in winter under logs and stones.

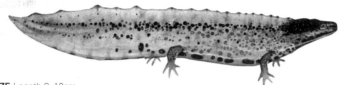

SIZE Length 8–10cm
BREEDING Females lay eggs individually on pondweed leaves in early spring
FOOD Invertebrates
HABITAT Ponds, canals, damp woodlands
and ditches
VOICE Always silent
DISTRIBUTION Widespread in Britain and Ireland, commonest in southern England

Palmate newt
Triturus helvetica

Breeding male easy to identify by webbed hind feet and deep tail ending in a thin thread. Underside is yellow and throat has no spots. Females are very similar to female smooth newts. Outside breeding season males lose bold colours, but still have no spots on throat. Prefers more acid waters than smooth newt. Hibernates under logs in winter.

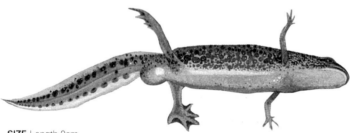

SIZE Length 9cm
BREEDING Females lay eggs individually on pondweed leaves in March–April
FOOD Small invertebrates
HABITAT Ponds, canals, moorland pools
and bogs, damp woodlands and ditches
VOICE Always silent
DISTRIBUTION Widespread on mainland Britain

Great crested newt
Triturus cristatus

Britain's largest and rarest newt. In breeding season male has large jagged crest along the back and a striking black-spotted orange belly. The upperparts are black and the skin is very warty. Females are also black above and orange below, but lack the crest. Prefers deep, weedy ponds close to woodland. Swims very well and may be found in very large colonies, but is absent from large areas.

SIZE Length 14cm
BREEDING Females lay eggs individually on pondweed leaves in March–April
FOOD Invertebrates
HABITAT Large weedy ponds, damp woodlands and ditches
VOICE Always silent
DISTRIBUTION Rare in Britain, absent from Ireland

FROGS AND TOADS
● *Body rounded and compact* ● *Legs long and powerful*
● *Often seen out of water, especially at night*

Common frog
Rana temporaria

Colours are variable but background colour is usually greenish-brown with darker blotches and a hint of a dark 'mask' on the face. In the breeding season the males have a blue-grey throat and thickened pads on the first finger to help grasp the females during mating. Females are larger than males, especially when ready to spawn.

SIZE Length 6–9cm
BREEDING Females lay up to 2,000 eggs in jelly-like spawn in early spring
FOOD Invertebrates, including flies, spiders and woodlice
HABITAT Ponds, canals, marshes, wet woodlands and gardens
VOICE Deep croaks from males in chorus in breeding season
DISTRIBUTION Widespread in mainland Britain; introduced to Ireland

Marsh frog
Rana ridibunda

Similar to common frog, but greener in colouration. The head is more pointed and lacks the 'mask' seen in common frog. Males inflate grey-coloured vocal sacs on either side of the mouth when croaking in spring. More inclined to stay near water throughout year than common frog. Introduced into Britain.

SIZE Length 6–10cm
BREEDING Females produce spawn in March–April
FOOD Aquatic invertebrates
HABITAT Marshes and drainage ditches
VOICE Incessant croaking from males in spring
DISTRIBUTION Introduced to Romney Marsh and Lewes Brooks

Common toad
Bufo bufo

Warty olive-brown skin and less shiny appearance distinguish toad from common frog. Underside is white with black spots. Females are much larger than males. Apart from breeding season, can be found in much drier habitats than frog and has habit of walking rather than hopping. Warty skin releases unpleasant taste which deters predators. If attacked, adopts hunched threat posture, standing up on all four legs.

SIZE Length 6–8cm
BREEDING Females lay spawn in long strings of jelly twined around pondweed in spring
FOOD Invertebrates
HABITAT Ponds in spring, rest of year in
woodlands, gardens and meadows
VOICE High-pitched incessant croaking from males at breeding sites
DISTRIBUTION Widespread and common in mainland Britain

Natterjack toad
Bufo calamita

Smaller than common toad, with conspicuous yellow stripe down back and more mottled upperparts. The body also looks more flattened. May run, rather than walk or hop. Mostly active at night, especially after thundery rain. Very rare in Britain because of restricted sandy heath habitat with suitable pools for breeding.

SIZE Length 6–8cm
BREEDING Females lay single-stranded spawn in spring
FOOD Invertebrates
HABITAT Sandy heaths and dunes
VOICE High-pitched incessant croak,
likened to a football rattle, from males in spring
DISTRIBUTION Very rare in Britain and SW Ireland, mainly at coastal and heathland sites

FISH

FRESHWATER
- *Some migrate to sea* ● *Many introduced species*
- *Adapted to either still or flowing water*

Brook lamprey
Lampetra planeri

Eel-like at first glance, but has a disc-shaped mouth with a ring of blunt white teeth. There is a line of gill openings behind the mouth and two connected dorsal fins on the back. Bronze-grey upperparts, grading into yellowish-white below. The sucker is used to move stones for building a 'nest' on the river bed. Most of life is spent as a larva buried in mud. Adults do not feed.

LENGTH 12–15cm
BREEDING Lays up to 2,000 eggs in depression in gravel in spring
FOOD Larvae feed on plankton and fine organic matter
HABITAT Clear, unpolluted streams and rivers
DISTRIBUTION Widespread in suitable habitats in Britain and Ireland

River lamprey
Lampetra fluviatilis

A larger, migratory species, moving up into shallow reaches of rivers from the sea to spawn. The mouth has a ring of yellowish teeth and the two dorsal fins are separated. Normal colouration is silvery-grey, but becomes more golden during migration up rivers in autumn. After spawning in spring they die. Larvae metamorphose and migrate back to sea after 4–5 years.

LENGTH 30cm
BREEDING Lays immense numbers of tiny eggs in spring
FOOD Larvae feed on plankton and detritus; adults suck blood from fish
HABITAT Adults live in open sea and migrate up clear rivers
DISTRIBUTION Widespread around coasts of Britain and Ireland

Eel
Anguilla anguilla

Slender snake-like body is covered with a thick slime. Flattened head with a large mouth and large eyes. The gills are covered, with only a tiny opening to the outside and there are two small pectoral fins. Short dorsal fin runs from the middle of the back around the underside of the tail. In freshwater, eels are a bronzy-yellow, but after migrating to the sea they change to a leaden silver.

LENGTH Up to 1m
BREEDING Migrates to Sargasso Sea to spawn, laying many thousands of small eggs
FOOD Wide range of fish, aquatic invertebrates and
amphibians
HABITAT Ponds, ditches, canals and muddy rivers
DISTRIBUTION Widespread and common in most of Britain and Ireland

Grayling
Thymallus thymallus

An attractive member of the salmon family with an unusually large and colourful dorsal fin. The flanks are mostly silvery-bronze with a few scattered spots and blotches and long purplish lines. Small, forward-pointing mouth. Grayling usually live in small shoals in fast-flowing, clear rivers. When handled, they smells of herbs.

LENGTH Up to 50cm
BREEDING Spawns in early summer on gravel beds
FOOD Small aquatic invertebrates
HABITAT Clear, fast-
flowing gravelly rivers, and large lakes
DISTRIBUTION Widespread in England and Wales; introduced to Scotland; absent from Ireland

Atlantic salmon
Salmo salar

An elegant and streamlined fish and a powerful swimmer; adults are strong enough to swim against the current in fast rivers and 'climb' waterfalls. Mainly silvery-blue above and silver below with scattered spots, and typical fleshy adipose fin near tail. Young, called 'parr', have strong pattern of spots and bars on flanks.

LENGTH Up to 120cm
BREEDING Migrates up rivers, usually in winter, to spawn in gravelly shallows
FOOD Aquatic invertebrates in sea; does not feed as adult in freshwater
HABITAT Open sea as adult; breeds in clear, fast-flowing rivers
DISTRIBUTION Widespread in Britain and Ireland, but declining and absent from polluted areas

Brown trout
Salmo trutta

A powerfully built and streamlined fish with a bold pattern of red-rimmed spots on brownish flanks, but variable depending on habitat. Often very active at the surface, taking flies and making small splashes. The sea trout is a migrant form of brown trout, with more silvery colouring, which lives in coastal waters but migrates upstream to spawn.

LENGTH Up to 50cm, rarely 75–80cm
BREEDING Spawns in winter or early spring in gravelly shallows in clear water
FOOD Aquatic invertebrates, small fish
and insects at surface
HABITAT Clear, unpolluted rivers and large lakes
DISTRIBUTION Widespread across most of Britain and Ireland in suitable habitats

Pike
Esox lucius

One of the largest and fiercest of freshwater fish, with excellent camouflage. Marbled green and brown markings enable the pike to blend in with waterweeds; its usual hunting technique is to remain motionless and then dash forwards to catch its prey in its very large mouth, which is armed with rows of backward-pointing teeth. The streamlined shape and broad tail aid rapid swimming.

LENGTH 30–120cm
BREEDING Lays thousands of sticky eggs in early spring, attaching them to pondweed
FOOD Invertebrates when small; fish and
some waterbirds and mammals when older
HABITAT Weedy lakes and rivers, canals
DISTRIBUTION Widespread across Britain and Ireland

Carp
Cyprinus carpio

A large and bulky fish with mostly golden-brown colouration and large scales. The fins and tail are relatively large and thick, and the upper lip has two long and two short barbels. Varieties with irregular scales occur; mirror carp has few scales with gaps between them and leather carp has almost no scales.

LENGTH 25–80cm
BREEDING Lays vast numbers of eggs in May–June in weedy places
FOOD Aquatic invertebrates, many sifted out of mud
HABITAT Weedy ponds and lakes, gravel pits and slow rivers
DISTRIBUTION Introduced but now widespread across Britain and Ireland

Gudgeon
Gobio gobio

A small, bottom-living fish with a cylindrical body and two barbels at the side of the mouth. The colourings are mostly brownish-green with darker mottlings along the flanks. Sometimes found in small shoals. An important prey species for larger fish.

LENGTH 7–18cm
BREEDING Lays up to 3,000 eggs in April–June
FOOD Aquatic invertebrates
HABITAT Fast-flowing
rivers and large stony lakes
DISTRIBUTION Widespread across England, Wales and Ireland

Roach

Rutilus rutilus

A mostly silvery, flat-bodied fish with large scales and a small head and mouth. The fins are tinged with red and the eye is relatively large and black. Roach are normally found in shoals, and can be difficult to spot from above because of darker colourings on the back. May be confused with rudd, but colourings and shape are different, and dorsal fin starts immediately above pelvic fins.

LENGTH 10–25cm
BREEDING Lays several thousand sticky eggs among pondweeds in midsummer
FOOD Small aquatic invertebrates and some plant material

HABITAT Slow-moving rivers, canals, weedy lakes and gravel pits
DISTRIBUTION Common and widespread in Britain, rare in Ireland (where rudd is called roach)

Rudd

Scardinius erythropthalmus

Deeper-bodied than the roach with a distinct golden tinge to the flanks and red fins. Small head, and the mouth points upwards slightly to help with feeding at the surface. The dorsal fin starts well back along the body, behind the pelvic fins. Usually found in shoals, and often active at the surface taking flies.

LENGTH 20–35cm
BREEDING Lays many thousands of sticky eggs in weed beds in early summer
FOOD Small aquatic invertebrates and flies on water surface

HABITAT Large lakes and rivers, canals and weedy gravel pits
DISTRIBUTION Widespread in England, Wales and Ireland (where it is called roach)

Minnow

Phoxinus phoxinus

A small but well-marked fish with a streamlined torpedo-shaped body. The back and flanks are brown with darker bands often merging into lateral stripes, grading into silvery-yellow on the underside. In the breeding season males have a bright red underside and white tubercles on the head. Minnows usually live in quite large shoals in fast-flowing rivers and are an important prey species for larger fish and birds.

LENGTH 4–10cm
BREEDING Lays up to 1,000 eggs in depressions in gravel in shallow rivers in spring
FOOD Small aquatic invertebrates

HABITAT Clear, fast-flowing rivers and large, stony upland lakes
DISTRIBUTION Widespread in Britain and Ireland

Dace

Leuciscus leuciscus

A slender silvery fish with greyish-yellow fins. The upperparts are slightly darker than the flanks and belly, making it difficult to spot from above in murky water. Usually found in shoals and can be seen at the surface when flies are available. One of the most active members of the carp family.

LENGTH 15–25cm
BREEDING Lays several thousand eggs in shallow gravelly areas in spring
FOOD Small aquatic invertebrates and some plant material

HABITAT Fast-flowing clear rivers, sometimes in large lakes
DISTRIBUTION Widespread in Britain, scarce in Ireland

Chub

Squalius cephalus

A robust, almost cylindrical fish with a golden tinge to the flanks and a darker back. Slightly reddish fins. Small chub may be confused with dace, but are stockier and the anal fin is rounded, not concave as in the dace. The mouth is large and forward-pointing. Chub are rather solitary and can be voracious feeders, but are very wary and difficult to observe.

LENGTH 30–40cm
BREEDING Lays several thousand eggs (up to 200,000) in May–June
FOOD Aquatic invertebrates and small fish

HABITAT Clean, weedy rivers and canals
DISTRIBUTION Commonest in England, scarce in Wales and Scotland, absent from Ireland

Stoneloach

Nemacheilus barbatula

A small, slender, bottom-dwelling fish with a cylindrical body and excellent camouflage. The downward-pointing mouth is surrounded by three pairs of barbels which help locate its food. Its usual habit is to hide under stones, emerging at night to feed. Although quite common, it is often overlooked; usually absent from polluted rivers.

LENGTH 5–10cm
BREEDING Lays eggs in small batches under stones which may be guarded by male
FOOD Small aquatic invertebrates

HABITAT Fast-flowing, clean gravelly rivers and streams
DISTRIBUTION Widespread over most of Britain and Ireland

Perch

Perca fluviatilis

A powerful fish with striking markings. Its strangely hump-backed appearance is accentuated by the large spiny dorsal fin which can be raised when the fish is startled. Dark vertical bars on the body offer good camouflage in weedy rivers. Small perch live in shoals and are aggressive feeders; larger specimens are more solitary.

LENGTH 25–40cm
BREEDING Lays many thousands of sticky eggs in weedy ponds in early summer
FOOD Aquatic invertebrates when small; fish when larger, including other perch

HABITAT Weedy ponds and lakes, slow rivers and streams
DISTRIBUTION Widespread throughout Britain and Ireland, apart from far north

Bullhead

Cottus gobio

A very well-camouflaged, small fish of stony rivers and streams. The head and mouth are very large, but the body tapers rapidly towards the tail. Most of the fins and the gill covers are armed with sharp spines, but despite this bullheads are frequently caught and eaten by kingfishers. Hard to observe as they remain under stones for most of the day, but will dart off quickly if disturbed.

LENGTH 8–15cm
BREEDING Lays small number of large sticky eggs which are guarded by male under stone
FOOD Invertebrates, fish fry and eggs

HABITAT Clear stony rivers and streams
DISTRIBUTION Widespread in England and Wales, absent from Scotland and Ireland

Three-spined stickleback

Gasterosteus aculeatus

A common and widespread small fish of rivers, ponds and brackish water, with a rather ungainly body shape and three sharp spines in front of the dorsal fin. Colourings are mostly shiny olive-green, but in the breeding season the male acquires a bright red belly and blue eye, and builds a nest on the bottom of the pond into which he lures females to spawn. Spines are defence against other fish, but does not repel the kingfisher, which is a common predator.

LENGTH 4–7cm
BREEDING Up to 100 eggs laid in weed nest and guarded by male
FOOD Small aquatic invertebrates

HABITAT Ponds, canals and brackish water
DISTRIBUTION Widespread and often very common throughout Britain and Ireland

Nine-spined stickleback

Pygosteus pungitus

Britain's smallest fish, and best recognised by the 9 (sometimes 10) spines on the back which are raised when the fish is alarmed. The colourings are rather plain olive-brown for the most of the year, offering good camouflage in weedy ponds, but males become black in the breeding season with white spines on the pectoral fins. Males build a weed nest near the bottom of the pond.

LENGTH 2–6cm
BREEDING Females lays small number of eggs in nest guarded by male
FOOD Small aquatic invertebrates

HABITAT Weedy ponds and rivers, canals and brackish water
DISTRIBUTION Widespread in Britain and Ireland, absent from Scotland

SEASHORE
● *Often feed close to shore* ● *Many move into deep water to spawn*
● *Some may become stranded in rock pools*

Lesser spotted dogfish
Scyliorhinus canicula

Resembles a small shark, with spotted upperparts and a creamy-white underside. Very rough skin to the touch. The tail is long and slender and, in common with all sharks, the upper lobe is larger than the lower. Large mouth on the underside of the flat head, and large black eyes. Egg cases are familiar 'mermaid's purses', often washed up on beaches.

LENGTH Up to 95cm
BREEDING Lays 20 eggs in large capsules with trailing tendrils in winter and spring
FOOD Small fish, crustaceans and invertebrates
HABITAT Shallow seas, mouths of estuaries and rocky coasts
DISTRIBUTION Widespread and common around coasts of Britain and Ireland

Thornback ray
Raja clavata

A flattened, diamond-shaped member of the shark family, normally confined to the seabed. The back is marked with variable numbers of spots on a sandy-brown background and the underside is creamy-white. There are many spines on the upperparts, particularly along the spine and long tail. Sometimes occurs in quite shallow coastal waters and may be trapped in estuarine pools.

LENGTH Up to 90cm
BREEDING Lays eggs in large, flattened capsules in spring
FOOD Bottom-dwelling fish and crustaceans
HABITAT Sandy and muddy seabeds, large estuaries
DISTRIBUTION Common and widespread around the coasts of Britain and Ireland

Five-bearded rockling
Ciliata mustela

An elongated and rather cylindrical fish with five barbels around the mouth. The body is mostly uniform brown on the back and flanks, but is paler below. Long dorsal and anal fins are almost continuous with the tail. Usually remains concealed beneath stones, feeding mainly at night; sometimes stranded at low tide in pools.

LENGTH Up to 25cm
BREEDING Lays many thousands of eggs in spring and summer
FOOD Small fish and invertebrates
HABITAT Shallow, coastal waters
DISTRIBUTION Common and widespread around coasts of Britain and Ireland

Thick-lipped grey mullet
Chelon labrosus

A rather plain, silvery-grey fish with large scales and a thick upper lip on the small mouth, which can be protruded slightly. The lower lip has tubercles that aid in the normal feeding method of rasping algae off rocks or moored ships' hulls. Cylindrical and powerfully built body. Although mullet normally swim around slowly in shoals when feeding, they can move quickly if alarmed.

LENGTH Up to 50cm
BREEDING Lays large numbers of eggs in late autumn
FOOD Green algae, detritus and small invertebrates
HABITAT Estuaries, sheltered coasts, sewage and power station outfalls
DISTRIBUTION Common around most of British and Irish coasts, except north

Bass
Dicentrarchus labrax

A powerfully built fish with mostly silvery-grey colourings. The mouth and eyes are large, and there are two dorsal fins, the first having powerful spines. Small bass live in schools, often close to the shore, but older specimens are more solitary and highly predatory. Highly prized by anglers and chefs, becoming scarce in some areas.

LENGTH Up to 65cm
BREEDING Lays tens of thousands of small eggs in early spring
FOOD Invertebrates and fish
HABITAT Estuaries, rocky and sandy shores and open sea
DISTRIBUTION Widespread around most of Britain and Ireland

Corkwing wrasse
Crenilabrus melops

A very attractive small fish with variable colours and patterns, and large scales. The greenish-red body usually has a pattern of blue and orange lines and a dark spot at the base of the tail. The dorsal fin is large and the front portion spiny. Powerful teeth and jaws.

LENGTH Up to 20cm
BREEDING Lays small eggs in a seaweed nest in early summer
FOOD Small invertebrates, molluscs
HABITAT Unpolluted rocky coasts
DISTRIBUTION Widespread around coasts of Britain and Ireland

Butterfish
Pholis gunellus

An elongated fish with a bold pattern of white-rimmed black spots along the length of the back. The rest of the body is brownish. Long dorsal and anal fins, and short, rounded tail. Usually lives under stones and seaweeds close to the shore, and is often stranded by low tides, but can survive in damp conditions until tide returns.

LENGTH 15cm
BREEDING Lays sticky eggs which adhere in a ball and are guarded by adult
FOOD Small invertebrates
HABITAT Rocky shores with good seaweed growth
DISTRIBUTION Widespread around coasts of Britain and Ireland, commonest in north

Common blenny
Blennius pholis

A lively and attractive small fish of rocky shores. Usually noticed when rocks are lifted at low tide and it splashes around vigorously. The head is large and blunt, and the body tapers away to a small tail. There are several tiny tentacles around the nostrils. Minute scales set in the skin, which is extremely well camouflaged; the blenny can modify its colours to match its background, but is usually greenish-brown.

LENGTH Up to 10cm
BREEDING In summer lays sticky eggs which adhere to rocks
FOOD Small invertebrates, barnacles and green algae
HABITAT Rocky shores, estuarine pools and clean harbours
DISTRIBUTION Common and widespread around coasts of Britain and Ireland

Rock goby

Gobius paganellus

A well-camouflaged, small fish of rocky shores with a large rounded head and a tapering body. There are two dorsal fins, the first being shorter and spiny. Large mouth with thick lips. Tiny branched tentacles are located just above the nostrils. There are only a few visible scales on the body, located around the head. Rock gobies live under rocks and seaweed on the shore and are very difficult to spot unless they move.

LENGTH Up to 19cm
BREEDING Lays eggs in spring under rocks and seaweed
FOOD Small invertebrates
HABITAT Rocky shores and shallow coastal waters
DISTRIBUTION Common around coasts of Britain and Ireland, scarce in eastern England

Grey gurnard

Eutrigla gurnardus

An odd-shaped fish with a very large head and mouth and a rapidly tapering body. The pectoral fins support three feeler-like rays below the body on each side of the head; these are used for detecting food on the seabed in darkness. Very well camouflaged on the back and flanks, and silvery-white on the underside.

LENGTH Up to 30cm
BREEDING Lays tens of thousands of eggs in spring or summer
FOOD Small, bottom-dwelling invertebrates

HABITAT Sandy and muddy seabeds, often near rock outcrops
DISTRIBUTION Common and widespread around coasts of Britain and Ireland

Father lasher

Myoxocephalus scorpius

A very well-camouflaged, small fish with a relatively large head and mouth and a rapidly tapering body. The head and gill covers are well-armed with spines, and the first dorsal fin is also spiny. Dark and mottled upperparts; the underside is yellowish in females and redder with white spots in males. Also known as sea scorpion.

LENGTH Up to 15cm
BREEDING Lays up to 2,500 sticky eggs which are guarded in clumps by the male
FOOD Small fish and invertebrates
HABITAT Rocky seashores and shallow coastal waters
DISTRIBUTION Common and widespread around coasts of Britain and Ireland

Lumpsucker

Cyclopterus lumpus

A deep-bodied fish with a sucker on the underside formed from modified pelvic fins; this is used to help it hold on to rocks near the shore in rough seas. The body is covered with rows of tubercles and platelets, and is quite well camouflaged, making the fish hard to see among seaweeds. Adult males are reddish-brown, while females are greenish. The eggs are harvested and sold as a form of caviar.

LENGTH Up to 40cm
BREEDING Lays many thousands of sticky eggs which adhere to rocks in masses in early summer
FOOD Small invertebrates and fish
HABITAT Rocky coasts and open seas, especially where there are dense growths of seaweeds
DISTRIBUTION Widespread around coasts of Britain and Ireland

Common sea snail

Liparis liparis

A small, brownish fish resembling a large tadpole at first glance. The body is smooth and oval in profile with a large downward-pointing mouth and a tapering tail. Dorsal, tail and anal fins are continuous. The colourings are mostly a dull red or reddish-grey. Usually hides under rocks or seaweeds and is very hard to find.

LENGTH Up to 10cm
BREEDING Lays many very small sticky eggs in tiny clumps, which stick to rocks
FOOD Tiny invertebrates

HABITAT Rocky sea shores, clean coastal waters and estuaries in winter
DISTRIBUTION Widespread around coasts of Britain and Ireland

Cornish sucker

Lepadogaster lepadogaster

A small tadpole-like fish with a pointed snout and two tentacle next to the nostrils. Slightly flattened body with pelvic fins modified to form a sucker to help the fish cling on to rocks. The colourings are mostly reddish-brown and there are two blue 'eye-spots' on the head behind the true eyes. Usually found under stones or seaweeds, and hard to locate until it moves.

LENGTH Up to 6cm
BREEDING Lays sticky eggs in late summer, fixing them in patches under rocks
FOOD Small invertebrates

HABITAT Rocky shores and shallow coastal waters
DISTRIBUTION south-west coasts of Britain and Ireland

Sole

Solea solea

A flattened fish, which lies on its left side on the seabed. Oval outline; the dorsal and ventral fins are continuous with the tail. The upper side is mottled to match the seabed, and when the fish settles it ripples its fins to cover itself with sand. Moves in short bursts along the seabed, but usually remains still, waiting for prey to come close.

LENGTH Up to 25cm
BREEDING Lays large numbers of small floating eggs in summer
FOOD Small fish and bottom-living invertebrates
HABITAT Sandy and gravelly seabeds and large estuaries
DISTRIBUTION Widespread around coasts of Britain and Ireland

Flounder

Platichthys flesus

A flattened fish, lying on its left side, with a rounded-oval outline. The body is fringed by the dorsal and anal fins which do not join at the tail; the tail has a distinct, short stock and is relatively long. The upper side is well marked with spots and blotches and the fish can modify its colourings to suit its background. It usually lies on the seabed, but can swim in open water in pursuit of prey.

LENGTH Up to 50cm, usually much smaller
BREEDING Lays up to two million minute eggs in late winter
FOOD Small fish and bottom-dwelling invertebrates
HABITAT Estuaries, sandy seabeds and large river mouths
DISTRIBUTION Common and widespread around coasts of Britain and Ireland

INSECTS

BUTTERFLIES

● *Tend to rest with wings closed* ● *Antennae are club-tipped*
● *Fly during the day*

Large white

Pieris brassicae

WINGSPAN 60mm
Upperwings are creamy-white with dark tips on the forewing; females have two dark spots in the centre of the forewings. The underwings are yellowish. Flies May–September. The greenish-yellow and black caterpillars feed on cabbages and related plants. Widespread and fairly common throughout most of Britain in lowland areas.

Small white

Artogeia rapae

WINGSPAN 45mm
Smaller than large white but with similar markings; the creamy-white upperwings have a dark tip and there are two dark spots on the forewings in females. The underwings are yellowish. The caterpillars feed on cabbages and related plants. Flies April–May and July–August. Widespread and common throughout Britain in gardens and farmland.

Green-veined white

Artogeia rapae

WINGSPAN 45mm
Superficially like small white, but has prominent dark veins on upperwings and greenish veins on underwings. Caterpillars eat garlic mustard and related plants. Double-brooded, flying in spring and again in late summer. Common and widespread in open lowland areas.

Orange tip

Anthocharis cardamines

WINGSPAN 40mm
Male is easily recognised by large orange patches on dark-tipped forewings. Underwing of both sexes marbled greenish-brown; females lack orange patch. Flies in spring and caterpillars feed on cuckooflower and garlic mustard. Widespread and locally common.

Wood white

Leptidea sinapsis

WINGSPAN 40mm
A rather frail-looking, small, white butterfly with dark-tipped, rounded forewings. On the wing May–July, usually double-brooded. Flight is very weak and fluttery. The caterpillars feed on plants in the pea family. A local species of southern and SW England and southern Ireland.

Brimstone

Gonepteryx rhamni

WINGSPAN 60mm
One of the earliest butterflies to emerge in spring. Males have sulphur-yellow wings, females have the same angular shape but their wings are paler greenish-white and may be mistaken for large white in flight. Caterpillars feed on alder buckthorn. Common and widespread.

Clouded yellow

Colias croceus

WINGSPAN 50mm
A summer migrant, common in some years, looking all yellow in flight. Upperwings are orange-yellow in males, yellow in females, and have a dark border in both sexes. Underwings are mostly plain yellow. May breed in Britain in hot summers, but cannot survive the winter.

Small tortoiseshell

Aglais urticae

WINGSPAN 42mm
An attractive butterfly, common and widespread, especially in flower-filled parks and gardens. Upperwings are strongly marked with orange, yellow and black. The brownish underwings offer camouflage when the wings are closed. The caterpillars feed on stinging nettles. Adults may hibernate in outbuildings.

Painted lady

Vanessa cardui

WINGSPAN 60mm
A summer migrant, most common near coasts July–August. The upperwings are marbled pinkish-buff, with contrasting black and white wing tips. The underwings are a paler, buff version of the upperwings. May breed, laying eggs on thistles, but it cannot survive the winter in Britain.

Red admiral

Vanessa atalanta

WINGSPAN 60mm
Upperwings are mostly black with a pattern of red bands and white spots. The underwings are a mottled smoky-grey. Small numbers hibernate, but main influx is of summer migrants. Caterpillars feed on nettles. Very common and widespread in good summers.

Peacock

Inachis io

WINGSPAN 60mm
Easily recognised by the four large eye-spots on the maroon upperwings. The underwings are a dark brown and help camouflage the butterfly when hibernating. Caterpillars feed on stinging nettles. Common and widespread, apart from in the north.

Comma

Polygonia c-album

WINGSPAN 45mm
Wings have a striking ragged edge and the brown, mottled underwings bear the characteristic white 'comma' mark. The upperwings are an attractive mottled orange-brown. Double-brooded, flying in spring and autumn, and will hibernate. Adults visit rotting fruit, and caterpillars feed on nettles. Common and widespread.

White admiral

Ladoga camilla

WINGSPAN 50mm
Upperwings are black with broken white bands. The underwings are rich brown with a darker pattern. A powerful flier, on the wing June–July. Restricted to woodlands in southern England. Caterpillars feed on honeysuckle leaves; adults visit bramble flowers.

Pearl-bordered fritillary

Boloria euphrosyne

WINGSPAN 42mm
A small butterfly of woodland glades. Upperwings are orange with dark brown spots and blotches; underwings marked with paler orange. Distinctive silver spots on the hindwing – seven on the margin and two in the centre. The caterpillars feed on violets. Most common in southern England, rare in western Ireland.

Small pearl-bordered fritillary

Boloria selene

WINGSPAN 40mm
Very similar to the slightly larger pearl-bordered fritillary, but underwing has several silver spots in the centre, in addition to the seven on the margin. Flies in June in woodland clearings. Caterpillars feed on violets. Widespread but local.

Silver-washed fritillary

Argynnis paphia

WINGSPAN 60mm
A colourful orange-brown butterfly which flies in woodland clearings June–August. Often seen basking in the sun on bramble flowers. The underwings have a silvery sheen. The caterpillars feed on violets. Locally common in suitable woodlands in south and SW England.

Marsh fritillary

Euphydryas aurinia

WINGSPAN 40–50mm
Upperwings are marked with a bold pattern of yellow, brown and orange. A local species of marshy areas where larval food plant, devil's-bit scabious, occurs. Caterpillars also feed on plantains, so this species may also occur on dry chalk grasslands. Flies in May–June, but only when it is warm and sunny.

Speckled wood

Pararge aegeria

WINGSPAN 45mm
Upperwings are dark brown with yellowish markings and small eye-spots. The underwings are rufous brown. Enjoys basking in sunny woodland clearings and males defend territories. On the wing April–June and July–September.

Wall brown

Lasiommata megera

WINGSPAN 45mm
Resembles a fritillary at first glance, but has small eye-spots on the wings. The underwings are plainer. Formerly widespread and common, now more local and found on dry grasslands, heaths and coasts. Caterpillars feed on grasses. On the wing in April–May and again in July–September.

Marbled white

Melanargia galathea

WINGSPAN 50mm
Bold black and white patterns on the wings make this species easy to identify. On the wing in July–August, preferring flowery meadows and chalk downs, and often colonises roadside verges. Caterpillars feed on grasses. Confined mainly to SE and CS England, scarce elsewhere.

Grayling

Hipparchia semele

WINGSPAN 50mm
A difficult butterfly to see when resting as it sits with wings folded, showing well-camouflaged underwings. Upperwings brown with eye-spot. On the wing June–August, favouring warm, dry places. Widespread, apart from in Scotland.

Ringlet

Aphantopus huperantus

WINGSPAN 48mm
Males are darker brown than females, but both have variable numbers of eye-spots on the wings. Widespread, found in grassy places, roadsides, meadows and open woodlands. Absent from northern Scotland.

Gatekeeper

Pyronia tithonus

WINGSPAN 40mm
A common butterfly of hedgerows and grassy places, flying in late summer. The upperwings are a dusky brown with large orange patches and eye-spots on the forewings. Adults visit bramble flowers and ragwort, caterpillars feed on grasses. Widespread in southern England and Wales.

Meadow brown

Maniola jurtina

WINGSPAN 50mm
A common and widespread brown butterfly with small orange patch on the forewing containing an eye spot. The orange patch is larger in females. The caterpillars feed on various grasses. Occurs on roadside verges and many other grassy places, including woodland rides. Scarce in northern Scotland.

Scotch Argus

Erebia aethiops

WINGSPAN 40-53mm
A brown butterfly with black spots resembling eyes on the wings. The single flight of this species takes place between July and early September, the butterflies seldom taking to the wing unless the weather is sunny. Found in Scotland and northern England. Restricted to grassy areas, usually near forests in hills and mountains. Caterpillar feeds on couch grass.

Small heath

Coenonympha pamphilus

WINGSPAN 30mm
A small orange-brown butterfly with a eye-spot on the orange forewing. Double-brooded, flying in May-June and August-September. Caterpillars feed on grasses. Widespread, but only common in the south.

Small copper

Lycaena phlaeas

WINGSPAN 25mm
A small butterfly with attractively marked orange and brown wings; the patterns and colours are strongest on the upperwings. On the wing in two or three flight periods May–September. Caterpillars feed on sheep's sorrel. Common and widespread in suitable habitats.

Purple hairstreak

Quercusia quercus

WINGSPAN 38mm
Upperwings have a purple sheen which can be seen in good light, but when at rest closed wings show greyish underwing with white 'hairstreak' line and orange spot. Usually found around top branches of mature oaks. Flies July–August. Locally common in southern England and Wales; scarce in northern areas.

Green hairstreak

Callophrys rubi

WINGSPAN 25mm
A small, lively butterfly with bright green underwings and a faint broken white hairstreak line. The brown upperwings are rarely seen at rest. On the wing May–June. Caterpillars feed on gorse, heathers and trefoils; adults usually seen on heaths, cliffs and chalk scrub. Widespread and locally common.

Common blue

Polyommatus icarus

WINGSPAN 32mm
Male has blue upperwings and greyish-brown underwings with a pattern of white-rimmed black and orange spots. Females have similar underwings but are browner on the upperwing. On the wing in several broods April–September in a good summer. Caterpillars feed on trefoils. Common and widespread in most of Britain.

Chalkhill blue

Lysandra coridon

WINGSPAN 40mm
Male has attractive sky-blue upperwings, female's are dark brown with orange spots along the margins. The underwings are grey-brown with a pattern of spots. Caterpillars feed only on horseshoe vetch. Flies July–August. Restricted to chalk and limestone grassland in southern England.

Adonis blue

Lysandra bellargus

WINGSPAN 32mm
The male's upperwings are iridescent blue with black and white margins. Female has brown upperwings with a line of orange spots along the margin. The underwings of both sexes are brownish-grey with a pattern of spots. Caterpillars feed on horseshoe vetch. Flies July–August. Restricted to chalk downs in southern England.

Holly blue

Celastrina argiolus

WINGSPAN 30mm
A small butterfly that appears silvery in flight; at rest the violet upperwings are hardly ever seen. Underwings are very pale with a pattern of black dots. First brood fly April–May, laying eggs on holly, second brood flies August–September, laying eggs on ivy. Widespread in southern England and Wales, and southern Ireland.

Small blue

Cupido minimus

WINGSPAN 25mm
A tiny, very lively butterfly with smoky-brown upperwings showing a purplish sheen in males. The underwings are grey with a faint pattern of dots. Flies June–July on chalk grassland where kidney vetch, the food plant of caterpillars, is common. Locally common in southern England and Wales.

Silver-studded blue

Plebejus argus

WINGSPAN 25–30mm
Male has violet-blue upperwings with a white border; female has brown upperwings. Underwings of both sexes are grey with a pattern of orange and black spots. On the wing June–July, occurring mainly on heaths in southern England, and occasionally further north where caterpillar's food plants, gorse and ling, are common.

Brown argus

Aricia agestis

WINGSPAN 25mm
Like a small female common blue, but with a more prominent pattern of orange spots on the upperwing. Underwings are grey with white-bordered orange and black spots. Caterpillars feed on rock-rose and stork's-bills. Local in southern and central England.

Small skipper

Thymelicus flavus

WINGSPAN 25mm
A small, lively butterfly of sunny meadows and grasslands, usually seen feeding on thistles and daisies. Upperwings are mostly orange-brown with darker lines; underwings are paler. Wings held partly open at rest. Caterpillars feed on grasses. Flies July–August. Common in southern England and Wales.

Essex skipper

Thymelicus actaeon

WINGSPAN 25mm
Very similar to small skipper, but antennae have black, not brown, undersides to the tips. Often occurs in same areas as small skipper. Flies June–July, and is restricted to SE England. Caterpillars feed on various grasses; adults visit knapweeds and thistle.

Large skipper

Ochlodes venatus

WINGSPAN 34mm
The upperwings are mostly dark orange-brown with a pattern of paler orange markings. The underwings are buff-orange with a pattern of paler spots. On the wing June–July in open, grassy areas. It is common in England and Wales, but absent from Scotland and Ireland.

Dingy skipper

Erynnis tages

WINGSPAN 25mm
May be mistaken for a moth. Upperwings are dark grey-brown, underwings reddish-brown; the sexes are similar. Rapid and erratic flight. On the wing May–June, favouring meadows, rough grassland and woodland rides. Caterpillars feed on trefoils and vetches. Locally common in England and Wales, scarce in Scotland.

Grizzled skipper

Pyrgus malvae

WINGSPAN 20mm
A small butterfly with grey-brown upperwings mottled with white spots and a white border; the reddish-brown underwings are also patterned with white spots. On the wing May–June. Found mainly in southern England and Wales in rough grassland and woodland rides where the caterpillar's food plants, wild strawberry and cinquefoils, occur.

MOTHS

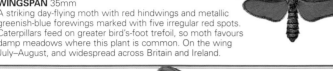

- *Feathery antennae* ● *Most are night-flying*
- *Tend to rest with camouflaged wings open*

Five-spot burnet

Zygaena trifolii

WINGSPAN 35mm
A striking day-flying moth with red hindwings and metallic greenish-blue forewings marked with five irregular red spots. Caterpillars feed on greater bird's-foot trefoil, so moth favours damp meadows where this plant is common. On the wing July–August, and widespread across Britain and Ireland.

Lappet moth

Gasteropacha quercifolia

LENGTH AT REST 40mm
An extremely well-camouflaged moth when resting during the day among fallen leaves. The reddish wings have scalloped margins and the head tapers to a pronounced snout. On the wing July–August. Caterpillars are also well camouflaged, feeding on hawthorn. Most common in southern England and Wales.

Ground lackey moth

Malacosoma castrensis

LENGTH AT REST 17mm
A slightly hairy-looking moth. Caterpillars, which feed on sea-lavender and other saltmarsh plants, sometimes seen in or on communal, silken webs. Adult flies in July and August but difficult to observe. Confined to coastal areas in southeast England and distinctly local.

Emperor moth

Saturnia pavonia

WINGSPAN 50–60mm
A large and striking day-flying moth of heaths and moors. The wings are marked with large eye-spots; the hindwings are 'flashed' to scare off predators. Females are mostly grey, males are more rufous. Caterpillars are bright green and spotted, feeding mainly on ling. They pupate in pear-shaped silken cocoons. Widespread throughout Britain and Ireland.

Lime hawkmoth

Mimas tiliae

WINGSPAN 65mm
Adults are well camouflaged when resting on leaves. Colours can vary, but are usually olive-green and buff with darker markings. Wings have a scalloped trailing edge. On the wing May–June and common in southern England, rarer elsewhere. Caterpillars feed on lime, so they are often found in parks and gardens.

Small elephant hawkmoth

Dielephila elpenor

WINGSPAN 50mm
An attractive small moth with pink and orange wings and body; sometimes seen on the wing at dusk in June–July. The caterpillar is brown with eye-spots at the head end, but lacks a 'horn' on the tail. It feeds on bedstraws and is restricted to heaths and grasslands. Widespread, but scattered.

Broad-bordered bee hawkmoth

Hemaris fuciformis

WINGSPAN 43 mm
Transparent wing panels give it the appearance of a bumblebee. On the wing during the day in May–June, usually visiting bugle. Caterpillars feed on honeysuckle. Found in southern woodlands.

Eyed hawkmoth

Smerinthus ocellatus

WINGSPAN 80mm
The forewings are grey-brown, concealing the rosy hindwings which have large eye-spots, exposed only when the moth is startled. Scalloped trailing edges to the wings. The bright green caterpillars feed on willows and apple; when mature they have stripes and a 'horn' on the tail. Common in southern England, scarce elsewhere.

Pine hawkmoth

Hyloicus pinastri

WINGSPAN 80mm
Very well camouflaged when wings are closed whilst resting on pine bark during the day. Hindwings are buff-orange, but rarely exposed. On the wing June–July. Caterpillars feed on pine needles, have lateral stripes and 'horn' at tail end. Increasingly common in southern England.

Privet hawkmoth

Sphinx ligustri

WINGSPAN 100mm
Well camouflaged when resting with closed wings, but if alarmed hindwings are revealed to show black and pink stripes. Caterpillars are large and green with purple and white diagonal stripes and a 'horn' on the tail. They feed on privet and lilac, so are often seen in gardens, mainly in southern England. Adults fly in June and July.

Elephant hawkmoth

Dielephila elpenor

WINGSPAN 70mm
A colourful moth with pink and olive colourings; body tapers to a sharp point. The large, brown caterpillars have eye-spots to deter birds; a slight resemblance to elephant's trunk explains the common name. Caterpillars usually feed on willowherbs and fuchsias. On the wing May–June and common only in Wales and southern and central England.

Poplar hawkmoth

Laothoe populie

WINGSPAN 70mm
A very well-camouflaged moth when at rest, with grey-brown wings and a broken outline. The hindwing has a reddish patch which is exposed suddenly if the moth is startled. Caterpillars feed on poplars and willows; they are large and green with a 'horn' on the tail. Common and widespread in mainland Britain.

Hummingbird hawkmoth

Macroglossum stellatarum

WINGSPAN 45mm
A summer migrant, mainly to southern England, seen on the wing during the day, hovering in front of colourful flowers and taking nectar with its long tongue. Caterpillars feed on bedstraws and may occur in exceptionally warm summers. Very well camouflaged when at rest, and flies off rapidly if disturbed.

Puss moth

Cerura vinula

LENGTH AT REST 35mm
A light grey, rather furry-looking moth with a pattern of darker lines on the wings. On the wing May–July. The caterpillar is truncated and mostly green with two long tail appendages; it is usually found on willows and poplars. The moth is common and widespread in most of Britain.

Garden tiger moth

Arctia caja

WINGSPAN 65mm
A very striking moth with a bold pattern on the forewings and orange and black hindwings, which are exposed when danger threatens. On the wing July–August; attracted to lights and common in parks and gardens. The caterpillars are hairy, and feed on a wide range of plants.

Lobster moth

Stauropus fagi

LENGTH AT REST 32mm
The caterpillar bears a remote resemblance to a lobster – hence the name – and can be found on young beech and oak leaves. The adult moth is remarkably well camouflaged on tree bark, with greyish-buff wings and the habit of remaining motionless. On the wing May–July.

White ermine

Spilosoma lubricipeda

LENGTH AT REST 28mm
A mostly white moth with a scattering of black dots on the wings. The head is very hairy. The wings conceal the yellow and black abdomen when the moth is resting. On the wing May–July and attracted to lights. Caterpillars eat a wide range of plants. Widespread and common in many habitats.

Buff tip

Phalera bucephala

LENGTH AT REST 30mm
The buff head and wing tips, and the silvery, mottled wings create the impression of a snapped-off twig, and the moth normally remains motionless to complete the illusion. On the wing May–July and found in woodlands and gardens over most of Britain and Ireland. The yellow and black caterpillars feed on a variety of trees and shrubs.

Cinnabar moth

Tyria jacobaeae

LENGTH AT REST 22mm
Overall colour is charcoal-grey, but the wings have red lines and spots. On the wing May–July, usually at night, but is sometimes day-flying. The orange and black striped caterpillars feed on toxic ragwort and groundsel, and become poisonous to birds. Widespread and common.

Yellow-tail moth

Euproctis similis

LENGTH AT REST 24mm
A bright white moth, but with a yellow-tipped abdomen which it exposes when in danger. Caterpillars are black and red and very hairy, feeding on a variety of deciduous shrubs. Irritant hairs can cause skin rashes if handled. On the wing July–August and sometimes very common.

Large yellow underwing

Noctua pronuba

LENGTH AT REST 25mm
Forewings vary considerably: sometimes straw-brown but frequently much darker, almost black. Hindwings usually hidden at rest, but are bright orange-yellow with a well-defined but narrow dark sub-terminal band around border. When alarmed, sometimes flashes hindwings but often scuttles off or flies away. On the wing July–September. Caterpillars feed on a range of herbaceous plants. Widespread and common.

Sallow kitten

Furcula furcula

LENGTH AT REST 20mm
A small moth with greyish wings covered by a darker band, spots and lines. It flies in two broods, May–August, and is attracted to lights. The caterpillars feed on willows and poplars, and are bright green with a blunt head and two appendages on the tail. Found throughout most of Britain.

Heart and dart

Agrotis exclamationis

LENGTH AT REST 20mm
English name derives from the dark heart and dart-shaped markings on the buff-brown wings. On the wing May–July and attracted to lights, often occurring in hundreds in moth traps. Very common and widespread in a range of habitats. Larvae eat a range of herbaceous plants.

Pale prominent

Pterostoma palpina

LENGTH AT REST 30mm
Resting moth is well camouflaged, resembling a chip of wood. Profile shows outgrowths on the wings and tufts projecting from the abdomen and head. On the wing May–August and found mainly in damp woodland areas. Caterpillars feed on sallow and aspen.

Chocolate tip

Clostera curtula

LENGTH AT REST 17mm
The grey-brown wings are marked with silvery lines and a chocolate-maroon tip; the brown tip to the abdomen is sometimes exposed if the moth is threatened. On the wing, in two broods, May–September. Usually found in wooded areas where larval food plants of aspen, poplar and willows occur. Attracted to lights. Widespread and locally common.

Hebrew character

Orthosia gothica

LENGTH AT REST 20mm
Wings are brownish buff with faint markings and the typical black 'hebrew character' mark on each side. Caterpillars feed on a range of plants. Common and widespread in many habitats. On the wing March–April.

Great prominent

Peridea anceps

LENGTH AT REST 30mm
Very well camouflaged when resting on bark, with marbled grey-brown wings and hairy legs and head. Flies from May–July and is attracted to light. Caterpillars feed on oak, and are large and green with diagonal stripes. Confined mainly to areas with mature oaks.

Burnished brass

Diachrisia chrysitis

LENGTH AT REST 21mm
A very eye-catching moth with golden-metallic patches on the forewings, which are held over the body to give a wedge shape. Double-brooded, flying June–July and later in August; attracted to lights. Caterpillars feed on nettles and other herbaceous plants. Widespread across Britain and Ireland in a wide range of habitats.

Silver Y

Autographa gamma

LENGTH AT REST 21mm
A migrant, arriving in summer and autumn from the Continent, numbers depending on weather conditions. May fly during the day in summer and visits flowers at dusk. Sometimes attempts breeding but cannot survive the winter. Commonest near southern and eastern coasts.

Red underwing

Catocala nupta

WINGSPAN 65mm
Extremely well camouflaged when at rest on bark with wings closed, but forewings open to reveal striking red and black striped hindwings when moth is threatened. Flies August–September. Caterpillars feed on willows and poplars. Restricted mainly to open woodlands in southern England.

Pebble hooktip

Drepana facataria

WINGSPAN 28mm
Flattened triangular outline of wings shows hooked tips. Colours are variable, but there are usually darker transverse lines and two central eye-spots. Caterpillars feed mainly on birches. On the wing May–June and widespread where food plants are available.

Large emerald

Geometra papionaria

WINGSPAN 42mm
A very attractive, large, bright green moth, especially when newly emerged. Caterpillars feed on birch and hazel. Adults are on the wing July–August and are attracted to lights. Commonest in mixed woodlands in southern Britain.

Canary-shouldered thorn

Ennomos alniaria

WINGSPAN 35mm
Name is derived from the bright yellow thorax. The wings are usually yellowish-buff with darker specklings. On the wing August–September in wooded areas; widespread but never very numerous. Caterpillars feed on trees and shrubs, including birch and hazel.

Brimstone moth

Opisthographis luteolata

WINGSPAN 28mm
Bright yellow wings with a few small brown blotches make recognition easy. On the wing April–October in several broods, especially in a good summer. May fly during the day if disturbed. Caterpillars feed on blackthorn, hawthorn and hedgerow shrubs. Common and widespread.

Swallowtailed moth

Ourapteryx sambucaria

WINGSPAN 52mm
A large, pale yellow moth with distinctive angular wings terminating in short tail-streamers. On the wing June–July and found in most of Britain and Ireland, apart from the far north. Prefers open woodlands, hedgerows and gardens. Caterpillars feed on ivy and hawthorn.

Angle shades

Phlogophora meticulosa

LENGTH AT REST 27mm
When at rest the forewings have in-rolled leading edges and a ragged margin. The colourings can be olive-green or buff-brown, with a pinkish-brown triangular mark on each wing. Adults can be found on the wing through most of the summer and are attracted to lights. Widespread throughout most of Britain and Ireland.

Herald

Scoliopteryx libratrix

LENGTH AT REST 20mm
The forewings are brick-red with darker brown areas and thin white bars, and have a scalloped trailing edge. On the wing in autumn, and then appears again in spring after hibernation. Caterpillars feed on many shrubby plants. Widespread in England, Wales and Ireland in a range of habitats.

Mother shipton

Callistege mi

WINGSPAN 23mm
Name derives from supposed profile of the witch 'Mother Shipton' on each forewing. On the wing May–July, often flying during the day; easily disturbed from vegetation. Caterpillars feed on clovers. Commonest in England, Wales and Ireland in a variety of grassy and shrubby habitats.

Magpie moth

Abraxas grossulariata

WINGSPAN 38mm
A very distinctive pattern of black spots and yellow patches cover the white wings. On the wing July–August. A widespread and common moth everywhere apart from Scotland, found in a range of habitats where food plants occur. Caterpillars feed on various shrubby plants.

Speckled yellow

Pseudopanthera macularia

WINGSPAN 30mm
The wings are yellow with numerous grey-brown blotches. Will fly in daytime if disturbed from vegetation. On the wing May–June and commonest in southern Britain and Ireland, preferring open woodlands, scrub and hedgerows. Caterpillars feed on wood sage and other herbaceous plants.

Peppered moth

Biston betularia

WINGSPAN 48mm
May be all sooty-black, but is usually white with a varying degree of dark speckling on the broadly triangular wings. Very well camouflaged on lichen-covered bark. Adults are on the wing May–August. Caterpillars feed on the leaves of a wide range of shrubs and trees. Widespread in most of Britain and Ireland, scarce in Scotland.

MAYFLIES, DRAGONFLIES AND DAMSELFLIES

● *Nymphs live in freshwater streams and ponds*
● *Nymphs usually carnivorous* ● *Adults are shortlived*

Mayfly

Ephemera vulgata

BODY LENGTH 20mm
Adult is a short-lived insect with large, delicate wings and a yellowish body with darker markings on the abdomen. On the wing for brief periods during mid-summer. Nymph is orange-brown, has three thin 'tails', and lives in burrows in sand in clean rivers.

Southern hawker

Aeshna cyanea

BODY LENGTH 70mm
A large and highly active dragonfly, common on most clean ponds, lakes and canals. Adults patrol a territory, and may wander along woodland rides well away from water. Thorax and abdomen show large patches of green on a brownish background, males have blue markings at tip of abdomen. Found mainly in southern and central England.

Brown hawker

Aeshna grandis

BODY LENGTH 74mm
A very large dragonfly with all brown and bronze colourings. Males have blue spots on two segments of abdomen. Highly active, defending a large territory. Prefers well vegetated, still or slow-moving water, and found mainly in southern and central England.

Emperor dragonfly

Anax imperator

BODY LENGTH 78mm
Large dragonfly, mostly blue in males and greenish-blue in females, with a dark line running the length of the abdomen. Active and alert, and difficult to approach. Hunts over open water, preferring lakes, ponds and canals, mainly in southern England.

Golden-ringed dragonfly

Cordulegaster boltonii

BODY LENGTH 78–80mm
Abdomen is boldly marked with bright yellow rings on a black background. Usually found on clean, fast-flowing rivers and streams, often in upland areas. Commonest in western England, Wales and Scotland.

Broad-bodied chaser

Libellula depressa

BODY LENGTH 43mm
Abdomen is broad and flattened and wings have brown spots at base. In mature males the abdomen is dusty blue with lateral yellow spots, but in immature males and females it is brown with larger yellow spots. Hunts over water, but also uses perches for lookouts. Favours still waters and is commonest in southern England.

Black-lined skimmer

Orthetrum cancellatum

BODY LENGTH 50mm
Abdomen is broad but tapering, with black lines on a yellow background in females and immature males. Mature males have black-tipped, blue abdomen with yellow spots on sides. Hunts low over water and uses perches. Prefers weedy, still water; confined to SE England.

Common sympetrum

Sympetrum striolatum

BODY LENGTH 36mm
A very common and widespread species of late summer in much of England and Wales. Male has red abdomen, immature males and females have orange-brown abdomen. Hunts over water. Prefers well-vegetated, still waters.

Banded demoiselle

Calopteryx splendens

BODY LENGTH 45mm
A bright, metallic blue-green damselfly with a fluttering flight, especially in females. Males are metallic blue with a blue 'thumbprint' on the wings, females are metallic green with greenish-brown wings. Favours fast-flowing clean streams; widespread, but absent from Scotland.

Demoiselle agrion

Calopteryx virgo

BODY LENGTH 45mm
Male is metallic blue with wings mostly blue-brown, females are metallic green with dull brownish wings. Flight is fairly weak and fluttering. Prefers fast-flowing, clear streams.

Common coenagrion

Coenagrion puella

BODY LENGTH 33mm
A small damselfly, widespread and common over most of Britain and Ireland, but scarce in Scotland and Wales. Male is sky blue with black bands along abdomen. Second segment has black 'U' mark. Females are mostly black with blue tip to abdomen. Favours well-vegetated, still water.

Common blue damselfly

Enallagma cyathigerum

BODY LENGTH 32mm
Very similar to common coenagrion but second abdomen segment has black dot on a stem marking against a blue background. Females are marked with green and black. Prefers well-vegetated ponds and other still water. Common and widespread.

Blue-tailed damselfly

Ischnura elegans

BODY LENGTH 32mm
Sexes are similar with mostly black body and sub-terminal bright blue band on abdomen. Widespread and common apart from northern Scotland. Prefers still water.

Large red damselfly

Pyrrhosoma nymphula

BODY LENGTH 35mm
Abdomen is bright red in both sexes, but more black in males. Usually first species to emerge in spring; flight is weak. Usually seen on waterside plants. Common and widespread.

GRASSHOPPERS AND BUSH-CRICKETS
- Large hind legs for jumping ● Biting jaws
- Adult males produce sounds by rubbing legs or wings

Common field grasshopper
Chorthippus brunneus

BODY LENGTH 18–24mm
A common and widespread species with mostly brownish-buff colourings and some darker markings, giving good camouflage. Females are larger than males. Prefers drier grassy habitats.

Common green grasshopper
Omocestus viridulus

BODY LENGTH 17–20mm
Usually all green, but may show some darker or buff colouration on abdomen and wings. The top of the head has a keel. Common in a range of grassy places over most of Britain and Ireland.

Meadow grasshopper
Chorthippus parallelus

BODY LENGTH 17–23mm
A widespread and common species, but absent from Scotland. Both sexes have forewings shorter than abdomen, especially in female, and no hindwings. Colour variable, but usually green with brown parts.

Dark bush-cricket
Pholidoptera griseoaptera

BODY LENGTH 15–17mm
Upperparts mostly brown, underside yellowish. Wings are vestigial and used to produce calls in males. Most common in southern England and Wales in shrubby habitats, hedgerows and gardens.

Speckled bush-cricket
Leptophyes punctatissima

BODY LENGTH 14mm
Body is bright green with a covering of black speckles, wings are vestigial and females have broad, upcurved ovipositor. Legs and antennae are relatively long. Commonest in southern England and Wales, favouring shrubby areas, gardens and hedgerows.

Oak bush-cricket
Meconema thalassinium

BODY LENGTH 15mm
A slender green bush-cricket. Female has a thin ovipositor at the tip of the abdomen. Wings are longer than body and legs, and antennae are long and thin. Found in woodlands and gardens; attracted to lights. Commonest in southern England and Wales.

Bog bush-cricket
Metrioptera brachyptera

BODY LENGTH 17mm
Mostly brown on upperparts, but with bright green underside. Wings can be brown or green; some forms have very short wings. There is a pale line on the edge of the pronotum. Restricted to bogs and wet heaths in England and Wales.

EARWIG
- No wings ● Plant feeders
- Males have abdominal 'pincers'

Earwig
Forficula auricularia

BODY LENGTH 13mm
A very common and widespread insect found in a variety of habitats where there is leaf litter, stones or other things to hide under. Wings are vestigial; males have curved 'pincers' at tip of abdomen. Most active at night, feeding on plant debris.

WATER BUGS
- One pair of wings
- Tube-like mouthparts ● Air-breathers

Pond skater
Gerris lacustris

BODY LENGTH 10mm
Always seen skimming over water surface, supported on tips of long legs. Feeds on insects trapped in surface film. Widespread and common on ponds, lakes and canals. Adults hibernate out of water.

Lesser water boatman
Corixa punctata

BODY LENGTH 10mm
Very common in weedy ponds and lakes, swimming on long, paddle-like legs. Common throughout the year. In summer may leave the water and fly, and is attracted to lights. Feeds on pondweeds and detritus.

Water boatman
Notonecta glauca

BODY LENGTH 14mm
Larger than lesser water boatman, and swims upside down using fringed legs as paddles. Feeds on other insects trapped in surface film, capturing them from below. May have silvery appearance due to air film on body surface. Common and present all year round.

Water scorpion
Nepa cinerea

BODY LENGTH 30mm
Well-camouflaged in weedy ponds with its leaf-like body shape. The long tube at its tail end is used to breathe air from surface while the front legs form pincers to grasp prey. Moves slowly through pondweeds, preferring still waters. Widespread, but can be difficult to locate.

Water stick insect
Ranatra linearis

BODY LENGTH 50mm
A very well-camouflaged insect with a long, slender body resembling a pondweed stem. Remains still when caught in a pond sample. When feeding, adopts the posture of a praying mantis, with breathing tube extended to surface. Commonest in weedy ponds in southern Britain.

BUGS
● *Tube-like mouthparts* ● *One pair of wings*
● *Feed on plant sap*

Hawthorn shield bug
Acanthosoma haemorrhoidale

BODY LENGTH 13mm
A flattened, shiny green bug with a stippling of black dots on the wings which are membranous at the tips. Mouthparts are formed into long tube used for feeding on hawthorn berries. Only occurs where hawthorn is present. Adults hibernate in leaf litter. Widespread, apart from Scotland.

Green shield bug
Palomena prasina

BODY LENGTH 13mm
Rounded oval in outline, and mostly green with black dots and dark wingtips. Adults hibernate, emerging in May. Widespread and common, apart from northern Scotland. Feeds on hazel and other shrubs.

Forest bug
Pentatoma rufipes

BODY LENGTH 14mm
Mostly reddish-brown with an orange spot in the centre of the back, and orange legs. Shield-shaped outline with lateral outgrowths on the pronotum. Common in wooded areas, especially where oak dominates. Adults present in autumn; larvae hibernate.

Red and black leafhopper
Cercopis vulnerata

BODY LENGTH 9mm
Conspicuous shiny red and black leafhopper, usually found in small colonies on low vegetation or bark. Jumps well when disturbed. Adults feed on plant sap and nymphs feed on roots. Common and widespread in wooded and shrubby areas.

APHIDS
● *Tube-like mouthparts* ● *Usually have no wings*
● *Produce live young*

Blackfly or black bean aphid
Aphis fabae

BODY LENGTH 2mm
A widespread and sometimes abundant species, often occurring in gardens on beans in huge colonies. Females mostly wingless, but winged females appear in summer and fly off to found new colonies. May be 'milked' by ants for honeydew, and eaten by ladybirds.

Rose aphid
Macrosiphum rosae

BODY LENGTH 2mm
Often known as greenfly – may be green or pink. Has two black projections near tip of abdomen. Normally wingless. Found in large crowded colonies, mainly on roses but spreads to other plants later in summer.

ALDERFLY
● *Aquatic larvae* ● *Sensitive to pollution*
● *Prominent veins on wings*

Alderfly
Sialis lutaria

BODY LENGTH 14mm
Adult resembles lacewing, but brownish wings have more veins and are held over the body in a tent-shape when resting. Associated with clean water and very widespread. Several similar species occur. Larvae are aquatic.

LACEWING
● *Predatory larvae* ● *Adults eat insects*
● *One pair of wings*

Lacewing
Chrysoperla carnea

BODY LENGTH 15mm
Wings are delicate and transparent. Body usually greenish with bright metallic eyes. Larvae feed on aphids and hide themselves in cases made from their empty skins.

Scorpionfly
Panorpa communis

BODY LENGTH 14mm
A fierce-looking fly with a beak-like head and jaws used to feed on insects and detritus; may scavenge from spiders' webs. The male has a scorpion like tip to the abdomen. Common in summer in hedgerows and scrub.

CADDISFLY
● *Aquatic larvae* ● *Larvae make cases from stones, shells, pondweed*
● *Adults fly at night*

Caddis fly
Limnephilus elegans

BODY LENGTH 12mm
A conspicuous caddis with rather hairy, grey-brown wings covered with darker lines. In common with other caddis species, the antennae are held forward at rest. Commonest in slow-flowing rivers and upland pools. Larvae make a large case of plant materials.

Caddis fly
Glyphotaelius pellucidus

BODY LENGTH 16mm
A common and widespread species of still water. The larvae make cases from sections of leaf and are very hard to find unless they move. Adults emerge in early summer and have marbled brown and white wings.

Caddis fly
Limnephilus spp larva

LENGTH OF LARVAL CASE 18mm
Larval case is constructed from small pieces of pondweed with new pieces added as larva grows. Head end of tube is green where pondweed is freshest. Common and widespread in clean, weedy ponds and lakes.

Caddis fly
Phrygaena striata

BODY LENGTH 25mm
A large caddis fly which is sometimes found in moth traps. Widespread and common, especially in north and west. The wings are mostly brown with buff marblings and some darker lines. The female has a broken dark line on the forewing.

FLIES
- *One pair of wings* ● *Tube-like mouthparts*
- *Larvae often feed on carrion or waste material*

Cranefly

Tipula maxima

BODY LENGTH 30mm
A common and widespread insect of grasslands, including garden lawns, with a fluttering flight and trailing legs. Adults appear in late summer. Larvae feed underground on plant roots and are called 'leatherjackets'.

Mosquito

Culex sp.

LARVA BODY LENGTH 6mm
Larvae are common in stagnant water, seen wriggling near surface and coming up to breathe air. Adults are familiar mosquitoes; females suck blood, but males take only nectar.

St Mark's fly

Bibio marci

BODY LENGTH 11mm
Adults are often on the wing around St Mark's Day (25 April). Body is black and hairy and antennae are short. Flies with legs dangling and rests on vegetation. Larvae live in soil. Commonest in grassy areas and quite widespread.

Horse fly

Tabanus bromius

BODY LENGTH 14mm
A large horse fly with yellowish-brown and black markings on the abdomen. On the wing in summer and usually associated with farm animals; will inflict painful bite on humans. Larva is carnivorous, living in damp soil.

Bee fly

Bombylius major

BODY LENGTH 10mm
Short, hairy, bee-like body and long proboscis are distinctive. Habit of hovering, emitting high-pitched hum add to impression of being a bee. On the wing in spring and visits flowers for nectar. Larvae are predatory, feeding on solitary bee larvae. Widespread and common in southern Britain.

Drone fly

Eristalis tenax

BODY LENGTH 12mm
Bears a strong resemblance to honeybee, but large eyes and lack of pinched 'waist' between thorax and abdomen show this to be a fly. Visits flowers for nectar. Larva is 'rat-tailed maggot', which lives in stagnant water. Common and widespread.

Hoverfly

Heliophilus pendulus

BODY LENGTH 10mm
A common hoverfly of flower beds and hedgerows, visiting flowers for nectar, or hovering over water. Larvae feed in stagnant water. Commonest in damp woodlands and very widespread.

Hoverfly

Sericomya (borealis) silentis

BODY LENGTH 16mm
A convincingly wasp-like hoverfly often seen visiting flowers for nectar. Commonest in damp, boggy areas, moors and heaths, and widespread in Britain and Ireland. Adults on the wing in summer. Larvae live in damp soil.

Hoverfly

Volucella bombylans

BODY LENGTH 14mm
Very similar to a small bumble bee, with a hairy body and red- or white-tipped abdomen. Most often seen visiting flowers of brambles and other hedgerow species. Larvae live in nests of bees and wasps.

Greenbottle

Lucilia caesar

BODY LENGTH 9mm
Body is metallic green or bronzy-green, gleaming in sunlight when fly is basking. Eyes are red-brown. Common in wide range of habitats, feeding on flowers, carrion and detritus. Larvae feed on carcasses.

Flesh fly

Sarcophaga carnaria

BODY LENGTH 15mm
The dark greyish body has white markings on the abdomen and the eyes are red. The feet are larger than in most flies. Attracted to carcasses in which females give birth to live young. Common and widespread, but rarely found indoors.

Lesser house fly

Fannia canicularis

BODY LENGTH 5mm
Resembles a small housefly, but wing veins differ; fourth vein is straight, not bent. Often found indoors, with males flying round and round light fittings. Larvae feed on carcasses and dung.

Bluebottle

Calliphora erythrocephala

BODY LENGTH 11mm
Very frequent visitor to homes, dustbins, etc. Body is shiny blue and eyes are red-brown. Makes buzzing sound in flight. Females search for meat to lay eggs on. Present all year, but most numerous in summer.

Yellow dung fly

Scatophaga stercoraria

BODY LENGTH 9mm
Distinctive, furry, golden-brown fly, usually seen in small swarms on cowpats in summer. Males ambush females for mating. Adults eat other flies and larvae feed inside cowpat. Very common and widespread.

Birch sawfly

Cimbex femoratus

BODY LENGTH 21mm
A large fly with yellow-tipped antennae and yellow at the base of the abdomen. The wings are dark-bordered and slightly clouded. On the wing May–June, making a buzzing sound in flight. Larvae resemble green and yellow caterpillars and feed on birch leaves. Scattered, in areas where birch is common.

WASPS

● *Some have parasitic larvae*
● *May live in colonies* ● *May have a 'sting'*

Giant wood wasp

Uroceras gigas

BODY LENGTH 30mm
Alternative name is 'horntail' because of long ovipositor on female used to lay eggs in timber. Mostly black and yellow colours. On the wing May–August and widespread in pine forests.

Knopper gall

Andricus kollari

DIAMETER UP TO 28mm
Strange ridged outgrowths on acorns of pedunculate oak are caused by larvae of gall wasp, *Andricus quercuscalicis*, living inside acorn. Second generation lives inside catkins of turkey oak, so only common where both tree hosts are present.

Oak apples

Biorrhiza pallida

DIAMETER Up to 25mm
Rounded, buffish-brown clusters of 'fruits' on oak twigs in early summer are galls containing larvae of gall wasps, a separate sex in each gall. After emergence females lay eggs near ground and second generation live on roots.

Robin's pincushion

Diplolepis rosae

DIAMETER Up to 25mm
Red, bushy growths on dog rose contain a chambered gall in which larvae of gall wasp develop. Often parasitised by other gall wasps, so several different species may emerge. Common and widespread where host plant occurs.

Cherry galls

Diplolepis quercusfolii

DIAMETER Up to 10mm
Colourful spherical galls growing out of veins on underside of leaves of oak contain single larva of gall wasps. Adults emerge after leaves have fallen.

Spangle galls

Neuroterus quercusbaccarum

DIAMETER Up to 4mm
Disc-like galls found in clusters on underside of oak leaves protect larvae of gall wasp. Second generation causes clusters of 'currant galls' on oak catkins.

Ruby-tailed wasp

Chrysis ignita

BODY LENGTH 11mm
A small wasp with a shiny green head and thorax, and ruby-red abdomen tip. On the wing June–July; female may be seen searching for mason wasp nests to lay eggs inside the larvae.

Field digger wasp

Mellinus arvensis

BODY LENGTH 12mm
Resembles true wasp but pinched 'waist' is more pronounced. Digs deep burrow in sandy soil and collects flies to feed larvae after paralysing them with its sting. On the wing throughout summer; commonest in the south.

German wasp

Vespula germanica

BODY LENGTH 18mm
Black and yellow pattern is distinctive, and face has three black dots at front. Common and widespread in many habitats, including gardens. Builds papery nest underground or large cavity. Feeds its larvae on insects.

ANTS

● *Live in large colonies* ● *Single queen lays all eggs*
● *Most ants are 'workers'*

Wood ant

Formica rufa

BODY LENGTH 10mm
A large reddish-brown ant which forms enormous colonies in woodlands under huge mounds of dry plant material. Very active in sunny weather and will spray formic acid from abdomen if disturbed, even at people.

Black ant

Lasius niger

BODY LENGTH 3mm
A small black ant, very common in gardens, forming nests under paving stones. Diet varied; visits aphids to collect honeydew. Winged males swarm in hot sunny weather.

BEES

● *May live in large colonies* ● *Adults eat nectar*
● *Most have a 'sting'*

Honeybee

Apis mellifera

BODY LENGTH 12mm
Common due to domestication, but many colonies live in wild in hollow trees. Stores honey in wax-celled comb to survive winter. Wild bees usually darker than domesticated forms. Colonies are mainly worker females.

Buff-tailed bumblebee

Bombus lapidarius

BODY LENGTH 24mm
Females first seen in spring visiting flowers. Recognised by buff band on abdomen and thorax and buff 'tail'. Builds nest underground and numbers increase in hot summers. A common species almost everywhere, apart from the north.

BEETLES
● *Two pairs of wings* ● *Forewings form protective 'wing cases'*
● *Biting mouthparts*

Green tiger beetle

Cicindela campestris

BODY LENGTH 14mm
A predatory beetle, found in sandy, open habitats, often highly active and ready to fly. Wing cases are green with pale yellow spots; legs and edge of thorax are bronze. Common and widespread, especially on coasts.

Great diving beetle

Dytiscus marginalis

BODY LENGTH 30mm
A large water beetle found in weedy ponds and lakes. Males have front limbs adapted for clasping female and smooth shiny wingcases; female's are grooved. Adults and larvae are aggressive predators.

Sexton beetle

Nicrophorus vespilloides

BODY LENGTH 16mm
A black beetle with bold orange-red markings on the wingcases and all-black antennae. Attracted to animal carcasses, and buries corpses of small birds and mammals to provide food for larvae. Widespread and attracted to lights.

Devil's coach horse

Staphylinus olens

BODY LENGTH 24mm
A sooty-black, long-bodied beetle with short wings and an exposed abdomen which can be arched towards an attacker if threatened. An active predator, usually found under rotting wood, emerging at night to hunt small invertebrates. Common and widespread.

Stag beetle

Lucanus cervus

BODY LENGTH 40mm
A very impressive beetle with reddish-brown wingcases and a black head and thorax. Males have 'antlers' on the head used for grappling with other males over females, who are similar but lack antlers. Larvae feed in rotting tree stumps for several years.

Cockchafer

Melolontha melolontha

BODY LENGTH 35mm
A bulky, reddish-brown, rather hairy beetle, commonest in May–June, hence country name of 'May Bug'. Attracted to lights and may form swarms where common. Large, creamy-white larvae live underground and feed on roots.

Glow-worm

Lampyris noctiluca

BODY LENGTH 14mm (female)
Females are wingless and can be found on warm summer nights because of greenish glow emitted from underside of abdomen; this attracts the winged males. Larvae feed on snails in damp meadows, and can also emit light. Widespread but local in grassy places in the south.

Click beetle

Althous haemorrhoidalis

BODY LENGTH 14mm
A slender, reddish-brown beetle with a covering of downy hairs on the body. If handled or disturbed it can throw itself upwards with a loud click, startling predators for long enough to escape. Common and widespread, often found on leaves of trees in summer.

Cardinal beetle

Pyrochroa serraticornis

BODY LENGTH 14mm
A conspicuously red beetle, often seen visiting flowers to prey on insects in summer, but may also be found under flaking bark, or on rotting wood, where carnivorous larvae live. Locally common in England and Ireland.

7-spot ladybird

Coccinella 7-punctata

BODY LENGTH 6mm
A familiar ladybird, easily recognised by seven black spots on red elytra. Common and widespread, sometimes entering buildings to hibernate. Larvae are grub-like and dark purple with paler spots, and, like adults, feed on aphids. Commonly found in gardens.

Wasp beetle

Clytus arietus

BODY LENGTH 16mm
Mimics wasps in its colourings and its flight pattern. Visits flowers in sunny weather and is common in a range of habitats, including gardens and hedgerows. On the wing May–July. Widespread across Britain and Ireland.

Longhorn beetle

Strangalia maculata

BODY LENGTH 16mm
Name derives from two long antennae. Body is black but elytra have black and yellow pattern. Visits flowers to feed on pollen, and hides among leaves. Common and widespread; on the wing July–August.

Poplar leaf beetle

Chrysomela populi

BODY LENGTH 10mm
A rounded beetle with red elytra and a black head and thorax, giving the impression of a spotless ladybird. Adults occur in summer and are associated with poplars and willows where larvae feed. Widespread and locally common.

Hazel weevil

Curculio nucum

BODY LENGTH 6mm
A rounded beetle with a long, slender rostrum between the eyes. The elytra are brown with a pattern of darker blotches and are finely grooved. Females lay eggs inside growing hazel nuts where larvae develop; when nuts fall in autumn larvae pupate in soil. Always associated with hazel trees.

SPIDERS

Garden spider

Araneus diadematus

BODY LENGTH Up to 12mm
A familiar spider of gardens and
hedgerows. Body colouring varies from
grey-brown to reddish-brown, with
a pattern of white dots and transverse
streaks which form a broken cross on the
abdomen. Females are much larger than
males. Spins large webs, and occurs as
adult from July–October.

Common cross spider

Araneus quadratus

BODY LENGTH Up to 20mm
Similar (larger) to garden spider, but abdomen has
four large dots in a square shape and a thin
anterior white stripe. Body colours can range from
rich brown to red-orange. Mature females very
large and swollen before egg-laying. Widespread
and common in most well-vegetated habitats.

Water spider

Argyroneta aquatica

BODY LENGTH Up to 14mm
The only spider fully adapted to life
under water. Body looks silvery due
to trapped air on abdomen. Builds a
web in pondweeds which it fills with
air for breathing; locates prey with
silken strands among plant stems.
Locally common in clean, weedy
ponds and ditches.

Purse-web spider

Atypus affinis

BODY LENGTH Up to 12mm
Lives inside a silken tube concealed on
the ground. If a small creature walks
over the tube, the spider seizes it
through the tube and bites it with its
fangs. Widespread in dry areas of
permanent grassland or heaths, but
very hard to find.

Spider

Dysdera crocata

BODY LENGTH Up to 12mm
A large reddish-brown spider which
hides under stones and rotting wood
and preys on woodlice, capturing them
with its large opposable fangs.
Widespread and common wherever
woodlice occur.

Swamp spider

Dolomedes fimbriatus

BODY LENGTH Up to 25mm
A very impressive spider with a large
chestnut-brown body marked by long
yellow stripes and very long legs. It
feeds by sitting at the edge of a pool
with its feet on the water surface so
that it can detect the movements of
insects trapped in the surface film.
Restricted to damp heaths, mainly in
southern and eastern England.

Wolf spider

Lycosa (Pardosa) lugubris

BODY LENGTH Up to 6mm
A small dark spider with a pale band across the
back, commonest among leaf litter on
woodland floor where females may be seen
carrying a pale egg sac at the tip of the
abdomen. Does not spin a web, but finds food
by stalking prey among leaves. Active in
early summer.

Crab spider

Misumena vatia

BODY LENGTH Up to 10mm
Colours of females vary, but usually
white, pale green or cream with faint red
lines on the abdomen. Has habit of
sitting in flowers of matching colour with
front legs outstretched, lying in wait for
visiting insects. Common and
widespread in gardens, hedgerows
and heaths.

Daddy long-legs spider

Pholcus phalangioides

BODY LENGTH Up to 8mm
A very slender-bodied and long-legged spider,
always found in buildings where it makes long
untidy webs in corners of rooms and beneath
the ceiling. It usually hangs upside down,
touching its web. Cannot tolerate low
temperatures so restricted to the south and
homes with good heating.

Hunting spider

Pisaura mirabilis

BODY LENGTH Up to 14mm
A long-legged and slender-bodied
spider, with buff-brown colourings
and a dark-edged yellow stripe on
the carapace. Does not spin a web,
but hunts prey on the ground.
Females build 'nursery' tent before
eggs hatch. Common in
hedgerows, scrub and gardens.

Zebra spider

Salticus scenicus

BODY LENGTH Up to 7mm
A small but easy-to-spot spider because of
its black and white body and habit of
moving around in the open on sunny walls
and tree trunks. Jumps readily, and stalks
small prey in the open. Common and
widespread in lowland areas.

House spider

Tegenaria domestica

BODY LENGTH Up to 10mm
A large-bodied, long-legged spider, usually associated
with houses. Colours normally dark and body is very
hairy. Spins an untidy web which leads into a tunnel
where the spider retreats. Females may live for over
one year.

Crab spider

Xysticus cristatus

BODY LENGTH Up to 6mm
Usually pale brown in colour with
a pattern of paler buff markings
on abdomen. Sits on twigs with legs
outstretched in hunting posture. Common
and widespread in hedgerows, gardens,
meadows and heaths.

LAND AND FRESHWATER MOLLUSCS
● *Move on a muscular foot* ● *Have a rasping tongue* ● *Most are plant feeders*

Large red slug
Arion ater

BODY LENGTH Up to 12cm
A common species throughout Britain and Ireland but occurs in two forms – orange-red in the south and black in the north. Orange form is frequent in gardens, while black form is found in upland areas. Contracts into a furrowed, rounded shape when threatened. Lays eggs in clusters under logs.

Dusky slug
Arion subfuscus

BODY LENGTH Up to 7cm
A pale brown slug with a dark stripe along each side and a dark band on the back. May look golden-tinged due to mucus secretion. The underside is yellow. Common in woodlands, hedgerows and gardens everywhere apart from eastern England.

Leopard slug
Limax maximus

BODY LENGTH Up to 16cm
A large and strikingly marked slug with a pinkish-grey body covered with darker stripes and blotches. The rear end of the body has a prominent keel running as far as the tail. Common and widespread, favouring damp woodlands and gardens.

Brown-lipped snail
Cepaea nemoralis

SHELL DIAMETER 21mm
Shell is rounded and shiny with variable colours, but usually banded and with a brown shell lip. Widespread and common in most of Britain and Ireland in many habitats, including woodlands, chalk scrub and dunes.

Plaited door snail
Cochlodina laminata

SHELL LENGTH 16mm
A long narrow shell with a twisted appearance. Usually orange-brown, but shell becomes worn with age. Prefers damp shady woodlands and will climb up trees in wet weather or on humid nights. Commonest in England, scarce elsewhere.

Garden snail
Helix aspera

SHELL DIAMETER 40mm
Shell is rounded and marbled brown and black; colours become faded in older, worn specimens. Common in gardens, woodland edges and chalk scrub; mainly in lowlands of southern Britain and Ireland, absent from most of Scotland.

Amber snail
Succinea putris

SHELL LENGTH 15mm
Appears very delicate with an almost transparent, oval shell. Usually found in wetland habitats and may be seen climbing up stems of emergent plants. Widespread in lowland areas of England, Wales and Ireland.

Strawberry snail
Trichia striolata

SHELL DIAMETER 12mm
Shell is flattened, with tight narrow coils and shows growth ridges near lip. Usually buff-brown in colour and snail's body is dark grey. Widespread and fairly common in southern Britain and Ireland, preferring lowland woodlands and gardens.

River limpet
Ancylus fluviatile

SHELL LENGTH 8mm
Shell is a streamlined, flattened cone with a slightly hooked tip. Usually dark brown, but it may be disguised by a coating of algae. Found sticking to rocks in clear, fast-flowing streams, and in upland stony lakes. Not tolerant of pollution or silting.

Swan mussel
Anodonta cygnea

SHELL LENGTH Up to 12cm
A large bivalve mollusc which lives in the mud at the bottom of slow rivers, canals and large lakes. Shell is in two equal halves, usually shiny brown in colour, and often has a fine covering of silt. Feeds by filtering water. Widespread in suitable habitats, scarce in Scotland.

Common bithynia
Bithynia tentaculata

SHELL LENGTH 15mm
A conical, dark brown pond snail with an operculum, or horny plate, which can close over the opening of the shell; when the snail is moving the operculum lies on top of the foot. Common and widespread in southern Britain and Ireland, scarce in Scotland.

Great pond snail
Lymnaea stagnalis

SHELL LENGTH Up to 45mm
A very large pond snail with pointed shell which has sometimes has a flaking outer membrane. The snail's body is golden-brown and there are two pointed tentacles which appear when the snail is feeding. May be seen suspended upside down from surface film. Widespread and common in southern Britain and Ireland; scarce in Scotland.

Wandering pond snail
Lymnaea pereger

SHELL LENGTH 10mm
A rounded, oval shell with only a short coil at the tip. It is usually a mottled golden-brown and fairly smooth. The body is brownish and the tentacles are broad and flattened. Lays long gelatinous egg masses on pondweeds. Very common and widespread in ponds, canals and ditches in lowland areas.

Great ramshorn
Planorbis corneus

SHELL DIAMETER 25mm
Shell is a flattened coil, usually dark brown and ridged and sometimes with a fine covering of algae. Lays oval, flattened masses of eggs on pondweeds. Common in weedy ponds and ditches in lowland areas.

SEASHORE MOLLUSCS
- *Most have tough shells*
- *Many can survive out of water* • *Eggs may drift in the sea*

Edible periwinkle
Littorina littorea

SHELL LENGTH 25mm
Shell is a sturdy rounded oval with a pointed tip and a thick lip, usually brown in colour with darker stripes, but this may be disguised by a coating of algae. Common on most rocky seashores, and often abundant.

Flat periwinkle
Littorina littoralis

SHELL DIAMETER 10mm
Shell is rounded with a flattened tip and colours vary from black to white, but most common variations are yellows and reds. Very common on sheltered rocky shores around most of coastline of Britain and Ireland.

Peppery furrow shell
Scrobicularia plana

SHELL LENGTH Up to 50mm
A flattened bivalve with a thin, whitish shell, often stained by the estuarine mud it lives in. Remains buried just below mud surface, feeding and breathing through worm-like siphons which sweep around on the mud. Very common in muddy estuaries around whole of coastline.

Laver spire shell
Hydrobia ulvae

SHELL LENGTH 6mm
A small mollusc with a conical, coiled shell with a blunted apex, usually red-brown in colour but often faded and worn. Can be very abundant on some shores, with empty shells forming deep layers on strandline. Common and widespread, and an important food for birds.

Common octopus
Octopus vulgaris

LENGTH Up to 50cm
A highly modified mollusc with a fleshy, bulbous body and eight tentacles bearing powerful suckers. The mouthparts consist of strong, beak-like jaws. Found around south-west coasts of Britain and Ireland, usually just below low-tide line, sometimes in deep pools.

Common limpet
Patella vulgata

SHELL DIAMETER Up to 6cm
Shell is conical and ridged, and becomes encrusted with algae and barnacles with age. Normally found clamped to intertidal rocks in exposed situations, but may also occur under seaweeds. Moves off to feed at night or when under water. Common and widespread.

Slipper limpet
Crepidula fornicata

SHELL LENGTH 30mm
An ear-shaped shell, usually greyish in colour but sometimes encrusted with algae and tube worms. Lives in colonies attached to each other or other shell species. Abundant in some areas. Introduced to England from North America and established around southern and eastern England and southern Wales.

Common cockle
Cardium edule

SHELL WIDTH Up to 5cm
An almost spherical bivalve with two strongly ridged halves to its greyish-white shell. Lives almost buried in mud or sand, feeding by filtering seawater. Sometimes harvested commercially for food. Widespread and very common in suitable habitats.

Common mussel
Mytilus edulis

SHELL WIDTH Up to 9cm
Shell is dark grey-brown on the outside, and shiny with mother-of-pearl layer on inside. Lives in densely packed colonies, attached to rocks by tough threads, filtering seawater for food. Common and widespread around whole coast.

Common oyster
Ostrea edulis

SHELL WIDTH Up to 10cm
Lower valve is saucer-shaped and contains body of mollusc, upper valve is flattened and forms lid. Inner surface is white and shiny, but outer surfaces are grey-brown, rough and often coated with algae or barnacles. Widespread in areas of sheltered, shallow water. Farmed commercially for food.

Toothed topshell
Monodonta lineata

SHELL DIAMETER 24mm
Shell is cone shaped and greyish-brown but with pattern of darker lines. Opening is shiny and shows distinct 'tooth' in the lip. Widespread and common on moderately sheltered rocky shores; scarce or absent in north-east Britain.

Pod razorshell
Ensis siliqua

SHELL LENGTH Up to 18cm
A bivalve with a long, parallel-sided shell, hinged along one edge. Lives buried in sand at low-tide level, so only seen when shells are washed up after a storm. If living mollusc is disturbed, it can burrow down at great speed. Common in suitable habitats around most of coastline.

Common whelk
Buccinium undatum

SHELL LENGTH Up to 8cm
Shell is a large, ridged spiral, dirty white in colour, but usually obscured by coating of algae, tube worms and barnacles. Living molluscs feed on seabed, but empty shells are frequently washed up after storms. White egg masses are also common on tide line. Very common and widespread.

Dog whelk
Nucella lapillus

SHELL LENGTH Up to 3cm
Shell is oval and pointed and usually rather thick with ridges and a thick lip. Colours vary from white to grey-brown and banded forms occur. Preys on barnacles and mussels by drilling into their shells. Widespread and common, especially on exposed shores.

CRUSTACEANS
● *10 or more pairs of legs* ● *Touch outer skin or segmented shell*
● *Breathe through gills*

Edible crab

Cancer pagurus

CARAPACE WIDTH Up to 20 cm (rarely)
Small specimens found on the shore can be recognised by the pie-crust edge to the carapace margin and the pinkish-orange colouration. The pincers are powerful, larger in males than females, and have black tips. Widespread, and common in some areas.

Shore crab

Carcinus maenus

CARAPACE WIDTH Up to 5cm
Shell is usually greenish or dark olive-brown above and underside may be green or orange-red. The leading edge is sharply toothed and there are three blunt teeth between the eyes. A very common and widespread species found in most marine and brackish habitats.

Masked crab

Corystes cassivellaunus

CARAPACE LENGTH 4cm
A delicate-looking crab with an oval shell and long slender pincers, normally only seen when washed up after a storm. Lives buried in sand with antennae reaching the surface. Name derives from vague impression of mask on carapace. Common and widespread around all coasts.

Hermit crab

Eupagurus bernhardus

BODY LENGTH Up to 9cm
Most of body is protected inside abandoned mollusc shell. Legs and pincers are used to protect body when it withdraws; right pincer is larger than left. Colourings are mostly red-brown. Will move into larger shells as it grows. Common and widespread around most coasts.

Spider crab

Macropodia rostrata

CARAPACE LENGTH 10mm
Legs are long and spider-like and body is relatively small and triangular, but details are difficult to see as body is usually covered with tiny seaweeds and sponges, which give excellent camouflage. Common and widespread, but tricky to find.

Broad-clawed porcelain crab

Porcellana platycheles

CARAPACE WIDTH 13mm
Body is flattened and hairy with brownish colourings on the back and a porcelain-like texture beneath. The hairy back traps sediment, which aids camouflage. Usually hides in tiny crevices under stones on sheltered rocky shores. Common and widespread.

Velvet swimming crab

Macropipus puber

CARAPACE WIDTH 7cm
A very aggressive crab with red eyes and red joints on the legs which are displayed to warn off predators. The hind legs have flattened segments with fringing hairs to aid swimming. The carapace is velvety and traps silt, which aids camouflage. Widespread and common on most rocky shores.

Common lobster

Homarus vulgaris

CARAPACE LENGTH Up to 40cm
Full-size adults are only found in deep water, but small specimens sometimes turn up in rock pools at very low tides. Shell is always blue in live lobsters, turning red only when boiled. Widespread around most coasts, but heavily fished and scarce in some areas.

Acorn barnacle

Balanus balanoides

SHELL WIDTH Up to 12mm
An abundant species on exposed rocky shores, sometimes completely covering entire rock faces. Body is encased in rigid shell of six fused plates and protected when exposed by a 'trap door'. Under water the barnacle feeds by filtering sea water with modified legs. Widespread and common, apart from on south-west coasts where it is replaced by Chthalamus stellatus.

Goose barnacle

Lepas anatifera

SHELL LENGTH Up to 4cm
Body is encased in five egg-shell-like plates and suspended from long flexible stalk, usually fixed to driftwood. Found in colonies which drift in the sea but are sometimes washed up on beaches. Strange appearance gave rise to ancient belief that this was the embryo stage of the barnacle goose. Can occur on any stretch of coastline after a storm.

Common prawn

Leander serratus

LENGTH Up to 6cm
Body is almost transparent, but in good light shows a colourful pattern of purple and yellow dots and lines. Antennae are very long and there is a long rostrum between the eyes. Legs are long and thin. Common and widespread.

Common shrimp

Crangon vulgaris

LENGTH Up to 5cm
Body is almost transparent and speckled with small dots, giving good camouflage in usual habitat of sandy pools. Antennae are long, but rostrum is very short. Often numerous in estuarine pools at low tide. Common and widespread around most of coastline.

Sandhopper

Talitrus saltator

LENGTH Up to 15mm
One of many similar species found on rotting seaweeds on strandline. Body is flattened and slightly curved. Jumps readily when disturbed, and quickly burrows back under cover. An important food source for shore birds. Widespread and common wherever seaweeds accumulate on the shore.

Sea slater

Ligia oceanica

LENGTH Up to 25mm
Resembles a giant woodlouse, to which it is related. The segmented body is flattened and has two long antennae at head end and two forked appendages at tail end. Usually grey in colour. Common on the upper shore, emerging from hiding to scavenge at night. Widespread around most coasts.

Common woodlouse

Oniscus asellus

LENGTH 14mm
Body is mottled greyish-buff and flattened; cannot roll up into a ball. Usually found under logs, stones and in crevices. Common in gardens, hedgerows and woodlands, and other habitats where there is humus to feed on.

Pill woodlouse

Armadillidium vulgare

LENGTH 11mm
Body colour is uniform slate-grey and slightly glossy. Easily recognised by tendency to roll up into a ball when disturbed. Widespread and fairly common in woodlands, hedgerows and gardens, mainly in lowlands areas.

Freshwater louse

Asellus aquaticus

LENGTH 15mm
Resembles a flattened woodlouse with extra long antennae, but is always found in water, especially weedy ponds and ditches with a good detritus layer. Females carry clusters of white eggs in brood pouch on underside. Widespread and common.

Freshwater crayfish

Astacus pallipes

LENGTH Up to 40mm
Resembles small brownish-green lobster, but is always found in clean freshwater streams with high lime content in water. Usually hides under stones, emerging at night to scavenge. Increasingly scarce due to pollution, disease and competition from introduced species.

Water flea

Daphnia sp

LENGTH 1mm
A very small crustacean, sometimes so abundant in ponds that the water turns pink. Body is semi-transparent, and internal organs, eggs, etc., can be clearly seen. Swims by beating appendages in water and feeds on minute algae.

Freshwater shrimp

Gammarus pulex

LENGTH 11mm
Body is curved and flattened laterally, so shrimp swims on its side. Usually remains concealed in dense water plants and prefers unpolluted waters with high oxygen levels. Widespread and very common.

MILLIPEDES & CENTIPEDES
● *Segmented body* ● *One pair of legs per segment in centipedes*
● *Two pairs of legs per segment in millipedes*

Flat-backed millipede

Polydesmus angustus

LENGTH 24mm
Body is flattened and brownish, looking more like a centipede, but each segment has two pairs of legs. A scavenger, found in compost heaps, woodland floor leaf litter and under rotting wood. Widespread and common.

Millipede

Cylindrosulus punctatus

LENGTH 27mm
A cylindrical, reddish-brown millipede with a slightly glossy surface, found under rotting wood or leaf litter. Feeds on decaying plant material, and sometimes roots and bulbs. Very common and widespread in wooded areas.

Pill millipede

Glomeris marginata

LENGTH 20mm
Resembles a pill woodlouse, but is shiny brown, not grey, and more elongated. Readily rolls into a ball and is reluctant to unroll. Locally common in deciduous woodlands and damp habitats.

Centipede

Lithobius variegatus

LENGTH 30mm
A shiny orange-brown centipede with a relatively short body and a rounded head. Hides under rotting wood and stones, emerging at night to hunt small soil invertebrates. Widespread and common in suitable habitats.

HARVESTMAN
● *Spider-like with small rounded body* ● *Very long legs*
● *Does not spin a web*

Harvestman

Opilones spp

BODY LENGTH Up to 4mm
Body is small and rounded; the four pairs of legs are very long and thin. Usually found in hedgerows and low vegetation, where it preys on small invertebrates. Many similar species occur in a wide range of habitats. Very common and widespread.

WORMS
● *Segmented body* ● *Breathe through skin*
● *Leaches has sucker-like mouth*

Common earthworm

Lumbricus terrestris

LENGTH Up to 8cm
A common and widespread species of garden, pasture and woodland soils, which reveals its presence by leaving coiled worm casts of fine soil at the surface. Head end is dark and pointed, tail end is paler and flattened.

Fish leech

Piscicola geometra

LENGTH 10mm
Body is worm-like and pale with darker bands. There is sucker at each end, one of which adheres to the body of fish to suck body fluids. Can swim through water, but usually waits on pondweeds for host to swim past. Common and widespread.

HYDRA
● *Hollow body* ● *Attached by sucker*
● *Stinging tentacles*

Hydra

Hydra fusca

A very small freshwater relative of sea anemones. Slender body is attached to pondweeds by basal sucker and 'mouth' is surrounded by eight tentacles. Usually pale green in colour. Retracts to a small lump if disturbed, so very difficult to see. Common and widespread.

OTHER SEASHORE INVERTEBRATES

● *Many are burrowers* ● *May have stinging cells* ● *Some live in large colonies*

Jellyfish

Chrysaora isosceles

DIAMETER Up to 25cm
The body is marked with red lines radiating from a central spot. Normally lives in the open sea, but is sometimes carried by currents into bays and stranded on beaches. Commonest off southern and west coasts of Britain and Ireland.

Beadlet anemone

Actinia equina

HEIGHT Up to 5cm
When underwater the tentacles are extended in a ring around the mouth, but they can be retracted when feeding or when anemone is exposed by the falling tide. Colours variable, but usually red or green. Very common and widespread.

Snakelocks anemone

Anemonia sulcata

HEIGHT Up to 10cm
Body is rather compressed and tentacles cannot be retracted. Colours are usually grey-brown or purplish-green with tentacles showing iridescent purple tips. Common and widespread on exposed rocky shores on west and south-west coasts of Britain and Ireland.

Marine annelid

Amphitrite johnstoni

LENGTH Up to 10cm
Normally hidden in burrows under stones on sheltered muddy or sandy shores, but may be disturbed by bait diggers. Body is segmented and curved with red gills and mobile tentacles at the head end.

Lugworm

Arenicola marina

LENGTH Up to 18cm
Normally concealed in a U-shaped burrow which can be located by coiled sand cast at one end and depression at other. Worm has swollen, segmented body with gills and bristles in mid-section. Very common and widespread.

Ragworm

Nereis diversicolor

LENGTH Up to 10cm
Body is flattened and bears appendages and bristles on each segment to aid locomotion. Hides in burrows, but swims well in pursuit of prey which is captured with the aid of strong jaws. Common and widespread.

Peacock worm

Sabella pavonia

HEIGHT Up to 20cm
Worm lives in vertical tube of sand particles bound together by mucus; these protrude from seabed. When under water, radiating gill filaments form a 'peacock tail' fan to trap food particles. Widespread and common.

Cushion star

Asterina gibbosa

DIAMETER Up to 5cm
A small distinctly star-shaped starfish with five short arms. The upper surface is rough and mottled with various colours but usually greenish-brown or grey-yellow. The underside is dirty yellow with numerous tube feet. Found under rocks on the lower shore. Most common off southern and western coasts of Britain and Ireland.

Common starfish

Asterias rubens

DIAMETER Up to 40cm
Arms are long and slightly flexible, and reddish-orange; whole surface is covered with pale warts. Underside is creamy-white and covered with white tube feet. Preys on bivalve molluscs, so only common where these occur in good numbers.

Spiny starfish

Marthasterias glacialis

DIAMETER Up to 40cm
Arms are long and slender, and whole upper surface is covered with short but strong spines. Colourings vary, but background colour is usually pale brown with pink-purple spines.

Sea urchin

Echinus esculentus

DIAMETER Up to 10cm
Body is a flattened sphere covered in sharp spines and tube feet. Dead animals lose spines to uncover chalky test which is reddish-brown with a pattern of fine lines. Common around north and west coasts in deep water, but sometimes stranded in rock pools.

Heart urchin

Echinocardium cordatum

LENGTH Up to 8cm
Alternative name of sea potato alludes to its burrowing habits and potato-like shell. Usually buried in sand below low-water mark, using flattened bristles for movement, but often found washed up after storms. Widespread and common in suitable habitats.

Breadcrumb sponge

Halichondria panicea

THICKNESS Up to 2cm
Forms large shapeless patches on underside of rocks and in crevices. Surface is spongy and has numerous crater-like openings; colours variable, but may be green or orange if exposed to light, often yellowish. Common and widespread.

Star ascidian

Botryllus schlosseri

STAR DIAMETER Up to 5mm
Forms encrusting colonies on underside of rocks. Matrix is a tough jelly in which star-like clusters of animals are grouped around a common siphon. Widespread and commonest on sheltered west coasts.

PLANTS

TREES AND SHRUBS

● *Stems form woody tissue* ● *Some lose their leaves in winter*
● *Tree trunks tend to grow to at least 5 metres*

Larch
Larix decidua

HEIGHT Up to 35m
A deciduous conifer with delicate needles which are fresh green in spring but turn bright yellow before falling in autumn. Branches are pendulous and twigs bear ovoid cones about 2–3cm long when mature. Native European tree, widely planted, especially in uplands and on poor soils.

Scots pine
Pinus sylvestris

HEIGHT Up to 35m
Mature tree domed and sometimes misshapen with missing lower branches. Bark is red and furrowed, becoming flaky. Mature cones are conical and up to 7cm long when ripe after three years' growth. Native to Scotland, widely planted elsewhere.

Juniper
Juniperus communis

HEIGHT Up to 5m
A shrub of variable size, sometimes prostrate in exposed situations, or more straggling in sheltered areas. Needles are arranged in threes, bluish-green and stiff with sharp points. Ripe fruits are green and oval-shaped, becoming blackened and aromatic when mature. Widespread in uplands, native pine woods and chalk grassland.

Yew
Taxus baccata

HEIGHT Up to 25m
A dense evergreen tree, often clipped and pruned into neat shapes or used for hedges. Needles are flattened and aromatic, bark of mature trees is soft and deep red. Fruits are red and fleshy. Whole tree is very poisonous. Widely planted, but occurs naturally in areas of limestone and chalk.

Holly
Ilex aquifolium

HEIGHT Up to 10m
Common, widespread and very familiar evergreen tree. Sexes separate so only female trees bear red berries in winter, both bear white flowers in spring. Leaves usually bear stiff, sharp points, but on higher branches leaves may be more flattened with fewer spines. Common and widespread in uplands and lowlands.

Box
Buxus sempervirens

HEIGHT Up to 5m
A scarce native evergreen shrub on chalk hills in southern England, but widely cultivated and used for hedging in gardens everywhere. Leaves are small and leathery with inrolled margins; flowers are minute and green, opening in spring.

White willow
Salix alba

HEIGHT Up to 20m
Tree looks silvery at a distance on windy days due to colour of long, pointed leaves which have covering of silky hairs. Catkins appear in early spring before leaves and are up to 5cm long. Branches extend upwards and tree often leans over. Common and widespread in damp soils.

Grey willow
Salix cinerea

HEIGHT Up to 10m
A common tree of wetter habitats, forming a broad, rounded shape if given space. Leaves are rounded and softly hairy like ends of twigs when young. Male and female catkins are 2–3cm long, growing on different trees in March–April before leaves open.

Great sallow/goat willow
Salix caprea

HEIGHT Up to 10m
Grows into a rounded shrub or small tree if given room. Leaves are large and pale green below with twisted pointat tip. Male and female catkins (pussy willow) occur on separate trees in spring. Common and widespread, preferring damper soils.

Osier
Salix viminalis

HEIGHT Up to 5m
Rarely seen as a normal tree; usually occurs as heavily pollarded stumps which bear numerous thin, straight, orange-red twigs. Leaves are long and thin with pointed tips and silvery undersides. Catkins borne in early spring. Common along river banks and on wet soils.

White poplar
Populus alba

HEIGHT Up to 20m
The bark is very pale, and the leaves are green above but downy and white below; in windy weather the whole tree can look silvery. Catkins appear in early spring – males and females on separate trees. Common and widespread in damper areas.

Aspen
Populus tremula

HEIGHT Up to 20m
Leaves are small with toothed margins, borne on long, flattened stems; they flutter audibly in the slightest breeze and show pale undersides. Bark is smooth and pale, and the trunk is usually free of branches for two-thirds of height of tree. Common and widespread on damper soils.

Silver birch
Betula pendula

HEIGHT Up to 30m
Silvery-grey bark and elegant, pendulous branches give distinctive appearance to this common native tree. Triangular leaves turn yellow in autumn and small cones release many tiny papery-winged seeds. Greenish-yellow catkins appear in early spring. Widespread, even in upland areas.

Downy birch
Betula pubescens

HEIGHT Up to 30m
Resembles silver birch but tips of young twigs are downy and larger leaves have coarsely toothed margins. Bark is smooth and greyish in older trees. Commoner in damper soils and high-rainfall upland sites; short-lived. Often seen with large birch-bracket fungus on trunks.

Alder

Alnus glutinosa

HEIGHT Up to 20m
Leaves are rounded with shallow-toothed margin. Mature trees bear rounded woody cones. Male catkins are purple and pendulous, female flowers are short and green, both appearing on same tree before leaves open. Bark is dark and fissured and cut timber turns bright orange. Common and widespread in wet soils, river banks and boggy areas.

Bog myrtle

Myrica gale

HEIGHT Up to 1m
A small woody shrub of acid bogs with aromatic grey-green leaves. Bears orange male catkins and brown female catkins on separate plants in early summer. Fairly common in suitable boggy habitats.

Hazel

Coryllus avellana

HEIGHT Up to 12m
Leaves are rounded and have double-toothed margins, terminating in a point. Pendulous yellow male catkins and tiny red female flowers borne on same tree in early spring. Woody nuts develop in clusters through the summer. Coppiced to produce stems for woodland crafts. Common and widespread.

Hornbeam

Carpinus betulus

HEIGHT Up to 3m
A large, spreading tree when mature with a domed crown and a smooth but sometimes twisted trunk. Leaves have serrated margin and papery-winged seeds are borne in clusters. Catkins are produced in April–May.

Beech

Fagus sylvatica

HEIGHT Up to 40m
A very large and impressive tree when mature and given enough space to develop. Leaves are smooth with entire margins; seeds are triangular nuts borne in prickly cases. Trunk is sturdy and bark can be smooth and grey. Forms dense stands on dry, chalky soils. Common and widely planted.

English oak

Quercus robur

HEIGHT Up to 45m
Irregularly lobed leaves are borne on very short stalks but acorns grow in small clusters on long stalks. Trunk can be massive and crown is usually broadly domed in trees with room to spread. May be dominant species in woods on clay in lowland areas.

Sessile oak

Quercus petraea

HEIGHT Up to 40m
Leaves are shallowly lobed and borne on short yellow stalks. The acorns grow in small clusters directly on the twigs. The common oak in hilly and upland areas in the north and west of Britain and Ireland. Can become large and spreading, but is often stunted and deformed in exposed situations.

Horse chestnut

Aesculus hippocastanum

HEIGHT Up to 35m
A large spreading tree with palmate leaves, often planted as an ornamental specimen. Pyramidal white flower-clusters are conspicuous in early summer; these are followed by the large conkers in prickly cases in autumn. Leaves turn rich yellow and orange colours before falling.

Sweet chestnut

Castanea sativa

HEIGHT Up to 30m
An impressive tree when mature with a massive twisted trunk and spreading branches. Edible nuts are borne in very prickly cases in late autumn when leaves turn rich orange-brown. Strongly scented catkins are produced in mid-summer. Introduced and widely planted for timber, food and amenity value. Commonest in SE England.

English elm

Ulmus procera

HEIGHT Up to 35m
Mature trees are now a rare sight, but can be recognised by lofty, domed crown and twisted branches. Leaves have toothed margin and asymmetrical bases. Reddish flowers open in early spring. Diseased trees show yellowing foliage. Widespread in lowland areas, but no longer common.

Wych elm

Ulmus glabra

HEIGHT Up to 40m
Develops a broad spreading crown when mature and given space, but may be smaller in confined situations. Leaves are large and toothed with asymmetrical bases, one side overlapping the stalk. Commonest in north and west, often in upland woods.

London plane

Platanus x hispanica

HEIGHT Up to 35m
Easily recognised by its attractive, multi-coloured peeling bark and smooth palmate leaves. Flowers are spherical clusters on short stalks and develop into rounded, brown fruits. Usually planted on city streets and in urban parks because of its tolerance of air pollution. A hybrid species.

Sycamore

Acer pseudoplatanus

HEIGHT Up to 35m
Leaves are 5-lobed and have slightly toothed margins. Papery seeds are bi-lobed and borne in clusters. Mature trees form broad, domed crowns and have smooth greyish bark. Introduced and widely planted. A vigorous coloniser and common in most areas.

Field maple

Acer campestre

HEIGHT Up to 25m
Forms a small tree, or more usually a hedgerow shrub, easily spotted in autumn when lobed leaves turn bright yellow. Papery-winged seeds form in autumn and differ from sycamore in forming 180° angle. Common and widespread in lowland areas.

Ash

Fraxinus excelsior

HEIGHT Up to 40m
A tall tree with a sturdy trunk and untidy, spreading crown. The bark is grey and fairly smooth, becoming ridged in older trees. Leaves are divided into 7–12 leaflets and fall when still green. Twigs bear sooty-black buds. Seeds are winged and produced in bunches. A common and widespread native tree, especially on base-rich soils.

Rowan

Sorbus aucuparia

HEIGHT Up to 15m
Small bush tree with alternative name of mountain ash due to compound leaves and ability to grow in upland areas. Bears umbels of white flowers in spring, followed by clusters of bright orange berries in autumn. Common in upland areas and woods on damp soils. Widely planted for ornament.

Whitebeam

Sorbus aria

HEIGHT Up to 25m
Large leaves have silvery undersides, making tree look white on windy days. Clusters of white flowers open in May–June, followed by dark red ovoid fruits in autumn. Common native tree in limestone areas, widely planted elsewhere for ornament.

Wild service tree

Sorbus torminalis

HEIGHT Up to 25m
Maple-like leaves are finely toothed and have two lobes at 180° at base; they are among the first to change colour in autumn. Flowers are small and white, opening in early summer, and are followed by clusters of small brownish fruits in autumn. A scarce native tree, commonest on heavy soils in southern and eastern England.

Wild pear

Pyrus communis

HEIGHT Up to 20m
Easily spotted in woods and hedgerows in early summer when tree is covered in white blossom. This is followed by small, hard, brownish pears. Bark cracks into squarish plates. Widespread and scattered, commonest in southern England.

Crab apple

Malus sylvestris

HEIGHT Up to 15m
Produces attractive pink and white blossom in early summer which is followed by small green and very sour apples in autumn. Trees often isolated in ancient woodlands or hedgerows with massive trunks and untidy branches. Widespread and commonest in the south.

Wild cherry

Prunus avium

HEIGHT Up to 30m
An attractive tree at all times, with shiny reddish-brown bark peeling in horizontal bands. Conspicuous in spring when covered in blossom, and produces good leaf colour in autumn. Small cherries are dark red-purple and taken by birds. Common and widespread in woods and hedgerows.

Bird cherry

Prunus padus

HEIGHT Up to 15m
Dense spikes of strong-smelling white flowers appear in May after leaves have opened, followed by clusters of black fruits. Bark is grey and pungent-smelling. Usually forms a compact, rounded tree. Native to upland, limestone areas; widely planted elsewhere.

Blackthorn

Prunus spinosa

HEIGHT Up to 5m
A common hedgerow shrub, conspicuous in spring when covered in white blossom before leaves open and again in autumn when covered in dark blue-purple fruits with a white bloom. Its mass of tangled branches and long sharp spines on the twigs make it an ideal hedgerow shrub. Common and widespread.

Hawthorn

Crataegus monogyna

HEIGHT Up to 15m
A common hedgerow shrub, but can also grow to a medium-sized tree with a thick twisted trunk. White blossom appears in May after leaves open and this is followed by bunches of red berries which remain after leaves have fallen. Twigs bear sharp thorns. A very common and widespread native shrub.

Spindle tree

Euonymus europaeus

HEIGHT Up to 6m
Small tree or untidy shrub best recognised by orange and pink fruits which appear in autumn. Leaves are narrowly oval and finely toothed; bark is thin and furrowed. A native shrub on limestone soils, commonest in central and northern England, but scattered over a wider area.

Buckthorn

Rhamnus catharticus

HEIGHT Up to 8m
A thorny bush or small tree if given space to grow. Leaves are up to 6cm long, oval and have toothed margins. Greenish-yellow flowers appear in May–June and are followed by clusters of poisonous black berries in autumn. Native to lowland areas and lime-rich soils in central and eastern England, but planted elsewhere.

Alder buckthorn

Frangula alnus

HEIGHT Up to 5m
A straggling, thorn-free bush or small tree with smooth, oval leaves which turn lemon yellow in autumn. Flowers are minute, but develop into green, red and then black berries in autumn. Commonest in damp woodlands, boggy areas and scrub in England and Wales.

Sea buckthorn

Hippophae rhamnoides

HEIGHT Up to 8m
A dense shrub with narrow grey-green leaves and tangled thorny twigs. Clusters of bright orange berries ripen in autumn. Usually seen as a dense shrub on coastal dunes but widely planted inland for its ornamental value. Native to coastal dunes, commonest in SE England.

Gooseberry
Ribes uva-crispa

HEIGHT Up to 1m
A small, spiny-stemmed shrub with rounded, coarsely toothed leaves. Flowers are small and yellowish, opening in spring, which are followed by familiar gooseberry fruits in late summer. Native, but rather local in woodlands in southern and central England, and Wales.

Common lime
Tilia x vulgaris

HEIGHT Up to 45m
A stately, tall tree with a domed crown and dense branches. Leaves are large and roughly heart-shaped, exuding sap in summer when infested with aphids. Flowers are rich in nectar, and borne on a papery bract. Seeds are encased in a hard round fruit. Widely planted as an ornamental tree. A hybrid species.

Rhododendron
Rhododendron ponticum

HEIGHT Up to 5m
An evergreen shrub with large, shiny, elliptical leaves and clusters of large pinkish-red flowers in May–June. Forms dense clumps and is invasive in damp woodlands. Widely planted introduced species, flourishing in damper areas on acid soils.

Dogwood
Cornus sanguinea

HEIGHT Up to 4m
Red stems are distinctive feature. Leaves are opposite, oval shaped and have prominent veins. Clusters of white flowers in early summer are followed by black berries in autumn. A common hedgerow shrub on chalky soils in southern England, but planted for ornament elsewhere.

Privet
Ligustrum vulgare

HEIGHT Up to 5m
Oval leaves are opposite and may persist in winter. Terminal spikes of scented white flowers are followed by clusters of black berries in autumn. A common hedgerow shrub of chalky areas in the south, but widely cultivated and planted elsewhere as a garden hedge. Naturalises freely.

Elder
Sambucus nigra

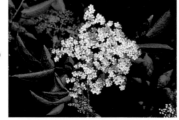

HEIGHT Up to 10m
An unpleasant-smelling, rather straggly shrub with corky bark, slightly pendulous branches and compound leaves. Flat-topped umbels of white flowers are followed by clusters of black berries in autumn. A very common wayside and woodland tree, and a rapid coloniser of disturbed ground.

Guelder-rose
Viburnum opulus

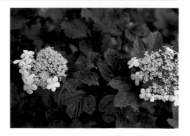

HEIGHT Up to 4m
Leaves are 5-lobed and smooth. Flowers appear in early summer in flat-topped clusters, with the outer flowers much larger than the inner ones. Shiny red berries are produced in autumn. A common shrub of hedgerows and open woods, but scarce in the north.

Wayfaring tree
Viburnum latana

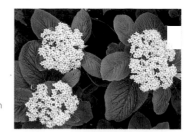

HEIGHT Up to 6m
A small tree or hedgerow shrub with large leaves which have pale undersides. Flat umbels of white flowers appear in spring, followed by berries that turn from red to shiny black. Widespread and commonest on lime-rich soils.

Honeysuckle
Lonicera periclymenum

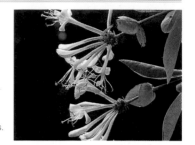

HEIGHT Up to 10m
A woody-stemmed climber with attractive creamy-white, strongly scented flowers. Clusters of red berries form in late summer. Usually seen scrambling over other shrubs and trees and can be abundant in damp woodlands and hedgerows on neutral and acid soils. Bark peels away in papery shreds.

Hop
Humulus lupulus

HEIGHT Up to 6m
Twining stems support 5-lobed, roughly-toothed leaves and clusters of pale creamy-green flowers. These ripen to form the papery cone-like hop fruits in autumn which have typical bitter smell and taste. Widespread in England and Wales, scarce in Scotland.

Old man's beard
Clematis vitalba

LENGTH up to 20m
An untidy scrambling perennial, confined to chalky soils. Flowers are small and creamy and are followed by clusters of feathery fruits in autumn. Commonest in hedgerows and scrub patches, mostly in southern and central England, and Wales.

White bryony
Bryonia cretica

HEIGHT Up to 4m
A climber which clings to other plants with tendrils. Leaves are 5-lobed and slightly rough in texture. Creamy-white flowers, produced in summer, are followed by bright red berries in autumn. Widespread and common, especially on lime-rich soils.

Ivy
Hedera helix

HEIGHT Up to 20m
An evergreen climber which clings on to trees or walls with root-like tendrils, but may also carpet the ground. Leaves may be lobed or elliptical. Tight heads of yellowish-green flowers open in September–October, and black berries ripen in winter. Very common and widespread.

Black bryony
Tamus communis

HEIGHT Up to 4m
Climbs without the aid of tendrils. Leaves are glossy and heart-shaped with pointed tips. Flowers are minute (male and female on separate plants) and form red shiny berries in autumn. Common and widespread in hedgerows, scrub and open woodlands.

Common nettle ①

Urtica dioica

HEIGHT Up to 1m
Large oval leaves are toothed and pointed, in opposite pairs, and bear stinging hairs. Male and female flowers are green and pendulous, growing on separate plants. Common and widespread, especially on disturbed ground.

Water-pepper ②

Polygonum hydropiper

HEIGHT Up to 70cm
An upright, branched annual of damp, bare ground. The narrow oval leaves have a strong peppery taste. The flowers are pale pink and borne on long drooping stalks. Common in damp places, but scarce in the north.

Red goosefoot ③

Chenopodium rubrum

HEIGHT Up to 60cm
The leaves are shiny and diamond-shaped with toothed margins and the whole plant has an upright habit. Flowers are borne on leafy spikes in midsummer and the whole plant may turn red in late summer. Common in southern England but scarce elsewhere.

Good King ④ Henry

Chenopodium bonus-henricus

HEIGHT Up to 50cm
An upright perennial with triangular, mealy leaves which become greener with age. The small pale flowers are borne on leafless spikes in late summer. Introduced and now common on waste ground and marginal arable land.

Sea beet ⑤

Beta vulgaris

HEIGHT Up to 1m
A straggling perennial with glossy dark green leaves, often leathery when mature, and reddish stems. Flowers are produced in summer on terminal leafless spikes. Common and widespread on a variety of coastal habitats, including shingle banks and crumbling cliffs.

Broad-leaved ⑥ dock

Rumex obtusifolius

HEIGHT Up to 1m
A very common and widespread upright perennial of waste ground, pastures and waysides. The large leaves are oval with heart-shaped bases and the flowers are borne on long spikes, which are leafy at the base.

Curled dock ⑦

Rumex crispus

HEIGHT Up to 1m
The leaves are narrow and up to 25cm long, with wavy margins. The flattened, oval flowers grow on leafless, terminal spikes, appearing in late summer. A very common perennial of rough meadows and disturbed ground.

WILD FLOWERS
● *Small and medium-sized plants* ● *Flowers often attractive to pollinating insects*
● *More than 1,500 species in Britain, of which about 500 are common*

Fat hen ⑧

Chenopodium album

HEIGHT Up to 1m
A common annual with mealy-surfaced leaves which can be oval or diamond-shaped. Flowers are borne on dense spikes and look white or pale green. Very common and widespread in disturbed and waste ground.

Common ⑨ sorrel

Rumex acetosa

HEIGHT Up to 60cm
Usually a short perennial of grassy habitats with deep green, arrow-shaped leaves which have a faint vinegary taste. The flowers are small and red, growing in densely packed spikes. Common and widespread.

Bistort ⑩

Polygonum persicaria

HEIGHT Up to 60cm
A patch-forming perennial of wet meadows and river banks with narrow, pointed leaves and terminal cylindrical spikes of pink flowers borne on upright stems. Commonest in the north.

Knotgrass ⑪

Polygonum aviculare

USUALLY PROSTRATE
A much-branched annual with tough stems, oval leathery leaves with silvery leaf bases, and small white flowers borne in the leaf axils. Very common and widespread on bare ground, waste places and paths.

Black ⑫ bindweed

Bilderdykia convolvulus

HEIGHT Up to 1m
A climbing annual which scrambles through hedgerow plants and forms loose mats on the ground. Leaves are arrow-shaped and arise from angular stems. Flowers grow in clusters in the leaf axils. Common and widespread in waste places and cultivated ground.

Great water ⑬ dock

Rumex hydrolapathum

HEIGHT Up to 1.5m
A tall, branched perennial, usually found in or close to water. Dense flower spikes are produced in midsummer. Widespread and locally common in southern and eastern England; absent from the north.

Monks ⑭ rhubarb

Rumex pseudoalpinus

HEIGHT Up to 1m
Distinguished from other docks by its large leaves with wavy margins. A large plant, originally introduced to Britain as a pot-herb, now found in meadows, usually near habitation.

Moss campion ①

Silene acaulis

DIAMETER Up to 20cm
A cushion-forming perennial covered in a mass of pink flowers in summer. The leaves are small and hairless and densely packed on the stems. Normally found on mountain ledges from Wales to Scotland, but may occur near sea level farther north.

Greater stitchwort ②

Stellaria holostea

HEIGHT Up to 50cm
A common hedgerow and open woodland plant bearing white flowers with notched petals borne on thin stems. The leaves are thin and grass-like, and the plant is easily overlooked until in flower. Very common and widespread.

Bladder campion ③

Silene vulgaris

HEIGHT Up to 80cm
A hairless perennial with upright, sparsely leafy stems which bear white flowers with inflated bladder-like sepal tubes. Common on chalk and limestone grasslands in the south, scarce elsewhere.

Sea sandwort ④

Honkenya peploides

USUALLY PROSTRATE
A mat-forming perennial of coastal sand and shingle. Fleshy, oval leaves are tightly packed on the creeping stems. The greenish-white flowers open in May–August and are followed by greenish, inflated seed pods. Common and widespread on all coasts.

Red campion ⑤

Silene dioica

HEIGHT Up to 1m
A hairy biennial or perennial with pink flowers borne on the ends of upright stems. The 5 petals are deeply notched. A common plant of hedgerows, open woodlands and grassy places. Widespread and common, apart from in eastern England and the far north.

Procumbent pearlwort ⑥

Sagina procumbens

PROSTRATE
A small creeping perennial with tiny leaves and petal-less green flowers arising from side shoots throughout the summer. Occurs on bare, damp ground. Widespread and common.

Common mouse-ear ⑦

Cerastium fontanum

HEIGHT Up to 30cm
A small hairy perennial with opposite grey-green leaves, resembling the ears of a mouse. The flowers are small and white with notched petals. Common and widespread in open grassy habitats.

Rock sea spurrey ⑧

Spergularia rupicola

HEIGHT Up to 20cm
A sticky perennial which forms clumps and bears attractive pink flowers about 8–10mm across in midsummer. Usually confined to coastal rocks and walls. Widespread and common in suitable habitats.

Glasswort ⑨

Salicornia europaea

HEIGHT Up to 30cm
A variable, yellowish-green succulent annual which has branched stems with a segmented appearance. Minute flowers with no petals appear in late summer. Widespread and common on saltmarshes around all coasts.

Common chickweed ⑩

Stellaria media

HEIGHT Up to 30cm
A common annual plant of waste ground and unkempt gardens. The flowers are small and white with deeply notched petals. The leaves are oval and in opposite pairs. Widespread and often in flower all year.

Annual seablite ⑪

Suaeda maritima

HEIGHT Up to 50cm
A multi-stemmed, slightly fleshy plant of saltmarshes and strandlines. The leaves are small and cylindrical and vary in colour from grey-green to yellow; minute flowers appear in late summer. Common and widespread in suitable habitats around all coasts.

White campion ⑫

Silene alba

HEIGHT Up to 1m
A hairy perennial with white flowers about 25mm across. There are 5 deeply notched petals. The leaves are oval and grow in opposite pairs. Widespread and common in grassy places and disturbed ground.

Spring sandwort ⑬

Minuartia verna

HEIGHT Up to 10cm
The leaves are narrow and grow in whorls of 3 around slender stems. The pure white, 5-petalled flowers open in summer. Often found on spoil heaps outside abandoned lead mines, and also occurs on limestone rocks.

Sea purslane ⑭

Halimione portulacoides

HEIGHT Up to 1m
A spreading mealy-looking perennial which forms dense colonies on saltmarshes. The leaves are oval at the base of the stem, but narrower near the top. Spikes of yellowish flowers appear in late summer. Common and widespread on saltmarshes on all coasts.

Bulbous buttercup ①

Ranunculus bulbosus

HEIGHT Up to 45cm
Leaves are divided into 3 stalked lobes and whole plant is hairy. The yellow flowers are up to 3cm across and the sepals are folded back below the flower. Common in dry grassy places, chalk downs and roadsides.

Celery-leaved buttercup ②

Ranunculus scleratus

HEIGHT Up to 50cm
The lower leaves are celery-like and divided into 3 lobes; the upper leaves are smaller and stalkless. The flowers are up to 1cm across and grow in small clusters. Fairly common in damp grassy places in the south, often on grazed marshes

Marsh marigold ③

Caltha palustris

HEIGHT Up to 25cm
Large, shiny, kidney-shaped leaves. The flowers are bright yellow, consisting of 5 yellow sepals, and open in April-June. Common and widespread in damp woodlands, pond margins and marshes.

Lesser spearwort ④

Ranunculus lingua

HEIGHT Up to 50cm
A small creeping or scrambling perennial with narrow, spear-shaped leaves, occasionally rooting where stems touch the ground. Solitary flowers are yellow and up to 1.5cm across. Common in wet, grassy places.

Ragged robin ⑤

Lychnis flos-cuculi

HEIGHT Up to 65cm
Leaves are narrow, grass-like and in opposite pairs. The flowers are pink and have 5 deeply divided petals, giving a feathery appearance. A widespread and common perennial of damp meadows and marshes.

Winter aconite ⑥

Eranthis hyemalis

HEIGHT Up to 10cm
The single stem supports 3 leaves, each being 3-lobed and horizontal. The bright yellow flowers open in January–April. Introduced as a garden plant, but widely naturalised.

Lesser celandine ⑦

Ranunculus ficaria

HEIGHT Up to 25cm
A patch-forming perennial with heart-shaped, glossy dark green leaves and shiny yellow flowers up to 3cm across which only open fully in bright sunshine. One of the first spring flowers in sheltered places. Common and widespread in a range of lowland habitats.

Maiden pink ⑧

Dianthus deltoides

HEIGHT Up to 20cm
Small hairy perennial with narrow, grey-green leaves. Pink flowers up to 2cm across; they have white spots at the base and toothed margins to the petals. Widespread in dry sandy places in the south, but only locally common.

Greater spearwort ⑨

Ranunculus lingua

HEIGHT Up to 1m
A robust plant of pond margins with upright stems and rooting runners, and long, spear-shaped leaves. Large yellow flowers up to 4cm across appear in midsummer. Locally common in lowland ponds, ditches and wet marshes.

Meadow buttercup ⑩

Ranunculus acris

HEIGHT Up to 60cm
The leaves are rounded and divided into 3–7 lobes; those nearest the flowers have no stalks. Yellow flowers up to 2.5cm across, consisting of 5 bright yellow petals and upright green sepals. Very common and widespread.

Creeping buttercup ⑪

Ranunculus repens

HEIGHT Up to 50cm
Recognised by long rooting runners which aid rapid spread. Leaves have 3 lobes, the middle one being on a short stalk. The flowers are yellow with upright sepals. Common and widespread in grassy habitats, including gardens and lawns.

Globeflower ⑫

Trollius europaeus

HEIGHT Up to 60cm
The leaves are deeply divided into toothed lobes. The flowers are almost spherical, remaining closed, and consist of 10-15 yellow sepals. Common in damp meadows, mountain pastures and ledges from North Wales northwards.

Stinking hellebore ⑬

Helleborus foetidus

HEIGHT Up to 75cm
A robust perennial with strongly toothed lobed leaves which are present in winter. The flowers are bell-shaped and pea green, appearing very early in the year. Smells unpleasant when bruised. Restricted mainly to woods on lime-rich soils in the south, but common as a garden plant.

Corncockle ⑭

Agrostemma githago

HEIGHT Up to 70cm
Leaves are narrow and grass-like and the plant has an upright habit. The flowers are reddish-pink with slightly lobed petals and long, narrow, radiating sepals. Once widespread in cornfields, but now rare.

Greater celandine ①

Chelidonium majus

HEIGHT Up to 80cm
Despite the name, not a relative of lesser celandine. Flowers are long-stalked, composed of 4 non-overlapping yellow petals and are up to 3cm across. The leaves are grey-green and divided pinnately. Widespread but scattered in hedgerows, open woodlands and dry habitats.

Hedge mustard ②

Sisymbrium officinale

HEIGHT Up to 70cm
An upright annual or biennial with terminal heads of small 4-petalled yellow flowers, opening from May–October. Seed pods are cylindrical and pressed close to the stem. The lower leaves are divided and the stem leaves are long and narrow. Common on waste ground and disturbed soil.

Common meadow rue ③

Thalictrum flavum

HEIGHT Up to 1m
Erect hairless perennial with pinnate leaves divided into toothed lobes. Small white flowers have long yellow anthers and are borne on terminal spikes. Locally common in wet meadows, fens and ditches in southern and eastern England.

Wood anemone ④

Anemone nemorosa

HEIGHT Up to 30cm
Flowers are solitary, on long stalks, and have 5–10 pink-tinged white sepals and yellow anthers. Stem leaves are divided into 3 deeply toothed lobes. Widespread and locally common in woodlands, old hedgerows and mountain ledges.

Hairy bittercress ⑤

Cardamine hirsuta

HEIGHT Up to 30cm
Common annual with slightly hairy stems and leaves; the lower leaves are pinnate and form a basal rosette, but the upper leaves are smaller. The small white flowers are up to 3mm across and the seed pods are slender and cylindrical. Flowers can be found all year. Widespread in a range of open and disturbed habitats.

Common poppy ⑥

Papaver rhoeas

HEIGHT Up to 60cm
A hairy annual with divided leaves and red flowers up to 10cm in diameter. The 4 petals are large and papery; flowers are present from June–August, followed by large, ovoid seed pods. Common on arable and disturbed ground.

White water-lily ⑦

Nymphaea alba

FLOATING
The round floating leaves are up to 30cm in diameter, and the pinkish-white flowers can be up to 20cm across. They appear in midsummer and only open fully in sunshine. Widespread and common in still waters, canals and large ditches.

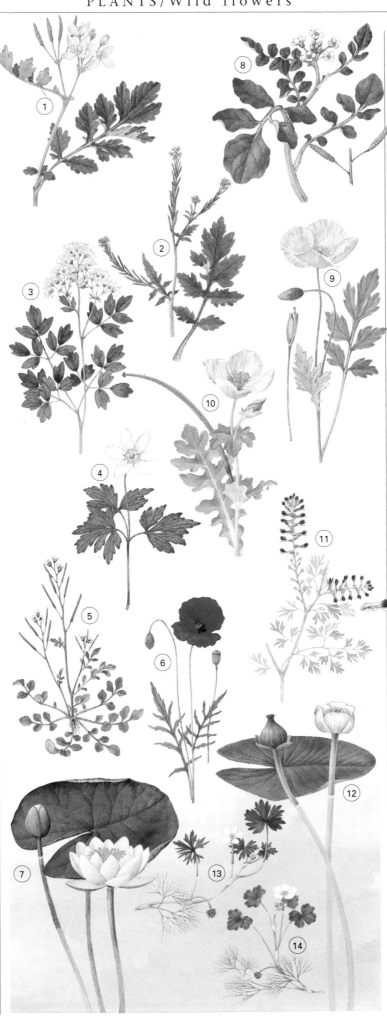

Watercress ⑧

Nasturtium officinale

HEIGHT Up to 15cm
A common patch-forming perennial of shallow streams and clear ditches. The 4-petalled white flowers grow in rounded heads May–October. Leaves are bright green and pinnately divided; there are often adventitious roots arising on the stem between the leaves. Widespread.

Welsh poppy ⑨

Meconopsis cambrica

HEIGHT Up to 50cm
Flowers are up to 8cm in diameter, with 4 overlapping yellow petals on a long stalk. Leaves are pinnate and long-stalked. Native to damp woods in SW England, Wales and Ireland.

Yellow horned-poppy ⑩

Glaucium flavum

HEIGHT Up to 50cm
A perennial with rough, blue-grey stem and leaves; the lower leaves are lobed and the upper leaves clasp the stem. The yellow flowers, up to 9cm across, are followed by long, curved seed pods. Widespread on shingle beaches.

Common fumitory ⑪

Fumaria officinalis

HEIGHT Up to 10cm
A scrambling annual with delicate, deeply lobed leaves and crimson-tipped pink flowers. The flowers are up to 7mm long, spurred and 2-lipped, and can be seen from April–October. Very common and widespread.

Yellow water-lily ⑫

Nuphar lutea

FLOATING
The floating leaves are oval and can be up to 40cm in diameter. The long-stalked yellow flowers are up to 6cm across, appearing in midsummer but only opening in sunshine. Widespread and locally common apart from in northern Scotland.

Common water-crowfoot ⑬

Ranunculus aquaticus

FLOATING
Normally aquatic, with thread-like submerged leaves and entire floating leaves. The flowers are white with a yellow centre and up to 2cm across, appearing in profusion in April–August. Common and widespread in clear, shallow streams and rivers, and some still waters.

Pond water crowfoot ⑭

Ranunculus peltatus

FLOATING
The floating leaves are rounded and lobed, and the submerged leaves are short and thread-like. The white, yellow-centred flowers appear in May–August, often in great abundance. Widespread and common in ponds, lake margins and ditches.

Wild cabbage ①

Brassica oleracea

HEIGHT Up to 1.25m
A tough perennial with leathery, cabbage-like leaves and thickened stems. The flowers are yellow, 4-petalled and up to 2cm across, opening in April–August. Occurs on lime-rich cliffs in southern and western England, and west Wales.

Common ②
whitlowgrass

Erophila verna

HEIGHT Up to 20cm
A small annual with a basal rosette of narrow, toothed leaves and slender upright flower stems. The flowers have 4 small notched petals and are up to 6mm across, open at any time from March–May. Widespread and common.

Navelwort ③

Umbilicus rupestris

HEIGHT Up to 15cm
A perennial with fleshy leaves which are rounded with a depressed centre. Tall spikes of creamy-white flowers appear in June–August. Common on rocks and walls in western Britain and Ireland; tolerant of partial shade.

Weld ④

Reseda lutea

HEIGHT Up to 1.2m
A slender biennial with a basal rosette of shiny green leaves in the first year and a tall flower spike of yellowish 4-petalled flowers in the second summer. Widespread and common on calcareous soils and disturbed ground.

Wild radish ⑤

Raphanus raphanistrum

HEIGHT Up to 60cm
A robust, hairy annual with pinnately divided lower leaves and narrow, entire upper leaves. The 4-petalled yellow flowers grow on terminal spikes, opening from May–July, and are followed by short, beaded seed pods. Widespread and common on rough grasslands and waste places.

Common ⑥
scurvy-grass

Cochlearia officinalis

HEIGHT Up to 50cm
Basal leaves kidney shaped, upper ones clasp the stem and are narrower and pointed. White 4-petalled flowers are up to 8mm across borne in untidy terminal clusters. Flowers April–October, followed by round seed pods. Common on coasts and inland mountain ledges.

Shepherd's-purse ⑦

Capsella bursa-pastoris

HEIGHT Up to 35cm
An annual with loose heads of small, white, 4-petalled flowers and flattened triangular seed pods; flowers and seeds can be found at any time of year. Lower leaves are mainly lobed, the upper ones may be entire or have toothed margins. Widespread and very common in gardens and waste places.

Field pepperwort ⑧

Lepidium campestre

HEIGHT Up to 50cm
A grey-green hairy annual with oval, untoothed basal leaves and arrow shaped, clasping stem leaves. The white flowers are very small, opening from May–August, and the seed pods are oval and notched. Widespread and common on dry, bare ground. Scarce in the north.

Round-leaved ⑨
sundew

Drosera rotundifolia

HEIGHT Up to 20cm
An insectivorous plant with long-stalked, red-bordered rounded leaves covered in sticky hairs which trap insects. The small flowers are white and grow on tall, drooping flower spikes. Widespread and common in acid bogs and moors.

Wild mignonette ⑩

Reseda lutea

HEIGHT Up to 70cm
A biennial with pinnately divided leaves and compact spikes of yellowish, 6-petalled flowers which open in June–August. Widespread, but absent from northern Scotland, preferring disturbed calcareous soils.

Sea-kale ⑪

Crambe maritima

HEIGHT Up to 50cm
A robust perennial with tough, fleshy leaves with wavy margins; the lower leaves have long stalks. The flowers are white, grow in flat-topped clusters and open in midsummer. The seed pods are oval and slightly woody when ripe. Widespread and common on sand and shingle beaches.

Garlic mustard ⑫

Alliaria petiolata

HEIGHT Up to 1m
A tall hairless biennial with long-stalked, heart-shaped leaves which smell strongly of garlic when crushed. The 4-petalled white flowers open from April–August and are followed by long thin pods. Very common in hedgerows, open woodlands and grassy places.

Cuckoo flower ⑬

Cardamine pratensis

HEIGHT Up to 50cm
A perennial with a basal rosette of dark green pinnately divided leaves with rounded lobes. The pale lilac flowers are up to 2cm across and are borne in rounded, terminal spikes, opening in April–May. Widespread and locally common in damp grassy places.

Sea rocket ⑭

Cakile maritima

HEIGHT Up to 25cm
An untidy fleshy annual with white or pale lilac flowers, up to 12mm across, which open from June–September. The seed pods are egg-shaped and grow on angled stalks. The leaves are long and pinnately lobed. Widespread and common on most sandy coasts.

Meadowsweet ①

Filipendula ulmaria

HEIGHT Up to 1.25m
A perennial with dense sprays of small, creamy-white, strongly scented flowers, opening in June–September. The leaves are dark green and divided into 3–5 pairs of oval leaflets. Widespread and common in damp meadows and marshes.

Grass-of-② Parnassus

Parnassia palustris

HEIGHT Up to 25cm
A compact perennial with stalked, heart-shaped basal leaves and 5-petalled white flowers, up to 3cm across, borne on upright stems with clasping leaves. Locally common on peaty marshes, bogs and dune slacks in northern Britain and Ireland.

Salad burnet ③

Sanguisorba minor

HEIGHT Up to 35cm
A perennial with reddish, rounded flower heads which open in midsummer, and pinnate leaves with 4–12 pairs of rounded, toothed leaflets. The basal leaves form a rosette. Locally common in calcareous grassland, absent from northern Scotland.

Biting stonecrop ④

Sedum acre

HEIGHT Up to 10cm
A mat-forming perennial with fleshy leaves that have a peppery taste. The leaves are crowded and pressed close to the stem. The flowers are yellow and star-shaped, opening in May–July. Widespread and common on sand dunes, shingle and, increasingly, gravelly roadsides and waste ground.

Meadow saxifrage ⑤

Saxifraga granulata

HEIGHT Up to 45cm
A perennial with kidney-shaped leaves that have bulbils forming at their base in autumn. The 5-petalled white flowers are borne on long reddish stalks in April–June. Locally common in meadows in eastern England, scarce elsewhere.

Purple saxifrage ⑥

Saxifraga oppositifolia

CREEPING
A mat-forming perennial bearing many small purple flowers in March–April. The trailing stems support opposite pairs of tiny dark green leaves. Locally common on mountain ledges and rocks in northern England, North Wales and Scotland.

Roseroot ⑦

Rhodiola rosea

HEIGHT Up to 30cm
The strong stems bear overlapping, slightly fleshy oval leaves. The dense flower heads of yellow flowers open in May–July and are followed by attractive orange seed heads. Occurs on sea cliffs and mountain ledges in western Wales, northern England, Scotland and Ireland.

Parsley piert ⑧

Aphanes arvensis

CREEPING
A small annual with downy, fan-shaped leaves which are divided into 3 lobes and bear a fanciful resemblance to parsley. The flowers are minute and green, opening in April–October. Widespread and sometimes common on dry, bare ground, tracks and waste places.

Agrimony ⑨

Sanguisorba officinalis

HEIGHT Up to 50cm
A perennial with narrow upright spikes of yellow, 5-petalled flowers which open in June-August. The leaves are divided into 3–6 pairs of oval leaflets with smaller leaflets between them. Widespread and common in grassy places and roadsides.

English ⑩ stonecrop

Sedum anglicum

HEIGHT Up to 5cm
A mat-forming perennial with fleshy leaves which may be tinged with red; star-shaped, 5-petalled white flowers opening from June–September. Widespread and locally common on sea cliffs, bare rocks, walls and shingle.

Lady's-mantle ⑪

Alchemilla vulgaris

HEIGHT Up to 30cm
A perennial with variable palmately lobed leaves which have a finely toothed margin. The tiny yellowish-green flowers open in May–September. Locally common in grasslands in uplands in the north; very scarce elsewhere, but many garden varieties exist.

Field rose ⑫

Rosa arvensis

HEIGHT Up to 1m
A clump-forming perennial with trailing purple-tinged thorny stems and leaves composed of 5–7 oval leaflets. The flowers are white, with notched petals, opening in July–August. Widespread and locally common in southern Britain and Ireland, scarce in the north.

Dog-rose ⑬

Rosa canina

HEIGHT Up to 3m
A scrambling shrub with flexible, thorny stems and leaves composed of 5–7 oval leaflets. The flowers are pale pink and open in June–July, followed by large orange-red hips. Widespread in suitable habitats, commonest in the south.

Opposite-leaved ⑭ golden saxifrage

Chrysosplenium oppositifolium

HEIGHT Up to 12cm
The rounded stalked leaves have slightly toothed margins and are carried in opposite pairs. The yellow flowers have no petals and are borne on short leafy stalks, opening in March–July. Locally common in the north and west on shady streambanks and in damp woodlands.

Bramble ①

Rubus fruticosus agg

HEIGHT Up to 3m
A very variable, prickly shrub with long trailing stems which root when they touch the ground. The white or pink flowers open in early summer and are followed by edible blackberries in late summer and autumn. Extremely common and widespread.

Petty whin ②

Genista anglica

HEIGHT Up to 1m
A sparsely leafy shrub with hairless, spiny stems and small, narrow leaves. The yellow flowers are up to 1.5cm long, opening in April–June. Only locally common on wet heaths and moors; absent from Ireland.

Burnet rose ③

Rosa pimpinellifolia

HEIGHT Up to 50cm
A low, clump-forming rose with very thorny stems and leaves made up of 7–11 oval leaflets. The creamy-white flowers, which open in May–July, are followed by purplish-black hips in the autumn. Widespread on sand dunes, calcareous grasslands and dry heaths.

Common gorse ④

Ulex europaeus

HEIGHT Up to 2m
A very spiny evergreen shrub with dense spikes of yellow, keeled flowers which release a smell of coconut. Flowers open mainly in February–May, and are followed by flattened black seed pods. The spines are straight and grooved. Widespread and very common, usually on more acid soils.

Tormentil ⑤

Potentilla erecta

HEIGHT Up to 30cm
A creeping perennial with unstalked, trifoliate leaves which have 2 large stipules giving a 5-lobed appearance. The yellow, 4-petalled flowers are up to 1cm across and can be seen from May–September. Widespread and common on heaths, moors and acid grassland.

Wild strawberry ⑥

Fragaria vesca

HEIGHT Up to 30cm
A low perennial with long, rooting runners and compound leaves composed of 3 leaflets which are hairy on the underside The white 5-petalled flowers open from April–July and give rise to sweet red fruits. Widespread and common in dry grassy places.

Creeping cinquefoil ⑦

Potentilla reptans

CREEPING
A creeping perennial with stems which root at the nodes. The leaves are 5–7 lobed and carried on long stalks. The yellow flowers are 5-petalled and up to 2.5cm across, and can be seen from June–August. Widespread and common in grassy places.

Water avens ⑧

Geum rivale

HEIGHT Up to 50cm
A perennial with pinnate basal leaves and trifoliate stem leaves. The flowers are bell-shaped, carried on nodding stalks, with pink petals and dark red sepals; they open from May–September. Widespread and locally common in damp, base-rich meadows, mostly in the north.

Dwarf gorse ⑨

Ulex minor

HEIGHT Up to 1m
A dense, spiny evergreen shrub with straight, smooth spines up to 1cm long. Small trifoliate leaves grow between the spines. The flowers are yellow and keeled, opening in July–September. Locally common on acid soils and heaths in southern and SE England.

Herb bennet ⑩ or wood avens

Geum urbanum

HEIGHT Up to 50cm
A hairy perennial with pinnate basal leaves and yellow flowers on drooping stalks. There are 5 petals and the flower is up to 1.5cm in diameter. The seed heads look prickly as each seed has a hooked red style. Widespread and locally common in woodlands and hedgerows.

Marsh cinquefoil ⑪

Potentilla palustris

HEIGHT Up to 40cm
The flowers, open May–July, are reddish-purple and star-shaped, the sepals being much larger than the petals. Leaves are greyish-green and divided into 3–5-toothed, oval leaflets. Widespread and locally common in northern Britain and Ireland, scarce in southern England.

Dyer's greenweed ⑫

Genista tinctoria

HEIGHT Up to 1m
A spineless perennial with narrow, slightly downy leaves and broom-like flowers about 1.5cm long which open in June–July on leafy stalks. The seed pods are oblong and hairless. Widespread and locally common in grasslands in England, Wales and southern Ireland.

Broom ⑬

Cytisus scoparius

HEIGHT Up to 2m
A deciduous shrub with ridged green twigs and trifoliate leaves. The keeled flowers are up to 2cm long and bright yellow, opening from April–June; they are followed by flattened black seed pods. Widespread and common on acid soils in open areas, heaths and roadsides.

Silverweed ⑭

Potentilla anserina

CREEPING
A creeping perennial with silvery leaves divided up into maximum of 12 pairs of toothed leaflets with smaller ones between them. The yellow flowers are 5-petalled and up to 2cm across, opening from May–August. Widespread and common in damp grassy places.

Yellow vetchling ①

Lathyrus aphaca

HEIGHT Up to 80cm
A scrambling annual with angled stems; the leaves are reduced to tendrils and pairs of grey-green leaf-like stipules. The yellow flowers are solitary, opening in June–August. Only locally common on chalk grassland in southern England.

Horseshoe vetch ②

Hippocrepis comosa

HEIGHT Up to 10cm
A small perennial with leaves composed of 4–5 pairs of narrow leaflets and single terminal leaflet. The circular flower heads are seen in May–July, and the seed pods contract into horseshoe-shaped segments. Locally common on chalk grassland, mainly in southern England.

Tufted vetch ③

Vicia cracca

HEIGHT Up to 2m
A scrambling perennial with leaves made up of up to 12 pairs of tiny leaflets and a branched tendril. The purplish-blue flowers grow in spikes up to 4cm long and can be seen from June–August. Widespread and often very common.

Bird's-foot trefoil ④

Lotus corniculatus

USUALLY CREEPING
A perennial with creeping stems and leaves which look trifoliate but have an extra pair of leaflets at base of petitole. Flowers are yellow or orange, opening from May–September. Ripe seed pods form a bird's-foot pattern. Widespread and common in grassy places.

Kidney vetch ⑤

Anthyllis vulneraria

HEIGHT Up to 30cm
A perennial covered with fine silky hairs; the leaves are composed of pairs of fine leaflets and the flowers are mostly yellow, but orange or red forms occur. They are borne in paired rounded heads on long stalks. Widespread on calcareous grassland and sea cliffs.

Purple milk-vetch ⑥

Astragalus danicus

A spreading perennial with hairy pinnate leaves made up of up to 12 pairs of oval leaflets. The purple flowers are around 15mm long, growing in dense heads and open from May–July. Local and uncommon in eastern Britain, rare in Ireland.

Restharrow ⑦

Ononis repens

HEIGHT Up to 70cm
A tough, creeping perennial with hairy stems and trifoliate, stickily hairy leaves. The pink flowers grow in loose clusters on leafy stalks, opening in July–September. Locally common on calcareous grasslands and dune slacks.

Ribbed mellilot ⑧

Melilotus officinalis

HEIGHT Up to 1.5m
A biennial with trifoliate leaves and tall spikes of yellow flowers opening from June–September. The ripe seed pods are brown. Widespread native in grassy places in England and Wales; introduced and scarce elsewhere.

Bush vetch ⑨

Vicia sepium

HEIGHT Up to 1m
A scrambling perennial with leaves made up of 5–9 pairs of narrow leaflets and a branched tendril. The pale lilac flowers grow in small clusters of 2–6, opening from April–October. Widespread and common in all regions.

Sainfoin ⑩

Onobrychis viciifolia

HEIGHT Up to 75cm
A perennial with conical spikes of red-veined pink flowers, opening in June–August. The leaves are made up of 6–14 pairs of oval leaflets. Common on dry calcareous grasslands in the SE where it may be native; introduced elsewhere in England and Wales.

Sea pea ⑪

Lathyrus japonica

HEIGHT Up to 12cm
A spreading, grey-green perennial with long stems leaves made up of 2–5 pairs of oval leaflets. The clusters of bluish-purple flowers open in June–August. Restricted to coastal shingle in southern and eastern England.

Wood vetch ⑫

Vicia sylvatica

HEIGHT Up to 1.5m
A straggling perennial with leaves made up of up to 12 pairs of narrow leaflets and a branched tendril. The purple-veined white flowers grow in open spikes and can be seen from June–August. Widespread, but only locally common in shady woods and coastal slopes; commonest in the west.

Greater bird's-foot trefoil ⑬

Lotus uliginosus

HEIGHT Up to 50cm
A perennial with upright, but often scrambling stems and grey-green, apparently trifoliate leaves made up of 5 leaflets. The yellow flowers are carried on long stalks and are seen from June–August. Locally common in damp grassland and fens.

Meadow vetchling ⑭

Lathyrus pratensis

HEIGHT Up to 50cm
A scrambling perennial with long, angled stems. The leaves are made up of a single pair of leaflets and tendrils. The yellow flowers grow in clusters of 4–12, opening from May–August. Widespread and common in a range of open grassy habitats.

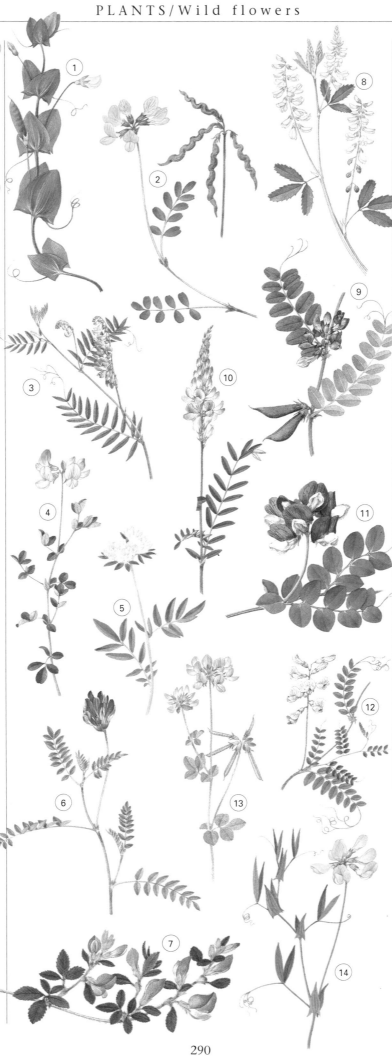

Cut-leaved crane's-bill (1)

Geranium dissectum

HEIGHT Up to 45cm
A small, hairy annual with leaves cut into very narrow lobes. The small pinkish flowers open from May–September and are up to 1cm across. Widespread and common on disturbed ground, open grasslands and waste places.

Black medick (2)

Medicago lupulina

HEIGHT Up to 20cm
A small, downy annual with trifoliate leaves, each rounded leaflet terminating in a point. The yellow flowers grow in dense rounded heads and are followed by clusters of black seed pods. Widespread and common in short grassland and waste places.

Red clover (3)

Trifolium pratense

A perennial with trifoliate leaves, each oval leaf segment having a crescent-shaped white mark. The pinkish-purple flower heads are unstalked and up to 3cm across, and can be seen from May–October. Very common and widespread in grasslands everywhere.

Wood crane's-bill (4)

Geranium sylvaticum

A perennial with downy, deeply cut 5-lobed leaves. The reddish-purple flowers are up to 3cm across, opening in June–August. Locally common in damp grassland and open woodlands on base-rich soils, but absent from most of southern England.

White clover (5)

Trifolium repens

HEIGHT Up to 40cm
A perennial with trifoliate leaves; the leaflets are rounded and may have faint white marks. The rounded flower heads are 2cm in diameter, creamy-white but becoming brown with age, seen from May–October. Widespread and common in grasslands.

Wood sorrel (6)

Oxalis acetosella

HEIGHT Up to 10cm
A delicate, creeping perennial with trifoliate leaves normally folded down on the long stem. The cup-shaped flowers are white with lilac veins and open in April–June. Widespread and locally common in ancient woodlands and damp shady places.

Bird's-foot (7)

Ornithopus perpusillus

HEIGHT Up to 30cm
A small, trailing, downy annual with leaves made up of 5–13 pairs of small leaflets. The small flowers are creamy-white with distinct red veins and open from May–August. The seeds pods form a bird's-foot shape. Locally common in dry sandy places in England and Wales, scarce elsewhere

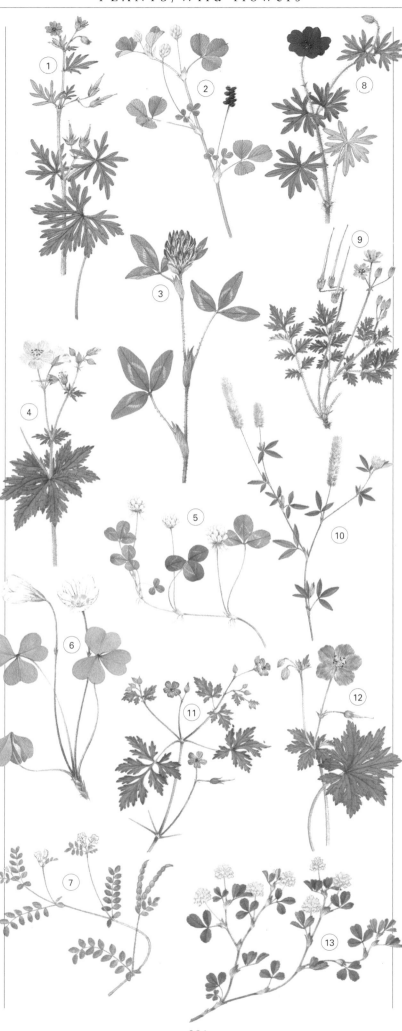

Bloody crane's-bill (8)

Geranium sanguineum

HEIGHT Up to 25cm
A downy, clump-forming perennial with deeply-cut 5–7-lobed leaves. The flowers are bright reddish-purple and up to 3cm across, opening in June–August. Widespread in Britain in calcareous grassland and limestone rocks; absent from SE England, but found in western Ireland.

Common storksbill (9)

Erodium cicutarium

HEIGHT Up to 25cm
A small annual covered in sticky hairs; the leaves are deeply cut, having a feathery appearance, and form a basal rosette. The pink flowers appear in May–August, often losing their petals rapidly. The seed pod resembles a bird's beak. Widespread and locally common in dry grassy places, especially SE England and sandy coasts.

Hare's-foot clover (10)

Trifolium arvense

HEIGHT Up to 25cm
An annual covered with soft greyish hairs; the leaves are trifoliate and have narrow leaflets and the flower heads are oval or cylindrical, appearing in June–September. Widespread and sometimes common in dry grassland and dunes, but absent from northern Scotland.

Herb robert (11)

Geranium robertianum

HEIGHT Up to 30cm
A straggling annual or biennial, with downy, unpleasant-smelling stems and leaves. The leaves are deeply divided into 3–5 lobes and the pink flowers appear from April–October. The seed pods resemble a bird's beak. Widespread and very common in damp, shady places, hedgerows and woodlands.

Meadow crane's-bill (12)

Geranium pratense

HEIGHT Up to 75cm
A perennial with deeply divided, downy lower leaves. The flowers are up to 5cm across and bluish-violet, opening in June–August. Widespread and sometimes common in grassy places on base-rich soils, mostly in central and northern England, and Scotland.

Hop trefoil (13)

Trifolium campestre

HEIGHT Up to 25cm
A small hairy annual with alternate, trefoil leaves. The pale yellow flowers, usually seen from May–October, grow in compact rounded heads and when dead look like small brown hops. Widespread and often common in dry grassland and waste places, but scattered in Ireland and the north.

Common mallow ①

Malva sylvestris

HEIGHT Up to 1.5m
An upright and sometimes spreading perennial with rounded basal leaves and 5-lobed stem leaves. The pink flowers have purple veins and are up to 4cm across, opening in June–October. Widespread and common in southern Britain, scarce elsewhere.

Tutsan ②

Hypericum androsaemum

HEIGHT Up to 80cm
An upright, shrubby perennial with opposite pairs of oval leaves. The yellow flowers are up to 2.5cm across and open from June–August; they are followed by black berries. Locally common in shady woods and hedgerows in southern and western Britain, and Ireland.

Wood spurge ③

Euphorbia amygdaloides

HEIGHT Up to 80cm
A robust downy perennial with reddish stems and unstalked dark green lanceolate leaves. The flowers grow in flat umbels and are bright greenish-yellow, appearing in April–June. No petals or sepals. Common in woodlands only in southern England and Wales.

Dog's mercury ④

Mercurialis perennis

HEIGHT Up to 35cm
A perennial with upright stems bearing bright green, oval, toothed leaves and loose spikes of small green flowers, male and female occurring on separate plants. Widespread and often very common in woodlands and shady places. Scarce in northern Scotland and Ireland.

Sea spurge ⑤

Euphorbia paralias

HEIGHT Up to 60cm
A short, greyish perennial with fleshy leaves closely packed on the upright stems. The flowers lack petals and sepals and appear in May–November. Widespread and locally common on sand dunes on coasts of southern and western England, Wales and western Ireland.

Perforate St ⑥ John's-wort

Hypericum perforatum

HEIGHT Up to 80cm
An upright perennial with a double-lined stem bearing narrow paired leaves which show translucent dots against the light. Yellow flowers are up to 2cm across, open in June–September. Found in grassy places, commonest in south.

Marsh ⑦ St John's-wort

Hypericum elodes

HEIGHT Up to 20cm
A creeping, hairy perennial with rounded grey-green clasping leaves. Yellow flowers borne singly on the tops of the stems are seen from June–August. Widespread in peaty ground and marshes in SW Britain.

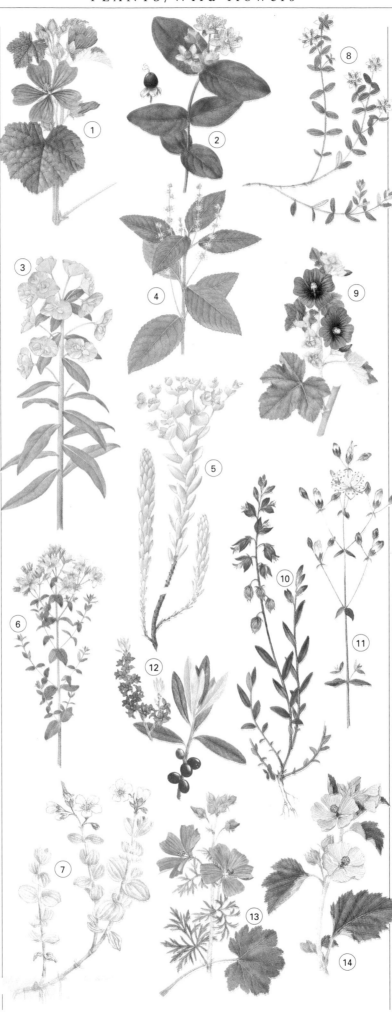

Trailing St ⑧ John's-wort

Hypericum humifusum

CREEPING
A hairless, creeping perennial with small paired leaves showing translucent dots. The small yellow flowers open in June–September. Widespread on bare, open ground, usually on acid soils; commonest in western Britain.

Tree mallow ⑨

Lavatera arborea

HEIGHT Up to 3m
A robust woody biennial with large 5–7 leaves. The large pink flowers have purple veins and open from June–September. Locally common on west coasts of Britain and southern and western Ireland, often near seabird colonies. Scattered elsewhere.

Common ⑩ milkwort

Polygala vulgaris

HEIGHT Up to 30cm
A small perennial with narrow, pointed, alternate leaves. The flowers can be white, pink or blue, appearing in short terminal clusters in May–September. Widespread and sometimes common in grasslands of all types, apart from very acid areas.

Slender St ⑪ John's-wort

Hypericum pulchrum

HEIGHT Up to 80cm
An upright perennial with small paired oval leaves with margins curling inwards and showing translucent dots. Goblet-shaped yellow flowers, which are seen from July–August, have black dots along petal edges. Widespread in grassy places, scrub and open woodland.

Mezereon ⑫

Daphne mezereum

HEIGHT Up to 2m
A deciduous shrub with dark green oval leaves. The pink flowers open in February–April before the leaves appear and are followed by red, berry-like fruits. Local and scarce native of open woods and scrub on calcareous soils in central–southern England. Often seen as a garden plant.

Musk mallow ⑬

Malva moschata

HEIGHT Up to 75cm
A perennial with deeply dissected leaves, especially those near the top of the stem. The pale pink flowers are up to 6cm across and open in July–August. Widespread and locally common in dry grassy places in England and Wales, scarce elsewhere.

Marsh mallow ⑭

Althaea officinalis

HEIGHT Up to 2m
A downy perennial with triangular, slightly lobed leaves and upright stems. The pale pink flowers open in August–September. Locally common on south coasts of Britain and Ireland, usually in upper reaches of sheltered saltmarshes.

Common dog violet (1)

Viola riviniana

HEIGHT Up to 12cm
A perennial with long-stalked, heart-shaped leaves. The bluish-violet flowers have a blunt pale spur and no scent, and are open from March–May. Widespread and sometimes common in woodland rides and grassland.

Purple loosestrife (2)

Lythrum salicaria

HEIGHT Up to 1.5m
An upright, downy perennial with opposite pairs of narrow, unstalked leaves. The reddish-purple flowers have six petals and grow in tall, dense spikes, opening in June–August. Widespread and often common, except in the north, on riverbanks and in fens and ditches.

Great willowherb (3)

Epilobium hirsutum

HEIGHT Up to 2m
A tall perennial with unstalked hairy leaves and hairy stems. The pinkish-purple flowers have pale centres and are up to 2.5cm across, opening in July–August. Widespread and common, apart from in far north, on riverbanks, fens, ditches and damp meadows.

Spurge laurel (4)

Daphne laureola

HEIGHT Up to 1m
An evergreen shrub with a cluster of shiny dark green oval leaves at the top of the woody stems. The yellowish, trumpet-shaped flowers open in January–April. Found in woodlands and scrub in England and Wales.

Enchanter's nightshade (5)

Circaea lutetiana

HEIGHT Up to 65cm
A delicate perennial with opposite pairs of thin, oval leaves terminating in points. The tiny white flowers are borne in loose, terminal spikes, and open in June–August. Widespread and common, apart from in the north, in damp shady woodlands.

Common rock-rose (6)

Helianthemum nummularium

HEIGHT Up to 40cm
A spreading shrubby perennial with narrow paired leaves which are downy and white on the underside. The yellow flowers are up to 2.5cm across and have a crinkled appearance, opening in June–September. Widespread and locally common in SE and southern England, scarce in the north and west.

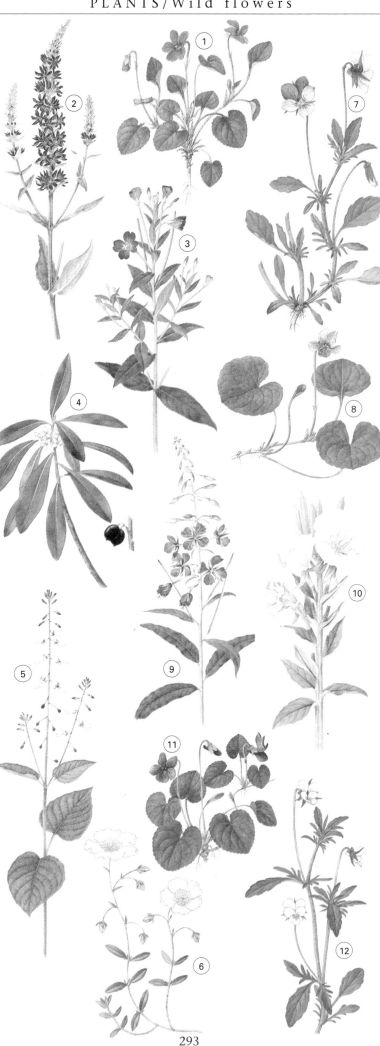

Wild pansy (7)

Viola tricolor

HEIGHT Up to 12cm
A variable annual or biennial, which may be hairy, with oval or lanceolate leaves and leafy stipules. The flowers are mostly violet with yellow areas, or may be all yellow, and can be seen from April–October. Widespread and sometimes common in grassy areas.

Marsh violet (8)

Viola palustris

HEIGHT Up to 10cm
A hairless perennial with long-stalked, round or kidney-shaped leaves. The flowers are pale violet and have dark veins and a short spur, opening in April–June. Widespread, but only found in acid bogs and lime-free wetlands, and absent from most of eastern England.

Rosebay willowherb (9)

Epilobium angustifolium

HEIGHT Up to 1.5m
A tall perennial with lanceolate leaves arranged spirally up the stem. The pinkish-purple flowers are up to 3cm across and grow in a spike, opening in July–September. Long pods split to release cottony seeds. Widespread and very common on waste ground, roadsides, cleared woodlands and riversides.

Common evening primrose (10)

Oenothera biennis

HEIGHT Up to 1.25m
An upright, downy biennial with red-veined lanceolate leaves. The large yellow, four-petalled flowers are up to 5cm across, opening from June–September. Introduced from North America, and now naturalised in dry areas such as sand dunes and industrial sites.

Sweet violet (11)

Viola odorata

HEIGHT Up to 15cm
A perennial with long-stalked leaves which are rounded in spring but larger and heart-shaped in summer. The fragrant flowers may be violet or white, opening in February–May. Widespread and locally common in England and Wales, mainly in woods and hedgerows on calcareous soils.

Field pansy (12)

Viola arvensis

HEIGHT Up to 15cm
An annual with long-stalked leaves and leafy semi-pinnate stipules. The flowers are creamy with an orange patch on the lower petal, and are up to 15mm across, opening from April–October. Widespread on arable land and cultivated ground, commonest in SE England.

Giant hogweed ①

Heracleum mantegazzianum

HEIGHT Up to 4m
A very large and robust perennial or biennial with a purple-spotted, ridged, hollow stem. The large leaves are pinnate and the umbels are up to 50cm across, seen in June–July. Introduced from South-west Asia, but established in scattered locations, usually in damp places. Causes skin blisters if touched.

Hogweed ②

Heracleum sphondylium

HEIGHT Up to 2m
A robust perennial with tall, hollow stems bearing broad, hairy, pinnate leaves. The large umbels are up to 20cm across and made up of small white flowers with unequal petals. Flowers are seen from May–August. Very common and widespread in grassy places, roadsides and waste ground.

Wild angelica ③

Angelica sylvestris

HEIGHT Up to 2m
A robust perennial with a hollow purplish stem and pinnate leaves. The upper leaves are smaller than the lower ones, and their bases form inflated sheaths around the stem. The umbels of white flowers are domed, and are seen in July–September. Widespread and sometimes common in damp woods, meadows and shady places.

Sea holly ④

Eryngium maritimum

HEIGHT Up to 60cm
A striking perennial with prickly grey-green, holly-like leaves and spherical umbels of blue flowers which open in July–September. Widespread on coastal shingle and sand around the coasts of England, Wales and Ireland, but absent from northern and eastern Scotland.

Fennel ⑤

Foeniculum vulgare

HEIGHT Up to 2m
A grey-green perennial with feathery aromatic leaves. The umbels of yellow flowers appear in July–October. Widespread and common in coastal locations in England and Wales, usually in grassy, disturbed places, often close to the shore.

Ground elder ⑥

Aegopodium podagraria

HEIGHT Up to 50cm
A persistent, patch-forming perennial with doubly trifoliate basal leaves. The compact umbels of small white flowers open in June–August. A troublesome garden weed, and widespread and common in grassy waste places, often in the shade.

Pignut ⑦

Conopodium majus

HEIGHT Up to 25cm
An almost hairless perennial with an edible root tuber. The finely cut basal leaves wither quickly, but the stem leaves persist. The umbels of small white flowers are up to 6cm across and appear in April–June. Locally common in open woodland and grassland, mostly on drier acid soils.

Burnet ⑧ saxifrage

Pimpinella saxifraga

HEIGHT Up to 70cm
A downy perennial with pinnate lower leaves, the segments being rounded and toothed, and finely divided upper leaves. The umbels of white flowers appear in June–September. Widespread and locally common in dry, calcareous grassland; absent from NW Scotland.

Upright hedge ⑨ parsley

Torilis japonica

HEIGHT Up to 1m
A hairy annual with solid upright stems and leaves which are two or three times pinnately divided. The compact umbels of small white flowers have both upper and lower bracts. Widespread and common in hedgerows and grassy places.

Cow parsley ⑩

Anthriscus sylvestris

HEIGHT Up to 1m
A downy perennial with upright, ridged and hollow stems bearing two or three times pinnately divided leaves. The umbels of small white flowers have no lower bracts, and open in April–June. Widespread and often very common on roadside verges, lanes and hedgerows.

Sanicle ⑪

Sanicula europaea

HEIGHT Up to 50cm
A slender, hairless perennial with five-lobed basal leaves and small umbels of pinkish flowers on the top of reddish stems. The flowers are seen from May–August. Widespread and common in deciduous woodland on neutral or base-rich soils; scarce in the north.

Hemlock ⑫

Conium maculatum

HEIGHT Up to 2m
A very poisonous and unpleasant-smelling biennial with three or four times pinnately divided leaves and hollow, purple-blotched stems. Rounded umbels of white flowers open in June–July. Widespread and locally common in grassy places, roadsides and waste ground.

Marsh ⑬ pennywort

Hydrocotyle vulgaris

CREEPING
A creeping perennial with rounded leaves held up on short stalks. The flowers are very small and pinkish-green and usually hard to find among the leaves; they appear in June–August. Widespread and sometimes common, especially in the west, in damp grassy places, including some brackish habitats.

Yellow loosestrife ①

Lysimachia vulgaris

HEIGHT Up to 1m
A downy perennial with upright stems and broadly lanceolate, sometimes black-dotted leaves, usually grouped in short-stalked clusters of two–four. The yellow flowers grow in leafy spikes, appearing in July–August. Widespread and sometimes common in damp ground and fens. Scarce in the far north.

Wild parsnip ②

Pastinaca sativa

HEIGHT Up to 1m
A downy, rather pungent perennial with pinnate leaves composed of toothed leaflets. The umbels have no bracts and are made up of small yellow flowers, appearing in June–September. Widespread and sometimes common in dry calcareous grassland in the south, but scarce or absent elsewhere.

Pepper saxifrage ③

Silaum silaus

HEIGHT Up to 1m
A tall, hairless perennial with two to four times pinnately divided leaves. The small yellow flowers are grouped into loose umbels with upper bracts, and appear in June–September. Common in England in dry undisturbed grassland; rare elsewhere.

Cowslip ④

Primula veris

HEIGHT Up to 25cm
A hairy perennial with long leaves narrowing abruptly at the base and forming a basal rosette. The small orange-yellow flowers grow in one-sided heads on long stalks, appearing in April–May. Locally common on unimproved grassland, preferring calcareous soils. Less common in Scotland.

Scarlet pimpernel ⑤

Anagallis arvensis

CREEPING
A hairless annual with square stems and pointed, oval leaves, usually in opposite pairs. The star-like flowers, which may be pink, lilac or blue, appear in May–October, only opening fully in sunshine. Widespread and common in cultivated ground and waste places. Scarce in Scotland.

Rock samphire ⑥

Crithmum maritimum

HEIGHT Up to 40cm
A grey-green hairless perennial with fleshy leaves divided into narrow lobes. The umbels of small yellowish flowers are seen in June–September. Widespread on rocks and shingle around the coasts of southern and western Britain and Ireland.

Hemlock water dropwort ⑦

Oenanthe crocata

HEIGHT Up to 1.25m
A tall, hairless perennial with a scent of parsley. The ridged, hollow stem bears two to four times pinnately divided leaves and domed umbels of small white flowers, which appear in June–August. Widespread and sometimes common in ditches and wet meadows. Very poisonous.

Wild carrot ⑧

Daucus carota

HEIGHT Up to 75cm
A hairy biennial with three-pinnate leaves and ridged stems. The small flowers are pinkish in bud but become white when open, growing in dense, sometimes domed umbels which become concave in fruit. Flowers appear June–September. Widespread and common in grasslands, especially near coasts.

Yellow pimpernel ⑨

Lysimachia nummularia

CREEPING
A hairless, evergreen perennial with oval or heart-shaped leaves growing in opposite pairs on trailing stems. The bright yellow star-like flowers are borne on thin stalks, appearing in May–August. Widespread and sometimes common in damp woodlands and shady, damp grasslands.

Water violet ⑩

Hottonia palustris

AQUATIC
A delicate perennial, best seen when the emergent flower spikes bearing pale lilac flowers appear in May–June. The submerged leaves are feathery, and there are also some floating feathery leaves. Local in still or slow-flowing water in southern and eastern England. Scarce or absent elsewhere.

Wild celery ⑪

Apium graveolens

HEIGHT Up to 1m
A hairless, celery-scented biennial with one to two times pinnately divided shiny yellowish-green leaves. The small white flowers appear in June–August, growing in small umbels up to 6cm across. Commonest in rough coastal grasslands, mainly in southern England. Absent from Scotland.

Bog pimpernel ⑫

Anagallis tenella

CREEPING
A delicate perennial with opposite pairs of short-stalked, rounded leaves growing on thin trailing stems. The short-stalked, goblet-shaped flowers are pink with darker veins, appearing in June–August. Locally common on damp ground and bogs, mainly in the west.

Creeping jenny ⑬

Lysimachia nemorum

CREEPING
A hairless, creeping perennial with rounded opposite leaves. The clear yellow, bell-like flowers have broad sepal teeth and grow on short stalks, appearing in June–August. Locally common in damp grassland in England, scarce or absent elsewhere.

Primrose ⑭

Primula vulgaris

HEIGHT Up to 20cm
A low hairy perennial with a rosette of oval leaves up to 12cm long. The fragrant pale yellow flowers are solitary and borne on long hairy stalks, appearing in February–May. Widespread and sometimes very common in woods, hedgerows and shady places.

Ling ①

Calluna vulgaris

HEIGHT Up to 50cm
A dense undershrub, often known as 'heather', with short narrow leaves growing in four rows along the tough woody stems. The pink flowers are small, up to 5mm long, and grow in dense terminal spikes, appearing in July–October. Widespread and often very common on acid soils on heaths and moors.

Cowberry ②

Vaccinium vitis-idaea

HEIGHT Up to 20cm
A small evergreen shrub with leathery, dark green oval leaves. The small pink bell-shaped flowers open in May–July and are followed by red berries in autumn. Locally common in northern England and Scotland on acid soils, growing in woods and on moors. Scarce elsewhere.

Crowberry ③

Empetrum nigrum

HEIGHT Up to 10cm
A mat-forming shrub with reddish stems bearing narrow dark green leaves with inrolled margins. The small pink six-petalled flowers appear in April–June, followed by small black berries in autumn. Widespread on upland moors and mountain slopes in northern Britain.

Thrift ④

Armeria maritima

HEIGHT Up to 20cm
A cushion-forming perennial with long, dark green leaves and pink, rarely white, flowers borne in globular heads on long stalks. The flowers are seen in April–July. A very common coastal plant in many areas, often forming a complete carpet on steep cliffs.

Bell heather ⑤

Erica cinerea

HEIGHT Up to 50cm
A hairless undershrub with narrow leaves growing in whorls of three on thin woody stems. The purplish-red flowers, up to 6mm long, are bell-shaped and grow in tight groups along the stem; open in June–September. Widespread and common on dry heaths and moors, commonest in the north and west.

Common ⑥
sea-lavender

Limonium vulgare

HEIGHT Up to 30cm
A perennial with stalked, spoon-shaped leaves. The pinkish-lilac flowers are borne in clustered, flat-topped heads on long curved stems, opening in July–September. Widespread on saltmarshes around coasts of England and Wales.

Bogbean ⑦

Menyanthes trifoliata

HEIGHT Up to 15cm
An aquatic perennial with trifoliate emergent leaves resembling those of broad bean. The star-shaped pinkish-white flowers have fringed petals, and open in March–June. A widespread and sometimes common plant of shallow water, damp peaty soil and marshes.

Round-leaved ⑧
wintergreen

Pyrola rotundifolia

HEIGHT Up to 15cm
A perennial with long-stalked, round leaves which form a basal rosette. The white bell-shaped flowers are up to 12mm across, have a curved, protruding style and are borne on upright spikes. They appear in May–August. Widespread in damp grassy places with calcareous soils such as fens and dune slacks.

Cross-leaved ⑨
heath

Erica tetralix

HEIGHT Up to 30cm
A downy, grey-green undershrub with narrow leaves in whorls of four along the woody stem. The pink flowers are up to 7mm long and grow in small terminal clusters, opening in June–October. Widespread and locally common on the wetter parts of acid heaths and moors.

Common ⑩
wintergreen

Pyrola minor

HEIGHT Up to 20cm
An evergreen perennial with oval, toothed and stalked leaves forming a basal rosette. The white rounded flowers grow on a tall stalk, opening in June–August. Locally common in woods and on moors in northern England, Scotland and Northern Ireland. Scarce elsewhere.

Bilberry ⑪

Vaccinium myrtillus

HEIGHT Up to 75cm
A deciduous shrub with bright green oval leaves growing on green three-angled stems. The greenish-pink, rather globular flowers appear in April–June and are followed by purplish edible fruits in autumn. Widespread on acid moors and in open woods on acid soils; commonest in Scotland.

Cranberry ⑫

Vaccinium oxycoccos

HEIGHT Up to 12cm
A creeping, evergreen shrub with trailing stems bearing small dark green leaves with inrolled margins. The attractive pink flowers, open in May–July, have reflexed petals and protruding stamens; followed by red fruits. Locally common on acid bogs in North Wales, northern England and eastern Ireland.

Fringed water-lily ⑬

Nymphoides peltata

FLOATING
An aquatic perennial with floating kidney-shaped or rounded leaves up to 8cm across. The yellow flowers are up to 3.5cm across and have fringed petals, opening in June–September. Locally common in still waters in southern England, naturalised elsewhere.

Common centaury ①

Centaurium erythraea

HEIGHT Up to 25cm
An upright, hairless annual with a basal rosette of oval leaves and opposite pairs of leaves on the stem. The five-petalled pink flowers grow in terminal clusters, opening in June–September. Widespread and common in dry grassy places, including sand dunes and coastal grassland.

Field bindweed ②

Convolvulus arvensis

HEIGHT Up to 2–3m
A twining perennial with long-stalked, arrow-shaped leaves up to 5cm long. The pink flowers have white stripes and are up to 3cm across, opening in June–September. Widespread and very common in disturbed ground and waste places.

Field madder ③

Sherardia arvensis

CREEPING
A small hairy annual with narrow, oval leaves arranged in whorls of four–six along the stem. The tiny pink star-like flowers are grouped in small heads surrounded by leaf-like bracts. Widespread and common on disturbed ground and in short grass in the south, scarce in the north.

Lady's bedstraw ④

Galium verum

HEIGHT Up to 30cm
A much-branched, almost hairless perennial with four-angled stems carrying whorls of 8–12 narrow leaves with rolled margins. Dense clusters of small yellow flowers appear in June–September. Widespread and often common in dry grassland.

Yellow-wort ⑤

Blackstonia perfoliata

HEIGHT Up to 30cm
An upright grey-green annual with a basal rosette of leaves and opposite pairs of clasping stem leaves. The bright yellow flowers have six–eight petals and open in June–October. Locally common in calcareous grassland in central and southern England, Wales and western Ireland.

Sweet woodruff ⑥

Galium odoratum

HEIGHT Up to 25cm
An upright, hairless perennial with square stems carrying lanceolate leaves with prickly margins in whorls of six–eight. The small, white, four-lobed flowers appear in May–June. Cut plants smell of hay. Widespread and locally common in shady woodlands on base-rich soils.

Marsh gentian ⑦

Gentiana pneumonanthe

HEIGHT Up to 30cm
An upright perennial with opposite pairs of narrow leaves up the stem and clusters of intense-blue trumpet-shaped flowers up to 45mm long, often with green stripes on the outside; the flowers open in July–October. Scattered colonies occur on bogs and wet heaths in England and Wales.

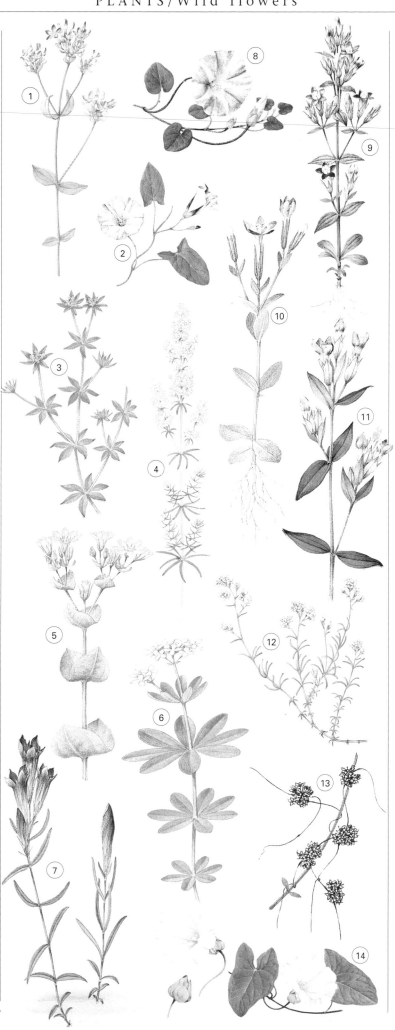

Sea bindweed ⑧

Calystegia soldanella

CREEPING
A creeping perennial with long-stalked, kidney-shaped leaves. The attractive flowers are pink with white stripes and open in June–August. Widespread and locally common on coastal sand dunes except in eastern England and Scotland, where it is absent from large areas.

Autumn gentian ⑨

Gentianella amarella

HEIGHT Up to 25cm
A biennial with a basal rosette in the first year but only stem leaves in the second when the flowers appear. The purple flowers have four or five lobes and open in July–October. Widespread and locally common in dry calcareous grassland and dunes.

Lesser centaury ⑩

Centaurium pulchellum

HEIGHT Up to 15cm
A slender annual, rather similar to common centaury but without the basal rosette. The dark pink flowers appear in June–September. Widespread around coasts of England and Wales, and some inland sites, usually in damp, grassy places.

Field gentian ⑪

Gentianella campestris

HEIGHT Up to 10cm
A short, branched biennial with oval, blunt leaves near the base and more pointed leaves on the stem. The small bell-shaped flowers are four-lobed and usually blue, but mauve and sometimes white forms occur; the flowers open in July–October. Locally common in northern England and Scotland.

Squinancywort ⑫

Asperula cynanchica

HEIGHT Up to 15cm
A low or prostrate, hairless perennial with four angled stems bearing whorls of four narrow leaves. The tiny pink flowers grow in dense clusters, opening in June–September. Locally common in dry calcareous grassland in southern England, scarce or absent elsewhere.

Common dodder ⑬

Cuscuta epithymum

CLIMBING
A parasitic, leafless annual plant which derives its nutrition from other plants such as gorse, ling, clovers, etc. The thread-like red twining stems often smother host plants. Minute pink flowers appear in clusters in July–September. Common and widespread where host plants occur, especially on heaths and grassy places.

Hedge bindweed ⑭

Calystegia sepium

HEIGHT Up to 2–3m
A twining perennial with large arrow-shaped leaves up to 12cm long. The trumpet-shaped flowers can be up to 4cm across and appear in June–September. Widespread and common in hedgerows and untidy gardens in the south, but scarce in the north.

Houndstongue ①

Cynoglossum officinale

HEIGHT Up to 75cm
A downy biennial with a strong smell of mice when the leaves are crushed. The narrow, hairy leaves are stalked near the base of the stem. The maroon, five-lobed flowers appear in June–August. Commonest in SE England, favouring dry grassy places, often coastal.

Common ② comfrey

Symphytum officinale

HEIGHT Up to 1m
A hairy perennial with winged stems and oval leaves, upper ones clasping stems. The pinkish-purple flowers grow in curved, drooping clusters and appear in May–June. Widespread in central and southern England on damp ground.

Viper's bugloss ③

Echium vulgare

HEIGHT Up to 80cm
A roughly hairy biennial with narrow, pointed leaves, the lower ones having stalks. The bright blue funnel-shaped flowers, individually up to 2cm long, grow in dense spikes, appearing in May–September. Widespread on dry grassland, mostly on sandy or calcareous soils, and commonest near the coast.

Greater skullcap ④

Scutellaria galericulata

HEIGHT Up to 40cm
A low, creeping perennial which may be downy. The stems are square and bare stalked, oval leaves with toothed margins. The blue-violet flowers are up to 1cm long and are carried on upright, leafy stems, opening in June–September. Widespread, but common only on damp ground.

Bugloss ⑤

Anchusa (Lycopis) arvensis

HEIGHT Up to 50cm
A hairy annual: the stem leaves have wavy margins; the lower ones are stalked and the upper ones clasp the stem. Blue flowers appear in May–September, growing in forked clusters. Widespread and locally common in eastern England, on disturbed, sandy ground.

Wood sage ⑥

Teucrium scorodonia

HEIGHT Up to 40cm
A downy perennial with stalked, heart-shaped leaves and dense, leafless spikes of paired yellowish flowers which are seen from June–September. Widespread and locally common on woodland rides, heaths, sea cliffs and stony slopes on acid soils.

Bugle ⑦

Ajuga reptans

HEIGHT Up to 20cm
A creeping perennial with rooting runners, and ovate, stalked leaves. Pale blue flowers are up to 15mm long and grow in tall leafy spikes, sometimes tinged with purple, in April–June. Grows in woodlands and damp shady places.

Common ⑧ cleavers

Galium aparine

HEIGHT Up to 1.5m
A scrambling annual covered with small backward-pointing prickles. The small white flowers appear May–September and are followed by rounded, prickly fruits. Widespread on disturbed ground.

Wood ⑨ forget-me-not

Myosotis sylvatica

HEIGHT Up to 50cm
A hairy perennial with spreading hairs on the narrow oval leaves and stem. The bright blue flowers grow in clusters, opening in April–July. Locally common in damp woodlands in southern and SE England; scarce or absent elsewhere.

Crosswort ⑩

Cruciata laevipes

HEIGHT Up to 50cm
A low, hairy perennial with elliptical, yellowish-green leaves borne in whorls of four around the stem. Tiny yellow flowers grow in clusters, appearing April–June. Widespread in grassy places on calcareous soils; most common in northern and eastern England.

Hedge bedstraw ⑪

Galium mollugo

SCRAMBLING
A variable, scrambling perennial with smooth, square stems and small oval leaves with a single vein and pointed tips, borne in whorls of six–eight. The small four-lobed white flowers are borne in dense clusters, appearing in June–September.

Selfheal ⑫

Prunella vulgaris

HEIGHT Up to 20cm
A creeping, downy perennial with paired oval leaves and blue-violet flowers carried in dense heads on short leafy stems, opening in June–October. Widespread and common in a range of open habitats, especially grassland and bare ground.

Ground ivy ⑬

Glechoma hederacea

HEIGHT Up to 15cm
A low perennial with softly hairy, strong-smelling leaves and stems; the stems root at regular intervals. The violet flowers grow in whorls of two–four, opening in March–June. Widespread and common in grassland, woodlands and hedgerows.

Water ⑭ forget-me-not

Myosotis scorpioides

HEIGHT Up to 12cm
A low, creeping perennial with hairy stems and leaves and upright flowering shoots. The leaves are narrow and parallel-sided. Clusters of sky blue, or, rarely, pink or white, flowers appear in June–September. Widespread in water habitats, usually on calcareous soils.

Common calamint ①

Calamintha sylvatica

HEIGHT Up to 50cm
A branched, hairy perennial with a strong smell of mint. Leaves small and rounded. Pink-lilac flowers grow out of the leaf axils, opening June–September. Common in dry grassland, usually on calcareous soils, in southern England.

Common hemp-nettle ②

Lamium amplexicaule

HEIGHT Up to 50cm
A hairy-stemmed annual with stalked, ovate, toothed leaves and stems swollen at the leaf nodes. The pinkish-purple flowers grow in whorls, opening in July–September. Widespread on cultivated land and disturbed ground.

Marjoram ③

Origanum vulgare

HEIGHT Up to 50cm
An aromatic, hairy perennial with paired oval, pointed leaves and reddish stems. The small pinkish flowers grow in dense terminal clusters, opening in July–September. Widespread and common on dry calcareous grassland in the south, but scarce or absent elsewhere.

Wild basil ④

Clinopodium vulgare

HEIGHT Up to 35cm
An aromatic, hairy perennial with ovate, toothed leaves and whorls of pinkish-purple flowers surrounded by bristle-like bracts. Locally common in southern and eastern England on calcareous grasslands, but scarce or absent elsewhere.

White dead-nettle ⑤

Lamium album

HEIGHT Up to 40cm
A perennial with downy stems and heart-shaped leaves similar to stinging nettle but without stinging hairs. The white flowers are up to 25mm long and are carried in whorls on leafy stems, opening in March–November.

Black horehound ⑥

Ballota nigra

HEIGHT Up to 50cm
A strong-smelling hairy perennial with stalked ovate or heart-shaped leaves. The whorls of pinkish-purple flowers appear in June–September. Widespread and common in England and Wales on disturbed ground and waste places; scarce elsewhere.

Yellow archangel ⑦

Lamiastrum galeobdolon

HEIGHT Up to 45cm
A strong-smelling, hairy perennial with nettle-like leaves and large yellow flowers carried in whorls on leafy stems. The flowers can be seen from May–June. Locally common in England and Wales in woodlands and hedgerows on basic soils; scarce elsewhere.

Betony ⑧

Stachys (Betonica) officinalis

HEIGHT Up to 50cm
An upright, hairy perennial with stalked heart-shaped leaves on the lower stem and narrower leaves on the flower spike. The reddish-purple flowers appear in dense spikes in June–September. Common in England and Wales in grassland or open woods on chalky or sandy soils, scarce or absent elsewhere.

Gipsywort ⑨

Lycopus europaeus

HEIGHT Up to 75cm
A hairy perennial, lacking scent, with deeply lobed leaves and whorls of small off-white flowers growing at the bases of the upper leaves. Widespread and common in ditches and pond margins in central and southern England, but scarce or absent elsewhere.

Hedge woundwort ⑩

Stachys sylvatica

HEIGHT Up to 75cm
A hairy perennial with a strong smell and long-stalked, toothed, heart-shaped leaves. The reddish-purple flowers have white markings on the lip and grow in spikes, appearing in June–October. Widespread and common in most areas in hedgerows and grassy places.

Red dead-nettle ⑪

Lamium purpureum

HEIGHT Up to 30cm
An aromatic downy, branched annual with stalked, heart-shaped leaves with toothed margins. The purplish-pink flowers are up to 17mm long, growing in whorls on upright stems and opening in March–October. Widespread and common in disturbed ground and cultivated soil.

Water mint ⑫

Mentha aquatica

HEIGHT Up to 50cm
A strongly mint-scented perennial with oval, toothed leaves and hairy, red-tinted stems. The lilac-pink flowers grow in dense terminal heads up to 2cm long in July–October. Widespread in damp ground, ditches and pond margins.

Meadow clary ⑬

Salvia pratensis

HEIGHT Up to 1m
A downy perennial with long-stalked, toothed, oval leaves on the lower stem and tall spikes of attractive blue-violet flowers, growing in whorls, opening in June–July. Rare in chalk grassland in southern England, naturalised in a few other localities.

Corn mint ⑭

Mentha arvensis

HEIGHT Up to 30cm
A pungently mint-scented perennial with short-stalked, toothed oval leaves and lilac flowers borne in dense whorls at intervals along the stem, but not at the stem tip. Widespread and common in damp fields, path edges and disturbed ground.

Round-leaved fluellen ①

Kickxia spuria

CREEPING
A creeping, stickily hairy annual with trailing stems bearing rounded leaves. The small yellow-and-purple flowers are spurred and appear in July–October. Common in southern and eastern England on cultivated soils.

Thyme-leaved speedwell ②

Veronica serpyllifolia

HEIGHT Up to 20cm
A low or creeping perennial with scentless thyme-like leaves. Small blue flowers up to 6mm across are carried on short upright stems, appearing in April–October. Widespread and common in grassy places and cultivated ground.

Common field-speedwell ③

Veronica persica

CREEPING
A creeping hairy annual with paired, short-stalked oval leaves growing on reddish stems. Blue flowers have darker veins and lower petal is usually white. Flowers may be seen all year round.

Great mullein ④

Verbascum thapsus

HEIGHT Up to 2m
A robust biennial with a basal rosette of large leaves in the first year and a tall leafy spike of yellow flowers up to 3cm across. Whole plant covered in woolly white hairs. Widespread in grassy areas.

Henbane ⑤

Hyoscyamus niger

HEIGHT Up to 75cm
A branched, stickily hairy and strong-smelling annual or biennial with oval pointed leaves and leafy clusters of dark-veined yellow flowers up to 2cm across. Flowers appear in June–August. Common on disturbed coastal ground, in southern and eastern England.

Deadly nightshade ⑥

Atropa bella-donna

HEIGHT Up to 1m
A branched perennial with pointed oval leaves up to 20cm long and purplish bell-shaped flowers which appear in June–August. The berries are black and poisonous. Locally common in southern and eastern England in scrub and waste ground on calcareous soils.

Common figwort ⑦

Scrophularia nodosa

HEIGHT Up to 70cm
An upright perennial with square stems and nettle-like leaves. The small maroon-and-green flowers with yellow anthers appear in June–September. Widespread and common in damp woodlands and shady places everywhere apart from northern Scotland.

Common toadflax ⑧

Linaria vulgaris

HEIGHT Up to 75cm
A grey-green perennial with upright, usually unbranched stems bearing narrow leaves. The yellow flowers have an orange centre and long spurs and grow in dense spikes, opening in June–October. Widespread.

Germander speedwell ⑨

Veronica chamaedrys

HEIGHT Up to 20cm
A perennial with prostrate stems rooting at the nodes and hairy, oval, toothed leaves. Upright stems have two lines of hairs. Flowers are blue with a white centre. Widespread and common.

Thyme ⑩

Thymus serpyllum

HEIGHT Up to 5cm
An aromatic mat-forming perennial with runners and paired, short-stalked, ovate leaves. The small pinkish-purple flowers grow in dense terminal heads, opening in June–September. Widespread and common on dry grassland and heaths.

Dark mullein ⑪

Verbascum nigrum

HEIGHT Up to 1m
A biennial with ridged stems and large, toothed oval- to heart-shaped leaves. The yellow flowers, which appear in June–August, are up to 2cm across and have purple stamens. Locally common in southern and eastern England on roadsides and disturbed ground.

Ivy-leaved toadflax ⑫

Cymbalaria muralis

TRAILING
A perennial with five-lobed, ivy-shaped leaves borne on long, trailing, reddish stems. The lilac flowers have a yellow centre and appear in April–November. Seen widely on rocks and walls.

Bittersweet ⑬

Solanum dulcamara

HEIGHT Up to 1.5m
A scrambling, slightly downy perennial with pointed oval leaves, many of them having two lobes at the base. The bright purple flowers have reflexed petals and contrasting yellow stamens; followed by poisonous red berries. Widespread in hedgerows and waste places.

Blue water-speedwell ⑭

Veronica anagallis-aquatica

HEIGHT Up to 25cm
A hairless perennial with upright stems bearing oval, pointed leaves. The pale blue flowers grow in opposite stalked spikes arising from the upper leaf axils, opening in June–August. Widespread and locally common in ditches, pond margins and shallow streams; scarce in Scotland.

Monkey flower ①

Mimulus guttatus

HEIGHT Up to 50cm
A perennial with opposite pairs of toothed, oval leaves, the upper ones clasping the stem. The large, bright yellow flowers, up to 4.5cm across, have small red spots on the lower lip. Introduced from North America and now widely naturalised in wet places, ditches and streamsides.

Lousewort ②

Pedicularis sylvatica

HEIGHT Up to 20cm
A spreading, unbranched and almost hairless perennial with feathery leaves. The pink flowers are up to 25mm long and have a double-toothed upper lip. The sepal tube looks rather inflated. Flowers appear in April–July. Widespread and locally common on damp heaths and moors.

Cornsalad ③

Valerianella locusta

HEIGHT Up to 30cm
A small, much-branched, almost hairless annual with spoon-shaped lower leaves and oblong upper leaves. The minute pale lilac flowers grow in flat-topped clusters with leaf-like bracts below them, opening in April–August. Widespread and locally common in grassy places and dunes.

Knapweed broomrape ④

Orobanche elatior

HEIGHT Up to 70cm
A robust root parasite, with a yellowish-brown stem and brown, scale-like leaves. The yellow-brown flowers grow in dense terminal spikes, appearing in June–July. Parasitises knapweeds and is locally common on calcareous grasslands in southern and eastern England.

Red bartsia ⑤

Odontites verna

HEIGHT Up to 40cm
A downy, branched annual with opposite pairs of narrow, toothed leaves. The pink-purple flowers have a three-lobed lower lip and appear in June–September. A semi-parasite on grasses. Common and widespread in grassy places, disturbed ground and tracks.

Toothwort ⑥

Lathraea squamaria

HEIGHT Up to 25cm
An entirely parasitic perennial, lacking green leaves. The slightly downy stem bears a dense, curved, one-sided spike of short-stalked pale pink flowers, opening in April–May. Parasitises woody plants, especially hazel. Widespread, but only locally common; not in far north.

Red valerian ⑦

Centranthus ruber

HEIGHT Up to 75cm
A grey-green, hairless perennial with pointed oval or lanceolate leaves. The small pink, rarely red or white, fragrant flowers grow in dense rounded heads, appearing in May–September. Introduced and now widely established on walls and coastal cliffs in SW Britain.

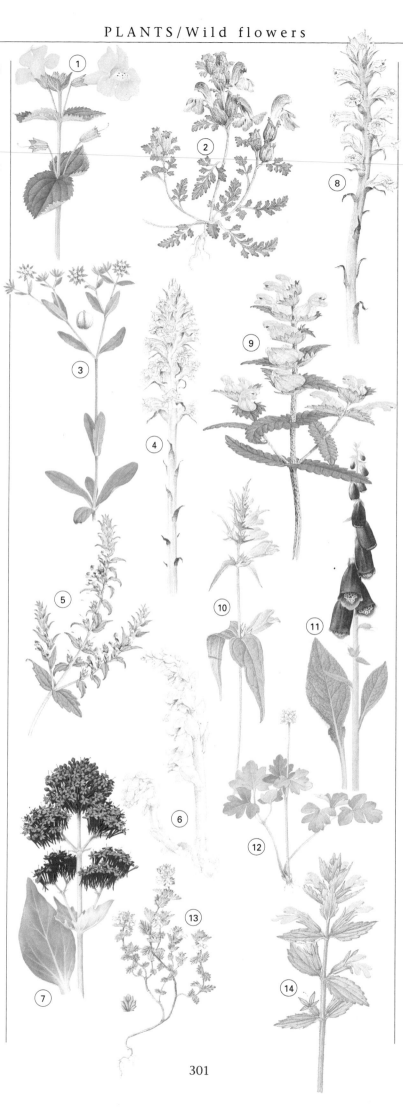

Common broomrape ⑧

Orobanche minor

HEIGHT Up to 40cm
A parasitic annual lacking green leaves. Upright stem has purplish-brown tinge and the purple-veined, pinkish-yellow flowers grow in a dense terminal spike, appearing in June–September.

Yellow-rattle ⑨

Rhinanthus minor

HEIGHT Up to 45cm
A semi-parasitic annual with black-spotted stems and opposite, unstalked oblong leaves with rounded teeth. The yellow flowers are up to 2cm long. The papery, inflated seed pods produce a rattling sound. Widespread and common in old meadows and dune slacks.

Common cow-wheat ⑩

Melampyrum pratense

HEIGHT Up to 35cm
A short, slightly downy semi-parasitic annual with unstalked opposite lanceolate leaves. The two-lipped yellow flowers arise in pairs from the leaf axils, appearing in May–September. Widespread and locally common on woodland rides and grassy heaths, usually on acid soils.

Foxglove ⑪

Digitalis purpurea

HEIGHT Up to 1.5m
A tall biennial with a basal rosette of downy, greyish-green, oval leaves up to 30cm long in the first year and a tall spike of tubular pink-purple flowers in the second year. Widespread and often common in woods, moorlands and sea cliffs, usually on acidic soils.

Moschatel ⑫

Adoxa moschatellina

HEIGHT Up to 10cm
A small, hairless, patch-forming perennial with long-stalked two-trefoil leaves. The small green flowers grow in square heads of five at right-angles to each other, appearing in April–May. Locally common in damp woodlands and shady places, especially in the south.

Eyebright ⑬

Euphrasia officinalis

HEIGHT Up to 25cm
A low, branched, hairy annual, semi-parasitic on the roots of other plants; the upper leaves are usually oval, toothed and alternate. The flowers, which appear in June–October, are white with small patches of violet and yellow. Widespread in grassy places.

Yellow bartsia ⑭

Parentucellia viscosa

HEIGHT Up to 40cm
A stickily hairy, unbranched annual with opposite pairs of stalkless, toothed lanceolate leaves. The bright yellow flowers have a three-lobed lower lip and appear in June–October. Very local in dune slacks and damp grassy places in SW Britain and western Ireland.

Greater plantain ①

Plantago major

HEIGHT Up to 20cm
A perennial with a basal rosette of broad oval leaves up to 25cm long. The dense, greenish flowers are borne on a long, stalked spike and appear in June–October. An extremely widespread and common plant in lawns and disturbed grassy areas.

Sea plantain ②

Plantago maritima

HEIGHT Up to 15cm
A low, almost hairless perennial with long thin leaves forming a rosette. The flower heads are borne on long smooth stalks. Widespread on rocks and shingle around the coasts of Britain and Ireland, often very close to the high-tide line and tolerant of salt spray.

Teasel ③

Dipsacus fullonum

HEIGHT Up to 2m
A tall, hairless biennial with a rosette of spiny leaves in the first year and a tall, angled and spiny stem bearing the conical head of small purple flowers in the second year. The dead seed-bearing heads persist all winter. Widespread and common in disturbed ground.

Field scabious ④

Knautia arvensis

HEIGHT Up to 75cm
A robust, hairy perennial with pinnately lobed leaves on the lower stem and almost entire leaves on the upper stem. The bluish-lilac flowers grow in flattened heads up to 4cm across, opening in June–October. Widespread and common in dry grassland, absent from northern Scotland.

Small scabious ⑤

Scabiosa columbaria

HEIGHT Up to 65cm
A hairy, branching perennial with a basal rosette of pinnately lobed leaves, and finely divided stem leaves. The bluish-violet flower heads are up to 3cm across, appearing in June–September. Locally common in calcareous grassland in England and Wales.

Nettle-leaved ⑥ bellflower

Campanula trachelium

HEIGHT Up to 75cm
A roughly hairy perennial with nettle-like stem leaves and stalked, heart-shaped basal leaves. Large violet-blue flowers are up to 4cm long, in July–August. Locally common in southern and eastern England in hedgerows.

Devil's-bit ⑦ scabious

Succisa pratensis

HEIGHT Up to 75cm
A hairy perennial with spoon-shaped basal leaves and narrow stem leaves. The blue-purple flowers are borne in rounded heads and have slightly protruding stamens, appearing in June–October. Widespread in damp grassland and woodland rides.

Sheep's-bit ⑧ Scabious

Jasione montana

HEIGHT Up to 30cm
A spreading, slightly hairy biennial with a basal rosette of wavy-edged leaves and narrow stem leaves. The blue flowers are borne in rounded heads, appearing in May–September. Widespread in dry, grassy places on acid soils, often near the sea.

Harebell ⑨

Campanula rotundifolia

HEIGHT Up to 40cm
A slender, hairless perennial with rounded basal leaves which are short-lived, and thin, lanceolate stem leaves. The nodding blue flowers are up to 1.5cm long, and grow on long stalks in loose clusters, opening in July–October. Widespread.

Clustered ⑩ bellflower

Campanula glomeratum

HEIGHT Up to 25cm
A downy perennial with long-stalked, heart-shaped basal leaves and narrow clasping leaves higher on the stem. Dark blue flowers up to 2cm long grow in clusters at the top of the stem.

Round-headed ⑪ rampion

Phyteuma tenerum

HEIGHT Up to 50cm
A hairless, unbranched perennial with oval basal leaves and narrow unstalked stem leaves. Deep blue flowers borne in untidy globular heads, appearing in June–August. Restricted to the south.

Butterwort ⑫

Pinguicula vulgaris

HEIGHT Up to 15cm
An insectivorous perennial with a basal rosette of yellow-green sticky leaves with inrolled margins, which trap and digest small insects. The long-spurred, violet flowers are borne on long stalks, appearing in May–August. Widespread in acid bogs; commonest in Ireland and NW Britain.

Daisy ⑬

Bellis perennis

HEIGHT Up to 10cm
A perennial with spoon-shaped basal leaves forming flat rosettes. The flower heads are up to 1.5cm across and are borne singly on long stalks, appearing all year in most areas. Very common and widespread, especially in lawns and short grass.

Buckshorn ⑭ plantain

Plantago coronopus

HEIGHT Up to 15cm
A downy, grey-green perennial with a basal rosette of deeply cut, pinnately lobed leaves, which may be very small in exposed situations, or more lush in sheltered sites. The flowers are borne in spikes on long stalks, appearing in May–October. Widespread.

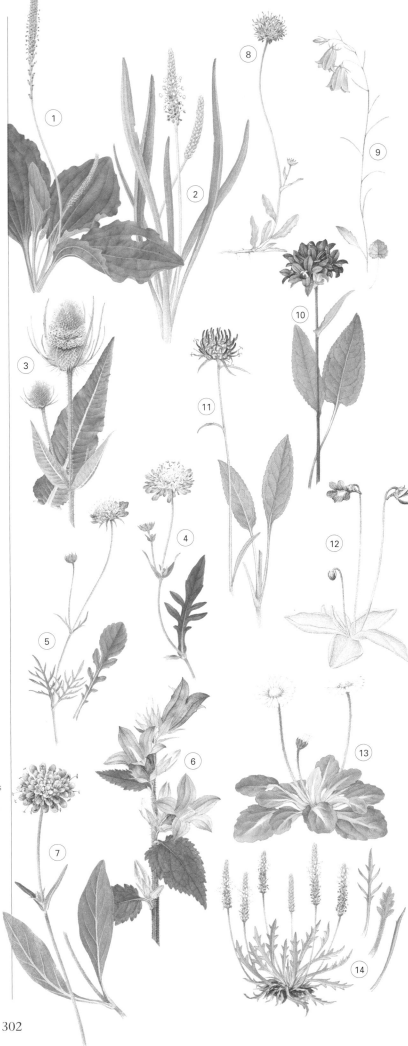

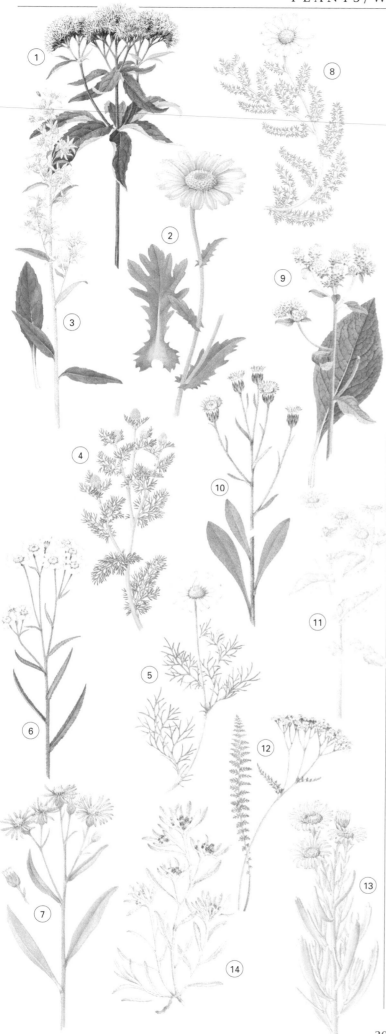

Hemp agrimony ①

Eupatorium cannabinum

HEIGHT Up to 1.5m
A tall, downy perennial with opposite pairs of trifoliate leaves on reddish, usually branched stems. Dense heads of dull, rayless pink flowers open in July–September. Widespread and common in damp grassland.

Corn marigold ②

Chrysanthemum segetum

HEIGHT Up to 50cm
A hairless annual with narrow, deeply lobed leaves, the upper ones clasping the stem. The bright yellow daisy-like flowers appear in June–October. Widespread and sometimes common in cultivated ground, mostly on sandy soil.

Goldenrod ③

Solidago virgaurea

HEIGHT Up to 75cm
A variable, downy or hairless perennial with stalked, spoon-shaped basal leaves and narrow, unstalked stem leaves. The bright yellow short-rayed flowers grow in short, branched spikes, appearing in June–September. Widespread in woodlands and rocky places.

Pineapple mayweed ④

Matricaria matricarioides

HEIGHT Up to 12cm
A bright green perennial with finely divided feathery leaves and strong scent of pineapple when crushed. Rounded oval flower heads are made up of rayless disc florets, and are open from May–November. Widespread on tracks.

Scentless mayweed ⑤

Tripleurospermum inodorum/ Matricaria perforata

HEIGHT Up to 75cm
A scentless, hairless perennial with much-divided leaves. The long-stalked, daisy-like flower heads are up to 4cm across and appear in April–October. Widespread and common on disturbed ground and waste places.

Sneezewort ⑥

Achillea ptarmica

HEIGHT Up to 60cm
A non-aromatic, upright downy perennial with narrow, finely toothed leaves. The flower heads, seen in July–September, have short rays and creamy disc florets, and grow in a small, loose umbel. Locally common in damp meadows and open woods.

Sea aster ⑦

Aster tripolium

HEIGHT Up to 75cm
A hairless, fleshy perennial with narrow stem leaves and oval untoothed basal leaves. The flowers have yellow disc florets and purple or blue ray florets, appearing in July–September. Salt-tolerant and locally common on cliffs and saltmarshes around all coasts.

Wild chamomile ⑧

Chamaemelum nobile

HEIGHT Up to 25cm
A creeping, aromatic perennial with finely divided feathery leaves. The daisy-like flower heads are up to 24mm across and open in June–August. Grows on areas of short, grazed turf, on sandy soils in southern England.

Ploughman's spikenard ⑨

Inula conyza

HEIGHT Up to 1m
A downy perennial with red stems, large oval lower leaves and narrow stem leaves. The rayless yellow flower heads are borne in clusters, appearing in July–September. Locally common in England and Wales on dry, calcareous grassland.

Blue fleabane ⑩

Erigeron acer

HEIGHT Up to 30cm
A small hairy annual or biennial, often with purple stems and lanceolate untoothed leaves. The flower heads are long-stalked, clustered and up to 18mm across, appearing in June–August. Widespread and common in England and Wales in dry grassy areas.

Common fleabane ⑪

Pulicaria dysenterica

HEIGHT Up to 50cm
A woolly perennial with short-lived basal leaves and clasping, heart-shaped stem leaves. The yellow flower heads are up to 3cm across, appearing in July–September. Widespread and common on heavy soils in ditches and damp meadows in central and southern Britain and Ireland.

Yarrow ⑫

Achillea millefolium

HEIGHT Up to 50cm
A strongly aromatic downy perennial with finely divided dark green leaves. The white flower heads are up to 6mm across and grow in flat-topped clusters, appearing in June–November. Widespread and very common in grassy places in all areas.

Golden samphire ⑬

Inula crithmoides

HEIGHT Up to 75cm
A tufted, hairless perennial with bright green, fleshy, narrow stem leaves. The flower heads are up to 3cm across, appearing in July–September. Widespread and locally common on saltmarshes and coastal cliffs in SW Britain and Ireland.

Marsh cudweed ⑭

Gnaphalium uliginosum

HEIGHT Up to 20cm
A woolly, grey-green branched annual with narrow leaves up to 4cm long. The small flowers are composed of dense heads of yellow florets and brown bracts, and are surrounded by leaves. Widespread and common on damp disturbed ground and wheel ruts.

Coltsfoot ①

Tussilago farfara

HEIGHT Up to 15cm
A downy, creeping perennial with toothed, heart-shaped leaves, 20cm across, arising at ground level after the flowers. The yellow flowers appear in February–April, growing singly on scaly stems. Widespread and often common in bare, disturbed ground.

Greater burdock ②

Arctium lappa

HEIGHT Up to 1m
A branched biennial with large heart-shaped, downy leaves. The purplish, egg-shaped flower heads appear in July–September, followed by prickly seed heads. Locally common in open woodland, scrub and verges in England and Wales; scarce elsewhere.

Feverfew ③

Tanacetum parthenium

HEIGHT Up to 50cm
An aromatic downy perennial with yellowish, pinnately lobed leaves. The daisy-like flowers are white rayed with a yellow centre, up to 2cm across and appear in July–August. Introduced and now widely naturalised in disturbed ground and waste places.

Butterbur ④

Petasites hybridus

HEIGHT Up to 50cm
A downy, patch-forming perennial with enormous, heart-shaped leaves, up to 1m across, appearing after the flowers. Thick spikes of pinkish rayless flower heads appear in March–May. Widespread and locally common in damp ground, except in N Scotland.

Wormwood ⑤

Artemisia absinthium

HEIGHT Up to 80cm
A very aromatic perennial with pinnate leaves, silvery-hairy above and below, and rather stiff spikes of small yellowish flowers which open in July–September. Locally common in coastal grassland and waysides in England and Wales only.

Common ragwort ⑥

Senecio jacobaea

HEIGHT Up to 1m
A poisonous, usually hairless biennial, with pinnately divided leaves terminating in a blunt lobe. The small yellow flower heads, up to 25mm across, grow in dense clusters, appearing in June–November. Widespread and very common in grazed grassland, verges and waste places.

Stemless thistle ⑦

Cirsium acaule

HEIGHT Up to 5cm
A creeping, almost hairless perennial with a basal rosette of very spiny, pinnately lobed leaves. The purple flower heads are normally stalkless, opening in June–September. Locally common in calcareous grassland in southern and eastern England and southern Wales.

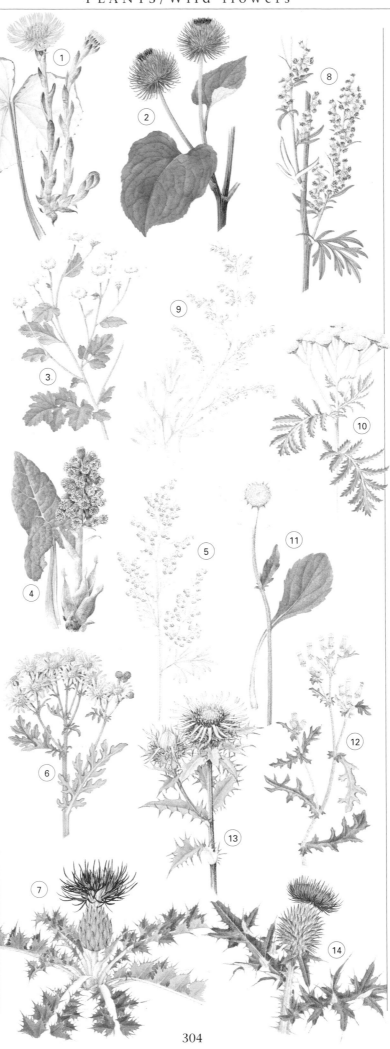

Mugwort ⑧

Artemisia vulgaris

HEIGHT Up to 1.25m
A downy, aromatic perennial with reddish stems and dark green pinnate leaves with silvery undersides. The tiny, red-tinged flower heads are borne in branched spikes, appearing in July–September. Widespread and common on roadsides and waste places.

Sea wormwood ⑨

Artemisia maritima

HEIGHT Up to 65cm
A downy, greyish, strongly aromatic perennial with pinnate leaves and woody, down-covered stems. The small yellow flowers are borne in leafy, branched spikes, opening in August–October. Locally common in saltmarshes, sea walls in S and E England.

Tansy ⑩

Tanacetum vulgare

HEIGHT Up to 75cm
An aromatic, slightly downy perennial with pinnately divided and toothed leaves on a tall, upright stem. The yellow flower heads are up to 12mm across and form flat-topped clusters, appearing in July–October. Widespread and common.

Ox-eye daisy ⑪

Leucanthemum vulgare

HEIGHT Up to 60cm
A slightly hairy perennial with a basal rosette of dark green, spoon shaped and toothed leaves and narrow, toothed clasping stem leaves. The solitary daisy-like flower heads are up to 5cm across, opening in May–September. Widespread and common in dry grassy meadows and disturbed ground.

Groundsel ⑫

Senecio vulgaris

HEIGHT Up to 40cm
A small, often downy annual with pinnately lobed leaves, the lower ones stalked, the upper ones clasping. The small yellow flower heads grow in open clusters, appearing almost all year round. A widespread and very common weed of cultivation.

Carline thistle ⑬

Carlina vulgaris

HEIGHT Up to 60cm
A spiny biennial with very prickly, oblong lobed leaves, the lower ones cottony. The flower heads are rayless and yellowish-brown with large ray-like bracts around them. Flowers appear in July–September and persist when dead. Locally common on dry calcareous grassland, except in N Scotland.

Spear thistle ⑭

Cirsium vulgare

HEIGHT Up to 1m
A robust, downy and very spiny biennial with pinnately lobed leaves. The flower heads are composed of purple florets above a round head of spiny bracts, opening in June–September. Widespread and very common, especially in disturbed ground.

Melancholy thistle ①

Cirsium helenoides

HEIGHT Up to 1m
An unbranched perennial with cottony, spineless and unwinged stems. The toothed, oval leaves are sparsely spiny, green above and white below. The large purple flower heads are up to 5cm across, opening in June–August. Locally common in damp meadows in N England and Scotland.

Black knapweed ②

Centaurea nigra

HEIGHT Up to 1m
A hairy perennial with grooved stems and narrow leaves, those at the base being slightly lobed. The purple flower heads are up to 4cm across and sit on a globular head of brownish bracts. Widespread and common in grassy places.

Bristly ox-tongue ③

Picris echioides

HEIGHT Up to 80cm
A branched, prickly-stemmed perennial with narrow, clasping leaves covered with bristles and whitish blisters. The pale yellow flower heads are up to 25mm across, and grow in clusters, appearing in June–October. Locally common in S Britain in dry, disturbed grassland.

Creeping thistle ④

Cirsium arvense

HEIGHT Up to 1m
A hairless, creeping perennial with upright, unwinged stems, and spiny, pinnately lobed leaves. The clustered flower heads are pinkish-lilac, up to 15mm across and appear in June–September. Widespread and very common on disturbed ground.

Musk thistle ⑤

Carduus nutans

HEIGHT Up to 1m
An upright, cottony, biennial with pinnately lobed, spiny leaves. The drooping flower heads are rayless, purple and up to 5cm across. Fringed by spiny bracts, they appear in June–August. Locally common in dry grassland in England and Wales.

Smooth sowthistle ⑥

Sonchus oleraceus

HEIGHT Up to 1m
A hairless, greyish annual; pinnate leaves with toothed margins and pointed basal lobes. Stems release a milky sap. Pale yellow flower heads are up to 25mm across, grow in clusters and open in May–October. Widespread and common in disturbed and cultivated ground.

Dandelion ⑦

Taraxacum officinale

HEIGHT Up to 35cm
A very variable perennial, usually hairless and releasing milky juice from stems. Leaves are deeply lobed, sometimes spoon-shaped and form basal rosette. Yellow flower heads are up to 6cm across and are followed by a white 'clock', appearing in March–October. Very common and widespread.

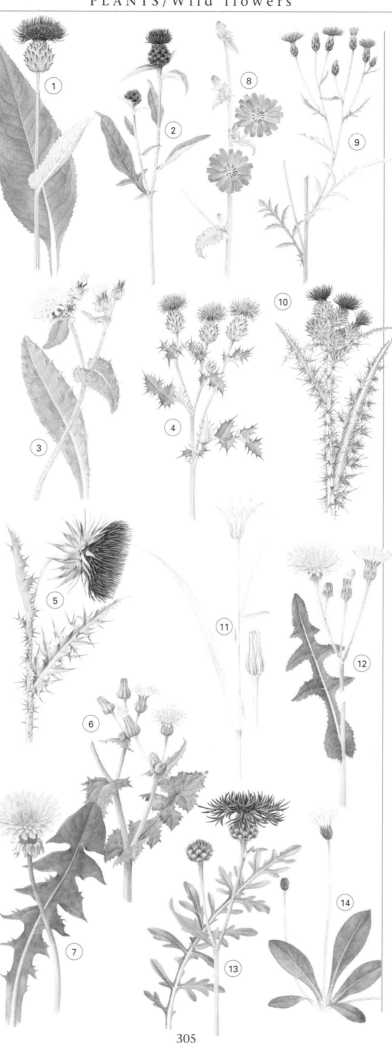

Chicory ⑧

Cichorum intybus

HEIGHT Up to 1m
A tall, branched perennial, sometimes hairy, with stalked and lobed lower leaves and narrow, clasping upper leaves. The sky-blue flower heads are up to 4cm across, appearing in June–September. Locally common in grassy places in S England, scarce elsewhere.

Saw-wort ⑨

Serratula tinctoria

HEIGHT Up to 75cm
A slender, hairless thistle-like perennial lacking spines with variable saw-tooth edged leaves. The pale purple flower heads are up to 2cm long, appearing in July–October. Locally common in damp meadows and open woods in SW England.

Marsh thistle ⑩

Cirsium palustre

HEIGHT Up to 1.5m
A tall, branched biennial, covered in cottony down and with spiny-winged stems. The flower heads are up to 15mm across, usually purplish, sometimes white and appear in July–September. Widespread and common in damp grassland.

Goatsbeard ⑪

Tragopogon pratensis

HEIGHT Up to 60cm
A hairless perennial with narrow, clasping or sheathing leaves. The yellow flower heads are up to 4cm across and fringed by long bracts, closing on sunny days. They are followed by a large white 'clock'. Locally common in grassy places in England and Wales.

Perennial sowthistle ⑫

Sonchus arvensis

HEIGHT Up to 2m
A tall, almost hairless, patch-forming perennial with grey-green clasping, lobed leaves. The yellow flower heads are up to 4cm across, appearing in branched clusters in July–September. Widespread and common in damp grassy places and disturbed ground.

Greater knapweed ⑬

Centaurea scabiosa

HEIGHT Up to 1m
A downy perennial with deeply pinnately lobed oblong leaves. The large flower heads are up to 5cm across and have elongated outer florets, appearing in June–September. Common in S and E England on dry calcareous grassland, scarce or absent elsewhere.

Mouse-ear hawkweed ⑭

Heiracium pilosella

HEIGHT Up to 25cm
A spreading perennial with spoon-shaped leaves which are green and hairy on top and white and downy below, forming a basal rosette. The solitary flower heads are lemon-yellow, up to 3cm across and appear in May–October. Widespread and common in dry grassy places.

Yellow iris ①

Iris pseudacorus

HEIGHT Up to 1m
A robust, hairless perennial with grey-green, lanceolate, often wrinkled leaves. Clusters of large yellow flowers, up to 10cm across appear in May–August. Widespread and common in ditches, pond margins and river banks.

Lily of the ② valley

Convallaria majalis

HEIGHT Up to 20cm
A creeping, hairless perennial with large, paired oval leaves and strongly-scented nodding white flowers borne on leafless, one-sided spikes in May–June. Local in dry, calcareous woodland in England and Wales, often naturalised as a garden escape.

Lords and ladies ③

Arum maculatum

HEIGHT Up to 50cm
A low, hairless perennial with large arrow-shaped leaves, sometimes spotted, and a cowl-like spathe surrounding a purple spadix, the whole designed to attract and trap pollinating insects. Locally common in shady places in southern Britain and Ireland, scarce elsewhere.

Snowdrop ④

Galanthus nivalis

HEIGHT Up to 25cm
A hairless, bulbous perennial with narrow, grooved, greyish-green leaves and single, drooping white flowers with green tips on the inner petals. Flowers appear in January–March. Widely naturalised in woodlands, hedgerows and churchyards.

Wild daffodil ⑤

Narcissus pseudonarcissus

HEIGHT Up to 50cm
A hairless, bulbous perennial with narrow, grey-green basal leaves and single yellow trumpet shaped fragrant flowers which appear in March–April. Locally common in well-managed woodlands in England and Wales.

Wild tulip ⑥

Tulipa sylvestris

HEIGHT Up to 40cm
A hairless perennial with long, narrow grey-green leaves and solitary, fragrant yellow flowers up to 4cm across when fully open in May–June. Introduced and naturalised in undisturbed grassland in southern England.

Common ⑦ water plantain

Alisma plantago-aquatica

HEIGHT Up to 1m
An aquatic perennial with long-stalked, parallel-veined oval leaves and small pale lilac flowers, up to 1cm across, borne in many-branched clusters, opening in June–September. Locally common in pond margins and ditches, scarce in SW England and NW Scotland.

Rough hawkbit ⑧

Leontodon hispidus

HEIGHT Up to 35cm
A roughly hairy perennial with a basal rosette of wavy-lobed leaves. Yellow flowers heads are solitary, up to 4cm across and borne on leafless, unbranched stalks, opening in June–October. Locally common on dry, usually calcareous grassland, scarce in Scotland.

Common ⑨ catsear

Hypochaeris radicata

HEIGHT Up to 50cm
A hairy perennial with a basal rosette of lanceolate, lobed leaves. The yellow flower heads are up to 3cm across and are borne on branched stalks with purple-tipped bracts, opening in June–September. Widespread and common on dry grassland.

Bluebell ⑩

Hyacinthoides non-scripta

HEIGHT Up to 50cm
A hairless, bulbous perennial with long, narrow basal leaves and a one-sided spike of fragrant blue flowers, opening in April–June. Widespread and abundant in undisturbed woodlands, coastal cliffs, shady lanes.

Smooth ⑪ hawksbeard

Crepis capillaris

HEIGHT Up to 1m
A hairless annual or biennial with a basal rosette of lobed leaves and clasping, arrow-shaped stem leaves. The flower heads are up to 2.5cm across, in branched clusters, opening in May–July. Common in dry grassland on lowlands.

Ramsons ⑫

Allium ursinum

HEIGHT Up to 35cm
A hairless, bulbous perennial with a strong garlic smell. The ovate, pointed leaves arise from the bulb and the white flowers are borne in rounded clusters on leafless stems, opening in April–May. Forms large patches in damp woodlands.

Solomon's seal ⑬

Polygonatum multiflorum

HEIGHT Up to 60cm
A hairless perennial with a rounded, arched stem, alternate ovate leaves and hanging clusters of up to 3 white bell-shaped flowers which appear in May–June, and black berries which follow in July. Locally common in dry woods in southern England.

Bog asphodel ⑭

Narthecium ossifragum

HEIGHT Up to 20cm
A hairless, tufted perennial with a flattened fan of narrow leaves and a spike of bright yellow flowers appearing in June–August; the spike turns orange in fruit. Locally common in peaty soils on heaths and moors, absent from eastern and central England.

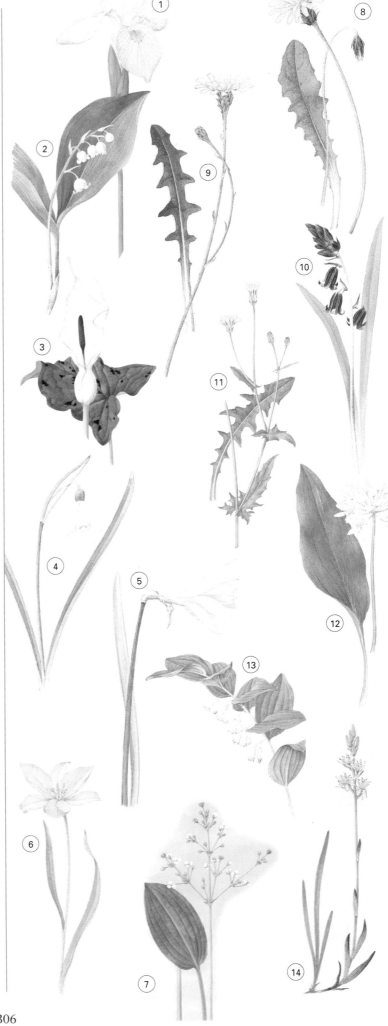

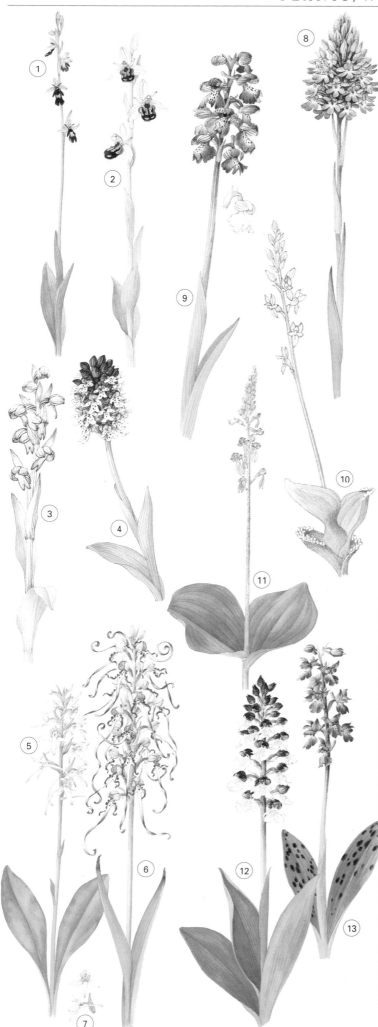

Fly orchid ①

Ophrys insectifera

HEIGHT Up to 40cm
A hairless perennial with a basal rosette of glossy leaves and narrow stem leaves. The flowers consist of green sepals and two antenna-like petals and the lower petal resembles a large hairy fly. Locally common in dry grassland in southern Britain and Ireland.

Bee orchid ②

Ophrys apifera

HEIGHT Up to 30cm
A hairless perennial with a basal rosette of leaves and two sheathing stem leaves. The flowers are up to 12mm across with three pink sepals, two green petals and an inflated, bee-like lower petal. Locally common in dry grassland in southern Britain and Ireland.

Frog orchid ③

Coeloglossum viride

HEIGHT Up to 20cm
A low hairless perennial with lanceolate leaves, some clasping the stem, and small yellow-green flowers showing a red tinge. The forked lip has a minute central tooth. Widespread and locally common in calcareous grassland, including uplands.

Burnt orchid ④

Orchis ustulata

HEIGHT Up to 15cm
A small hairless perennial with pointed, unspotted leaves. The small, fragrant flowers grow in a short dense spike; the hood is maroon and the lip white and spotted. Scattered and confined to chalk grassland in southern England.

Greater ⑤ butterfly orchid

Platanthera chlorantha

HEIGHT Up to 50cm
Hairless perennial with one pair of broad, shiny green unspotted leaves and lax spike of greenish-white, long-spurred flowers, open in June–July, with yellow pollen sacs forming a V-shape. Locally common in undisturbed woodlands, grasslands and scrub.

Lizard orchid ⑥

Himantoglossum hircinum

HEIGHT Up to 1m
An upright, hairless perennial with oval leaves which wither quickly and grey-green, red-tinged flowers which smell of goats. The hooded flowers have a long strap-like lip. Rare and elusive in grassland, scrub, dunes in southern and eastern England.

Lesser ⑦ butterfly orchid

Platanthera bifolia

HEIGHT Up to 40cm
Similar to greater butterfly, but shorter and smaller with narrower basal leaves and parallel pollen sacs. Locally common in undisturbed grassland, woodland moors and marshes.

Pyramidal ⑧ orchid

Anacamptis pyramidalis

HEIGHT Up to 30cm
Narrow leaves are grey-green and unspotted, partially clasping the stem. The pink or rose-purple flowers grow in a pyramidal shaped head; the lip is 3-lobed and there is a long spur. Locally common in dry grassland and dunes, mainly in southern Britain.

Green winged ⑨ orchid

Orchis morio

HEIGHT Up to 40cm
A hairless perennial with narrow, unspotted leaves and spikes of fragrant purple, pink or white flowers. The sepals form a hood and are green-veined; the 3-lobed lip has a pale spotted centre. Locally common in undisturbed grassland in southern Britain and central Ireland.

Bog orchid ⑩

Hammarbya paludosa

HEIGHT Up to 8cm
A very small hairless perennial with small leaves often bearing bulbils on their margins. The minute yellowish flowers grow in slender spikes, opening in July–September. Widespread in sphagnum bogs in Scotland, much rarer in southern Britain.

Twayblade ⑪

Listera ovata

HEIGHT Up to 50cm
A hairless perennial with two broad, opposite oval leaves near base of stem. The small yellowish-green flowers have a deeply forked lower lip and grow in a tall spike, opening in May–July. Widespread and locally common in grassland and open woods.

Lady orchid ⑫

Orchis purpurea

HEIGHT Up to 1m
A tall, hairless perennial with large, shiny, unspotted leaves, mostly basal, and pale pink manikin-shaped flowers covered by a hood formed from the sepals. Rare and found mainly in the SE.

Early purple ⑬ orchid

Orchis mascula

HEIGHT Up to 40cm
A hairless perennial with glossy, spotted leaves and a flower spike of purple or pink flowers appearing in April–June; the lower lip is 3-lobed. Widespread and locally common in woodland, hedgerows and unimproved grassland.

Heath spotted orchid ①

Dactylorhiza macurlata

HEIGHT Up to 50cm
Similar to common spotted orchid, but flowers are usually paler and lip has wavy edge and small central tooth. Mainly confined to acid soils and heaths. Flowers appear in May–August. Widespread and locally common.

Common spotted orchid ②

Dactylorhiza fuchsii

HEIGHT Up to 60cm
A hairless perennial with lanceolate, keeled, usually spotted leaves. Spikes of pale pink, pale purple or white, spotted flowers with 3-lobed lips appear in June–August. Widespread and common in calcareous or neutral grassland.

Autumn lady's tresses ③

Spiranthes spiralis

HEIGHT Up to 15cm
A low perennial with a basal rosette of oval leaves and short, downy, spirally twisted spikes of tiny, fragrant greenish-white flowers which appear in August–September. Locally common in dry grassland in southern Britain and southern Ireland.

Southern marsh orchid ④

Dactylorhiza praetermissa

HEIGHT Up to 70cm
A robust perennial with dark green, lanceolate, unspotted leaves. The flowers are rose-purple with a broad, spotted lip and a short, stout spur. Locally common in southern Britain in water meadows, fens, dune slacks, replaced by northern marsh orchid in the north.

Marsh helleborine ⑤

Epipactis palustris

HEIGHT Up to 50cm
A tall perennial with elliptical, folded leaves and a terminal spike of drooping flowers. The sepals are purplish-brown, the petals crimson and white and the lip mostly white. Seed pods are downy. Locally common in southern Britain and Ireland in fens, dune slacks and marshes.

Broad-leaved helleborine ⑥

Epipactis helleborine

HEIGHT Up to 75cm
A clump-forming perennial with rounded leaves arranged spirally up stem. Greenish flowers, and rest of plant often purple tinged. Lip appears rounded due to recurved tip. Locally common in woodlands and scrub, scarce in northern Scotland.

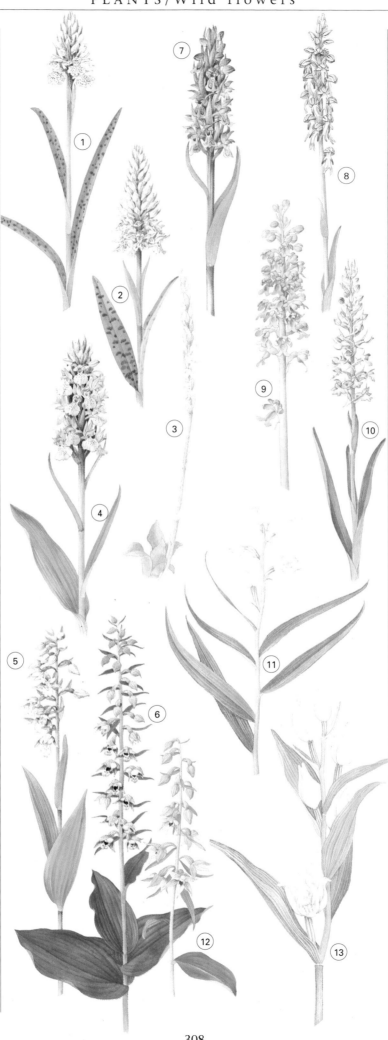

Early marsh orchid ⑦

Dactylorhiza incarnata

HEIGHT Up to 60cm
A hairless perennial with lanceolate, unspotted yellowish-green leaves with hooded tips. The flowers are usually flesh pink but can range from white to rose-purple; the lip has a small tooth. Locally common in damp grassland, dune slacks and fens.

Man orchid ⑧

Aceras anthropophorum

HEIGHT Up to 25cm
A low, hairless perennial with shiny, lanceolate, keeled leaves. The greenish-yellow manikin-shaped flowers are covered with a hood of sepals, growing on a tall spike and opening in May–June. Rare and only found on calcareous grassland in SE England.

Bird's-nest orchid ⑨

Neottia nidus-avis

HEIGHT Up to 35cm
A leafless, saprophytic orchid, coloured brown due to lack of chlorophyll. Flowers are papery-brown with no spur and 2-lobed lip, and have strange scent. Widespread, but nowhere common, in dry, undisturbed woodlands, often under beech.

Fragrant orchid ⑩

Gymnadenia conopsea

HEIGHT Up to 40cm
A hairless perennial with narrow unspotted leaves and an elongated spike of fragrant pink flowers; the lip is 3-lobed and the spur is very long. Locally common in calcareous grasslands and fens, commonest in southern and eastern Britain.

Narrow-leaved helleborine (Swordleaved) ⑪

Cephalanthera longifolia

HEIGHT Up to 50cm
A narrow-leaved hairless perennial with a terminal spike of pure white flowers which open wide enough to show small orange spot at base of lip. Locally common only in southern England in calcareous woods and scrub.

Narrow-lipped helleborine ⑫

Epipactis leptochila

HEIGHT Up to 75cm
Similar to broad-leaved helleborine, but tinged with yellow and slightly downy with leaves in two rows up stem. Flowers greenish-yellow. Scarce, grows in beech woods on lime soils.

White helleborine ⑬

Cephalanthera damasonium

HEIGHT Up to 50cm
A hairless perennial with bluish-green lanceolate leaves, narrower near top of stem, and creamy-white flowers which often remain tightly closed, hiding the yellow base of lip. Locally common in calcareous woods and scrub in southern England.

WATER PLANTS

- *Roots always grow in wet conditions* ● *Leaves float or are submerged*
- *Flowers often emerge from water*

Canadian pondweed

Elodea canadensis

AQUATIC
Submerged, easily-snapped stems carry narrow, down-curved leaves in whorls of three; stems branch frequently and send out slender white rootlets. Minute flowers are rarely seen. Introduced and widely naturalised, often choking still waters in lowland areas.

Marestail

Hippuris vulgaris

AQUATIC
An unbranched perennial, mostly submerged with upright emergent stems bearing whorls of 6–12 very narrow leaves. Minute male and female flowers grow at the base of the leaves. Widespread in shallow freshwater, absent from very acidic areas.

Greater bladderwort

Utricularia vulgaris

AQUATIC
Long submerged stems have finely-divided leaves and tiny bladders which trap water fleas. Yellow flowers are borne on emergent stems, appearing in July–August. Widespread in still waters, commonest in eastern England.

Common duckweed

Lemna minor

AQUATIC
A tiny floating annual with rounded fronds and a single root. Forms complete cover on still waters. Minute flowers are rarely seen, plant reproducing by division. Widespread and locally common in still waters.

Broad-leaved pondweed

Potamogeton natans

AQUATIC
Floating leaves are long-stalked, oval, up to 12cm long and dark green; submerged leaves are long and narrow. Greenish, plantain-like flowers are borne on emergent stalks. Widespread and common in still or slow-flowing waters.

Common cottongrass

Eriophorum angustifolium

AQUATIC
HEIGHT Up to 75cm
A perennial with narrow, dark green leaves which arise in a basal clump. The flower head consists of drooping, stalked spikelets, but the most distinctive feature is the cottony seed head. Locally common on very wet acid bogs.

Hare's-tail cottongrass

Eriophorum vaginatum

A narrow-leaved, tussock forming perennial. Flower spikes emerge from inflated sheaths, and cottony seed heads are slightly more compact than common cotton grass. Widespread and locally common in acid bogs in northern and western Britain and Ireland.

Common reed

Phragmites communis

HEIGHT Up to 2m
A tall, robust perennial with long, broad leaves and terminal spikes of brownish flowers. Plants turn light brown and persist through winter. Widespread and often very common, covering huge areas of marsh and water margins.

Branched bur-reed

Sparganium erectum

HEIGHT Up to 1m
An upright, hairless perennial with iris-like keeled leaves and a branched flower spike bearing unstalked heads of greenish-yellow spherical flowers, appearing in June–August. Widespread in shallow still and slow-flowing freshwater.

Saw/great fen sedge

Cladium mariscus

HEIGHT Up to 2.5m
A large perennial with long, saw-edged leaves, sometimes bent over. Flowers heads are dense, with clusters of brown spikelets, appearing in June–August. Locally common in eastern Anglia and NW Ireland.

Water horsetail

Equisetum fluviatile

HEIGHT Up to 1m
A tall, unbranched, non-flowering plant with jointed stems bearing whorls of thin unjointed branches. Spores are produced in cone like heads at tips of stems. Widespread and common in marshes and pond margins.

Common horsetail

Equisetum arvense

HEIGHT Up to 75cm
A patch-forming perennial producing sterile shoots with ridged stems and whorls of slender unbranched shoots. Fertile stems appear in May with cone-like heads. Very common and widespread in dry, grassy places.

Wood horsetail

Equisetum sylvaticum

HEIGHT Up to 50cm
An attractive horsetail resembling a miniature conifer; the upright stem bears whorls of branched shoots. Widespread and locally common in shady woodlands and moors, commonest in northern Britain.

Water fern

Azolla filiculoides

AQUATIC
A surface-floating fern with yellowish-green fronds, red-tinged late in year. Fronds comprise overlapping scales and have thread-like rootlets below. Introduced and naturalised in still water in southern England.

Shoreweed

Litorella uniflora

CREEPING
A hairless aquatic perennial with narrow, fleshy leaves forming a basal rosette. Very small flowers with minute petals appear in June–August. Widespread on muddy lake shores and pond margins in northern and western Britain, scarce and local in southern areas.

GRASSES, RUSHES AND SEDGES
● *Flowers are wind pollinated* ● *Leaves have parallel veins*
● *Root systems are fibrous*

Sharp rush
Juncus acutus

HEIGHT Up to 1.5m
A robust, hairless, tufted perennial with tall narrow stems terminating in a very sharp point. Clusters of reddish-brown flowers are followed by shiny brownish seeds which persist in winter. Coastal grasslands and dune slacks, mainly in southern Britain and Ireland.

Compact rush
Juncus conglomeratus

HEIGHT Up to 1m
A tufted, hairless perennial with ridged stems bearing compact clusters of brown flowers, although more lax flower clusters sometimes appear. Widespread and common in damp grassland, usually on acid soils.

Common sedge
Carex nigra

HEIGHT Up to 50cm
A variable, creeping perennial with tufts of long narrow leaves and longer, 3-angled stems. Flower heads have 1–2 male spikes above 3–4 female spikes. Widespread and common in damp grassland and marshes.

False fox sedge
Carex otrubae

HEIGHT Up to 80cm
A tufted perennial with strong, three-sided stems and long pointed leaves with auricles at the bases. The dense flower head is greenish brown with a long lower bract. Locally common on heavy soils in southern England.

Greater Tussock sedge
Carex paniculata

HEIGHT Up to 1m
A robust plant forming massive tussocks up to 1m across. The rough, 3-sided stems may be up to 1.5m long and the green leaves up to 1.2m long. Flowers are brownish. Widespread in fens and marshes, mainly in southern Britain.

Purple moor grass
Molinia caerulea

HEIGHT Up to 80cm
A tussock-forming perennial with narrow grey-green leaves and long, purplish flower spikes which appear in August–September. Dried leaves and seed heads persist in winter. Widespread and locally common on acid heaths and moors.

Marram grass
Ammophila arenaria

HEIGHT Up to 1m
A tough perennial with extensive creeping underground stems and tough grey-green leaves, usually rolled inwards to conserve moisture. Flower heads are yellowish and oval-elongate. Widespread and common on coastal dunes.

Quaking grass
Briza media

HEIGHT Up to 40cm
A tufted perennial grass with non-flowering shoots and loose panicles of ovoid, nodding spikelets, resembling hops, usually purple-tinged which move in the slightest breeze. Locally common on calcareous grassland in England and Wales.

Cocksfoot grass
Dactylis glomerata

HEIGHT Up to 1m
A tufted, tussock-forming perennial with rough leaves, often having slightly inrolled margins. The flower spikes bear purplish, rounded flower heads with a vague resemblance to a bird's foot. Widespread and common in damp grassland and waste ground.

Tufted hair grass
Deschampsia caespitosa

HEIGHT Up to 1.5m
A tufted, clump-forming perennial, persistent in winter with narrow, dark green leaves and long, graceful spikes of 2-flowered silvery spikelets. Widespread and locally common in damp grassland, woodland rides and marshes.

Sea lyme grass
Elymus arenarius

HEIGHT Up to 1.5m
A blue-grey perennial with long leaves up to 15mm wide and usually having inrolled margins. The flower heads are grey-green and slender, appearing in June–September. Widespread and common on sandy parts of eastern coast of Britain, scarce elsewhere in suitable habitats.

Yorkshire fog
Holcus lanatus

HEIGHT Up to 1m
A tufted grey-green perennial; both leaves and stems are downy. The flower heads are pale yellow-brown, compact and cylindrical at first, spreading later, and opening in May–August. Widespread and often common in grasslands, cliffs and waste ground.

Wood melick
Melica uniflora

HEIGHT Up to 50cm
A delicate, creeping perennial with pale green leaves and a lax inflorescence of oval, brown spikelets. Widespread and locally common in woodlands in England and Wales, scarce or absent elsewhere.

Timothy grass
Phleum pratense

HEIGHT Up to 1.5m
A tufted perennial with flat, grey-green leaves and a compact, cylindrical flower head up to 20cm long borne on a long slender stem. Widespread and common in meadows, roadsides and agricultural land. Scarce in the extreme north.

FERNS AND MOSSES

● *No flowers* ● *Reproduce by means of spores*
● *Favour damp habitats*

Bracken

Pteridium aquilinum

HEIGHT Up to 2m
A large, spreading and robust fern. Curled-tipped fronds appear above ground in spring, developing into large 3-pinnate fronds in summer, green at first, turning golden-brown in winter. Widespread and abundant in woods, open hillsides, uplands.

Male fern

Dryopteris filix-mas

HEIGHT Up to 1.25m
A large, clump-forming perennial fern with broadly oval 2-pinnate fronds. Stems bear pale brown scales and the spore cases are round. Widespread and very common in woodlands, hedgerows and damp shady places.

Hart's tongue fern

Phyllitis scolopendrium

HEIGHT Up to 60cm
An evergreen fern with fresh green, undivided fronds, usually with curled tips. Linear spore cases develop beneath the fronds. Widespread, but commonest in the west in shady places, hedgerows, woodlands.

Lady fern

Athyrium filix-femina

HEIGHT Up to 1.5m
A large, but delicately divided fern, forming spreading clumps of fresh green 2-pinnate fronds. The spore cases are curved, maturing in autumn. Widespread and common in damp woods, hedgerows and shady places.

Parsley fern

Cryptogramma crispa

HEIGHT Up to 25cm
Superficially resembles clumps of parsley, with finely divided fronds forming bright green tufts; the stems have scales at their bases and the whole frond dies back in winter. Widespread but nowhere common on mountain screes in northern Wales and NW England.

Polypody fern

Polypodium vulgare

HEIGHT Up to 50cm
Patch-forming small fern with tough 1-pinnate fronds growing on thin stalks. Often grows as an epiphyte on old trees, also on rocks and walls. Widespread and common, especially in western Britain and Ireland.

Adder's-tongue fern

Ophioglossum vulgare

HEIGHT Up to 20cm
A small fern with a single, undivided bright green frond and an upright fertile spike bearing the spores. Widespread, but rarely common in damp, undisturbed grassland, dune slacks and grazed marshes.

Stagshorn clubmoss

Lycopodium clavatum

HEIGHT Up to 10cm
A creeping perennial with long trailing stems which bear the upright, vaguely antler-like stems and long-stalked yellowish cones. Locally common in short grassland on moors, mountain slopes in northern Wales, northern England and Scotland.

Moss

Polytrichum commune

HEIGHT Up to 20cm
A large upright moss with erect stems and narrow needle-like leaves growing at right angles to the stems. The large brown spore capsules are borne on tall slender stems. Widespread and common on acid soils in damp woodland and moorlands.

Sphagnum moss

Sphagnum recurvum

HEIGHT Up to 5cm
One of many very similar species of Sphagnum with a sponge-like texture and fresh green leaves which become recurved at the tips when dry. Locally common on damp peaty ground and acid bogs on heaths, moors and mountain slopes.

Moss

Thuidium tamariscinum

SPREADING
A distinctive moss with dark stems and feathery 3-pinnate fronds, usually bright green in colour, resembling small fern fronds. Widespread and common in damp woodlands, spreading over fallen branches and tree stumps

Liverwort

Metzgeria furcata

SPREADING
A small spreading liverwort with a narrow, branched thallus usually found creeping over damp wood or rocks in shady places. Widespread and common in suitable habitats.

Liverwort

Pellia epiphylla

SPREADING
A patch-forming liverwort with a broad, flattened thallus which has a thickened midrib. Spore capsules are round and shiny black, appearing on long delicate stalks in spring. Widespread and common in damp, shady places.

Lichen

Cladonia floerkeana

SPREADING
Encrusting patches of greyish-white scales give rise to scaly stalks on top of which bright red spore producing tissue is carried. Widespread and locally common on bare peaty ground on heaths and moors.

SEAWEEDS AND COASTAL PLANTS

- *Some attach to rocks via a 'holdfast'* ● *Reproduce by spores*
- *Internal structure simple*

Egg wrack

Ascophyllum nodosum

LENGTH Up to 150cm
A tough seaweed with long, leathery, flat stems supporting large air bladders and branching repeatedly. Sultana-like fruiting bodies are borne on the ends of the fronds in summer. Widespread and abundant around all coasts on sheltered rocky shores.

Gutweed

Enteromorpha intestinalis

LENGTH Up to 75cm
A delicate green seaweed with inflated tubular fronds resembling lengths of intestine. Usually attached to rocks, but may become detached and form floating masses. Widespread and common in sheltered estuaries, rock pools, around all coasts.

Serrated wrack

Fucus serratus

LENGTH Up to 65cm
Fronds are greenish-brown, forked and flattened with distinctly saw-toothed margins. Orange-yellow fruiting bodies form at tips of fronds in summer, and there are no air bladders. Widespread and common on sheltered rocky shores on all coasts.

Spiral wrack

Fucus spiralis

LENGTH Up to 35cm
The flattened, brownish fronds are branched and twisted spirally towards the tip. There are no air bladders but swollen reproductive bodies grow at the tips. Widespread and common on sheltered rocky shores around all coasts.

Bladder wrack

Fucus vesiculosus

LENGTH Up to 1m
Tough fronds are olive-green, repeatedly branched and support paired bladders on either side of midrib; swollen reproductive bodies grow at tips in summer. Widespread and common on sheltered rocky shores on all coasts.

Thongweed

Himanthalia elongata

LENGTH Up to 2m
Long strap like fronds grow from a brown button-like hold fast attached to rocks on the lower shore; the frond forks near the tip and is olive-brown and slimy to touch. Widespread and common on very sheltered rocky shores around all coasts.

Kelp or Oarweed

Laminaria digitata

LENGTH Up to 1m
A very large seaweed with a tough branched holdfast, a thick but flexible stipe and a broad, flattened, much-divided dark brown frond. Forms dense beds at the low water mark on rocky shores on all coasts.

Channelled wrack

Pelvetia canaliculata

LENGTH Up to 15cm
A small seaweed, confined to the upper shore, with divided fronds which have inrolled margins to conserve moisture. There are no air bladders, but the tips have swollen reproductive bodies. Widespread and common on rocky shores.

Sea lettuce

Ulva lactuca

LENGTH Up to 40cm
A delicate membranous seaweed with thin green fronds. They are attached to rocks on the upper shore, but may become detached and form floating masses in sheltered areas. Widespread and common; thrives in brackish water.

Crab's-eye lichen

Ochrolechia parella

SPREADING
An encrusting, patch-forming lichen, mostly grey on the surface with a pale margin. Clusters of rounded, flat-topped spore-producing discs cover the surface. Grows on rocks and walls, mainly in northern and western Britain.

Sea ivory

Ramalina siliquosa

LENGTH Tufts up to 3cm long
A tufted and much-branched lichen with greyish, flattened branches bearing disc-like spore-producing bodies. Sometimes abundant on coastal rocks and walls in areas free from air pollution.

Map lichen

Rhizocarpon geographicum

SPREADING
The yellowish-green surface is dotted with dark spore producing bodies and individual colonies are divided by black lines, resembling countries on a map. Widespread on rocks and walls, mainly in uplands and mountains.

Yellow scales lichen

Xanthoria parietina

SPREADING
A very colourful lichen forming bright orange-yellow patches; the shape is often rounded and the surface is covered with overlapping scales. Often very common on coastal rocks and walls around whole of coastline; susceptible to air pollution.

Cord grass

Spartina maritima

HEIGHT Up to 75cm
A tufted perennial grass with grey-green, flattened leaves and an elongated inflorescence consisting of 2–3 long yellowish flower heads. Hybridises with other species. Common in mudflats and saltmarshes in southern England.

FUNGI

MUSHROOMS AND TOADSTOOLS

● *No flowers or leaves* ● *Reproduce by means of spores*
● *Feed on dead or living plants and animals*

Orange peel

Aleuria aurantia

SIZE Up to 20cm across
A very conspicuous fungus, easily spotted because of its bright orange wavy-edged disc, usually found growing on bare ground in September–November. Widespread and sometimes common.

White helvella

Helvella crispa

HEIGHT Up to 15cm
A strange-looking fungus with a creamy-white distorted cap and a greyish, deeply furrowed stem. Appears on woodland rides and grassy verges in autumn. Widespread and locally common.

Candle snuff fungus

Xylaria hypoxylon

HEIGHT Up to 5cm
Dry, flattened stems, resembling miniature antlers grow out of dead wood. Fresh stems are white but they become blacker with age. Widespread and often very common in woodlands, present all year.

King Alfred's cakes

Daldinia concentrica

SIZE Up to 5cm across
Irregular, rounded balls grow out of decaying wood of deciduous trees, mainly ash. Surface is usually shiny black, and interior is charcoal-like with concentric rings. Present all year, widespread and sometimes common.

Coral spot fungus

Nectria cinnabarina

SIZE Up to 2mm across
A small but easily-recognised fungus which forms clusters of small orange-pink mounds on dead and dying twigs of most deciduous trees. It can be found at any time of year and is widespread and common.

Birch polypore

Piptoporus betulinus

SIZE Up to 20cm across
A familiar bracket fungus which grows only the trunks of birch trees. The semi-circular fruiting bodies are buff-brown above and white below with minute pores; there is no stalk. Widespread and sometimes very common.

Many-zoned polypore

Coriolus (Trametes) versicolor

SIZE Up to 7cm across
Brackets are semi-circular with concentric rings on upper surface and pores on lower surface. Very common on dead stumps and fallen branches of deciduous trees. Widespread and present all year.

Chanterelle

Cantherellus cibarius

HEIGHT Up to 10cm
A yellow-orange fungus with a funnel-shaped cap when mature and gills which run down the stem from the cap. Smells of apricots. Locally common in mature woodlands.

Blushing bracket

Daedaleopsis confragosa

UP TO 18cm across
The brackets are irregularly semi-circular with a pattern of concentric buff and brown rings above and white pores below which bruise reddish and become darker when mature. Widespread and common on dead willows, sallows and birches.

Dryad's saddle

Polyporus squamosus

UP TO 50cm across
Often very large, and forming tiered brackets on deciduous trees, especially ash and elm. Upper surface is creamy buff and scaly, lower surface is greyish-white with pores. Appears in June–September. Widespread in deciduous woodlands, hedgerows.

Hoof fungus

Fomes fomentarius

UP TO 30cm across
A tough, solid fungus closely resembling a hoof growing out of a tree trunk. The surface is grey and ridged with darker lines. Occurs on mature birch trees and is mainly confined to Scottish highlands.

Hairy stereum

Stereum hirsutum

UP TO 4cm across
Irregular layers of wavy-edged, rubbery brackets form on dead wood. The colour is usually orange-yellow below, but grey and hairy above. Present all year and widespread in woodlands, hedgerows, parks.

Oyster fungus

Pleurotus ostreatus

UP TO 13cm across
Layers of large, fleshy brackets form on trunks of beech and other deciduous trees. The upper surface is smooth and greyish buff, and the underside is covered with white gills. Widespread and locally common in mature deciduous woodlands.

Honey fungus

Armillaria mellea

HEIGHT Up to 15cm
Cap is brown and scaly and the brown stalk has a ring; usually grows in tufts out of dead or dying trees, but parasitises and kills some trees. Bioluminescent if infected bark is peeled away. Widespread and very common in woods, parks and gardens.

Wood blewit

Tricholoma nudum

HEIGHT Up to 8cm
The cap is smooth and buff-lilac, starting with a conical shape but flattening with age. The gills are lilac-purple and the stout stem is streaked with lilac. Widespread in deciduous woodlands and hedgerows in autumn.

Clouded agaric

Clitocybe nebularia

HEIGHT Up to 12cm
The cap is blue-grey, but paler towards the margins, rounded when first seen, but flattening with age. The creamy-coloured gills run partly down the stem which is fatter at the base. Widespread and common in autumn in deciduous woodlands.

Deceiver

Laccaria laccata

HEIGHT Up to 8cm
Variable in appearance but cap usually orange-brown and rounded. Gills are pinkish-buff and the twisted, fibrous stem is usually the same colour as the cap. Widespread and common in autumn amongst leaf litter in deciduous and coniferous woods.

Amethyst deceiver

Laccaria amethystea

HEIGHT Up to 9cm
Cap, gills and stalk are all lilac or purple. The domed cap expands with age and the gills are widely spaced. The twisted stem has a few white hairs at the base. Widespread and locally common in autumn in deciduous woodlands.

Fairy-ring champignon

Marasmius oreades

HEIGHT Up to 10cm
A ring-forming fungus, usually found in circular colonies on grassland. Cap is pale buff or tan, sometimes darker, the gills are white and widely spaced and the flesh is white. Widespread in grasslands in autumn.

Porcelain fungus

Oudemansiella mucida

UP TO 7cm across
An almost pure white, slimy and translucent fungus, normally found growing in tufts out of trunks and branches of beech trees, and rarely other deciduous species. Widespread in mature beechwoods and parks in autumn.

Fly agaric

Amanita muscaria

HEIGHT Up to 20cm
An easily recognised toadstool with a bright orange-cap covered with white flecks which may be washed off in heavy rain. Cap is domed at first, then flat. Stem, which has ring, and gills are white. Widespread and common and always associated with birch.

False death cap

Amanita citrina

HEIGHT Up to 8cm
Cap is whitish or yellow-tinged and may have flecks of veil covering it. Flesh is white and smells of raw potatoes. Stem is swollen with ring at base. Widespread and fairly common in deciduous woodland, especially under beech.

Death cap

Amanita phalloides

HEIGHT Up to 10cm
Highly poisonous toadstool with unpleasant smell. Cap is rounded and tinged green. White stem arises out of cup at base. Gills and flesh are white. Appears in autumn in deciduous woods, especially under beech or oak.

The blusher

Amanita rubescens

HEIGHT Up to 15cm
Cap is buffish-brown and flecked with pink-grey pieces of the veil. Gills and flesh are white but show pinkish blush if damaged. Stem has a ring. Widespread and common in deciduous woodlands, appearing in late summer and autumn.

Parasol mushroom

Lepiota procera

HEIGHT Up to 30cm
A large fungus with a pale buff, scaly cap, egg-shaped at first, but flattening when mature. Gills and flesh are white, but stem has darker brownish scales. Widespread in grassy places, appearing in July–October.

Wood mushroom

Agaricus silvicola

HEIGHT Up to 10cm
Typical 'mushroom' appearance with cap which becomes flatter with age; skin is white but bruises yellow and smells of aniseed. Gills and flesh are pinkish. Widespread in deciduous and coniferous woodland, appearing in autumn.

Field mushroom

Agaricus campestris

HEIGHT Up to 8cm
Familiar mushroom with pale buff-brown cap and pink gills which become browner with age. Flesh has 'mushroom' smell. Stem has no ring. Widespread in permanent pastures and grasslands, but declining.

Shaggy ink-cap

Coprinus comatus

HEIGHT Up to 30cm
Pale cap is egg-shaped at first, then elongates on tall stem. Surface is shaggy, becoming darker and then turning to black ink. Flesh and gills are white in young specimens. Common on verges and grassy places, appearing in summer and autumn.

Sulphur tuft

Hypholoma fasciculare

HEIGHT Up to 8cm
A tufted fungus, mostly yellow in colour with a darker centre to the cap and a greenish-blue tinge to the gills. Grows out of dead stumps and fallen branches of deciduous trees, appearing in autumn. Widespread and common.

Cortinarius

Cortinarius crocolitus

HEIGHT Up to 18cm
An eye-catching fungus with a yellow cap which has small scales in the centre and a sticky texture. Gills are white, becoming buff when mature. Stem is yellow with a bulbous base. Widespread and locally common in deciduous woodland, appearing in autumn.

Cep

Boletus edulis

HEIGHT Up to 25cm
Cap is brown, and may be lobed and dimpled in mature specimens. Pores white at first, becoming creamy or yellow. Stem is fat with more bulbous base. Widespread and found in deciduous woodlands, often under oaks, appearing in autumn.

Bay bolete

Boletus badius

HEIGHT Up to 15cm
Cap colour varies from tan to buff, stem is similar colour and it may taper, pores are yellow but bruise bluish-green. Flesh is white but flushes blue when cut. Widespread and sometimes common in deciduous and coniferous woodland.

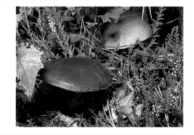

Blackening wax cap

Hygrocybe nigrescens

HEIGHT Up to 5cm
Cap is conical at first, becomes rounded with age, but still pointed at apex. Usually orange-red when young, blackening when mature. Widespread and common in grasslands, appearing in August–September.

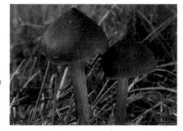

Common yellow russula

Russula ochroleuca

HEIGHT Up to 10cm
A colourful fungus with an ochre-yellow cap, rounded at first, but becoming more irregular with age. Gills, flesh and stalk are white. Widespread and common in deciduous woods in lowland areas, appearing in autumn.

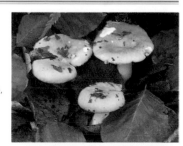

The sickener

Russula emetica

HEIGHT Up to 8cm
The cap is bright red, rounded at first, but flattening with age. The gills, flesh and stalk are pure white and rather brittle. A poisonous species, mainly confined to coniferous woodlands and often common, appearing in autumn.

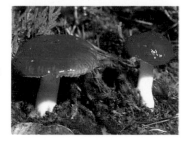

Woolly milk cap

Lactarius tomentosus

HEIGHT Up to 8cm
The pale orange cap has darker concentric rings and a covering of pale woolly fibres. The gills and flesh are white, and if broken release a white milk. Widespread and common in deciduous woodlands in autumn, especially under birch trees.

Stinkhorn

Phallus impudicus

HEIGHT Up to 15cm
Distinctive fungus starting as a soft white ball or 'witch's egg', 5–6cm across, and then emerging as a tall fruit body with a wrinkled brown, slime-covered, foul smelling cap which attracts insects. Widespread and common in deciduous woods from May–September.

Giant puffball

Langermannia giganteum

DIAMETER Up to 40cm
A large white irregularly rounded fungus growing out of the ground without a stalk. Flesh is white at first but in mature specimens develops into a mustard-like powder. Widespread but local in old pastures and undisturbed grassland, appearing in late summer.

Common puffball

Lycoperdon perlatum

HEIGHT Up to 7cm
Club-shaped fruiting bodies appear in clusters on dead and buried decaying wood. Fruit body has whitish papery skin, and dust-like spores are released through opening at top. Widespread and common, appearing in autumn in woodlands.

Common earthstar

Geastrum triplex

SIZE Up to 10cm across
Strange, star-shaped fungus which at first resembles onion, but opens to reveal central spore producing structure which is lifted off ground by rays of 'star'. Drops of rain make spores emerge. Scattered in deciduous woodlands, appearing in autumn.

Ear fungus

Hirneola auricula-judae

WIDTH Up to 5cm across
Fruit bodies bear close resemblance to fleshy ears, with a wrinkled, veined appearance. They grow out of dead branches of deciduous trees, especially elder, appearing in late autumn and winter. Widespread and often common.

Yellow stagshorn fungus

Calocera viscosa

HEIGHT Up to 7cm
An easily recognised fungus with bright yellow, much branched fruiting bodies, which have an antler-like appearance. Widespread and quite common in coniferous woodlands growing on dead stumps and twigs. Appears in late autumn.

Index

A

Abberton Reservoir 124
aconite, winter 285
adder 70, 255
agrimony 288
 hemp 303
alder 280
alderfly 269
Alderley Edge 154
alexanders 21
amphibians 256
anemones
 beadlet 278
 snakelocks 278
angelica, wild 294
Anglesey 85, 91, 112-13
annelid, marine 278
ants
 black 271
 wood 271
aphids
 black bean 269
 rose 269
Arbor Low 157
archangel, yellow 299
Ardnamurchan 198-99
Argyll 198-99
Arnside 154
arrowgrass, marsh 143
ascidian, star 278
ash 281
 mountain 100
Ashdown Forest 54, 70-71
aspen 279
asphodel, bog 37, 185, 306
aster, sea 303
auks 239
 little 239
avens
 mountain 165
 water 46, 289
 wood 289
avocet 32, 135, 233
azalea, trailing 203

B

badger 48, 121, 219
Bardsey Island 85, 92
barnacles
 acorn 276
 goose 276
 star 27
bartsias
 red 301
 yellow 32, 301
basil, wild 299
bass 259
Bass Rock 188
bats 220
 Daubenton's 220
 greater horseshoe 220
 lesser horseshoe 45, 220
 long-eared 101, 220
 natterer's 220
 noctule 220
 pipistrelle 220
 serotine 220
beaches
 sandy 146-47
 shingle 52-53
Beachy Head 56, 58, 60
bedstraw
 hedge 298
 lady's 297
beech 80, 280
bees
 buff-tailed bumblebee 271
 honeybee 271
beetles 272
 cardinal 272

click 272
cockchafer 272
devil's coach horse 272
glow-worm 134, 272
great diving 272
green tiger 272
hazel weevil 272
longhorn 272
poplar leaf 272
rainbow leaf 109
7-spot ladybird 272
sexton 272
silver water 43
stag 272
wasp 272
bellflowers
 clustered 302
 giant 143
 nettle-leaved 302
Ben Nevis 188
Berkeley Vale 46
Berwyn Mountains 90, 92
betony 299
bilberry 167, 296
bindweed
 black 283
 field 297
 hedge 297
 sea 139, 297
birch 117
 downy 279
 silver 204, 279
bird's foot 291
bird's-foot trefoil 107, 290
 greater 290
bistort 283
bithynia, common 274
bittercress, hairy 286
bittern 134, 136, 223
bittersweet 300
blackbird 156, 249
blackcap 156, 247
blackfly 269
blackthorn 281
Blackwater Estuary 124
bladderwort 137
 greater 309
Blakeney Point 138-39
Blean Woods 60
blenny, common 259
bluebell 49, 120, 306
boatmans
 lesser water 268
 water 268
bog 87
bog myrtle 280
bogbean 159, 209, 296
Border Country 146, 192-93
Bough Beech Reservoir 60
box 279
bracken 71, 158, 311
bramble 289
brambling 252
Breckland 116, 117, 120, 121,
 132-33
Brecon Beacons 102-03
Breidden Hills 92, 106
Bridgwater Bay 24
Broads, Norfolk 123, 136-37
broom 289
 butcher's 64
broomrape
 common 301
 knapweed 301
Brownsea Island 17, 38, 39
Brue Valley 42
bryony
 black 282
 white 282
buckthorn 281
 alder 281
 sea- 139, 281
bugle 298
bugloss 298
 viper's 298

bugs
 forest 269
 green shield 269
 hawthorn shield 269
 red and black leafhopper 269
 water 268
bullfinch 252
bullhead 258
buntings 251
 cirl 251
 corn 69, 251
 reed 251
 snow 76, 251
 yellowhammer 74, 251
burdock, greater 304
Burry Inlet 92
bush-crickets
 bog 268
 dark 268
 great green 37
 oak 268
 speckled 268
butterbur 121, 304
buttercups
 bulbous 285
 celery-leaved 285
 creeping 285
 meadow 47, 285
butterfish 259
butterflies 261-63
 adonis blue 53, 69, 263
 brimstone 261
 brown argus 17, 157, 263
 chalkhill blue 75, 263
 chequered skipper 199
 clouded yellow 72, 261
 comma 261
 common blue 143, 148, 263
 dark green fritillary 177
 dingy skipper 263
 Essex skipper 67, 263
 gatekeeper 262
 Glanville fritillary 63
 grayling 262`
 green hairstreak 263
 green-veined white 261
 grizzled skipper 263
 heath fritillary 41
 holly blue 81, 263
 large copper 140
 large heath 201, 262
 large skipper 263
 large white 261
 Lulworth skipper 34
 marbled white 68, 262
 marsh fritillary 30, 262
 meadow brown 262
 orange tip 261
 painted lady 28, 73, 261
 peacock 261
 pearl-bordered fritillary 262
 purple hairstreak 263
 red admiral 261
 ringlet 262
 Scotch argus 197
 silver-studded blue 36, 263
 silver-washed fritillary 105,
 262
 small blue 263
 small copper 45, 262
 small heath 262
 small pearl-bordered fritillary
 262
 small skipper 263
 small tortoiseshell 56, 261
 small white 261
 speckled wood 127, 262
 swallowtail 137
 wall brown 262
 white admiral 261
 wood white 261
butterwort 302
 pale 41
buzzard 41, 44, 103, 229
 honey 229

C

cabbage, wild 287
caddis fly 269
Cairngorm Mountains 181,
 202-03
calamint, common 299
Caledonian Forest 150, 204-05
Cambrian Mountains 100-01
Cambridgeshire 116, 117, 119
campions
 bladder 284
 moss 171, 284
 red 94, 284
 sea 62
 white 284
Canna Isle 206, 207
Cannock Chase 124
capercaillie 197, 203, 204, 231
carp 257
carrot, wild 295
Castle Eden Dene 154
cat's-foot 209
catchfly, alpine 170
catsear, common 306
celandines
 greater 286
 lesser 285
celery, wild 295
centaury
 common 297
 lesser 297
centipede 277
Central Lowlands 185, 186
chaffinch 252
chamomile, wild 303
char, Arctic 111
chats 248-49
Cheddar Gorge 23, 44
cherry
 bird 281
 wild 281
Chesil Beach 18, 34-35
chestnuts
 horse 280
 sweet 280
Cheviot Hills 146, 150, 174,
 192, 193
chickweed
 common 284
 Shetland mouse-ear 212
chicory 305
chiffchaff 246
Chiltern Hills 53, 80-81
chough 97, 195, 254
chub 258
cinquefoils
 creeping 289
 marsh 159, 289
clary, meadow 299
cleavers, common 298
cliffs 180-81
cloudberry 172
clovers
 hare's-foot 291
 long-headed 29
 red 291
 western 26
 white 291
club-moss, stag's-horn 311
coastal plants 312
cockle, common 275
coltsfoot 187, 304
columbine 172
comfrey, common 298
coniferous forest 150-51
conifers 90, 204
coot 232
coppicing 118-19
coral-necklace 65
cormorant 39, 79, 191, 223
corncockle 285
corncrake 184, 208, 232
cornsalad 301

Cornwall, North coast 24
Cotswold Hills 16, 24
Cotswold Water Park 24
cotton-grass 309
 hare's-tail 201, 309
Cow Green 155
cow-wheat, common 301
cowberry 185, 296
cowslip 295
crab apple 281
crabs 276
 broad-clawed porcelain 276
 edible 276
 hermit 276
 masked 276
 shore 276
 spider 276
 velvet swimming 19, 276
Craig-y-Cilau 102
cranberry 166, 296
crane's-bills
 bloody 28, 149, 157, 291
 cut-leaved 291
 meadow 184, 291
 wood 175, 291
crayfish, freshwater 277
Creswell Crags 154
crocus
 autumn 49
 sand 33
crossbills 159, 174, 253
 common 253
 Scottish 204, 253
crosswort 298
crowberry 193, 296
crowfoots
 common water- 105, 286
 pond water 286
crows 254
 carrion 254
 hooded 193, 254
crustaceans 276-77
cuckoo 46, 166, 240
cuckoo flower 287
cudweed, marsh 303
curlew 159, 167, 235
 stone- 118, 132, 232

D

dace 258
daffodil, wild 306
daisy 302
 ox-eye 45, 304
damselflies 267
 banded demoiselle 55, 267
 blue-tailed 267
 common blue 267
 common coenagrion 267
 demoiselle agrion 267
 large red 267
Danbury Woodlands 124
dandelion 305
Dark Peak 158-59
Dartmoor 21, 22, 23, 30-31
deciduous woodland 120-21
Dedham Vale 124
Dee Estuary 92
deer 126, 221
 fallow 48, 122, 194, 221
 munjac 80, 126, 221
 red 41, 187, 221
 roe 71, 132, 221
 sika 38, 221
Derbyshire Dales 152, 156
dipper 85, 103, 200, 245
divers
 black-throated 198, 222
 red-throated 183, 206, 213,222
docks
 broad-leaved 283
 curled 283
 great water 283

Scottish 197
dodder, common 297
dog's mercury 292
dogfish, lesser spotted 259
dogwood 282
dolphins
 bottle-nosed 17, 221
 common 26, 206, 221
dormouse 44, 118, 216
 edible 80, 216
Dorset Coast 34-35
Dorset Heaths 20, 36-37
dotterel 89, 203, 233
Dove Dale 156
doves
 collared 57, 240
 rock 240
 stock 240
 turtle 240
dragonflies 182, 267
 black-lined skimmer 267
 broad-bodied chaser 33, 71, 267
 brown hawker 267
 common sympetrum 267
 emperor 129, 267
 golden-ringed 110, 199, 267
 hairy 113
 Norfolk aeshna 137
 ruddy darter 131
 southern hawker 267
dropwort, hemlock water 295
Druridge Bay 154
ducks 225-229
duckweed, common 309
dunes 146-47
Dungeness 53, 57, 58, 72-73
dunlin 234
dunnock 245

E

eagles
 golden 152, 172, 202, 229
 white-tailed 209
earwig 268
East Anglia, Fens 123, 140-41
East Coast 160-61
eel 47, 257
egret, little 39
eider 99, 177, 227
Eigg Isle 185, 206, 207
Elan Valley 101
elder 282
elms
 English 280
 wych 280
Epping Forest 126-27
Essex 116, 117, 122
estuaries 116-17
Exe Estuary 18, 32-33
Exmoor 21, 22, 23, 40-41
eyebright 183, 301

F

Fair Isle 188, 212
Fairburn Ings 155
falcons 230
farmland 118-19
Farne Islands 151, 176-77
fat hen 283
fennel 294
fens 87, 121
Fens, East Anglia 123, 140-41
ferns 311
 adder's tongue 311
 hart's tongue 311
 lady 311
 male 311
 parsley 109, 311
 polypody 311
 water 309
feverfew 304
ffridd 86-87
field boundaries 23
fieldfare 139, 249
figwort, common 300

finches 252-53
Fingringhoe Wick 124
firecrest 133, 247
Firth 185
fishes
 freshwater 257-58
 seashore 259-60
Flat Holm 84
flea, water 277
fleabanes
 blue 303
 common 303
Fleet Lagoon 18, 34, 35
flies 270-71
 bee 270
 birch sawfly 271
 bluebottle 270
 cranefly 270
 drone 270
 flesh 270
 greenbottle 270
 horse 270
 hoverfly 270
 lesser house 270
 mosquito 270
 St Mark's 270
 yellow dung 270
flounder 117, 260
Flow Country 188
fluellen, round-leaved 300
flycatchers
 pied 31, 48, 248
 spotted 248
Forest of Bowland 154
Forest of Dean 48-49
forests, coniferous 150-51
forests of Middle England 126-27
forget-me-nots
 water 298
 wood 298
fox 71, 79, 219
foxglove 49, 120, 301
 fairy 199
fritillary 119
frogs
 common 256
 marsh 72, 256
fulmar 95, 223
fumitory, common 286
fungi 313-15
 amethyst deceiver 127, 314
 bay bolete 315
 birch polypore 313
 blackening wax cap 315
 blusher 314
 blushing bracket 313
 candle snuff fungus 313
 cep 315
 chanterelle 313
 clouded agaric 314
 coral spot fungus 313
 cortinarius 315
 death cap 314
 deceiver 314
 dryad's saddle 313
 ear fungus 315
 earthstar, common 315
 fairy-ring champignon 314
 false death cap 314
 field mushroom 314
 fly agaric 70, 314
 hairy stereum 313
 honey fungus 313
 hoof fungus 313
 King Alfred's cakes 313
 many-zoned polypore 313
 orange peel 313
 oyster fungus 313
 parasol mushroom 314
 porcelain fungus 65, 314
 puffball, common 315
 puffball, giant 315
 shaggy ink-cap 314
 sickener 315
 stinkhorn 315
 sulphur tuft 315
 white helvella 313
 wood blewit 314
 wood mushroom 314
 woolly milk cap 315
 yellow russula, common 315
 yellow staghorn fungus 315

G

gadwall 129, 226
Galloway 190-91
galls
 cherry 271
 knopper 271
 spangle 271
gamebirds 231
gannet 96, 181, 212, 223
garganey 137, 226
geese 194, 224-25
 barnacle 185, 190, 194, 224
 bean 225
 brent 32, 67, 76, 224
 Canada 79, 224
 greylag 225
 pink-footed 190, 225
 white-fronted 47, 110, 225
gentians
 autumn 161, 297
 field 169, 297
 marsh 36, 55, 297
geological structure
 Heart of England 114-23
 Northern England 152-53
 Scotland 186-87
 Southern England 58-59
 Wales 90-91
 West Country 20-23
Gibraltar Point 125
gipsywort 299
gladiolus, wild 64
glasswort 32, 163, 284
Glen Coe 188
globeflower 164, 285
Gloucester 46
glow-worm 134, 272
goat 174
goatsbird 305
goby, rock 260
godwits
 bar-tailed 62, 236
 black-tailed 66, 236
goldcrest 109, 247
goldeneye 190, 228
goldenrod 303
goldfinch 142, 252
Good King Henry 283
goosander 89, 111, 228
gooseberry 282
goosefoot, red 283
Gordano Valley 24
gorse 20, 53, 70, 120, 135, 172, 289
 dwarf 289
 western 31, 36
goshawk 159, 174, 229
Gower peninsula 98-99
grass-of-Parnassus 193, 288
grasses 310
 cocksfoot 310
 cord 312
 marram 146, 147, 310
 purple moor 88, 310
 quaking 310
 sea lyme 310
 Timothy 310
 tufted hair 310
grasshoppers
 common green 268
 common field 268
 marsh 65, 77
 meadow 268
grassland 119-20, 148-49
grayling 257
Great Orme 92
grebes 222
 black-necked 222
 great crested 128, 222
 little 110, 222
 red-necked 222
 Slavonian 222
greenfinch 252
greenshank 77, 235
greenweed
 dyer's 289
 hairy 29
ground elder 294
groundsel 304
grouse

black 175, 192, 231
 red 158, 166, 231
gudgeon 257
guelder-rose 165, 282
guillemots 97, 180, 211, 239
 black 173, 192, 195, 239
gulls 237
 black-headed 39, 237
 common 163, 237
 glaucous 237
 great black-backed 63, 237
 herring 29, 112, 237
 kittiwake 16, 176, 237
 lesser black-backed 161, 237
 little 160
 Mediterranean 73, 237
 ring-billed 98
gurnard, grey 260
gutweed 312
Gwent Levels 92

H

Hadrian's Wall 151, 152, 153, 175
Hainault Forest 127
Hamford Water 125
Hamsterley Forest 154
Harbottle Crags 155
harebell 190, 302
hares
 brown 132, 218
 mountain 150, 158, 218
harriers
 hen 90, 211, 230
 marsh 134, 136, 139, 230
 Montagu's 230
harvestman 277
Hatfield Forest 126
Havergate Island 125
hawfinch 65, 252
hawkbit, rough 306
hawksbeard, smooth 306
hawkweed
 mouse-ear 305
 spotted 148
hawthorn 281
Hayle Estuary 19, 24
hazel 120, 280
heathers 64, 184, 187
 bell 20, 36, 40, 55, 70, 296
heathland 54-55, 120-21
heaths
 Cornish 28
 cross-leaved 166, 174, 296
 Dorset 37
Hebrides, Inner 183, 184, 206
Hebrides, Outer 183, 184, 208-09
hedgehog 57, 216
hedgerows 20-21, 123
helleborine, stinking 285
helleborines
 broad-leaved 308
 marsh 308
 narrow-leaved (swordleaved) 308
 narrow-lipped 308
 white 308
hemlock 294
henbane 300
herb bennet 289
herb-Paris 127
herb robert 291
heron, grey 78, 128, 223
Hickling Broad 136
High Weald 54, 55
Highland Boundary Fault 186, 187
Highlands 150, 181, 182, 184, 185, 186, 187
hobby 42, 64, 230
hogweed 294
 giant 294
Holderness 160-67
holly 279
Holy Island 151, 176-77
honeysuckle 21, 282
hoopoe 26
hop 282
horehound, black 299
hornbeam 280

Hornsea Mere 160
horsetails
 common 309
 water 309
 wood 309
houndstongue 298
hydra 277

I

Inner Hebrides 183, 184, 206
insectivores 216
invertebrates 274-78
iris, yellow 168, 306
Islay 194-95
Isle of Man 168-69
Isle of May 188
Isle of Sheppey 76-77
Isle of Wight 62-63
Isles of Scilly 19, 26-27
ivy 282
 ground 298

J

jackdaw 254
Jacob's ladder 156
jay 107, 254
jellyfish 278
jenny, creeping 295
juniper 279

K

kelp 312
Kenfig Pool and Dunes 92
kestrel 74, 230
kingfisher 104, 134, 242
kite, red 80, 91, 100-01, 229
kittiwake 16, 176, 237
knapweed
 black 305
 greater 68, 305
knot 139
knotgrass 283

L

lacewing 269
lady's mantle 288
ladybird, 7-spot 272
Lake District 151, 152, 153, 170-73
lakes 182-83
lampreys
 brook 257
 river 257
Land's End peninsula 18, 24
landscape features
 Heart of England 114-23
 Northern England 152-53
 Scotland 186-87
 Southern England 58-59
 Wales 90-91
 West Country 22-23
lapwing 119, 164, 181, 233
larch 279
larks
 shore 77, 243
 skylark 68, 192, 243
 woodlark 30, 243
lasher, father 260
laurel, spurge 293
Lee Valley 60
leech, fish 277
leek, three-cornered 27
lettuce, sea 312
lichen 311-12
 crab's-eye 312
 map 171, 312
 sea ivory 312
 yellow scales 312
lily, Snowdon 108

lily-of-the-valley 102, 306
lime 282
 small-leaved 118
limpets
 common 19, 275
 river 274
 slipper 275
Lincolnshire Wolds 142-43
Lindisfarne 151, 176-77
ling 54, 64, 120, 135, 193, 296
linnet 43, 253
liverwort 311
Lizard peninsula 18, 28-29
lizards
 common 255
 sand 37, 255
 slow-worm 255
Llangorse Lake 103
Lleyn 92
lobster, common 276
Loch Lomond 196-97
Loch of Lowes 188
Loch of Strathberg 189
lochans 182-83
lochs 182-83
London 59, 78-79
long-tailed duck 228
loosestrifes
 purple 130, 293
 yellow 295
lords and ladies 306
louse, freshwater 277
lousewort 301
Low Weald 54
Lower Derwent Valley 155
Lulworth Cove 34
lumpsucker 260
Lundy Island 19, 24
lungwort, narrow-leaved 63

M

madder, field 297
magpie 254
mallard 225
mallows
 common 292
 marsh- 136, 292
 musk 292
 tree 292
Malvern Hills 92
mandarin 225
maple, field 280
Marches 91, 106-07
mare's-tail 197, 309
marigolds
 corn 26, 208, 303
 marsh 136, 211, 285
marjoram 299
Martin Mere 155
martins
 house 243
 sand 104, 243
mayfly 267
mayweed
 pineapple 303
 scentless 303
meadow rue, common 286
meadows 119-20, 148
meadowsweet 288
medick, black 291
melick, wood 310
mellilot, ribbed 290
Mendip Hills 16, 44-45
merganser, red-breasted 228
merlin 165, 167, 198, 230
mezereon 292
mignonette, wild 287
milkwort, common 292
millipedes
 flat-backed 277
 pill 277
mink, American 218
minnow 258
Minsmere 134-35
mint
 corn 299
 water 299
mole 216
molluscs

freshwater 276
 land 274
 sea 275
monk's rhubarb 283
monkey flower 301
Montrose Basin 189
moorhen 232
moorland 184-85
Moray Firth 189
Morecambe Bay 153, 162-63
moschatel 301
mosses 311
moths 264-66
 angle shades 266
 brimstone 266
 broad-bordered bee hawk-
moth 264
 broad-bordered yellow
underwing 265
 buff tip 265
 burnished brass 266
 canary-shouldered thorn 266
 chocolate tip 265
 cinnabar 265
 drinker 47
 elephant hawkmoth 264
 emperor 166, 170, 264
 eyed hawkmoth 264
 five-spot burnet 264
 garden tiger 78, 265
 great prominent 265
 ground lackey 77
 heart and dart 265
 hebrew character 265
 herald 266
 hummingbird hawkmoth
 29, 264
 lackey 264
 lappet 264
 large emerald 266
 lime hawkmoth 264
 lobster 265
 magpie 266
 mother shipton 266
 northern eggar 171, 205
 pale prominent 265
 pebble hooktip 266
 peppered 266
 pine hawkmoth 264
 poplar hawkmoth 264
 privet hawkmoth 264
 puss 265
 red underwing 266
 sallow kitten 265
 silver Y 266
 six-spot burnet 142
 small elephant hawkmoth
 264
 speckled yellow 266
 swallowtailed 266
 white ermine 265
 yellow-tail 265
mountain everlasting 209
mouse
 harvest 131, 216
 house 217
 wood 126, 217
 yellow-necked 217
mouse-ear, common 284
Muck Isle 206, 207
mugwort 304
 Breckland 133
mulleins
 dark 300
 great 300
mullet, thick-lipped grey 259
mushrooms 313-15
mussels
 common 275
 swan 274
mustard
 garlic 287
 hedge 286
mustelids 218

N

navelwort 287
nettles
 common 283

common hemp- 299
 red dead- 299
 white dead- 299
New Forest 55, 64-65
Newborough Forest 113
newts
 great crested 256
 palmate 103, 256
 smooth 256
nightingale 249
nightshades
 deadly 300
 enchanter's 293
nightjar 54, 241
Norfolk Broads 123, 136-37
Norfolk Coast, Northern 138-39
North Downs 52, 68, 74-75
North Norfolk Coast 138-39
North Solway Coast 190-91
North York Moors 152, 166-67
Northumberland 174-75
nuthatch 64, 157, 251

O

oak apple 271
oaks 120
 English 280
 sessile 22, 41, 91, 101, 110,
 280
oarweed 312
octopus, common 275
old man's beard 282
open sea 16-17
orchids 307-08
 autumn lady's tresses 308
 bee 69, 307
 bird's-nest 308
 bog 56, 307
 burnt 307
 burnt-tip 69
 common spotted- 105, 308
 dense-flowered 168
 early marsh 308
 early-purple 20, 107, 307
 fly 307
 fragrant 34, 308
 frog 307
 ghost 81
 greater butterfly 307
 green winged 173, 307
 heath spotted- 21, 308
 lady 74, 307
 lesser butterfly 307
 lizard 307
 man 308
 marsh- 67, 86, 141, 177
 military 133
 pyramidal 143, 307
 southern marsh 308
 twayblade 307
Orford Ness 125
oriole, golden 245
Orkney Islands 210-11
osier 279
osprey 184, 202, 203, 229
otter 18, 43, 212, 219
Ouse Washes 121, 130-31
Outer Hebrides 183, 184, 208-09
owls 241
 barn 143, 241
 little, 241
 long-eared 241
 short-eared 40, 89, 241
 snowy 212
 tawny 78, 104, 127, 241
ox-tongue, bristly 305
oyster, common 275
oystercatcher 33, 153, 191, 207,
 233

P

pansies
 field 293
 mountain 87
 wild 198, 293
parakeet, ring-necked 79

parkland 121-22
parsley
 cow 294
 upright hedge 294
parsley piert 288
parsnip, wild 295
partridges
 grey 231
 red-legged 231
pasque flower 16, 81
pastures 119-20, 148
pea, sea 290
Peak District 146, 148, 149, 150,
 156-59
pear, wild 281
pearlwort, procumbent 284
Pembrokeshire coast 85, 96-97
Penclacwydd 92
Pennine Way 158, 174
Pennines 146, 147, 149, 150, 153
pennywort, marsh 294
pepper, water 283
pepperwort, field 287
perch 258
peregrine 86, 110, 112, 170, 230
periwinkles
 edible 275
 flat 99, 275
petrel, storm 95, 223
petty whin 289
Pevensey Levels 57, 60
phalaropes
 grey 236
 red-necked 209, 236
pheasant 231
pigeons
 feral 240
 wood 240
pignut 294
pike 257
pimpernels
 bog 31, 295
 scarlet 295
 yellow 295
pine marten 151, 219
pinks
 Cheddar 44
 maiden 285
pintail 207, 226
pipewort 206
pipits
 meadow 167, 169, 244
 rock 207, 244
 tree 133, 170, 244
plane, London 280
planned countryside 116
plantains
 buckshorn 302
 common water 306
 greater 302
 sea 302
plovers
 golden 150, 175, 233
 grey 116, 233
 little ringed 233
 ringed 33, 147, 233
Plynlimon massif 88
pochard 172, 227
polecat 87, 102, 107, 218
pond skater 268
ponds 123, 182-83
pondweed
 broad-leaved 309
 Canadian 309
ponies
 Dartmoor 30
 New Forest 55, 65
Poole Harbour 17, 38-39
poplar, white 279
poppies 116
 common 286
 Welsh 104, 286
 yellow-horned 52, 286
porpoise, harbour 221
Portland peninsula 34
prawn, common 276
Preseli Hills 97
primroses 195, 295
 common evening 293
 Scottish 210
privet 282
ptarmigan 203, 231

puffin 19, 94, 213, 239
Purbeck 17, 22, 24, 36
purslane, sea 284

Q

Quantocks 25

R

rabbit 75, 107, 218
radish, wild 287
ragged robin 141, 285
ragwort, common 304
rampion, round-headed 302
Ramsey 85
ramshorn, great 274
ramsons 306
rat, brown 79, 218
raven 100, 113, 254
ray, thornback 259
razorbill 95, 211, 239
razorshell, pod 275
redpoll 126, 253
redshanks 42, 67, 235
 spotted 128, 235
redstarts 174, 248
 black 72, 248
redwing 249
reeds 123, 153
 branched bur- 309
 common 86, 309
reindeer 203
reptiles 255
rest-harrow 290
rhododendron 282
ring ouzel 109, 184, 249
rivers 84-85
roach 258
robin 59, 248
robin's pincushion 271
rock-rose
 common 293
 spotted 112
rocket, sea 287
Rockingham Forest 127
rockling 259
rocky shores 18-19
rodents 216-17
Romney March 57, 72-73
rook 254
roses
 burnet 289
 dog 288
 field 288
rosemary, bog 106
roseroot 288
rowan 281
rudd 258
ruddy duck 228
ruff 131, 236
Rum Isle 206, 207
rushes 310
 compact 310
 flowering 42
 sharp 310
Rutland Water 128-29
Rye Harbour 60

S

sage, wood 123, 298
sainfoin 290
St John's-worts
 marsh 292
 perforate 292
 slender 292
 trailing 292
salad burnet 288
sallow, great 279
salmon 31, 200-01, 201
 Atlantic 257
Saltfleetby Dunes 125
samphires
 golden 35, 117, 303
 rock 35, 295

sanderling 162, 234
sandhopper 276
Sandlings 125
sandpipers
common 200, 235
curlew 234
green 235
purple 19, 234
wood 35, 235
Sands of Forvie 188
Sandwich Bay 58, 60
sandworts
sea 147, 284
spring 45, 284
sandy shores and beaches 146-47
sanicle 294
saw 309
saw-wort 305
saxifrages
burnet 294
meadow 288
mountain 171
opposite-leaved golden 288
pepper 295
purple 102, 108, 288
starry 175
scabious
devil's bit 302
field 302
sheep's bit 302
small 302
scaup 194, 227
Scilly Isles 19, 26-27
scorpion, water 268
scorpionfly 105, 269
scoters
common 227
velvet 227
Scots pine 150, 151, 182, 279
scurvy-grass, common 287
sea beet 113, 283
sea birds 237-39
sea-holly 53, 294
sea ivory 312
sea-kale 73, 287
sea-lavender 67, 76, 296
Portland 35
seablite 284
seals
common 138, 219
grey 85, 96, 183, 206, 210, 219
seaweeds 18-19, 312
sedges 310
common 310
false fox 310
great fen 309
greater tussock 310
Sedgemoor 42
Selbourne 60
selfheal 298
Seven Sisters 56, 60
Severn, River 46-47
Severn Estuary 19-20
shag 95, 223
shark, basking 169
shearwater, Manx 169, 223
sheep
Manx loghtan 169
Romney Marsh 72
Soay 44, 209
Welsh 86, 108
shelduck 47, 225
Shell Ness 77
shells
laver spire 163, 275
peppery furrow 275
shepherd's purse 287
Sherwood Forest 120, 121, 127
Shetlands 212-13
shingle beaches 52-53
shore-weed 183, 309
shores
rocky 18-19
sandy 146-47
shoveler 161, 226
shrews
common 216
pygmy 216
water 129, 216
shrikes

great grey 141, 245
red-backed 245
shrimps
common 276
freshwater 277
shrubs 279-82
Silverdale 154
silverweed 119, 289
siskin 252
Skokholm 94-95
Skomer 94-95
skuas
Arctic 17, 211 238
great 213 238
skullcap, greater 298
Skye 206-07
slate, Welsh 89, 90-91
slater, sea 276
Slimbridge 19, 46-47
slow-worm 255
slugs
dusky 274
leopard 274
Small Isles 206-07
smew 129, 228
snail, common sea 260
snails 274
amber 274
brown-lipped 274
garden 274
great pond 274
plaited door 274
strawberry 274
wandering pond 274
snakes
adder 70, 255
grass 255
smooth 17, 36, 255
sneezewort 303
snipe 164, 181, 236
Jack 236
Snowdonia 89, 91, 108-11
snowdrop 306
sole 260
Solent 56, 66-67
Solomon's seal 306
Solway Coast, Northern 190-91
Somerset Levels 17, 23, 42-43
sorrels
common 283
wood
South Coast estuaries 66-67
South Downs 52, 53, 68-69
Southern Uplands 185, 186
sowthistles
perennial 305
smooth 305
spagnum moss 311
sparrowhawk 108, 156, 229
sparrows
house 253
tree 129, 253
spearworts
greater 285
lesser 87, 285
speedwells
blue water- 300
common field- 300
germander 300
spiked 133
thyme-leaved 300
spiders 273
common cross 273
crab 273
daddy long-legs 273
garden 273
house 273
hunting 273
purse-web 273
raft 106, 121
swamp 273
water 273
wolf 273
zebra 273
spikenard, ploughman's 303
spindle tree 281
Spurn Head 153
spurrey, rock sea 27, 284

squill, spring 97, 194
squinancywort 69, 297
squirrels
grey 217
red 62, 117, 150, 205, 217
starfishes
common 278
cushion star 278
spiny 278
starling 245
stick insect, water 268
sticklebacks
nine-spined 258
three-spined 258
stillwater 182-83
stints
little 77, 234
Temminck's 234
stitchwort, greater 284
stoat 173, 218
stock, sea 98
Stodmarsh 60
stonechat 54, 70, 99, 248
stonecrops
biting 288
English 27, 288
stoneloach 258
storksbill, common 291
strawberry 289
streams 84-85
Strumble Head 93
sucker, Cornish 260
sundew 39
round-leaved 287
Surrey Heaths 61
Swale, The 61, 77
swallow 26, 130, 243
swans 224
Bewick's 46, 47, 131, 224
mute 34, 35,66, 224
whooper 191, 224
swift 241
sycamore 280

T

tansy 304
Taw/Torridge Estuary 25
Tayside 200-01
teal 34, 226
teasel 302
terns 238
Arctic 176, 238
black 238
common 38, 238
little 53, 66, 162, 238
roseate 177, 238
Sandwich 73, 238
Test Valley 61
Thames Estuary 76-77
Thames Valley 58
thistle
carline 304
creeping 305
marsh 305
melancholy 201, 305
musk 305
spear 304
stemless 304
thongweed 312
Thor's Cave 148, 157
thrift 19, 35, 160, 181, 296
thrushes 249
mistle 58, 249
song 27, 249
thyme 191, 300
tits 250
bearded 135, 153, 250
blue 250
coal 250
crested 151, 205, 250
great 250
long-tailed 75, 250
marsh 250
willow 250
toadflax
common 300
ivy-leaved 300
toads
common 130, 256

natterjack 173, 256
toadstools 313-15
toothwort 301
topshell, toothed 275
tormentil 31, 149, 187, 289
treecreeper 46, 65, 251
trees 279-82
trefoil, hop 291
Tregaron 101
Tring Reservoirs 61
trout, brown 85, 257
tufted duck 197, 227
tulip, wild 306
turnstone 163, 176, 234
tutsan 292
twite 138, 253
Tywi Valley Woodlands 93

U

uplands 88-89, 152
Upper Teesdale 149, 155
urban wildlife 56-57
urchins
heart 278
sea 278

V

valerian, red 301
verges 20-21
vetch
bush 290
horseshoe 290
kidney 157, 290
purple milk- 290
tufted 290
wood 290
vetchling
meadow 290
yellow 290
violets
common dog 293
fen 140
marsh 293
sweet 293
water 295
Virginia Water 61
voles
bank 217
short-tailed 149, 217
water 140, 217
Vyrnwy, Lake 92

W

waders 233-36
wagtails
grey 87, 201, 244
pied 244
yellow 66, 244
warblers 246-48
Cetti's 96, 246
Dartford 38, 55, 247
garden 247
grasshopper 246
marsh 246
melodious 94
reed 43, 246
sedge 246
willow 246
wood 246
Wash, The 138
wasps
field digger 271
German 271
giant wood 271
ruby-tailed 271
water bugs 268
watercress 286
water-lilies 182
fringed 296
white 97, 286
yellow 286
water plants 309
water rail 141, 168, 191, 232

waterfalls, Wales 89-90
waxwing 161, 244
wayfaring tree 282
Weald 53-55
weasel 101, 218
weld 287
Wembury 25
Wester Ross 189
wetlands 86-87
whale, minke 199, 221
wheatear 30, 106, 248
whelks
common 275
dog, 275
whimbrel 162, 235
Whin Sill 151, 153
whinchat 101, 248
White Cliffs of Dover 52, 58
White Peak 156-57
whitebeam 281
whitethroat 99, 247
lesser 247
whitlowgrass, common 99, 287
Wicken Fen 140
wigeon 226
wild service tree 63, 281
wildcat 182, 204, 219
willows
goat 279
grey 279
mountain 202
white 279
willowherbs
great 293
rosebay 293
Wiltshire Downs 16, 25
Windsor Great Park 58, 61
wintergreens
chickweed 186
common 296
round-leaved 296
single-flowered 205
Wolds, Lincolnshire 142-43
Wolds, Yorkshire 153
wood anemone 286
woodcock 236
woodland 118-19
deciduous 120-21
woodlouse
common 277
pill 277
woodpeckers 64, 242
great spotted 49, 121, 242
green 127, 242
lesser spotted 242
wryneck 242
woodruff, sweet 297
Woodwalton Fen 141
worms
earthworm, common 277
lugworm 278
peacock worm 278
ragworm 278
wormwood 304
woundwort, hedge 299
wracks
bladder 312
channelled 312
egg 312
serrated 312
spiral 312
wrasse, corkwing 259
wren 245
Writtle Forest 127
wryneck 242
Wye Valley 104-05
Wyre Forest 93

Y

yarrow 303
yellow-rattle 75, 301
yellow-wort 142, 297
yellowhammer 74, 251
yew 279
Yorkshire Dales 146, 148, 149, 150, 152, 164-65
Yorkshire Wolds 153
Yorkshire fog 310
Ythan Estuary 188

Picture acknowledgements

Bird illustrations by Richard Allen, Norman Arlott, Trevor Boyer, Hilary Burn, John Cox, Dave Daly, John Gale, Robert Gillmor, Peter Hayman, Ian Lewington, David Quinn, Darren Rees, Chris Rose, Christopher Schmidt. All other illustrations by Ian Garrard

11: VG/Mike Guy; **14:** BC/Derek Croucher; **16:** NPL/Andrew Cleave, FLPA/Winfried Wisneiwski, VG/Vic Guy; **17:** AA, NPL/Colin Carver, NPL/PS, FLPA/Roger Wilmshurst; **18:** NPL/Andrew Cleave, NPL/E A Janes, Biofotos/Jason Venus; **19:** FLPA/Michael Callan, NPL/PS, NPL/Andrew Cleave; **20:** NPL/E A Janes, Heather Angel; **21:** NPL/PS, **22:** NPL/Andrew Cleave, AA; **23:** AA, NPL/E A Janes, NPL/Frank Blackburn; **24:** NPL/Andrew Cleave, NPL/Jean Hall; **25:** NPL/Richard Mearns; **26:** BC/Mark Carwardine, NPL/Andrew Cleave; **27:** Heather Angel, NPL/PS, FLPA/Roger Wilmshurst; **28:** WWI/David Woodfall, BC/Kim Taylor, NPL/Robin Bush; **29:** Nicholas Phelps Brown, NPL/Andrew Cleave, FLPA/Eric & David Hosking, NPL/ PS; **30:** NPL/PS, NPL/Tony Wharton, BC/Robert Maier; **31:** Heather Angel, AA, NPL/PS, NPL/Frank Blackburn; **32:** WWI/Mike Powles, NPL/PS; **33:** WWI/Nigel Hicks, WWI/Bob Glover, NPL/PS, NPL/Andrew Cleave, NPL/Roger Tidman; **34:** FLPA/Hugh Clark, FLPA/Roger Wilmshurst, Ardea/Bob Gibbons, Heather Angel; **35:** NP/PS, David Boag; **36:** WP/David Tipling, NPL/Hugh Clark, NPL/E A Janes; **37:** NPL/Peter Craig-Cooper, WP/David Tipling, WP/Dr C R Tyler, NPL/E A Janes; **38:** WP/Sylvia Undata, WP/David Tipling, NPL/Hugh Clark, NPL/E A Janes; **39:** NPL/Peter Craig-Cooper, WP/David Tipling, WP/Dr C R Tyler, NPL/E A Janes; **40:** AA, NPL/Robin Bush; **41:** NPL/PS, NPL/W S Paton, FLPA/R P Lawrence; **42:** AA, NPL/David Osborn, NPL/PS; **43:** Mike Read, NPL/PS, Heather Angel; **44:** NPL/Andrew Cleave, Heather Angel, NPL/Owen Newman; **45:** NPL/PS, NPL/Robin Bush, NPL/S C Bisserot, AA, Heather Angel; **46:** FLPA/C Mullen, FLPA/D Hosking, NPL/David Osborn; **47:** NPL/Paul Sterry, Heather Angel, FLPA/Roger Wilmshurst; **48:** NPL/Robin Bush, NPL/A R Hamblin, NPL/PS; **49:** NPL/Hugh Clark, FLPA/ Catherine Hullen, NPL/PS, Heather Angel; **50:** AA; **52:** NPL/PS, WWI/Bob Gibbons; **53:** AA, FLPA/Ian Rose, NPL/Brinsley Burbidge, NPL/PS; **54:** NPL/Paul Sterry, AA, FLPA/John Hawkins, NPL/Frank Blackburn, NPL/E A Janes; **55:** NPL/PS, NPL/Frank Blackburn; **56:** NPL/PS, FLPA/Roger Wilmshurst, NPL/Robin Bush; **57:** NPL/Andrew Cleave, NPL/Frank Blackburn, NPL/Geoff du Feu;

58: NPL/Robin Bush, NPL/T D Bonsall, NPL/PS; **59:** AA, Heather Angel, NPL/Frank Blackburn; **60:** NPL/Frank Blackburn, NPL/Robin Bush; **61:** NPL/Robin Bush; **62:** FLPA/H D Brandl, NPL/PS, AA; **63:** Biofotos/Ken Pilsbury, Heather Angel, NPL/Jim Russell, NPL/PS; **64:** NPL/PS, NPL/Frank Blackburn; **65:** NPL/PS, NPL/Ron Croucher, AA, Heather Angel; **66:** AA, NPL/PS; **67:** BC/Bob Glover, NPL/PS, NPL/Andrew Cleave; **68:** AA, BC/Kim Taylor, NPL/PS; **69:** NPL/PS, NPL/Roger Tidman; **70:** NPL/PS, Heather Angel, WP/Richard Revels; **71:** NPL/W S Paton, NPL/PS, AA; **72:** AA, Heather Angel, NPL/PS; **73:** BC/Jan Van de Kam, NPL/PS, Heather Angel; **74:** AA, NPL/Philip J Newman, Heather Angel; **75:** NPL/Geoff Du Feu, NPL/PS, NPL/Robin Bush, NPL/W S Paton; **76:** FLPA/R Wilmshurst, Heather Angel, NPL/PS; **77:** NPL/PS, FLPA/G E Hyde, NPL/Roger Ridman; **78:** WP/D Mason, WP/Les Borg, NPL/PS; **79:** NPL/Derrick Scott, BC/Colin Varndell, NPL/PS, WP/David Tipling, Heather Angel; **80:** NPL/PS, BC/Wener Layer, NPL/E A Janes; **81:** NPL/PS, NPL/Robin Bush, Heather Angel; **82:** V K Guy Ltd; **84:** AA, NPL/PS, **92:** NPL/PS, NPL/R H Fisher; **85:** FLPA/C Mullen, AA, NPL/Michael J Hammett, NPL/Philip Newman; **86:** AA, NPL/W S Paton, NPL/E A Janes; **87:** Heather Angel, NPL/Frank B Blackburn, NPL/W S Paton, NPL/Brinsley Burbidge; **88:** NPL/PS, AA, NPL/Geoff Du Feu; **89:** NPL/PS, NPL/Philip Newman; **90:** FLPA/ A J Roberts, NPL/Andrew Cleave, NPL/W S Paton, AA; **91:** NPL/PS, FLPA/Martin Withers, NPL/Andrew Cleave; **93:** NPL/N A Callow; **94:** NPL/PS, NPL/Robin Bush, NPL/Roger Tidman; **95:** NPL/Len Jessup, NPL/PS, NPL/Andrew Davies; **96:** Geoff Doré; Heather Angel, AA; **97:** Heather Angel, NPL/PS, NPL/Colin Carver, AA; **98:** V K Guy Ltd, NPL/Brinsley Burbidge; **99:** BC/Mike McKavett, NPL/PS, NPL/Robin Bush, NPL/Colin Carver, FLPA/W Wisniewski, AA; **100:** BC/Hans Reinhard, NPL/Andrew Cleave, AA; **101:** AA, NPL/Philip Newman, NPL/Owen Newman, NPL/Andrew Cleave, NPL/S C Bisserot; **102:** Heather Angel, NPL/W S Paton, NPL/Andrew Weston; **103:** NPL/Philip Newman, AA, Laurie Campbell, NPL/PS; **104:** FLPA/Silvestris, NPL/PS; **105:** AA, NPL/PS, NPL/Robin Bush, Heather Angel; **106:** FLPA/W Broadhurst, NPL/Brinsley Burbidge, NPL/PS; **107:** BC/Felix Labhardt, NPL/PS, FLPA/Roger Hosking, NPL/W S Paton; **108:** Heather Angel, NPL/David Elias; **109:** FLPA/Roger Wilmshurst, NPL/PS, FLPA/H D Brandl; **110:** VG/Mike Guy, Heather Angel, FLPA/R Wilmshurst,

Biofotos/Jason Venus; **111:** VG/Mike Guy, FLPA/ Buckhorn/Silvestris, NPL/Michael Hammett; **112:** AA, NPL/PS, NPL/David Elias; **113:** NPL/PS, AA, NPL/Geoff Du Feu; **114:** AA; **116:** NPL/E A Janes; **117:** AA, FLPA/E & D Hosking, NPL/PS; **118:** Ardea/Bob Gibbons, Ardea/Ian Beames, NPL/E A Janes; **119:** Ardea/John Mason, FLPA/Winfried Wisniewski, NPL/W S Paton; **120:** NPL/Frank B Blackburn, Ardea/C Knights, NPL/PS; **121:** Heather Angel, NPL/PS; **122:** AA, NPL/E A Janes, NPL/Jean Hall; **123:** NPL/E A Janes, NPL/PS, AA, NPL/Geoff Du Feu; **124:** AA; **126:** AA, NPL/PS, NPL/E A Janes; **127:** NPL/PS, NPL/Don Smith, NPL/Hugh Clark; **128:** Heather Angel, BC/Paul Van Gaalen, NPL/PS; **129:** NPL/PS, NPL/Roger Tidman, NPL/Geoff Du Feu; **130:** NPL/PS, NPL/Robin Bush; **131:** NPL/PS, NPL/E A Janes, Heather Angel; **132:** NPL/Geoff Du Feu, NPL/Robin Bush, NPL/Chris Knight; **133:** NPL/Robin Bush, NPL/Colin Carver, NPL/PS; **134:** BC/Werner Layer, NPL/PS; **135:** AA, NPL/Roger Ridman, FLPA/Roger Wilmshurst, NPL/E A Janes; **136:** NHPA/Darek Karp, NPL/Brinsley Burbidge, NPL/Jon J Wilson; **137:** NPL/E A James, NPL/Robin Bush, AA, NPL/Colin Carver; **138:** NPL/Roger Tidman, FLPA/Derek A Robinson; **139:** NPL/Andrew Cleave, NPL/PS, WP/David Tipling, NPL/E A Janes; **140:** NPL/Robin Bush, AA, Heather Angel; **141:** NPL/PS; **142:** NPL/Colin Carver, NPL/PS, Lincolnshire County Council; **143:** BC/Kim Taylor, NPL/Andrew Weston, NPL/Robin Bush, Heather Angel; **144:** V K Guy Ltd; **146:** V K Guy Ltd, NPL/PS; **147:** NPL/Heather Angel, NPL/Robin Bush, NPL/Andrew Cleave; **148:** AA, Ardea/Bob Gibbons, NPL/Robin Bush, NPL/Frank B Blackburn; **149:** AA, Heather Angel, NPL/PS; **150:** Ardea/Åke Lindau, Ardea/Eric Dragesc, AA, NPL/PS; **151:** V K Guy Ltd, NPL/W S Paton; **152:** Heather Angel, Laurie Campbell, NPL/Brinsley Burbidge; **153:** NPL/Colin Carver, NPL/Robin Bush, Biofotos/Geoff Moon, Heather Angel, NPL/Andrew Cleave; **154:** Heather Angel, NPL/Neil Wilmore; **155:** NPL/Robin Bush; **156:** AA, NPL/Robin Bush, BC/Jose Luis Gonzalex Grande; **157:** NPL/PS, AA, NPL/Len Jessup; **158:** Mark Hamblin, NPL/PS, FLPA/Michael Callan; **159:** NPL/E A Janes, NPL/Frank Blackburn, Heather Angel; **160:** NPL/PS, Heather Angel; **161:** BC/Colin Varndell, NPL/PS, NPL/Andrew Cleave; **162:** NPL/PS; **163:** NPL/PS, NPL/Robin Bush, NPL/Andrew Davies, NPL/Andrew Cleave; **164:** NPL/PS, NPL/Andrew Weston, NPL/Philip J Newman; **165:** NPL/Bringsley Burridge, AA, NPL/Philip

Newman, NPL/E A Janes; **166:** VG/Vic Guy, NPL/PS; **167:** NPL/Philip Newman, NPL/E A Janes, FLPA/M Ninmo; **168:** NPL/PS, IOM Dept of Tourism and Leisure; **169:** IOM Dept of Tourism and Leisure, NPL/PS, FLPA/J Hawkins, BC/Michael Glover; **170:** AA, NPL/Robin Bush, NPL/PS, FLPA/Silvestris; **171:** NPL/PS, NPL/Andrew Weston, Heather Angel; **172:** VG/Vic Guy, BC/John Shaw, NPL/PS, FLPA/Roger Wilmshurst; **173:** Ardea/Richard Vaughan, Ardea/John Daniels, BC/Hans Reinhard, NPL/PS; **174:** NPL/PS, AA; **175:** FLPA/John Hawkins, NPL/Andrew Weston, AA, NPL/Robin Bush, Biofotos/Brian Rogers; **176:** NPL/Brinsley Burbidge, AA, NPL/PS; **177:** NPL/PS, NPL/Jean Hall, NPL/Andrew Cleave, NPL/Mark Bolton; **178:** AA; **180:** SHPL, NPL/Brinsley Burbidge; **181:** NPL/PS, Heather Angel, FLPA/P Moore; **182:** Heather Angel, Ardea/Kennth W Fink; NPL/Andrew Cleave; **183:** Biofotos/John Heath, NPL/Robin Bush, Ardea/John Mason, NPL/PS; **184:** Ardea/Bobby Smith, Ardea/Bob Gibbons, NPL/Frank B Blackburn, FLPA/Fritz Polking; **185:** BC/Andy Purcell, NPL/Richard Mearns; **186:** NPL/David Hutton, NPL/PS, SHPL/Sue Anderson; **187:** SHPL, NPL/Dr Michael Hill; **188:** NPL/David Hutton, NPL/PS; **189:** NPL/Tony Schilling; **190:** NPL/PS, AA; **191:** NPL/PS; **192:** NPL/Philip Newman, AA, WWI/Mark Hamblin; **193:** NPL/Brinsley Burbidge, NPL/PS, Heather Angel, NPL/Andrew Cleave, FLPA/Roger Wilmshurst; **194:** NPL/Dr Michael Hill, BC/George McCarthy, Heather Angel, NPL/E A Janes; **195:** NPL/PS, BC/Antonio Manzanares, Heather Angel, NPL/Hugh Miles; **196:** AA; **197:** Heather Angel, NPL/PS, BC/Rob Jordan, NPL/Don Smith; **198:** FLPA/M B Withers, NPL/E K Thompson, Heather Angel; **199:** NPL/N A Callow, AA, NPL/PS, NPL/Len Jessup; **200:** NPL/Michael J Hammett, NPL/PS, Ardea; **201:** Heather Angel, NPL/PS, FLPA, W Wisniewski; **202:** Heather Angel, BC/Tom Schandy; **203:** NPL/PS, Heather Angel; **204:** FLPA/Michael Callan, Heather Angel, NPL/PS; **205:** NPL/Hugh Clark, NPL/T D Bonsall, NPL/Robin Bush, NPL/Philip Newman, Caledonian Partnership LIFE '94 Pinewood Project (mapping information) **206:** NPL/PS, NPL/Geoff du Feu, NPL/Robin Bush; **207:** NPL/PS, AA, BC/W S Paton; **208:** NPL/PS; **209:** BC/Konrad Wothe, Heather Angel, FLPA/F de Nooyer, NPL/PS; **210:** NPL/PS; **211:** NPL/Philip Newman, NPL/PS, BC/Alan G Potts, NPL/Michael Gore; **212:** NPL/Hugh Miles, NPL/PS, FLPA/M Callum; **213:** NPL/PS, Heather Angel, BC/Gordon

Langsbury; **257:** NPL/PS, NPL/Michael J Hammett, NPL/S C Bisserot, NPL/Andrew Cleave; **258:** NPL/Michael J Hammett, NPL/PS, NPL/Hugh Miles, NPL/S C Bisserot; **259:** NPL/PS, NPL/S C Bisserot, NPL/Michael J Hammett; **260:** NPL/Michael J Hammett, NPL/PS; **267:** NPL/PS, NPL/Roger Tidman, NPL/Chris Gomersall, NPL/E K Thompson, NPL/Geoff Du Feu; **268:** NPL/PS, NPL/Nicholas Phelps Brown, NPL/S C Bisserot; **269:** NPL/PS, NPL/Geoff Du Feu, NPL/Michael J Hammett; **270:** NPL/Nicholas Phelps Brown, NPL/PS, NPL/S C Bisserot, NPL/N A Callow, NPL/Geoff Du Feu; **271:** NPL/PS, NPL/Hugh Clark, NPL/Frank B Blackburn, NPL/Idris Bowen, NPL/N A Callow, NPL/Nicholas Phelps Brown, NPL/S C Bisserot; **272:** NPL/Geoff Du Feu, NPL/PS, NPL/Tony Wharton, NPL/N A Callow, NPL/K Blamire, Premaphotos/K G Preston-Mafham; **273:** NPL/Geoff Du Feu, NPL/PS, NPL/Idris Bowen, NPL/N A Callow, NPL/Nicholas Phelps Brown; **274:** NPL/PS, NPL/S C Bisserot; **275:** NPL/PS, NPL/Andrew Cleave, NPL/S C Bisserot, NPL/Don Smith; **276:** NPI / PS, NPL/Andrew Cleave; **277:** NPL/PS, NPL/S C Bisserot, NPL/Nicholas Phelps Brown; **278:** NPL/Jean Hall, NPL/PS, NPL/S C Bisserot, NPL/Andrew Cleave; **279:** NPL/Frank B Blackburn, NPL/David Osborn, NPL/Andrew Cleave, NPL/Brinsley Burbidge, NPL/E A Janes; **280:** NPL/PS, NPL/Andrew Cleave, NPL/E A Janes, NPL/Brinsley Burbidge, NPL/Andrew Davies; **281:** NPL/PS, NPL/E A Janes, NPL/Andrew Cleave, NPL/Frank B Blackburn, NPL/Brinsley Burbidge; **282:** NPL/PS, NPL/Brinsley Burbidge, NPL/Andrew Cleave, NPL/Andrew Weston, NPL/E A Janes **309:** NPL/PS, NPL/Lee Morgan, NPL/E A Janes, NPL/Jean Hall, NPL/Andrew Cleave; **310:** NPL/Andrew Cleave, NPL/PS, NPL/Brinsley Burbidge, NPL/Jeff Watson, NPL/David Elias; **311:** NPL/E A Janes, NPL/PS, NPL/J Russell, NPL/Brinsley Burbidge, NPL/Robin Bush, NPL/Jeff Watson, NPL/David Elias; **312:** NPL/PS, NPL/Andrew Cleave; **313:** NPL/David Osborn, NPL/Robin Bush, NPL/PS, NPL/E A Janes; **314:** NPL/Robin Bush, NPL/PS, NPL/Frank B Blackburn, NPL/Len Jessup; **315:** NPL/Brinsley Burbidge, NPL/PS, NPL/Frank B Blackburn, NPL/Robin Bush, NPL/E A Janes;

AA = AA Photo Library; BC = Bruce Coleman; FLPA = Frank Lane Picture Agency; NPL = Nature Photographers Ltd (PS = Paul Sterry); SHPL = Scottish Highland Photo Library; WP = Windrush Photos; WWI = Woodfall Wild Images